RENOIR
HIS LIFE, ART, AND LETTERS

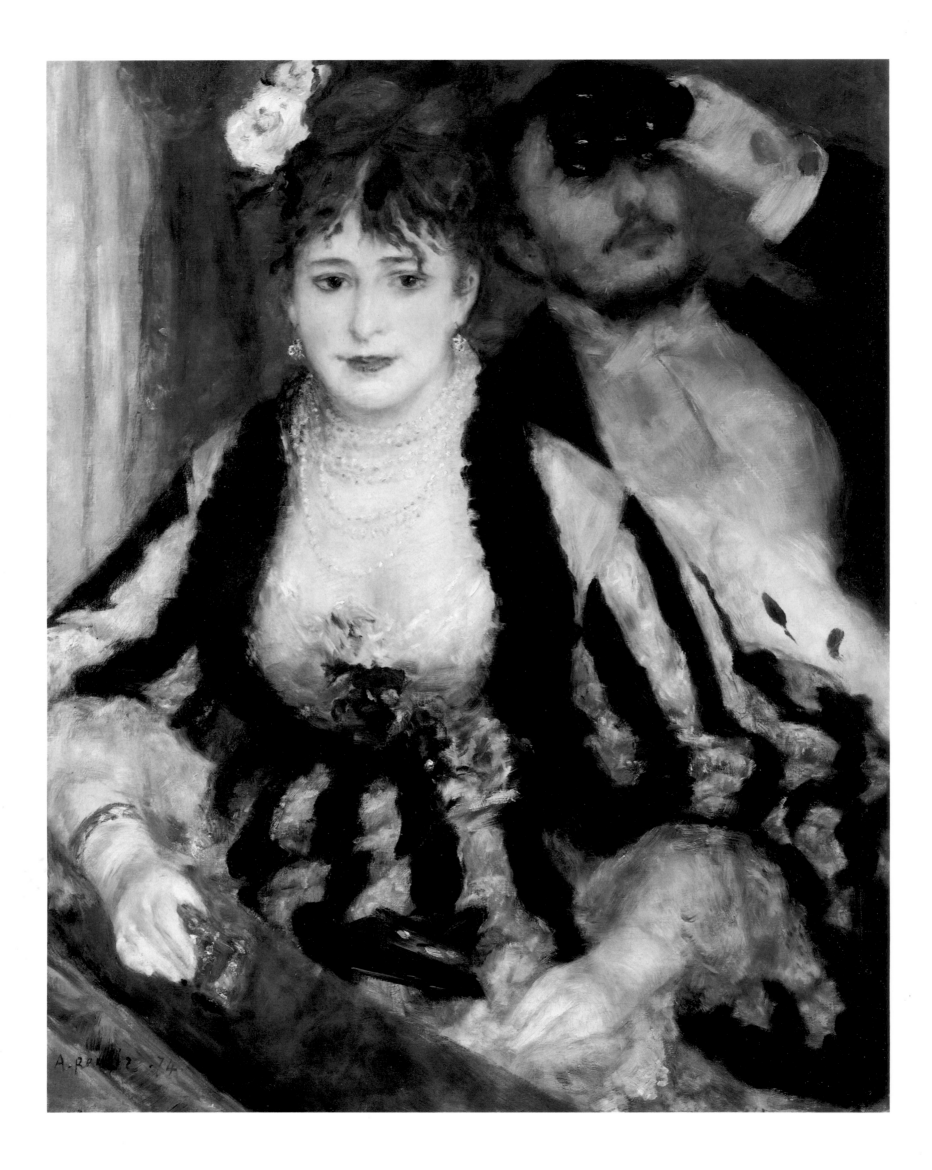

BARBARA EHRLICH WHITE

RENOIR
HIS LIFE, ART, and LETTERS

HARRY N. ABRAMS, INC.
PUBLISHERS, NEW YORK

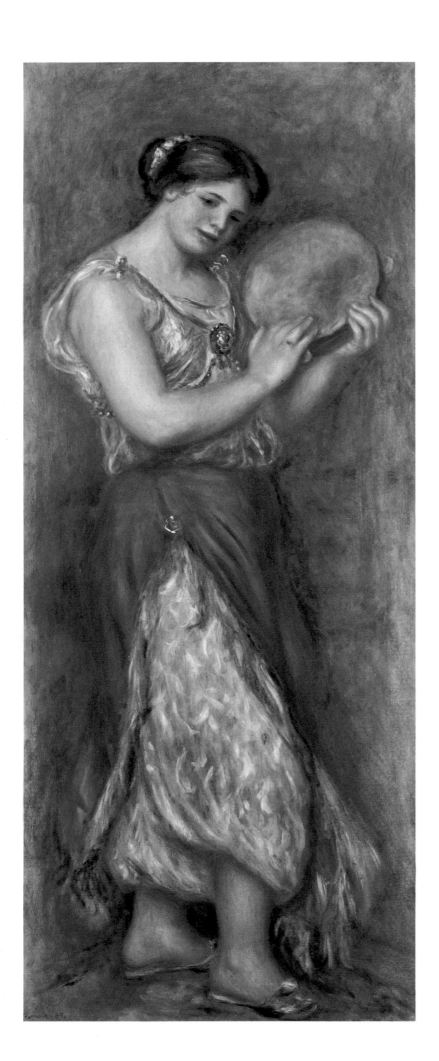

PAGE ONE:
Alexander Thurneyssen as a Shepherd

PAGE TWO:
La Loge

PAGE FOUR:
Dancer with Tambourine

PAGE FIVE:
Dancer with Castanets

PAGE SIX:
The Artist's Son Jean Drawing

PAGE EIGHT:
The Swing

PAGE TEN:
Bather Arranging Her Hair

EDITOR: Phyllis Freeman
DESIGNER: Judith Michael
RIGHTS AND REPRODUCTIONS: Eric Himmel

Translations from the French by John Shepley,
with Claude Choquet

LIBRARY OF CONGRESS CATALOGING IN PUBLICATION DATA
White, Barbara Ehrlich.
Renoir, his life, art, and letters.

Bibliography.
Includes index.
1. Renoir, Auguste, 1841–1919. 2. Painters—France—Biography.
I. Renoir, Auguste, 1841–1919. II. Title.
ND553.R45W452 1984 759.4 [B] 84-406
ISBN 0-8109-1555-3

CONTENTS

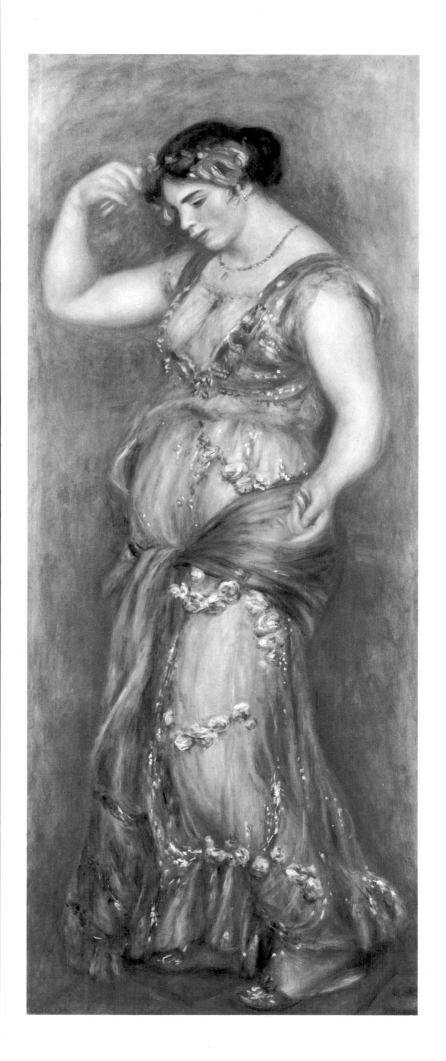

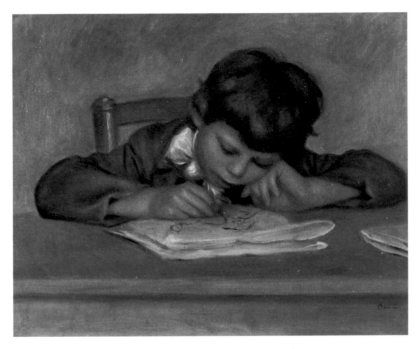

*To my husband, Leon, who has patiently and selflessly encouraged
my Renoir work throughout the past twenty-three years.
He was always available to provide emotional support, and his
analytical thinking helped me to unravel many complex problems.
Without him, this book would never have come to fruition.
To our sons, Joel and David, who have cheered me on
to complete this undertaking*

PREFACE

THIS BIOGRAPHY assumes that there is a significant connection between the changes in Renoir's life circumstances, ideas, attitudes, and feelings and the transformations in his themes, figure types, treatments of form, and styles. By juxtaposing Renoir's words and the words of his friends and critics (most in English for the first time) with his work from the same year, we can find links between changes in his life and innovations in his art that offer a new basis for understanding how and why his art evolved as it did.

The relationship between life and art shifted over time from parallelism to compensation. When Renoir was a young, outgoing Paris bachelor, he painted his most innovative and original paintings of modern life, where men and women socialize in the urban democratic society of the restaurants and dance halls. From youth to middle age, he changed from being a leader of the avant-garde to an independent artist who worked in a conservative manner. When he was middle-aged and poor, he became a father. Often he was isolated from his friends in the provinces; occasionally he became depressed. He painted private, domestic, timeless, and classless themes such as nudes and mothers and children in a rural setting. Although he still attempted to paint joyful and relaxed people, they appear rigid and isolated, self-conscious and affected. When he was old and ill, and had won financial, critical, and popular success, he regained a gregarious life style and an optimistic attitude, which is reflected in his scenes of bathers and mothers and children and in his portraits. As he became more emaciated, immobilized, and weak, his art seemed to compensate for his physical deterioration: his figures became heavier, more active, and more sensuous.

The transformations throughout Renoir's lifetime as well as external events affected the course of his artistic development. These complex and shifting influences include: aging, health, mental attitude, fatherhood and marriage, financial situation, social status, attitude toward success, friends, dealers and patrons, critical reception, travels, as well as the avant-garde, the taste of the buying public, the political and economic situation in France, and the influence of traditional and contemporary art.

There is no lack of recollections of Renoir. After the artist's death, many of his friends and his son Jean wrote colorful, anecdotal accounts of his life and art.[1] Because these memoirs and biographies are based not on letters and reviews, but on each writer's memory of long-ago events, it is not surprising that they contradict one another about facts and about Renoir's opinions and motives, thoughts and feelings. Furthermore, they present different interpretations of the course of his development and different definitions of his Impressionism, Classicism, and Realism.[2] Although these memoirs are often amusing, this biography does not use recollections and witness accounts. Instead, Renoir's life story is here based exclusively on primary source materials in order to provide a new, intimate understanding of the artist, his work, and his creative process.

Among the many books about Renoir, there is no anthology of his letters. Furthermore, of a projected multivolume catalogue of his work, only one volume has appeared—the figure paintings of 1860–90 —comprising in all only 646 works. Consequently, my first goal was to locate Renoir's letters and other writings as a means of separating the legend of the artist from the reality of the man. Since 1961, I have located 977 letters, published statements, and interviews by Renoir in 88 different sources: 447 letters published in 38 books and articles, 213 unpublished letters in 30 libraries, museums, and private collections, and 317 excerpts in 20 catalogues of autograph dealers and auction houses.

The search also extended to unearthing other primary sources: letters from his friends and family, diary entries, government documents, contemporary reviews of his art, and data about his exhibitions and sales, as well as photographs of the works and the principal people in Renoir's life. This sleuthing enabled me to establish dates for undated letters and paintings. Sometimes a letter helped date a painting; sometimes a painting helped date a letter.

My hope is that this biography will suggest links between life and creativity that will engage today's reader and will challenge others to explore further how life and art are intertwined.

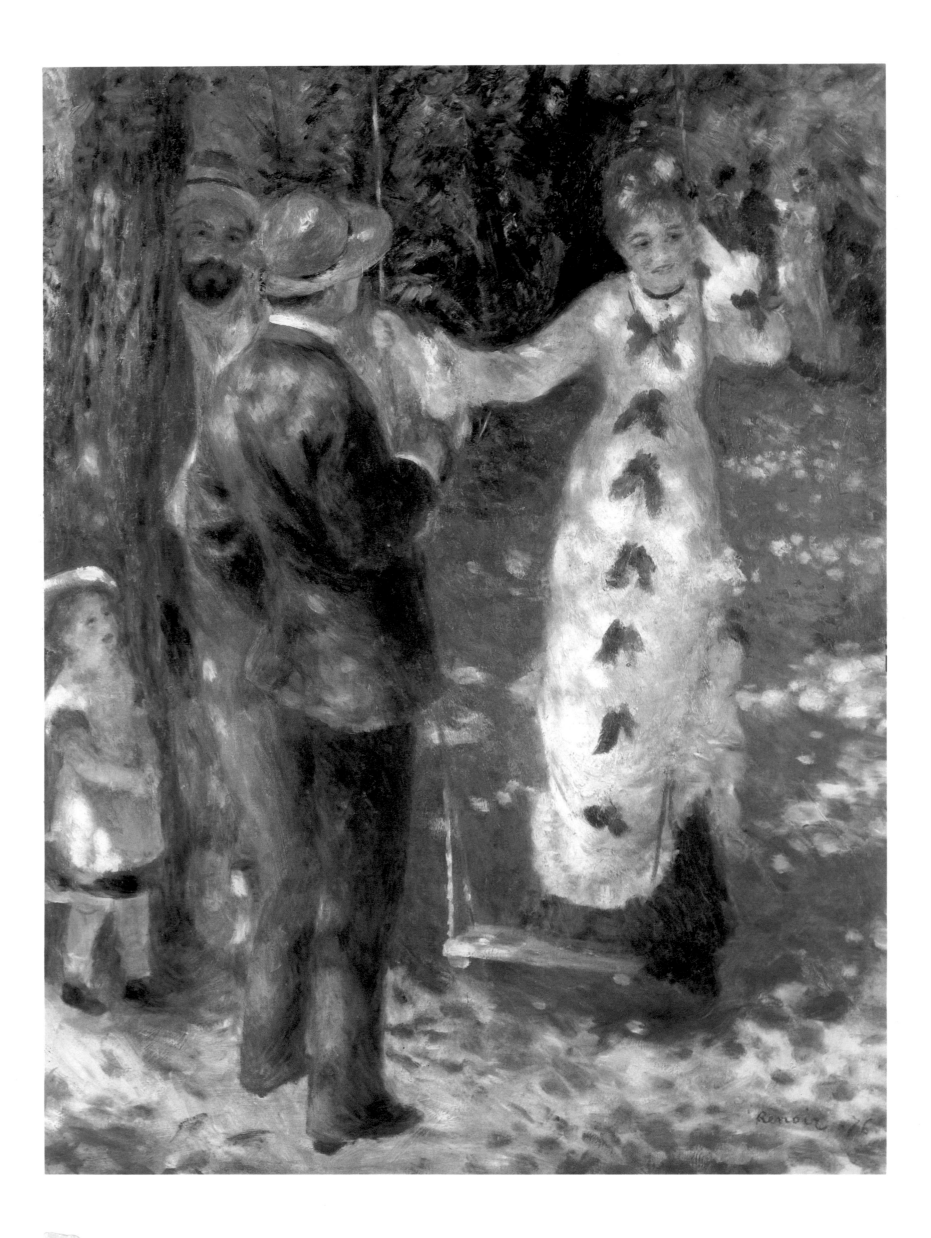

ACKNOWLEDGMENTS

I WOULD first like to thank Meyer Schapiro, who steered me into Renoir research in 1961. As my dissertation adviser at Columbia University during the Ph.D. years until 1965, Schapiro opened my eyes to the relationships between Renoir's life and art as a means of investigating how and why his work evolved as it did. His Impressionist course (with its seminal Renoir lecture) was the foundation for all my Renoir work. Schapiro's brilliance, creativity, and passionate love of art and history have been a constant source of inspiration. Always generous with information, ideas, and assistance, he has been the ideal mentor.

Theodore Reff's excellent course at Columbia "Modern Art and Tradition" provided a valuable background for the study of Renoir. He has been a model of rigorous scholarship.

Five works were extremely important for this study: François Daulte, *Auguste Renoir: Catalogue raisonné de l'oeuvre peinte, figures 1860–90* (1971); Michel Drucker, *Renoir* (1944); Sophie Monneret, *L'Impressionnisme et son époque* (1978–81); John Rewald, *The History of Impressionism* (1973); and the Durand-Ruel publication, Lionello Venturi, *Les Archives de l'Impressionnisme* (1939).

This book could not have been published without the permission of the Renoir heirs—Mrs. Jean Renoir, Claude Renoir, and Paul Renoir. Each is warmly thanked.

My gratitude goes to people who were helpful in my search for letters and for works of art and to those who offered valuable assistance. I am indebted to those who allowed me to print unpublished letters from their personal collections or from institutions for which they were responsible. I also appreciate the permission to reproduce already published letters and works of art. Each of the following is sincerely thanked, as are those people who preferred to remain anonymous: Bill Acquavella, Hélène Adhémar, Georges Alphandéry, Henriette Angel, Annie Angremy, Roseline Bacou, Rutgers Barclay, P. M. Bardi, Germain Bazin, Frances E. L. Beatty, Alain Beausire, Maurice Bérard, Jacqueline Georges Besson, F. Bibolet, Jean Bonnafous, Annie Brugère, Ken Buchanan, Christopher Burge, Herbert Cahoon, François Chapon, the late Denis-Jean Clergue, Shelagh Coogan, Pierre Courthion, Guy-Patrice Dauberville, François Daulte, Jean-François Denis, Ronald Drauschke, Marguerite Dubuisson, Ellen S. Dunlap, Charles Durand-Ruel, Georges Dussaule, Richard L. Feigen, Peter Findlay, Michel Florisoone, Willa Foch-Pi, Donald Gallup, Philippe Gangnat, D. Gazier, Jean V. Gimpel, H. Spencer Glidden, Gilbert Gruet, Jelena Hahl, Stephen Hahn, John Hanlin, Carlos van Hasselt, William Hauptman, Martine Hautebert, Daphne Hoch, Werner Hofmann, Ay-Whang Hsia, Anahid Iskian, Jules Joëts, Diana Hamilton Jones, Claudie Judrin, Rose Kissel, James Lawton, L. Longequeue, Cecile Mandrile, J. Patrice Marandel, Madeleine Marcheis, Jeff Marsh, Violette de Mazia, Patrick Mehr, David Nash, Robert Nikirk, Mrs. Walter Pach, Isabelle du Pasquier, Roger Pierrot, Geneviève Ravaux, Christian Renaudeau d'Arc, Alain Renoir, the late Edmond Renoir, Jr., Claude Richebé, Alexandre P. Rosenberg, Denis Rouart, the late Julie Manet Rouart, Agathe Rouart-Valéry, C. A. Ryskamp, Anne de Sainte-Phalle, Marcel Schneider, Maurice Sérullaz, Pierre F. Simon, John L. Slade, P. Stouvenot, John Tancock, Nicole Villa, and Eddie Wolk.

I would like to express my appreciation to the following autograph dealers, galleries, and auction houses: Mary Benjamin of Walter R. Benjamin, Pierre Berès, Thierry Bodin, Michel Castaing of Charavay, R. L. Davids of Sotheby Parke Bernet, Lucien Goldschmidt, Charles Hamilton, Kornfeld & Co., Jacques Lambert, Bernard Loliée, Marc Loliée, Maggs Bros., G. Morssen, J. Naert of Cabinet Henri Saffroy, J. H. Pinault of the Librairie de l'Abbaye, Mme. Privat, Nicholas Rauch, The Rendells, J. A. Stargardt, Swann, and J. Vidal-Mégret of the Hôtel Drouot.

I am grateful to those institutions that awarded me grants, enabling me to pursue my research: The National Endowment for the Humanities, the Samuel H. Kress Foundation, and Tufts University.

Friends who were particularly supportive during the long haul and who deserve special mention include Pat Brennan, Lucille Gerbaut, Claudine Godot, Lucretia Slaughter Gruber, Patricia Iannuzzi, Ruth Ice, Linda Krimsley Lechner, Arnelda Levine, Blanche B. MacKenzie, Janet Mechanic, Christiane Petite, and all of my wonderful friends in the writers' support group.

I greatly appreciate the constructive suggestions made by various people who read the manuscript: Leon S. White, Meyer Schapiro, Gabriel P. Weisberg, Albert Elsen, Anne Gibson, Ruth Ice, and Ann Mochon.

At different stages throughout the three years of writing this book, six people were particularly important: Elizabeth Gleason Humez and Robin Bledsoe were skillful and conscientious in helping me in the difficult task of transforming a 900-page manuscript into a 300-page book. Anne Gibson, Regina Fraser, and Caroline Cornell Guion were intelligent, loyal, and industrious assistants. My agent, John Hochmann, was unfailingly supportive, attentive, and helpful throughout the long process.

Finally, I would like to thank the many individuals at Harry N. Abrams, Inc., who assisted me in this project. My editor, Phyllis Freeman, made many important suggestions for the book. Skillfully, she smoothed the flow of words and ideas to integrate life, letters, and art in a seamless manner. The translator, John Shepley, did a beautiful job of capturing the nuances and argot of late nineteenth—early twentieth-century French prose. Eric Himmel was extremely conscientious and painstaking in ferreting out illustrations from sources throughout the world. Judith Michael did an exquisite job on the book design. Jennifer Rogers and Larry Adamo are also to be warmly thanked, as are Paul Gottlieb, president of Abrams, and Margaret Kaplan, senior vice-president.

Tufts University, 1984

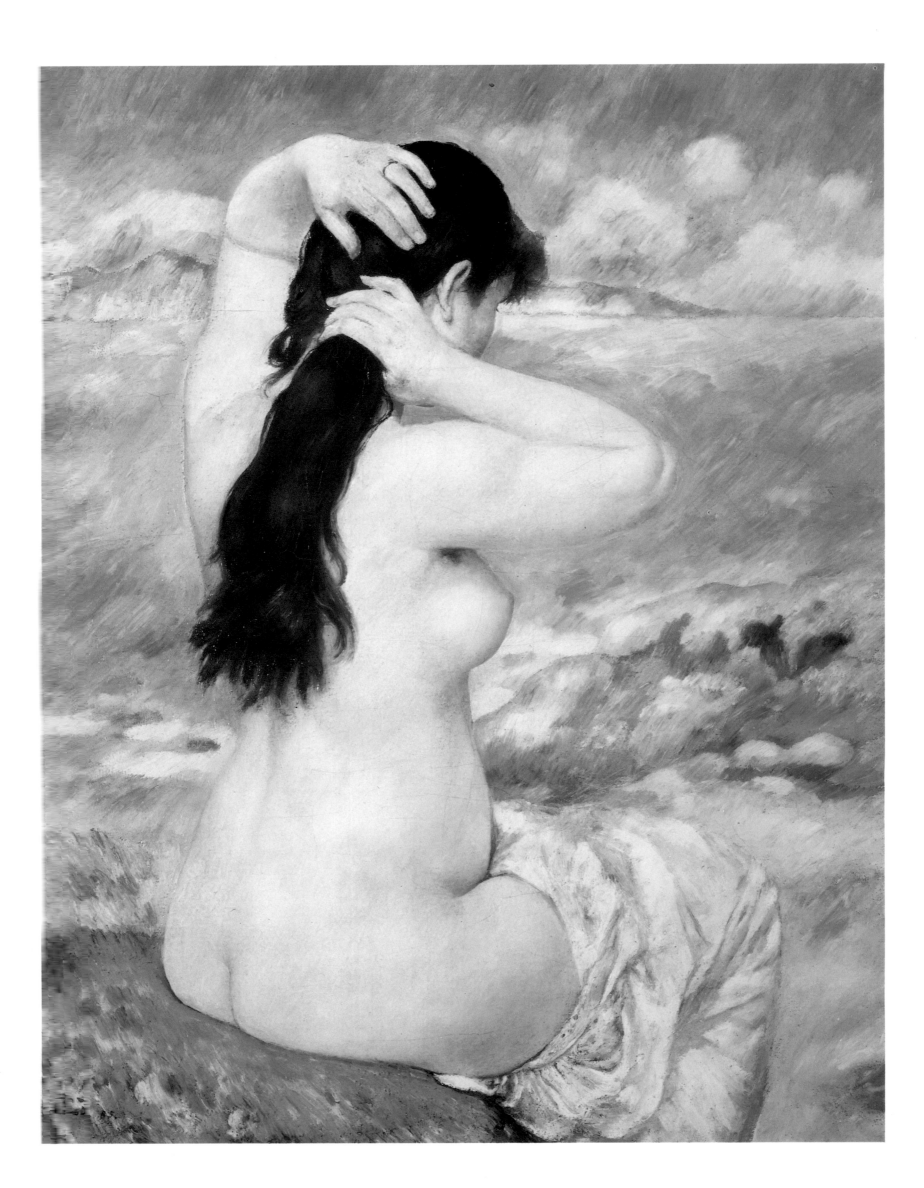

RENOIR
HIS LIFE, ART, AND LETTERS

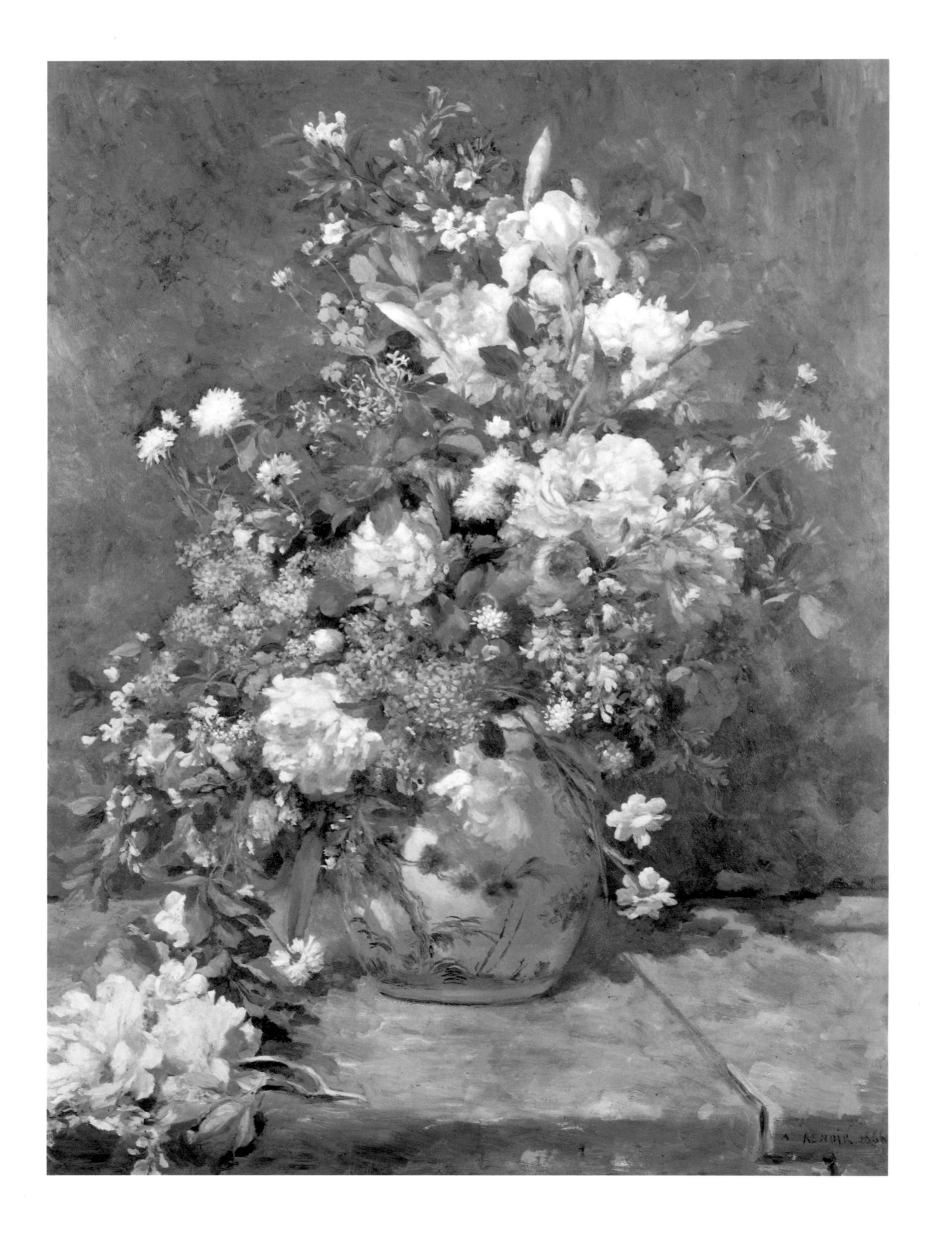

AT THE TIME of Renoir's birth, February 25, 1841, France had been ruled for nearly eleven years, since the "July days" of 1830, by Louis-Philippe, who had seized power with the backing of liberal factions. His early rule betrayed his ineptness, particularly in foreign affairs—despite the undeniable achievement of the conquest of Algeria for France. But his faltering grasp of domestic policy was still more dangerous. Since the 1820s, France had been in a period of rapid industrialization—its own Industrial Revolution—and the deplorable factory conditions denounced by Marx and Engels and native-born Socialists such as Proudhon (whose *Qu'est-ce que la propriété?*, an attack on the notion of private property, appeared in the very year of Renoir's birth) generated an underclass of discontented factory workers, whose problems have not yet been solved to this day. Crop failures all over Europe in 1846 drove prices up and touched off a widespread depression. Having refused to extend suffrage to the propertyless, Louis-Philippe compounded his doom by failing to neutralize the insurrection in June 1848 of unemployed urban and rural workers. Not only was 1848 the year when *The Communist Manifesto* was published, it was the year when revolution blazed all over Europe, and in France it swept Louis-Philippe off his throne. To replace this last of the royal line to rule in France, a nephew of Napoleon's—who had twice failed to overthrow Louis-Philippe—presented himself as a candidate for president of the Second Republic. He rode to victory on his uncle's coattails. From this post, Louis Napoleon managed to circumvent the prohibition against reelection and with the aid of a carefully staged plebiscite, had himself named Napoleon III, emperor of the French.

He proved to be an unexpectedly enlightened despot. He sponsored expansion of the railroad system radiating out from Paris, begun under his predecessor, modernization and enlargement of instruments of credit for commerce, recognition of trade unions, improvement of ports and canals, extension of suffrage, and public education. Had it not been for foreign disasters, he might have been remembered with few cavils. And his empress, the beautiful Eugénie, was, in many quarters, a significant asset. However, his involvement in the Italian wars proved inglorious, and his foolhardy plan to install the Austrian archduke Maximilian as emperor of the Mexicans terminated after four woeful years with his protégé's execution in 1867.

The final blow to Napoleon III's regime came with the French declaration of war on Germany, July 19, 1870. Two months later Napoleon himself was taken prisoner, and with the end of the war, in January 1871, Napoleon's reign also came to an end.

For the Renoir family, a tailor, his wife, and four children, in Limoges—a city about 300 miles southwest of Paris famous above all for

A Large Vase of Flowers. d. 1866. 41¾ x 32″. The Fogg Art Museum. Harvard University, Cambridge, Mass. Bequest of Grenville L. Winthrop

its porcelain—the shaky economy of the region prompted a move to Paris in 1845.

The Renoirs' beginnings in Limoges had been simple. Pierre-Auguste's paternal grandfather, François, a foundling born in 1773, made wooden shoes. In 1796, he married Anne Regnier, daughter of a carpenter; both were illiterate. The couple had nine children. Renoir's father, Léonard, a tailor, was born in 1799. In 1828, he married Marguerite Merlet, a twenty-one-year-old seamstress. Neither had much education beyond reading and writing.

No brothers or sisters were near Auguste in age: two had died in infancy.[1] When Auguste was born, Pierre-Henri was eleven, Marie-Élisa seven, and Léonard-Victor five; Edmond was born eight years later. Thus Auguste was the "baby" of the family for the longest span of time.

Soon after the Renoirs settled in the center of Paris, Auguste began to attend a free, state-run Catholic school. Two years later, when he was nine, he joined Charles Gounod's choir at the Église St.-Eustache and received voice lessons from the master. At fifteen, his schooling was over, and "my worthy brother was thus obliged to learn a trade that would bring him a living later on. From the fact that he would use up ends of charcoal on the walls, they concluded that he had a bent for an artistic profession. Our parents therefore placed him with a painter of china."[2] Thus in 1879, Edmond Renoir, who had become a journalist, described his brother's earliest attempts at art. Renoir was apprenticed to the Lévy brothers, in the rue des Fossés-du-Temple, in Paris. Copying was part of his assignment, and his earliest known works are pencil copies of decorative motifs of birds, flowers, and musical instruments. These were followed by painted embellishments of plates, teapots, and vases, whose motifs sometimes included nudes. This training during his formative years gave Renoir a lifelong respect for the craftsmanship of painting. "When the day was over," Edmond continued, "equipped with a portfolio bigger than himself, he would go to attend free courses in drawing.... Among the workmen, there happened to be a nice old gentleman whose passion was to do oil painting at home: perhaps happy to have a pupil, he offered to share with the youngster his supply of canvases and paints."[3]

Renoir was also teaching himself painting and drawing by copying masters of the past. On January 24, 1860, at nineteen, he registered for a year's pass to copy paintings at the Louvre, and did so for the next three years; the last permit is dated April 9, 1864. Two oil copies made during this period are of Rubens's *Enthronement of Marie de Medici* and the central part of his *Portrait of Helena Fourment with Her Son.* An early allegorical painting of Venus exhibits the same Baroque spirit found in his copies.

By the age of twenty, Renoir's talent had displayed itself so unmistakably that he left the china factory and enrolled as an art student.[4] He entered the studio of Charles Gleyre. The exact date that Renoir

Copy of the Central Part of Rubens's Portrait of Helena Fourment with Her Son.
1860–64. 28¾ x 23¼". Private collection

Vase. 1857. Oil on bronze-mounted porcelain, height 11¾".
Private collection

Venus and Love (Allegory). 1860. 18⅛ x 15". Private collection

Copy of Rubens's Enthronement of Marie de Medici. 1860–64. 16⅞ x 31⅞".
Private collection

began at Gleyre's is not known; however, in October 1861, he identified himself as a "student of Gleyre" in applying for permission to use the print room of the Imperial Library to copy engravings.[5] He remained in Gleyre's classes for the next two and a half years.

In attending the state-run École des Beaux-Arts, Renoir followed the traditional route to training and publicizing himself as an artist. Gleyre's was one of the oldest and most esteemed studios at the École; it had been established by Jacques-Louis David, who was succeeded by Baron Gros, and later by Paul Delaroche. Gleyre's instruction was aimed at preparing his students to submit works to the official Salons, the government-sponsored art exhibitions held in Paris each April at the Palace of Industry. France's thousands of professional painters were invited to submit up to three paintings each to a jury composed of academicians and elected officials.[6] The jury chose the works to be shown, decided where they would be hung, and awarded prizes and medals. In essence, the Salon provided a consumer's guide to current painting. Art critics wrote about the works on view. Prospective buyers—collectors and delegates from the government—read what the critics wrote and came to the Salons. Prices for purchases and commissions were based on the ratings of the Salon jury and the opinions of the critics. In Paris, as is usually the case with government-sponsored taste, the tenor was conservative, and acceptance of anything novel was cautious. Private buyers were no more open-minded. Even as late as 1882, Renoir wrote: "There are hardly fifteen connoisseurs in Paris capable of liking a painter without the Salon. There are 80,000 of them who won't even buy a nose [of a portrait] if a painter is not in the Salon."[7]

Despite the entrenched status of Gleyre's studio, he did not hew entirely to standard practice. Unlike many other masters, he charged his students a modest ten francs a month for the classroom rent and models' fees without adding any charges for his teaching. Also, he provided academic discipline without stifling originality. What he taught was the craft of painting: drawing from plaster casts and studio models and copying bas-reliefs, prints, and oil paintings. And he was "modern" enough to encourage his students to paint landscape studies out-of-doors.

Gleyre's teaching had a lifelong influence on Renoir, who identified himself as late as the Salon of 1890 as a "student of Gleyre." Gleyre stressed the importance of composition as the framework for painting. He insisted that painted studies of the general effect—the overall relationships between light and dark values, on an elaborate scale of gradations—be made first; then drawings of individual details could be worked out to be traced onto the primed canvas. He also revered the color ivory black.[8]

Gleyre's teachings stayed with Renoir throughout his life: his method was often traditional, his compositions were ordered, and although he did not use black for shadows, he occasionally used it as a color, as it is in nature. In addition, Renoir retained in some degree the impress of Gleyre's style—Academic Realism, a mode that in the 1860s was popular both at the École des Beaux-Arts and at the Salons. The subject matter of Academic Realism included literary (often Oriental or Classical themes) and historical narratives, as well as nudes and portraits. Gleyre's *Hercules at the Feet of Omphale,* for example, tells a story from Greek legend; the near-photographic realism and slick execution produce a theatrical "you are there" effect. One of the prime sources for the subjects and manner of the academic artists of the 1860s was the great painter Jean-Auguste-Dominique Ingres. However, these epigones had none of Ingres's brilliant originality or stylistic uniqueness.

15

Of this period of training, Renoir recalled: "I was an extremely hard-working student; I ground away at academic painting; I studied the classics, but I did not obtain the least honorable mention, and my professors were unanimous in finding my painting execrable."[9] His account is corroborated by the results of seven competitions in drawing and painting from April 1862 through April 1864. The assignments included drawing in perspective the four gradients of an ancient temple, rendering "Ulysses at the House of Alcinous," and painting "Joseph Sold by His Brothers." Renoir once placed tenth out of ten; his best showing was tenth out of one hundred six.[10]

Charles Gleyre. *Hercules at the Feet of Omphale.* d. 1863. 56½ x 42⅞".
Musée d'Art et d'Histoire, Neuchâtel

Jean-Auguste-Dominique Ingres. *Jacques-Louis Leblanc.* 1823. 47⅝ x 37⅝".
The Metropolitan Museum of Art, New York. Wolfe Fund. Catherine Lorillard
Wolfe Collection

In October and November 1862, after Renoir had been in Gleyre's studio for at least a year, three new students enrolled: Claude Monet, twenty-two years old, from Le Havre; Alfred Sisley, twenty-three, born in Paris but recently returned from London; and Frédéric Bazille, twenty-one, from Montpellier. The four became friends and began an association that was to provide Renoir with much of his psychological, material, and artistic support for the next twenty-two years.

In 1863, through Monet, the "Gleyre group" met Camille Pissarro, aged thirty-three, and twenty-four-year-old Paul Cézanne, who were both studying at the Académie Suisse.[11] At Eastertime, the four Gleyre students went to Fontainebleau Forest, a short distance from Paris, to paint landscapes. As Edmond Renoir wrote in 1879:

In those days, even more than now, art students would go in a group to swoop down on the forest of Fontainebleau; they didn't have their studios there like today—that was an unknown luxury–; the inns of Chailly, Barbizon, or Marlotte would welcome them all, well-known and unknown, and they would go and work outdoors with their knapsacks. This is where my brother met [Gustave] Courbet, who was the idol of the young painters, and Diaz [Narcisse Diaz de la Peña], who won their admiration to an even higher degree. It was Diaz who gave him the best lesson he may ever have received in his life; it was Diaz who told him that "no self-respecting painter should ever touch a brush unless he has his model before his eyes."

This axiom remained deeply engraved on the beginner's memory. He told himself that flesh-and-blood models were too expensive and he could get some on much better terms, the forest being there and ready to let itself be studied at one's leisure. He stayed there for the summer, he stayed there for the winter, and for years. It was by living in the open air that he became an open-air painter. The four cold walls of the studio did not weigh on him; the gray or brown uniformity of the walls did not dull his eye; also the surroundings have an enormous influence on him; not having any memory of the servitude to which artists too often submit, he lets himself be carried away by his subject and above all by the milieu in which he finds himself.[12]

Monet was the first of the four to complete a landscape "entirely executed from nature," out-of-doors; he sent it to Bazille October 14, 1863.[13] Renoir soon adopted this new procedure. Actually, the year before Renoir had already begun to paint partly outdoors in the first of his open-air genre, or daily life, scenes—*Return of a Boating Party.* It anticipates the holiday outing theme that appeared countless times in Impressionist works several years later: figures in contemporary dress take down the sails, chat, and enjoy a free sociability in a sun-filled, happy scene.

Early in 1864, there were hints that the pattern of student life was about to be shattered. Bazille wrote his father: "M. Gleyre is quite sick, it seems that the poor man is in danger of losing his eyesight, all his pupils are very sad, for he is well liked by all those who know him. The studio itself is sick, I mean it is short of funds.... At any rate, we will still hold on for six months, since we have two terms paid in advance." Later Bazille reported: "M. Gleyre is better, the studio is still sick."[14] It soon closed.

In the spring of 1863, even before this definitive end to his student days, Renoir had submitted a canvas to the Salon for the first time. We do not know what it was, but we know that it was rejected. The next spring, however, a work was accepted. The catalogue states: "Renoir (Pierre-Auguste), born in Limoges. Pupil of Gleyre, 23 rue d'Argenteuil [his parents' address], no. 1618 *Esmeralda* dancing with her goat around a fire that illuminates a whole crowd of vagabonds." The painting, which has not survived, illustrated a scene from Victor Hugo's popular novel *Notre-Dame de Paris.* Renoir's effort to make his reputation as a narrative painter brought neither an award nor critical attention.

In 1865, Renoir's address changed—and with it his lifestyle. Arthritis had so advanced in his father's legs that he had to give up his shop;

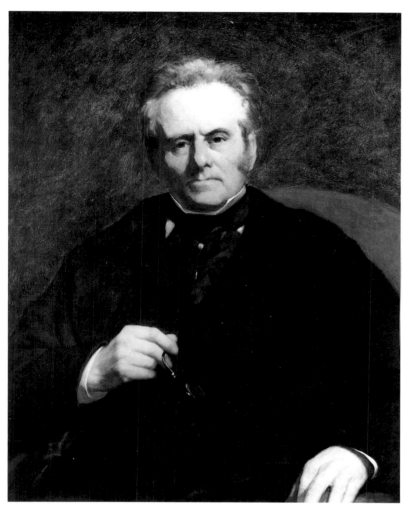

William Sisley. d. 1864. 32 x 26″. Musée d'Orsay, Galerie du Jeu de Paume, Paris

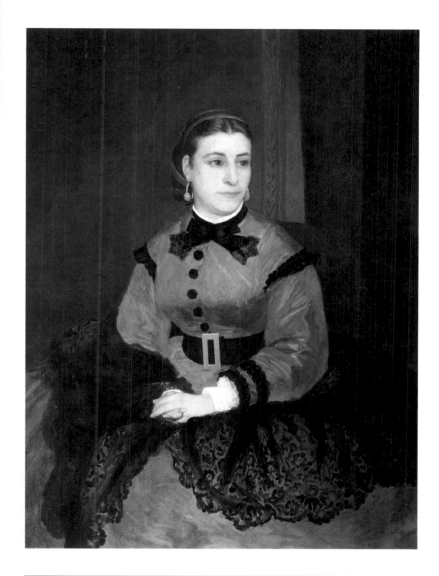

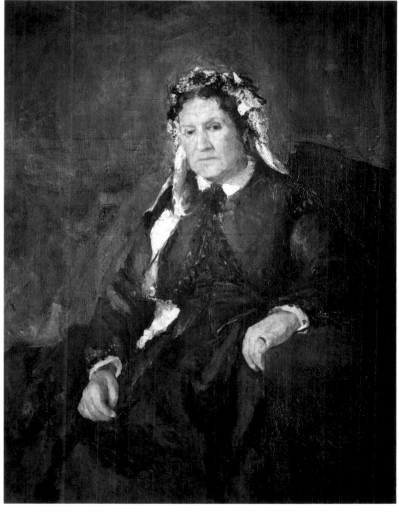

he and his wife moved to Ville-d'Avray, a suburb southwest of Paris. From time to time, their son stayed with them, but more often he lived with his friends and shared their studio space in the open-door bohemian way practiced by artists and young people before and after Renoir.

Although Renoir was receiving some commissions, they did not provide enough money to live on. Now he began to cultivate artists, patrons, and dealers who had money and good connections, as well as esteem for his art and a desire to help him; until he was almost fifty he depended upon such benefactors. They were his close personal friends; they welcomed him into their city and country homes as they would a member of their own family. They gave him money to buy paints and canvases. They commissioned portraits of themselves and of their children and ordered paintings and murals for their homes. They helped him to obtain other commissions. Renoir served them as a charming, warm, good-natured companion and gave them the pleasure of believing they were nurturing a genius.

In addition, he developed even closer friendships with the "Gleyre group." Renoir and Bazille were primarily figure painters; Monet, Sisley, and Pissarro primarily landscapists. They admired each other's

RIGHT, ABOVE:
Mlle. Sicot. d. 1865. 45¾ x 35¼. The National Gallery of Art, Washington, D.C. Chester Dale Collection

RIGHT:
Mme. Joseph Le Coeur. 1866. 45⅝ x 34¼″. Musée Municipal, Limoges

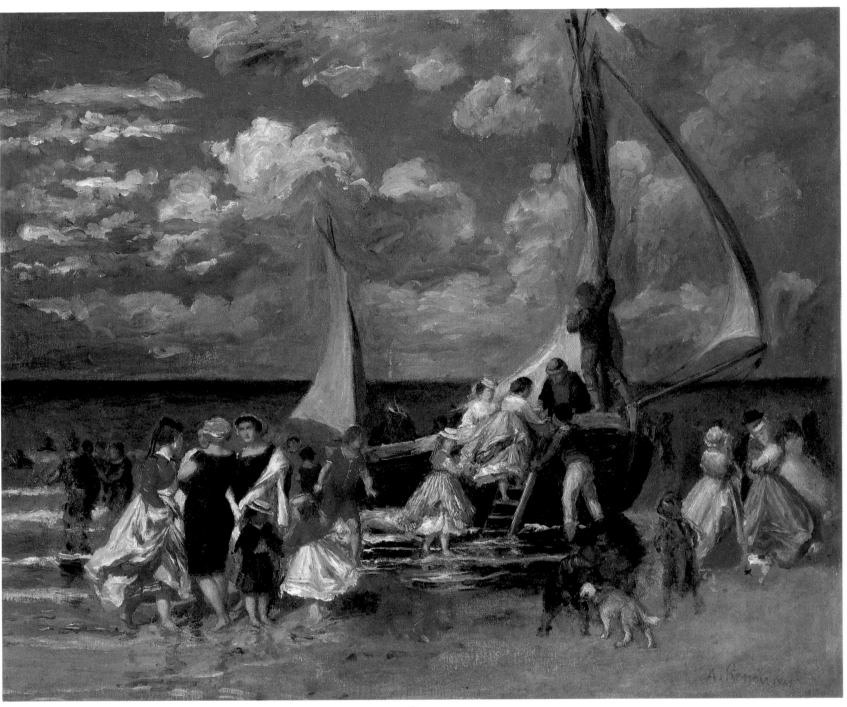

Return of a Boating Party. d. 1862. 20 x 24".
Collection Mr. and Mrs. Maxwell Cummings, Montreal

paintings. Often working in pairs, they painted one another and shared models.

Renoir painted in two distinct modes for the six years after Gleyre's studio closed, in mid-1864, until the Franco-Prussian War in mid-1870. Commissions and works for the Salon tended to be posed portraits or nudes, painted in a style that is formal, eclectic, and realistic. For example, in 1864, he painted a life-size portrait of Alfred Sisley's father, William, who was a prosperous importer of artificial flowers. The almost-photographic quality of this imposing image closely resembles Ingres's style of portraiture in its smooth, finished surface and attention to details. The frozen pose and serious demeanor give weighty dignity to the sitter. And indeed the *William Sisley,* exhibited under the title *Portrait of M. W. S. . . ,* was accepted at the Salon of 1865 (along with a now-lost figure study or landscape, known only through its title, *Summer Evening*). Other canvases done on commission or in hope of sale, such as the large *Arum and Conservatory Plants,* are in

this same detailed, realistic style. In contrast, in works destined for his friends, such as the portrait of a fellow artist, Émile-Henri Laporte, the small, intimate canvas is loosely executed, and Renoir catches his friend in an off-guard moment. In these works not meant for sale, his themes tended to be relaxed also; they were scenes of convivial groups in the suburbs or contemporary Parisians, or informal landscapes and still lifes.

After the Salon, Renoir was commissioned to paint Mlle. Sicot, an actress of the Comédie-Française. The formality of her realistic portrait matches that of William Sisley.

From 1865 until Alfred Sisley's marriage in June 1866, Renoir often stayed with the Sisley family in Paris. On July 3, 1865, he wrote Bazille from "Chez Sisley, avenue de Neuilly 31, Porte Maillot":

M. Henri Sisley [Alfred's older brother], little Grange [a young male model from Édouard Manet's studio] whom you know from our dinner, and I are leav-

18

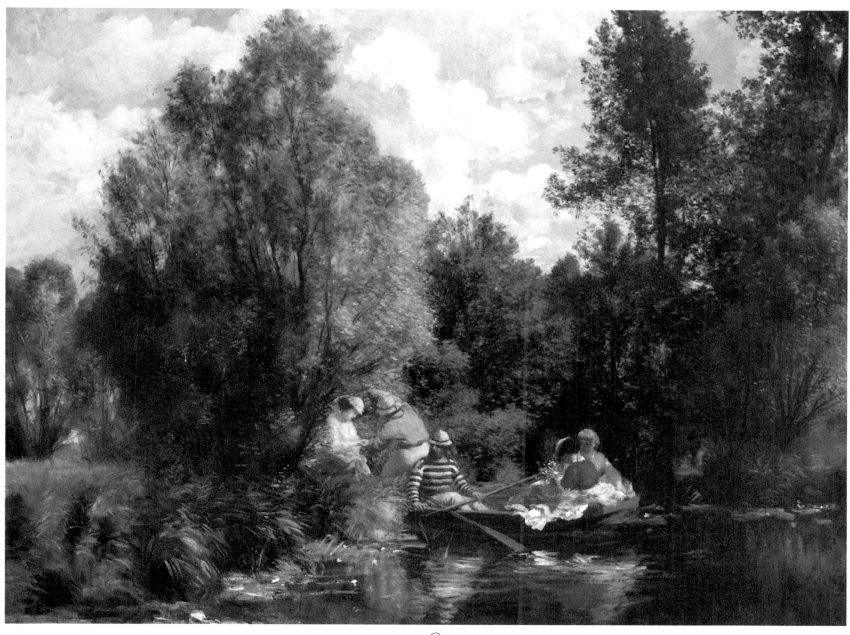

ing on Thursday for a long trip by sailboat. We are going to see the regattas at Le Havre. We plan to stay there for about ten days and the whole expense will be about fifty francs. If you want to be part of it, I would be glad. There is room for one more on our boat. I am taking my paint box in order to make sketches of the places I like. I think it may be charming. There's nothing to keep you from leaving a place you don't like, nor anything to keep you from staying on in an enjoyable one. Very frugal meals. If you want to come, I'll tell you later what we intend to do. We have figured out the expenses more or less exactly. We'll have ourselves towed as far as Rouen by the *Paris et Londres,* and from then on we're on our own. You don't have to feel embarrassed about refusing. The truth is, I'd be very glad to have you with us, but take this invitation as a simple offer if you like the idea. Since you've already been there, I thought you might enjoy seeing again the places you found beautiful. This is why I think of you. So don't be embarrassed, don't feel obligated for anything. Just answer.[15]

The exuberant letter has the same joyful tone as Renoir's landscape with five figures, *Outing in a Rowboat,* painted a year later.

Beginning in 1865 and continuing until 1874, Renoir was frequently the guest of Jules Le Coeur, a wealthy painter nine years older than he, who had a house in Marlotte, on the edge of Fontainebleau Forest; a family home in Berck, on the Channel coast near Boulogne; and a Paris residence.[16]

The entire Le Coeur family befriended him. Marie Le Coeur, Jules's sister, wrote on March 29, 1866, of Renoir's conflict between duty and an enticing outing:

Mother's portrait has been put aside [this portrait had been begun on March 18]; M. Renoir left today for Marlotte with Jules. That poor boy is like a body without a soul when he is not working on something. At this moment he doesn't know what to start next, since his pictures for the exhibition are finished. The day before yesterday, Jules had already persuaded him to go with him, but he preferred to wait a little and finish Mother's portrait, while his friend Sisley found a place there for the two of them to stay; friend Sisley, who had already left, was pestering him from one side, Jules from the other; finally yesterday morning he came to work, saying that he wasn't leaving after all. This morning he was still resolved to stay, but he went to see Jules off at the railroad station and at the last moment he left.

He has no luggage and so he'll have to come back and get his things. I'm sure that by now he's sorry that he gave in. Jules is quite wrong to use his influence in a bad way, he should make use of it to help that poor fellow.[17]

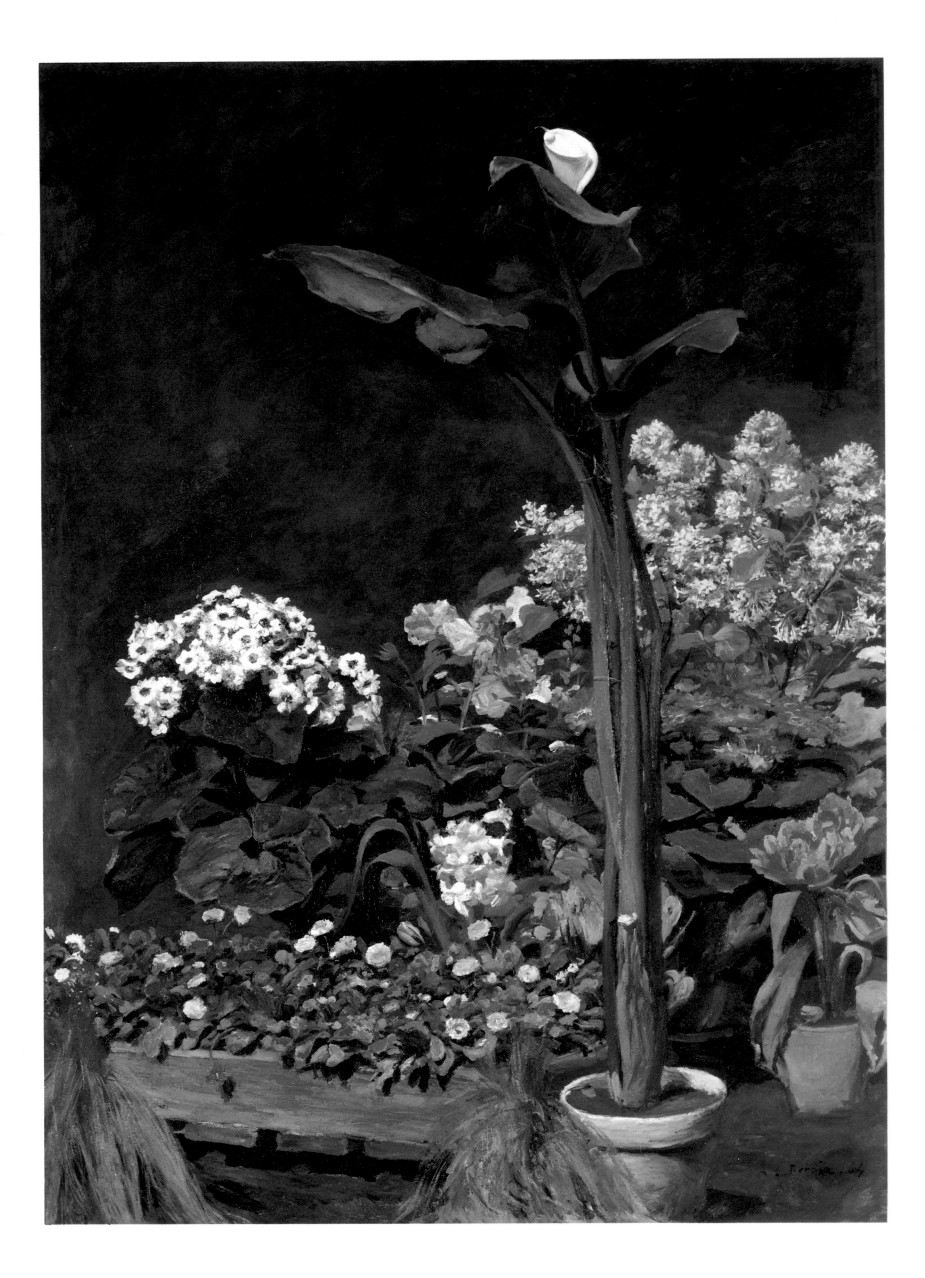

Arum and Conservatory Plants. d. 1864. 51¼ x 37¾". Oskar Reinhart Collection
Am Römerholz, Winterthur

Renoir never completed Mme. Le Coeur's portrait; it remained in the family in its unfinished state. However, during the summer of 1866, he completed the richly colored *Jules Le Coeur in Fontainebleau Forest* and *A Large Vase of Flowers* (p. 12), both for the Le Coeur family. This sensuous still life foreshadows the Impressionist style in the visible brushstrokes, bright tones, and combination of real and imagined hues.

Renoir's good fortune with the Salon of 1865 was not repeated in 1866. Again it is Marie Le Coeur who reports on his troubles:

M. Renoir, poor man, has been rejected. Just imagine, he had done two pictures: a landscape with two figures—everybody says that that one is good, that it has defects and virtues—the other was done at Marlotte in two weeks [possibly the small work now known as *Landscape with Two Figures*], he calls it a sketch, and he only sent it to the exhibition because he had the other one that carried more weight, otherwise he would have decided that he shouldn't exhibit it.

On Friday, since nobody could tell him whether he'd been accepted or rejected, he went to wait for some members of the jury at the exit from the exhibition and when he saw Messrs. Corot and Daubigny (two well-known landscape painters) coming out, he asked them if they knew whether the paintings of a friend of his, Renoir, had been accepted. Whereupon M. Daubigny remembered the work and described Renoir's painting to him, telling him: We're very sorry about your friend, but his painting was rejected. We did all we could to prevent that, we asked for that painting to be reconsidered ten times, without being

Jules Le Coeur in Fontainebleau Forest. d. 1866. 41¾ x 31¾".
Museu de Arte de São Paulo

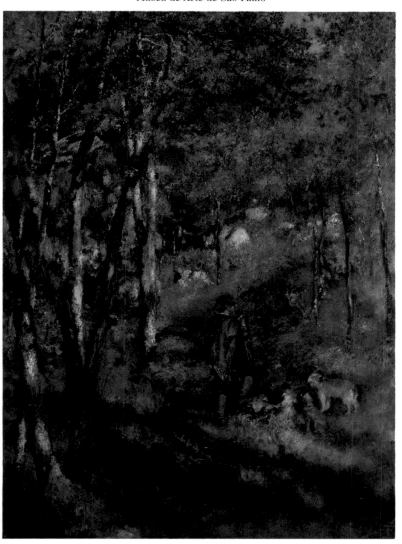

Landscape with Two Figures. 1865–66. 13 x 9½".
Collection Mrs. Norman B. Woolworth, New York

able to get it accepted, what could we do, there were six of us in favor of it against all the others. Tell your friend not to get discouraged, there are great qualities in his painting; he should get up a petition and ask for an exhibition of rejected paintings.

So in his misfortune he has the consolation of having been congratulated by two artists whose talents he admires.

In the evening he went into a café and overheard some artists talking about the exhibition, and one of them said: There's a painting by someone named Renoir that is very good and was rejected.

Now what annoys him most is that he learned yesterday that his Marlotte painting was accepted. The other having been rejected, he would have preferred that this one be rejected too.[18]

Since no painting by Renoir is listed in the catalogue of the Salon of 1866, he must have withdrawn the Marlotte sketch. Because of this fiasco, Renoir made a tactical decision—never again to submit a landscape to an official Salon.

In July, after Sisley's marriage, Renoir began sharing Bazille's Paris studio at 20 rue Visconti. Bazille wrote his parents: "I am giving hospitality to a friend of mine, a former pupil of Gleyre, who for the time being has no studio. Renoir, that's his name, works very hard, he is able to use my models and even helps me partly in paying them."[19]

Later he announced to his mother: "Since my last letter there is something new in the rue Visconti. . . . [Monet] is going to sleep at my place until the end of the month. Along with Renoir, that makes two needy painters to whom I'm giving shelter. It's a real infirmary. I'm

21

At the Inn of Mother Anthony, Marlotte. d. 1866. 76 x 51″.
Nationalmuseum, Stockholm

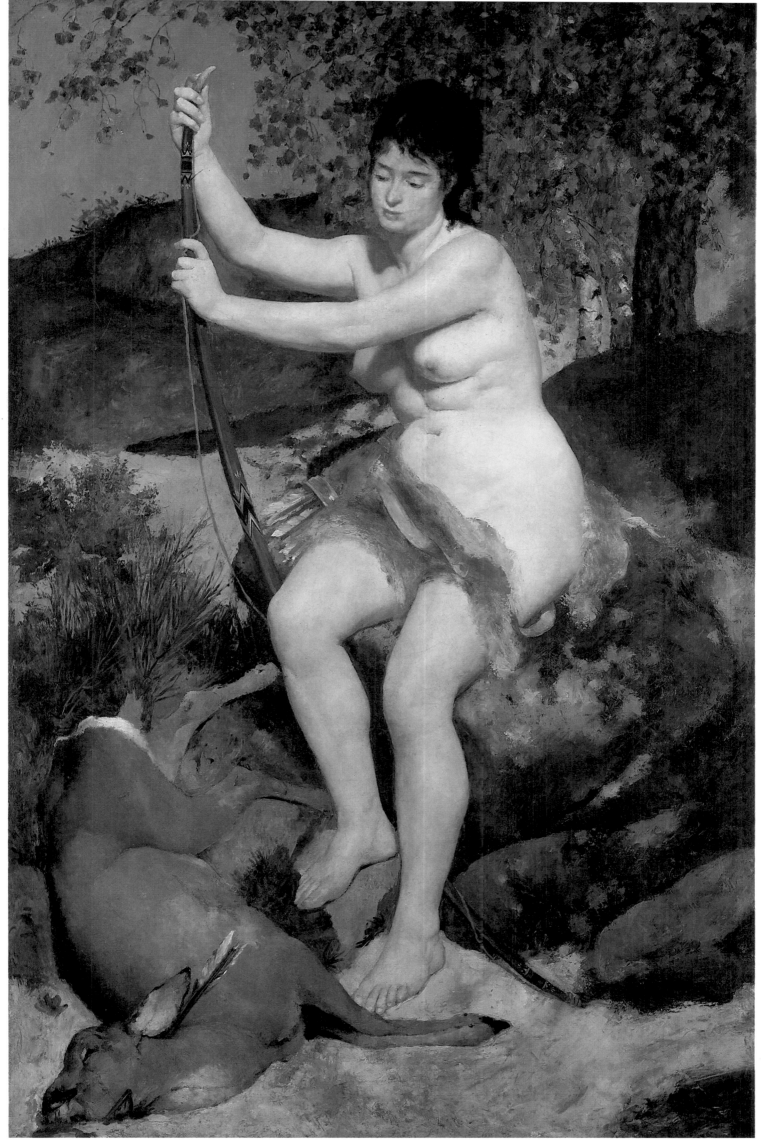

Diana. d. 1867. 77 x 51¼". The National Gallery of Art, Washington, D.C.
Chester Dale Collection

delighted, I have enough space, and they're both very cheerful."[20] He told his father: "Yesterday, Sunday, I went to the Conservatory, I had an extra seat...I took Renoir."[21]

Renoir's joyful bachelor existence is captured in an early masterpiece, *At the Inn of Mother Anthony, Marlotte* of 1866. The large canvas shows his friends—Monet, standing; Le Coeur in the center; and Sisley

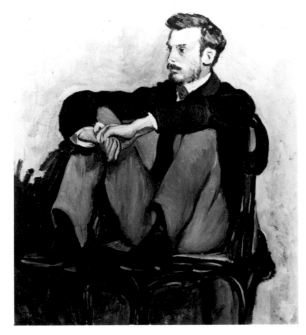

Frédéric Bazille. *Auguste Renoir.* d. 1867. 24½ x 20".
Musée National des Beaux-Arts, Algiers

at the right—relaxing after a meal at one of their habitual dinner spots near Le Coeur's house in Marlotte. The fresco on the rear wall caricatures Henri Murger, author of the *Scènes de la Vie de Bohème*, which was to give Puccini the theme for an opera depicting a lifestyle somewhat parallel to Renoir's. Framing the trio are the waitress, Nana, at the left; the proprietress, Mother Anthony, at rear right; and Le

Renoir, 1861

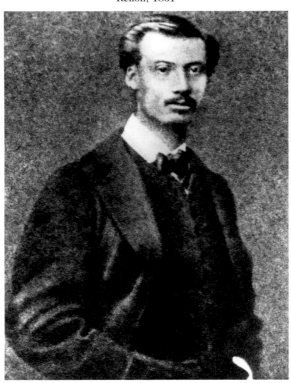

24

Coeur's dog, Toto, a bichon. Its effect of immediacy is enhanced by the casual postures and mobile glances of Renoir's three friends.

Renoir and Bazille, who continued to share a studio, made revealing portraits of each other in 1867. Bazille's oil, which he gave to his friend, closely resembles a photograph taken about the same time. In both images, we see that Renoir's light-brown hair is beginning to recede. Although his five-foot-ten-inch frame is drawn up beneath him in a casual, relaxed position, his amber eyes are sharp and keen—as they remained to the last days of his life.

In November, Renoir executed the much larger portrait of *Frédéric Bazille at His Easel,* which he gave to Manet in an allusion to the Gleyre group. Bazille is seen painting *Still Life with Heron,* a subject on which both he and Sisley were working.[22] On the wall above his head is Monet's *Road near Honfleur in the Snow* of about 1867, which the artist had given Bazille.

In the spring of 1867, Renoir completed *Diana,* a large painting he hoped would be accepted at the Salon. His model was Lise Tréhot, a woman of about eighteen who had begun to pose for him in late 1865 or early 1866. Her older sister, Clémence, was the mistress of Jules Le Coeur, who introduced Renoir and Lise. She posed for at least thirteen Renoir paintings during the next seven years, and it is probable that she was his mistress. She also modeled in 1869 for two of Bazille's works.[23]

Like Gleyre's *Diana* of 1838, Renoir's goddess of the hunt is portrayed realistically, surrounded by a dead animal, arrows, and loincloth. Like Gleyre, Renoir used a studio backdrop instead of an outdoor setting. But *Diana* also calls to mind Courbet's *The Woman with a Parrot,* a success at the 1866 Salon. Renoir followed Courbet in the careful finish of the figure, the dark hues, and the use of a palette knife to build up an impasto in parts of the canvas. Nonetheless, even in this rather derivative nude, Renoir shows his distinctive flecked brushstrokes in the luminous, multicolored leaves. And the sensitivity and shyness of the model give it an unexpected authenticity.

Bazille wrote his mother about *Diana*: "My friend Renoir has done an excellent painting that has startled everybody. I hope he'll be successful at the Exposition, he needs it very badly."[24] But surprisingly, *Diana* was rejected at the 1867 Salon. That year's jury, which was especially conservative, also turned down paintings by Bazille, as well as Monet, Sisley, Pissarro, and Cézanne.

The friends were determined to challenge the system this time. In 1863, there had been a Salon des Refusés, at which works rejected by the official Salon jury were exhibited. Daubigny had urged Renoir to ask for such a show in 1866. It is not known whether Renoir did make such a petition. In any case, the superintendent of fine arts, Count de Nieuwerkerke (Alfred Émilien O'Hara), decided against one for that year.

Now, in 1867, Renoir and his colleagues signed a petition officially asking for a Salon des Refusés, but again the government did not authorize it. "A dozen talented young people agree with me," Bazille wrote. "So we've decided to rent each year a large studio where we will exhibit as many of our works as we like."[25] Artist-sponsored exhibitions were not unheard of in the nineteenth century. In 1855, Courbet himself had held one, after a particularly galling rejection by the Salon. In 1867, he held another, and Manet did likewise. In the case of

Frédéric Bazille at His Easel. d. 1867. 41⅞ x 29¼".
Musée d'Orsay, Galerie du Jeu de Paume, Paris

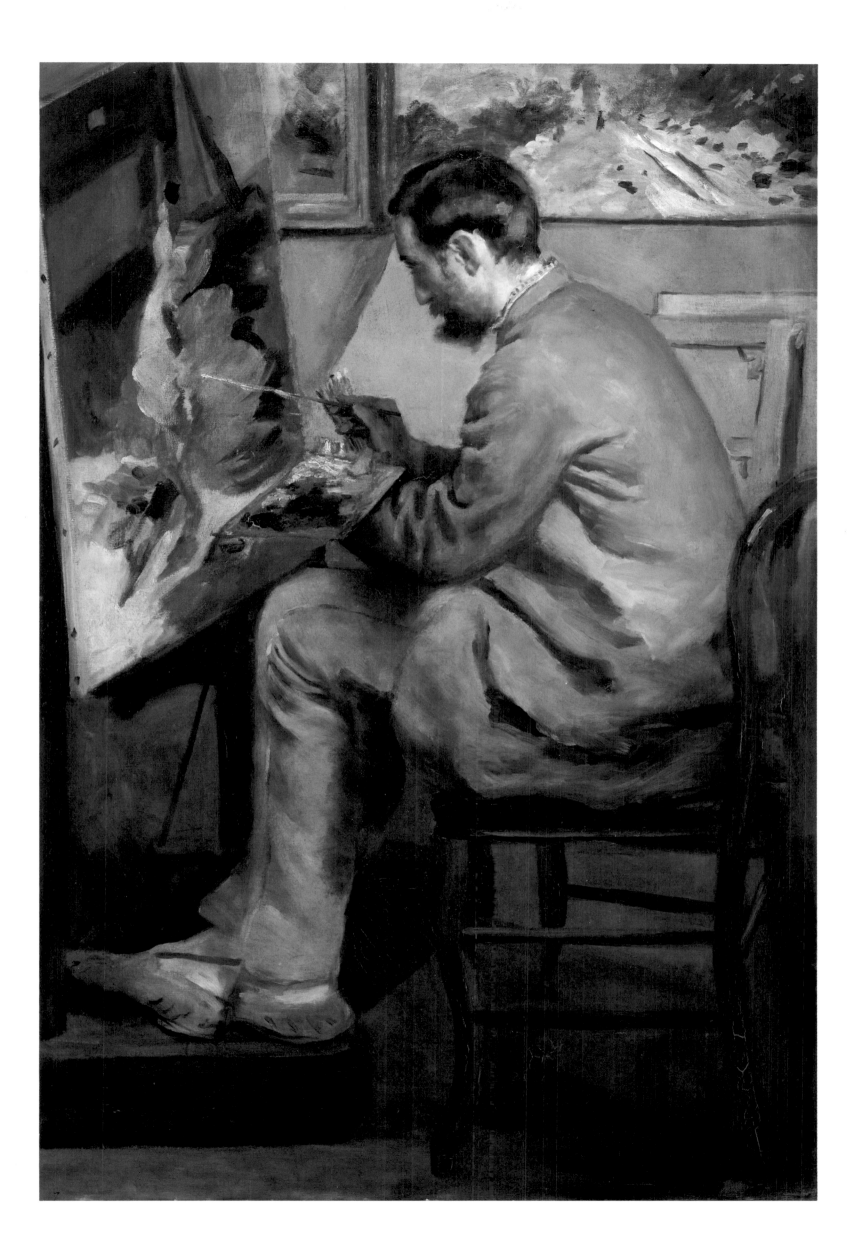

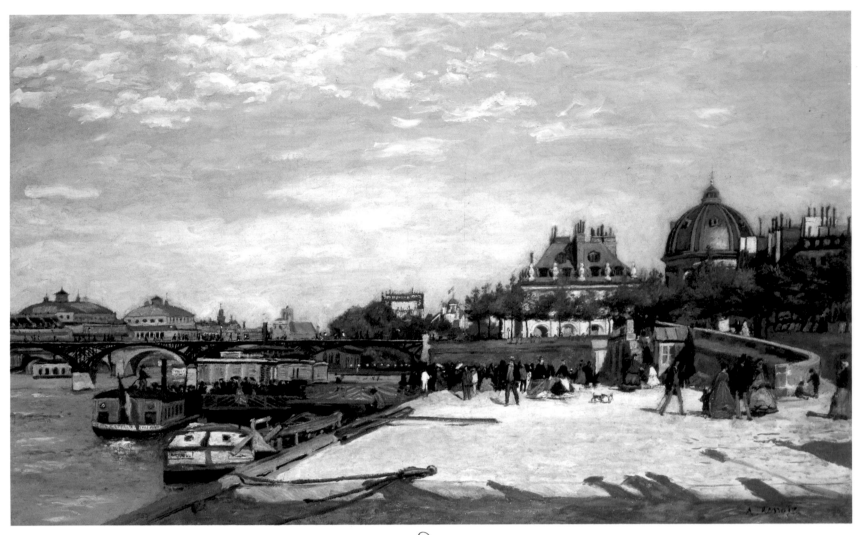

The Pont des Arts, Paris. 1867. 24½ x 40¼″. The Norton Simon Foundation, Los Angeles

Renoir and his friends, the plan fell through because they could not muster sufficient funds, but seven years later many of these same artists—Renoir, Monet, Sisley, Pissarro, Cézanne, Berthe Morisot—succeeded in holding the first Impressionist exhibition.

Renoir and Monet continued to paint out-of-doors. In May, Monet wrote Bazille: "Renoir and I are still working on our views of Paris."[26]

Skating in the Bois de Boulogne. d. 1868. 28⅞ x 36⅛″. Collection the Marquess of Northampton, Warwick

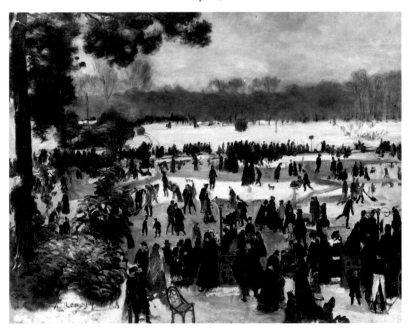

26

The Pont des Arts, Paris, with its wide-angle view and cast shadows, seems to have been influenced by contemporary photography, already a popular art form. Another urban scene was *Skating in the Bois de Boulogne,* done the next year. In the summer of 1867, Renoir did his first life-size figure painting *en plein air:* it was *Lise* of 1867. Here he followed Monet, who, a year earlier, had begun to paint entirely outside his studio, on the large canvas *Women in the Garden. Lise* has a modern theme: a fashionably dressed city woman stands waiting for her escort during an outing to Fontainebleau Forest, which was now easily accessible by railroad from Paris. In painting *Lise,* Renoir used a new technique that the amateur musician Edmond Maître described to Bazille on August 23: "The painter Renoir is at the moment in Chantilly. The last time I saw him in Paris he was doing a strange sort of painting, having traded the turpentine for a disgusting sulfate and abandoned his palette knife for the little syringe that you know about."[27] The palette knife was a holdover from his Courbet idolatry, and Renoir seldom used it from this point on.

Lise was accepted for the Salon of 1868, as were paintings by Bazille, Monet, Sisley, Pissarro, Degas, Manet, and Morisot. Although it was hung close to the ceiling, it was mentioned in several reviews, most of which discussed the influence of Manet, then considered the leader of the avant-garde. Zacharie Astruc, a critic who was also a sculptor, painter, composer, and poet, was favorable in *L'Étandard* of June 27: "M. Renoir's *Lise* completes the bizarre trinity started by the very strange and powerfully expressive *Olympia* of stormy memory. Following Manet, Monet created his *Camille* shortly thereafter.... Now here

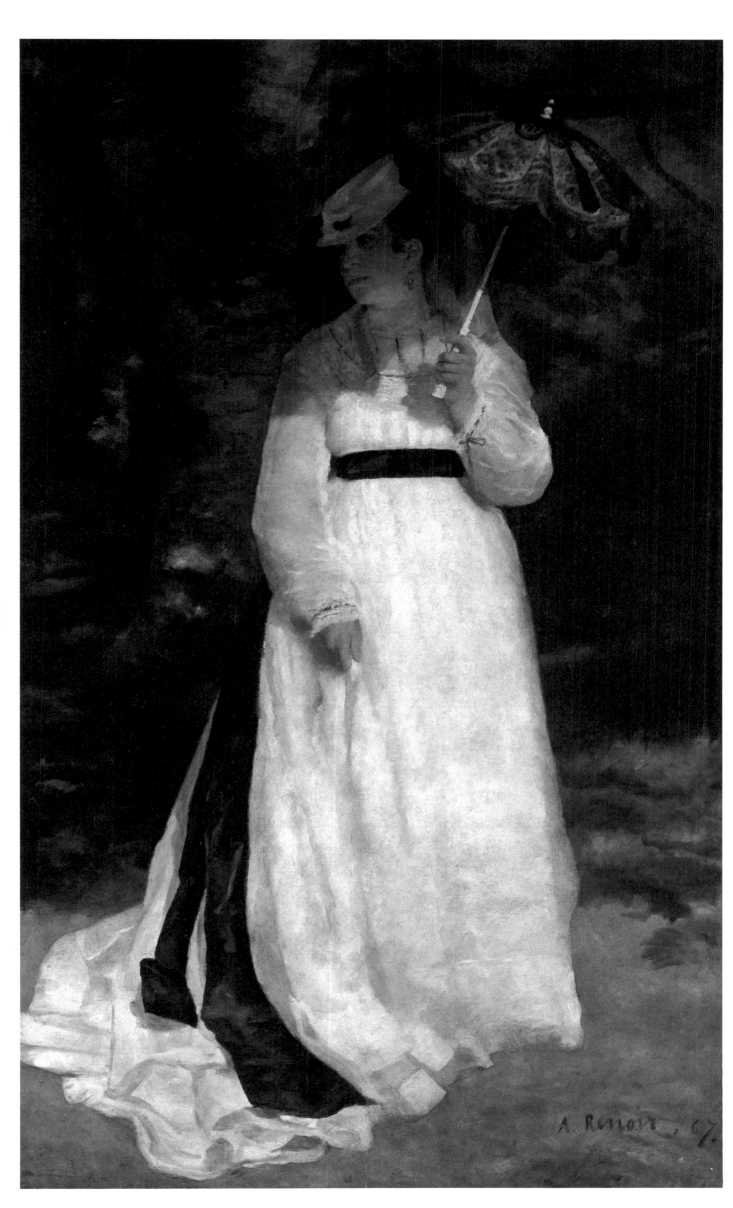

Lise. d. 1867. 71½ x 44½".
Museum Folkwang, Essen

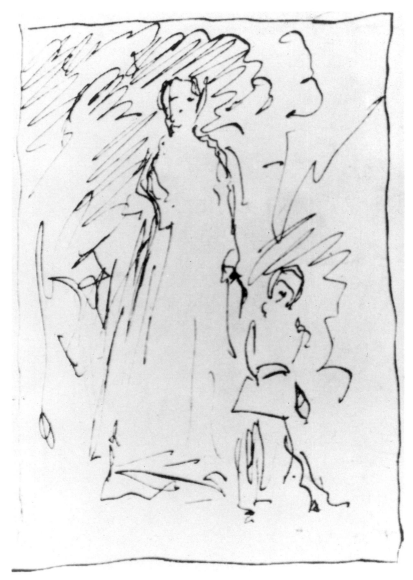

Sketch for projected portrait of Mme. Charles Le Coeur and her son Joseph in the garden, from a letter to Charles Le Coeur. Pen and black ink on paper, 2¾ x 2″. 1868

is *Lise*, the most restrained of all. She is the pleasant girl of Paris, at the Bois."[28]

Another well-disposed critic was Jules-Antoine Castagnary: "Youth is arriving on the scene, a youth that will no longer give up its weapons since it is aware of its aspirations. . . . Do you think that M. Renoir will not harbor some resentment for the injury that has been done him . . . the strong always resist. Didn't Courbet resist? Didn't Manet resist?"[29]

Other critics were not so positive. Marius Chaumelin wrote: "Apparently M. Manet is already a master since he has imitators; among them is M. Renoir, who under the title of *Lise* has painted a life-size woman strolling in a park; this painting holds the attention of connoisseurs as much by the oddity of its effect as by the accuracy of its tones. It is what is called in the language of the realists a fine spot of color."[30]

Ferdinand de Lasteyrie mocked: "In the back room, the one known as the Room of the Reprobates, I discovered, labeled with the simple name of *Lise*, the figure of a fat woman daubed with white, whose creator, M. R. (may I be allowed to designate him only by an initial), obviously took his inspiration no longer even from the great examples of M. Courbet, but from the curious models of M. Manet. And this is how, from imitation to imitation, the realist school threatens to fade out completely . . . by leaps and bounds. So be it!"[31]

Jules Le Coeur's older brother, Charles, an architect who was constructing a Paris mansion for Prince Georges Bibesco, asked Renoir to submit preparatory drawings for two ceiling decorations in the spring of 1868. Renoir's study, *Figures on a Balcony*, a trompe-l'oeil outdoor scene that recalls the eighteenth-century murals of Tiepolo and Fragonard, was accepted and his two architectural pieces were painted.[32]

Renoir was eager to obtain portrait commissions, which were the most certain source of money. A few months after the Bibesco work was finished, he wrote Charles Le Coeur:

If you care to ask your lady if she'd like me to do her portrait standing and holding Jo[seph, their young child] by the hand. In the garden during the day when the weather is gray, and when the weather isn't gray, between 6 and 7 P.M. As I don't suppose you'll leave for Berck before a fortnight, I will have time to finish my portraits. But there's a but. Be careful. If you agree to what I'm asking, you'll have to pay for the canvas, since I couldn't ask for it from Carpentier [an artists' supplier], who would say no altogether.

As soon as you've decided, write to Carpentier asking him to send you immediately a 120 canvas, fine and very smooth, primed with several layers, and then I'll start immediately.

P.S.: There is a stretcher of that size somewhere in the attic or storeroom, you can tell Carpentier to bring only the canvas and nail it on this stretcher. It's true that that might take a little time.

OPPOSITE:
Alfred Sisley and His Wife. d. 1868. 42¼ x 30″.
Wallraf-Richartz-Museum, Cologne

Illustration from *Modes de Paris*, 1865

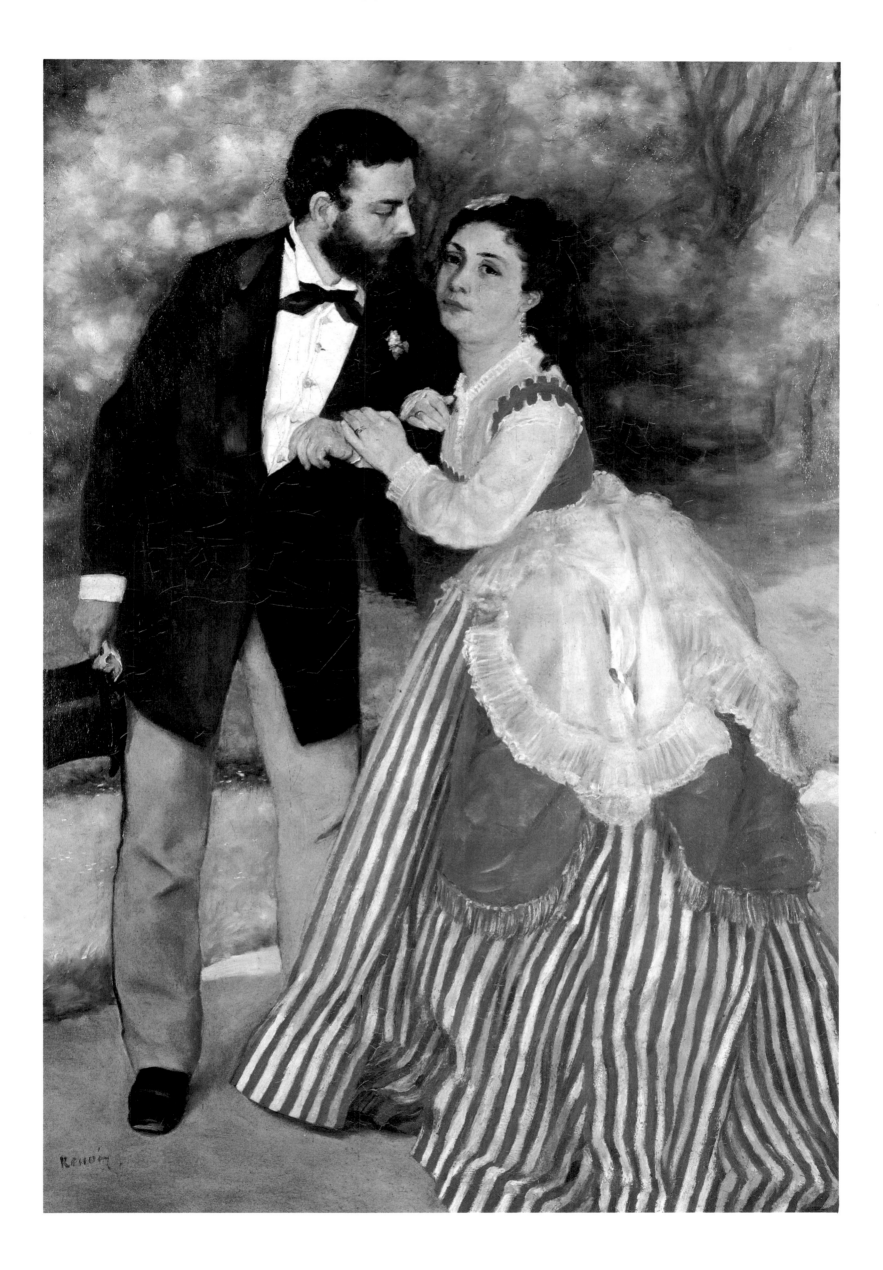

If it's impossible, don't be embarrassed to say no. That's all there is to it. At any rate, I'll come Friday evening at 6 to work if the canvas has come, and to do nothing if it hasn't. Don't count on me too much. You never know what can happen. I may find the omnibuses full and not be able to reach the rue Humboldt.[33]

On the second page of this letter, Renoir drew a small sketch of Mme. Le Coeur holding Joseph's hand in their garden, but the portrait was never executed.

Another of Renoir's artist friends did agree to pose at this time: Renoir's *Alfred Sisley and His Wife* (1868) is an urbane double portrait, stressing the intimate relationship between an amorous man and a demure woman.[34] And Renoir reveals his love of the ornamental and the decorative in the attention he lavishes on Marie's striped gown—an example of the latest in Paris fashion. Renoir's interest in fashion may have been fostered by his family's occupations: his father and his brother Léonard-Victor were both tailors, his mother a seamstress, and his brother-in-law, Charles Leray, a fashion illustrator. Throughout his career Renoir was attentive to fashion details.

By 1869 and 1870, Renoir and his friends had established the custom of meeting from half-past five to seven at their favorite café or brasserie to talk about art and the art world. This tradition had begun with several of the older painters who attracted younger artists to come to listen and learn. Corot drew Gleyre's students to the Café de Fleurus. Fantin-Latour could be found at the Café Taranne. Courbet went to the Brasserie Andler Keller or to the Brasserie des Martyrs. Manet began going to the Café de Bade in 1862 and in 1867 moved to the Café Guerbois, 11 grande rue des Batignolles (now the avenue de Clichy in the seventeenth arrondissement), in the northwest section of the city, then the artistic center of Paris. The Café Guerbois was five minutes from the studio to which Bazille, and with him Renoir, had moved in January 1868, at 9 rue de la Paix (soon renamed rue de la Condamine). At the Café Guerbois, Manet expounded on modernity and innovation as opposed to the conservatism of the Salon. Several of the artists who would exhibit five years later at the first Impressionist group show were regulars: Astruc, Bracquemond, Cézanne, Degas, Monet, Pissarro, Renoir, and Sisley. Other artists were also invited: Guillemet, Guillaumin, Fantin-Latour, Alfred Stevens, Constantin Guys, and the artist-physician Paul Gachet. The photographer Gaspard-Félix Tournachon, known as Nadar, and Bazille's musician friend Maître also came. Sympathetic writers and critics could also be found at the Guerbois: Théodore Duret, Émile Zola, Edmond Duranty, Philippe Burty, Paul Alexis (called Trublot), Armand Silvestre, Catulle Mendès (who wrote under the name Jean Prouvaire), and Théodore de Banville.[35]

Monet later summarized the importance for Impressionism of the Café Guerbois: "Nothing could be more interesting than these *causeries* with their perpetual clash of opinions. They kept our wit sharpened, they encouraged us in sincere and disinterested research, they provided us with stores of enthusiasm that for weeks and weeks kept us up, until the final shaping of an idea was accomplished. From them we emerged tempered more highly, with a firmer will, with our thoughts clearer and more distinct."[36]

For Renoir, the most important person at the Guerbois was unquestionably Manet. For years, he had been admiring and absorbing Manet's work, as even the derisive critics Chaumelin and De Lasteyrie could observe. In 1868, when he was commissioned to do a wall deco-

ration for the Paris Café of the Cirque d'Hiver, he looked back to Manet's *Mlle. Victorine in the Costume of an Espada* (1863) in portraying the clown-violinist James Bollinger Mazutreek. The format of *The Clown* is a large vertical, as is Manet's, and the perspective is high, with a sharp difference in focus between near and far. And both Victorine and Mazutreek are skillfully caught in arrested motion. For this portrait, the café owner had promised Renoir one hundred francs, but the café went bankrupt, and Renoir had to keep the painting.

Manet indicated his own high regard for Renoir when Fantin-Latour painted Manet and his disciples of the Guerbois and Les Batignolles quarter for the Salon of 1870: Manet requested that Renoir be placed near him. In the painting, Renoir's head is centered in a gold frame, and he stands directly behind Manet. In a letter to a friend, Fantin identified the figures and wrote that Renoir was "a painter who will get himself talked about."[37]

That was just what Renoir wanted. For the Salon of 1869, he had submitted a painting of Lise Tréhot under the title *Study: In the Summer*. Calling it a "study" seems an apology for the sketchy execution of the background. At the same time, he conformed to the prevailing taste for thinly veiled eroticism in Lise's décolleté blouse, the suggestive position of her hands, and her seductive expression. Although the painting was accepted for the 1869 Salon, it was poorly placed and seems to have been overlooked by the critics.

This was a particularly inopportune time for the critics to pass over Renoir in silence. He was very nearly down to his last sou. In even worse straits was his friend Monet, who had a wife, Camille, and an infant son, Jean. Renoir was aware of Monet's plight because he was living during the summer in Ville-d'Avray with his parents, close to St.-Michel, near Bougival, where the Monets were living. Their closeness and interdependence from August through October are evident in letters they wrote to Bazille, who was with his parents in Montpellier, in southern France. On August 9, Monet wrote Bazille: "Renoir . . . brings us bread from his house so that we won't croak."[38]

Late in August, Renoir also spoke of poverty when he wrote Bazille:

I'm coming from Les Batignolles, and I've read your letter. Here are the measurements of the windows: four meters high by three meters wide; so you must have four curtains made four meters high and two meters wide, counting the pleats. . . . I can't find the pawn ticket for your watch; tell me exactly where it is. I'm in Ville-d'Avray and come to Les Batignolles only very rarely and only to get some little things. In order for what you ask me to be done, and if you have some money, you'd better send it to me right away, just so that you won't eat it up. You don't have to worry about me, since I have neither wife nor child and am not about to have one or the other. Drop me a line so that I'll know whether I have to take care of the carpentry work immediately, which would upset me a lot since first of all I'm working and also I don't always have enough to eat in Paris and here I get along all right. I'll write you more some other time, because I'm hungry and I have a plate of turbot with white sauce in front of me. I'm not putting a stamp on the letter, I have only twelve sous in my pocket, and that's for going to Paris when I need to.[39]

The curtains Renoir discusses appear in Bazille's painting *The Artist's Studio,* where the thirteen-foot windows flood the room with light. The figures are (from left to right): Monet, Sisley, Renoir, Manet, Bazille, and Maître.

In late August or early September Renoir wrote a news-filled letter

The Clown. d. 1868. 76 x 51¼". Rijksmuseum Kröller-Müller, Otterlo, The Netherlands

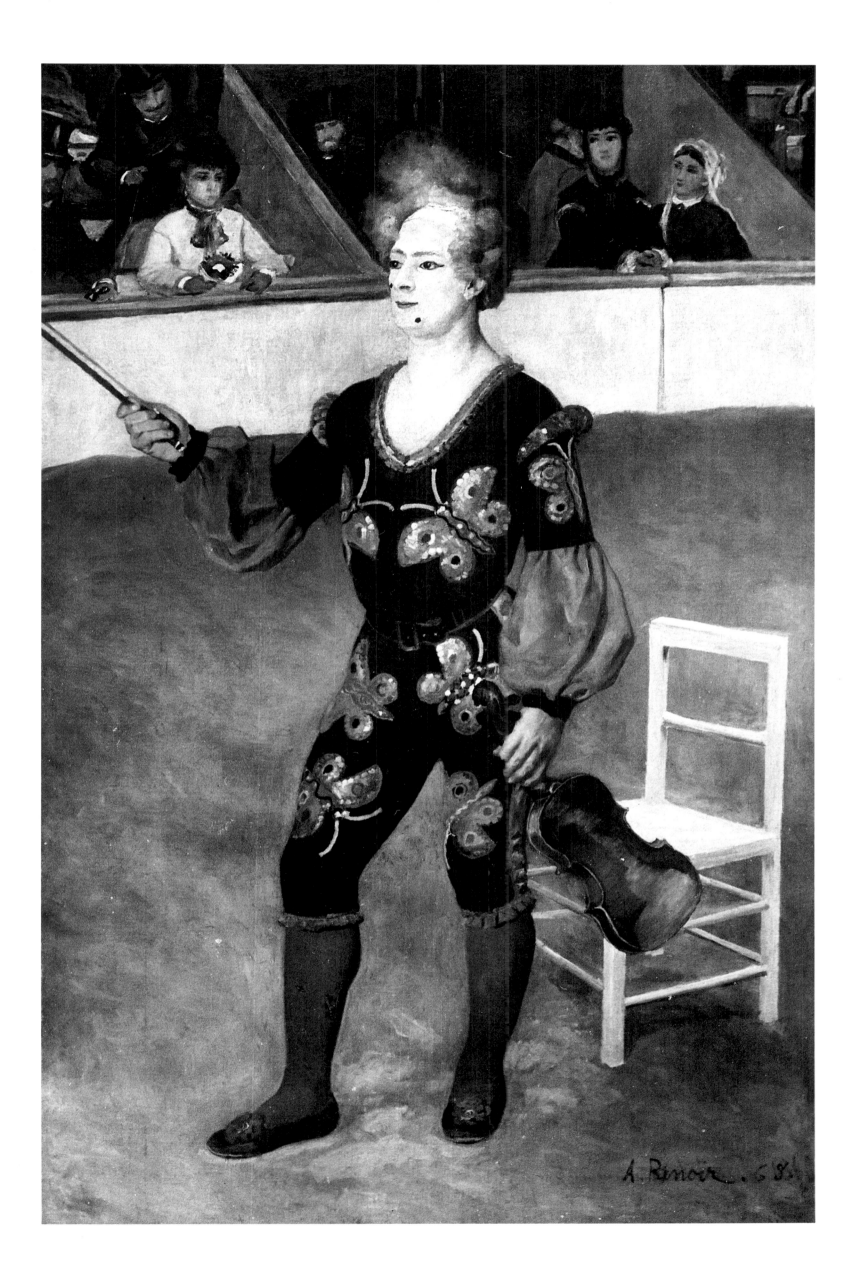

to Bazille in which he shows his characteristic gaiety in spite of adversity:

Your Salon painting is in the studio. I put everything back in order as best I could, and gave the key back to the landlord, promising myself to come and see that he doesn't play any tricks in the studio. Anyway, whenever I go there, I promise him to come back in the evening, which will restrain him if he feels like letting in any bedfellows again. Lise saw your letter and thinks that *corbeille* ["basket"] is a very low word. She prefers the word *caisse* ["chest"] as before. (I'm talking about the famous grapes.) I'm waiting for your masterpieces. I intend to criticize them mercilessly when they arrive. I haven't seen anybody. I'm staying with my parents and I'm almost always at Monet's, where by the way they're getting rather old. [Baby Jean Monet was two.] They don't eat every day.

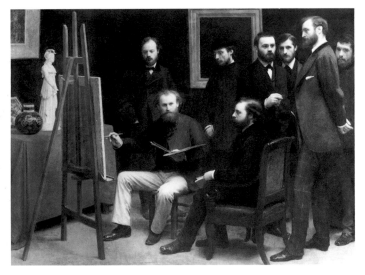

Henri Fantin-Latour. *A Studio in the Batignolles Quarter.* d. 1870. 68½ x 82″. Musée d'Orsay, Galerie du Jeu de Paume, Paris

Frédéric Bazille. *The Artist's Studio, Rue de la Condamine.* d. 1870. 38⅞ x 47″. Musée d'Orsay, Galerie du Jeu de Paume, Paris

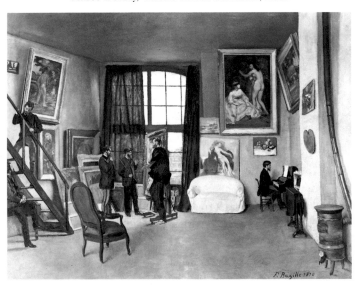

But I'm happy just the same because as far as painting is concerned, Monet is good company. I'm doing almost nothing because I don't have many colors. Things may go better this last month. If they go better, I'll write you. I send you many greetings from these girls [Lise and friends]. Not for you but for your *chest* of grapes. They kiss you as many times as there were bunches of grapes in your *chest*, and not *basket*. I shake your hand.[40]

In the fall, Renoir wrote a letter to Bazille with affectionate greetings that suggest he must have been a guest of Bazille's family in Montpellier: "Kiss your father and mother for me. Say hello to the whole family,

to your cousins, and to that nice aunt whom we like to talk about, to your sister-in-law; a big kiss to the little one. I like him a lot, he's a child who will go far. Be careful of the traffic!"[41]

At this time, while living with his parents, Renoir painted a portrait of his father; he had painted his mother several years earlier. This work gives no clue to the fact that both he and Monet were at particularly innovative stages in their artistic development. It was in October of 1869 that they began painting in a style that we now call Impressionism; Pissarro may have come to this style independently at the same time.[42]

Monet wrote to Bazille a few weeks earlier of plans to paint with Renoir at La Grenouillère, a place that played a fateful role in Impressionism: "I have a dream, a painting, the baths of La Grenouillère, for which I've done a few bad sketches, but it's a dream. Renoir, who has just spent two months here, also wants to do this painting."[43]

La Grenouillère (literally, the Frog Pond) was an eating, bathing, and boating spot on the Seine at Croissy near Chatou. For about twelve sous, people took the train from Paris for a day's outing to relax, swim, and boat. Here, side by side, Renoir and Monet made three pairs of landscape paintings that may properly be considered the first Impressionist images. They present a casual moment of daily life, creating an effect of freedom, randomness, and mobility by the use of visible all-over brushstrokes, vivid varied colors, and pervasive light. They aimed to give an effect of spontaneous execution, when in fact their method required a sensitive, painstaking weighing of tiny parts. They understood that the natural color of an object is modified by the light in which it is seen, by reflections, colored shadows, and contrasts of juxtaposed colors.

To paint outdoors at La Grenouillère, Renoir and Monet had special folding easels, wooden palettes, and traveling paint boxes. They also carried prepared canvases, and it was here that they differed most radically from their predecessors, who had used a dark warm brown or red ground over the raw canvas and under the painting. Renoir and Monet used white or pastel grounds to enhance the luminosity of their images.

Impressionist painting was revolutionary and vastly different from all previous art in its emphasis on capturing the effect of a fleeting moment in nature. To be sure, earlier painters had made preliminary sketches out-of-doors; however, they then returned to their studios to complete the work and give it an effect of "finish." Impressionist painters, on the other hand, prized the sketchiness of their work in order to render the variability of light and movement with a new spontaneity, and they often executed the entire work outdoors. They gave primary importance to tiny, moving, brightly colored strokes to portray movement and create form. With virtuosity and inventiveness, Impressionists varied their repertoire of strokes from dry to wet, from thin to impasto, and they expanded their palette to include hundreds of different hues in one work—thereby achieving an intense richness and expressiveness. Black was used as a color but not to depict shadows. Until now, painting tended to range in tone from bright to middle to dark, with deep browns and blacks in the shadows; Impressionist painting had predominantly light tones with few middle and fewer dark tones; high-keyed shades were used as reflected hues in the shadow so that the entire canvas was bright and colorful. Where traditionally attention was devoted to detail, surface, line, weight, volume, and relief, the Impressionists' assertive brushstrokes blurred detail, dissolved line, and eroded mass, thereby forcing the viewer to recreate

the unfinished image into a new whole, and in so doing to become involved in the creative process in an unprecedented manner. A free ordering of the composition was suggested by the flicker of small colored strokes across the canvas, which called attention to the surface plane. Distant parts of the surface were related by brushstrokes of similar hue, intensity, value, weight, size, and direction. In the conservative milieu of late nineteenth-century France, the Impressionists' everyday subject matter stressing the joyful and accidental in nature, their light, bright palette, mobile brushstrokes, ostensibly random arrangement, and hazy forms appeared scandalous and disrespectful of high culture. Furthermore, Impressionism seemed to go beyond Realism. Each artist captured his own imaginative impression; each sought to render the ever-changing character of the visible world as it appeared in an instant in his own perception. The uniqueness of each perception was paramount; there was nothing approaching homogeneity among the Impressionists. Even two close painting comrades such as Monet and Renoir manifest wide differences in painting La Grenouillère.

Renoir's favored subjects differed in basic ways from Monet's. Renoir was more interested in people, social relationships, and attractive dress; Monet was primarily concerned with nature. Usually, when Renoir painted a landscape, he was really making a figure painting in which diminutive men and women disported themselves in a pleasurable setting. The exuberance and gregariousness of his letters appear in the mood of his paintings. He used soft, caressing brushstrokes to

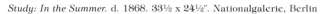

Study: In the Summer. d. 1868. 33½ x 24½″. Nationalgalerie, Berlin

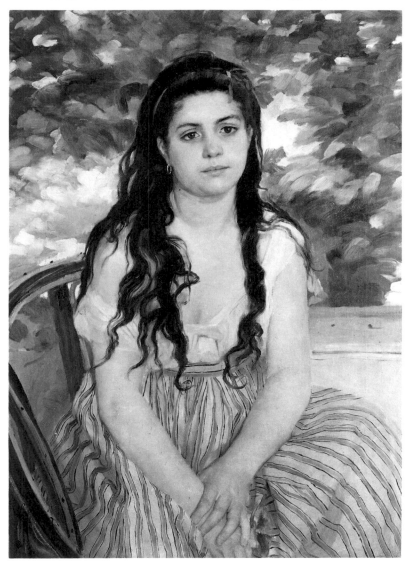

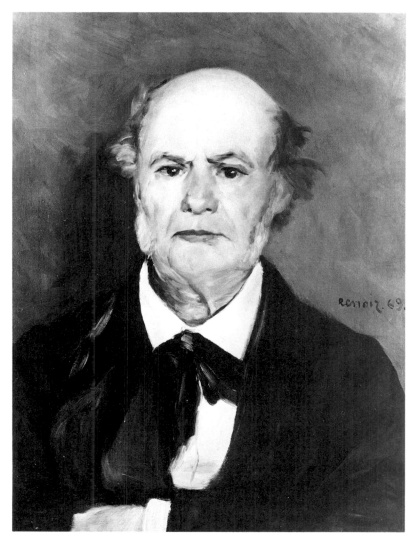

Renoir's Father. d. 1869. 24 x 18⅞″. The City Art Museum, St. Louis

endow the entire image with a solid, tactile human quality.

In Renoir's *La Grenouillère* the people are larger and closer to us than in Monet's version. Monet's figures are less colorful, less individualized in dress and posture, and less substantial. Monet does not invite us to create our own human-interest story from the scene. Rather, as a landscapist, he draws our attention to the multicolored ripples of the water, to the crescendo of the distant foliage, and to the source of bright light in the pale blue sky. His vigorous, objective brushstrokes depersonalize the image.

Despite these innovative landscapes, the two paintings that Renoir sent to the Salon of 1870 were made with the conservative jury in mind, and both were accepted: *Bather* and *Woman of Algiers. Bather* echoes well-known sources (which were likely to appeal to the jury): the pose comes from the Greek sculpture *Aphrodite of the Cnidians* (c. 350 B.C.), and the reclining woman and the rowboat moored near a tree were inspired by Courbet's *Two Girls of the Banks of the Seine.* Nonetheless, the nude of 1870 (for which Lise Tréhot posed) is much less realistic than the *Diana* of 1867; the tones are lighter, with a fuller range of hues throughout the image, the strokes are visible but soft and delicate, and the technique is freer. By 1870, even in Salon painting, Renoir had moved away from Academic Realism and toward Impressionism.

Woman of Algiers also had roots in well-known sources: the tradition of the exotic harem—Ingres's *Grande Odalisque,* with its long horizontal format and the model's seductive reclining pose (and Renoir's picture is sometimes known as *Odalisque*). It also draws from Delacroix's

33

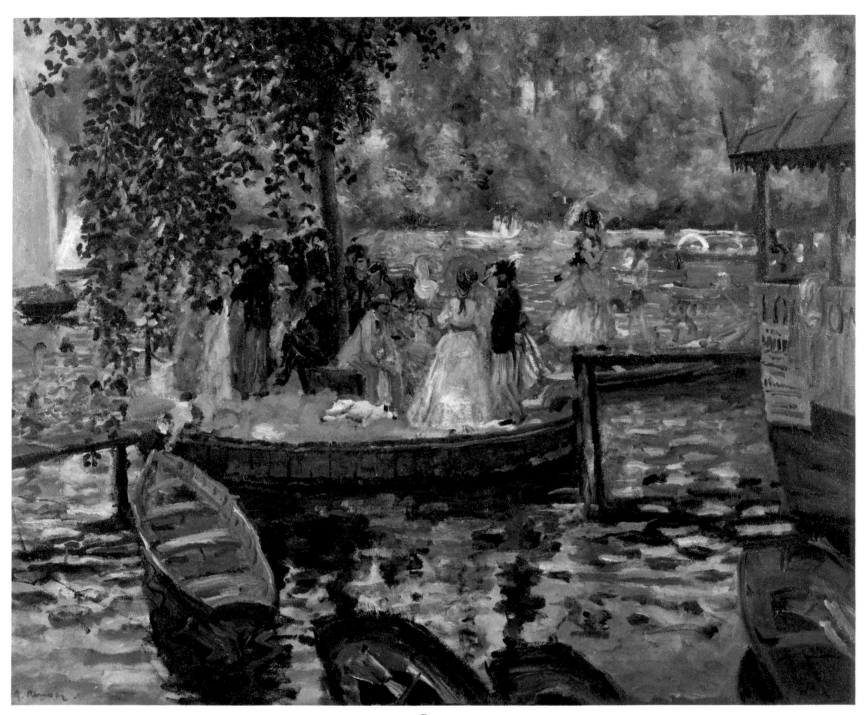

La Grenouillère. 1869. 26 x 31⅞". Nationalmuseum, Stockholm

Claude Monet. *La Grenouillère*. 1869. 29⅜ x 39¼". The Metropolitan
Museum of Art, New York. The H. O. Havemeyer Collection.
Bequest of Mrs. H. O. Havemeyer

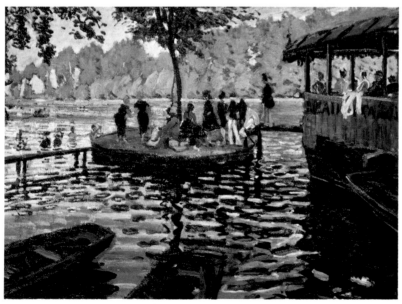

OPPOSITE:
The Promenade. d. 1870. 32 x 25½". Private collection, England

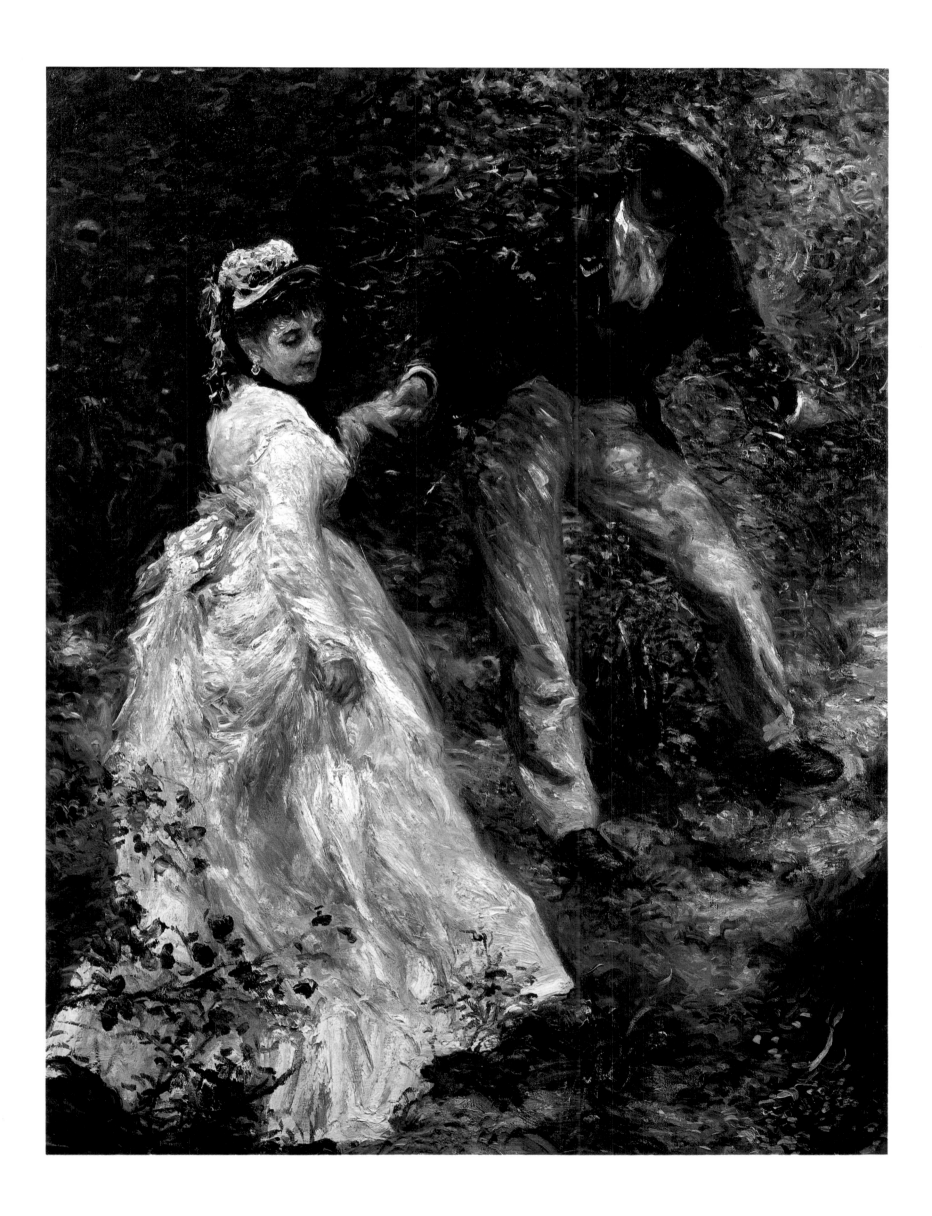

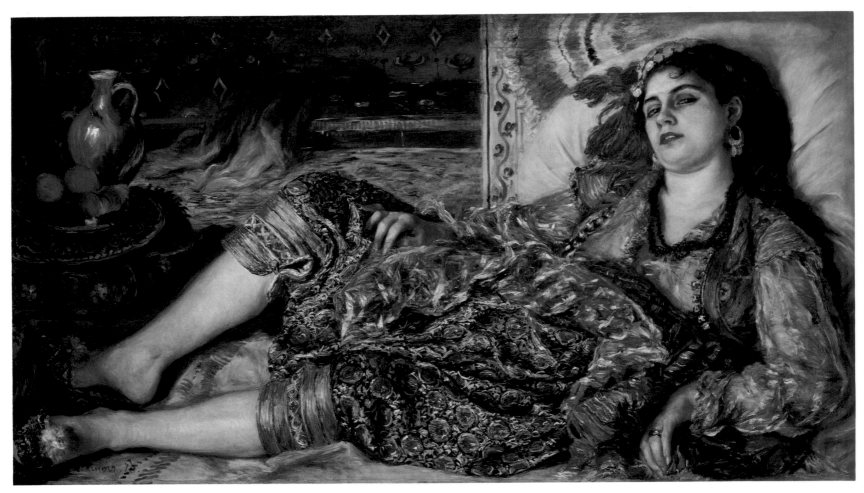

Woman of Algiers. d. 1870. 27 x 48½″. National Gallery of Art,
Washington, D.C. Chester Dale Collection

Nymph at the Stream. 1869–70. 26¼ x 48⅜″. The National Gallery, London

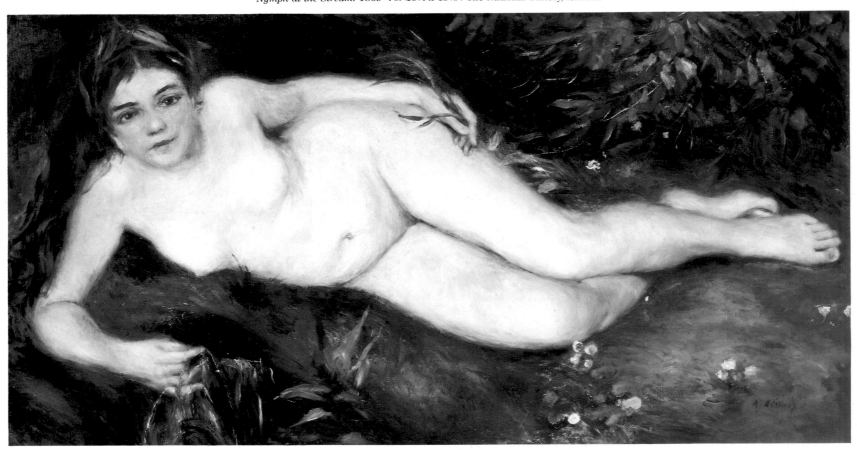

The Women of Algiers, one of whom has the same pose, and it also has the colorful patterned interior that Delacroix used. In addition, Renoir here shows off his technical mastery—and delight—in the exquisite gold brocade of the knickers, the multicolored striped sash, the gauze blouse. And the woman's gaze is as defiant in its confrontation as was Manet's wholly unclothed *Olympia.*

The writer Arsène Houssaye was full of praise: "One can study the proud painterly temperament which appears with such brilliance in *Woman of Algiers* which Delacroix would have signed. Gleyre... must be thoroughly surprised to have trained such a 'prodigal son' who makes fun of all the laws of grammar because he dares to make one of his own. But Gleyre is too fine an artist not to recognize art whatever its expressions are."[44]

In 1870, the same year that he painted these two conservative images, Renoir did his first large-scale Impressionist figure paintings: *Nymph at the Stream* and *The Promenade.* To translate the innovations of *La Grenouillère* into figure painting took courage, since Renoir could predict that his unconventional and original figure style would displease public taste. But he retained this figure style from 1870 through 1877 and in modified form thereafter.

Nymph at the Stream seems to be a pendant to *Woman of Algiers,* and Lise posed for both. Further, they exemplify the diversity of Renoir's style in 1870. These two paintings are almost identical in size and format: the life-size women nearly fill the long horizontal frames, in almost mirror-image poses. The Algerian inhabits a harem; she is enclosed in a cramped interior space. Elaborately dressed from head to toe, propped up by pillows, accompanied by food and drink, she appears the willing seductress. The outdoor nude is a natural woman, who, with a wreath in her hair and weeds in her fingers, is relaxing comfortably. She becomes part of her mossy setting through all-over feathery brushstrokes, a pervasive yellow light, suffused shades of green, and a subtle range of flesh tones. In *Woman of Algiers* the emphasis on lines and contours makes up a fragmented, mosaiclike image.

The paintings for which Lise posed included not only the extremes of dress and undress, but also Renoir's daily experience as a twenty-nine-year-old bachelor. As such, the theme of romance—which would interest him through the early 1880s—first emerged on canvas in *The Promenade.* In this rhapsody on the pleasures of love between a fashionable lady and her more rustic (and eager) companion, Renoir was developing his unique Impressionist style for large-scale figures. He sought to express the joyfulness he felt about the world of holidays, amusement, leisure, and comfort. Happiness and vitality are expressed through the intensity of bright, rich colors and high-keyed light tones. Free, seemingly spontaneous strokes hint at form and allow the figures to breathe and move about.

In mid-May, two weeks after the Salon opened, Renoir and Bazille again moved their studio, this time to the Left Bank, at 8 rue des Beaux-Arts. The seventh-floor studio was in the house where Fantin-Latour lived and very close to Maître's apartment. After spending about a month there, Bazille went south, as he usually did, to spend the summer with his family. Renoir moved into Maître's apartment on the third floor of 5 rue Taranne (now the boulevard St.-Germain).

Quite unexpectedly, France declared war on Germany on July 19, 1870. Bazille was still painting near his home on August 2, when he wrote to Maître: "Give me news of our friends. . . . Renoir must be about to become a father, will he give birth to a painting?"[45]

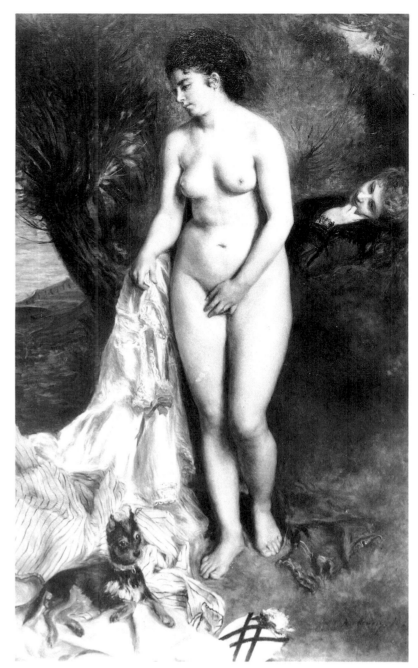

Bather. d. 1870. 73½ x 46⅛". Museu de Arte de São Paulo

A week later, on August 10, Bazille volunteered to serve in a Zouave regiment. When Maître learned in mid-August of the enlistment, he wrote an imploring, emotional letter to Bazille:

My dear and only friend, I've just received your letter; you are mad, stark raving mad, I embrace you with all my heart. God protect you, you and my poor brother! Ever yours. E. Maître.
Why not consult a friend? You have no right to go ahead with this enlistment. Renoir has just come in. I'm giving him my pen. E.
Triple shit, stark raving bastard! Renoir.[46]

Renoir was drafted on October 28 and was sent to Bordeaux. Manet enlisted. To avoid conscription, Cézanne hid in Marseilles. Monet, Pissarro, and possibly Sisley,[47] all fathers of young children, fled to London. Renoir was assigned to a regiment of cuirassiers (armored soldiers on horseback) and was moved to southwest France, to Tarbes in the Pyrenees. There he became gravely ill with dysentery. On November 28, Bazille—Renoir's friend, a great talent, and a generous human being—was killed at Beaune-la-Rolande.

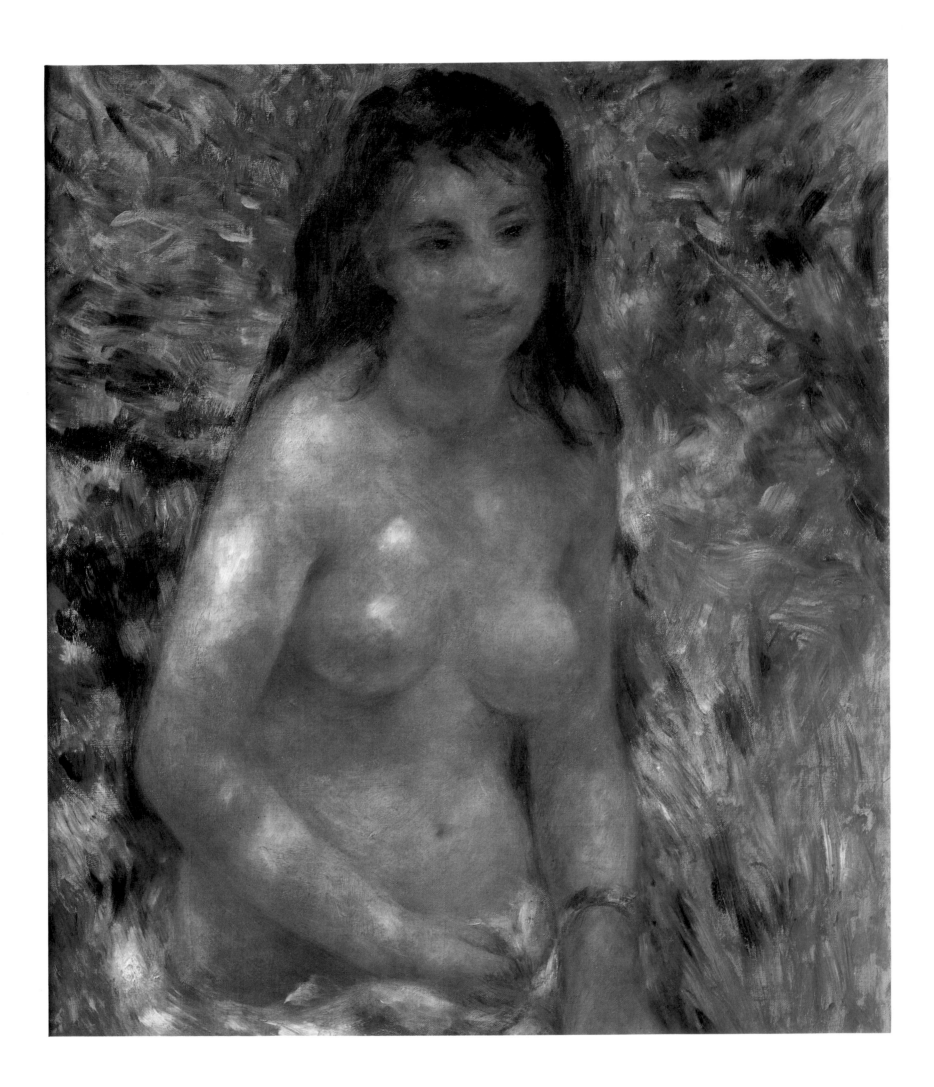

ENOIR spent a little over four months in the army, never seeing any combat. After France's defeat and surrender on January 28, 1871, he was obliged to remain in the service for about a month. On March 1, before he returned to civilian life, he wrote to Charles Le Coeur from Vic-Bigorre in the Hautes-Pyrénées:

Kiss everyone for me, the little children, Mme. Charles, Mlle. Louise, your mother, whom I'll be very glad to see again, and your sister.

I'll be so happy when I can shake your hand. If you only knew how anxious I am to get back. I can hardly sit still. I have lots of things to tell you but just now I don't have the patience. I'd just like to fill my letter by telling you that I'm longing to see you again. I was really scared during the siege, I who was stuffing myself with good things while you were starving. How many times I said to myself, if only it were possible to send them a bite. And I who wasn't hungry would have deserted to go and suffer with you. All the same I can tell you I wasn't happy for four months when I felt deprived of letters from Paris. I was so bored to death, it was impossible to eat or sleep. Finally I treated myself to dysentery, and I'd just about have kicked the bucket if it hadn't been for my uncle who came to get me in Libourne and took me to Bordeaux. There it reminded me a little of Paris, and then I saw something besides soldiers, which made me recover fast. And what made me realize how sick I had been was seeing my comrades. They were flabbergasted when they saw me come back. They had thought I was dead, and anyway they're used to it, especially with Parisians. There are a lot of them lying in the shade of the Libourne cemetery. It was very strange. On the day before we were at the wine merchant's. The next day you see a boy who has stopped speaking to anyone. He goes to be examined to have himself put on the sick list. The doctor throws him out. Next day he's delirious and starts laughing and kissing his family. The day after that there's no one there. And apparently if my uncle hadn't come, which changed things for me, it would have been the same for me. I'm telling you this little story so you'll understand how happy the letters from Paris made me....

I'm waiting to hear from Jules. In case the letter I'm writing to my brother doesn't reach him, please share this one with him.[1]

Two weeks later, civil war erupted in Paris, leading to election of a commune as the city's governing body. Its members, as the name suggests, were Socialists and others further to the left. The elected national government, which had fled the city, trained guns on Paris and effectively put it under siege. During its two-month reign, the Commune instituted numerous reforms of a somewhat Socialist cast. Gustave Courbet, a member of the ruling Commune, abolished the perpetrators of artistic conservatism—the Academy in Rome and the École des Beaux-Arts in Paris—and he ended the system of medals and honors connected with the Salon. He left the Salon jury in place, however.

Nude in the Sunlight. 1875–76. 31½ x 25¼″. Musée d'Orsay, Galerie du Jeu de Paume, Paris. Bequest of Gustave Caillebotte

Under the Commune and the siege, Parisian life became desperately austere; there was starvation, disease, and lack of coal and other vital materials. Renoir soon braved the dangers of leaving the encircled city and entering the ground held by government troops in order to take refuge with his parents, sister, brother-in-law, and younger brother, Edmond, in Louveciennes, where they had moved from adjacent Ville-d'Avray. Sisley his wife, and their children were also living in Louveciennes, and the two artists often painted together in the forest of Marly.

In June, after the bloody defeat of the Commune, in which, by a conservative estimate, 20,000 Parisians were killed, Renoir returned to the city. By this time he knew of Bazille's death in battle, a severe blow for him. He took a room on the rue Dragon, near Maître's apartment, and soon afterward he painted Maître relaxing indoors, against an ex-

Edmond Maître. 1871. 8¼ x 11″. Private collection, New York

otically flowered drapery, reflecting the vogue for *japonisme* that held sway in Paris for much of the latter part of the century. Renoir stayed in Paris for only a short while before moving to the suburb of St.-Cloud.

Another of Renoir's friends had a taste for Japanese art—Théodore Duret, a wealthy collector and art critic whom Renoir had known at the Café Guerbois. Duret had first visited the Orient in 1863 and had begun a collection of Japanese prints and artifacts. Now he was about to embark on a round-the-world trip with a long stop in the Far East. Since 1865 he had also had a close relationship with Manet. Both Oriental art and Manet's art are alluded to in Renoir's *Still Life with Bouquet* of 1871, a painting that could well have been inspired by Duret,

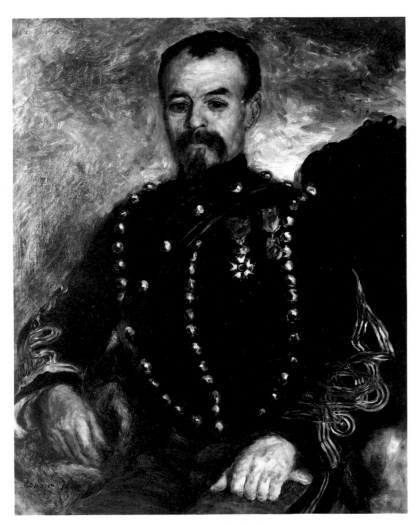

Captain Paul Darras. d. 1871. 31⅞ x 25⅝″.
Staatliche Gemäldegalerie, Dresden

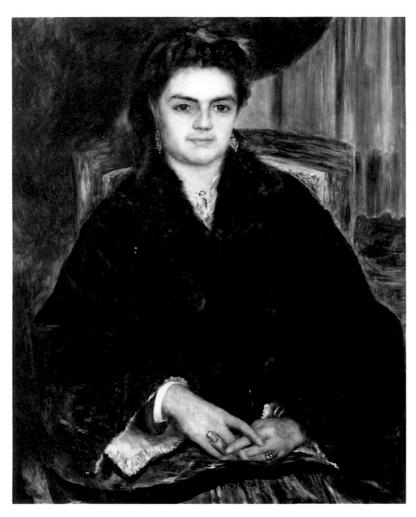

Mme. Darras. d. 1871. 30¾ x 24½″. The Metropolitan Museum of Art, New
York. Gift of Margaret Seligman Lewisohn, in memory of her husband, Samuel
Lewisohn, and her sister-in-law, Adele Lewisohn Lehman

OPPOSITE:
Still Life with Bouquet. d. 1871. Oil on canvas, 29½ x 23¼″. The Museum of
Fine Arts, Houston. The Robert Lee Blaffer Memorial Collection

whom he invited to St.-Cloud.[2] The fan and vase are literally Oriental, and the bright color, shallow picture space, and flat decorative arrangement owe a debt to Japanese prints. The still life is an homage to Manet, who had copied the Velázquez painting on the wall (the original today is attributed to a follower); and Manet is evoked in the cornucopia of flowers wrapped in white florist's paper, which calls to mind Olympia's bouquet in his scandalous painting at the Salon of 1865.

In mid-August Renoir was once again a guest at Jules Le Coeur's home at Marlotte. Jules wrote to his mother, "Renoir is here for a few days and we're both working as best we can."[3] The Le Coeurs continued, as they had before the war, to help Renoir find commissions. In the fall of 1871, they introduced him to Captain Paul Darras, who asked Renoir to paint himself and his wife, Henriette. In their dark tonalities and the Courbet-like weightiness of the figures, the portraits are reminiscent of Renoir's formal paintings of the 1860s.

With the money from Darras, Renoir rented his first studio, on the rue des Petits Champs, on the Right Bank near the Louvre and south of the Café Guerbois. In November, Monet took a studio not far away, near the Gare St.-Lazare. The friends were reunited. Slowly Paris began to resume its artistic and intellectual life.

From 1871 on, Renoir, Monet, Pissarro, and Sisley were aware that they were painting in an original avant-garde style. Renoir's particular bent from 1870 to 1877 was to experiment with what can be considered open form in large-scale figures. Seen from close up, the people are unclear, without line, detail, weight, volume, or relief; from a distance, the colored strokes suggest people and objects. Yet Renoir's treatment of form in large-scale figures was never as summary as Monet's because of his fascination with the sensuousness of flesh and clothing. This underlying Classicist concern with materiality, hinted at in the figure paintings of the early 1870s, became more apparent in 1878, when Renoir's treatment of the human body became increasingly defined, idealized, monumental, and tangible.

Renoir ordered his figure paintings from a typically Impressionist high vantage point (learned from Manet, Japanese prints, and perhaps from photography); this stresses the two-dimensional surface of the canvas and enhances the intimacy between image and viewer, expressive of Renoir's own warm, optimistic outlook. Just as Renoir's treatment of form never takes Impressionism to its extremes, his treatment of composition is also less than totally Impressionist but retains Classical means of arrangement in order to achieve balance, order, and harmony.

Early in 1872, Monet introduced Renoir to Paul Durand-Ruel, whom he had met in London during the war. Durand-Ruel had a Paris gallery that could be entered at either 16 rue Laffitte or 11 rue Le Peletier; he also had a branch in London at 168 New Bond Street. In March 1872, he purchased two paintings from Renoir: a still life for 400 francs and *The Pont des Arts, Paris* of 1867 for 200 francs.[4] Its crisp realistic style is very different from the fanciful, Impressionist execution of *The Pont Neuf, Paris,* painted in 1872. Both cityscapes, however, show the influence of photography. Characteristic of photographs of Paris that Renoir must have seen is the dual sense that action continues beyond

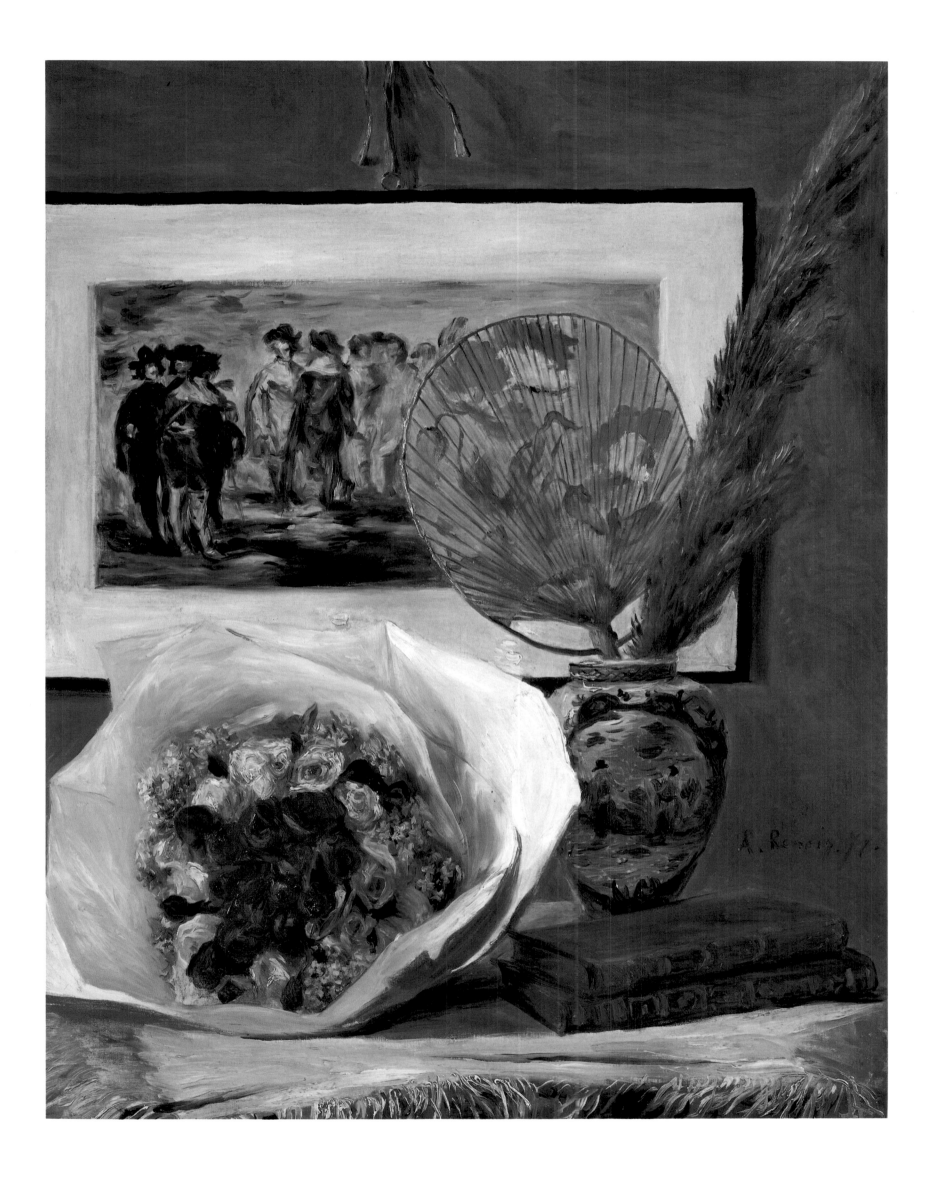

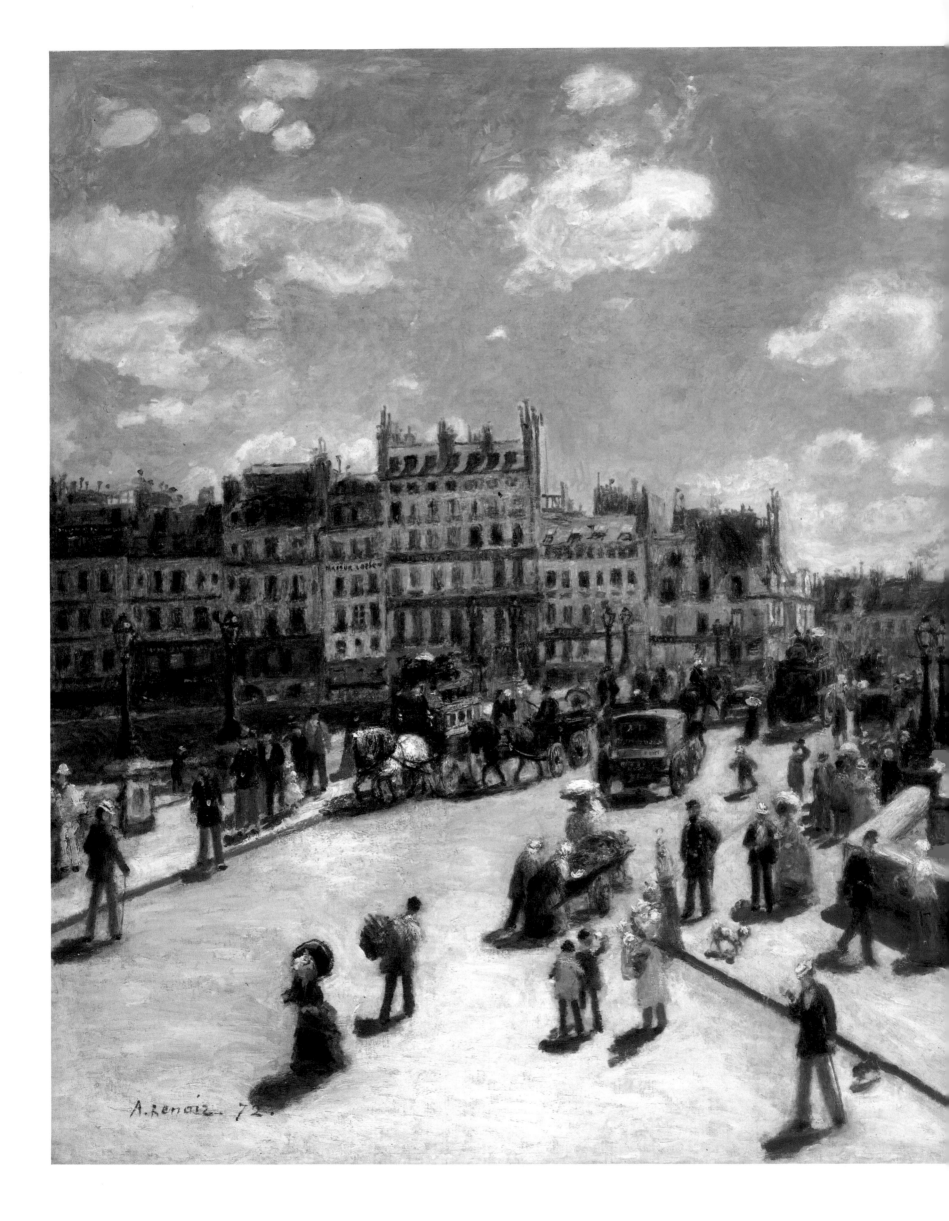

The Pont Neuf, Paris. d. 1872. 29⅝ x 36⅞". The National Gallery of Art, Washington, D.C. Ailsa Mellon Bruce Collection

The Pont Neuf. Photograph by Adolphe Braun, 1855

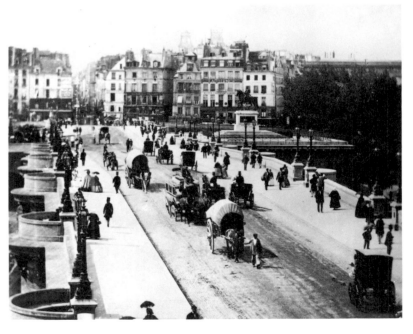

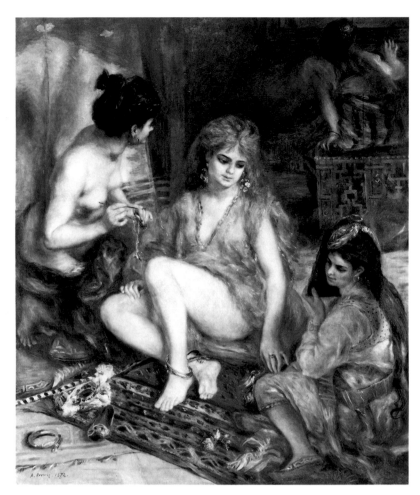

The Harem (Parisian Women Dressed as Algerians). d. 1872. 62 x 51¼". The National Museum of Western Art, Tokyo

the borders of the frame and that a split second is captured, producing an effect of instantaneousness.[5]

As in *La Grenouillère,* Renoir's primary interest in *The Pont Neuf* is not nature but people's interactions. At the lower right, a man and two women talk; nearby a man leans against the parapet and watches a fashionably dressed woman walking with a child; a bourgeois couple strolls leisurely; behind them, a young child runs in the street; a peddler in white coat and beret stands by his cart while several people scrutinize his wares; an elegantly dressed man with a cane walks toward the lower left; a similarly stylish woman walks in the same direction from the lower left. Will their paths converge?

At the same time, Renoir was completing *The Harem (Parisian Women Dressed as Algerians)* for the first postwar Salon, in 1872. It is the last painting for which Lise posed; she was married in April 1872.[6] This large canvas has a theme that was meant to please the Salon jury: like *Woman of Algiers,* it depicts an exotic brothel in Paris, and the figures' postures recall Delacroix's *Women of Algiers.* Renoir's titillating exotic costumes also allude to Henri-Georges-Alexandre Regnault's *Salomé,* a work that had received unprecedented acclaim at the Salon of 1870. But Renoir's painting was not in the prevailing Academic Realist style and was rejected by the Salon jury. He again signed a petition for its inclusion in a Salon des Refusés, but again the government did not establish the alternative show.

The Harem was soon purchased by a new patron, Hyacinthe-Eugène Meunier, called Murer, a widower whose wife had died in 1871, leaving him with a two-year-old son. With his half sister, Marie, he ran a bakery and restaurant at 95 boulevard Voltaire. He was in addition a writer, painter, and collector.

44

Murer gave dinners for artists almost every Wednesday from 1872 through 1880. There Renoir regularly dined with his close friends Monet, Sisley, Pissarro, and Cézanne, and with other painters he had known from the Café Guerbois, notably Guillaumin and Dr. Paul Gachet, best known as Van Gogh's last physician. Murer also invited others who were sympathetic to Impressionist art, such as Alphonse Legrand, a former employee of Durand-Ruel who had opened a small gallery of his own at 22 bis rue Laffitte, and Père (Julien-François) Tanguy, a Montmartre dealer in painters' supplies. The composer François Cabaner also attended.[7] When an artist could not afford to pay for his dinner, Murer would extend credit to be applied toward the acquisition of a painting. In this way, and through direct purchases, he built up a remarkable collection, including at least fifteen Renoirs.

During the summer of 1872, Renoir visited the Monets in Argenteuil, a town along the Seine twelve minutes by railroad from the Gare St.-Lazare. There he achieved wonderfully relaxed portraits of Claude and Camille. Both are reading a newspaper, Claude puffing on his pipe, while his wife has momentarily looked up to gaze directly at Renoir. Contemporary photography had explored variations of focus as well as unfocused images. If one looks just at Camille's eyes, the whole painting seems in normal focus. As one looks elsewhere, it is clear that Renoir did not use a roving focus, but literally painted what he saw from a fixed point of view; her face is sketchy, her body merely suggested. Here for the first time, he painted a body with a diffused form: no modeling, no substance, no weight, yet she has a penetrating glance that rivets us.

At the same time that he was developing his innovative styles,

Claude Monet Reading. 1872. 24 x 19⅝". Musée Marmottan, Paris. Bequest of Michel Monet

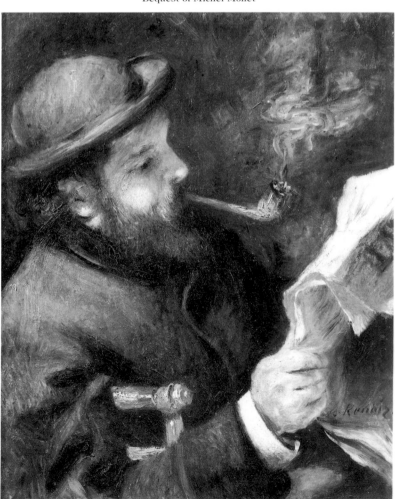

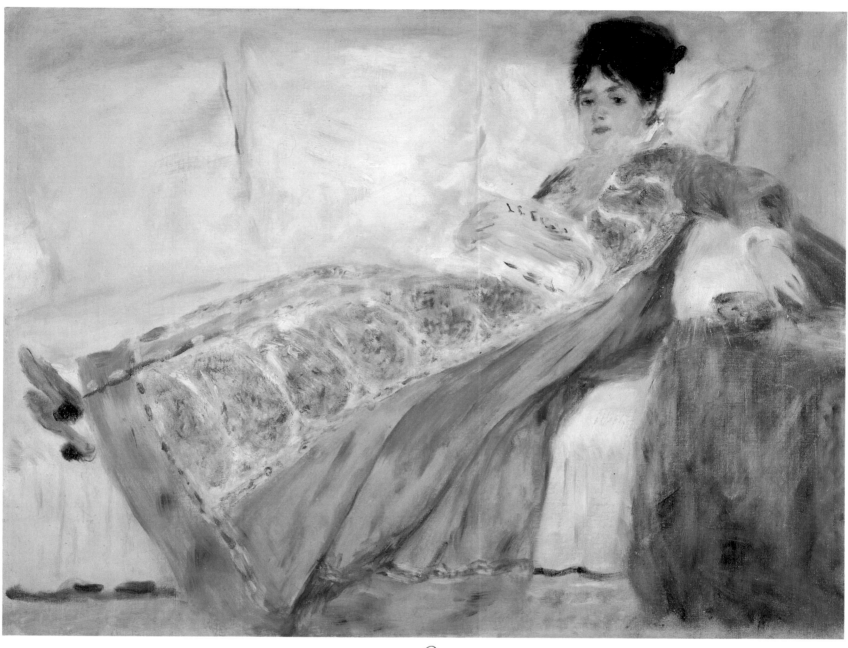

Renoir continued to paint more conservative work for the Salon. His submission in 1873, *A Morning Ride in the Bois de Boulogne,* was huge, which was an element likely to appeal to the jury, as were the obviously upper-class riders, Henriette Darras and Joseph Le Coeur (son of Charles), and the smooth, "finished" surface of the forms. Renoir had made a life study of Mme. Darras's head in bust length; he painted the horses, the background, and the full-length figures at various times, but not outdoors in natural light. In spite of these efforts in what was his last Academic Realist work, *A Morning Ride* was rejected. But there was a Salon des Refusés that year, and it was hung there.

Castagnary and Burty, who had praised Renoir's paintings in the past, continued to write favorably. Other critics were negative. Jules Claretie criticized the "improbable horsewoman, impossible horses,"[8] and Ernest Chesneau—with no evidence whatsoever—associated Renoir with the Commune of 1871: Renoir "has been revoltingly wicked" and "justifies all the rebels."[9]

Despite all this, the work was soon purchased by Henri Rouart, industrialist, collector, painter, and friend of Degas. Renoir had other significant sales that year: Duret, back from the Orient, bought *Lise* (1867) for 1,200 francs and *Study: In the Summer* (1868) for 400 francs. Durand-Ruel made two small purchases, for 100 and 600 francs, but at this time, he was much less interested in Renoir than in the other Impressionists. His account books of 1873 record a total of 19,050 francs paid to Monet; 6,400 francs to Degas; 6,260 francs to Sisley; and 5,300 francs to Pissarro.[10] But since his friends were doing well, Renoir had hopes for himself. And the assumption of Renoir and his colleagues that Durand-Ruel had an obligation to them, and his reciprocal assumption of their relation to him, signaled the fact that in the 1870s a new dealer-critic system was emerging to compete with the old academic Salon system. Independent dealers and critics for journals became involved in publicizing, taste-making, group shows, and dealer shows. While the academic system was geared to evaluate individual canvases, award prizes, exhibit and purchase works for the state, the dealer-critic system was based on the notion that the career of an artist should be handled by a benevolent dealer, who would provide visibility, publicity, purchases, loans, advances, and social support.[11]

In September, Renoir moved to a larger studio at 35 rue St.-Georges in Montmartre. He occupied the top floor, and his brother Edmond had an apartment on the floor below. They kept these lodgings for the next

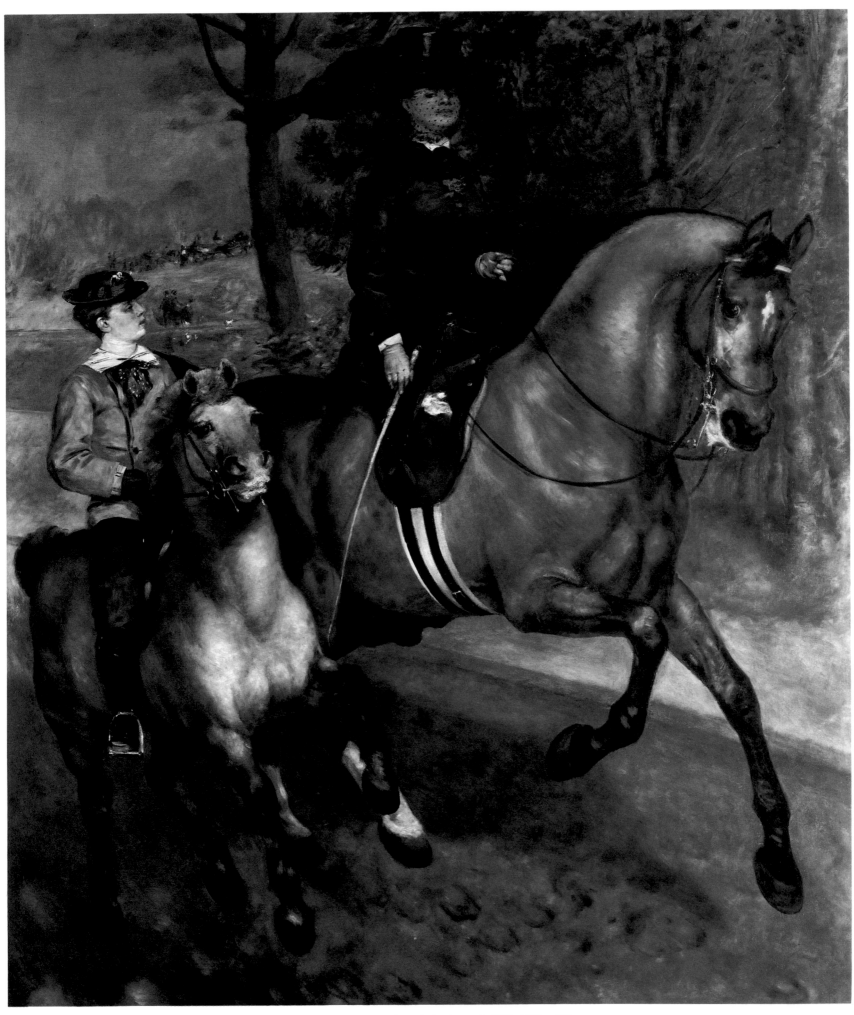

A Morning Ride in the Bois de Boulogne. d. 1873. 102¾ x 89″.
Kunsthalle, Hamburg

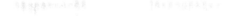

Claude Monet. *Mme. Monet and Her Son in the Garden.* d. 1873. 23¼ x 31¼".
Private collection

LEFT:
Woman with Umbrella (Camille Monet). d. 1873. 18⅛ x 15". Private collection

eleven years. Edmond continued to write articles promoting his broth-
er's art and frequently posed for him as well.

In the summer and fall of 1873, Renoir was again a guest of the
Monets in Argenteuil. In a letter to Pissarro in September, Monet im-
plies that Renoir regularly occupied their spare bed: "Renoir is not
there, you will be able to use the bed."[12] At this time, Monet already
had become obsessed with the possibilities of flowers in their natural
setting, which he later raised to an art in itself at Giverny. Renoir
showed him at Argenteuil before a thicket of red and yellow roses
(p. 59).

Among all the paintings Renoir and Monet did together, the two of
the *Duck Pond* are the most similar. The canvases are almost identical
in size, motif, and style. When they painted figures side by side, howev-
er, the results were always quite dissimilar, as in Renoir's *Woman with
Umbrella (Camille Monet)* and Monet's *Mme. Monet and Her Son in the
Garden.* Renoir's portrait explores a decorative antithesis between lin-
ear patterns (ringed hand, striped blouse, umbrella, linear strokes in
foliage) and smoother surfaces (Camille's eyes, lips, skin, hair), but

47

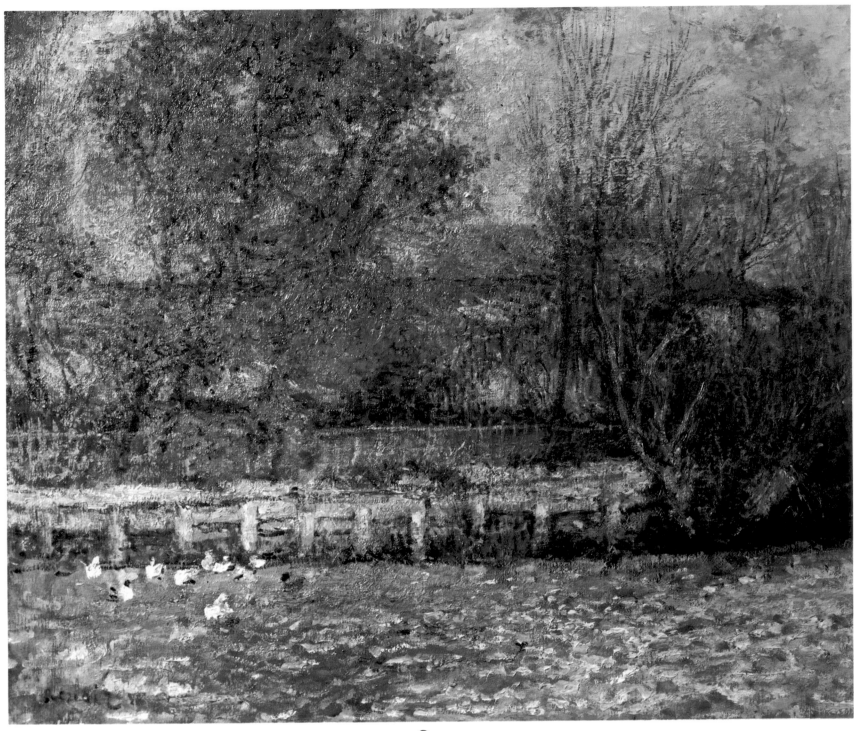

Duck Pond. 1873. 20 x 24½". Valley House Gallery, Inc., Dallas

what draws us most strongly is the straightforward gaze of this modern woman. Monet presents his wife as part of nature in her own milieu with her son, maid, flower garden, and house. Light is important in both paintings, yet Renoir's Camille seems not only to be bathed in natural light but to emit her own light and warmth.

Back in Paris, Renoir's sociability was again in evidence. Late in the afternoon, after he had spent a full day in his studio, friends would start dropping by. They included the painter and caricaturist Jean-Louis Forain and some second-rank artists—Frédéric Cordey, Pierre Franc-Lamy, and Norbert Goeneutte. There were also men of other vocations, the most important of whom was Georges Rivière, fourteen years younger than Renoir, who worked at the Ministry of Finance and was a journalist as well.[13] Apart from his artist friends, Rivière and Edmond Renoir were the men closest to Auguste Renoir. Others who gravitated to his studio after work were Eugène-Pierre Lestringuez, a

civil servant; Paul Lhote, of the merchant marine, an amateur painter; and Emmanuel Chabrier, the composer. As a rule, they would meander down to the Café de la Nouvelle-Athènes, a brasserie at nearby place Pigalle that replaced the Guerbois in the 1870s and won over its clientele. Writers also joined in their discussions. Some of them were old acquaintances from the Guerbois: Alexis, Burty, Duret, Houssaye, Duranty, Mendès, and Silvestre. In addition, the composer Cabaner and the collector Dr. Georges de Bellio also frequently came,[14] and there were newcomers—Gustave Caillebotte and Marcellin Desboutin. These friends at the café helped Renoir to find patrons and obtain commissions, and no less important, they often modeled for him.

Part of their reason for coming to 35 rue St.-Georges was to be with the women with whom they both modeled and socialized. Besides hiring professional models, Renoir often employed milliners, seamstresses, laundresses, and actresses to pose for him. Sometimes he so

48

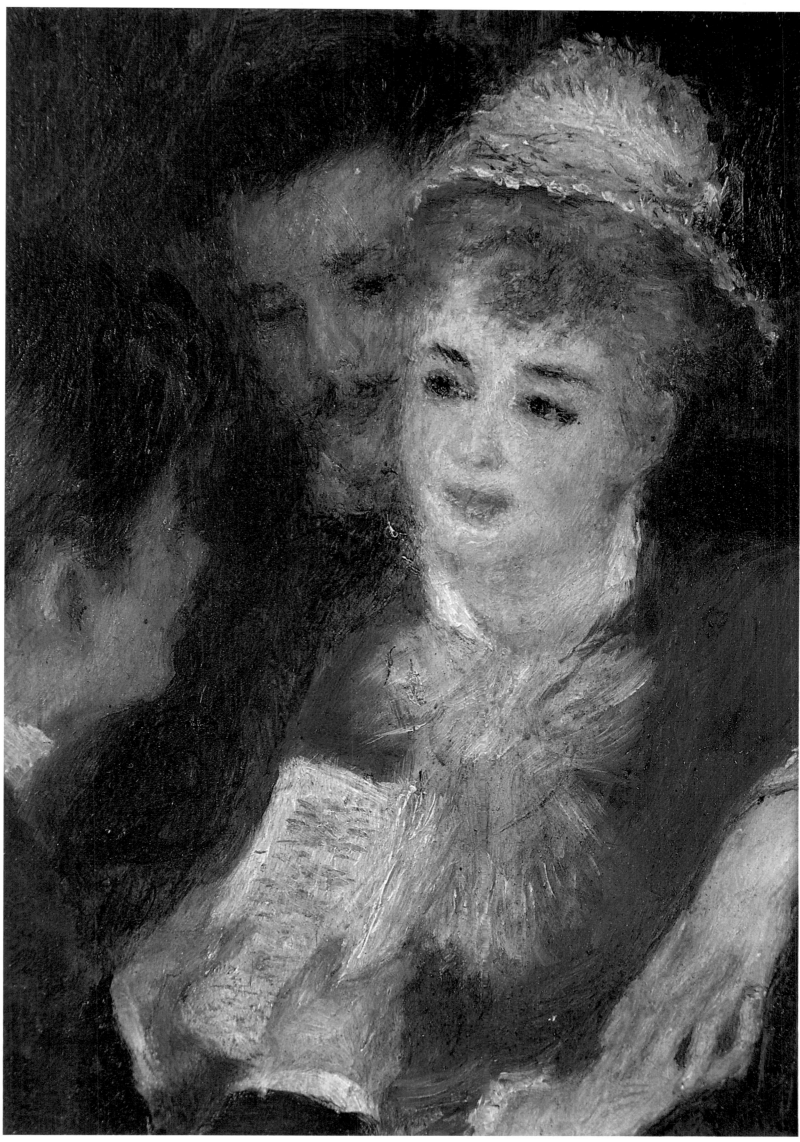

Reading the Role. 1874. Oil on wood, 36¼ x 27⅝″. Musée St.-Denis, Reims

idealized his models that it is difficult to be sure who was posing. Yet the fact that these were his friends and not strangers enabled him to capture the intimacy in the relationships.

In 1874, Renoir had three new models. Henriette Henriot was an actress who had played at the Odéon Theater in Paris. Her profession suggested the theme of *Reading the Role*. In the foreground, Georges Rivière appears as the prompter. The mustachioed, bearded Edmond Renoir is the male protagonist. A subtle interaction links the three through glance, gesture, physical closeness, color, and light.

Mme. Henriot also posed for *Parisian Lady*. Her costume and the painting's lack of a specific setting resemble aspects of contemporary fashion illustration and recall some Manet figures and Japanese prints. However, Renoir gives free rein to his model's personality; Mme. Henriot gazes out magnetically at a presumed male spectator as if to suggest they take a walk together. Renoir's color is striking. In 1898, the painter Paul Signac commented in his diary about *Parisian Lady:* "The dress is blue, an intense and pure blue which, by contrast, makes the flesh yellow, and, by its reflection, green. The tricks of color are admirably recorded. And it is simple, it is beautiful, and it is fresh. One would think that this picture painted twenty years ago had only left the studio today."[15]

Another model, known today solely by her humorous nickname, Nini "Gueule de Raie" ("Fish Mouth"), posed with Edmond Renoir for *La Loge*, one of Renoir's most brilliant images. Following Impressionist precepts, he never used dark colors like black or brown in the shadows, but in *La Loge*, black becomes a dominant color; it takes on a regal quality in its combination with gold and pink.

A third new model, Nini Lopez, posed for the large *Mother and Children*, Renoir's first painting of a theme that would become increasingly important in his art.

By late 1873, the postwar economic boom in France had come to an end. Early in 1874, a worldwide economic crash and depression ensued. From 1874 through 1877, Renoir was in the direst financial straits of his entire career. He was rejected at the Salons of 1874 and 1875; he did not even submit in 1876 and 1877. "All these [Salon] rejections or these bad placements were not helping my paintings to sell... and it was necessary to earn enough money to buy food, which was difficult,"[16] he recalled in an interview in 1904. His dealer, Paul Durand-Ruel, could offer little help; he could barely make ends meet himself. He had closed his London gallery, and was drastically limiting his new purchases of canvases.

This forced withdrawal of Durand-Ruel's support and the persistent refusal of the Salon judges to permit Renoir, Monet, Sisley, Pissarro, and Cézanne to show in official exhibitions—thereby denying them access to the buying public—spurred the drafting December 27, 1873, of the founding charter of the Society of Painters, Draftsmen, Sculptors, and Engravers. This document did not lay down a unified program or prescribe a consistent style; the group never constituted a school or a formal organization; its membership and artistic styles were continually in flux. But it did mount exhibitions, the first of which took place in 1874, and it supported a journal, which materialized in 1877.[17]

From April 15 until May 15, 1874 (one and a half weeks before the opening of the official Salon), the first exhibition of the Society of Painters, Draftsmen, Sculptors, and Engravers was held at 35 boulevard de Capucines. Thirty-nine artists took part, including Eugène Boudin, Bracquemond, Cézanne, Degas, Guillaumin, Monet, Morisot, Pissarro, Renoir, Rouart, and Sisley. Among those who had been invit-

ed but had declined were Manet, Fantin-Latour, and James Tissot.

Edmond Renoir wrote the essay for the exhibition catalogue. Auguste was a member of the hanging committee and ended up arranging the show practically singlehandedly. In a letter to his old friend the critic Burty, he apologized: "Forgive me for not having been able to see you today, but I'm not yet completely finished with this complicated hanging."[18]

Renoir exhibited six paintings and one pastel. The most important were three recent large interior scenes: *Parisian Lady, La Loge,* and *The Dancer* (a portrait of Ninette Legrand, daughter of his friend Alphonse). He also sent a head, a landscape, and a still life but no commissioned portraits and no nudes.

Ten days after the show opened, the name "Impressionists" appeared in a mocking article by the satirist Louis Leroy in the April 25 *Charivari* titled "Exhibition of the Impressionists."[19] Although it was first used pejoratively, the term was gradually accepted, and by 1877, the group called its newspaper *L'Impressionniste: Journal d'art.*

Most of the reviews, which were written by friends including Burty, Castagnary, Ernest d'Hervilly, and Mendès, were favorable. Mendès suggested that Renoir's large paintings represented three stages in the life of a Parisian girl.[20] There were some generally negative com-

Parisian Lady. d. 1874. 63 x 41½". National Museum of Wales, Cardiff

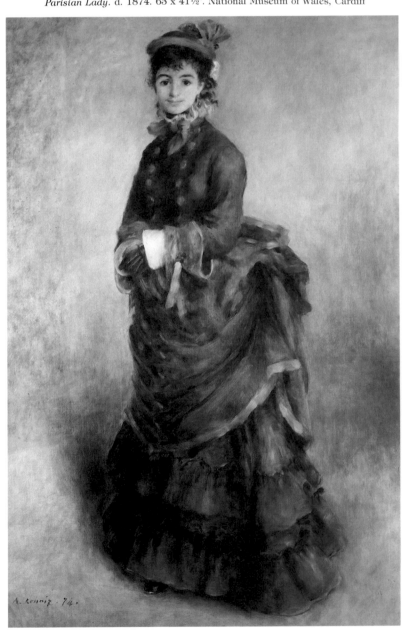

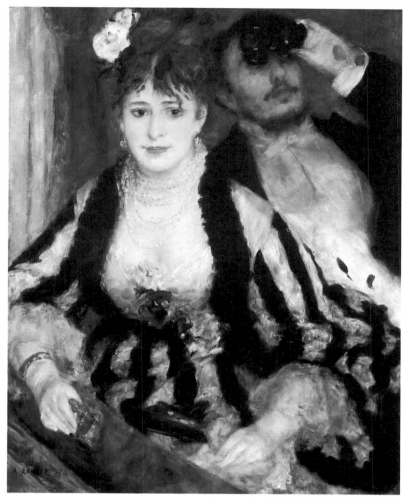

La Loge. d. 1874. 31½ x 25″. Courtauld Institute Galleries, London.
Courtauld Collection

ments, but the only specific criticism of Renoir came from Louis Leroy, who mocked *The Dancer:* "His dancer's legs are as cottony as the gauze of her skirts."[21]

The attendance and proceeds of the exhibition were disappointing. In its four weeks, only 3,500 visitors came, compared to the 400,000 who went to the Salon in the same length of time. At an entrance fee of 1 franc, the gate receipts totaled 3,500 francs. Three hundred fifty catalogues were sold at 50 centimes each, bringing in an additional 175 francs. The expenditures totaled 9,272 francs; hence, the group had a sizable deficit. Renoir sold *La Loge* to Père Martin, a dealer, for 425 francs, a low sum compared to the going prices for Pissarro's landscapes, which had brought up to 950 francs at a January 1874 auction.

Perhaps these disheartening figures were due to the national economic situation or perhaps to the vicious attack launched by the popular press, which charged that the Impressionists were sloppy artists of no talent who exhibited their sketches as a revolutionary gesture to offend people of traditional good taste. Ironically, the Impressionists desperately wanted to be appreciated and accepted by the very public and critics who derided them, for they needed to sell their works. The negative reaction of the Salon jury and the aggressively antagonistic behavior of the press only unified the group.

Of the eight Impressionist shows of 1874–86, Renoir participated in four, Monet in five, Sisley in four, Pissarro in all, and Cézanne in two. Besides these leaders, other consistent exhibitors were Morisot, Degas, Gustave Caillebotte, and Mary Cassatt. Forty-five other artists exhibited in the course of the eight shows.[22] Durand-Ruel, dealer for

the Impressionists, acted also as a patron and exhibition and auction coordinator, and linked the group together. After the last group showing in 1886, Durand-Ruel and other dealers continued to mount Impressionist shows throughout the world.[23]

At the end of 1874, an accounting was made of the financial returns from the exhibition. On December 17, Renoir presided at a meeting of fourteen members at 35 rue St.-Georges. The treasurer's report indicated that each artist would have to pay 184 francs to reestablish the basic operating fund. The membership voted to dissolve the society, and Renoir helped oversee the liquidation.

In the spring of 1874, Renoir had to appeal to friends: "My dear M. Duret, I have a payment to make this morning. Can you let me have something or tell me when and what amount so that I could make an exact promise? I am very sorry to bother you but I cannot succeed in finding money anywhere. Excuse me, please. I will be at home around 1 o'clock."[24] Or another letter to Duret: "I should be very grateful to you for not forgetting me this month because I'm in a bottomless pit."[25]

When the summer came, Renoir visited Charles Le Coeur and his family at their country estate at Fontenay-aux-Roses. He painted their garden (p. 56), and there a strange incident occurred that is known only through Le Coeur family word of mouth. Renoir, then thirty-three, sent a love note to Charles's sixteen-year-old daughter, Marie. Jules intercepted the note to his niece and showed it to Charles. Abruptly, after a ten-year friendship, Renoir was banished forever from the Le Coeur circle.[26]

In July, Renoir went to stay with the Monets at Argenteuil, where he painted Monet fishing while Camille read. When Sisley came by, Renoir painted his portrait.[27] One afternoon, Manet also paid a visit. Side by side, he and Renoir painted Camille and her son. At this moment in Manet's artistic development, his work was beginning to show the influence of Renoir and his colleagues. Here both Manet and Renoir paint an Impressionist moment of joyful relaxation outdoors with a light, colorful palette and a sketchy execution. Renoir gave this painting to Monet (who had painted Manet painting that afternoon).

During this summer, Renoir and Monet saw a great deal of Caillebotte, a wealthy bachelor whom they knew from the Nouvelle-Athènes. Caillebotte was an engineer, painter, and collector who was beginning to buy paintings by Renoir and other Impressionists.

On December 22, Renoir's father died at Louveciennes, at the age of seventy-five. His mother stayed on with her daughter and son-in-law in the house, and Renoir visited them frequently throughout the next twenty years.

In 1875, a new model entered Renoir's art and perhaps his private life. Margot (Marguerite) Legrand (no relation to Ninette and Alphonse) became one of his favorite models for the next four years. His strong reaction to her illness and death in 1879 suggests that they were lovers. This would explain why the theme of romance blossoms in his paintings from 1875 on, as in *The Lovers* and *Confidences* (p. 57). Margot also posed affectionately in *Woman with a Cat* (p. 58).

During 1875, Renoir's financial situation continued to be desperate. Luckily he could still count on the assistance of several friends. He wrote to Murer around this time: "Since you must come on Tuesday to

OVERLEAF LEFT:
Mother and Children. 1874. 67 x 42⅝″. Copyright The Frick Collection, New York
OVERLEAF RIGHT:
The Dancer. d. 1874. 56⅛ x 37⅛″. The National Gallery of Art, Washington, D.C. Widener Collection

51

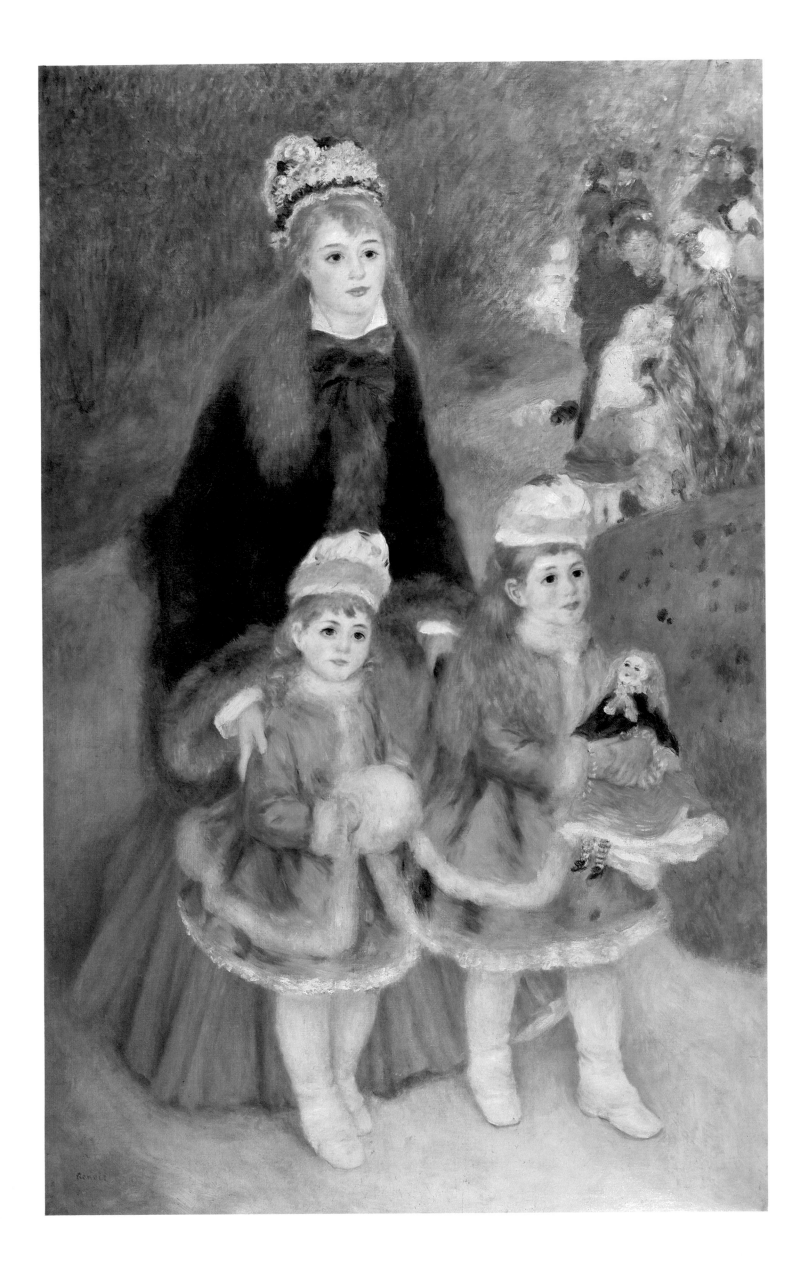

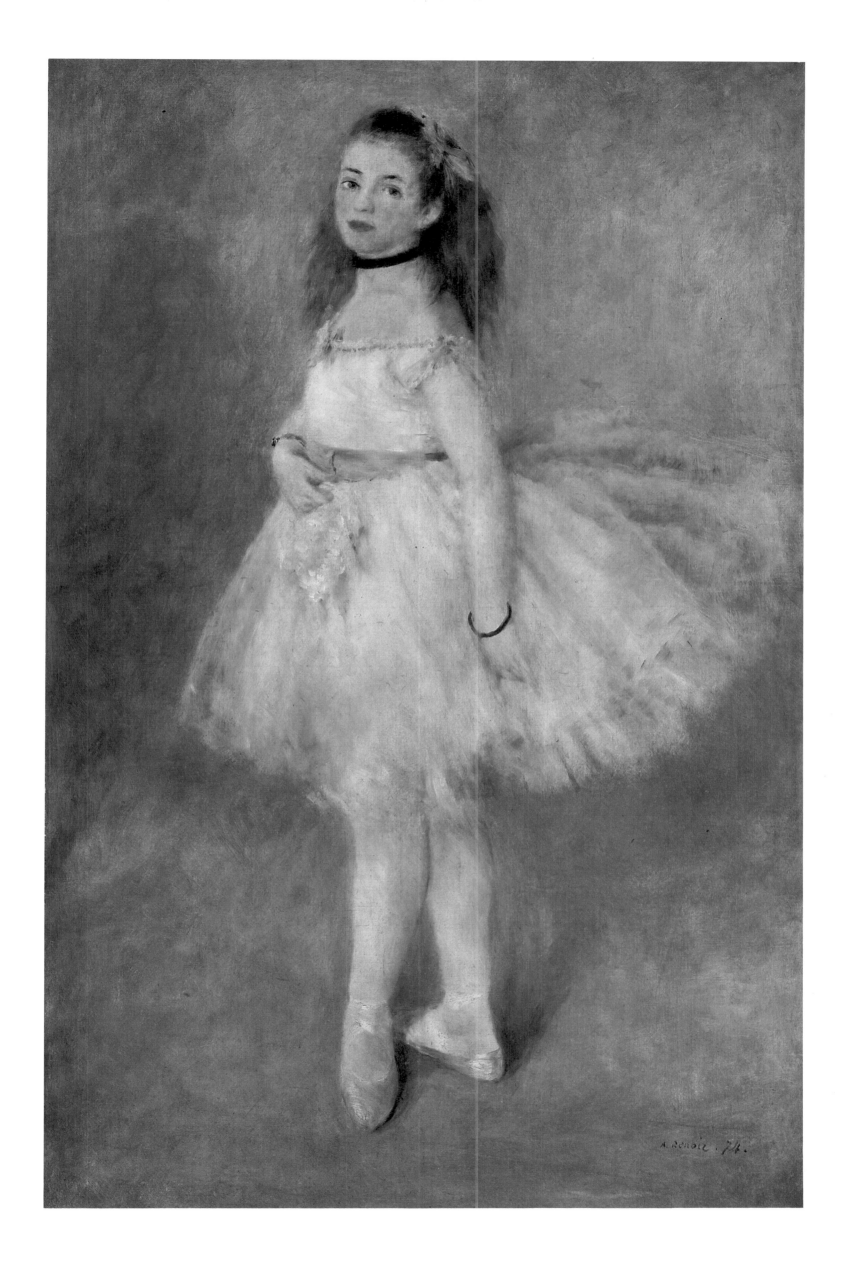

Fisher with Rod and Line. 1874. 21¼ x 25⅝″. Private collection

M. Legrand's to pick out some canvases, could you do me the favor of advancing me 100 francs? New Year's gifts left me broke and I have a bill to pay today."[28]

Duret also continued to be very helpful. In an undated letter that seems to have been written in 1875, Renoir pleaded with him: "Everybody is letting me down for my rent. I'm extremely annoyed. I'm not asking you for any more than you can do, but you would be doing me a real favor. In any case, I'll stop by and see you tomorrow morning. Of course, if you can't do it, I will understand."[29] In another undated letter, apparently from the same period, he wrote Duret: "I am in trouble this morning for 40 francs, which I do not have. Do you have them or a part? I'll make up the rest by asking other people. But I must find 40 francs before noon and I have exactly 3 francs. Greetings. Renoir. If you have them, you can give them to the messenger."[30] As he promised, he made a plea to an unknown person. This second letter is identical, except that it omits the last sentence.[31] With only 3 francs, Renoir was really destitute, for in 1875 a pound of coffee cost 3 francs 20 centimes; a liter of wine, 1 franc; a pound of sugar, 80 centimes.

Other undated letters to Duret seem to have been written in this year: "If you can spare a little money at this time you would make me really happy. I am completely broke." Or: "Can you give me a little money or tell me when? I'd be much obliged. Ever yours." Renoir's pleas for money were always written with warmth, good humor, and charm, and no trace of self-pity or anger. His optimism in spite of adversity was one of the traits that endeared him to others.

Besides helping Renoir with money, Duret was a good friend; he dropped in at Renoir's home and Renoir at his without formality. He introduced Renoir to prospective patrons, and Renoir was not averse to asking Duret for invitations to mix business and pleasure. For example: "Will you be able to get me an invitation to the Chernuschi [*sic*] ball. I'd be much obliged."[32]

Henri Cernuschi, a close friend of Duret's, had accompanied him in 1871–72 on his trip around the world. Not only had Cernuschi purchased Japanese prints, he had acquired a Japanese dog, and after meeting Renoir in 1875, he commissioned its portrait—*The Dog Tama* (p. 58).

That same year Duret also introduced Renoir to Charles Ephrussi, a banker, collector, and art critic for the *Gazette des Beaux-Arts,* and Jean Dollfus, an Alsatian industrialist and collector who had a passion for Delacroix's paintings. Dollfus commissioned Renoir to copy Delacroix's *Jewish Wedding* (p. 59) in the Louvre, for which he paid 500 francs. Dollfus also purchased two full-face paintings of Monet: *Claude Monet Reading* (1872) and *Claude Monet* (1875).

To raise money after the debacle of the Impressionist exhibition, Renoir, Monet, Sisley, and Morisot held a painting auction on March 24, 1875, at the Hôtel Drouot in Paris. Durand-Ruel was the appraiser who set the minimum bids, Charles Pillet was the auctioneer, and Burty wrote the catalogue preface. On sale were twenty works by Renoir, twenty by Monet, twenty-one by Sisley, and twelve by Morisot. To the shock of Renoir and his friends, the sale turned out to be an event of unexpected violence; Pillet had to call in the police to prevent fights among members of the audience who tried to obstruct the auction and howled at each bid.[33]

Years later Renoir was still amazed at what had ensued:

If a few patrons came to our aid, it is much more because of the violence with which the public had attacked us than because of their admiration for our work.... This sale was a disaster. The fine arts students even paraded by in single file to demonstrate against our painting, and the intervention of the city police was necessary. From that day on, we had our defenders and, even better, our patrons.[34]

At the auction, Renoir's paintings brought the lowest prices of all. Ten canvases were practically given away for from 50 to 90 francs. The highest bid for a Renoir was 300 francs for *The Pont Neuf, Paris,* which

Alfred Sisley. 1874. 25¾ x 21⅜″. The Art Institute of Chicago. Mr. and Mrs. Lewis L. Coburn Memorial Collection

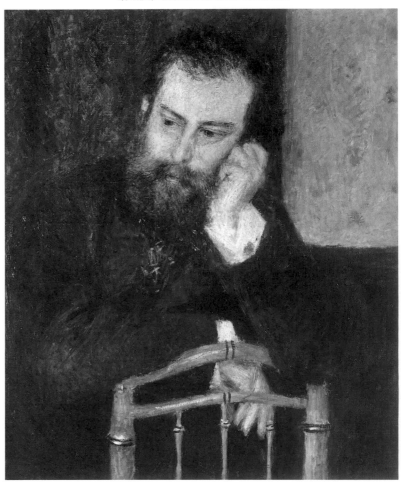

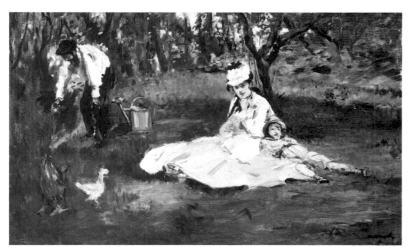

Mme. Manet and Her Son. 1874. 19⅞ x 26¾″. National Gallery of Art, Washington, D.C. Ailsa Mellon Bruce Collection

Édouard Manet. *The Monet Family in Their Garden in Argenteuil.* 1874. 19¼ x 38⅛″. The Metropolitan Museum of Art, New York. Bequest of Joan Whitney Payson

Durand-Ruel bought. In total, Renoir's twenty paintings sold for 2,250 francs. For the most part, his works were bought by people already familiar with both him and his work: the artists Rouart and Auguste de Molins, Berthe Morisot's cousin Gabriel Thomas and Monet's brother

Léon, the writers Houssaye and Émile Blémont (who used the nom de plume Léon Petitdidier), and Duret's friends Dollfus and Henri Hecht. However, one new buyer acquired three Renoirs and subsequently developed into an important patron—Georges Charpentier. He bought *Fisher with Rod and Line* for 180 francs, a head for 85 francs, and a landscape for 120 francs.

Newspaper reviews were divided equally. The day before the sale, March 23, Albert Wolff wrote in *Le Figaro,* the most widely read daily:

All these pictures have had somewhat the effect on us of a painting that you must look at from fifteen paces while squinting your eyes, and certainly you need a very large apartment to be able to house these canvases, if you wish to enjoy them even through the imagination.... The impression produced by the Impressionists is that of a cat walking on the keys of a piano, or a monkey that has got hold of a box of paints.[35]

Ernest d'Hervilly wrote in *Le Rappel:*

We are infinitely grateful to some painters for achieving with their palettes what the poets of their time have been able to render with a totally new emphasis: the intense heat of the summer sky, the poplar leaves turned into gold coins by the first hoarfrosts; the long shadows cast by the trees in winter on the fields;

55

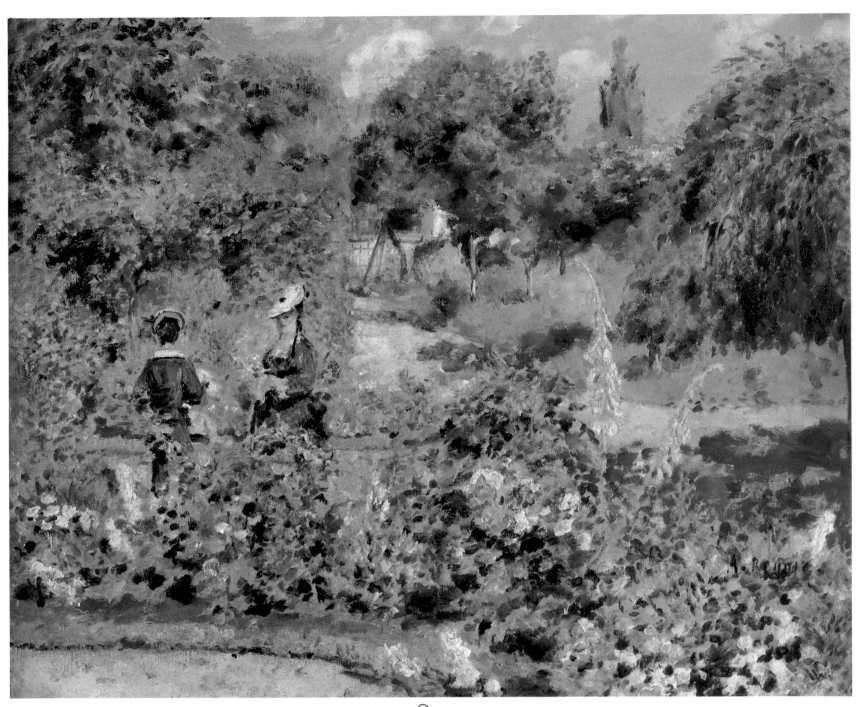

Garden at Fontenay. 1874. 19⅞ x 24¼". Oskar Reinhart Collection
Am Römerholz, Winterthur

the Seine at Bougival; or the sea on the coast, quivering in the morning breeze; children rolling on lawns dotted with little flowers. They are like small fragments of universal life, and the rapid and colorful, subtle and charming things that are there reflected have every right to be cared about and celebrated.[36]

Soon after the sale, the Charpentiers invited Renoir to their home. Georges Charpentier, five years younger than Renoir, had become head of a large publishing house after the death of his father in 1871. The following year he married Marguerite Lemonnier. They bought a luxurious town house at 11 rue de Grenelle, in the St.-Germain district. Soon Mme. Charpentier's salon became famous in Paris as the elite literary, artistic, and political gathering place. Those who frequented it included the writers Zola, De Banville, Alphonse Daudet, Guy de Maupassant, Edmond de Goncourt, Gustave Flaubert, Jules Barbey d'Aurevilly, and Joris-Karl Huysmans. Composers were also present: Chabrier, Camille Saint-Saëns, and Jules Massenet. Actors and actresses, including the popular Jeanne Samary, attended, along

with grandes dames of the aristocracy and politicians—among them Georges Clémenceau and Jacques-Eugène Spuller. Eminent Salon artists such as Carolus Duran and Jean-Jacques Henner were more likely to attend than were avant-garde artists,[37] but among the "modern" artists, Renoir was most often a guest at the Charpentier salons from 1875 through the early 1880s.

Sometime during the spring of 1875, Renoir met still another important future patron, Victor Chocquet, a customs official with a passion for paintings. His income was modest (though later increased by his wife's inheritance), but Chocquet built up a sizable collection and became a staunch advocate of Impressionism. At the time of his death in 1899, he owned fourteen Renoirs.

In 1875 he commissioned portraits of himself and his wife, Caroline. He asked Renoir to reproduce in the background sketches by Delacroix that he owned. Renoir also painted Mme. Chocquet reading on her terrace at 204 rue de Rivoli with a view of the Tuileries in the background.

As he had with his other patrons, Renoir soon formed a close friendship with Chocquet, as is evident in a note dashed off to him: "Just as I'm packing my bags, I suddenly get a portrait of a girl to do, someone leaving in 10 days. I absolutely can't say no. So excuse me if I have to let you go without me. This nice country excursion is only postponed. I am the one to feel sorry."[38]

In the fall of 1875, Renoir took Chocquet to Père Tanguy's shop, where Cézanne stored his canvases when he went south to Aix-en-Provence. Renoir, who considered Cézanne one of the greatest artists—if not the greatest—among the Impressionist group, anticipated that Chocquet would appreciate Cézanne's art. Chocquet began collecting Cézanne's paintings and through the next twenty years acquired thirty-five of them.

In the mid-1870s, Cézanne also made a bust-length portrait of Chocquet that, like Renoir's, reflects the artist's personality as much as the sitter's: Cézanne's *Chocquet* is forbidding and distant; his unfocused eyes look inward. The strongly rectilinear format makes the image appear rigid. Renoir's *Chocquet* seems approachable; his eyes gaze outward at the viewer; the curving forms depict a relaxed man.

Renoir's *Self-Portrait* painted around this time (p. 62) is not unlike his Chocquet portrait—or unlike all his portraits—in its depiction of a somewhat idealized personality with magnetic eyes straightforwardly confronting the viewer. His hat covers his balding pate. His self-image lacks the seriousness, even anxiety, evident in a contemporary photo-

The Lovers. 1875. 69 x 51¼". National Gallery, Prague

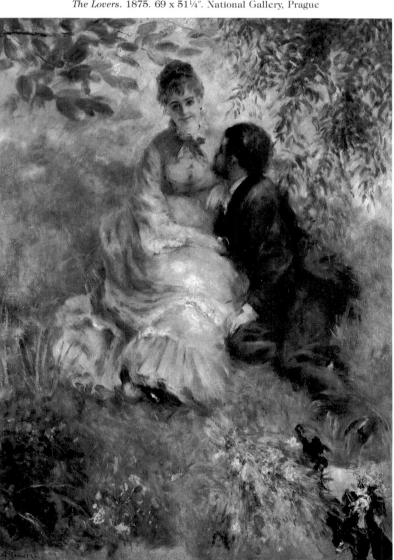

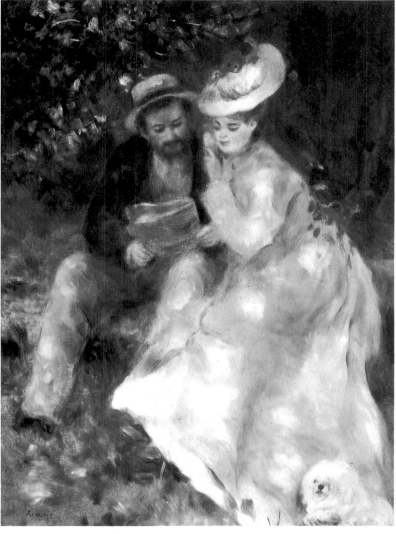

Confidences. 1875. 31⅞ x 25⅝". Joan Whitney Payson Gallery of Art, Westbrook College, Portland, Me.

graph of him. Yet he has captured the same intense glance that Desboutin conveys in his etching of c. 1876–77 (p. 62).

In 1875 and 1876, Renoir continued his Impressionist experimentation. In *Mme. Henriot* (p. 61), as in his own portrait, he went further than he had in his 1872 painting of Camille Monet reading *Le Figaro* in contrasting a rather sharply focused face with a vaporous body. In *Nude in the Sunlight* (p. 38), the entire image is blurred. The pervasive flickering strokes of light, bright color seem to merge her body with nature.

In 1876, because of a new rule suggested by Degas and supported by Monet, an artist of the Impressionist group could not submit both to the group show and to the Salon. Since Renoir had been rejected by the Salon jury each of the previous four years, he devoted all his energy to planning for the second Impressionist show, set for the spring.

In February, Renoir and Rouart sent out invitations to prospective exhibitors, for instance: "M. Caillebotte, We thought it would be a good idea to renew the joint endeavor of a special exhibition. For that purpose, we have reached an agreement with M. Durand-Ruel, who is renting us two rooms, including the largest one. We would be very pleased if you joined us in this new venture."[39] Caillebotte was one of the nineteen who agreed to exhibit.

That Renoir had sent no commissioned portraits to the first Impressionist show is strong evidence that he preferred to make his reputation as a chronicler of modern life. However, the 1874 exhibition had been a disappointment in sales and attendance, and he was realistic

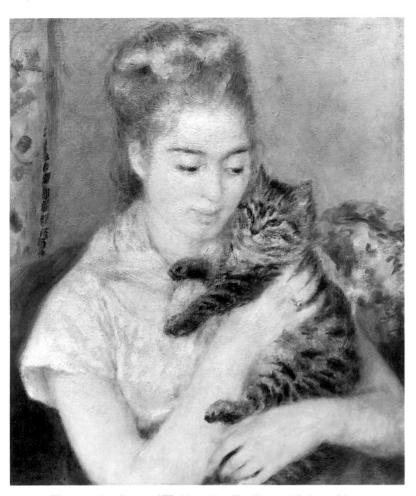

Woman with a Cat. c. 1875. 22 x 18¼". The National Gallery of Art, Washington, D.C. Gift of Mr. and Mrs. Benjamin E. Levy

The Dog Tama. 1875. 14⅝ x 12¼". Private collection

and sensible enough to conclude that he had to change his strategy. For the second show he chose twelve portraits, one nude, and three scenes of daily life (which were themselves casual portraits). Through this choice, Renoir was shrewdly appealing to patrons who might commission portraits. Further, the show catalogue specifies that several of his works were lent by collectors: six by Chocquet, two by Dollfus, two by Paul-Victor Poupin (a former employee of Durand-Ruel), one by Legrand, and one by Monet. It is likely that Renoir hoped that this information would give prospective patrons confidence to invest their money in his work.

The second Impressionist show opened in April 1876 at Durand-Ruel's gallery. Paintings by Degas, Monet, Morisot, Pissarro, Renoir. and Sisley accounted for the major part of the exhibition.

Renoir received a number of positive reviews, many written by his friends. Castagnary in *Le Siècle* stated that his portraits were "so subtle and lively."[40]

A new supporter, Alexandre Pothey, wrote in *La Presse:* "M. Renoir is exhibiting several portraits very different in execution. First there is the one of the painter Bazille [1867], killed during the war; he is seated, working at his easel. Next comes the one of M. Chocquet [1876], a blond and subtle work, then that of M. Claude Monet [1875], more vigorous, more daring. M. Renoir's *Bather* [*Nude in the Sunlight*] is a nude study with superb color."[41]

Some of the reviewers for the foreign press have names more memorable than the critics for local journals: Zola wrote for a St. Petersburg paper, *Le Messager de l'Europe:* "The portrait of Monet that he exhibited is very successful."[42] There were two new young enthusiasts: twenty-seven-year-old August Strindberg, writing for a Swedish publication, and thirty-four-year-old Stéphane Mallarmé, in the London *Art Monthly Review.*[43] Henry James, a correspondent for *The New York Tribune,* wrote an article on "Parisian Festivity," in which he described his reaction to the exhibition: "I have found it decidedly interesting. ...None of its members show signs of possessing first-rate talent, and indeed the 'Impressionist' doctrines strike me as incompatible, in an artist's mind, with the existence of first-rate talent. To embrace them you must be provided with a plentiful absence of imagination.... Some of their generalizations of expression are in a high degree curious ...the Frenchmen are cynics."[44]

These favorable or lukewarm reviews were overshadowed by a barrage of spitefully negative comments in the popular press. The influential Wolff wrote a long article in which he mocked *Nude in the Sunlight:* "These self-styled artists call themselves Intransigents, Impressionists; they take some canvases, paint, and brushes, throw a few colors on at random, and sign the whole thing.... Try to explain to M. Renoir that a woman's torso is not a mass of decomposing flesh with green and purple spots that indicate the state of total putrefaction in a corpse!"[45]

Other critics tried to prove that the Impressionists were revolutionaries in politics as well as art. In an unsigned article, a writer for the *Moniteur Universel* asserted: "The intransigents in art holding hands with the intransigents in politics, nothing could be more natural."[46] Charles Bigot of the *Revue Politique et Littéraire* wrote: "Here is the revolutionary school, and it looks as though France, wrongly accused of loving revolutionaries, today loves them less than ever in art as well as in politics."[47]

The press was actually more disapproving in 1876 than it had been two years earlier, and even fewer visitors came to the exhibition.

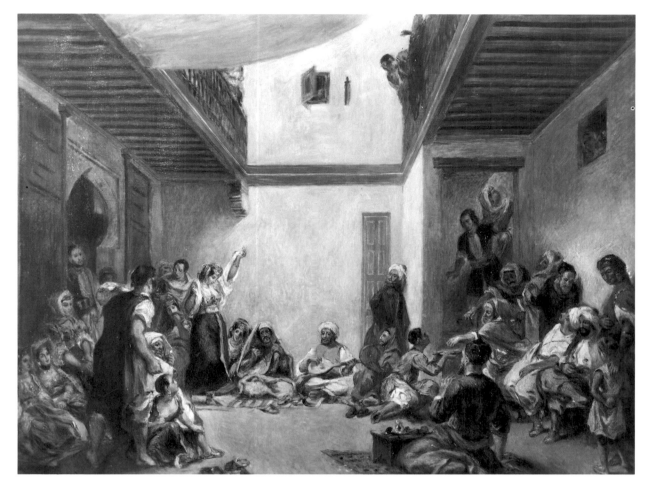

Copy of Delacroix's Jewish Wedding. 1875.
42¾ x 57″. Worcester Art Museum, Mass.

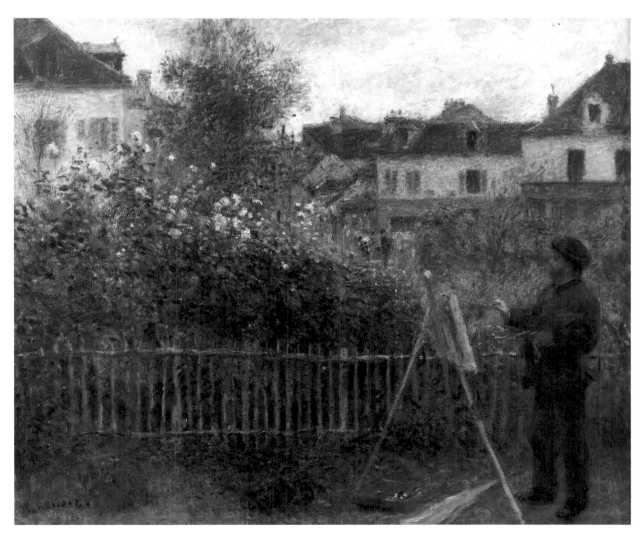

Monet Painting in His Garden at Argenteuil.
1873. 18⅜ x 23½″. Wadsworth Atheneum,
Hartford, Conn.
Bequest of Anne Parrish Titzell

Victor Chocquet. c. 1876. 18 x 14¼″. The Fogg Art Museum, Harvard University, Cambridge, Mass. Bequest of Grenville L. Winthrop

Mme. Chocquet. d. 1875. 28¾ x 23⅜″. Staatsgalerie Stuttgart

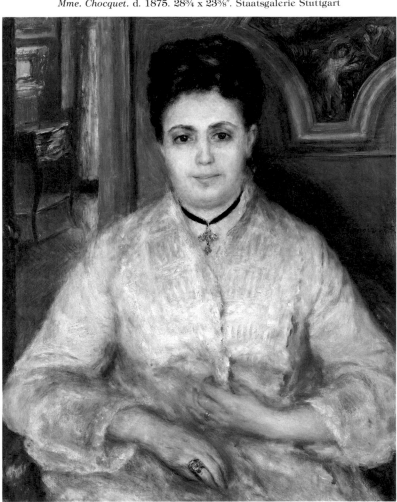

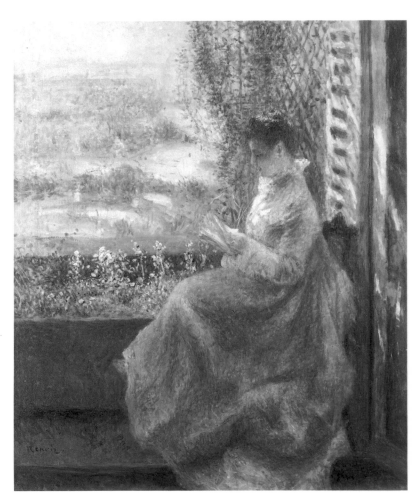

Mme. Chocquet Reading. 1875. 25⅝ x 21¼″. Private collection

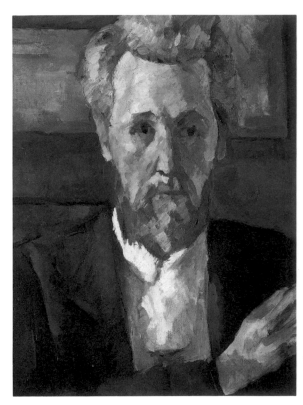

Paul Cézanne. *Victor Chocquet.* c. 1875–77. 13⅞ x 10¾″.
Collection Mr. and Mrs. Paul Mellon, Upperville, Va.

OPPOSITE:
Mme. Henriot. 1876. 26 x 19⅝″. The National Gallery of Art, Washington, D.C.
Gift of the Adele R. Levy Fund

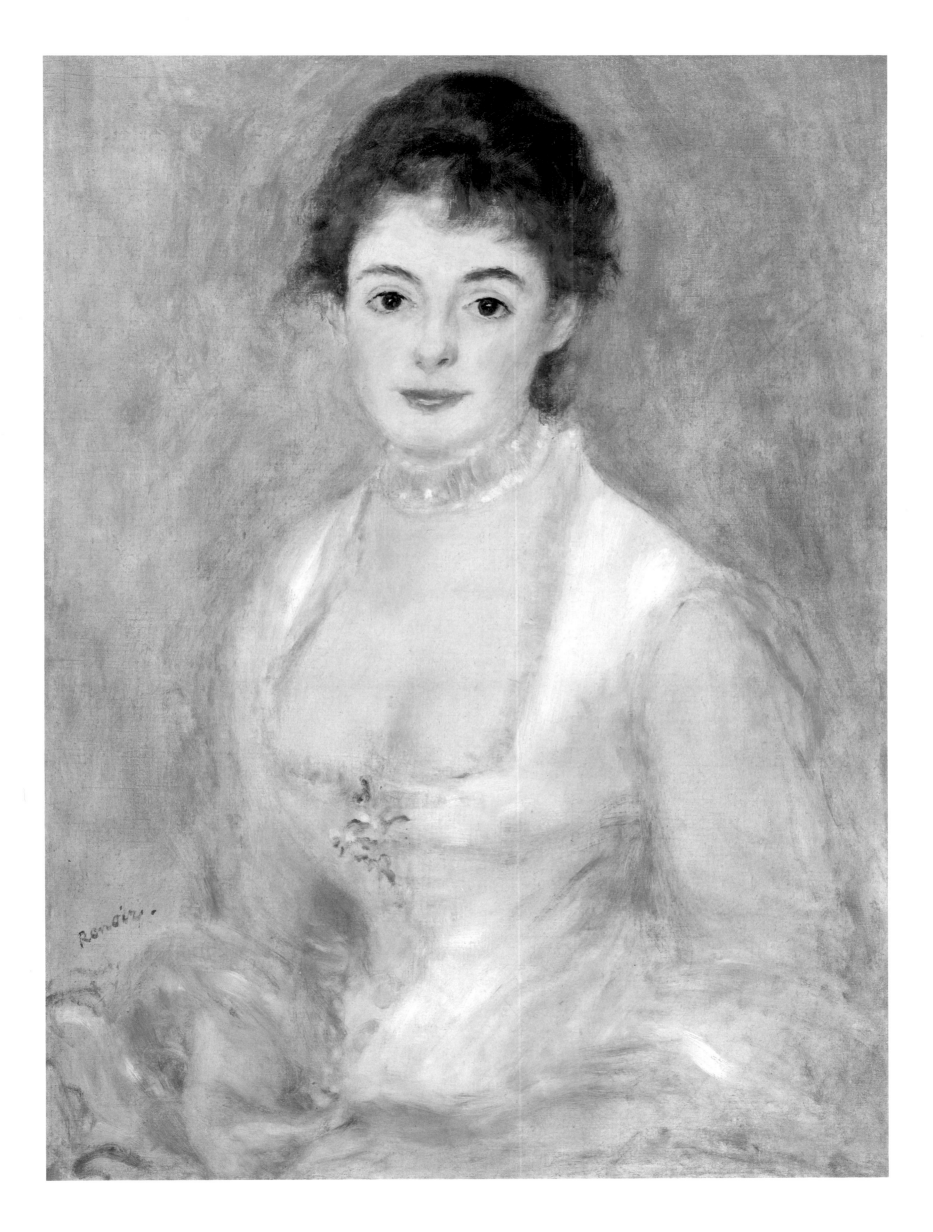

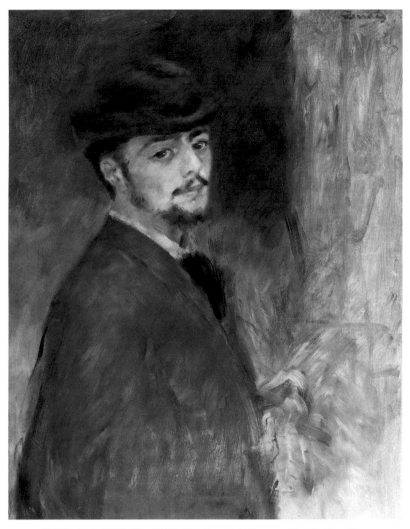

Self-Portrait. 1876. 29 x 22½″. The Fogg Art Museum, Cambridge, Mass.
Bequest of Maurice Wertheim

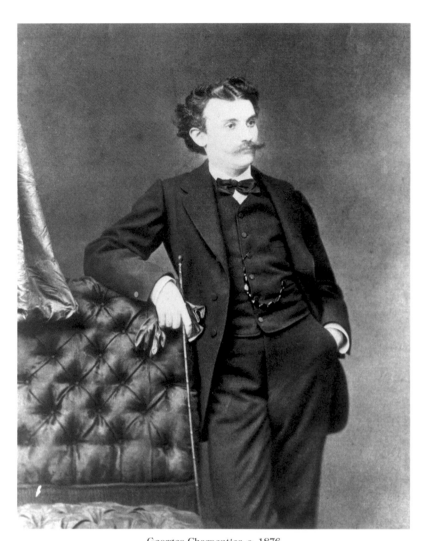

Georges Charpentier, c. 1876

Mme. Georges Charpentier, c. 1876

Marcellin Desboutin.
Auguste Renoir.
c. 1876–77.
Etching, 6¼ x 4⅜″.
Bibliothèque
Nationale, Paris

Man on the Staircase. 1876. 65⅛ x 24¾". Whereabouts unknown

Woman on the Staircase. 1876. 65⅛ x 24¾". Whereabouts unknown

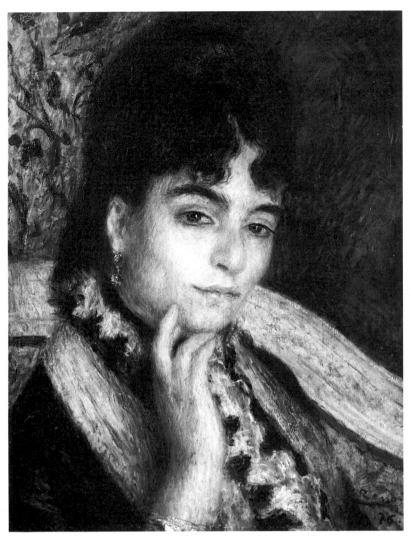

Mme. Alphonse Daudet. d. 1876. 18½ x 14⅝″. Musée d'Orsay,
Galerie du Jeu de Paume, Paris

Renoir sold no paintings, but thanks to his new patrons, his reputation as a portraitist was growing. The Charpentiers commissioned a portrait of their daughter, Georgette, and of Mme. Charpentier, which conveyed a dynamic impression of this self-assured woman.

Although his prospects were actually improving at this time, Renoir sent Charpentier numerous pleas for money. For example:

I will ask you, if it's in the realm of possibility, for the sum of three hundred francs before the end of the month, if that's possible, I am very sorry, it is the last time, and I will no longer have to write you anything but banal, completely silly letters without asking you for anything, because you will no longer owe me anything except respect, since I am older than you. I am not sending you my bill because I don't have any.

Now, my dear friend, be kind enough to thank Mme. Charpentier very much on behalf of her most devoted artist, and tell her that I will never forget that if one day I finally make it, I will owe it to her because I certainly am not capable of doing it on my own. I would like to be there already the sooner to express to her all my gratitude.[48]

To help Renoir pay off some of his debt to them, the Charpentiers commissioned him to paint oil-on-canvas murals for the stairwell of their house (p. 63). Renoir used his brother Edmond and Margot as models. He may also have referred to photographs of the Charpentiers, since there is a decided similarity between a pair of extant photographs and the man and woman on the stairwell. Reflecting the Charpentiers' interest in Japanese art, he gave the woman an Oriental

fan to hold, and in the curving lines of the balustrade he echoed the linearity of Japanese prints.

In September 1876, the writer Daudet, whom Renoir had met at the Charpentier salons, invited him to Champrosay for three weeks to paint a portrait of his wife. In addition to this pensive, clear-eyed portrait, cropped abruptly in what was to become a hallmark of Impressionism's acceptance of chance effects and significant fragments, Renoir also painted there the blue and golden, light- and windswept *Banks of the Seine at Champrosay* (pp. 76–77).

On May 17, 1876, Charles Deudon, a wealthy lawyer and owner of a well-known clothing store, Old England, purchased *The Dancer* of 1874 for 1,000 francs from Durand-Ruel. Deciding that it would be advantageous to make Deudon's acquaintance, and knowing that he and Duret were friends, Renoir wrote Duret that he would like to be introduced to Deudon.[49] Deudon became a close friend and eventually purchased five other Renoir paintings.

In 1875, Renoir had begun to work on his most ambitious and most original Impressionist genre painting, *Le Moulin de la Galette.* The Moulin was a dance hall in Montmartre, where young men and women went on Sunday afternoons to dance and chat. Renoir chose it as the setting that would sum up his experiments with large-scale figures in carefree, spontaneous activities—experiments that he had begun with *The Promenade* in 1870. Since he needed a studio close to the dance hall, he leased a small house with a garden at 12 rue Cortot, in April 1875. Under the roof were two big furnished rooms. On the ground floor, formerly a stable, was space to store canvases and easels.[50] Renoir kept this studio for a full year and a half, until he had completed the painting.

His brother recalled in 1879: "How does he go about painting the 'Moulin de la Galette'? He goes to live there for six months, makes friends with all that little world that has its own style, which models copying their poses would not render, and in the midst of the whirl of that popular merry-go-round, he expresses wild movement with a dazzling verve."[51]

Because the final canvas was to be large, Renoir did considerable preparatory work. He made a small oil study of the whole scene and also oil studies of the dancers, and a medium-size study of the entire picture (30⅞ x 44⅝″)—all probably executed at the dance hall. Years later, Rivière described how friends helped Renoir carry the canvas back and forth: "We would carry this canvas every day from the rue Cortot to the Moulin, because the painting was executed entirely on the spot. This was not without difficulties, when the wind blew and the big canvas threatened to fly away like a kite over the Butte."[52] (Ultimately, this version was bought by Chocquet.)

The final canvas was too large to move easily (51½ x 69″), so his friends came and posed at the rue Cortot garden. Rivière recalled: "Estelle, the sister of Jeanne, who is seen in the foreground, is sitting on the garden bench; Lamy, Goeneutte, and myself are sitting at a table on which are glasses of grenadine. There were also Gervex, Cordey, Lestringuez, Lhote, and others who appear as dancers. Finally, in the center of the picture, wearing 'Merd'Oye' trousers, is a Cuban painter called Pedro Vidal de Solares y Cárdenas dancing with Margot."[53] This large version was purchased by Caillebotte after the third Impressionist show, in 1877.

When *Le Moulin de la Galette* was first exhibited at this show, Rivière wrote an article which his close friend Renoir probably looked over before publication. We can surmise that Rivière here told the

LE MOULIN DE LA GALETTE

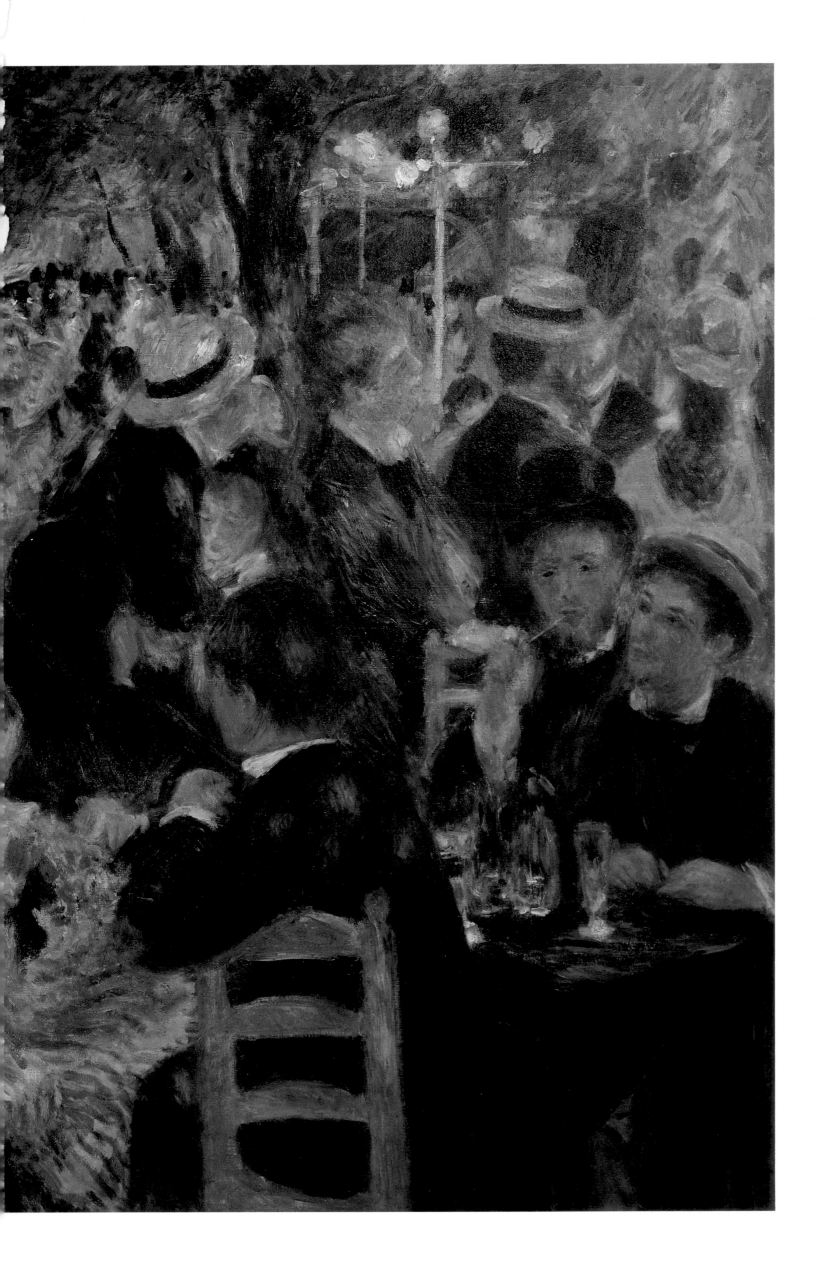

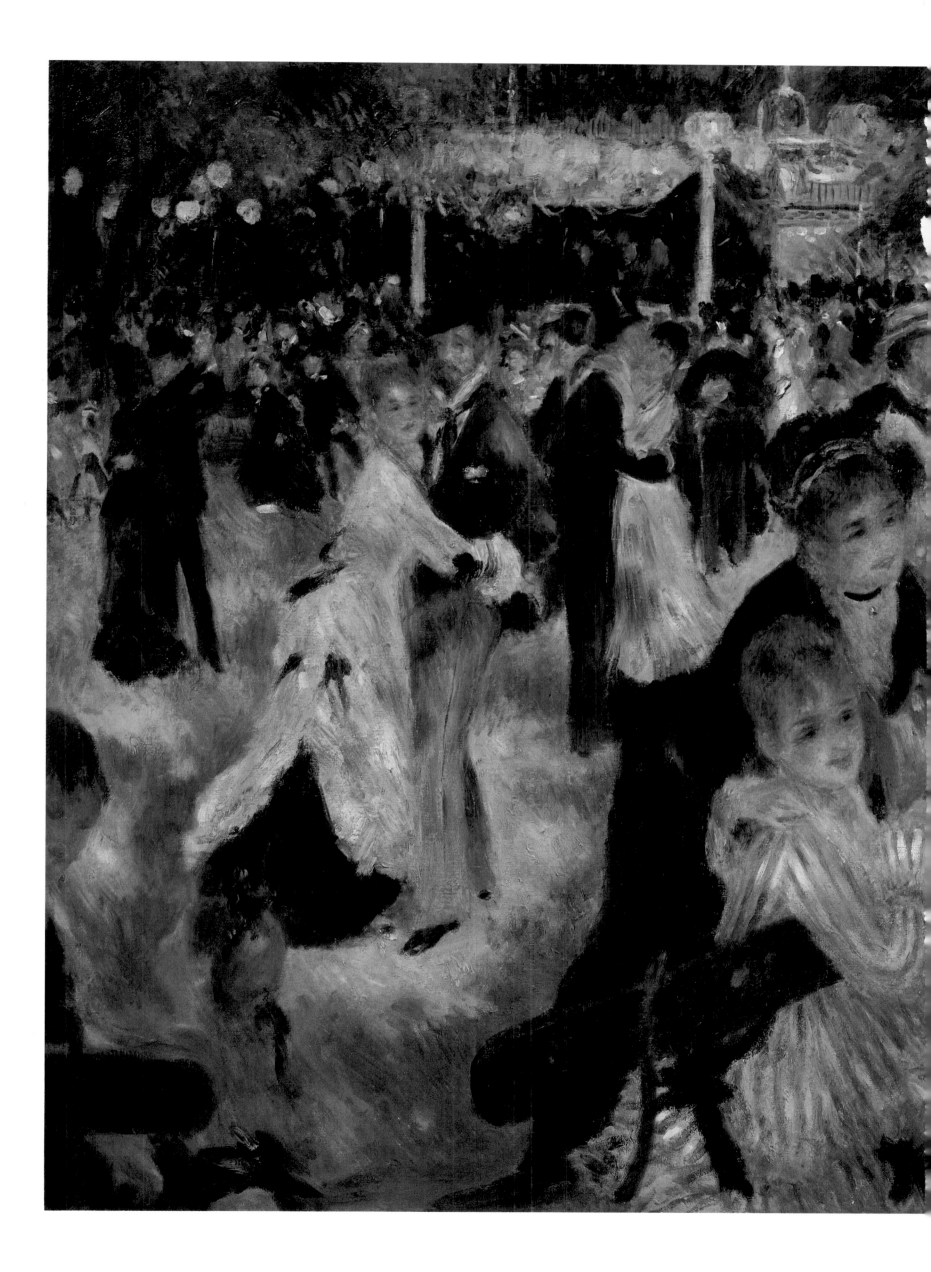

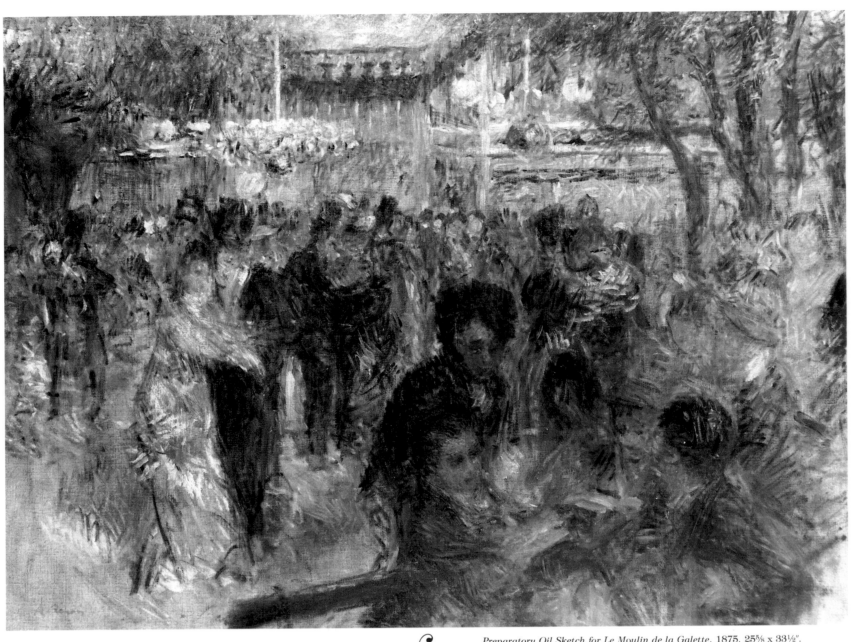

Preparatory Oil Sketch for Le Moulin de la Galette. 1875. 25⅝ x 33½".
Ordrupgaard Museum, Copenhagen

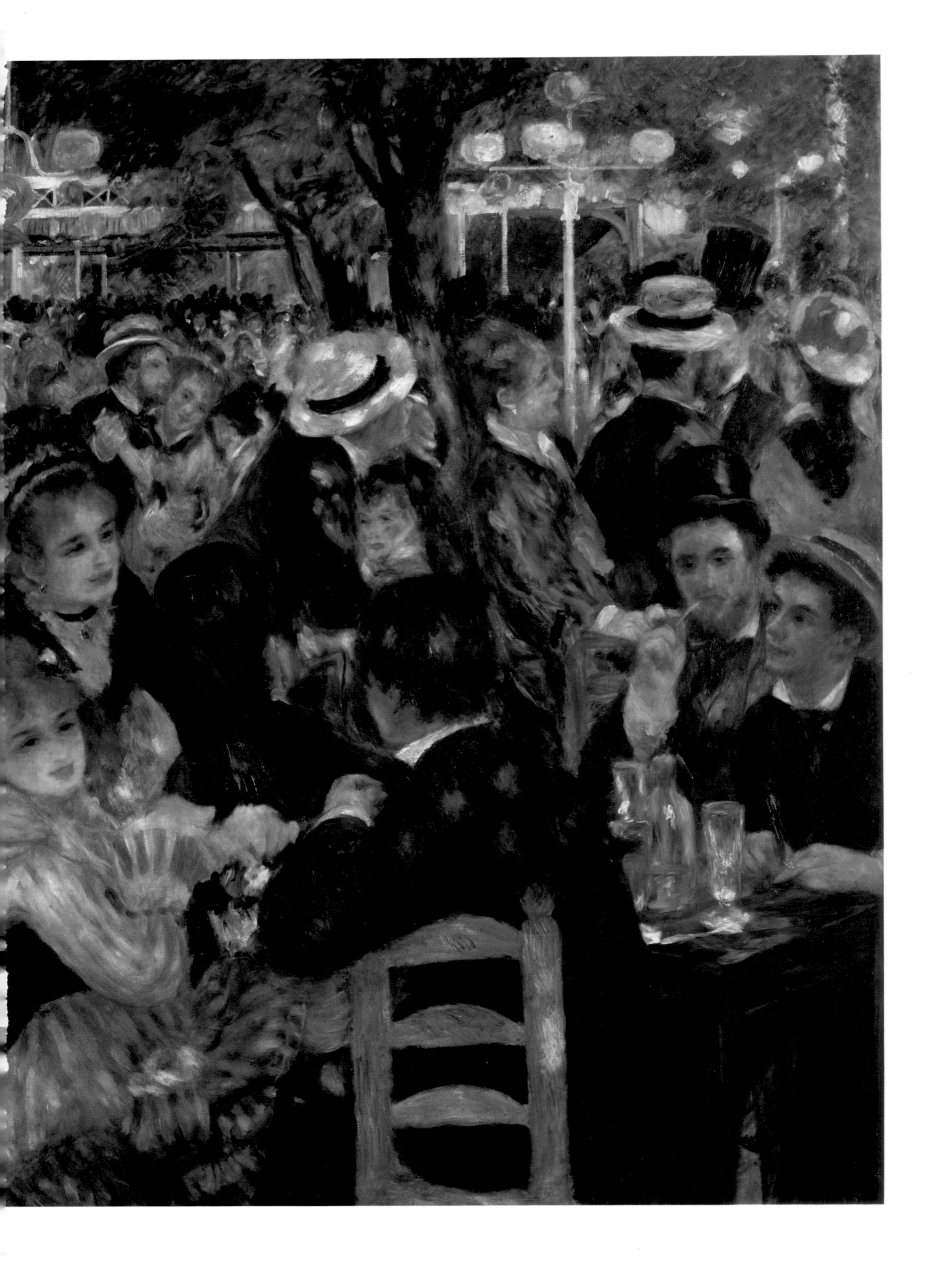

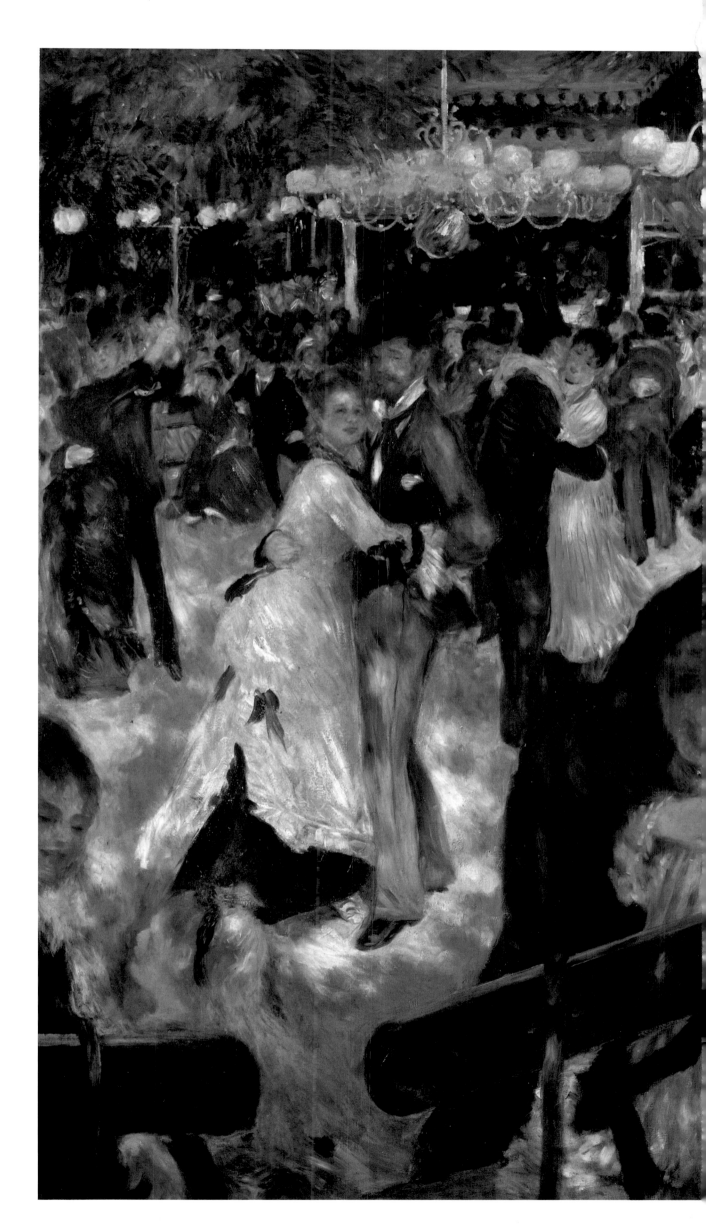

LEFT:
Le Bal au Moulin de la Galette.
d. 1876. 30⅞ x 44⅝".
Collection Mrs. John Hay Whitney, New York

RIGHT:
Le Moulin de la Galette. d. 1876. 51½ x 69".
Musée d'Orsay,
Galerie du Jeu de Paume, Paris.
Bequest of Gustave Caillebotte

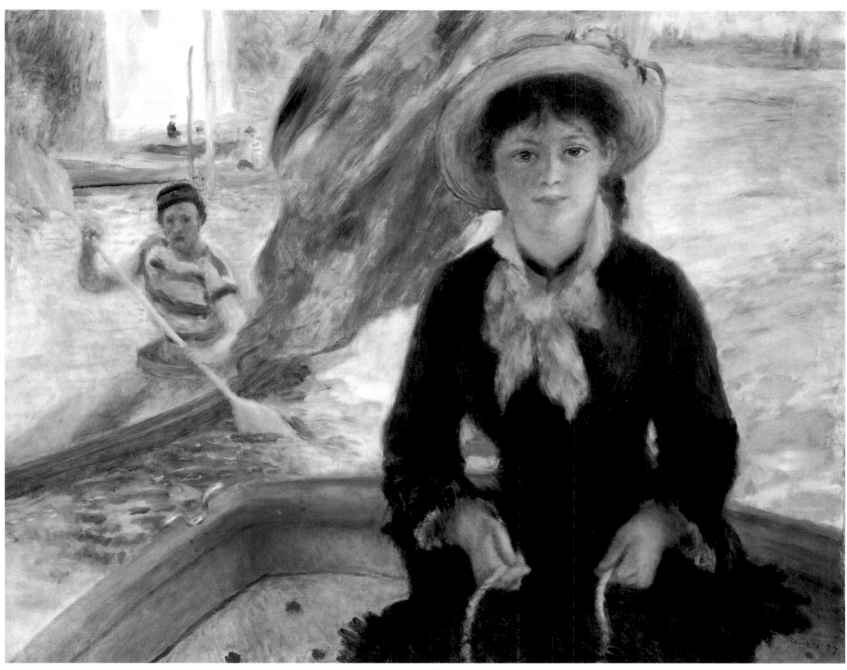

Girl in a Boat. d. 1877. 28¾ x 36⅜″. Private collection

public what Renoir wanted them to learn about his painting:

In a garden inundated with sunlight, barely shaded by some spindly acacia plants whose thin foliage trembles with the least breeze, there are charming young girls in all the freshness of their fifteen years, proud of their light home-made dresses fashioned of inexpensive material, and young men full of gaiety.... Noise, laughter, movement, sunshine, in an atmosphere of youth: such is *Le Bal* [*au Moulin de la Galette*] by Renoir. It is an essentially Parisian work. These young girls are the same ones with whom we rub elbows every day, and whose prattling fills Paris at certain hours. A smile and some shirt cuffs are enough to make them pretty. Renoir has proved it well. Look at the grace with which the girl leans on a bench! She is chatting, emphasizing her words with a subtle smile, and her curious glance tries to read the face of the young man speaking with her. And that young philosopher, leaning back on his chair and smoking his pipe, what profound disdain he must have for the jigging of the gallant dancers who seem oblivious to the sun in the ardor of a polka!

... It is a page of history, a precious monument to Parisian life, done with rigorous exactitude. No one before him had thought of portraying an event in ordinary life on a canvas of such big dimensions.[54]

At the same time, Renoir was also working on a smaller related pic-

ture, *The Swing.* This was to be his second most important work for the 1877 show. Dressed in the same fashionable gown that she wore in *Le Moulin de la Galette*, Margot here relaxes in this leisurely scene with Edmond Renoir and Norbert Goeneutte. A little child looks up at them. Though far less ambitious, and very different in mood, *The Swing* shares with *Le Moulin* the evidence of Renoir's interest in the effect of light as it falls through the trees to play on the forms below, and in both, a joyful atmosphere is created by the vibrant array of colors.

Caillebotte bought *The Swing* as soon as Renoir completed it. In 1876 and 1877 he also bought *Nude in the Sunlight, Banks of the Seine at Champrosay,* and several other paintings, which helped Renoir pay off the huge expense of maintaining two studios for such a long time. On November 3, 1876, Caillebotte, although only twenty-eight, wrote his will, in which he stated his desire that his paintings should go to the Louvre. "I ask Renoir to be my documentary executor and please to accept a picture that he will choose, my heirs will insist that he take an important one,"[55] he requested—an indication that he considered Renoir a close, trustworthy friend.

Renoir also continued experimenting with modern convivial scenes.

73

In *Girl in a Boat* (1877), for which Margot posed at Argenteuil, he boldly juxtaposed near and far, a figure at rest and one in movement. Burty purchased this painting as a wedding gift for his daughter, Madeleine Burty Haviland.

Another experimental genre scene of around 1877 is *After the Concert,* bought by the composer Chabrier. In the foreground, Margot, Nini Lopez, Rivière, and Edmond talk together. What is innovative is the intricate pairing and grouping of figures, which gives a sense of vitality and unfolding romantic possibilities. And like a photographer, Renoir captures a moment in time—that will shift in the next instant.

In addition to preparing work for the third Impressionist exhibition, Renoir also did several portraits, which were his bread-and-butter. At the Charpentier salons, he had met Jeanne Samary, a renowned actress at the Comédie-Française, who lived near his studio. She was twenty in 1877, when she started to model for him, and he did several portraits of her that year (p. 80). Before the April Impressionist exhibition, he put a bust portrait of her on view at Durand-Ruel's gallery as a means of gauging the public's reaction to his latest portrait style. "Go see the portrait of the little Samary at Durand-Ruel's," he wrote to Duret. "I think they won't understand anything about it. Nevertheless, I find it pretty, the flesh tones, with the pink, have a good effect. In my opinion, at any rate, it is worth seeing."[56] The reception of his latest portrait style must not have been so negative as he anticipated, for he included the painting in the Impressionist show.

Renoir was a leader in planning and implementing this third Impressionist show. On February 24, 1877, Guillaumin wrote Dr. Gachet from Paris: "The exhibition should take place on April 1.... I can't tell you any more, but I think that by writing to Renoir, 35 rue St.-Georges, you would have all the possible information, since that's where the exhibition is being prepared."[57] To commemorate this activity, Renoir painted *The Artist's Studio, Rue St.-Georges* (p. 81), a work that Murer acquired. The central figure is Rivière; to his left is Pissarro (his bald head in profile), and to Pissarro's left, Cordey. At Rivière's right, seated on a table, is Franc-Lamay. In the foreground is Caillebotte, who found and paid for the exhibition space at 6 rue Le Peletier, on the same block as Durand-Ruel's gallery.

Renoir did not merely lend his studio as the headquarters for the complex organization; he and Caillebotte sent out the invitations to the participants, and they along with Pissarro and Monet comprised the hanging committee.

By vote of the membership, the title "Exposition des Impressionnistes" was adopted for the third show, in acknowledgment that Impressionism was a common bond among the artists. Eighteen painters submitted a total of two hundred thirty works; Renoir sent twenty-one. As in 1874, his key paintings were of modern Paris: *Le Moulin de la Galette* and *The Swing,* and as in 1876, most of his works were portraits, twelve in all. In addition, he put on view five landscapes (including two city scenes) and two still lifes. He sent no nudes; perhaps he did not want to risk being mocked again by the powerful Wolff, who had singled out *Nude in the Sunlight* for ridicule in 1876.

Renoir was further involved with the direction of the exhibition through his role in publicity aspects. At Renoir's urging, Rivière put out a newspaper, *L'Impressionniste,* each Thursday of the month-long exhibition and wrote most of the articles for it.[58] His express purpose was to defend Impressionism against the hostility of the popular press. He eloquently voiced the aims and goals of all his artist friends, who may well have had a chance to check his texts, since he was writ-

ing as their spokesman. Since Rivière was closest to Renoir, he discussed his friend's work first and in greatest detail:

It is evident that the Renoir exhibition is very important, not only because of the number of canvases shown but also because of their worth. The show is even more complete than those of previous years.

We shall not say any more about it, it is up to the public to appreciate for itself these works shown for its benefit; it is to the heart that this painting addresses itself; if the public is moved, the goal is met; nothing more can be asked of the artist, and the painter will be sufficiently rewarded for his labors, we are sure.[59]

Later in this article Rivière praised the portraits of Georgette Charpentier, Mme. Charpentier, Mme. Daudet, Jeanne Samary, Jacques-Eugène Spuller (p. 79), and Alfred Sisley.[60]

Rivière also lauded Renoir's portraits in the third issue of *L'Impressionniste* in a letter addressed to women readers. On the cover was an engraving after Renoir's pen-and-ink drawing of *The Swing.* While Rivière does not mention Renoir by name, since, except for three portraits from Degas, the other exhibitors did not submit such themes, it is clear that he is trying to encourage women to commission Renoir to do their portraits:

Madame,

... You attended, Madame, the exhibition of the Impressionists, you saw there paintings full of sunlight and gaiety, and since you are young and pretty, you found the paintings to your taste, you saw there portraits of women, I am too gallant to insinuate that they are flattering, but after all they are very pretty, at

The Swing. d. 1876. 36¼ x 28¾". Musée d'Orsay, Galerie du Jeu de Paume, Paris

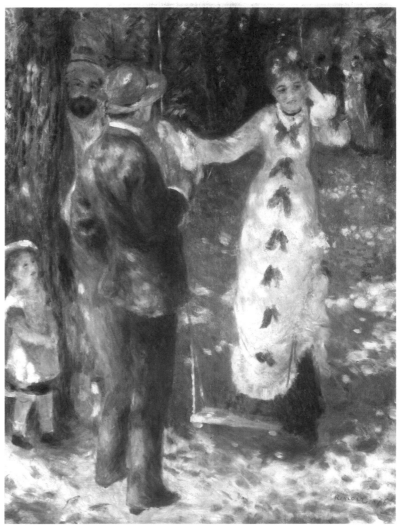

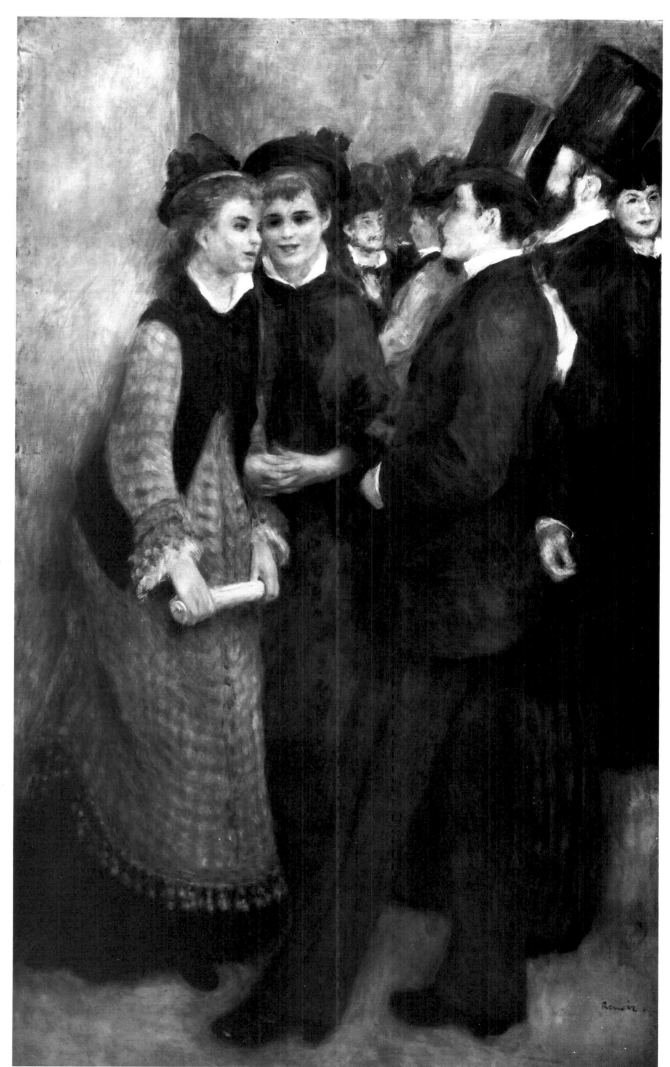

After the Concert. c. 1877.
73½ x 46¼". The Barnes Foundation,
Merion Station, Pa.

Banks of the Seine at Champrosay. 1876. 21½ x 26″. Musée d'Orsay, Galerie du Jeu de Paume, Paris

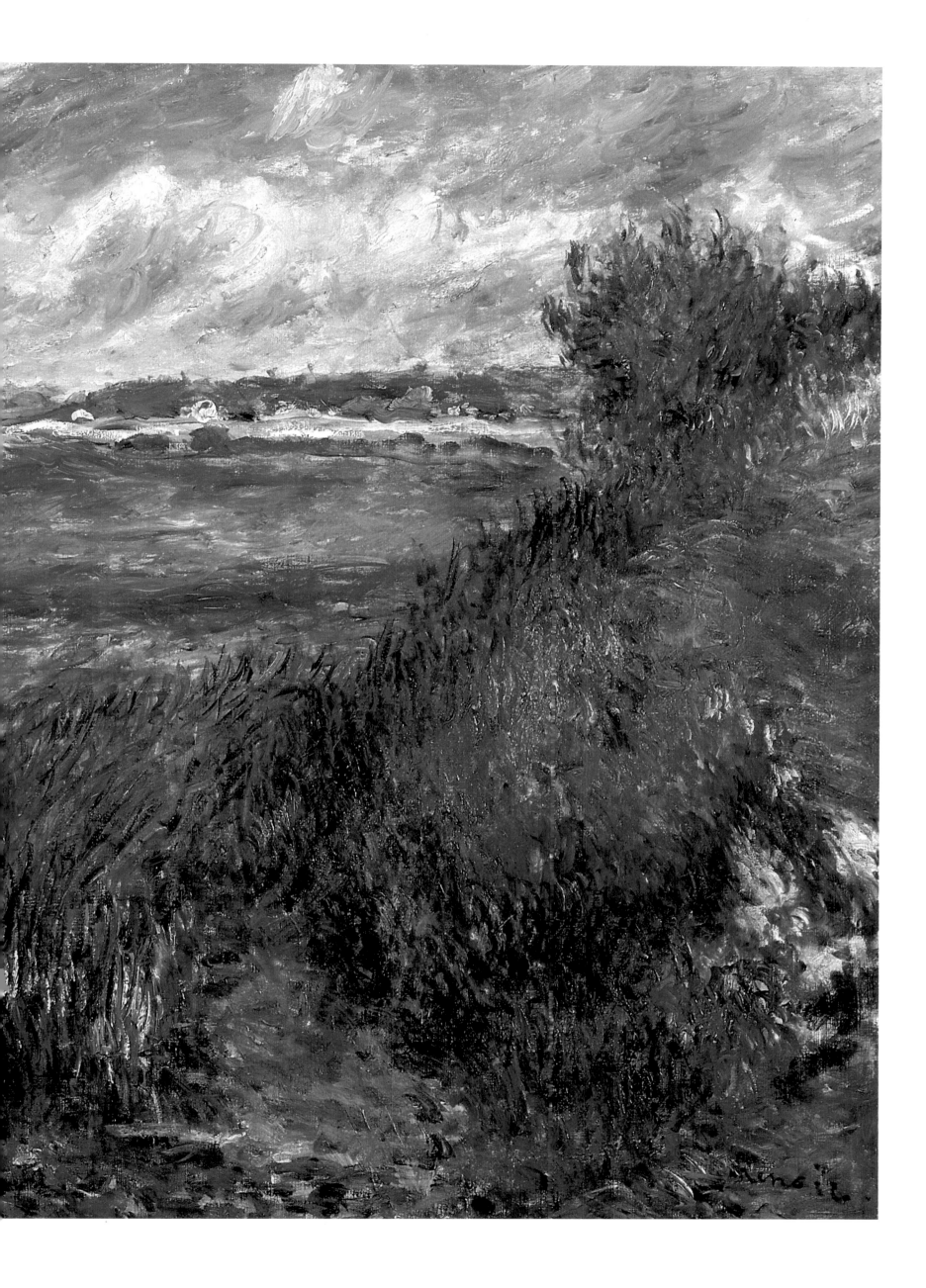

least in your opinion, and you would like to have in your own home a ravishing portrait in which the charm that floods your dear person would be found. But you have a husband.... Your husband, who may be a Republican, becomes enraged at a revolutionary who sows discord in the field of art.... He cries out against political tradition, against administrative tradition... but he looks at painting through the old pictures....

I have seen a few pretty women laughing in front of paintings at the exhibition of the Impressionists. It made me sad....[61]

In the Paris press, two positive reviews did appear. Charles Flor O'Squarr praised *Le Moulin de la Galette;*[62] Burty also wrote favorably of it, as well as of several of the portraits, yet he asserted that because Renoir is "of an extrasensitive temperament, he is always afraid of

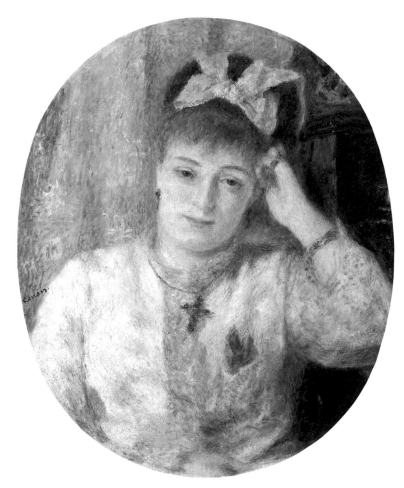

Marie Murer. 1877. 26⅝ x 22½″. The National Gallery of Art, Washington, D.C. Chester Dale Collection

overstatement.... The portrait of our friend Spuller lacks solidity in the drawing of the features; but the physiognomy is intense; the eyes think, the flesh is alive."[63]

Six negative reviews appeared, three by veteran anti-Impressionist writers. Wolff again mocked and deprecated: "Seen as a whole, the exhibition of the Impressionists resembles a collection of freshly painted canvases spread with gobs of pistachio, vanilla, and red currant cream."[64] As he had formerly, Maillard disparaged: "It appertains to madness; it is a deliberate excursion into the realm of the horrible and the execrable.... It is the very opposite of what is permissible in painting, the contrary of what is called light, clearness, transparency, shade and drawing."[65] And Leroy once more joked about Renoir's paintings: "So many studies done at the morgue to reach such a result!"[66]

Three new negative voices spoke out: Barbouillotte wrote that Impressionist painting evoked "a recollection of seasickness";[67] as Re-

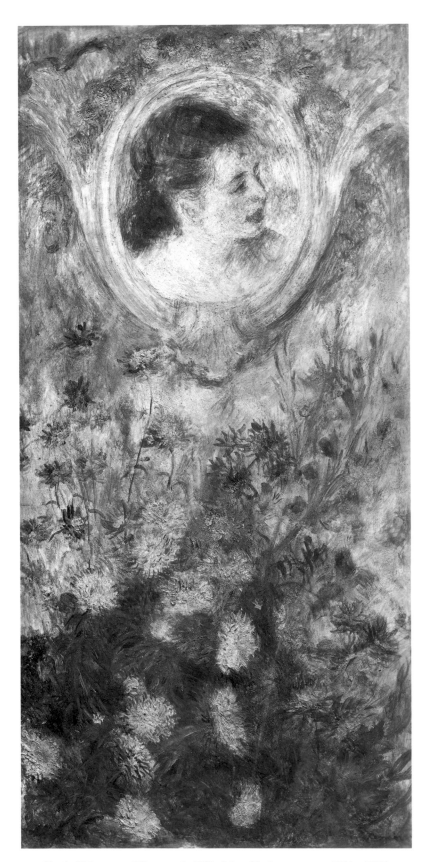

Head of Woman and Flowers. d. 1877. Oil on MacLean cement, 52⅛ x 23⅝″. Private collection

noir had predicted a reviewer might do, Roger Ballu belittled *Mlle. Samary:* "I confess I don't understand the *Portrait of Mlle. S....* The well-known head of the charming model is as though lost on this pinkish background with its brutal coloration, which does not allow the flesh tones to blossom. The lips and chin display blue shades that the artist felt forced to use if he was to succeed in modeling this figure drowned in brightness. What a strange portrait! Nothing, it seems to me, is further from true nature!"[68] *Le Charivari* published a number of graphic

and visual attacks such as the proclamation that the "police commissioner has required the addresses of the models so as to have them buried immediately in view of their advanced state of putrefaction."[69] Finally, Paul Mantz wrote that the Impressionists painted with their eyes closed and were weak, ignorant, and scornful.[70]

Although attendance during this third show was greater than for the earlier exhibitions—about five hundred people a day—most came to laugh. As Duret wrote: "The majority of the visitors were of the opinion that the exhibiting artists were perhaps not devoid of talent and that they might have executed good pictures if they had been willing to paint like the rest of the world, but that above all they were trying to create a rumpus to stir up the crowd."[71]

Nevertheless, at least once there was an excess of prospective buyers. Renoir and Rouart were in charge of the sale of paintings during the show. Renoir reported a misadventure to Pissarro: "Your painting was sold this morning for 150 francs to M. O'Doart. We were not aware that M. Mignon, without having seen it, only from the description, had reserved *Haystack* for the same price. Rouart does not know what to do about M. Mignon, and he only hopes that you would have another painting with a little haystack that we could give him and whose price would be returned to you. Please tell M. Rouart what you think of it."[72]

Some of Renoir's other dealings with Pissarro also touched on financial matters. Sometime in 1877 Renoir painted a rectangular and an oval portrait of Murer's half sister, Marie.[73] For each, he charged Murer 100 francs. A year later, Pissarro wrote Murer to negotiate a fee for his portrait of Marie: "You were surprised at the price of 150 francs, since Renoir insisted on only a hundred.... I am well aware that

Jacques-Eugène Spuller. c. 1877. 18⅛ x 15″.
Collection Mr. and Mrs. Charles Wohlstetter

Georges Rivière. 1877. Oil on MacLean cement, 14½ x 11½″. National Gallery of Art, Washington, D.C. Ailsa Mellon Bruce Collection

Renoir could ask more than I, being an eminent portrait painter, but less seemed to me impossible. If Renoir has lowered his price, it means that you have made him come down, that's what accounts for the difference."[74]

In 1877, Murer described in his diary a Wednesday night when Renoir (but not Pissarro) had come for dinner:

Over the dessert Renoir told us that all day long he had been about from place to place with a picture under his arm trying to sell it. Everywhere he had been bowed out with the words: "You have come too late. Pissarro has just been here. I've taken a picture from him as a matter of common humanity. You know. Poor chap, with all those youngsters." This "poor chap," repeated at every door he knocked at, exasperated Renoir, who was very much put out at not having sold anything.

"What," he cried, with that good-natured ogre's voice of his, and rubbing his nose nervously with his forefinger—a familiar gesture with him—"because I am a bachelor and have no children, am I to die of starvation? I'm in just as tight a corner as Pissarro; yet when they talk of me, no one says, 'that poor Renoir.'"[75]

The Impressionist show closed on April 30, and clearly it did nothing to relieve the financial pressures on the participants. They immediately decided to arrange another auction. It took place May 28, at the Hôtel Drouot. Works by Renoir, Caillebotte, Pissarro, and Sisley were put on the block. The appraiser was Legrand and the auctioneer was Léon Tual. Renoir put up for sale fifteen paintings and a pastel. The results were slightly poorer than those of the 1875 sale. For the sixteen works, he received a total of 2,005 francs, with individual paintings going for between 47 and 285 francs.[76]

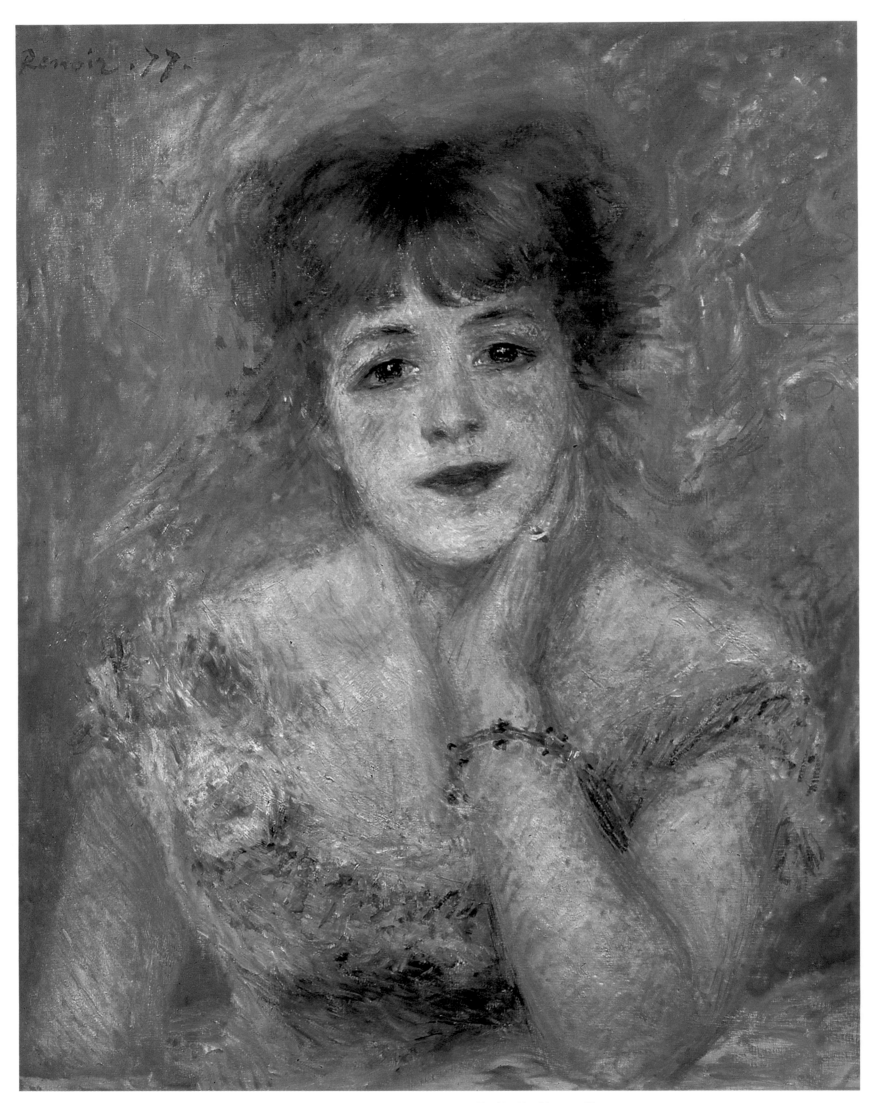

Bust Portrait of Jeanne Samary. d. 1877. 22 x 18⅛″. Pushkin Museum, Moscow

While the show was still on, the impecunious Renoir made use of *L'Impressionniste,* the newspaper that appeared during the show, to publicize himself as a decorative painter. He had done architectural decoration in 1868 for Charles Le Coeur and in 1876 for the Charpentier stairwell. He speculated that paintings such as *Le Moulin de la Galette* or *The Swing* could be on the walls of an opera house, a theater, an administrative building, or a school, and state commissions for mural paintings would be even more lucrative.

He pursued this avenue in a very direct fashion. In 1877, financed by Caillebotte, Legrand became the agent for the London cement company of MacLean. MacLean cement contained a fine white plaster, making it a good surface for varicolored painting[77] that could readily be used in architectural decoration. That year Renoir did at least five paintings on MacLean cement (pp. 78 and 79) in an effort to familiarize himself with the medium.

With this in mind, Renoir submitted two articles to *L'Impressionniste* signed "Un peintre." The first one dealt with the exterior decoration of buildings:

The ornamentation of the new Louvre is heavy, banal, and done by workmen picked at random, while the ornamentation of the old one is light and done by artists.... I would ask why Gothic monuments, which are from a period called barbarian, swarm, create masses, are superb, varied, while contemporary monuments are cold and lined up like soldiers on parade.[78]

In the second article, "Decorative and Contemporary Art," Renoir harshly criticized the traditional procedure of sending art students on pilgrimages to Italy (his statement is of great interest in light of the fact that he himself would make this trip four years later, and then he would have different observations about Raphael):

The decorative paintings in our public edifices are stiff, unbreathing, completely out of proportion, and far from being in harmony with what they are meant to decorate....

Only Delacroix understood the decoration of our time, and he even went so far as to change its harmonic balance. Thus his paintings in St.-Sulpice are the crowning achievement, the chapel is only the pretext for the creation of art. The painted work in decoration has value only because it is polychromatic; the more varied the tones are in their harmony, the more decorative such paintings will be....

One feels, however, the concern with previous periods. The training given to architects, painters, and sculptors at the École des Beaux-Arts is completely based on the past. Architects are sent to Rome to reconstruct a Greek monument, painters are sent to copy Raphael in Rome. Sculptors are likewise sent to Rome so that they may find inspiration in more or less mutilated Greek statues. When, after spending a few years in the Eternal City, these young men, painters, sculptors, and architects, come back to Paris, crammed with antiquities, still dazzled by the masters of Greece and Italy, one might suppose that they would be cured of these obsessions by the modern trend, and their works would become original; but no, the monuments retain all the lines, all the proportions, brought by the architect from Rome. They show the clumsiness, the groping, of the half-erased memory. The painters have fantasies of approaching Raphael or some other Italian master who makes them ridiculous; as for the sculptors, they are satisfied with a few movements displayed in famous statues, and that's where they remain.

...Who is responsible for this absence or this worthlessness of decorative art? First of all, the administrative organization of the École des Beaux-Arts, then the training given to architects....

In conclusion, I will say that until a new generation of architects comes to overthrow the present coterie by new training, direction of the construction of a public building should be entrusted to painters.

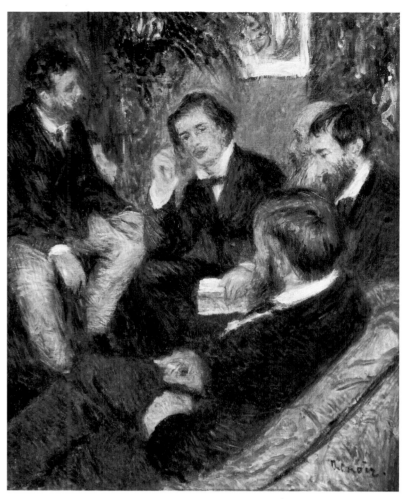

The Artist's Studio, Rue St.-Georges. 1876–77. 17¾ x 14½".
The Norton Simon Foundation, Los Angeles

I am convinced that there would emerge an originality, even a unity, that can be asked only from one who can be at the same time both head and arm.[79]

There are other indications that around this time Renoir was trying to obtain commissions from the state for decorative mural painting. In two frank and none too elegant letters to Charpentier, he mentioned efforts on his behalf by the lawyer, editor, and bureaucrat Spuller, whom he knew from the Charpentier salons, and whose portrait he was currently exhibiting:

Spuller is ready to do all he can to get me a commission from the state. But since he understands nothing and doesn't want to make mistakes, he has asked me to give him exact information about what is possible; he wants me to tell him: I want to have such-and-such a ceiling or such-and-such a wall or staircase in such-and-such a place. After racking my brains, I've wound up thinking that the only one who can give him this information is the secretary general M. [Joseph] Bardoux [minister of fine arts], who is the boss of your friend [Georges] Lafenestre [poet and overseer of the board of directors of the Beaux-Arts administration], through whom you might be able to help me. I want to speed things up because of the budget, etc., etc.

In short, could you give me a note to Lafenestre or go there yourself, whichever you think best. I leave it up to my friend Rivière to explain the rest to you. I will probably go see you tomorrow evening.[80]

In the second letter he reported, "I have seen Lafenestre...he told me to apply to the city, but I think that's a mistake."[81] Renoir never received the hoped-for commission.

Thus, at age thirty-six, Renoir found himself blocked at every turn, unable to support himself through his painting.

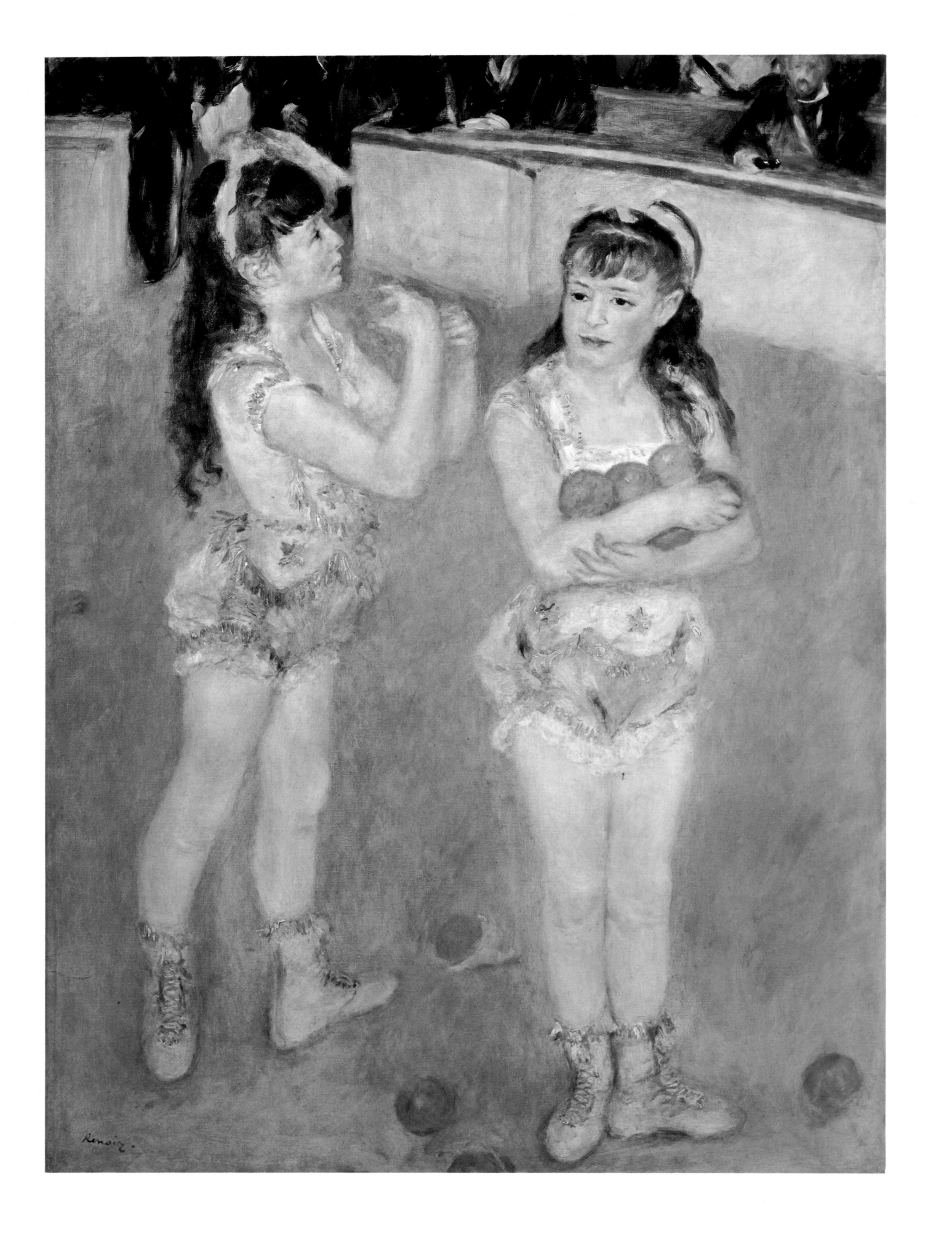

B Y THE END of 1877, Renoir's great frustration with his bad press, poor sales, and scoffing visitors led him to abandon his efforts to promote the Impressionist cause through exhibitions, sales, and writings. His campaign to become a modern decorative painter for public buildings had also failed. All this having come to naught, he decided to make a concerted effort to become a portraitist to rich Parisians. Encouraged by his wealthy friends the Charpentiers and Duret, he opted to try his luck again in the official Salons.

In putting some distance between himself and the other Impressionists by ceasing to exhibit at the Impressionist shows and by identifying himself as a portraitist, Renoir hoped to end the accusations that he was a revolutionary. In the late 1870s, these charges were profoundly disturbing since they alienated some potential patrons.

Actually, these accusations were accurate in regard to Renoir's paintings through 1877. They pointed to the truly original character of his urban themes—democratic, sociable, and often romantic—and to his indistinct, evocative delineations of the human form. By 1877, this imprecise treatment of the body had begun to trouble him both aesthetically and in terms of needed patronage. By the end of that year, in painting large-scale figures, he had ceased entirely to use open form, in which bodies have no line, detail, weight, volume, or relief.

Renoir's break with his Impressionist colleagues and the gradual change in his treatment of form met with sympathy from some of those closest to the situation. Pissarro wrote to Murer: "the question of art does not apply, it's a matter of a hungry belly, an empty purse, a poor devil."[1] He further explained to Caillebotte, "the Charpentiers are pushing Renoir."[2] Two years later, Zola, a staunch advocate of the Salon, defended Renoir:

I'm all for independence, in everything, and yet I confess that M. Renoir's behavior seemed to me perfectly reasonable. One must be aware of the excellent means for publicity that the official Salon offers to young artists; considering our customs, it is only there that they can seriously triumph. Of course, one must preserve one's independence in one's works, and not dilute anything in one's temperament, but afterward one should do battle in broad daylight, under the conditions most favorable to victory. A simple question of opportunism, as they say these days among our politicians.[3]

By 1878, in addition to the Salon question, aesthetic dissension had begun to split the Impressionists into two camps: the "pure Impressionists" (Monet, Renoir, Pissarro, Sisley, and Morisot) and the "Realists" (Degas and his many followers). While a clear schism did not manifest itself until a few years later, it was decided not to hold a group show that year. Renoir never again willingly exhibited in an Impressionist group show, although he acquiesced under pressure in 1882.[4]

Two Little Circus Girls. 1879. 51½ x 38¾″. The Art Institute of Chicago.
Potter Palmer Collection

Following Renoir's move, Sisley in 1879 and Monet in 1880 decided to submit to the Salon rather than to exhibit with the Impressionists. Although Renoir's departure from the group indicates that he put his self-interest above allegiance to his colleagues, he nevertheless kept up with his friends and saw them whenever they were in Paris. And despite his defection from the group shows, throughout the late 1870s and early 1880s he considered himself an Impressionist, and insisted that where he exhibited did not affect the art that he produced. Years later, he wrote to Durand-Ruel:

I don't want to succumb to the mania of believing that something or other is bad just because of its place. In a word, I don't want to waste my time resenting the Salon. I don't even want to look as though I do. I think that one should do the best possible painting. That's all. Oh, if I were accused of neglecting my art, or of sacrificing my ideas out of stupid ambition, then I'd understand the criticisms. But there is nothing of the sort, they have nothing to say to me, quite the contrary. . . . I want to do some stunning painting for you that you'll sell for a lot of money. . . . A little more patience, and soon I hope to give you some proofs that one can send things to the Salon and still do good painting.

I therefore beg you to plead my cause to my friends. My contribution to the Salon is completely commercial. In any case, it's like certain medicines. If it doesn't do any good, it doesn't do any harm either.[5]

Although Renoir argued that his opportunism did not compromise his work, his artistic development shows that both his financial need and his exhibiting at the Salon did influence his course away from the avant-garde and toward conservatism. It affected his choice of themes: about half of the figure paintings of 1878–80 are portraits, and more than half of these were commissioned. Renoir's growing friendships with upper-class men and women led to orders for portraits, to the likelihood of acceptance at the Salon, and to a more secure income. Inevitably this also made him vulnerable to *haut-bourgeois* taste. But none of these considerations affected the happy, self-confident state of mind he shows in his letters and in his prolific output in these years.

Cézanne ceased to participate in the Impressionist shows at the same time as Renoir but was rejected at the Salon of 1878. Renoir and the usually reclusive Cézanne had been close friends since 1876. Cézanne may have felt indebted to him for introducing his art to Chocquet, who became Cézanne's most important patron in the 1870s and 1880s. Renoir's development from soft-focus to tangible form was partially inspired by Cézanne, who in the *Bathers* of 1875–76 had successfully combined the modeled form and structured composition of Classicism with the light, varied color, expressive strokes, and surface design of Impressionism.[6] Beginning in 1878, Renoir too integrated these apparently opposing styles.

While Renoir was seeing Cézanne more, he was seeing Monet less. In 1878, Monet moved to Vétheuil, forty miles from Paris, where he established a complex living arrangement with his ailing wife, Camille (who died in 1879); a patron, Ernest Hoschedé; Hoschedé's wife,

Alice; and the six Hoschedé children. Monet and Alice were involved in a secret liaison that began in 1876 and eventually led to Ernest's departure. Monet and Renoir continued to be friends, but their art was evolving in different directions—although each retained certain qualities of Impressionism.

At the Salon of May 1878, Renoir received his first acceptance since 1870—*The Cup of Chocolate,* posed for by Margot. It is likely that he had some assistance from the Charpentiers, who were friends of a jury member, Jean-Jacques Henner. Since the canvas was destined for the Salon, it is large, and the woman's body is given a substantial, clear treatment. At the exhibition, the painting achieved little recognition.

Renoir was becoming increasingly interested in drawing—in pastel for portraits and in ink for illustrations for reproduction. When Zola asked him to illustrate a passage for a deluxe edition of his successful novel *L'Assommoir,* Renoir first made a brush-and-ink drawing upon which Zola copied the passage illustrated: "All six, arm in arm, taking up the whole width of the street, were going along dressed in light colors, with ribbons tied around their bare heads. L'Assommoir, page 453." Because the drawing was too sketchy for reproduction, Renoir had to copy it over in pen and ink. One hundred thirty copies of this edition of *L'Assommoir* were published by Marpon and Flammarion in 1878.

In May of that year, Théodore Duret published a pamphlet, *Les Peintres impressionnistes.* For the frontispiece, he asked Renoir to make a pen-and-ink rendering of a portrait of *Lise* (1867) that he owned. In his text, he described Renoir as one of the four key Impressionists (the others being Monet, Pissarro, and Morisot):

The Cup of Chocolate. 1878. 39⅜ x 31⅞". Private collection

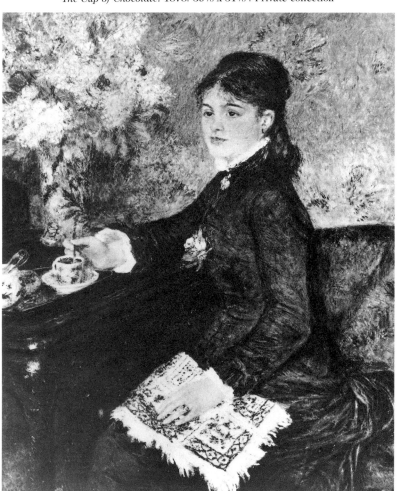

84

Renoir excels in portraits. Not only does he capture the exterior features, but on the features he establishes the model's character and inner way of being.

I doubt that any painter has ever interpreted woman in a more seductive way. Renoir's fast, light brush produces grace, suppleness, and abandon, makes flesh transparent, and tinges the cheeks and lips with a brilliant red. Renoir's women are enchantresses. . . . You will have a mistress. But what a mistress! Always sweet, gay, smiling, needing neither dresses nor hats, able to do without jewels, the truly ideal woman![7]

In the spring of 1878, Ernest Hoschedé, whose finances had deteriorated drastically, was forced by court order to sell his art collection at auction. At the sale, held June 5 and 6, his three paintings by Renoir fetched a total of only 157 francs: a landscape went for 42 francs, a genre scene for 31, and *Woman with a Cat* for 84. Eighty-four francs would not even have gained Renoir six dinners at Murer's, where Pissarro reported paying 15 francs a meal. Because the market for all art was depressed, these prices were decidedly worse than those at the Impressionist auctions of 1875 and 1877.

In the fall, Renoir began portraits of two well-known women for the Salon of 1879—the actress Jeanne Samary and Mme. Georges Charpentier, who had introduced Renoir to the actress. Jeanne Samary stands almost life-size in the foyer of the Comédie-Française, alluring and fashionably chic. On October 15, Renoir wrote Duret: "I have finished a standing portrait of little Samari [*sic*] that delights women and especially men. She is wearing a low-cut party dress"[8] (p. 86). The transformation from the vaporous bust-length portrait of the year before to the more naturalistic, finished, solid full-length portrait is striking.

The portrait of Mme. Charpentier and her children was Renoir's golden opportunity to catapult himself into the limelight. It was once more time for Mme. Charpentier's help. Renoir knew that Henner would again be on the Salon jury and that a new director of fine arts, Edmond-Henri Turquet, was an acquaintance of both the Charpentiers and Duret. Renoir's chances for acceptance and even for good placement were thus very good, but to be on the safe side, he used a very large canvas so it could not be hidden away.

The painting shows the Japanese salon of the Charpentiers' Paris town house. Seated next to Mme. Charpentier is three-year-old Paul, who is dressed as a girl, as was then customary. Six-year-old Georgette sits atop their Newfoundland dog. As contemporary photographs show, Renoir retained good although flattering likenesses of the group.

Renoir's execution of the elaborate, yet informal painting was painstaking. From September through mid-October, there were forty sittings. "I am working all these days at the Charpentiers'," he wrote Duret.[9] Edmond recorded that the portrait was "painted at her home, without any of her furniture having been moved from where it stood every day, without anything having been prepared to improve one part of the painting or another. . . . Is he doing a portrait? He will ask his model to maintain her customary manner, to sit the way she sits, to dress the way she dresses, so that nothing smacks of discomfort and preparation. This is why, in addition to its artistic value, his work has all the *sui generis* charm of a painting faithful to modern life."[10]

OPPOSITE, ABOVE:
Sketch for an Illustration for Émile Zola's L'Assommoir. 1878.
Brush and ink, 9¾ x 14½". Whereabouts unknown

OPPOSITE, BELOW:
Illustration for Émile Zola's L'Assommoir. 1878. Pen and ink, 9¾ x 14½".
Private collection

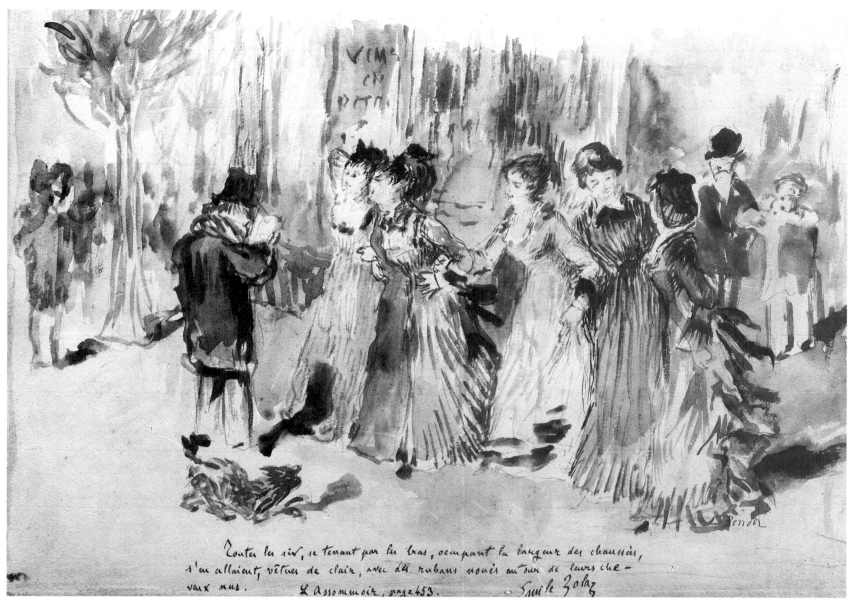

Toutes les soir, se tenant par les bras, occupant la largeur des chaussées,
s'en allaient, vêtues de clair, avec des rubans noués autour de leurs che-
veux nus. L'Assommoir, page 453. — Emile Zola

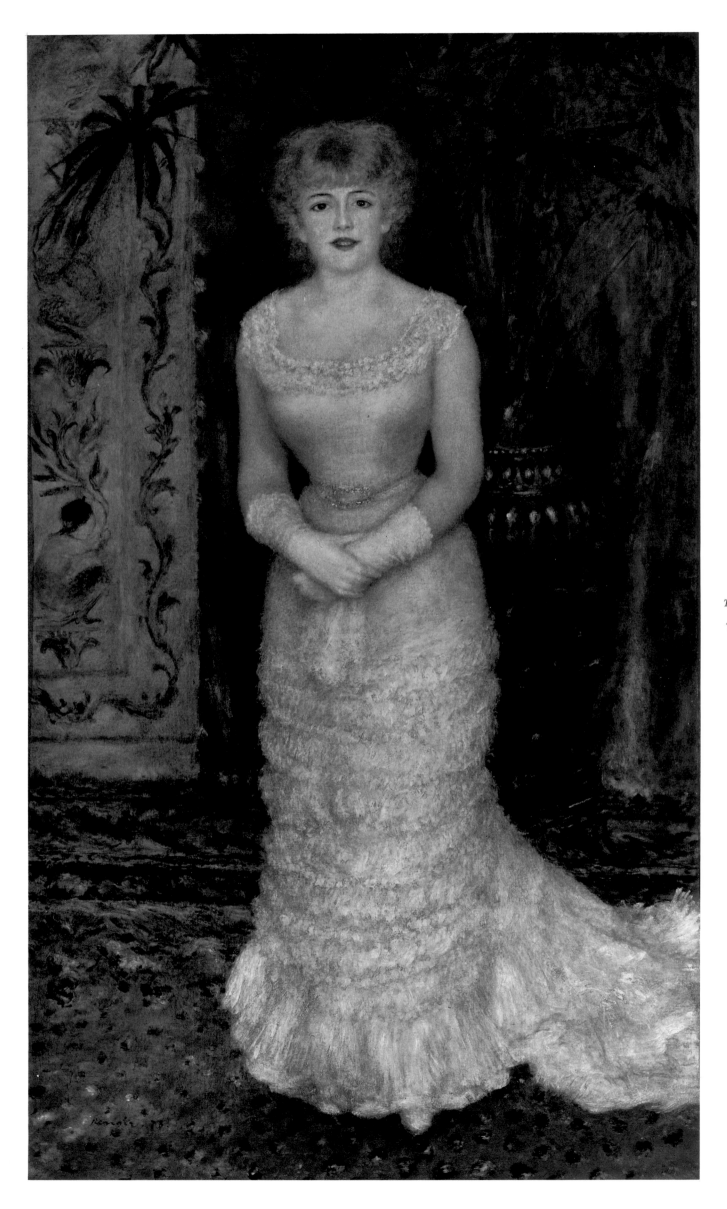

The Actress Jeanne Samary.
d. 1878. 68¼ x 40¾".
The Hermitage, Leningrad

With his clearer definition of form, Renoir seems to return to a more lifelike treatment, following the current taste for flattering naturalism, as he had done in his portrait of *Mlle. Sicot* of 1865. Yet he never went back to the limited palette, dark shadows, or smooth finish of the 1860s.

While painting the figure of Mme. Charpentier, Renoir may well have had in mind popular academic works. He seems to have relied even more on Ingres's portrait of Mme. Philibert Rivière in the Louvre, following its emphasis on silhouette, its languid posture, elegant gesture, and twisted torso.

In the Charpentier portrait, Renoir tried to counter the attacks on his figure painting. Because of the allegation that his execution lacked clarity and was violent, sloppy, and unfinished, he made his surfaces clearer and smoother and reduced visible strokes and reflected colors so that the faces and hands might display sensuous details and rich textures. In response to accusations that his form was unnatural, his figures dissolving, his drawing execrable, and his attitude destructive, he made the figures more solid, tangible, and real. To answer the charge that his compositions lacked design, he encompassed the sitters in one large pyramid.

Renoir retained some Impressionist methods of arrangement,

Letter from Renoir to Théodore Duret, October 15, 1878

however. Painting from a point above his subject, he emphasized the two-dimensional surface pattern as well as the three-dimensional placement. This resulted in spatial incongruities (such as the strange disproportion between Mme. Charpentier and the chair behind her or between the angle of the carpet and the three bamboo wall hangings). The pure high-key shades of vibrant local and reflected color and the spontaneous appearance, true-to-life setting, and postures are also Impressionist.

On October 15, after the Charpentier and Samary portraits were completed, Renoir wrote Duret: "The time that portraits make you waste is incalculable. . . . The portrait of Mme. Charpentier is entirely finished but I can't say what I think of it. I don't know at all. In a year I'll be able to judge it but not before."[11]

The Charpentiers paid 1,000 francs for the portrait—a sizable sum, which at this time in Paris would keep a worker's family of four in food and fuel for an entire year.[12] During the six months before he submitted it to the May 1879 Salon, Renoir arranged for many people to see it. Soon after it was finished, he wrote Mme. Charpentier: "Mme. Manet (Morisot, 40 rue Villejust) has asked M. Théodore Duret and me for permission to go and see your portrait. M. Théodore Duret and I have answered that you would be extremely flattered indeed."[13] On November 30, 1878, he wrote again: "Next Monday I'm having lunch with some close friends of Bonnat [who was on the Salon jury both in 1878 and 1879], Mrs. [*sic*] Charles Ephrussi and Mr. [*sic*] Deudon. They have asked me to get your permission to see your portrait. So if you give it to me, as your boundless kindness to me leads me to suppose, we will be at your place on Monday about 1:30. I'm not saying that I will be grateful for it, because my debt to you is already too heavy to be increased any more. Your resident painter, A. Renoir."[14]

The painting was presumably also acclaimed by many guests at the Charpentier salons. On February 7, 1879, Cézanne, then at L'Éstaque, wrote Chocquet: "I'm glad to hear of Renoir's success."[15]

Both paintings that Renoir had submitted to the 1879 Salon were accepted: the portrait of Jeanne Samary, as well as *Mme. Charpentier and Her Children*. In addition, two pastel portraits of men were also hung. Mme. Charpentier's portrait was prominently placed among the 3,040 works that lined the walls. Many years later, Renoir explained this unique experience: "Mme. Charpentier wanted to be in a good position, and Mme. Charpentier knew the members of the jury, whom she lobbied vigorously."[16]

Mme. Charpentier and Her Children was Renoir's greatest success to date; not until 1892 did he again receive such a good response from the press. Four critics who had been favorable in the past now wrote glowingly: Bergerat praised his "absolutely admirable general harmony," and De Banville lauded "his refined and delicate colors."[17] Castagnary affirmed:

His portrait of *Mme. Charpentier and Her Children* is a very interesting work. The figures may be a little short, a little dumpy in their proportions, but the palette is extremely rich. An agile and witty brush has flowed over all the objects that make up this charming interior; under rapid brushstrokes they have been arranged and modeled with that lively and smiling grace that provides the enchantment of color. Not the slightest trace of convention, either in the arrangement or in the technique. The observation is as clear as the execution is free and spontaneous. There are here the elements of a robust art whose further developments we await with confidence.[18]

Burty, who had supported Renoir as early as 1869, now explained:

Everything obeys a general impression of modern harmony. The poses are of a striking accuracy, and the flesh tones that the children innocently offer to the kisses of the light are as firm as ripening cherries. One thinks one has before one's eyes the velvetiness of a huge pastel.[19]

Two previously negative critics, Baignières and Bigot, now changed their views.[20] A third, Bertall, who had deprecated Renoir in 1876, wrote a lukewarm review complaining that the portrait showed a complete ignorance of drawing and lacked perspective. However, he congratulated Renoir for having broken with "the nihilists of the avenue de l'Opéra"[21] (where the Impressionists were then exhibiting).

On balance, it was clear that Renoir had calculated correctly in his campaign for the Salon. While it was still in progress, Pissarro reported to Murer: "Renoir . . . is having a great success at the Salon. I think he is launched, so much the better, poverty is so hard!"[22] And Caillebotte wrote Monet: "Renoir's paintings are very beautiful."[23] Durand-Ruel purchased the portrait of Jeanne Samary for 1,500 francs, and the success of the Charpentiers' portrait signaled an upswing in Renoir's fortunes for the next three years. He received many oil and pastel portrait commissions, and his new wealth enabled him to travel extensively in the early 1880s. One day he reported to Mme. Charpentier: "Today I started a thousand-franc portrait."[24] "Do not wait for me," he advised her another time. "I will very probably have the sorrow of not being able to dine with you. I started a portrait this morning. I am starting another one again this evening, and afterward I will probably go for a third. If I have to stay for dinner and start tomorrow, all these people are leaving soon and my head is completely upside down. As soon as I am a little freer, I will come to apologize to you and tell you about my likely failures or my most unlikely successes."[25]

In April 1879, shortly before the Salon had opened, the Charpentier firm had begun publishing *La Vie Moderne*, a weekly illustrated newspaper of art, literature, and social life. Émile Bergerat was listed as editor-in-chief, Georges Charpentier as administrative editor, Renoir as artistic contributor, and Edmond Renoir as literary contributor.

Renoir made some drawings for *La Vie Moderne* in a process called *gillotage*, a form of reproduction using a zinc relief plate. One of these, *Homage to Léon Riesener*, appeared on April 17, illustrating an article about the recently deceased painter.[26] A portrait of the poet Théodore de Banville came out in the July 10 issue.

Capitalizing on his Salon success, Renoir asked Mme. Charpentier (who took a hand in running the journal's affairs) to give him a one-man show at the editorial offices, which were well located on the boulevard des Italiens at the entrance of the passage des Princes. Edmond was in charge of organizing a series of exhibits. Renoir planned to show "portraits, which would attract lots of people, I think. I have a certain number of well-known ones."[27] His timing was excellent. The Salon ended in mid-June, and his show ran from June 19 to July 3.

Among the pastel portraits he showed were those of Mlle. Samary, Théodore de Banville (on which the *gillotage* drawing was based), Mlle. Plunkett, Alphonse Daudet's baby, and Élisabeth Maître, niece of his friend Edmond Maître. He also included a large double portrait in oil of Francisca and Angelina Wartenberg, gymnasts and jugglers at their father's circus in Montmartre (p. 82).

The day the exhibition opened, Edmond devoted an article to it in *La Vie Moderne*:

I will not use those big words Realism or Impressionism to say that here we have real existence with all its poetry and all its flavor. This absence of the "con-

Georgette and Paul Charpentier, c. 1878

Jean-Auguste-Dominique Ingres. *Mme. Philibert Rivière*. c. 1805. 45⅝ x 35½". Musée du Louvre, Paris

ventional" . . . gives me the impression of nature with all its unforeseen quality and intense harmony.

. . . In none of his works, perhaps, does one find the same way of proceeding, and yet the work holds up, it has been properly felt since the beginning, and pursued with the single concern of arriving, not at perfection of execution, but at the most complete perception of the harmonies of nature. . . .

Mme. Charpentier and Her Children. d. 1878. 60½ x 74⅞".
The Metropolitan Museum of Art, New York. Wolfe Fund

I promised you a portrait of twenty lines: the thoughtful, dreaming, somber expression, the vague look in the eyes, you have seen him twenty times running across the boulevard; absent-minded, disheveled, he will come back ten times for the same thing without realizing what he is doing; always running in the street, always motionless indoors, he will stay for hours without moving, without speaking: what is his mind on? On the painting he is doing or the painting he is about to do; he talks about painting as little as possible. But if you want to see his face light up, if you want to hear him—O miracle!—sing some cheerful refrain, do not look for him at the table, or in places where people go to amuse themselves, but try to take him by surprise while he is working.[28]

Despite his new success, Renoir did not abandon old friends. When Sisley, whose well-to-do father had died in financial straits after the Franco-Prussian War, was himself in difficulty and needed exhibition space after having been rejected at the Salon of 1879, Renoir turned to Georges Charpentier on June 12, a week before his own show was to open: "If you could hold an exhibition of Sisley as soon as possible, it would be very nice of you; he has 40 pretty canvases, and he would certainly sell some of them. I will ask you for an answer, and if it is at all

possible and when. I'll give him the good news this very day."[29] Charpentier did not give Sisley an exhibition until a year and a half later.

Shortly after Renoir's meteoric rise to fame, he had a private tragedy. Early in January 1879, Margot contracted smallpox. Renoir invited his friend Dr. Gachet to 35 rue St.-Georges for Thursday, January 9: "You come to have lunch with me next Thursday without fail; there is no possible excuse, you must. I'll tell you why."[30]

Because of Renoir's fear of contracting Margot's illness, he kept in contact with her by mail. His next letter to Gachet, also written from his studio, suggests that Gachet did not accept the first invitation. Renoir's agitation is evident in his sarcastic tone:

Please go tomorrow morning to see Mlle. L..., 47 rue Lafayette.

She has broken out in pimples and when she scratches them, a white blister appears.

I think it's acute. And she writes me that it's very painful, she has been waiting for you since Tuesday, you can imagine how much fun she must be having.

As for myself, I don't know what to think, and I'm afraid she'll decide to go

Homage to Léon Riesener, from *La Vie Moderne,* April 17, 1879

Théodore de Banville. 1879. Pastel, 20½ x 16¼″. Musée du Louvre,
Cabinet des Dessins, Paris

LEFT, BELOW:
Mlle. Élisabeth Maitre. d. 1879. Pastel, 17½ x 21½″. Private collection

and see her doctor, who could make the pimples go back inside.

It may be smallpox.

Well, I'm very impatient to know, so impatient that I've done nothing all day while waiting for you....

I count on your kindness to get in touch with me and relieve my anxiety, which is very great.

I'm almost at the point of waiting for you at your door.[31]

Gachet, who was a homeopathic and herbalist physician, went to Margot and gave her medicine. Renoir soon wrote him again: "It would be very kind of you to go and see the little one; she is waiting for you impatiently. She wrote me that she was following your treatment to the letter. Lots of pimples have come out."[32] In mid-January, when Gachet did not return to Margot, Renoir wrote: "The little one writes me that she is in pain and doesn't know what to do. Be good enough to go and see her, or tell me if you are sick or if something has happened to you. I am very worried and very perplexed."[33] But on January 17, Gachet was temporarily immobilized by a railroad accident. "I hope that you are only bruised somewhat," Renoir wrote, "and that all you'll need is a little time in bed and to keep warm and that I'll soon see you on your feet, stronger than ever.... I've given up on the smallpox; it may be more humane to let that poor little thing die in peace. If there were the slightest hope, I would do whatever is possible. But it's very serious."[34]

The homeopathic doctor De Bellio, a friend from the Café de la Nouvelle-Athènes, came to Margot's aid. To Gachet, Renoir related:

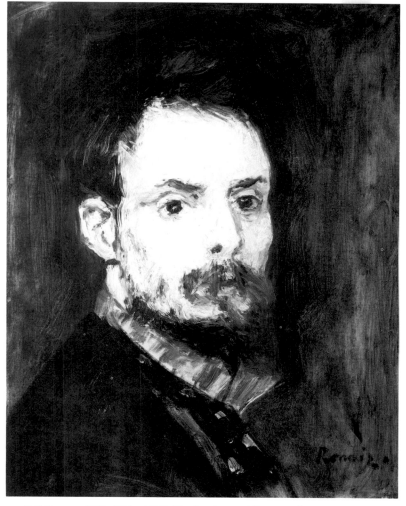

Self-Portrait. 1879. 15½ x 12½″. The Sterling and Francine Clark Art Institute, Williamstown, Mass.

RIGHT, BELOW:
Self-Portrait (with Head of a Woman). 1879. 7½ x 5½″. Musée d'Orsay, Galerie du Jeu de Paume, Paris

Margot. 1879. 18⅛ x 15″. Musée d'Orsay, Galerie du Jeu de Paume, Paris

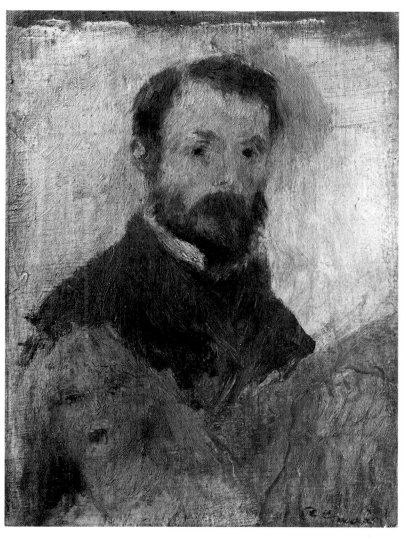

This morning De Bellio went to see my sick one, he had seen her several times at my place, and besides he has a portrait head of her in his house, I think.

In brief, he told me that although he didn't go there as a doctor, he nevertheless could tell that her case was absolutely hopeless.

He was kind enough to tell her that he would bring her a medicine.

I am informing you so that you can tell her that you know M. de Bellio, and that when spring comes she will be all right. . . .

P.S.—Let her take what De Bellio brings her; it will mean a week of hope; I think it's lycopodium [an herbal medicine].

Incidentally, he doesn't believe in it, but as I say, it means a week of hope.[35]

Margot died on February 25. Renoir paid the expenses of her burial and that same day wrote Gachet: "The little one whom you were kind enough to take care of, too late unfortunately, is dead. I am nevertheless very grateful to you for the relief you were able to give her, although we were both convinced that it was quite useless."[36]

In June, Renoir painted a small profile of Margot. He gave this image—wistful and faded, without warmth or vitality—to Dr. Gachet.[37] To Dr. de Bellio he gave a self-portrait, the most expressionistic painting he ever did, showing himself anguished and tormented. Around this time, he also did a *Self-Portrait* with a head of a woman. It is a small oil sketch in which he brilliantly captures the essence of human vitality with a few strokes.

One of Renoir's most important patrons came into his life in March 1879, when Deudon (who owned *The Dancer*) suggested to Paul Bé-

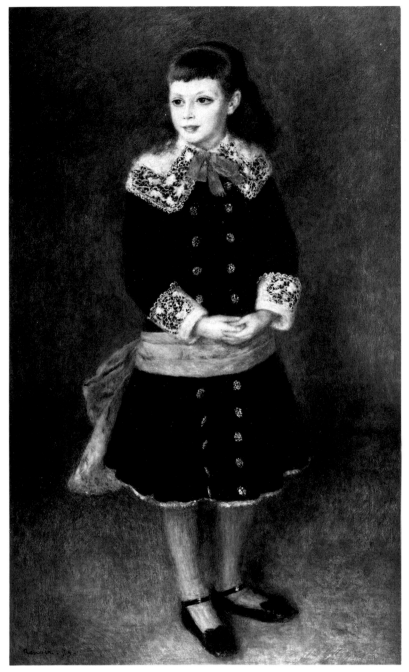

Marthe Bérard. d. 1879. 51¼ x 29½". Museu de Arte de São Paulo

rard that Renoir do a portrait of his eldest daughter, nine-year-old Marthe. Bérard, eight years older than Renoir, had been a diplomat and banker, until he retired to enjoy hunting and gardening.[38] He was a Protestant, a Republican, and a man of considerable inherited wealth. In spite of their different backgrounds, he and Renoir became close friends, and remained so until Bérard's death in 1905. Indeed, Renoir's many letters to Bérard are the most intimate and revealing of his entire correspondence.

In the early years of their friendship, Bérard commissioned numerous works from Renoir, who was a frequent guest at the family's Paris residence at 20 rue Pigalle and at their spacious Norman château at Wargemont, near Dieppe. On his first visit to the château in the summer of 1879, Renoir painted the rose garden. He also decorated wooden panels: floral arrangements (opposite) for the library, small drawing room, and other rooms, and *The Fall Hunt* (rabbit, pheasant, and woodcock) and *The Summer Hunt* (hare, partridge, and quail) for the dining room. From 1879 through 1885 he executed about forty paintings for the Bérards at Wargemont. Among them were sixteen

92

portraits of Paul; his wife, Marguerite; their four children, André, Marthe, Marguerite, and Lucie; and a nephew and niece, Alfred and Thérèse Bérard.

Renoir's longest stay at Wargemont was his first, from July through September 1879, when he made twenty paintings: ten portraits, four still lifes, three genres, two landscapes, and one fantasy. Several of the portraits are so remarkably similar to contemporary photographs of the sitters that one wonders whether Renoir used photographs as a supplement to painting from life. And in fact, the paintings resemble these photographs in their sharp contours, firm facial structure, and striking definition of the eyes.

Even while at Wargemont, Renoir was trying to get alternative commissions for subjects other than portraiture. He wrote playfully to Mme. Charpentier:

I want to tell you about an idea of Mme. Bérard's that in my opinion is not entirely senseless. It is to put the week's fashion on the last page of *La Vie Moderne.*

I would undertake to do the drawings, very accurately, as soon as I get back to

The Rose Garden at Wargemont. d. 1879. 25 x 31½". Private collection, Paris

The Château of Wargemont, near Dieppe, Normandy

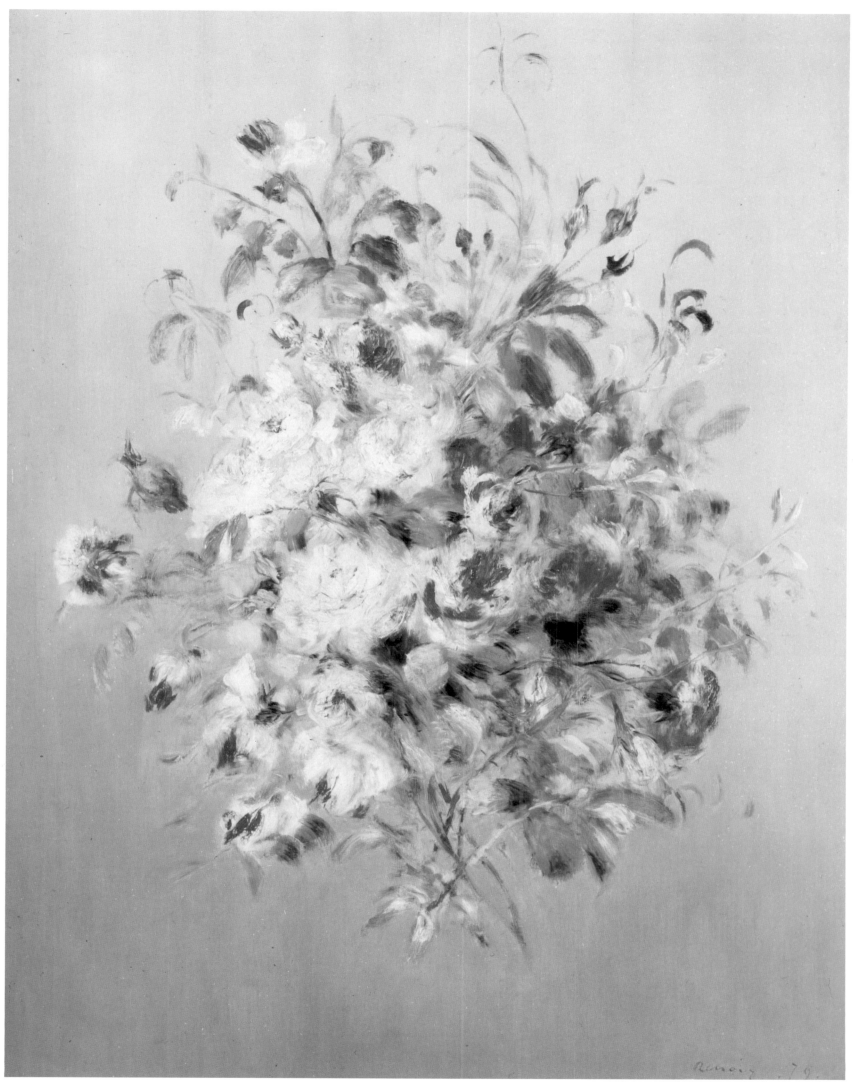

Bouquet of Roses. d. 1879. Oil on panel, 33 x 25¼". The Sterling and Francine
Clark Art Institute, Williamstown, Mass.

Paris. In this way, you will have on your side the whole female staff, who would not always be interested in sketches by [Jean-Louis] Meissonnier [*sic*] or others.

An arrangement could be made with milliners and dressmakers. One week of hats, another of dresses, etc. . . . I will go to them to do the drawings, from life, from different sides. There's an idea. I'm conveying it to you for what it's worth.[39]

Mme. Charpentier must have rejected the idea, since Renoir never did fashion drawings for *La Vie Moderne*.

While at Wargemont, Renoir paid a visit to friends of the Bérards who had a summer château in Dieppe, Mme. Blanche and her eighteen-year-old son, Jacques-Émile. Dr. Émile Blanche, director of an important mental clinic in Passy, was then working in Paris. Mme. Blanche wrote her husband that Renoir was very impressed with paintings by Jacques-Émile. She said Renoir had told him: " 'I am really surprised, there are some quite remarkable parts, it would be a pity for you not to be a painter, you have extraordinary qualities of color and composition, there are some very well-drawn things; I would be very happy to give you some advice in Paris.' "[40] Renoir gave Jacques-Émile lessons in Paris for the next two years and, his mother reported, when Jacques-Émile told Renoir that he often felt discouraged, Renoir said that "he would sometimes go for four months thinking that he was no longer capable of anything, and then all of a sudden he would start again much better."[41]

The dining room of the Château of Wargemont, with Renoir's decorative panels

94

At this time Renoir drew up a list with sketches of "what you need for painting" that includes colors, types of brushes, and other materials; he may well have prepared it for Jacques-Émile:

Flake White
Chrome Yellow
Naples Yellow
Yellow Ocher
Raw Sienna
Vermilion
Rose Madder
Viridian Green
Emerald Green
Cobalt Blue
Ultramarine Blue

palette knife
scraping knife
essence [of turpentine]
what you need for painting

Yellow Ocher, Naples Yellow, and Raw Sienna are only intermediary hues. Thus one can do without them because they can be made with other colors.

Pointed marten-hair brushes

Flat hog-hair brushes

Renoir's hand-written list of his palette and materials, c. 1879

Mme. Paul Bérard, 1879

Mme. Paul Bérard. d. 1879. 31½ x 25⅝". Musée d'Orsay,
Galerie du Jeu de Paume, Paris

Mlle. Thérèse Bérard. d. 1879. 22 x 18½". The Sterling and Francine Clark Art
Institute, Williamstown, Mass.

Renoir advised the greatest variety in yellows (four), which indicates
that this was the brightest palette of his career.

On Renoir's return to Paris, the Blanches asked him to paint two
panels for their Dieppe château. Since Dr. Blanche was an enthusiast
of Wagner, Renoir created fantasies based on *Tannhäuser.* In the panel
for act three, he depicts the nude Venus appearing to the hero, Tann-
häuser, who wishes to follow her, but is restrained by Wolfram.

In the fall of 1879, Renoir, now thirty-eight, met Aline Charigot, a
twenty-year-old woman from Essoyes in the Aube in Burgundy. She
did laundry for a seamstress and also for Renoir, and for Monet when
he was in Paris;[42] she lived on the rue St.-Georges near Renoir's studio
with her mother, Mélanie, who earned her living as a dressmaker, as
Aline subsequently did also. (Aline's father had deserted the family.)[43]
Aline soon became one of Renoir's models and eventually his wife.

Oarsmen at Chatou. the first painting in which Aline appears, com-
bines defined foreground figures against an Impressionist land-
scape—a blend of styles that Renoir continued throughout 1879 and
1880. In *Little Blue Nude,* the pose indicates that Renoir recalled var-
ious antique statues of a thorn being removed from a foot. In a more
original vein, he cropped the foreground figures by the frame in *After
Lunch, Young Woman Sewing,* and *At the Concert,* creating the feeling
that they exist in our space. He had used this device in the lower left
corner of *Le Moulin de la Galette* (as had Degas and contemporary pho-
tographers). Here, where the figures are more distinct, the bold
arrangement is more striking.

In January 1880, Renoir fell off his bicycle and broke his right arm.
Fortunately he was ambidextrous. He answered a letter from Duret on
February 12:

such scenes were popular and that Jules Breton, who had been on the Salon jury in 1878 and 1879, would again serve in 1880. Breton's Academic Realist peasant scenes (such as *The Recall of the Gleaners*) influenced by Italian Renaissance sources had won him the highest acclaim. Breton idealized rustic life, giving it a nobility and serenity that was attractive to bourgeois and aristocratic taste alike. As he celebrated the peasants of Brittany, so Renoir depicted Norman peasants.[45]

Both these paintings were accepted, as well as two portraits he sent to display his skill in that field: pastels of Mlle. M. B. and of Lucien Daudet. Monet had one work admitted; Sisley's and Cézanne's entries were rejected. Without Mme. Charpentier's help, Renoir's paintings were once again hung in obscure places and were ignored by the critics and public. Renoir was so upset by his lack of notice that he resolved to submit only portraits from then on.

He also made two proposals for official exhibitions in 1881. It is significant that in both he identified himself as an Impressionist even though he no longer adhered to pure Impressionist tenets in his treatment of form, and he no longer exhibited with the group. He considered himself an Impressionist nonetheless because of his use of color and light, his execution, parts of his composition, and his depiction of the freedom and joyousness of daily life. Along with Monet, whose submissions had also been hung in dark corners, he composed a joint letter to Turquet, a minister of fine arts: "Two artists known under the name of Impressionists are turning to you in the hope of being allowed to exhibit next year under suitable conditions at the Palais des Champs-Élysées."[46] They mailed a copy to Cézanne and asked him to enlist Zola on their behalf. On May 10, Cézanne dutifully wrote the novelist:

I send you enclosed a copy of a letter that Renoir and Monet are going to address to the minister of fine arts to protest against their poor locations and to demand an exhibition next year for the group of pure Impressionists. Here is what I have been asked to ask you to do:

I will be completely recovered in about a week. I owe this fast recovery to Dr. Terrier, he was marvelous. I am enjoying working with my left hand, it is very amusing and it's even better than what I would do with the right. I think it was a good thing to have broken my arm, it made me make some progress.... I don't thank you for the emotion that my accident caused you, but I am very flattered by it and I can only rejoice in the evidence of sympathy that I received from all sides. I've been spoiled with all kinds of nice little things, but in spite of that I don't feel like doing it again.[44]

A short while later, in order to show his versatility, Renoir submitted to the Salon two large everyday scenes—both very different from the portraits he had sent the previous year. *Sleeping Girl with Cat* of 1880, posed for by the Montmartre florist Angèle, recalls *Study: In the Summer,* which he had sent to the Salon of 1869; in both, the girl is *en décolleté,* passive, seductive.

The second work was a peasant genre scene, *Mussel Fishers at Berneval* (p. 102), painted at Wargemont the summer before. He knew that

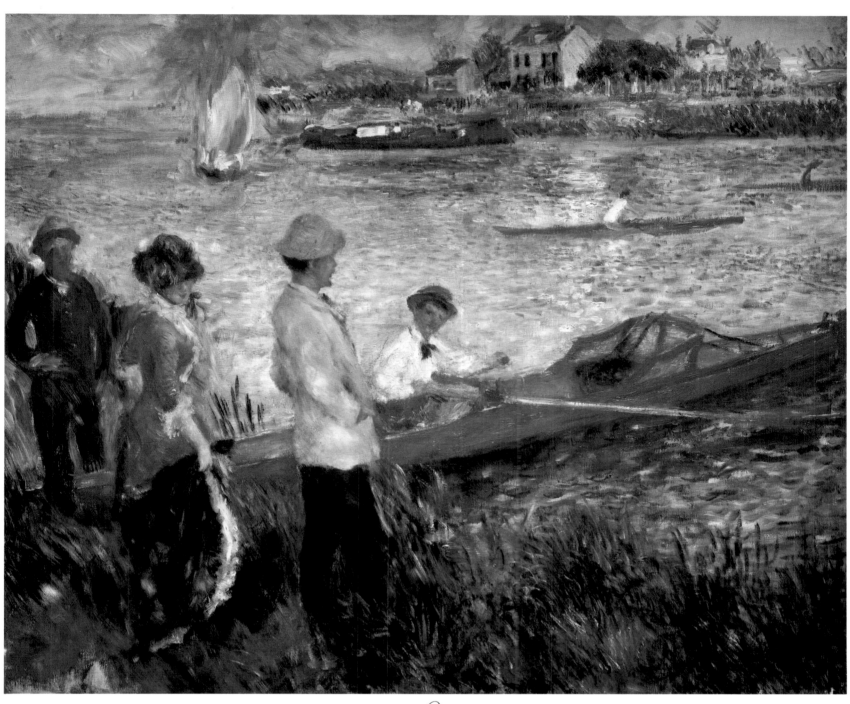

It would be to have this letter inserted in *Le Voltaire* by letting it precede or follow a few words about the group's previous exhibitions. The few words would aim to show the importance of the Impressionists and the real curiosity that they have aroused.[47]

Zola complied minimally. He did not support the idea of a separate Impressionist exhibition. In his articles of mid-June in *Le Voltaire,* he first wrote of Monet and then:

The other Impressionist painter, M. Renoir, who has exhibited at the Salon, is also very badly placed. His two canvases, *Mussel Fishers at Berneval* and *Sleeping Girl,* have been hung in the circular gallery that runs around the garden; and the bright daylight, the reflections of the sun, are very harmful to them, all the more since the artist's palette already tends to melt all the colors of the spectrum into a sometimes very delicate range of tones. But once again why get angry at the jury and the administration? It is a simple struggle, from which one always emerges the victor by dint of courage and talent.[48]

Early in May, just after the Salon was hung, Renoir devised a more ambitious proposal—to reorganize the Salon. The Salon jury system for 1880 gave him ammunition. Ten judges were responsible for choosing history and figure paintings, and five judges for selecting landscapes and still lifes. The total accepted came to more than six thousand works. According to a decision by Turquet, the paintings were grouped in four sections: "not in competition, exempt from the jury, not exempt, foreign," which would govern where they were to be hung. Nevertheless, mass confusion reigned to the extent that on opening day, two thousand paintings had not yet been hung. Renoir asked Murer's support for his second proposal: "I have spoken to several artists about my plan. No success so far. If you haven't done anything, I have another and simpler one, which will be better understood. In any case, thanks."[49]

On May 23, Murer published "Affaire du Salon" in *La Chronique des Tribunaux.* There he printed Renoir's plan:

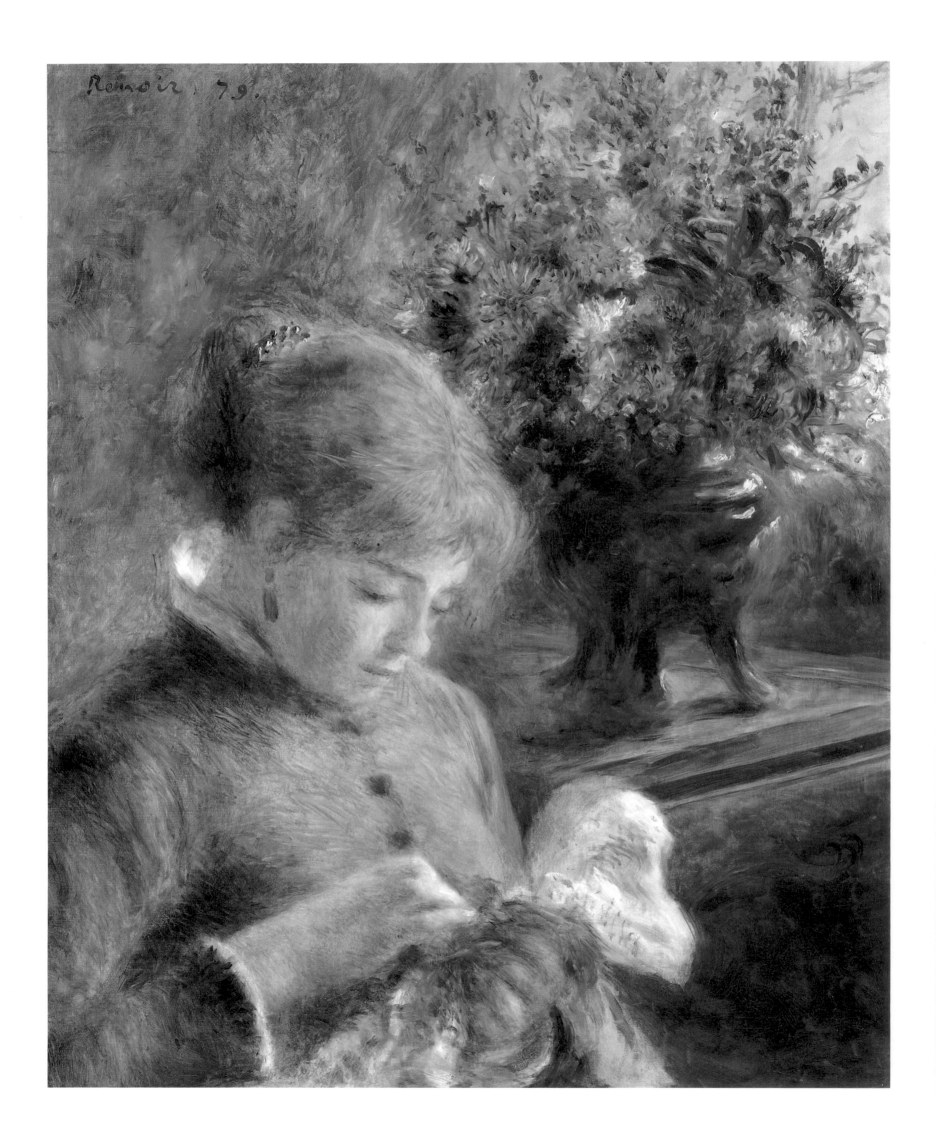

Little Blue Nude. c. 1880. 18¼ x 15⅛". The Albright-Knox Art Gallery, Buffalo

PLAN FOR ART EXHIBITION

For the year 1880[50]

Art. 1.—The Salon is divided into four groups, extending from the Salon of Honor to the Salons at the ends, which each group will share in pairs.

1st group. Members of the Institute and previous winners.

2nd group. Foreigners, judged by their delegates in Paris.

3rd group. Idealists. History, genre, etc.

4th group. Naturalists, Impressionists, still lifes, etc.

Art. 2.—Each group will be formed in advance. It will consist of four hundred members. This number cannot be exceeded.

Art. 3.—Each group will appoint its jury, which will meet to judge separately and freely the canvases that they believe to belong to their section.

Art. 4.—The various juries will not be allowed to receive more than one thousand canvases each.

Art. 5.—The rest of the canvases submitted but not accepted, after a final

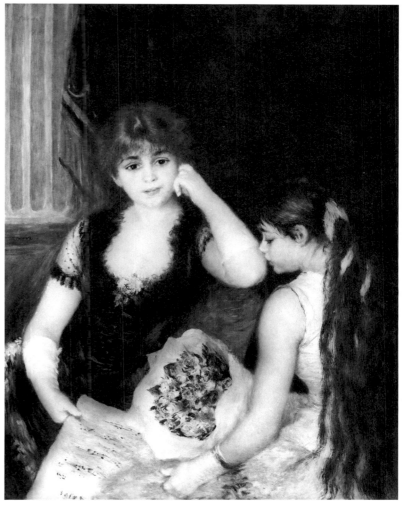

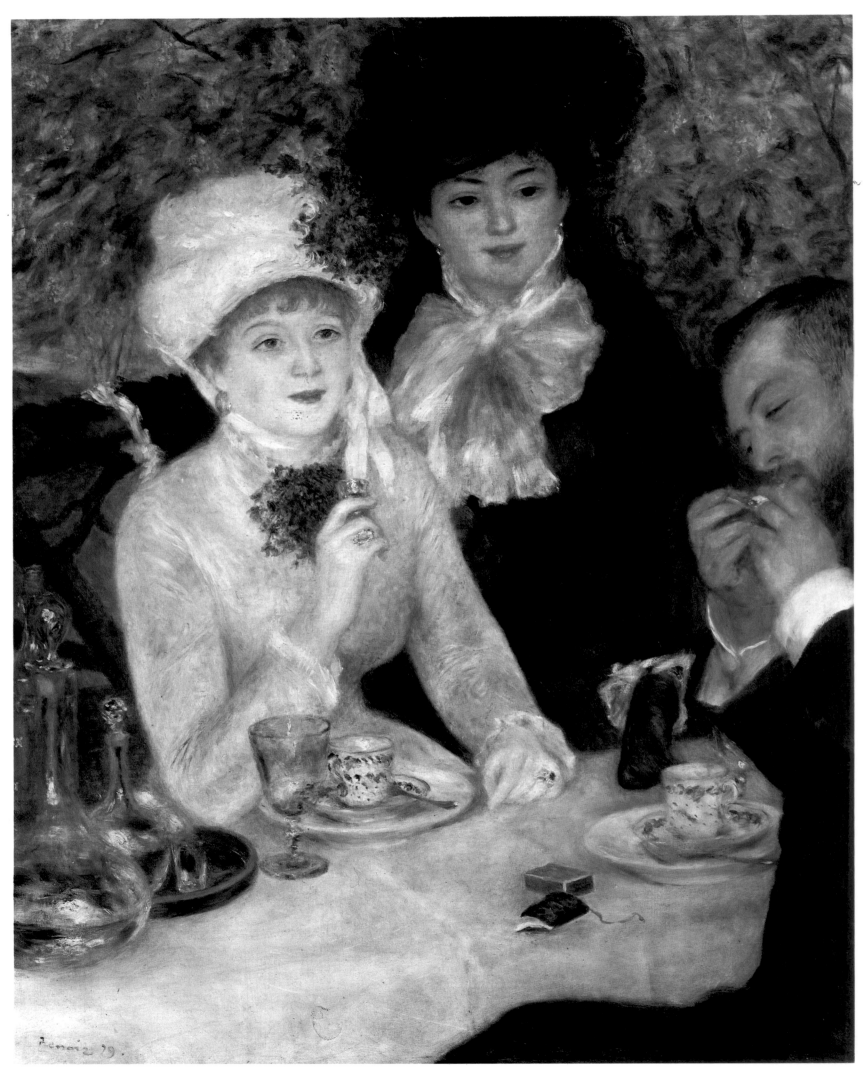

After Lunch. d. 1879. 39 x 32¼". Städelsches Kunstinstitut Frankfurt

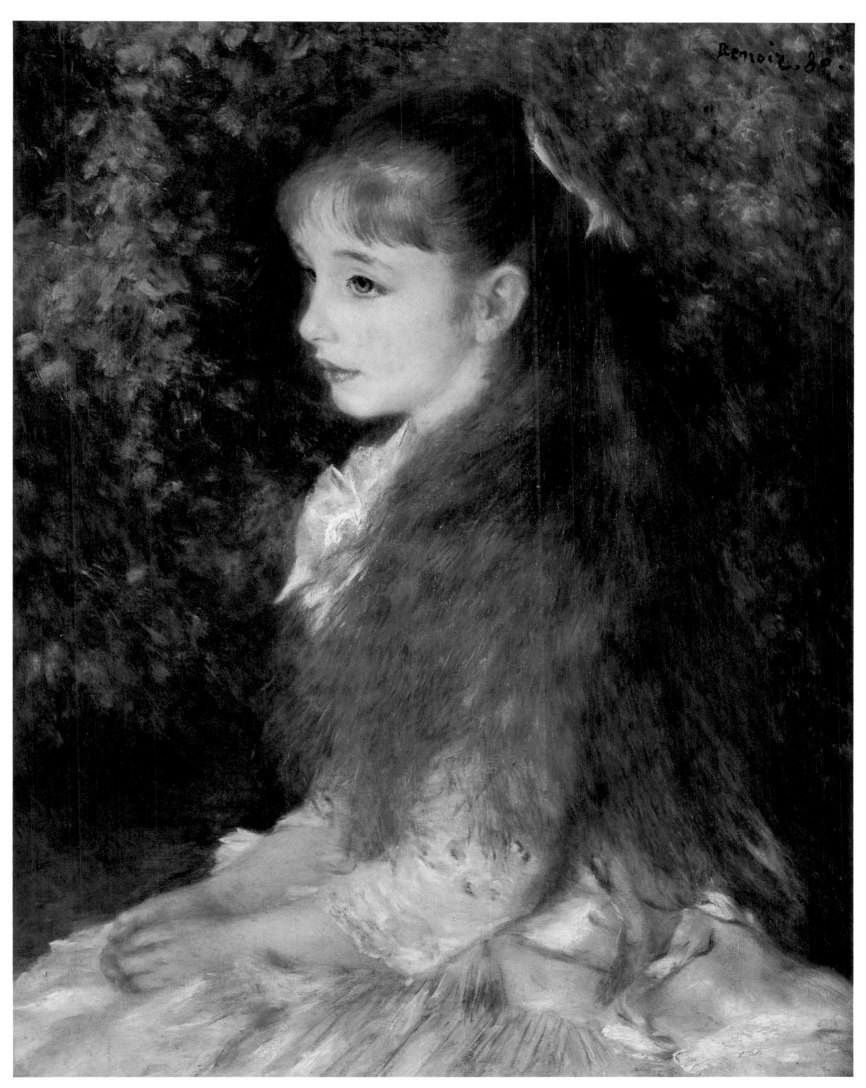

Mlle. Irène Cahen d'Anvers. d. 1880. 25¼ x 21 ¼".
Foundation E. G. Bührle Collection, Zurich

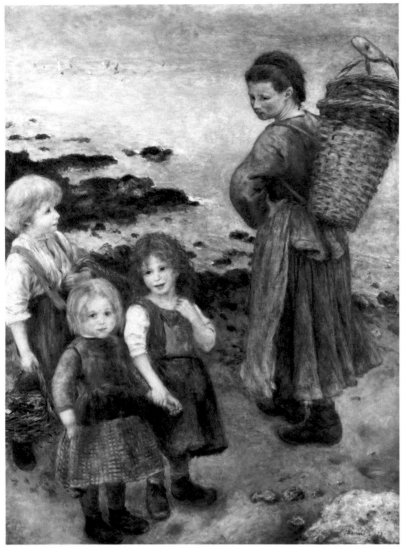

Mussel Fishers at Berneval. d. 1879. 69 x 51¼". The Barnes Foundation, Merion Station, Pa.

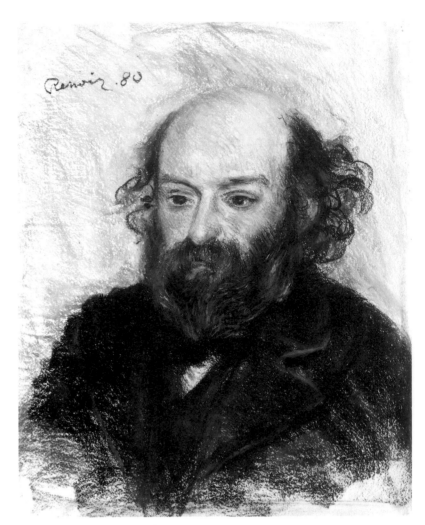

Paul Cézanne. d. 1880. Pastel on paper, 21⅜ x 17". Private collection

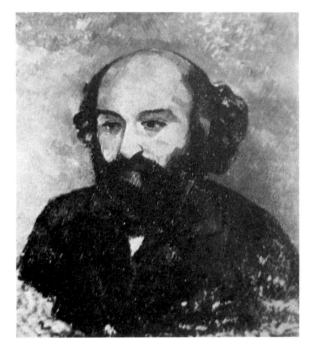

Paul Cézanne. *Copy of Renoir's Pastel Portrait of Cézanne.* c. 1880. Oil on wood, 22½ x 18½". Whereabouts unknown

review by the four juries meeting together, will be hung in other rooms under the heading *unclassified*. They will not be listed in the catalogue.

Art. 6.—Awards, no matter what they may be, will no longer entitle an artist to be accepted without examination.[51]

Neither of Renoir's schemes elicited any attention from Turquet, nor did the Salon ever recognize a category of Impressionist works. As in 1877, Renoir's idealistic plans came to naught, yet once again, he demonstrated his willingness to make concrete efforts for change.

Two months later Murer held his last Wednesday dinner in Paris. He then retired to Auvers-sur-Oise, where Dr. Gachet also had a house. Renoir's old group of friends was disbanding: already Monet was at Vétheuil, Pissarro at Pontoise, and Sisley at Veneux-Nadon.

Cézanne spent part of 1880 in Paris, where he had a studio on the rue Novins. While there, he posed for a pastel portrait that Renoir made for Chocquet. Cézanne was so pleased with it that he painted a copy on wood for Pissarro. Where Renoir's portrayal is mild, with eyes meditating off into space, Cézanne's version is harsh and withdrawn. As with some of the Bérard portraits, there is a close resemblance between Renoir's painting and a contemporary photograph that was a likely supplement to Renoir's studies from life.

Despite Renoir's neglect at the Salon, portrait commissions continued. Cézanne wrote Zola July 4 that "Renoir is supposed to have some good portrait commissions."[52] Bérard's associate at the Bérard-Grimprel bank, Armand Grimprel, arranged for Renoir to paint his

grandchildren, among them five-year-old Yvonne. Renoir's old friend the collector and publisher Charles Ephrussi introduced him to Louis Cahen d'Anvers, a banker who had a Paris town house on the rue Bassano. There, in two sittings in the garden, Renoir painted his eight-year-old daughter, Irène.

During the summer of 1880, Renoir briefly visited Wargemont, where he did a portrait of Paul Bérard. He spent most of the summer at Chatou trying to find respite from portraiture by painting genre subjects. He invited a model to "come to Chatou tomorrow with a pretty summer hat. So as to go outdoors. A light dress, wear something underneath, it's starting to get cold. . . . Do you still have that big hat that makes you look so pretty? If you do, that's the one I want, the gray one. The one you were wearing in Argenteuil."[53]

From Chatou, Renoir complained to Bérard about painting portraits of rich women who were hard to please. Possibly he was grumbling about Mme. Adela Ocampo de Heimendahl, a young Argentine woman whose parents were landowners in Buenos Aires. In any case, this letter is unusual for Renoir in its expression of annoyance: "I must still work on this damned painting because of a high-class tart who was imprudent enough to come to Chatou and want to pose, it has cost me two weeks of delay, and in short today I rubbed it out and . . . I don't know any more where I am, except more and more irritated."[54]

As the year 1880 ended, Renoir was faced with an increasingly critical dilemma: he was beginning to reap the dividends of cultivating well-to-do friends, and was finally receiving profitable portrait commissions, but time-consuming and demanding portraiture was becoming more and more distasteful. Yet what other kinds of subjects could attract equally affluent buyers?

Mme. Adela Ocampo de Heimendahl. d. 1880. 26 x 21⅝". Collection Alberto Casares Ocampo, Buenos Aires

RIGHT, ABOVE:
Mlle. Yvonne Grimprel with the Blue Ribbon. d. 1880. 17¾ x 13¾".
Private collection

Paul Bérard. d. 1880. 19⅝ x 15¾". Private collection

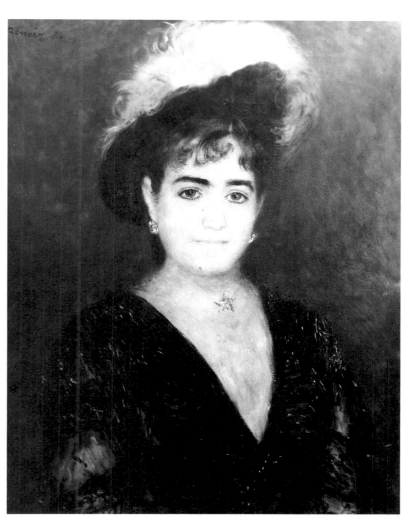

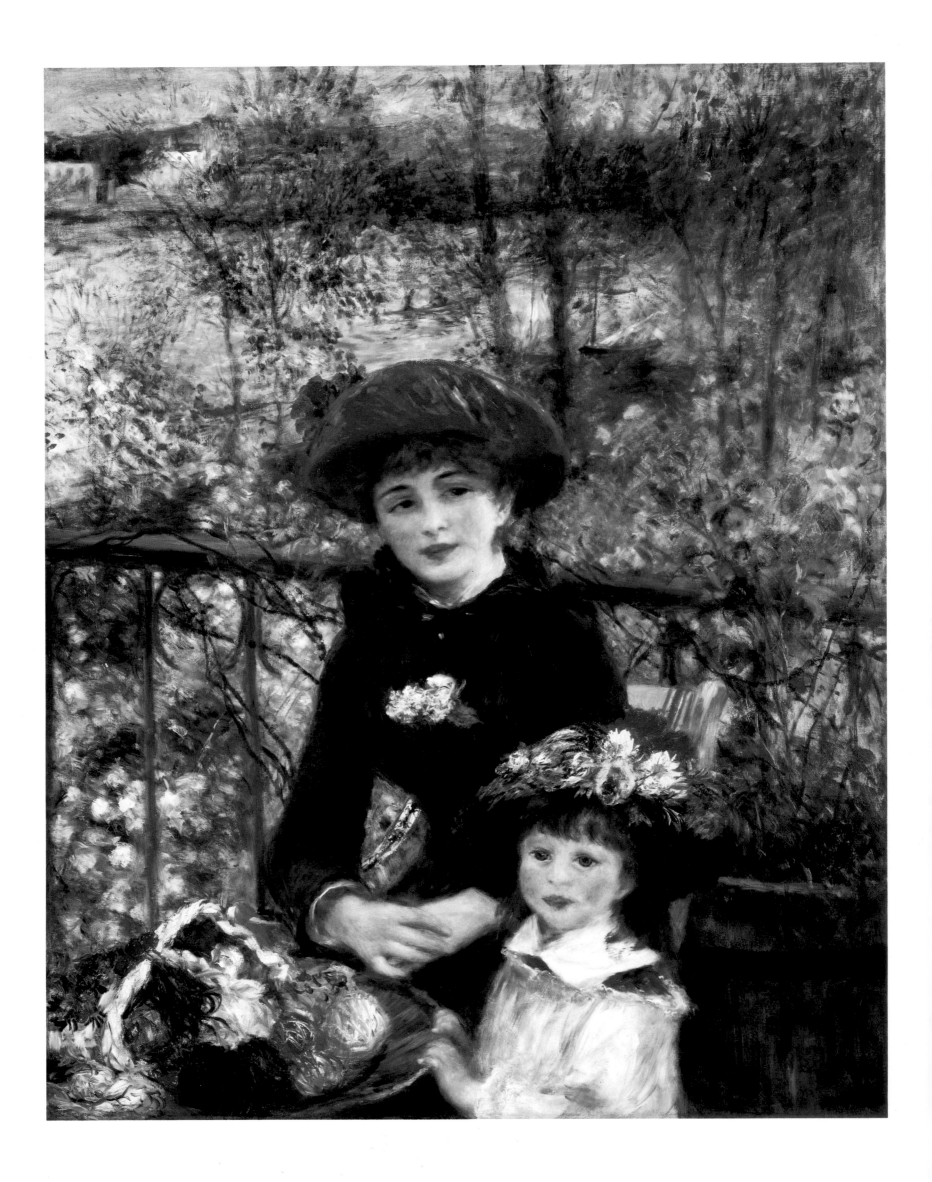

FACING multiple impasses in his career, feeling unfulfilled and dissatisfied despite increasing portrait commissions, Renoir resolved on a new course in style and subject. Early in 1881 he started on a series of travels that lasted for nearly three years. Never before had he voyaged far from home. Now he set off for Algeria, Italy, the Mediterranean coast of France, and the Channel Islands. He was, of course, hewing to an old tradition among painters. Journeys to Algeria and to Italy were especially popular with Salon artists, such as Bonnat, who had followed the path of Delacroix to North Africa and Ingres to Rome in search of exotic, romanticized themes.

Renoir also wanted to transform his figure style, but he nevertheless wanted to retain his Impressionism. Specifically, he sought to use light more pervasively in both his outdoor and indoor figure paintings. To him this light was both external (sunlight, atmosphere, reflections) and internal (the warmth of personality, the energy among figures, the magic between the model and the artist/observer). Eventually, he took lessons in the figure from Raphael and lesser Renaissance masters.

Other motivations for travel were related to his age and economic situation. At forty, Renoir was dissatisfied at not having achieved sufficient success, wealth, or honor. These travels were not only an important and urgent part of his artistic education, they were also a rite of passage into the bourgeoisie of which success as an artist would make him a member. Many of Renoir's closest friends—Bérard, Deudon, Charpentier, Caillebotte, and Durand-Ruel—were members of the upper class. In the early 1880s, it was commonplace for middle- and upper-class Frenchmen to make the Grand Tour—or at least to travel to Algeria, a French colony, and to Italy. Renoir, too, wanted to be a tourist, now that he could afford it.

In February 1881, Renoir wound up his affairs by completing a large, carefully rendered portrait of Cahen d'Anvers's younger daughters: seven-year-old Élisabeth (in blue) and five-year-old Alice (in pink). He intended it for the Salon. Late in the month, so tired that he could not tell if the painting was "good or bad,"[1] he left for Algeria with an old friend, the painter Frédéric Cordey.[2]

Renoir's letters from Algeria report problems. To Chocquet: "I'm working a little. I will try to bring back some figures but it's more and more difficult: too many painters in Algiers."[3] To Bérard: "Women so far are unapproachable, I don't understand their jabber and they are very fickle. I'm scared to death of starting something again and not finishing it. It's too bad, there are some pretty ones, but they don't want to pose."[4]

Nevertheless, he managed to paint *Algerian Girl,* a doll-like figure with attention focused on the eyes and hands. Despite the painting's brilliant, close-valued palette of oranges, reds, blues, and greens, and

On the Terrace. d. 1881. 39½ x 31⅞". The Art Institute of Chicago. Mr. and Mrs. Lewis L. Coburn Memorial Collection

its rich patterning, the girl still looks like a Parisian dressed in an Oriental costume.

If there were problems in acquiring models, Renoir was nevertheless effusive about the scenery. To Mme. Charpentier: "It is incredibly rich and green a dense, dense green."[5] To Mme. Bérard:

One ought to see this Mitidja Plain at the gates of Algiers. I have never seen anything more sumptuous and more fertile. At this moment they are planting vineyards with such frenzy that it looks as though they are doing it for the arrival of a king, as though to say, "Look how my people work," and it's real. Normandy (at least to the eye, since I've gone no further), Normandy is poor by comparison. Incidentally, there are parts that look very much like it, a marvelous green with the mixture of prickly pear and aloes in hedges, the fields full of flowers as at Vargemont [*sic*], all of it bordered by the gentle Chiffa Mountains, and on the other side the sea, eternally cheerful and almost always blue, a sea into which one feels like diving.

For comfort it's fantastic, the nights are cool, with no mosquitoes, and one can walk as in good summer weather at Berneval. By the way, it looks very much like it, but I tell you again this mixture of succulent plants, which in Paris look as though they're made of zinc, here have a very gay effect.

...These Arabs are charming people....[6]

Banana Plantation glitters with bright tropical color; *Muslim Festival at Algiers* conveys Renoir's excitement at the intense hues and sparkling light about him.

After about two months in Algiers, Renoir returned to Paris. For the next three months he painted there and in the suburbs at Chatou, Bougival, and Croissy.

Earlier, Duret, who was then living in London, had invited Renoir to visit. From Algiers, on March 4, Renoir had replied: "I will certainly go to London.... I had to give up my study of English, which I won't take up again until next winter, for the time being I'll do without it, because I want to see London this year, and the heat of Algeria will make me appreciate the refinement of England."[7]

But now he changed his mind. On Easter Monday, April 18, he wrote to Duret: "I am very embarrassed to tell you why I'm postponing my trip to London. I've just seen Wistler [James Abbott McNeill Whistler], he was very charming, he came to have lunch with me in Chatou and I am really very happy to have spent some moments with that great artist.... I'm having lunch with him tomorrow and I will ask him to explain to you the thousand reasons that make me delay my trip, perhaps until next year. I am struggling with blossoming trees, with women and children and I don't want to see anything beyond that. Still at every moment I have some regrets. I think of the trouble I have given you for nothing, and I wonder if you will easily swallow my womanish caprices, and still through all this I always glimpse those pretty English girls. What a pity always to be hesitant, but that is my basic nature and as I get older I'm afraid I won't be able to change. The weather is very good and I have models: that's my only excuse."[8]

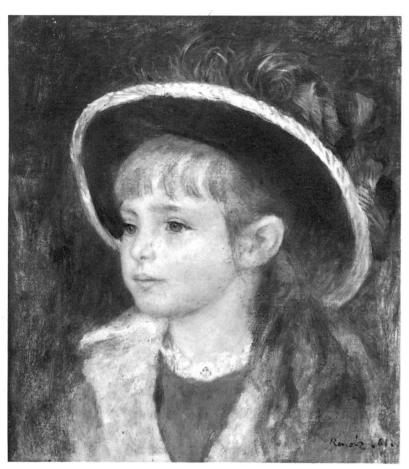

Jeanne Henryot. d. 1881. 15¾ x 13¾". Private collection

Alfred Bérard and His Dog. d. 1881. 25½ x 20". Philadelphia Museum of Art.
The Tyson Collection

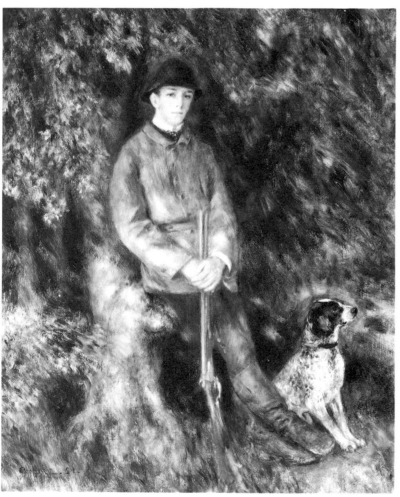

Renoir most likely deferred his trip to complete his large painting *Luncheon of the Boating Party* (pp. 110–11), on which he worked from mid-April through mid-July. He had begun this ambitious work late in the summer of 1880, explaining to Bérard: "I'm at Chatou.... I'm doing a picture of boaters which I've been itching to do for a long time. I'm getting a little old and I didn't want to postpone this little party for which I wouldn't be able to meet the expenses later on, it's already very hard. I don't know if I will finish it, but I told my misfortunes to Deudon, who agreed with me [that] even if the enormous expenses wouldn't let me finish my painting, it's still progress; one must from time to time try things beyond one's strength."[9]

Luncheon of the Boating Party is set on the terrace of the suburban Restaurant Fournaise on the island of Chatou in the Seine. Here Renoir's friends and models are enjoying themselves after a meal. At the lower left, Aline cuddles a dog. Behind her, Père Alphonse Fournaise, owner of the restaurant, looks toward his two grown children: Alphonsine, who leans on the balcony and listens to the Baron Raoul Barbier, and farther back, Alphonse Fournaise, Jr., who talks to the top-hatted Ephrussi. In the foreground, Caillebotte straddles a chair as he looks at Aline. The actress Ellen Andrée sits at his right; an Italian journalist, Maggiolo, leans over her. Behind them, at the right, Renoir's old friends Lhote (with a pince-nez) and Lestringuez (in a bowler hat) banter with Jeanne Samary. In the center, Angèle, model for the *Sleeping Girl with Cat*, drinks wine with a man seen in profile.

The Boating Party is a sequel to *Le Moulin de la Galette* of five years earlier. Both are paintings of contemporary urban sociability: gathering together people from the upper and lower classes, from the city and country. Renoir was modern and even revolutionary in portraying the democratic life that he lived. Although *Le Moulin* and *The Boating Party* are almost identical in size and format, the latter has fewer figures, and they are larger in scale, more tangible and individualized, and more separate from their setting. Through spatial telescoping here, he makes the foreground figures appear monumental in comparison with the more distant figures: Père Fournaise is much larger in scale than his daughter, who in turn is much larger than his son.

A pervasive blue tone unifies *Le Moulin de la Galette*, but diversity of hue is the striking characteristic of *The Boating Party*: richly saturated, adjacent complementaries in which reflected colors of myriad hues flicker. The dramatic color contrasts between large areas enhance the clarity of individual figures and details, and add to the solidity of the form and the structure of the composition. The distinct hues of individual strokes express the vitality and sensuality of the theme.

Around the same time that he finished *The Boating Party*, Renoir completed two other magnificent canvases, *On the Terrace* (p. 104) and *Flowers and Cats* (p. 113), which share *The Boating Party*'s intense color and subtle distortions of space and scale. According to Durand-Ruel's records, he purchased *The Boating Party, On the Terrace,* and a group of other paintings for a total payment to Renoir in 1881 of 16,000 francs—a considerable sum that suggests that Renoir's paintings were commanding good prices. This prosperity enabled him to carry out his travel plans.

Soon after he finished work on *The Boating Party*, Mme. Blanche invited Renoir to Dieppe in order to spend some time working with Jacques-Émile. Here Renoir painted the head of seven-year-old Jeanne Henryot, whose parents had a country house next door to the Blanches'.

Two letters from Mme. Blanche and Jacques-Émile to Dr. Blanche at this time shed light on Renoir's manners, habits, and his relationships

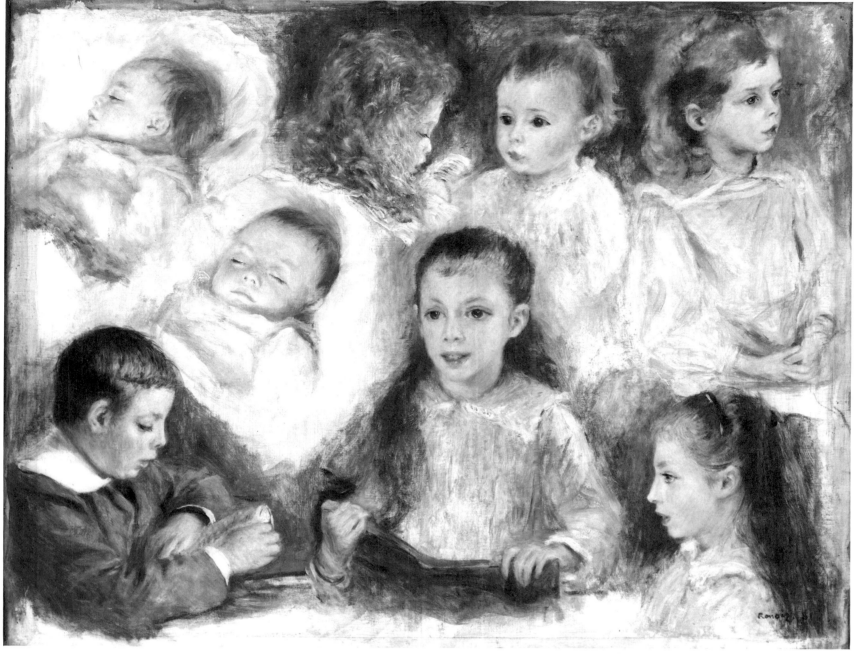

Study of the Bérard Children. d. 1881. 24½ x 32″.
The Sterling and Francine Clark Art Institute, Williamstown, Mass.

with certain upper-class people. Mme. Blanche wrote:

M. Renoir... is so crazy, in his painting, in his conversation, without any education, very *good*, but despising whatever is healthy; and I think [by having Renoir leave] I have done a great service to Jacques who is so clean, so careful with his studio; he [Renoir] needs pots of paint; he makes his canvases himself; he is not afraid of either rain or mud; he wants to do a large painting of naked children bathing and the sun shining on them; for that he wants it not to be too hot, and to be sunny, the children will want it not to be windy and not be cold, so that they can pose naked for two or three hours in the water; that would take him very far. If it were to become a habit, and if it were a matter of more than five or six days, I might have been led to violence, since all his tics at the table and his conversation at dinner have made just as disagreeable an impression on Nanny as on me. Don't forget that we have no male servant, and Dinah, even if our house were ready, would not at all care to serve men, to wash their dirty wet trousers and clean their shoes, caked to the tops with mud; because he is not a man to be stopped by the mud in our neighborhood, there is no reason for us to let our nice new rooms get soiled, with their fabric upholstery and mats underfoot.[10]

Jacques-Émile also detailed the situation:

Renoir came to see us yesterday. Mother had invited him, as you know, to come and work with me. Since we did not have a room ready, we were unable to put him up, and it's a good thing, as you'll see. Mother kept him for dinner. We were at the table for a little less than three quarters of an hour (usually it takes us fifteen or twenty minutes). Mother got so impatient that she said it would be impossible for her to have dinner with him. After having invited him, Mother told me the worst things about him. She says he is humorless, a dauber, slow in eating, and makes unbearable nervous movements. In short, Mother will do everything she can to disinvite him. And she finds it extraordinary that I love the solitude of this house!

... Renoir did an effect of sunset in ten minutes. That exasperated Mother, who told him that he was only "wasting paint"! Well, it's a good thing that this hit him, since he doesn't notice anything. As for me, I didn't say a word to Mother, I was so annoyed.[11]

After being told diplomatically that the Blanches had no room for him, Renoir went to stay for two months with the Bérards at nearby Wargemont. This aristocratic family treated him as an equal. He painted Paul's nineteen-year-old nephew Alfred about to go hunting. He also made a canvas with studies of Bérard's four children: thirteen-year-old

107

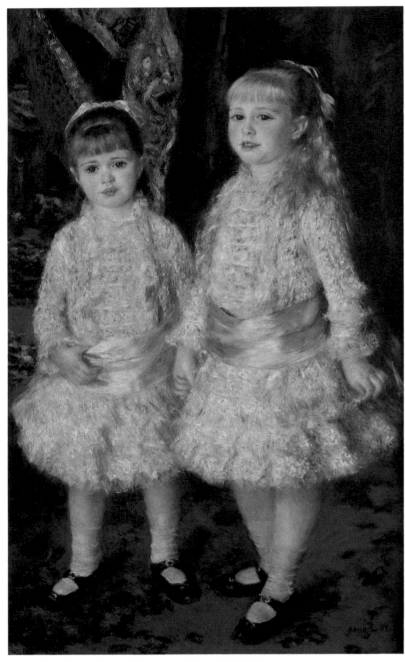

Pink and Blue: Alice and Élisabeth Cahen d'Anvers. d. 1881. 47 x 29″.
Museu de Arte de São Paulo

André at the left; eleven-year-old Marthe at lower right in profile and lower center full-face; seven-year-old Marguerite at the upper right and in quarter profile; and one-year-old Lucie, sleeping and awake. He completed another picture (signed: "Renoir, Wargemont, September 9, 81") of Albert Cahen d'Anvers, Louis's younger brother (p. 117). For this portrait, he was paid five months late and less than promised. He later wrote to Deudon: "As for the fifteen hundred francs from the Cahens, let me tell you that I find it hard to swallow. How stingy can you be? I definitely give up with Jews.... I'm not going to sue the Cahens."[12]

After completing the Cahen d'Anvers portrait, Renoir returned briefly to Paris en route to Italy.[13] Renoir wanted his friends to believe that he was traveling alone. He wrote to Deudon: "I think that the ugliest Parisian woman is still better looking than the most beautiful Italian."[14] And to Manet: "I am the only Frenchman."[15] None of the extant letters mentions Aline's presence, yet she accompanied him for at least part of the trip. In 1895, Julie Manet, daughter of Berthe Morisot and Eugène Manet, recorded in her diary: "Mme. Renoir was talking

about her trip to Italy after her wedding, it amuses us when we hear her telling all about it, since we have so often heard M. Renoir talking about it as though he had taken the trip all alone, when we didn't know his wife. She was 22 and very slim, she says, which is hard to believe."[16] Since the marriage did not take place until 1890, Aline was doubtless making her relationship with Renoir in Italy sound legitimate.[17]

From his letters and paintings, much of Renoir's trip to Venice, Rome, Naples, Calabria, Capri, and Palermo can be reconstructed. His five-by-eight-inch sketchbook is especially informative. He carried it with him not only on his initial trip to Algeria, but also on his subsequent trips to Italy and on his return to Algeria. Within it, thirty-one pencil drawings record his impressions of the scenery, buildings, and natives. These free sketches are embryonic ideas that he developed into landscape and figure paintings.

In his first letter from Italy to Bérard, written late in October, he states that he is staying where no one speaks French: "at a former *tenorini* singer's."[18] In a second letter to Bérard, he gives an unusually analytical description of his artistic quest:

to look for the sun, which I've found more or less.... I'm in love with the sun and with the reflections in the water, and to paint them I would go around the world. But when I'm at it, I realize my powerlessness.... Why look for the sun, since everything I do is not even a caricature of it.... [A museum] is nothing compared to nature, those great masters are dark and sad. Much as I may look for the light, I'll be dark like them, always dark. Sculptors are the lucky ones, their statues are in the sun and when they are of pure form, they are part of the light,

Algerian Girl. d. 1881. 20 x 15¾″. Museum of Fine Arts, Boston.
Juliana Cheney Edwards Collection.
Bequest of Hannah Marcy Edwards in memory of her mother

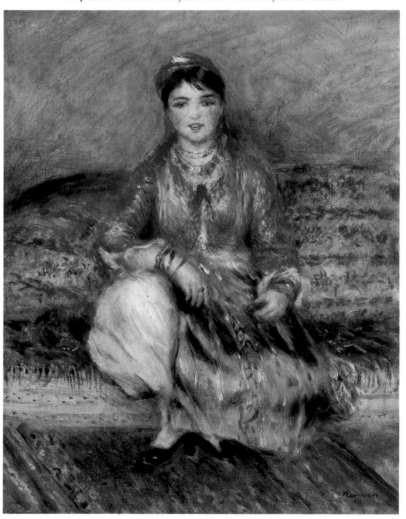

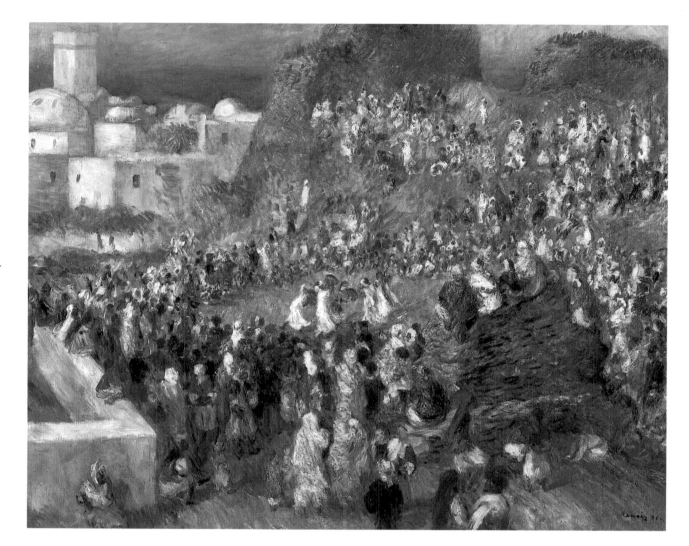

Muslim Festival at Algiers. d. 1881.
28¾ x 36⅝″. Musée d'Orsay,
Galerie du Jeu de Paume, Paris

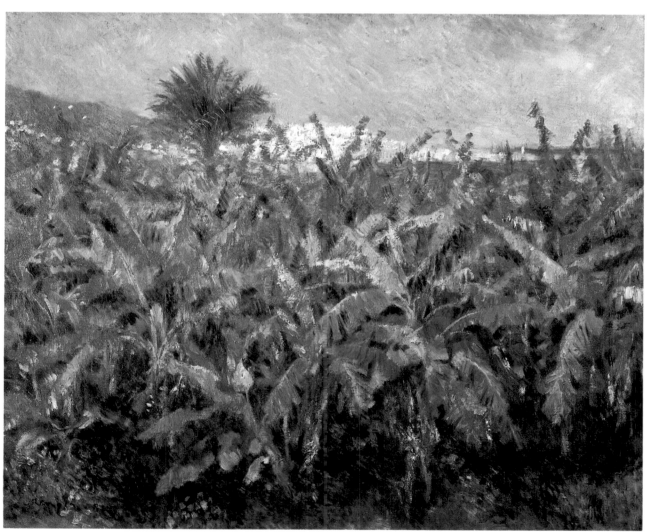

Banana Plantation. d. 1881.
19⅝ x 27⅞″. Musée d'Orsay,
Galerie du Jeu de Paume, Paris

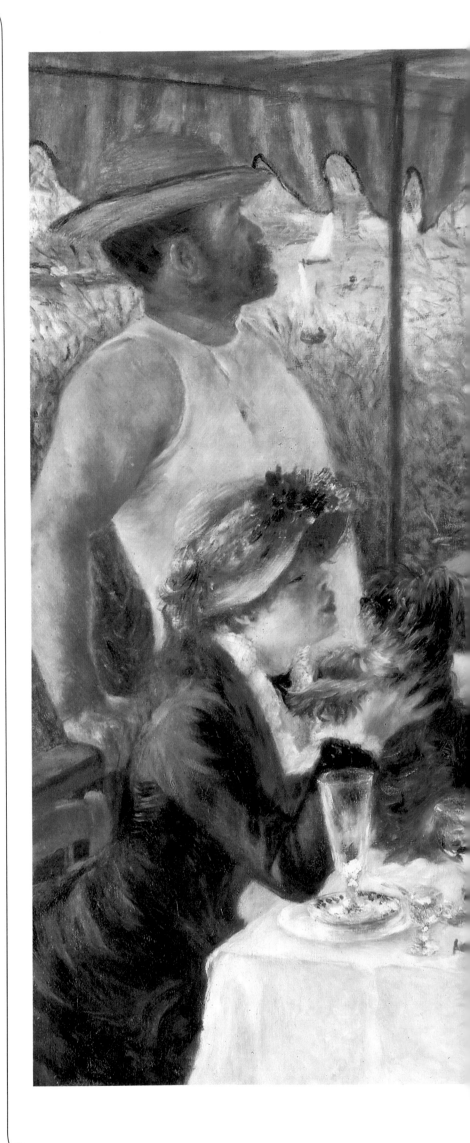

Luncheon of the Boating Party (The Boating Party). d. 1881. 51 x 68″.
The Phillips Collection, Washington, D.C.

Drawing of the Grand Canal, Venice, from Renoir's Travel Sketchbook. 1881.
Pencil on paper, 5 x 8″. Whereabouts unknown

Renoir seriously doubted that he would be impressed with the Raphaels in Rome, but after seeing them, he wrote to Durand-Ruel, to whom he felt increasingly close: "I went to see the Raphaels in Rome. They are very beautiful and I should have seen them earlier. They are full of knowledge and wisdom. He wasn't looking for impossible things like me. But they're beautiful. I prefer Ingres in oil paintings. But the frescoes are wonderful for simplicity and grandeur."[27]

In Raphael's frescoes, Renoir found what he was seeking: tangible form and pervasive light. For very much the same reasons, he was impressed with the Pompeian frescoes that he saw in Naples. Early in 1882, he explained to Mme. Charpentier what he learned from them: "I studied the museum in Naples a lot, the paintings from Pompeii are extremely interesting from all points of view, and so I stay in the sun, not to do portraits in broad daylight, but by warming up and doing a lot of looking, I will, I think, have gained that grandeur and simplicity of the ancient painters. Raphael, who didn't work outdoors, had nevertheless studied sunlight since his frescoes are full of it. Thus having seen the outdoors so much, I ended up seeing only the great harmonies without caring any more about small details that extinguish sunlight instead of making it blaze."[28]

Two years later, Renoir, still moved, wrote Deudon, himself then traveling near Naples: "Go see the museum in Naples. Not the oil paintings, but the frescoes. Spend your life there."[29]

While Renoir was not interested in the technique of fresco after his experiments with MacLean cement in 1877, he tried to duplicate in oils the permeating light that he found in the ancient wall paintings. From Naples, he described his efforts to Durand-Ruel: "I still have the experiment disease. I'm not pleased, and I rub out, I rub out again. I hope this mania will end. . . . I think I will have made some progress, which always happens after long experiments. One always goes back to his first loves, but with one note more. . . . I'm like the children in school. The white page should always be neatly written and bang! . . . a blot. I'm still at the age of blots . . . and I'm 40 years old."[30] Two days later, he was beginning to feel more optimistic when he again wrote his dealer: "I'm very pleased and I think I'm going to bring you back some pretty things. I'm back on my horse. It's going very well. I've started the figure of a girl with a child, if I don't scrape it off."[31]

He also told Bérard that he was immersed in artistic research: "I've tried everything, painting with turpentine, with wax, with dryers, etc., etc., all that to go back to my first way of painting. But from time to time I have one of these diseases that cost me a lot and bring me nothing." He concluded his letter by saying somewhat sarcastically that he hoped on his return to have made "progress enough to floor all the painters in Paris."[32] To Deudon he wrote: "Up until now I've spent my time searching. I don't dare tell you that I've found anything, since for about 20 years I've kept believing that I'd found art."[33]

His work was complicated by other problems. In Naples, as in North Africa, Renoir became dissatisfied with his models. First he wrote to Bérard brimming with optimism: "I get my landlord's daughters to pose, they're very pretty, the oldest looks exactly like Leonardo da

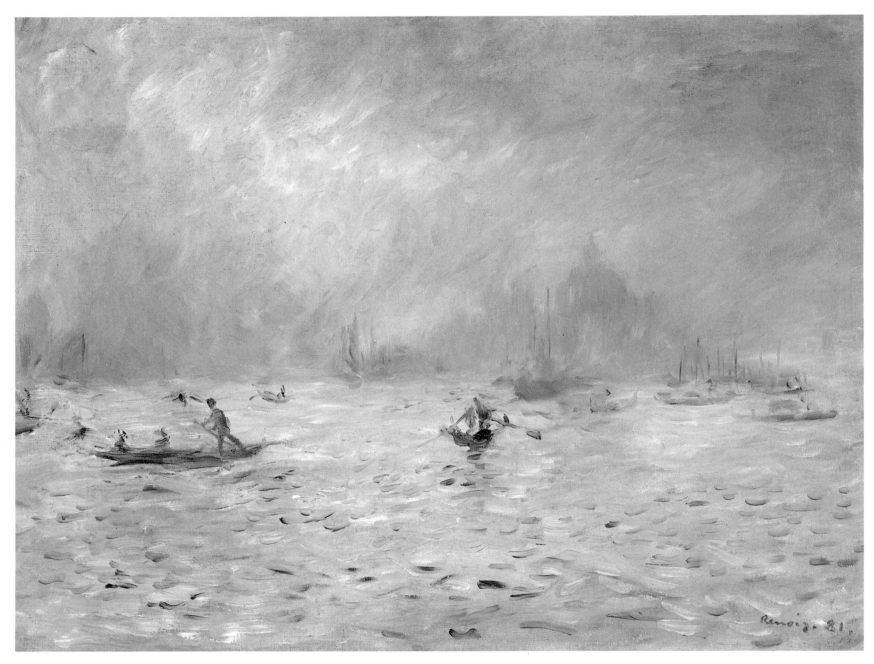

Venice—Fog. d. 1881. 17⅝ x 24¾″. Collection Mr. and Mrs. David Lloyd
Kreeger, Washington, D.C.

Vinci's Catherine."[34] Yet he soon became discouraged, as he com-
plained to Deudon: "I'm a little bored far from Montmartre and I'm
only continuing this series of trips so as not to start over. I'm dreaming
of the church tower [Sacré-Coeur].... I tried some figures, which
made me waste a lot of time. I have a bunch of models, but all of them,
once on the chair, a three-quarter pose, their hands on their knees, it's
disgusting!"[35]

Despite his doubts and difficulties, several paintings did result
from his stay in Naples in November and December 1881—*Mother and
Child; Blond Bather; Onions; Vesuvius, Morning;* and *Vesuvius, Eve-
ning.* These works clearly hark back to Raphael's and the Pompeian
frescoes. More than any of his previous paintings, they consist of solid
well-defined forms and luminous but pale color. They incorporate
qualities that Renoir admired in the Classical frescoes: "grandeur,"
"simplicity," and "great harmonies" that make the "sunlight...blaze."

In spite of his growing Classicism, Renoir was still an Impressionist
at heart. In Naples, he also experimented with using a careful parallel
stroke to create a shimmer of light and color on the surface of the can-
vas. Inspired by Monet, who had been doing series paintings (such as

Gare St.-Lazare) since 1877, he too tried such variations on a theme:
"I'm in the process of doing Vesuvius morning effect, Vesuvius evening
effect, and Vesuvius daytime effect."[36]

His letters about the Italian countryside are enthusiastic. After a
trip to Calabria, he wrote Deudon: "I've seen some marvelous things.
...If I ever travel again, I'll go back there. It is certainly the most
beautiful place I've seen."[37] He sent home some of his Italian paint-
ings to his Paris studio and others to Durand-Ruel to whom he wrote in
February 1882: "I have the paintings of Italy at my place, but they are
all more or less in need of retouching, and we'll see that together on
my return. Because I want to sell them to you for a very high price.
These studies have cost me an arm and a leg.... I will return to good
sense for the paintings I'll do in Paris, I'm increasing my prices only
for this series, which, I repeat, has cost me a lot of money and ef-
fort."[38]

On December 26, Renoir visited the island of Capri and expressed
his Impressionist sensibility to Bérard: "Capri is a charming island,
very tiny and everything you need to paint, grottoes of all colors, im-
possible to paint by the way."[39] He continued: the water of the Blue

116

Grotto has an "extraordinary transparency and a blue that we don't have in the palette....There is also the Emerald Green Grotto....A magnificent countryside, full of olive and orange and lemon trees, masses of wild flowers along rocks that are superb in color. Whether I succeed in expressing some part of it, you'll see perhaps, if the wind stops blowing."[40]

Two days later, still at Capri, Renoir wrote to two old friends. To Chocquet: "I am writing to you from an ideal little island where one lives outdoors in the sunlight, surrounded by the blue sea and orange trees, olive trees, and flowers."[41] As he often did when writing to Chocquet, Renoir added, "Give a handshake to Cézanne when you see him."[42] On the same day, Renoir wrote to Édouard Manet, who was awaiting official confirmation of his nomination as *chevalier* of the Legion of Honor: "I just happened to run across an old *Petit Journal*, which reports with transports of delight the purchase of some paintings by the master Courbet, which made me extremely happy; not for Courbet, that poor old man who [having died in 1877] cannot enjoy his triumph, but for French art.... I was expecting...you to be appointed *chevalier* [that came on December 30, 1881], which would have made

RIGHT, ABOVE:
Albert Cahen d'Anvers. d. 1881. 31⅞ x 25⅝". Private collection, Paris

RIGHT, BELOW:
Venetian Woman. d. 1881. 13¾ x 10½". Private collection

Drawing of a Venetian Woman from Renoir's Travel Sketchbook. 1881. Pencil on paper, 6¼ x 4½". Whereabouts unknown

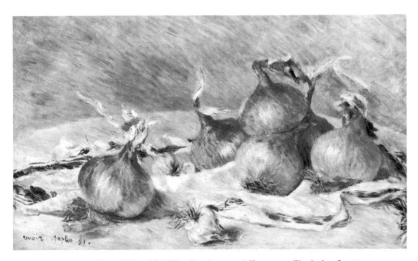

Onions. d. 1881. 15½ x 24″. The Sterling and Francine Clark Art Institute, Williamstown, Mass.

me applaud from my faraway island. But I hope it is only postponed, and that when I enter the capital, I will have to greet you as the officially recognized painter loved by all."[43]

In mid-January 1882, Renoir went to Palermo to paint Wagner's portrait. A Wagner enthusiast since the 1860s, he was nervous about meeting the much-lauded composer. In a long letter to an unidentified friend, he described his adventure:

January 14, 1882[44]

My dear friend,

I am very worried about my letter, because after sealing it, I weighed it, uncertain whether to put two stamps. But since I mailed several letters at the same time, I may have put it in another one. Where the hell did it go? Fortunately I have a torn draft of it, so I'm going to try to recopy it as it is, without even asking your indulgence. You know very well that I can't write. That's it, phew!

After having resisted my brother for a long time, he sends me a letter of introduction to Naples, from M. de Brayer. I don't read the letter and above all I don't look at the signature, and there I am on the boat with the prospect of being seasick for at least fifteen hours. It occurs to me to look in my pockets, no letter, I probably forgot it at my hotel, I go through everything on that boat, impossible to lay my hand on it, you see my predicament when I get to Palermo. I find the city sad and I wonder whether I shouldn't take the boat back in the evening. Finally I walk sadly to an omnibus on which is written: Hôtel de France. I go to the post office to find out where Wagner is staying; nobody speaks French and nobody knows who Wagner is, but at my hotel, where there are some Germans, I finally learn that he is at the Hôtel des Palmes. I take a carriage and go to visit Monreale where there are fine mosaics, and on the way I abandon myself to a lot of sad thoughts. Before leaving, I send a cable to Naples, without any hope by the way, and I wait; not seeing anything coming, I decide to introduce myself alone, and so there I am, writing a letter in which I ask to pay my respects to the master, my letter ended more or less like this: I will be happy to take news of you back to Paris, especially to M. Lascoux, to Mme. Mendès, I can't put to M. de Brayer, because I hadn't looked at the signature on my letter of introduction. Here I am at the Hôtel des Palmes; a servant takes my letter, comes back down after a few minutes, telling me in Italian: Non salue [*sic*] il maestro, and he walks away. Next day I receive my letter from Naples, and I present myself again to that same servant, who this time takes my letter from me with obvious scorn. I wait under the carriage entrance, hiding myself as much as possible, not in the mood to be received, because I only brought myself to this second attempt in order to prove to this family that I hadn't come to beg them for 40 sous.

Finally along comes a blond young man whom I take for an Englishman, but he's a Russian and his name is Joukovski. He ends up finding me in my corner and takes me into a little room. He says he knows my work very well, that Mme. Wagner is very sorry not to be able to receive me now, and he asks me if I could stay one more day in Palermo, because Wagner is putting the final notes to Parsifal and he is in a state of illness and nerves, and no longer eats, and so on.

118

I beg him to give my apologies to Mme. Wagner, but I ask only one thing, and that's to leave. We spend some time together and I tell him the purpose of my visit. I see by his smile that it's a failure, then he confesses to me that he is a painter, that he too would like to do a portrait of the master and that for two years he has been following him everywhere in order to fulfill this desire, but he advises me to stay, saying: what he denies me he may grant to you, and anyway you can't go away without seeing Wagner. This Russian man is charming, he ends up consoling me and we make an appointment for the next day at two o'clock. Next day I meet him at the telegraph office. He tells me that yesterday, February [*sic*] 13, Wagner completed his opera, that he is very tired and that I shouldn't come before five o'clock, that he will be there so that I won't be so ill at ease, I accept enthusiastically and go away happy. I'm there at five o'clock sharp, and I run into my servant who greets me with a deep bow, asks me to follow him, and he takes me through a little greenhouse, then into a small adjoining sitting room, sits me down in a huge armchair, and with a gracious smile asks me to wait a moment. I see Mlle. Wagner and a small young man who must be a little Wagner, but no Russian. Mlle. Wagner tells me that her mother is not there, but that her father is coming, and then she takes off. I hear a sound of footsteps muffled by thick carpets. It's the master, in his velvet dressing gown, the wide sleeves lined with black satin. He is very handsome and very courteous, and he shakes my hand, urges me to sit down again, and then the most absurd conversation begins, strewn with uhs and ohs, half French, half German with guttural endings.

I am very gontent. Ach! Oh! and a guttural sound, you are coming from Paris.

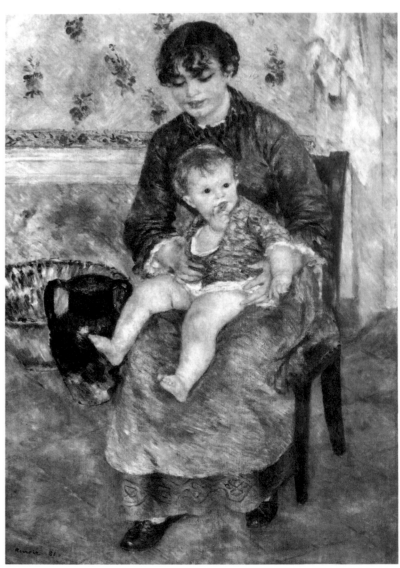

Mother and Child. d. 1881. 47½ x 33½″. The Barnes Collection, Merion Station, Pa.

OPPOSITE:
Blond Bather (first version). d. 1881. 32⅛ x 26″.
The Sterling and Francine Clark Art Institute, Williamstown, Mass.

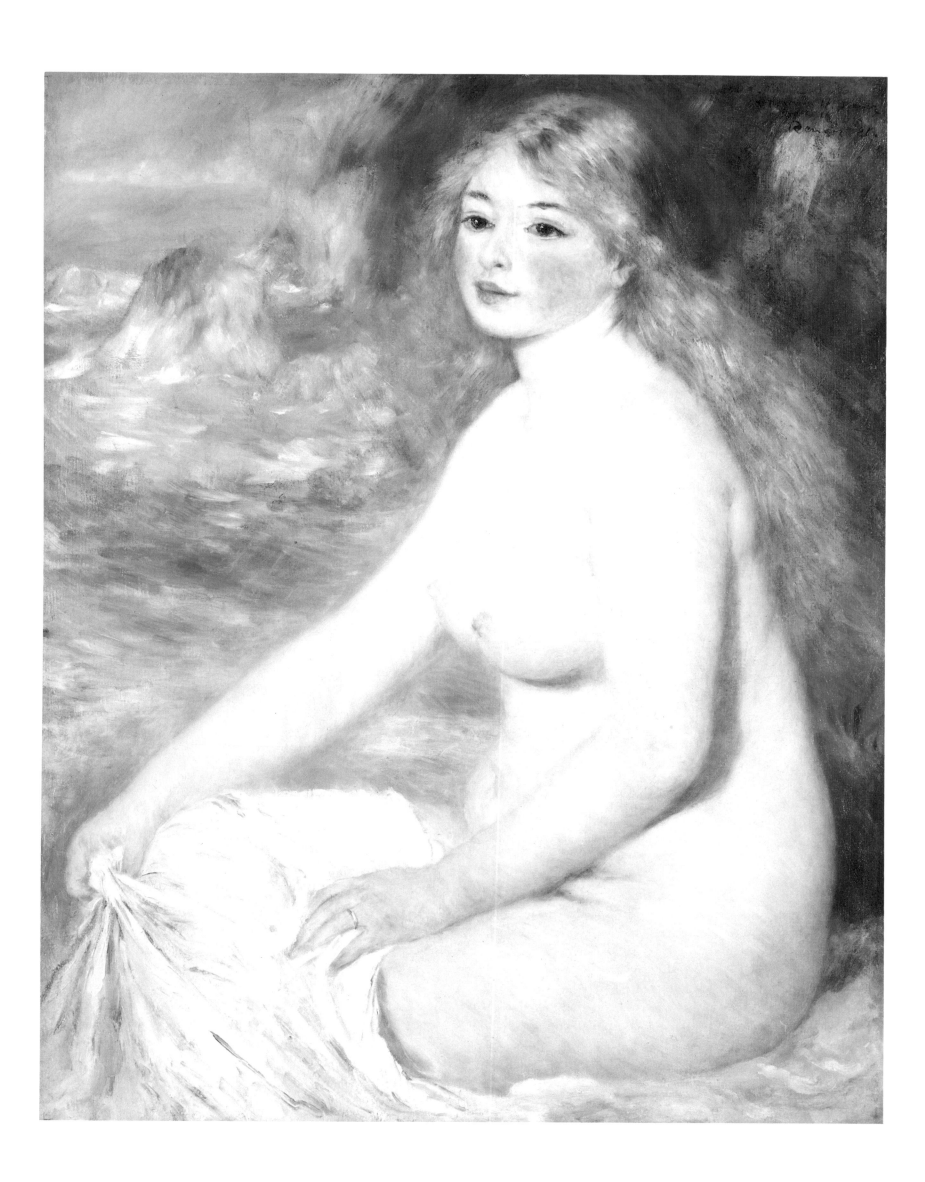

No, I am coming from Naples, and I tell him about losing my letter, which makes him laugh a lot. We talk about everything. When I say we, I only kept repeating: My dear master, of course, my dear master, and I would get up to leave, and then he would take my hands and put me back in my armchair. Vait a little more, my vife vill be coming, and that goot Lascoux, chow is he? I tell him that I haven't seen him, that I have been in Italy for a long time and he doesn't even know I'm here. Ach! Oh! and a guttural sound in German. We talk about Tannhäuser at the Opéra, in short it goes on for at least three-quarters of an hour, and meanwhile I keep looking to see if the Russian has arrived. Finally he comes in with Mme. Wagner, who asks me if I know M. de Brayer well. I raise my head. M. de Brayer, heavens no, madame, not at all, is he a musician? So then he is not the one who gave you this letter.

Oh, de Brayé, yes, very well, excuse me, we do not pronounce it the same, and I apologize, blushing. But I make up for it with Lascoux, I imitated his voice to show her that I knew him, then she told me to give their regards to their friends when I got back to Paris, and especially to Lascoux, she insisted on it; she repeated it again when I left. We talked about the Impressionists of music. How many foolish things I must have said! I ended up roasting, being completely giddy and red as a rooster. In short, the timid man who plunges in, and goes too far, and yet I know that he was very pleased with me, I don't know why. He detests the German Jews, and among others [the critic Albert] Wolff. He asked me whether we still like Les Diamants de la Couronne in France. I panned Meyerbeer.[45] In the end I had time enough to say all the silly things you can imagine. Then all of a sudden he said to M. Joukovski, if I'm feeling all right at noon, I may let you have a sitting until lunch, you know you'll have to be understanding, but I will do what I can, if it doesn't last very long it won't be my fault. M. Renoir, please ask M. Joukovski if it's all right with him if you do me too, if that doesn't bother him. Joukovski says: But, my dear master, I was just about to ask you, etc., etc. . . . How would you like to do it? I say, full face. He says to me, that's fine, I want to do your back, because I have a composition all ready. Then Wagner says to him, you will do me turning my back on France and M. Renoir will do me from the other side. Ach! Ach! Oh! . . .

Next day I was there at noon, you know the rest. He was very cheerful, but [I was] very nervous and sorry not to be Ingres. In short, I think my time was well spent, 35 minutes, which is not much, but if I had stopped sooner, it would have been excellent, because my model ended by losing a little of his cheerfulness and getting stiff. I followed these changes too much, anyway you'll see.

At the end Wagner asked to look, and he said Ach! Ach! I look like a Protestant minister—which is true. Anyway I was very glad not to have failed too badly: there is a little souvenir of that splendid head.

Best.

RENOIR

I'm not rereading my letter, I would tear it up again and it would be the fifteenth. If there are things I forgot, I will tell them to you.

He repeated several times that the French read the art critics too much. The art critics, Ach! Ach! and a big laugh. The German Jews! but, M. Renoir, I know that in France there are good guys whom I do not confuse with the German Jews. Unfortunately I'm unable to convey the openness and gaiety of this whole conversation of the master's.[46]

Renoir shipped the portrait of Wagner directly to the Charpentiers with the note, "If the portrait that I did for you of Wagner will do, and if you should wish to add a word of explanation to it, you can write that this portrait was done in Palermo on January 15, 1882, the day after Wagner finished Parsifal."[47] When Wagner died the following year, Renoir made a drawing after his painting for La Vie Moderne.

Back in Naples on January 17, Renoir asked a favor of Durand-Ruel: "Would you be kind enough to send me by return mail the sum of 300 to 500 francs, general delivery, Marseilles. I'm not sure I have enough to return to Paris. I'm bringing you back a grateful that I will show you when I arrive."[48]

In Marseilles, seemingly without prearrangement, Renoir sought out Cézanne, who often worked at L'Éstaque. On January 23, from the

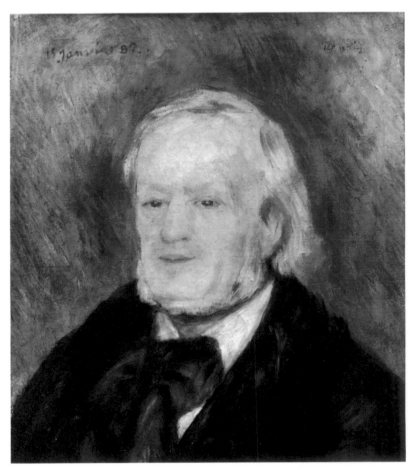

Richard Wagner. d. 1882. 17½ x 15¼". Musée d'Orsay, Galerie du Jeu de Paume, Paris. Gift of Alfred Cortot

Hôtel des Bains in L'Éstaque, he advised Durand-Ruel: "I'm staying here for another two weeks. . . . I've met Cézanne and we're going to work together."[49] He painted several canvases, among them *Rocky Crags at L'Éstaque*. The latter, which may have been painted alongside Cézanne, seems to represent the area shown in Cézanne's painting *Ravine near L'Éstaque.*

While painting with Cézanne, Renoir fell ill. On February 14, he wrote to Durand-Ruel that he had been in bed for a week with "severe flu,"[50] and he later wrote to Deudon of "my pneumonia."[51] He suffered from complications for the next five months.

Late in February, still sick, he received a last-minute invitation from Caillebotte urging him to participate in an Impressionist group show that was scheduled to open two weeks later, on March 1. This was somewhat different from the situation the previous year, when the sixth Impressionist show was held. For the 1881 exhibition, the issue of Renoir's participation had been raised by Caillebotte. After having exhibited with the Impressionists in 1874, 1876, and 1877, Renoir had not joined in the group shows of 1879 and 1880. On January 24, 1881, Caillebotte had written to Pissarro proposing that these artists be invited: "Monet, Renoir, Sisley, Mlle. Morisot, Mlle. [Mary] Cassatt, Cézanne, Guillaumin, if you like [Paul] Gauguin, perhaps Cordey, and me. . . . Degas has caused dissension among us. . . . Since Sisley, Monet, and Renoir have some talent, he will never forgive them. . . . He almost has a persecution mania. Doesn't he want to make people believe that Renoir has Machiavellian ideas? Really, not only is he unfair, but also he is not generous."[52]

In his reply, Pissarro had defended Degas's position: "You know me well enough to be sure that I would like nothing better than to have Monet and Renoir with us, but what I find extremely unfair is that,

having left us in the lurch and not being concerned for a moment about exposing us to an unmitigated disaster, they now, having failed to succeed with the official establishment, want to come back on their own terms as if they were victors, when in all justice one ought to put up with fair punishment for sins committed."[53]

The next day Caillebotte had written back: "Will you allow me, however, to straighten out a few points? Renoir and Monet are not imposing any conditions, so far as I know. I am the only one to have spoken and only on my own, without being authorized or urged by anyone. Renoir and Monet, if you want to know, are completely unaware of what is going on."[54] Caillebotte's plan had been vetoed and in protest he had abstained from exhibiting in the sixth Impressionist show with Pissarro, Degas, and the others. Also missing from the 1881 show were Renoir, Monet, Sisley, and Cézanne, all of whom submitted works to the Salon that year. Whether or not Renoir was aware of the squabbles is unclear.

Now, a year later, besides Caillebotte, Durand-Ruel also pleaded with Renoir to participate. The dealer's motives were financial. On February 1, 1882, the Paris stock market crashed, and the major bank, the Union Générale, failed. The prime stockholder, Jules Feder, who had loaned Durand-Ruel money, was demanding repayment. For the next four or five years, Durand-Ruel's financial state was precarious. Throughout the economic crisis, the market for paintings flagged.

From his sickbed in L'Éstaque, Renoir fired a volley of increasingly emotional letters to his dealer. All adamantly declare his opposition to exhibiting with the Impressionist group—for which he had several reasons. By 1882, he had come to the painful realization that his one success at the Salon of 1879 was entirely due to his powerful benefactor Mme. Charpentier, who had maneuvered for a good position for her own portrait but had not been willing to help him in later Salons. The momentum of the 1879 triumph had lasted through 1881. But without a Salon success each year, Renoir concluded that he would soon be forgotten by the buying public. Beginning with the 1880 Salon, he had grudgingly resigned himself to submitting nothing but portraits; despite this tactic, he was unable to make any impact in the succeeding Salons. But he continued to submit there—which by the Impressionists' own rules barred him from exhibiting with them. Moreover, he felt that to show with the Impressionists might taint him as a revolutionary, hurting his reputation and lowering the prices of his paintings.

Yet because he needed Durand-Ruel's support, he was unable to refuse his pleas outright. The almost hysterical tone of his letters to Durand-Ruel in late February reveal how trapped and frightened he felt. On February 24, he wrote Durand-Ruel of his extreme reluctance to be drawn into a venture with the group.[55] Two days later he wrote:

This morning I sent you a telegram as follows: "The paintings of mine that you have are your property, I can't prevent you from disposing of them, but I won't be the one who will exhibit."... This way I will not be an "Indépendant" in spite of myself, unless I'm allowed to be so completely.... I am only defending our mutual interests, since I think that exhibiting there would make my canvases drop by 50%.[56]

Later that same day, Renoir wrote what Edmond (who had come to help his sick brother) labeled "first draft of the letter of February 26":

Unfortunately I have one goal in my life, and that is to increase the value of my canvases. The way I go about it may not be good, but I like it. For me to exhibit with Pissarro, Gauguin, and Guillaumin would be like exhibiting with any Socialist. The next thing you know Pissarro would invite the Russian Lavrof [the anarchist Pierre Lavroff] or some other revolutionary. The public doesn't like what smells of politics, and as for me, I don't want, at my age, to be a revolutionary. To exhibit with the Jew Pissarro means revolution.

Besides, these gentlemen know that I have taken a big step because of the Salon. What they are doing is hurrying to make me lose what I have earned. They don't stop at anything for that, even if it means dropping me once I've fallen down. I don't want that, I don't want that. Get rid of those people and present me with artists like Monet, Sisley, Morisot, etc. and I'm your man, for that's not politics, it's pure art.[57]

A day or two later, Renoir was still writing angrily:

I hope these gentlemen will give up that idiotic name "Indépendant." Please tell these gentlemen that I am not giving up the Salon. It is not a pleasure, but as I told you, this removes from me the revolutionary aspect, which scares me. I don't want to hold anything against anyone. It's a small weakness that I hope will be forgiven me. If I exhibit with Guillaumin, I might just as well exhibit with Carolus Duran [an eminent Salon portraitist]. I don't much see the difference, but the important thing is that I don't share your illusion. As far as I'm concerned, nobody knows anything about art, and only a medal can tip the scales. Delacroix used to say rightly that a painter ought to have all the honors at any price. The more decorations you have, the better known you are, and the less your painting is laughed at. The painting of an unknown or little-known man is lost forever because, I repeat, the public knows only a name and a decorated name. The painting of a well-known man is always rediscovered.[58]

In spite of Renoir's vehemence and anger, his wishes were ignored: the exhibition was called "Exposition des Artistes Indépendants" (Exhibition of Independent Artists); Guillaumin, Gauguin, and Pissarro participated; and Durand-Ruel chose to exhibit twenty-five Renoir paintings from his stock. Many of them were works from 1881: twelve genres, including *The Boating Party;* eight landscapes, including *Banana Plantation; On the Grand Canal, Venice;* and *Doges' Palace, Venice;* four still lifes, including *Flowers and Cats,* and one portrait (*Woman with Fan,* a portrait of Alphonsine Fournaise).

A few weeks later Renoir apologized to Durand-Ruel, "I wrote you at the height of my illness. I'm not sure I was very wise."[59] On March 2, the day after the show opened for a month at 251 rue St.-Honoré, he wrote to Chocquet from L'Éstaque: "I've just been sick and I'm convalescing. I can't tell you how kind Cézanne has been to me. He wanted to bring me his whole house. With his mother, we are having a big dinner at his place for our separation because he is going back to Paris while I have to stay somewhere in the South: strict doctor's orders.... I'll probably go back to Algiers for two weeks.... Cézanne... will tell you all my suffering about that exhibition."[60]

A short time later, convalescing in Algiers, Renoir read Albert Wolff's review in *Le Figaro:*

What is especially strange about the Indépendants is that they are just as set in their ways as the painters who do not belong to their brotherhood. When you've seen one painting by an Indépendant, you've seen them all; these works are signed with different names, but they look as if they come from the same factory. Renoir or Claude Monet, Sisley, Caillebotte, or Pissarro, it is all the same note, the same principle of art that has its *raison d'être,* with the same failed works that make the public laugh and sadden art critics; if they had applied themselves with conviction and humility in the presence of nature, all these men would have succeeded. In the midst of so many ridiculous canvases, each of them is showing two or three things that reveal much talent. In the midst of some abominable views of Venice, one discovers a charming portrait by M. Renoir; had he learned to draw, M. Renoir would have made a very pleasing canvas out of his *Boating Party.*[61]

Vesuvius, Morning.
d. 1881. 23 x 31¾".
The Sterling and Francine
Clark Art Institute,
Williamstown, Mass.

Vesuvius, Evening
(also called *Bay of Naples*).
d. 1881. 23½ x 32".
The Metropolitan
Museum of Art, New York.
Bequest of
Julia W. Emmons

Rocky Crags at L'Éstaque.
d. 1882. 26⅛ x 31⅞".
Museum of Fine Arts,
Boston. Juliana Cheney
Edwards Collection.
Bequest of Hannah
Marcy Edwards in
memory of her mother

Renoir's reaction to Wolff's mellower than usual column was expressed in two letters. To Durand-Ruel: "I'm very glad I didn't send you my last batch, since you would have included it in the exhibition, and from Wolf's [sic] article, which is exactly the common bourgeois idea, I see that my painting must only be shown after being bottled for at least a year. In 3 or 4 years, Wolf will find my views of Venice very beautiful, but—what can you do—when one is accustomed to judge a painting that must look good [after] only three months, one is not in a position to see very clearly."[62]

And to Bérard: "I've read Wolf's [sic] article. Great! I'm going to write to him and load him with compliments. Painters are bores with their exhibitions. It's absolutely true.... I am watching Wolf. He finds my views of Venice bad. In 5 years he'll write an article especially about them and load them with compliments. An example to be followed."[63]

Friends of Renoir's wrote other absent members of his circle to give their opinion of Renoir's works. Eugène Manet's feeling was that "Renoir's painting of boaters looks very good. The views of Venice awful and real knitted goods. A landscape with palm trees very successful. Two very pretty female figures."[64] Pissarro showed special interest

Paul Cézanne. *Ravine near L'Éstaque.* c. 1879–82. 28¾ x 21¼". The Museum of
Fine Arts, Houston. John A. and Audrey Jones Beck Collection

123

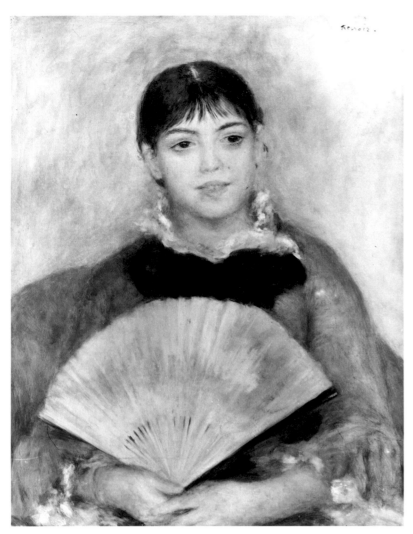

Woman with Fan. 1881. 25½ x 19¾". The Hermitage, Leningrad

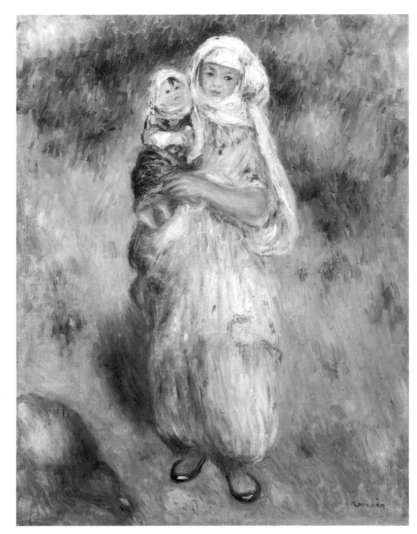

Algerian Woman and Child. 1882. 16 x 12½". Collection Samir Traboulsi, Paris

to De Bellio: Renoir "is admirably represented [by] portraits of children, girls, his boaters, some studies of Algiers, etc.; all this looks strange, full of pigment."[65] But without knowing of his friends' enthusiasm, Renoir wrote bitterly to Bérard early in April after the Indépendants' show had closed: "I have received a letter from Caillebotte. We won't make our expenses. I had foreseen it. The rue St.-Honoré is a second-rate neighborhood now."[66]

This was the last Impressionist show in which Renoir participated. He did not join in the next, and last, exhibition, in 1886.

Earlier in L'Éstaque, Renoir and Cézanne had planned their submissions to the 1882 Salon. Cézanne, who had been rejected consistently, at last had a portrait accepted. Ill and off the scene, Renoir wrote three letters to Bérard vacillating over a decision: "I will entrust my shipments to the Salon to you. . . . I intend to exhibit the little Yvone [sic] Grimprel [1880] and either your portrait [1880] or whatever you have that you like. I think your portrait is the one I prefer. It would make a nice contrast with the little Grimprel."[67]

A few days later: "I like your portrait. . . . If you're too much against it, send André [one of the two portraits of André Bérard, 1879]. . . . Whatever I exhibit at the Salon will be bad. But since I don't give a damn, if it's a flop, we'll have a good laugh together. . . . My dear friend, I have an idea, why not show Mme. Bérard [1879]. . . . Above all, no views, only portraits."[68] In still another letter: "I must have bored you with my shipment, but I want to talk to you more about it if there's still time. . . . Your portrait still needs to be bottled for a year. Don't take my advice and listen to Ephrussey [sic], that Jew. Super-bourgeois, he has

the right eye for what is called the (beauty) Salon. . . . One flop more or less, I don't care."[69]

The second portrait Bérard sent to the 1882 Salon has not been identified; only the 1880 portrait of Yvonne Grimprel was accepted. As Renoir feared, his reputation was sliding downhill. His predictions of February that exhibiting with the Impressionists would hurt his reputation proved to be true—or at least it did him no good. The art market was depressed, and his financial situation and reputation sank to a low point comparable to that of the early and mid-1870s; he had lost the popularity he had enjoyed from 1879 through 1881, and his work was ignored by the buying public.

Renoir had to remain in Algiers for two months (March 5 through May 3) because of his slow and uncertain recovery from his devastating pneumonia. Several letters to Bérard chronicle the fluctuating course of his illness. On March 14: "I saw the doctor this morning, and he took away all my medicines. I'm very well, but still my legs are not so good. I must stay in Algiers another month, says . . . the doctor. Little by little I must get out of the habit of flannel underclothing. He claims that it blocks the pores of the skin. . . . I've stopped smoking, but I eat enough for four."[70] Early in April: "I still don't feel well. I have a constant fever that I can't get rid of. . . . I can't get down to work. I'm taking some pills that are supposed to rid me of this nuisance in three days. We'll see. . . . I hope to write you soon that I'm feeling better. But it's unbearable. As soon as one thing is cured, another starts again."[71] Later in April, his fever disappeared. Renoir wondered if it was the

result of his pills or of the "cyroco" (sirocco, the hot wind).[72]

He was as eager to do figure paintings as he had been during his first Algerian visit. In late March he wrote to his dealer:

Here I am, more or less settled in Algiers and dickering with some Arabs to find models. Which is not easy, since it's a question of who will cheat the most. But I hope that this time I will manage to bring you back some figures, which I couldn't do on my last trip. I've seen some incredibly picturesque children. Will I get them? I'll do whatever is needed for it. I've also seen some pretty women. But I'll tell you later whether I've succeeded. I still need a few days before starting work. I'm taking advantage of them to look around, because as soon as I'm in shape, I want to do as much figure painting as I can and bring you back, if possible, some things that are not too ordinary.

... Models, even in Algiers, are getting more and more difficult to find. If you only knew how many bad painters there are here. It's insane, and especially some Englishmen who spoil the few available women. It's intolerable. Well, in spite of that, I hope to bring you back something.[73]

Renoir painted "pretty women," such as *Algerian Woman and Child,* and typical Arabs, such as *Old Arab Woman.*

He also began a portrait of Mlle. Fourcaud, whose father, Louis, was a writer for the *Gazette des Beaux-Arts, Le Figaro,* and *Le Gaulois.* In April, Renoir wrote Bérard: "I have some nice things to do, among others a pretty little ten-year-old girl. From Paris. We bought her a costume. She is ravishing.... This girl has to leave for Tunis in two weeks. That's something I wouldn't like to miss."[74] Delayed by his sickness, he finished the portrait in Paris in 1883.

Renoir was looking, too, for local color in his landscapes. He wrote Bérard: "I've seen ridiculous houses and superb landscapes."[75] A change to a more Classical style appears in two landscapes, *The Stairway, Algiers* and *Mosque at Algiers.* In both, the edges of the buildings are clearly defined, the solid character of the architecture is emphasized, and the composition balanced.

Early in May, Renoir returned to Paris after an absence of seven months. Unfortunately he continued to have problems related to his pneumonia, as he complained to Bérard in July: "Still getting the shivers, even in the middle of the day. I'm going to see Monot [the Bérard family doctor]."[76]

Again in financial difficulty and with a diminished reputation, Renoir was eager to obtain some portrait commissions. In June, when Casimir Stryenski, a professor at the University of Paris, inquired about having his child painted (possibly the child's head of 1882), Renoir replied: "Sir: I generally charge between 500 and... it depends on the difficulties. If this price seems too high to you, I will go see the child. If he does not pose too badly and if your hours can fit in with my schedule, I might give you a little discount. Would you be good enough to tell me when you would like to have this portrait done, should you so decide, since I must soon go away for a long period. I could then delay my trip for a few days. I plan to leave toward the end of the month."[77]

In mid-August, Renoir was again a house guest of the Bérards at Wargemont. He saw his former pupil Jacques-Émile Blanche, who wrote to his father on August 15:

At the moment I'm seeing a lot of Renoir, whom I like more and more. One is not aware of the vast qualities of that being, at first so boorish. M. Maître, whom I miss so much, writes me the following about him, which seems to me quite accurate:

"When Renoir is merry, which is seldom, and when he feels free, which is just as seldom, he speaks with plenty of life, a language full of the unexpected, which he has made up for himself and which is not displeasing to cultivated

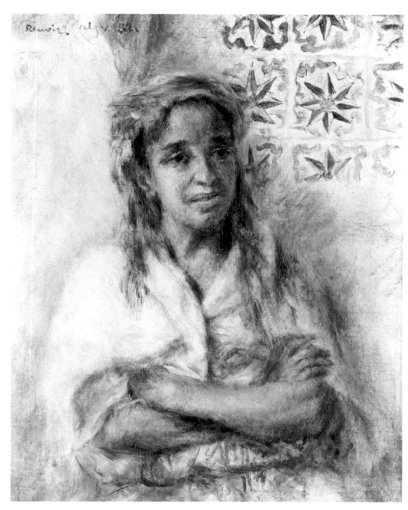

Old Arab Woman. d. 1882. 11¾ x 9½". Worcester Art Museum, Mass.

Mlle. Fourcaud Dressed as an Algerian. d. 1883. 14⅝ x 12⅝".
Courtesy the Lefevre Gallery, London

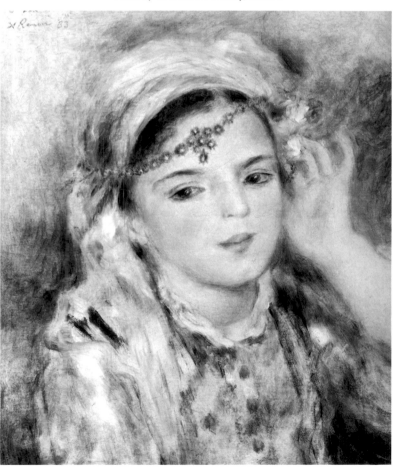

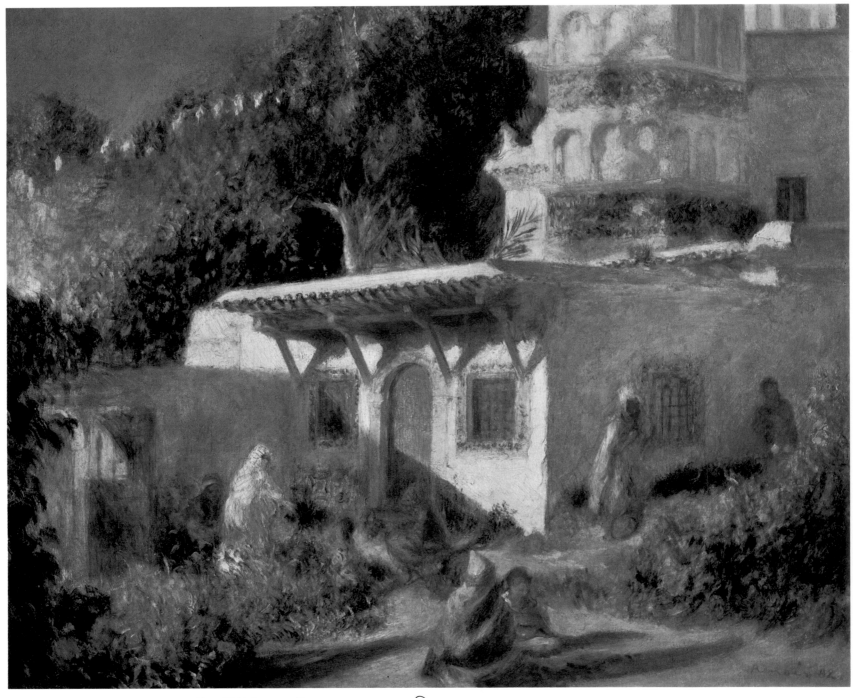

Mosque at Algiers. d. 1882. 19¼ x 23¼″. Private collection

people. And then there is in this being such great candor, such great kindness, that his conversation has always done me good. He is full of common sense, if you look at it closely, yes, common sense, and modesty, and in the most innocent and quiet way in the world, he produces without letup this diverse and refined *oeuvre,* which will make the heads of connoisseurs of the future spin."[78]

Later in the fall, Renoir wrote Bérard from Paris of a commission to paint the wife of a stockbroker and collector, Léon Clapisson: "I'm in the process of packing my canvases to do Mme. Clapisson's portrait. I say my canvases because I will work in the garden so as not to waste my time. This gentleman has just bought from Durand the little mosque [*Mosque at Algiers*], my little Kabyle servant, and the bust of a Negress [*Old Arab Woman*]; he wanted to buy the girl in Algerian dress [*Algerian Girl*], but Durand wasn't willing."[79] The Clapissons were not happy with their garden portrait, however. In a letter to Bérard, Renoir drew a pen sketch of the portrait and around it wrote: "This is the unfortunate portrait which isn't coming along well. Light

blue batiste dress with dark blue velvet collar and ribbons. . . . Small V-neck, trimmed with white lace. Foreground: beds of roses. (Small blue hat with a coq.)"[80]

In mid-September, Renoir was invited to Durand-Ruel's Dieppe château to paint the dealer's three sons and two daughters. These portraits continue to move away from realism toward a broader, more generalized treatment of form. A new sculptural and hard-edged quality, as well as a new stiffness of posture, appears in the bodies. Durand-Ruel also commissioned a second version of *Blond Bather* (which had been bought by Henri Vever, a jeweler and collector). *Blond Bather* (second version) is, like the Durand-Ruel portraits, more solid, linear, and sculptural than the 1881 version.

A few weeks later, when Bérard invited him for another visit to Wargemont, Renoir declined, with a lengthy explanation:

It's not going well for the moment. I must begin Mme. Clapisson's portrait all over again. It's a big flop. Durand, I believe, is not very pleased with his [por-

126

traits]. Well, all this takes a lot of thought, and with no exaggeration I must be careful if I don't want to slip in the public's esteem. You will understand that I can't get away at the moment. [My work on] my studio is not finished. If I go away, it will be the same when I get back.

I've been away a little too much. I must go back a little into my shell.

The day before yesterday I was packed to go and get some comfort at Vargemont [*sic*] and run away from Paris without telling anyone. I thought it over and I believe that I'm behaving more sensibly by not bringing you my bad mood and by not getting angry with anyone. Now I'm delighted with what is happening to me. I'm going to get back on the right path and I'm going to enlist in Bonnat's studio. In a year or two I'll be able to make 30,000,000,000,000 francs a year. Don't talk to me any more about portraits in the sunlight. Nice black backgrounds, that's the real thing. As soon as I have a minute, I'll come and copy the portrait [by Bonnat] of M. d'Haubersart [Comte d'Haubersart, Bérard's grandfather, who had died in 1868].[81]

In 1883 Renoir executed three of his most stunning paintings: *Country Dance, City Dance,* and *Dance at Bougival* (pp. 138–41). Just as he had painted Vesuvius morning, day, and evening in 1881, he now created a triptych of the romantic pleasures of young Parisians. *Dance at Bougival* is a summer scene of warmest color harmonies with a *petit-bourgeois* couple dancing while several of their friends enjoy themselves in the background. *Country Dance* depicts a springtime dance of warm color with a middle-class pair, separated from a smaller couple below them. *City Dance* depicts a winter dance of coolest color with upper-class figures alone in evening dress. (Suzanne Valadon and Lhote posed for the country and city scenes.)[82] Taken together, the three couples are in different stages of a dance and of a relationship, from a boisterous turn in Bougival with the man pursuing the woman, to a slower rhythm in Chatou with the woman flirting with a spectator

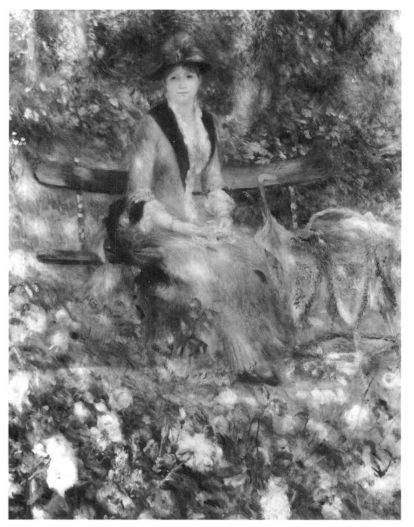

Among the Roses (Mme. Léon Clapisson). d. 1882. 39½ x 31⅞".
Private collection

Sketch for Among the Roses, from a letter to Paul Bérard, 1882

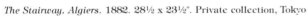
The Stairway, Algiers. 1882. 28½ x 23½". Private collection, Tokyo

(or with the artist), to an intimate relationship in Paris with the two partners oblivious to others.

Renoir may have intended to exhibit the three large dance panels together. The sequence in which he painted them can be surmised from the dates when they were first exhibited. *Country Dance* and *City Dance* were ready for the opening on April 1 of Renoir's one-man show at Durand-Ruel's in Paris. *Dance at Bougival* was first exhibited in

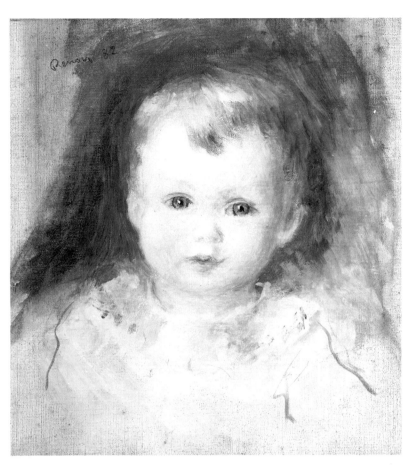

A Child. d. 1882. 10 x 9". Museen der Stadt St. Gallen, Switzerland

Charles and Georges Durand-Ruel. d. 1882. 25½ x 32". Private collection

light color and varied brushstrokes. Realist elements are the life-size figures and the anecdotal details of facial expression, hands, and dress. The bas-relief composition and solid monumental forms are Classical, as are the precise contours often reinforced by outline. In *Dance at Bougival* and *Country Dance* the scale and space are compressed and distorted to emphasize the expressive silhouette of the foreground couples, as in *The Boating Party.*

Joseph Durand-Ruel. d. 1882. 32 x 25¼". Private collection

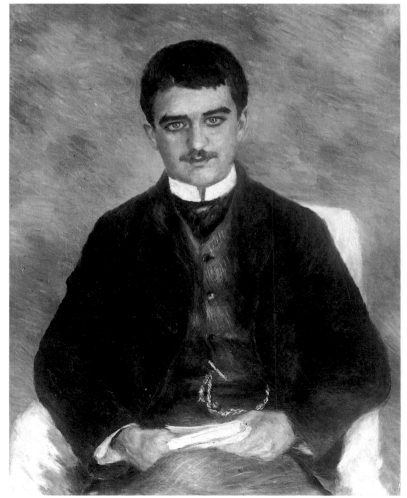

London on April 25, at an Impressionist show arranged by Durand-Ruel at the Dowdeswell Gallery, 133 New Bond Street. The *Dance at Bougival* arrived five days after the English show's opening. At this time, Messrs. Dowdeswell announced in the London *Standard* that the dance painting was "now to be seen among the other works by 'La Société des Impressionnistes.'"[83] Since nine other paintings by Renoir had arrived in England on time, it must be assumed that *Dance at Bougival* was completed at the last minute and somewhat after the two other dance panels.

Another painting probably executed around this time is *The Umbrellas.* First exhibited in New York in April 1886, it is variously dated between 1879 and 1886. A likely date is 1883 because of its similarity to the *Dance at Bougival.* In both, Aline modeled for the peasant woman and Lhote for the man who admires her. These four panels are Renoir's last paintings of men and women romantically socializing in a public urban setting. *The Umbrellas* is also a transitional work in which he seems to vacillate between Impressionism and a linearity that he was to develop increasingly in the mid-1880s, and that had come to the fore in the Durand-Ruel portraits and in the *Blond Bather* (second version).

The three dance panels and *The Umbrellas* are the tangible result of Renoir's research during his 1881 and 1882 travels. In them he achieved the solid yet luminous figures and the "simplicity" and "grandeur" of the Raphael and Pompeian frescoes. The dance panels have fewer and larger-scale figures, which have more sculptural form and more clearly defined contours.

These large panels integrate features from each style in which Renoir had worked. His careful preparatory work for the panels was a traditional procedure. The themes are Impressionist, as are the vivid

Early in 1883, Renoir wrote Bérard: "I've started the portrait, second edition, of *Mme. Clapisson* [p. 132] and I don't really see how it's going to turn out to look like her, I don't see anything in it any more. It will put me back in shape to start Lucie [*Child in White*, p. 132] as soon as you come."[84]

The second version of *Mme. Clapisson* is an elegant indoor portrait in which the sitter wears a chic low-cut gown. It shows the influence of Ingres and Bonnat. From Ingres Renoir had learned to place the figure close to the picture plane, to emphasize the outline of the body, and to attract attention by the passive, seductive sensuality of the face and body. Portraits by Bonnat, such as *Mrs. Francis Shaw*, seem to have led Renoir to stress the realistic presence of this wealthy woman.

Mme. Clapisson was his only work accepted at the 1883 spring Salon. Renoir was greatly disappointed by its reception. In the fall the artist John-Louis Brown wrote to Durand-Ruel, also his dealer: "Why does Renoir get discouraged? There is no reason for it, it seems to me. For my part, I would like to be in his shoes and have his baggage of art. If it is about the Salon, remind him that in spite of everything, the gentlemen of the jury (by their own admission) could not keep from exclaiming that his painting was a 'blond' Delacroix. What medal could equal this appreciation from enemies?"[85]

Luckily the Salon was not the only place where Renoir could display his work. In 1883, still trying to recover from financial disaster, Durand-Ruel very actively exhibited works by Renoir and other artists in Paris and abroad. In April, he gave Renoir his first one-man show at space rented at 9 boulevard de la Madeleine. (Durand-Ruel also gave one-man shows that year to Boudin, Monet, Pissarro, and Sisley.)

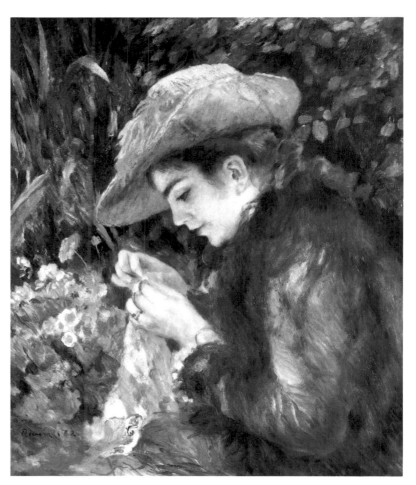

Mlle. Durand-Ruel Sewing. d. 1882. 25½ x 21″. The Sterling and Francine Clark Art Institute, Williamstown, Mass.

Marie-Thérèse and Jeanne Durand-Ruel. d. 1882. 32 x 25¾″. Chrysler Museum, Norfolk, Va. Gift of Walter P. Chrysler, Jr.

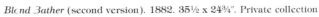

Blond Bather (second version). 1882. 35½ x 24¾″. Private collection

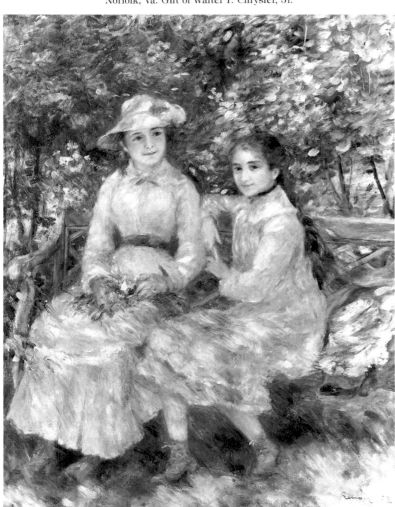

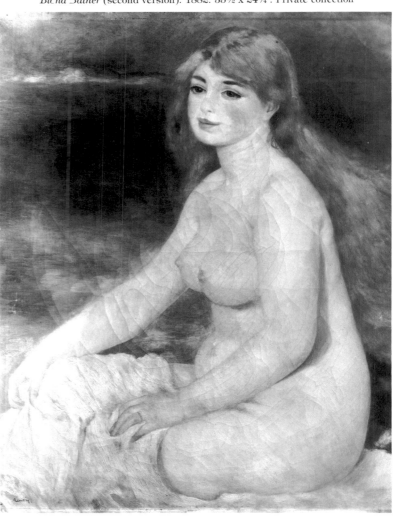

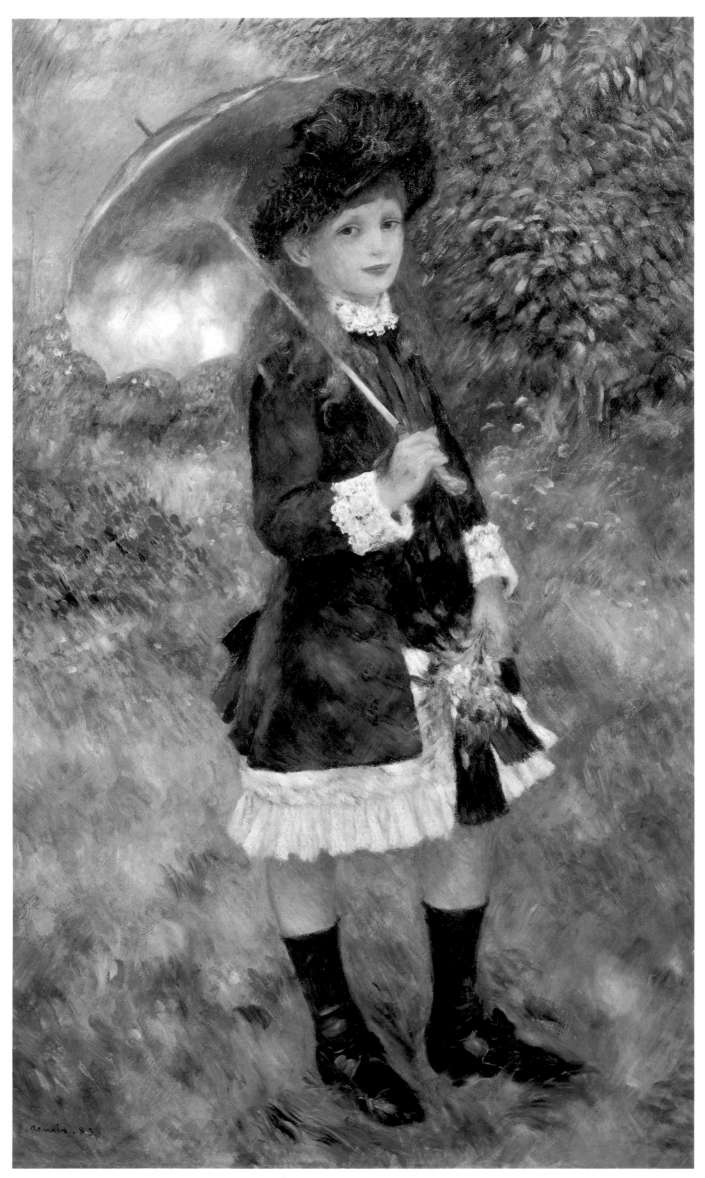

Girl with Parasol (Aline Nunès). d. 1883. 51¼ x 31½″. Private collection, Paris

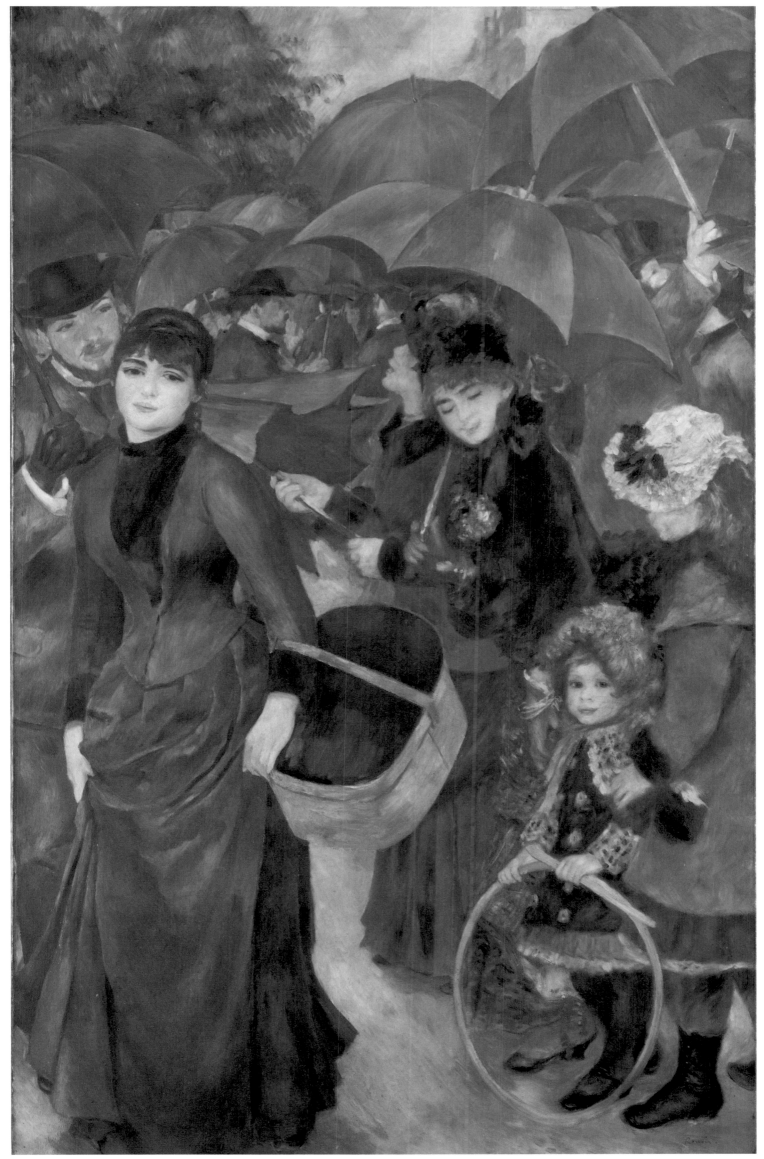

The Umbrellas. c. 1883. 71 x 45¼". The National Gallery, London

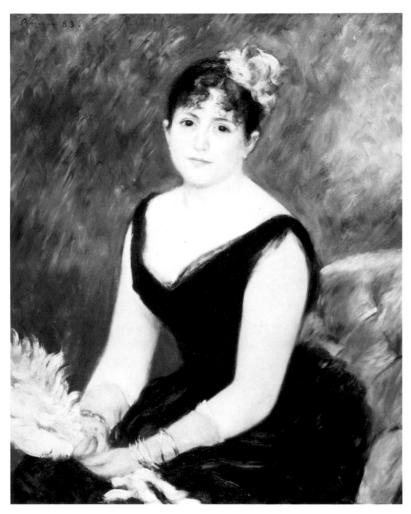

Mme. Clapisson. d. 1883. 31¼ x 25¼″. The Art Institute of Chicago.
Collection Mr. and Mrs. Martin A. Ryerson

RIGHT, BELOW:
Child in White (Lucie Bérard). d. 1883. 24¼ x 19¾″. The Art Institute of
Chicago. Collection Mr. and Mrs. Martin A. Ryerson

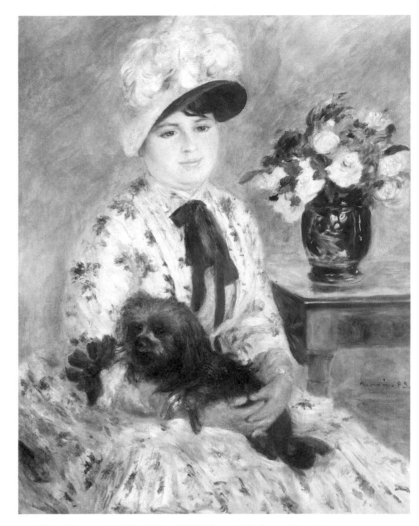

Mme. Hagen. d. 1883. 36¼ x 28¾″. National Gallery of Art, Washington, D.C.
Gift of Angelika Wertheim Frink

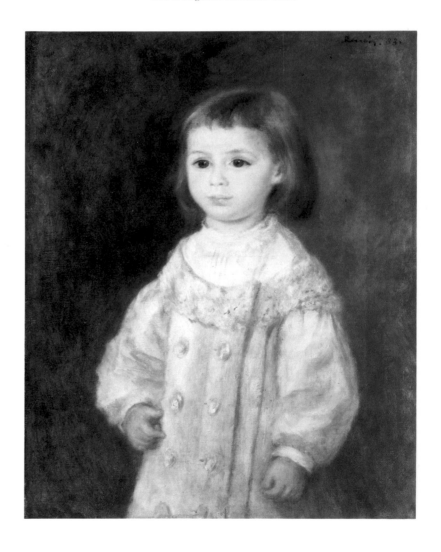

Renoir's exhibit contained seventy paintings from the decade 1874–
83: twenty-five portraits, twenty-one genres, thirteen landscapes, sev-
en still lifes, and four nudes. From his recent travels there were nine
Italian paintings, five from Algeria, and two from L'Éstaque. Among
his large pieces were *The Boating Party, Country Dance,* and *City
Dance.*

Most of the works were loans from his friends: Caillebotte—*Nude in
the Sunlight* (1875–76), *Woman Reading* (c. 1875–76, the Louvre), *Le
Moulin de la Galette* (1876), and *The Swing* (1876);[86] Murer—*Alfred
Sisley* (1874);[87] Cézanne—two L'Éstaque landscapes (1882),[88] and
other works from Durand-Ruel, Bérard, Clapisson, Ephrussi, Blanche,
Charpentier, Grimprel, and Deudon.

Duret wrote the preface to the catalogue:

[In Renoir] we recognize at first sight the ability to paint woman in all her grace
and delicacy, which has led him to excel particularly in portraits. The artist has
fully displayed this gift of charm from the beginning, and it is in his ability as a
painter and colorist that we must observe his progress and development. We
see him acquiring an increasingly broad and personal touch, imparting more
and more flexibility to his figures, surrounding them with more and more air,
bathing them in more and more light; we see him constantly accentuating his
coloring and finally succeeding in effortlessly achieving the most daring combi-
nations of colors.[89]

As was his practice, Renoir read the critics carefully and wrote

132

Duret: "I'm sending you the two articles mentioning your preface, one by Silvestre in *La Vie Moderne* and one from the *Courrier de l'Art* [by Arthur-Auguste Dargenty, pseudonym of Mallebay du Cluseau d'Echerac], they are curious to see. There is a third one [by Gustave Geffroy in *La Justice*], which says a few words about our exhibition. I'm sending it to you too, it's amusing. I'm glad that a man like Silvestre, who is a poet, appreciates your preface at its true worth."[90]

This first one-man show did not help his reputation significantly—either with the critics or with the buying public. Pissarro summarized the situation when he lamented to his son Lucien: "Renoir is having a superb exhibition, a great artistic success, of course not critical or financial, since here one must not expect anything else."[91]

The ten Renoir paintings that Durand-Ruel sent to the Dowdeswell Gallery late in April did not sell. However, several favorable reviews appeared in the British press. Of *Dance at Bougival*, a critic for the London *Academy* wrote: "It tells perfectly and with real subtlety of understanding the story of its Bohemian scene. A true knowledge of this picture persuades one thoroughly of its painter's powers of keen observation and of frank and unfettered record."[92] Another article in the *Academy* stated: "Renoir is a man of talent, a man of acquirements, a serious artist, by no means a prey to the caprices of the moment."[93] A critic for the *Standard* referring to *On the Grand Canal, Venice*: "He is interested in landscape, he is interested in effects of Venice . . . but he is primarily a figure painter—that is, he is primarily occupied with human character, and with the movement of the form, and with the disposition and colour of the drapery."[94]

On April 30, Manet died at the age of fifty-one. The funeral on May 4 was attended by Renoir and many of those who, as Félix Fénéon wrote, "drew inspiration from Manet without copying him . . . in the sincere expression of modern life."[95] Beyond the subject matter of his art, Renoir felt a special kinship with Manet in their attitude toward success. As Pissarro described it: "Manet, great painter that he was, still had a failing; he was dying to be recognized by the Establishment, he believed in diplomas, he aspired to honors."[96]

In July, Renoir visited Caillebotte at Argenteuil, where he painted a portrait of his friend's mistress, Charlotte Hagen. The smooth face, the static posture, the emphasis on the edge of the form once more reflect the influence of Ingres.

On August 1, he wrote to Bérard from Paris: "I'm just back from Caillebotte's . . . where I had gone to get a taste of some good weather. But I don't know why going away is something painful, and the place Pigalle has charms of which I'm not yet tired. The truth is that I'm getting old and that quiet work indoors suits my advanced age."[97] Perhaps Renoir's thoughts on his own mortality were prompted by a discussion at Argenteuil about Caillebotte's will. Three months after Renoir's visit, Caillebotte made an addition to the 1876 document: "It is my express intention that Renoir never have the slightest trouble because of the money I lent him. I forgive him the entire debt and I remove him completely from any obligation to M. Legrand."[98]

On August 21, Renoir was in Yport, Normandy, painting portraits of Aline and Robert Nunès (pp. 130 and 143). He described himself to Bérard as "busy . . . with two brats who make me furious. I can't yet speak to you of success since I'm not the one who has to be satisfied. I hope it will work out. They are very nice people and not Jewish at all so far as I can see. There are a few too many parties, that's the weak point. . . . For at their place you spend the whole day at the table."[99]

In September, Durand-Ruel sent fifteen Impressionist paintings to a large "Foreign Exhibition" of about 200 other works at the Mechanics Building in Boston. Among the Renoirs were *Mussel Fishers at Berneval* (called "Fisherman's Children"), *At the Concert* (called "A Box at the Opera"), and *The Boating Party* (called "Boatman's Breakfast at Bougival"). Renoir's paintings were ignored.[100]

Although Durand-Ruel was aggressive in sending Impressionist works abroad (he also sent them to Rotterdam and Berlin), Monet and Renoir were adamantly opposed to another Paris group show. Pissarro reported their feelings to Lucien in late October: "The Parisians have had enough of it; let's lie low."[101]

There had been no sense of Impressionist solidarity since the 1877 group show, although Monet, Renoir, Pissarro, Caillebotte, and Sisley had remained friendly and saw each other occasionally. Basically each man was eager to evolve his art individually, but each still considered himself an Impressionist, striving to reproduce natural light through a bright palette and visible brushstrokes.

In 1883, the Impressionists resumed meeting as a group in monthly dinners at the Café Riche, Thursday evenings at seven. The regular diners included the five artists mentioned above, as well as Duret and De Bellio. The gatherings continued through 1893 except for some interruption in the late 1880s.

From early September through October 8, Renoir, along with Lhote and Aline, went to the islands of Jersey and Guernsey. The visit to Guernsey inspired at least eighteen paintings. On September 5, he wrote to Bérard:

We arrived in Jersey (for we're a group). There we visited the island like simple bourgeois folk since now I lack nothing but Switzerland before I wear out my socks. But the goal is Guernsey, and despite the magnificent sites that unfold before our dazzled eyes, we are waiting impatiently for the boat that is to take us to see the rock on which the great poet [Victor Hugo] groaned for eighteen years.

At last the whistle blows, and with calm and sunny weather we go around Jersey on our way to the desired goal. What a pretty little country! What pretty paths! superb rocks, beaches such as Robinson [Crusoe] must have had on his island, besides rumpsteak and ale at prices one can afford. Well, so far it's all very nice. All I have to do now is to take advantage of the magnificent weather we're having and bring you back some nice things so as to be forgiven for my unfaithfulness to beautiful Normandy.[102]

On September 27, still from Guernsey, Renoir wrote Durand-Ruel:

Here we bathe among the rocks that serve as cabins, since there is nothing else; there's no better sight than this mixture of women and men crowded together on these rocks. You would think you were in a landscape by Watteau rather than real life.

I will therefore have a source of real, graceful subjects of which I'll be able to make use. Ravishing bathing outfits; and as in Athens, women are not at all afraid of the proximity of men on the rocks nearby. There's nothing more amusing, while walking around on these rocks, than to come upon some girls getting ready to bathe, and who, although English, do not get particularly scared. In spite of the small quantity of things I'll be able to bring back, I hope to give you an idea of these charming landscapes.[103]

Children on the Seashore and *By the Seashore* (which portrays Aline sewing by the Guernsey cliffs) were painted on this beach. The latter calls to mind Ingres's *Mme. Rivière*, with her smooth face and expressive silhouette. However, while Ingres's painting is unified in style, in Renoir's work, there is a striking difference between the finished foreground and the indistinct landscape.

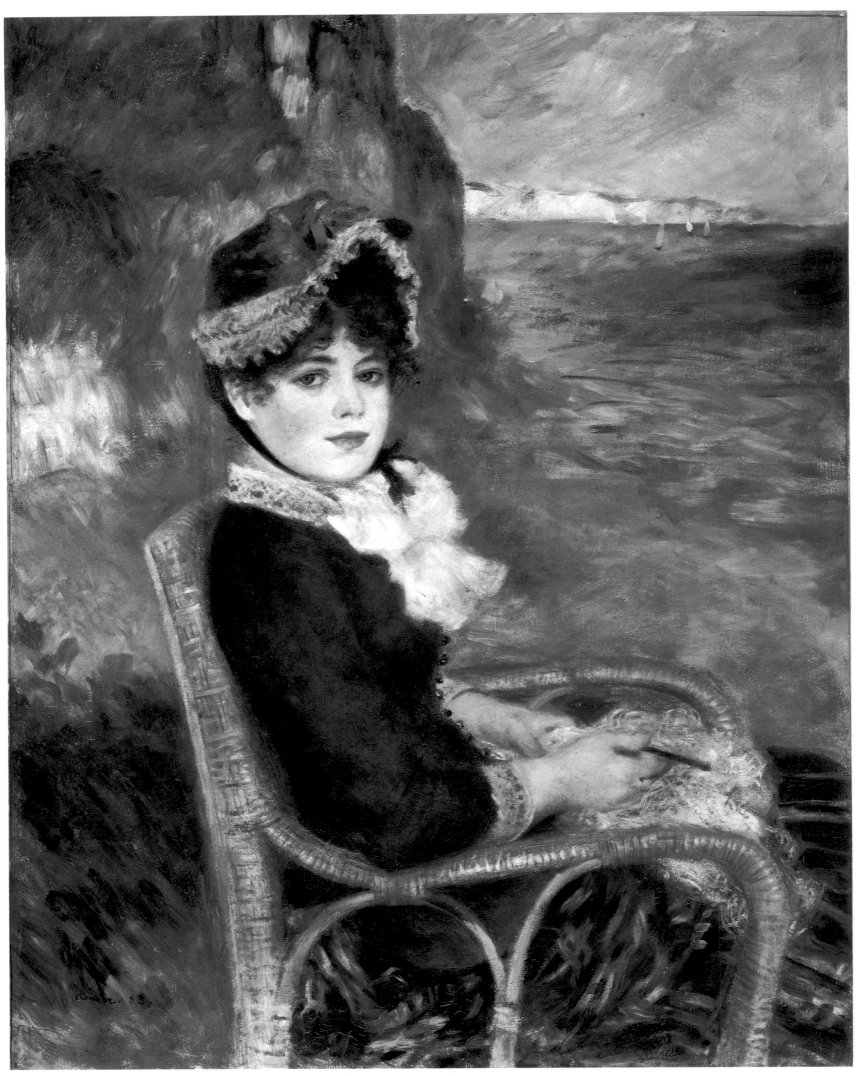

By the Seashore. d. 1883. 36¼ x 28½″. The Metropolitan Museum of Art, New York.
The H. O. Havemeyer Collection. Bequest of Mrs. H. O. Havemeyer

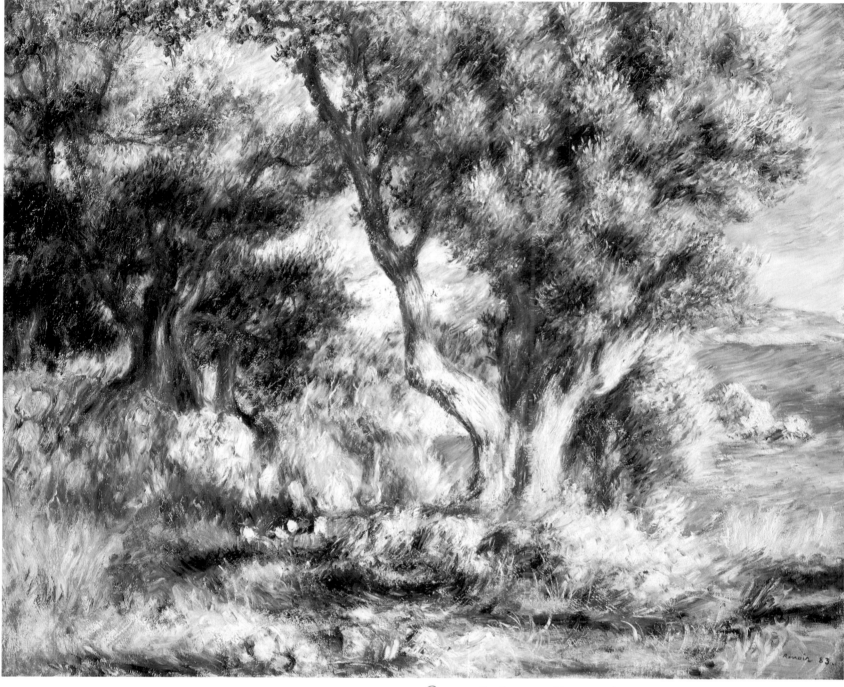

Landscape near Menton. d. 1883. 26 x 32″. Museum of Fine Arts, Boston. Bequest of John T. Spaulding

From December 16 through December 31, Renoir and Monet worked together on the Côte d'Azur.[104] In Marseilles they met Cézanne.[105] Renoir wrote Durand-Ruel:

We are delighted with our trip. We've seen marvelous things, we'll probably bring back nothing or not much, because we've been mostly on the move, but what a trip! One has to stay much longer to do something.... We've seen everything, or just about, between Marseilles and Genoa. Everything is superb. Vistas of which you have no idea. This evening the mountains were pink.

Hyères superb. St.-Raphaël, Monte Carlo, and Bordighera are virgin stands of pine trees.[106]

Renoir reported to Bérard from Monte Carlo:

Unfortunately our poor palette does not respond adequately. The beautiful, restrained tones of the sea become quite heavy on the canvas despite all the trouble one takes. All the same, it's worth seeing this from time to time.... I

went away more to see than to work.... I lost five francs at the Casino.[107]

On this trip Renoir painted *Landscape near Menton,* in which the outlines of the sturdy trees are reinforced and the intense vibrant colors and assertive parallel strokes give a dazzling, almost artificial effect.

On December 31, Renoir returned to Paris. His three years of travels had come to an end. His art was in a state of flux, for he still had not found the original style that would enable him to paint light yet solid figures that would please the public and sell for high prices. Yet, he had found subject matter that was varied and different from the other Impressionists', and he had succeeded in broadening his image from that of a portraitist to a more diversified painter. In spite of the fact that from 1881 through 1883 his popularity had been declining, he nonetheless continued to paint optimistically and prolifically because of his basic self-confidence and love of his craft.

135

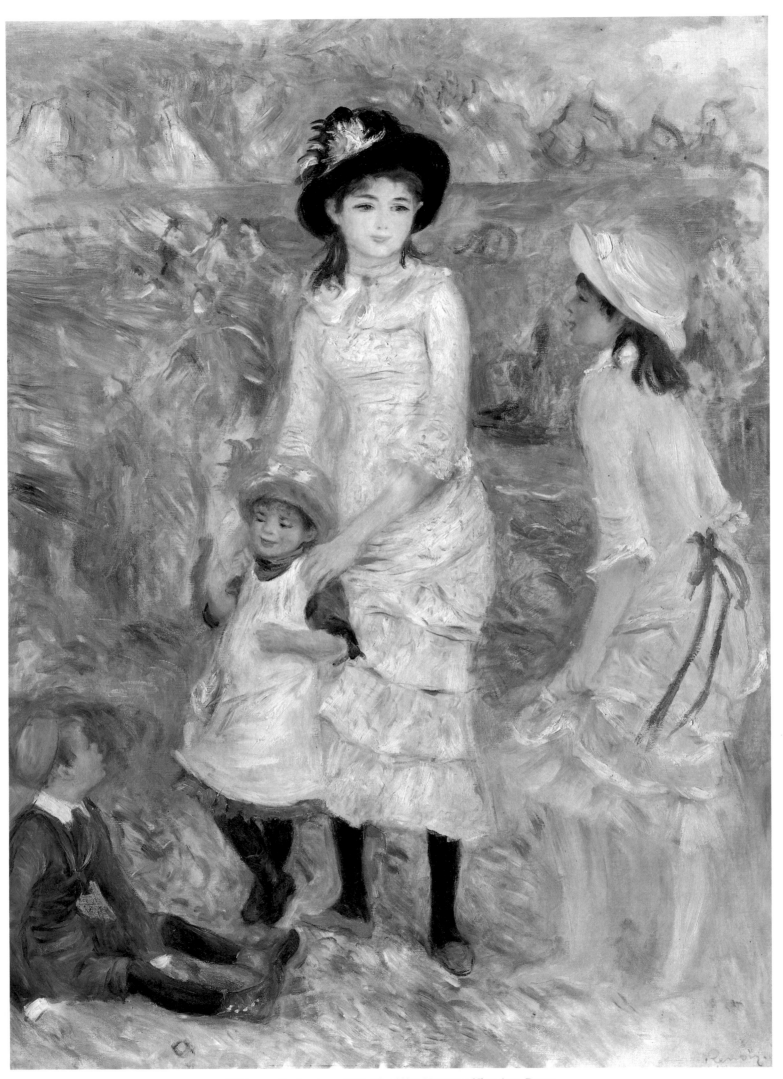

Children on the Seashore. 1883. 36 x 26¼". Museum of Fine Arts, Boston.
Bequest of John T. Spaulding

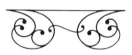

COUNTRY DANCE
CITY DANCE
DANCE AT BOUGIVAL

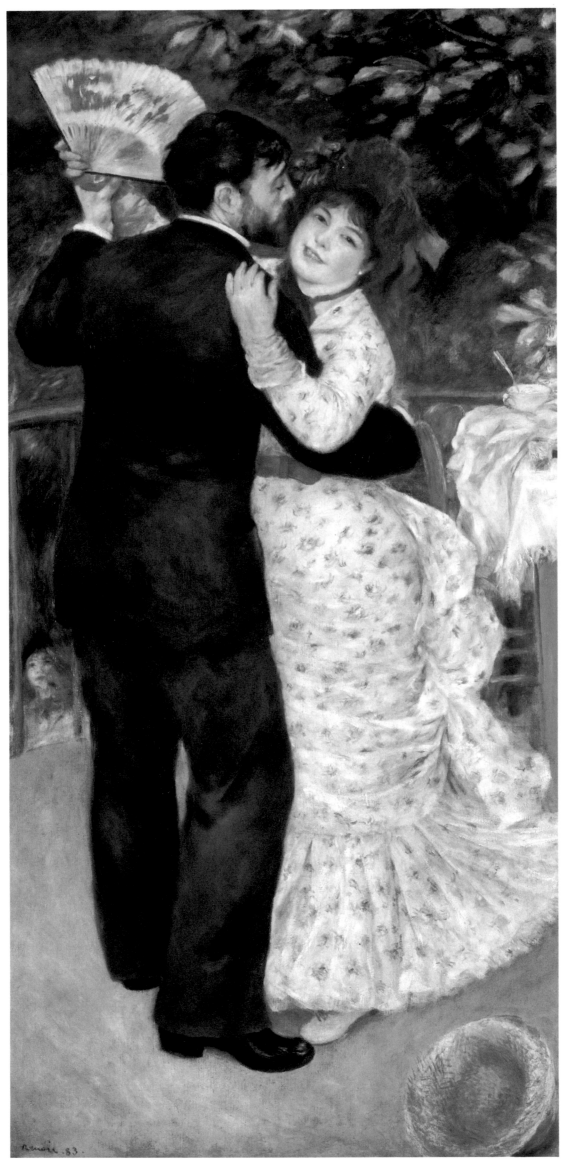

Country Dance (Dance at Chatou). d. 1883. 71 x 35½". Musée d'Orsay,
Galerie du Jeu de Paume, Paris

Sailor Boy (Robert Nunès).
d. 1883. 51¼ x 31½".
The Barnes Foundation,
Merion Station, Pa.

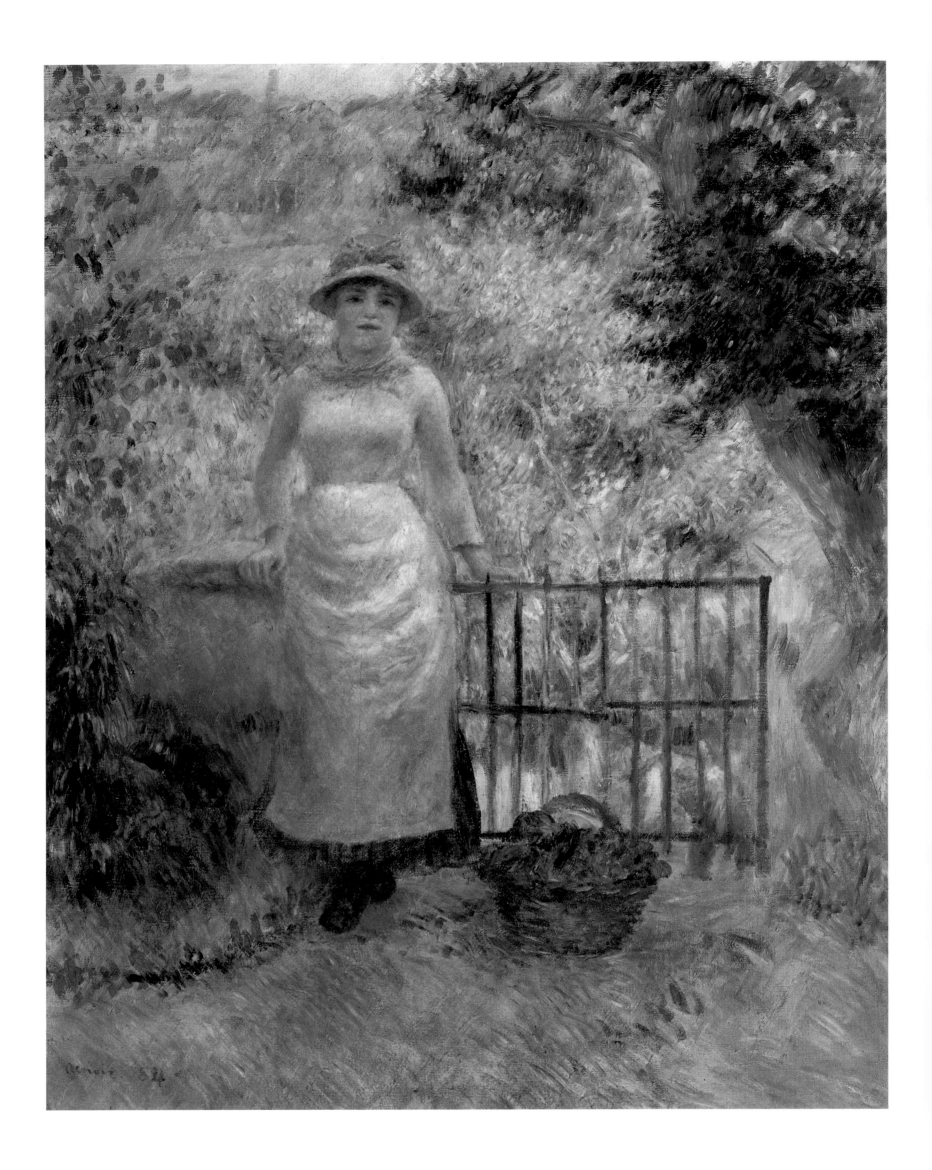

THE YEAR 1884 began with a disappointment: Renoir's plans to paint once again with Monet—as they had done at the time of *La Grenouillère* and the *Duck Pond*—were thwarted. The previous December, Renoir had written Durand-Ruel from Genoa: "We decided it was preferable to scout the countryside so as to go back and know immediately where to stop."[1] Monet knew of Renoir's expectations but had other plans for himself. On January 12, about to depart for the Côte d'Azur, he explained to Durand-Ruel:

> I ask you not to talk about this trip to *anyone,* not that I want to make a mystery of it, but because I insist on taking it alone: much as I enjoyed traveling with Renoir as a tourist, when it comes to work, it would bother me to do it together, I've always worked better in solitude and according to my own impressions. So keep it a secret until further notice. If Renoir knew I was about to leave, he would probably want to come with me, and that would be just as unfortunate for him as for me. You'll probably agree with me.[2]

But he was soon open with his old friend. "I've written to Renoir," he informed Durand-Ruel two weeks later, "and I'm making no mystery of my visit here; I only insisted on coming alone, so as to be freer with my impressions. It's always bad to work in pairs."[3]

Renoir did not express any disgruntlement to Monet (one of the few people to whom he wrote using the familiar "tu"). "I suppose that this time you will stay long enough to work peacefully," he wrote later in January. "Under these conditions, without feeling dogged by the pressure to return, one has an enormous advantage.... But I'm stuck in Paris where I'm bored to death and running after the unobtainable model, but I'm a painter of figures! Alas!—it's very pleasant sometimes, but not when the figures you find are not to your taste."[4] Since both Aline and Suzanne Valadon were posing for Renoir at this time,[5] his complaint about the lack of satisfactory models is odd—perhaps an attitude he adopted to assert his independence from Monet the landscapist.

Renoir's figure paintings no longer appealed to the taste of his patrons, and by the mid-1880s he had lost all his former supporters. Dollfus had acquired his last Renoir in 1876, Duret and Rivière in 1877, and Murer in 1878. By 1879, Ephrussi, Deudon, and Chocquet had all bought their last canvases, while Grimprel and Hoschedé stopped collecting his work in 1880. Cahen d'Anvers purchased his last painting in 1881, the Charpentiers in 1882. Although Renoir kept a cordial but rather distant relationship with M. and Mme. Charpentier until their deaths in the early 1900s, he told them in 1894: "[I realize that] you do not like my painting now."[6] By 1883, even Caillebotte and

Aline at the Gate (Girl in the Garden). d. 1884. 32¼ x 26".
Private collection

Clapisson had stopped buying work from Renoir. Bérard continued to be an intimate friend until his death in 1905, yet he too grew less fond of Renoir's work. He bought seventeen paintings in 1879, three in 1880, four in 1881, one in 1883, three in 1884, and his last one in 1885.

While Renoir had enjoyed three years of financial well-being—from 1879 through 1881—the crash of 1882 had severely depressed the art market. By 1884, he was poor once again. His expenses were high: the annual rent on his new studio at 37 rue de Laval was 3,000 francs, and he also had an apartment at 18 rue Houdon. And from 1884 to 1889, for the only time in his career, he had no regular patrons. For a man in his mid-forties, who had enjoyed steady patronage for two decades, this loss of support was certainly a terrible blow to his self-esteem.

His only hopes rested with his dealer, Durand-Ruel, and with new patrons. But Durand-Ruel was buying fewer works from him than before; in all of 1884 he paid Renoir a total of 7,850 francs, compared to 16,000 francs in 1881. By the spring of 1884, because of the continuing economic crisis in France, the dealer's debts were mounting, and he was thinking of reducing the prices of his artists' canvases. Nonetheless, Renoir remained staunchly loyal, writing in May 1884: "The help I can give you at this moment doesn't amount to much, but if you need me, please consider me all yours, no matter what may happen. I will always be at your service.... As for the paintings, if you are forced to make sacrifices, don't feel sorry about it, since I will do others for you and better ones."[7]

Despite—or because of—his continuing struggles, Renoir reported the birth of a new artists' group, to be called the Société des Irrégularistes: "I'm going to Paris one of these days to try to have a first meeting of the new society I want to start. I'm sending you what I plan to have printed or rather reproduced [in facsimile]. When you have time, tell me what you think of it." Along with this letter Renoir included his platform:

> In all the controversies matters of art stir up daily, the chief point to which we are going to call attention is generally forgotten. We mean Irregularity.
>
> Nature abhors a vacuum, say the physicists; they might complete their axiom by adding that she abhors regularity no less.
>
> Observers certainly know that despite the apparent simplicity of the laws governing their formation, works of nature are infinitely varied, from the most important to the least, no matter what their species or family. The two eyes of the most beautiful face will always be slightly unlike; no nose is placed exactly above the center of the mouth; the quarters of an orange, the leaves of a tree, the petals of a flower are never identical; it thus seems that every kind of beauty draws its charm from this diversity.
>
> If one looks at the most famous plastic or architectural works from this viewpoint, one easily sees that the great artists who created them, being careful to proceed in the same way as that nature whose respectful pupils they have al-

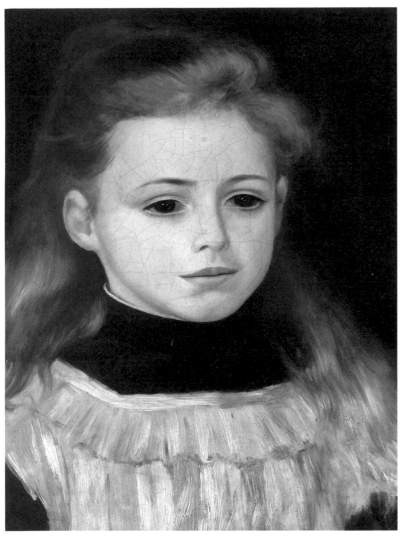

Lucie Bérard. 1884. 13¾ x 10½″. Private collection

ways remained, took great care not to transgress her fundamental law of Irregularity. One realizes that even works based on geometric principles, like St. Mark's, the little house of Francis I in the Cours La Reine . . . [as well as] all the so-called Gothic churches, etc. [erased: "French ogival"], do not have a single perfectly straight line, and that the round, square, or oval forms which are found there and which it would have been extremely easy to make exact, never are exact. One can thus state, without fear of being wrong, that every truly artistic production has been conceived and executed according to the principle of Irregularity; in short, to use a neologism which expresses our thought more completely, it is always the work of an Irregularist.

At a time when our French art, until the beginning of this century still so full of penetrating charm and exquisite imagination, is about to perish of regularity, dryness, and the mania for false perfection that nowadays makes the engineer's diagram the ideal, we think that it is necessary to react against the fatal doctrines which threaten to annihilate it, and that it is the duty of all men of sensitivity and taste to gather together without delay, no matter how repugnant they may otherwise find combat and protest.

An association is therefore necessary.

Although I do not want to formulate a final platform here, a few projected ideas are briefly submitted:

The association will be called the Society of Irregularists, which explains the general idea of its founders.

Its aim will be to organize as quickly as possible exhibitions of all artists, painters, decorators, architects, goldsmiths, embroiderers, etc., who take Irregularity as their aesthetic principle.

Among other conditions for admission, the rules expressly stipulate, as far as architecture is concerned: All ornaments must be derived from nature, with no motif—flower, leaf, figure, etc., etc.—being repeated exactly; even the least important outlines must be executed by hand without the aid of precision instru-

ments; as far as the plastic arts are concerned, goldsmiths and others [erased: "embroiderers, etc., painters on china, etc. . . ."] will have to exhibit alongside of their completed works the drawings or paintings from nature used to create them.

No work containing copies of details or of a whole taken from other works will be accepted.

A complete grammar of art, dealing with the aesthetic principles of the society, setting forth its tendencies, and demonstrating its usefulness, will be published by the founding committee with the collaboration of the members who offer their assistance.

Photographs of celebrated monuments or decorative works which show evidence of the principle of Irregularism will be acquired at the expense of the society and placed in a special room for the public.[8]

As in the years 1874 through 1877, when he was one of the leaders of the Impressionists, Renoir's new plan shows a public-mindedness and a will to organize. He was not interested in allying himself with his former group, now under the leadership of Degas and Pissarro, who invited artists with whom Renoir did not want to be associated (Gauguin and Guillaumin); furthermore, the group no longer included his friends Sisley, Cézanne, Caillebotte, and Monet. Nevertheless, Renoir sent a copy of his new platform to Pissarro.

Renoir's proposal was motivated by several concerns. He wanted first of all to establish a new artists' community. By 1884, in spite of the monthly dinners at the Café Riche, he felt isolated. Because rent and living expenses in the country were far lower than in Paris, his friends spent increasing amounts of time away from the capital: Monet in Giverny, Pissarro in Éragny, Sisley in Moret, Cézanne in Aix-en-Provence. Renoir too began the practice, which he retained for the rest of his life, of spending several months of every year in rural France.

A second reason involved his exhibition plans. In 1884, he decided to stop exhibiting at the official Salons, because for the past four years his paintings there, hung in obscure locations, had been ignored by the buying public and critics. Now he needed an alternative place to show his work.

A third incentive was provided by the Society of Independent Artists, led by twenty-five-year-old Georges Seurat. In the same month that Renoir drafted his manifesto, Seurat exhibited his *The Bathing Place (Une Baignade)* and established himself at the forefront of a new avant-garde movement, Pointillism (also called Neo-Impressionism or Divisionism). Pointillism (from the French *pointiller,* "to dot or to stipple") was an offshoot of Impressionism that aimed to enhance the brilliance and shimmer of natural color. The varied strokes of Impressionism were replaced by more uniform strokes, and separate dots of pure hues were applied side by side on the canvas to produce the desired color: red and yellow spots to create orange, red and blue spots to produce purple. Theoretically, at the right distance, the spectator's eye automatically mixed the colors. The artist modulated the stroke size according to the dimensions of the picture and the distance at which the image was to be seen.

Renoir was vehemently opposed to Seurat's style, which seemed to him based on regular, dry, and cold principles of engineering and industrialization rather than on the irregularities of nature and of past art that he celebrated.

No written response to Renoir's platform is known from Durand-Ruel, Duret, or Monet (to whom he also sent copies). On May 13, however, Pissarro reported to Monet that one plank was nearing realization: "Renoir came this morning; he is going to publish the *Abrégé de la grammaire des arts* [Summary of the Grammar of the Arts] immedi-

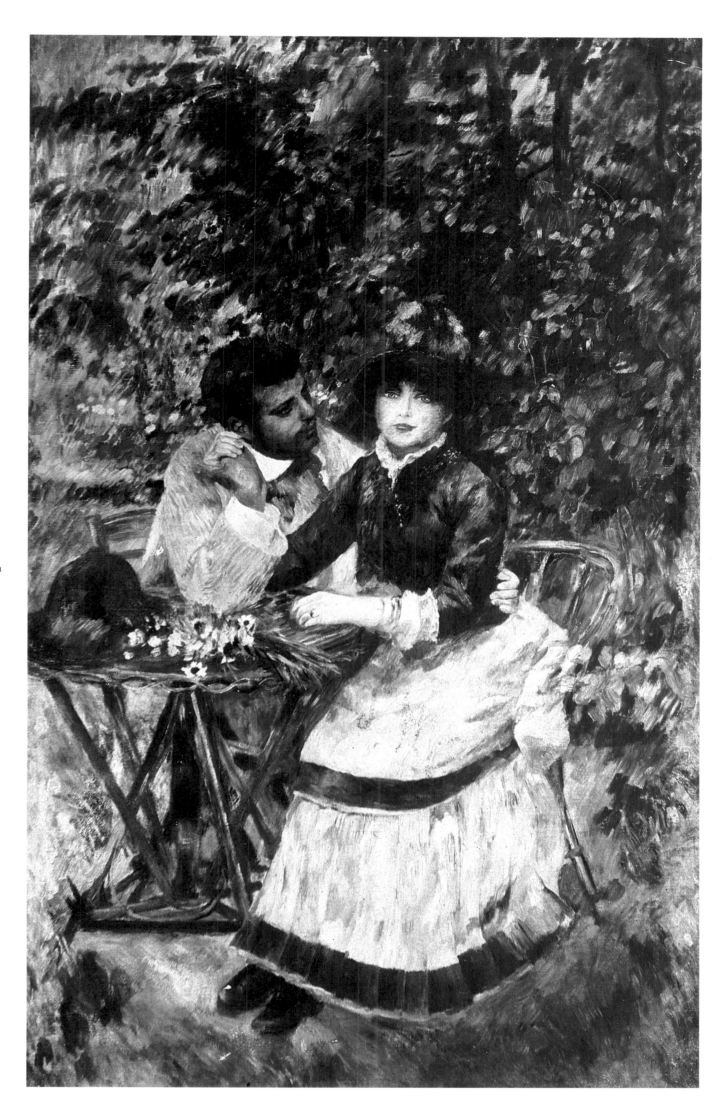

In the Garden. d. 1885.
67 x 44″. Private collection

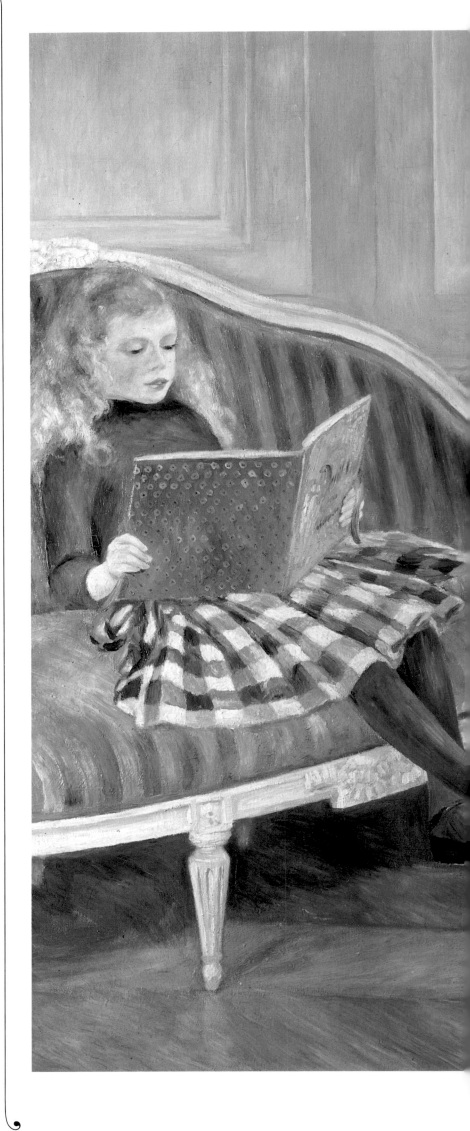

The Afternoon of the Children at Wargemont. d. 1884. 50 x 68¼".
Nationalgalerie, Berlin

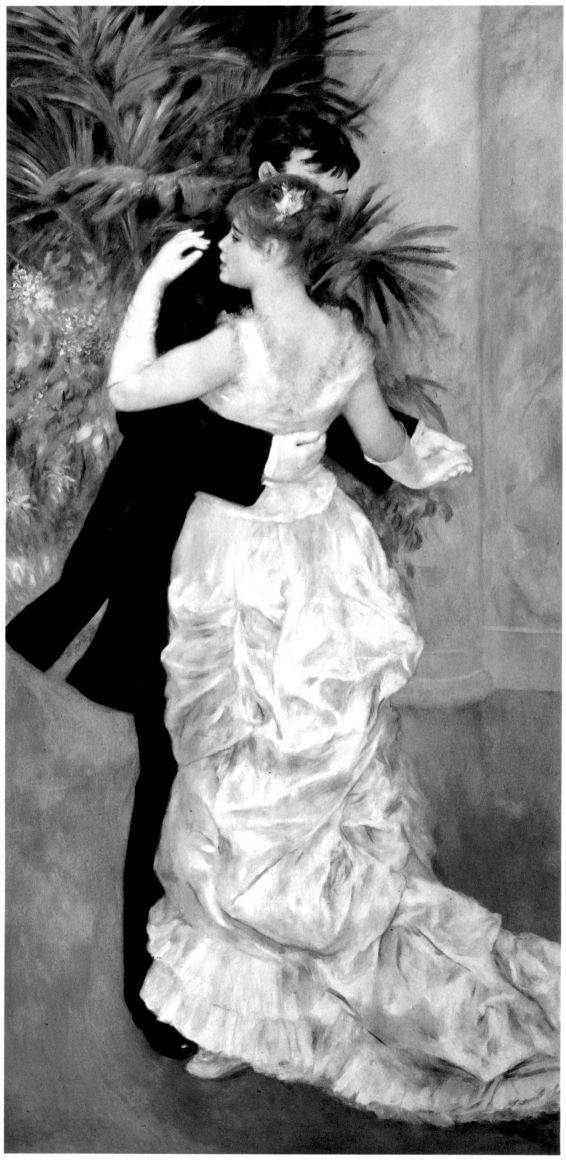

City Dance. d. 1883. 71 x 35½". Musée d'Orsay,
Galerie du Jeu de Paume, Paris

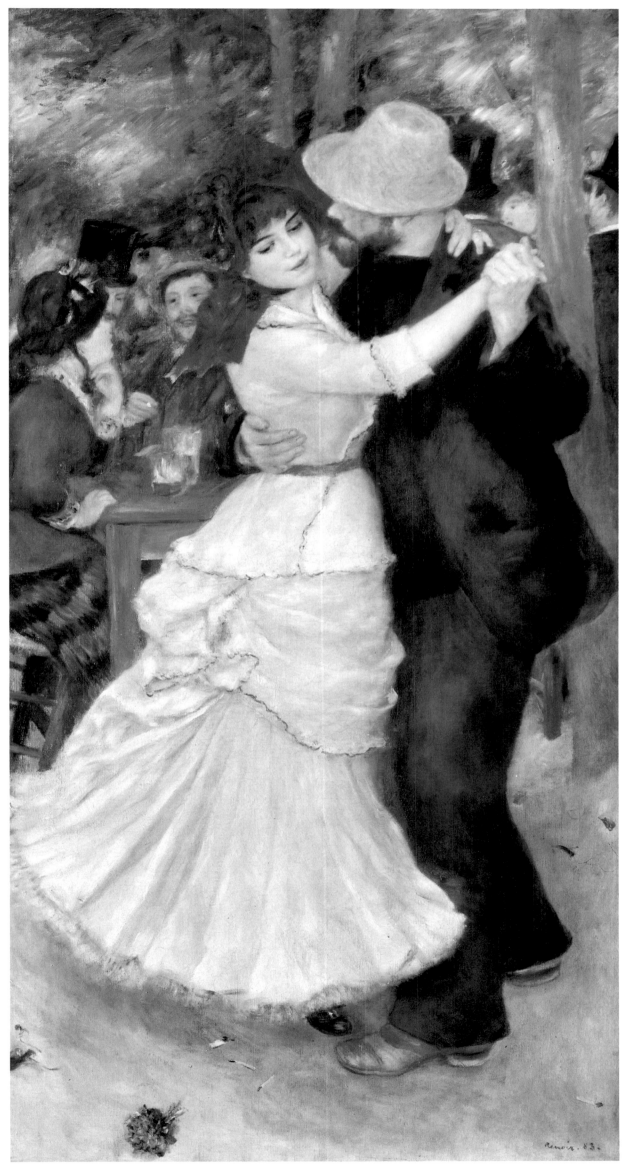

Dance at Bougival. d. 1883. 70⅝ x 37¾". Museum of Fine Arts, Boston.
Purchase, Picture Fund

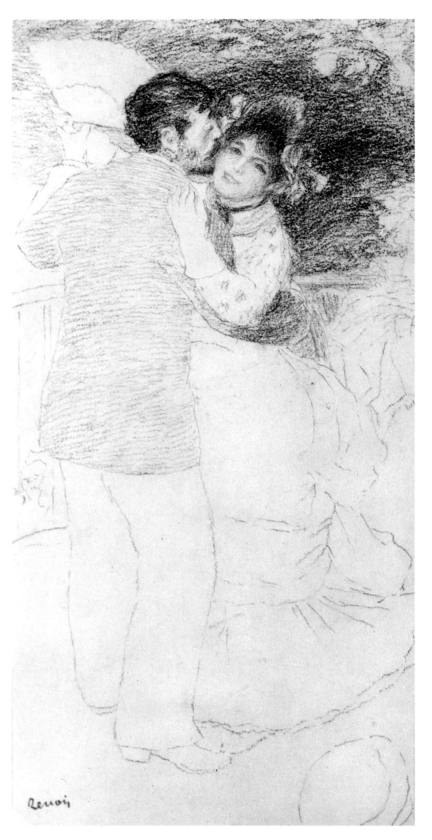

Preparatory Drawing for Country Dance. 1883. Black pencil, 9½ x 4¾″. Musée
du Louvre, Cabinet des Dessins, Paris

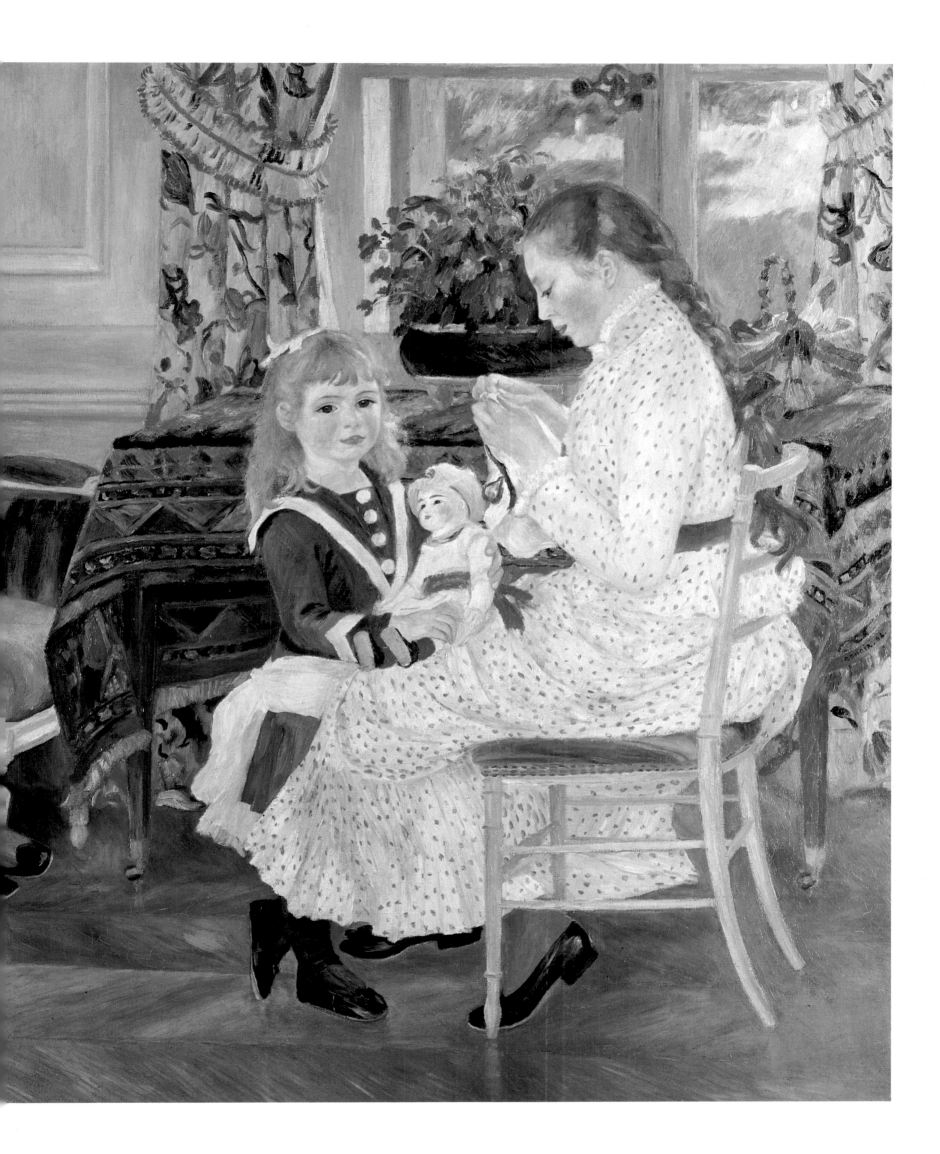

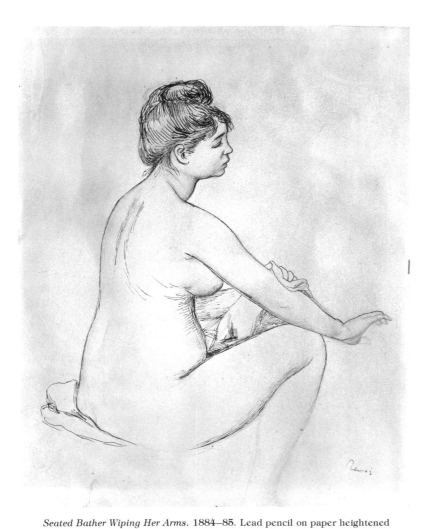

Seated Bather Wiping Her Arms. 1884–85. Lead pencil on paper heightened with pen and ink, 10¼ x 8½″. Musée du Louvre, Cabinet des Dessins, Paris

Bather Arranging Her Hair. d. 1885. 36¼ x 28¾″. The Sterling and Francine Clark Art Institute, Williamstown, Mass.

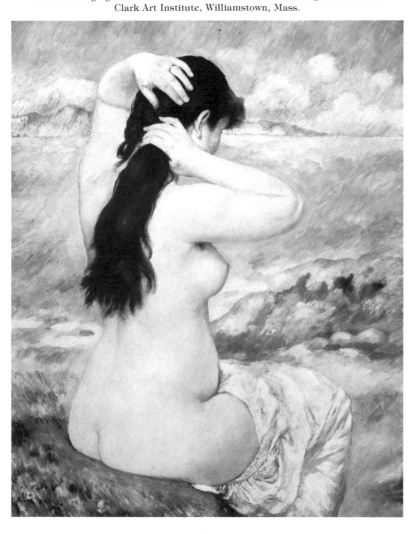

ately, in order to disseminate it as quickly as possible to friends; since the large publication requires a certain time for preparation, it will come out only later."[9] Pissarro's cousin Lionel Nunès, a lawyer (brother of Alfred, who had commissioned portraits from Renoir in 1883), was entrusted with researching and writing this publication. On May 23, he wrote to Pissarro: "The outline of the work that M. Renoir told me about is finished. I've been going quite regularly to the library in order to acquaint myself with the broad lines and the necessary technical details. I hope very soon to give him through you a first chapter dealing with art in general and containing a summary of the chief creations of geniuses of all centuries according to his views."[10] But Renoir was not happy with the result: "I've given up using it, it's too short and nobody understands," Renoir told Pissarro. "There are things that are easy to explain but difficult to write about; when the time is favorable for a meeting, we must take advantage of it, that will be better."[11]

Although no group, exhibition, or publication materialized from Renoir's plan, his manifesto is a general statement of his procedures and concerns. In it, he alludes to the two general principles of contrast and variation: art as a harmony of contrasts, and beauty as unity in variety. In particular, the manifesto helps explain the stylistic complexity of his work in the mid-1880s. Under the justification of Irregularity, he evolved a new style (most prominent in works of 1885–87 and to a lesser extent in 1884 and 1888–89) which lacked unity and which combined linear form, Realist details, structured composition, and smooth surfaces with the Impressionist palette, use of light, and brushstrokes.

Aware that he was painting in a new way, Renoir wrote to Bérard in 1884 about a portrait (apparently painted from a photograph) of his youngest daughter, Lucie (p. 146), which differed dramatically from her portrait of the year before (*Child in White*). Renoir said that he had not yet completed the "small head of Lucy [*sic*], new manner," but he promised that it would be "the last word in art.... One always thinks one has invented the locomotive until the day when one realizes that it doesn't work.... I'm beginning a little late to know how to wait, having had enough failures like this."[12] The portrait of Lucie Bérard resembles Ingres's head of *Mme. Rivière* in the closed expression, the precise outlines, the smooth skin, and the pale, dry surface.

Early in the summer of 1884, Renoir went to visit the Bérards and there painted *The Afternoon of the Children at Wargemont.* Four-year-old Lucie rests her doll on fourteen-year-old Marthe's lap, and ten-year-old Marguerite reads. In this large indoor composition, in which he incorporated the portrait head of Lucie, he elaborates a style that recalls Ingres in its complete capture of the suspended moment, the rich, mosaic patterning, the cut-out quality of the figures, and the prominent silhouettes. The style is light and dry. New control has appeared not only in the form but also in the division of color: cool hues on the left, warm on the right.

Unhappy working indoors, Renoir traveled later in the summer down along the Bay of Biscay. "I am stranded in La Rochelle," he wrote to Durand-Ruel. "The last painting I saw by Corot had given me a mad desire to see this harbor, and I am astonished to see, in spite of the vague memory I have of the painting, the extraordinary reality of the tone.... This is the first trip that will have been of some use to me, and precisely because the weather is so bad that I have had to think and see rather than do any real work.... I've lost a lot by working in the studio in a space of 4 square meters. I would have gained ten years by doing a little of what Monet has done."[13] Outdoors he painted several

works for which Aline posed, including *Aline at the Gate (Girl in the Garden)* (p. 144) and *In the Garden* (p. 147). *In the Garden*, a large but intimate canvas completed in 1885, is the last painting in which he depicts the love of a modern man for a modern woman in a rural setting, as *The Umbrellas* and the dance panels were the last contemporary courtship paintings in an urban setting.

In late June 1884, Aline became pregnant with Renoir's child. No extant letters mention this fact, nor do any shed light on the couple's relationship. But in late 1884 and early 1885, he made several drawings and a painting in which the model looks as if she were pregnant. These works resemble Ingres's drawings and paintings in their precision of execution, their manipulation of the figure to achieve an expressive silhouette, and their linear and sculptural treatment of the body. But beyond Ingres, Renoir had popular taste in mind. His *Bather Arranging Her Hair*, for instance, calls to mind Bouguereau's acclaimed *Bathers* in the realistic, smooth skin and affected pose.

However, *Bather Arranging Her Hair* is less successful than his previous studies of nudes, although he may have believed he was merely taking the Classicism of the second version of *Blond Bather* one step further. He seems first to have painted a woman indoors and then superimposed her upon a landscape. She is suspended in a stiff, uncomfortable posture. Her body is extended like a fan close to the picture plane, and the tip of her breast is centered exactly between the top and bottom of the canvas. Edges are sharply defined: a blue eyelash, a red crease of the ear, a blue line around the silhouette. Renoir exaggerated the contrast between the marblelike body and the Impressionist surroundings to emphasize the outline, especially around the breast and buttocks. Unlike his earlier nudes, this figure lacks warmth and credibility, and the painting seems contrived.[14]

On March 23, 1885, Aline had a baby, who was named Pierre Renoir. The birth certificate states that he was born at

18 rue Houdon, son of Pierre-Auguste RENOIR, age 44, painter, *who has acknowledged him*, and of Aline-Victorine CHARIGOT, age 25, no profession, residing at the same address. Drawn up by us, Prosper-Joseph GROS, Deputy Mayor, Registrar of the 18th arrondissement of Paris, on the presentation of the infant and the statement made by the father in the presence of Victor RENOIR, age 48, tailor, residing at 35 rue Laval, and of Corneille CORNET, age 39, cabinetmaker, residing at 1 rue des Trois Frères, witnesses who signed with the father and with us after reading.[15]

The couple's appearance at the time of Pierre's birth is shown in a photograph of Renoir and in a portrait of Aline in the new linear style (which Renoir kept in his own collection).

Instead of a fee, Renoir gave the doctor a crisply defined canvas, *Roses and Gladioli*, inscribed, "To Doctor Latty, souvenir of friendship, Renoir." It resembles a series of floral works of 1884 and 1885 in which he similarly treated the flowers and leaves.

Aline's peasant origin began to pose a problem for Renoir. It intensified the dichotomy between the two worlds in which he lived. On the one hand, among his artist friends, it was common to have a lower-class mistress and an illegitimate child. Cézanne, Pissarro, and Monet had such arrangements; they all eventually married the mothers of their children. Renoir shared information about Aline and Pierre with these friends, as well as with Gachet, Murer,[16] and De Bellio. Caillebotte was Pierre's godfather. Doubtless Edmond Renoir also knew. He too had become a father, on March 9, 1884, when Edmond, Jr., was born to Mélanie Porteret.

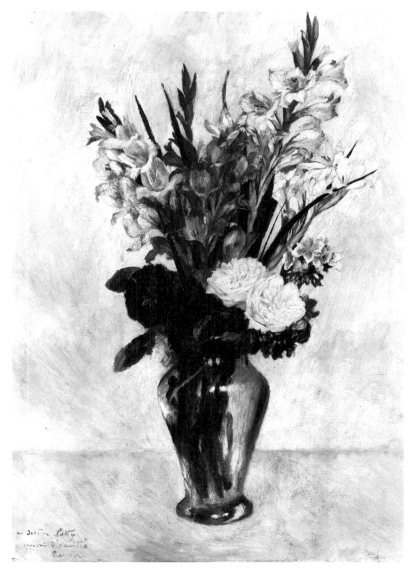

Roses and Gladioli. 1885. 29¼ x 21¼". Musée d'Orsay, Galerie du Jeu de Paume, Paris

On the other hand, a peasant common-law wife and child might have stigmatized Renoir as immoral among those whose patronage he desperately needed. His solution was to keep Aline and Pierre a secret from certain people, including his close friends Berthe Morisot and Stéphane Mallarmé, who moved in upper-class circles and whom he saw weekly at Morisot's Thursday dinners, beginning around 1885. Morisot's daughter, Julie, later recorded in her diary that "M. Mallarmé and M. Renoir were the closest friends, the Thursday regulars."[17] And still Renoir remained silent even during the first year of his marriage, when he spent several weeks in 1890 with Morisot and her family at their summer home in Mézy.[18] Fifteen months after his marriage, in July 1891, he unexpectedly visited Morisot and her husband, Eugène Manet, accompanied by a woman and six-year-old child, whom he did not introduce. Morisot and Manet were speechless until they deduced that Aline and Pierre were Renoir's own family.[19] That Renoir continued to conceal his relationship with Aline even after their marriage is difficult to understand now but was less strange in the late nineteenth century when discreet people did not discuss their private affairs. Morisot was a member of "society" and was a woman; hence Renoir kept his private life out of their friendship. Furthermore, Aline's girth and peasant manners may have embarrassed him. He may have feared how such sophisticated Parisians as Morisot and Mallarmé might react. A few months after he had first brought Aline and

151

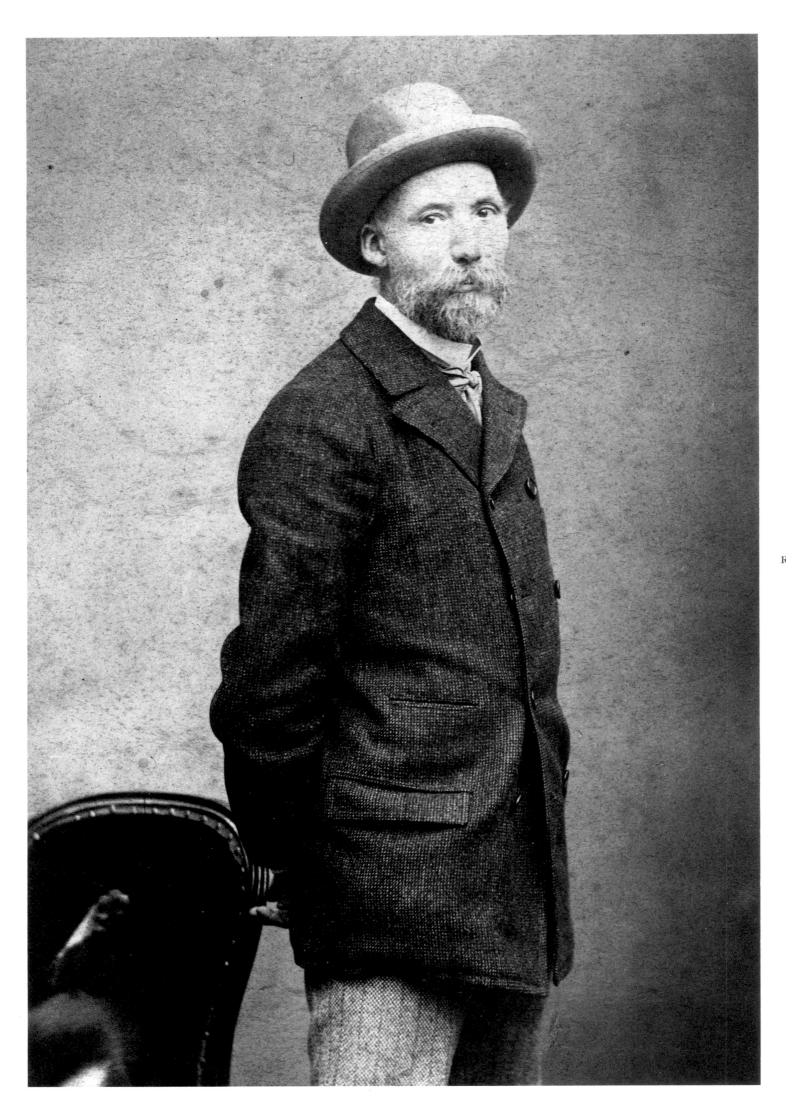

Renoir, c. 1885

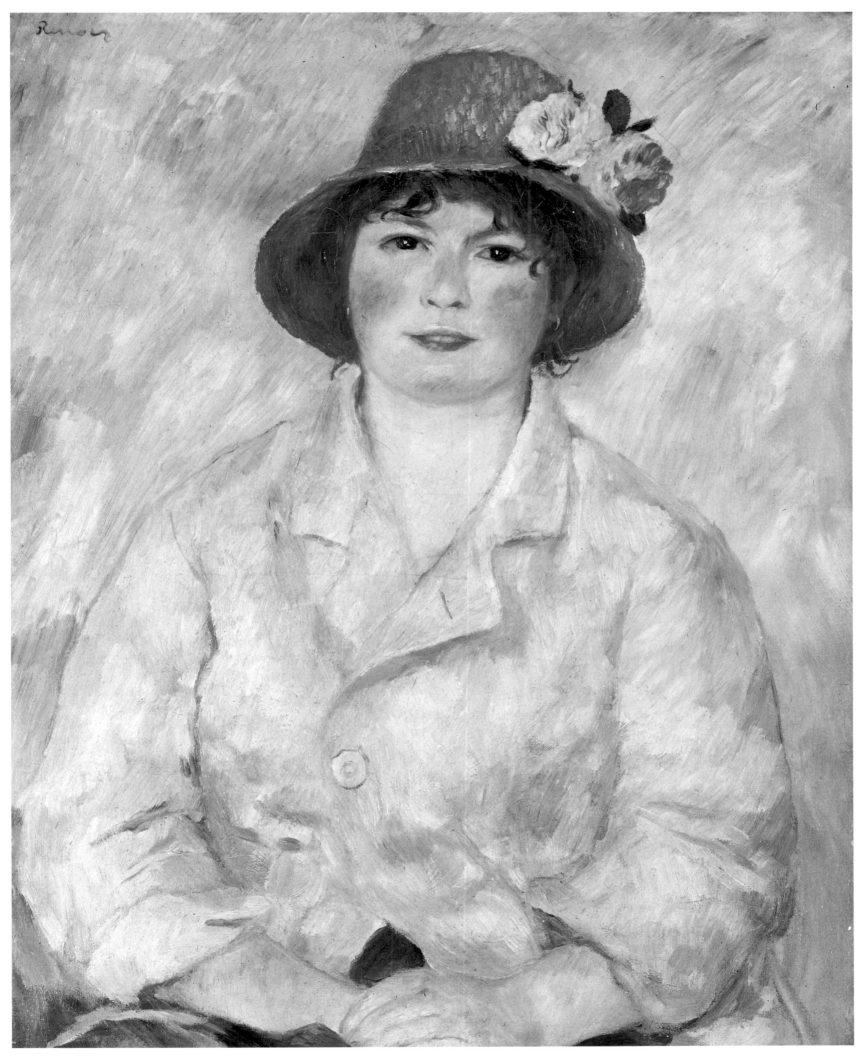

Aline. 1885. 25¾ x 21¼″. The Philadelphia Museum of Art.
The W. P. Wilstach Collection

little Pierre to her home, Morisot wrote to Mallarmé: "Renoir spent some time with us, without his wife this time. I will never be able to describe to you my amazement in the presence of this very heavy person, whom, I don't know why, I had imagined as resembling her husband's painting. I'll point her out to you this winter."[20]

Renoir also kept on guard lest something personal might appear in print. In 1887, when he learned that his old friend Paul Alexis was writing an article for *Le Cri du peuple* about Murer's painting collection, he wrote Murer: "If you see Trublot [Alexis], tell him that he's an excellent fellow, but that he'd make me very happy by not saying one *word* about me; about my canvases as much as he likes, but I hate to think that the public would find out how I eat my cutlet, and if I was born of poor but honest parents. Painters are a bore with their deplorable stories, and no one gives a damn about it."[21] Of Renoir's many problems during the mid- and late 1880s, this double life must have been one of the most burdensome.

Fatherhood and other changes in Renoir's life weighed heavily on him from age forty-four to forty-eight, his most difficult years, and they were reflected in changes in his painting. He moved from a primarily urban existence to a rural one, from active camaraderie to a less sociable life, from the freedom of a bachelor to responsibility for Aline and Pierre. Because of the severe economic crisis in France and the loss of patrons, he was again often without money. In his letters he often referred to the fact that he was aging.

From the fall of 1885 through the rest of the decade, Renoir's frame of mind—once resolutely optimistic—seems now to oscillate between optimism and pessimism. In letters to Bérard, who assumed the role of confidant, occasional phrases suggest that behind the jocular tone lay apathy, sarcasm, and despair. Letters to Durand-Ruel are less personal but also express indecision, unhappiness, and self-deprecation about his work. Renoir became increasingly dependent on his dealer's judgment about the quality of his art and about his artistic changes.

Renoir's unpredictable behavior (a character trait of which he was aware when writing to Duret in 1881)[22] seems to have been exacerbated in this period. On February 23, 1887, Pissarro wrote to Lucien that Renoir had changed his mind and acted friendly toward Albert Dubois-Pillet, a Neo-Impressionist, although Renoir despised this new style. "Nor can I understand what is in Renoir's mind—but who can fathom that most variable of men?"[23] Later that year, Pissarro confronted Renoir and accused him of artistic capriciousness.[24]

Psychological studies suggest that a mid-life crisis with periods of depression is common for men who feel that by middle age they have not achieved success in a personal or professional sphere.[25] Renoir's depression was mild and sporadic. His letters rarely mention Aline or Pierre, although this reticence suggests he was ambivalent about parenthood. Yet he often described his feelings about his career. At the age of forty-four (despite having painted *Le Moulin de la Galette, The Boating Party*, and the three dance panels), he felt he was a failure. His poverty was a daily reminder that his career was a fiasco in his eyes and in the eyes of his public.

Another theory postulates that depression hits hardest those who are unable to express anger outwardly. His letters never expressed his rage. He joked in a gentle, charming way about his indigence, implying that it resulted from his artistic inadequacy. Instead of becoming furious (as Monet and Pissarro did) with the real sources of his problems—the critics, the public, the French economy—he turned his rage against himself. Nevertheless, his despondency seems to explain the decline

in the number and quality of his paintings of 1884–89. From 1881 through 1883, he completed an average of twelve figure paintings in a year. In 1884 and 1885, he painted fewer works, and he signed and dated only two figure paintings in 1886 and three in 1887—the two least productive years of his career. He made more drawings than paintings, and the few canvases, often small, show a loss of originality, diminution of artistic energy, and drying up of creativity.

By late 1885, Renoir was spending several months a year with Aline and Pierre in rural France (in Aline's native village of Essoyes, in Burgundy, and in other towns where living was less expensive than in Paris). Contemporary city scenes were replaced by rural themes, groups by isolated figures, and stylish city fashions and sophisticated recreations by the more bland costumes and domestic pursuits of the country. Not only did he stop painting men and women socializing, but men almost vanish altogether. As in his own life, they became spectators in a woman's world, where women nurse, look after children, and care for themselves. From 1884 until the end of his career, most of his paintings idealize a timeless, rural, private world of children and women.

Renoir seems to have projected onto his figures his own unhappiness, loss of *joie de vivre*, and isolation. During these years he painted serious, static, lethargic figures, who have either glum expressions or frozen smiles. They are self-absorbed; in group scenes, they lose their easy sociability, naturalness, and sensuality. Indoors or outdoors, they are not comfortable in their settings. (See *The Afternoon of the Children at Wargemont, Girl Braiding Her Hair*, all the versions of *Nursing*, and *The Bathers*.)

His unhappiness may also have contributed to curtailing the freest part of his style, his Impressionism, and inhibiting his natural gift for beautiful color harmonies. As his life became more difficult, he seems to have tried to bring stability and calm to his art and to himself by working in a Classical direction. His search for linear control of form, as well as his intensified desire to assure himself that he was in the traditional ranks, may have been, in part, a result of his personal problems.

Finally, Renoir's difficulties undoubtedly made him unwilling or unable to take artistic risks. He concentrated on painting mothers and bathers—safe, conventional subjects. In order to attract moneyed patrons, he further developed his earlier inclination to model his art after that of Ingres—the acclaimed grand master of painting, who had died only some twenty years earlier. At the same time, Renoir tried to remain faithful to his own goal of originality through his new complex theory of Irregularism. It is not surprising that the paintings of the height of the Irregularist period (1885–87), when he tried to walk this artistic tightrope, are the least successful of his career because of the split between the theme and the expressive content.

There were professional reasons as well for Renoir's artistic change. A trend underway in France by 1883–84 paralleled Renoir's movement toward idealism.[26] The critic Téodor de Wyzewa later wrote that around 1883 enlightened people became tired of the visible world with its "harsh relief," "crude" light, and "blinding color."[27] Some writers of Zola's school were departing from his pseudoscientific Naturalism. This shift is exemplified most clearly by Huysmans's novel *À Rebours* (1884), in which he expresses his dislike for the modern world and its scientific progress. Renoir concurred, as in his attacks on industrialization in the platform for the Society of Irregularists. Several writers are likely to have encouraged Renoir's Classicism (the form his idealism took)—most notably Mallarmé, who was both a forerunner and an

exponent of the idealist aesthetic in literature. Renoir's development also bears some spiritual relationship to the musical equivalent, the "culte wagnérien."[28]

Renoir's Impressionist friends were each evolving their art in distinct ways. Each was seeking more individuality of style and each was hoping to paint in a manner that would be original and would sell.

Because Durand-Ruel could not make enough money from sales in Paris, he sought outlets abroad. In June 1885, he exhibited thirty-two Impressionist works in Brussels at the Hôtel du Grand-Miroir. Émile Verhaeren, a Belgian avant-garde poet, wrote: "Renoir's... brush is superb.... His art is most certainly of French lineage. He is descended from the magnificent eighteenth century, when Watteau, Fragonard, Greuze, Madame Vigée-Lebrun, [Angelica] Kauffmann, and Drouais were producing works of marvelous inventiveness. The resonant and high-pitched quality of his color, however, is more reminiscent of that great genius Eugène Delacroix."[29] In spite of this favorable review, Renoir had no sales.

In June, when Pierre was three months old, Renoir rented a house in the country at La Roche-Guyon, at which they stayed through August. From June 15 to July 11, Cézanne, Hortense Fiquet, and their son, thirteen-year-old Paul, came to visit Renoir, Aline, and Pierre.[30] Cézanne's situation resembled Renoir's, for he and Hortense were not yet married but he had registered his child under the name Paul Cézanne.

The two artists painted out-of-doors together. Cézanne gave his friend *Turning Road at La Roche-Guyon*. Renoir made several landscapes that are structured in composition and closed in form. In *La Roche-Guyon (Houses)* he even clearly defined the clouds in the sky and the ridges of the distant hills, displaying here his similarity to Cézanne. What Meyer Schapiro has written of Cézanne applies equally to Renoir: "Though painting directly from nature, like the Impressionists, Cézanne thought often of the more formal art he admired in the Louvre. He wished to create works of a noble harmony like those of the old masters.... [He sought their] completeness and order... that is, to find the forms of the painting in the landscape before him and to render the whole in a more natural coloring based on direct perception of tones and light."[31]

While Renoir and Cézanne were painting together in La Roche-Guyon, Edmond Renoir was stirring up dissension among Pissarro, Monet, and his brother in Paris. Early in July, Pissarro wrote to Monet:

Do you know, my dear Monet, that Renoir's younger brother is really unbearable? Not that his insanities have any effect on me, but for the discredit he throws on his brother in particular and our group in general.

...He had bad luck with a friend of mine, a fellow who is very enthusiastic about the group and is very fond of me outside of painting. This miserable [Edmond] Renoir has treated me in a fine way: it seems that I'm a first-class schemer, untalented, a greedy Jew, plotting underneath to replace both you, my dear friend, and Renoir.... This didn't go on for long, since my friend knows very well where I stand. But one might get a bad impression of Renoir the painter, who surely doesn't deserve it, but those who don't know him very well might believe it.... Here is a fellow [Edmond] whom I hardly know...[but] he manages to hate me intensely. Is it fraternal love that inspires him so badly? I don't know. It seems to me that I've always shown a great admiration for his brother's talent. Is it because I'm an intruder [i.e., by being Jewish] in the group? It would really be unfortunate to become aware of it so late!... I haven't wanted to push it too far, or to mention it to Renoir. I think it's better not to pay any attention to it, that's the simplest thing to do.... Are we going to become jealous of each other; frankly, it's enough to make you stay in your corner and send everyone packing....

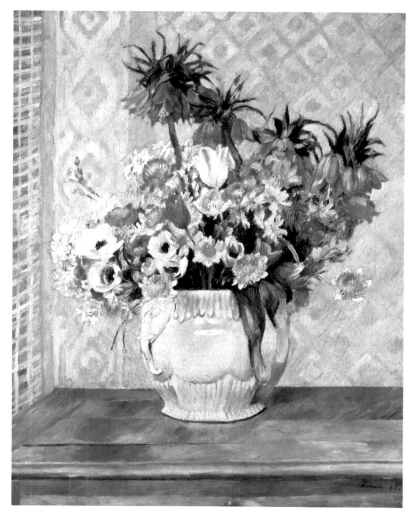

Still Life: Flowers. d. 1885. 32¼ x 25⅞". The Solomon R. Guggenheim Museum, New York. The Justin K. Thannhauser Collection

N.B.—I think it's better not to bother Renoir with all these problems; he has enough troubles without that, but I wanted to keep you informed, since it must be repeated all over the place.[32]

The difficulties to which Pissarro referred were financial: in 1885 Renoir would receive only 6,900 francs from Durand-Ruel.

From Giverny, on July 9, Monet replied: "What you tell me about young Renoir doesn't surprise me at all, I know him, and it's not the first time that he has attacked one of us thinking to help Renoir. It is very unpleasant, but don't get too upset, since he doesn't have much authority and I have the feeling that not very many people like him. I agree with you about not making a fuss about it, but it would be a good idea to say a word about it someday to Renoir, whom he can only hurt."[33] It is likely that either Monet or Pissarro talked to Renoir about Edmond, for around this time the once close friendship between the brothers permanently cooled.[34]

A month after Cézanne left La Roche-Guyon, Renoir wrote Bérard a letter that reveals frustration and anguish: "I'm involved in lots of things and not one of them is finished. I wipe out, I start over, I think the year will go by without one canvas, and that's why I turn down visits from painters, no matter who.... I stopped Durand-Ruel from coming to see me.... I WANT TO FIND WHAT I AM LOOKING FOR BEFORE GIVING UP. Let me look... I have gone too deeply into the series of experiments to give up without regret.... Success may be at the end."[35] Renoir exaggerated; he signed and dated at least nine figure paintings in 1885. Yet after five years of searching, he was increasingly dissatisfied.

155

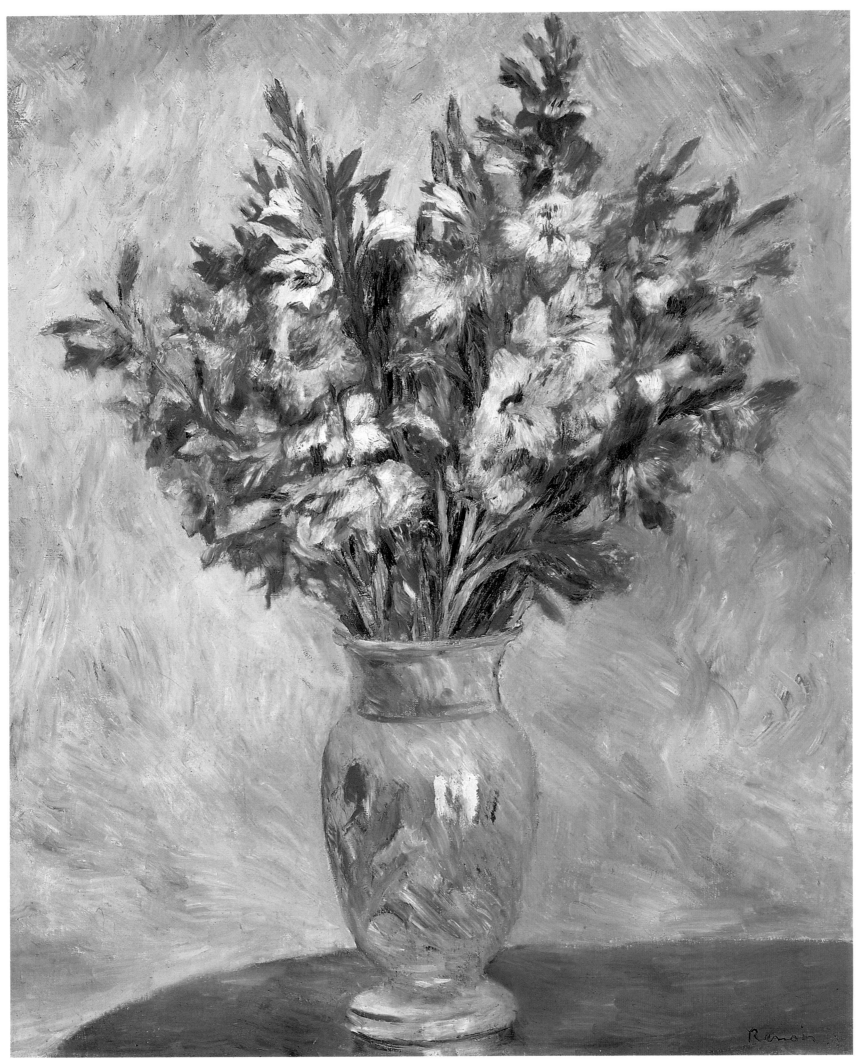

Gladioli. d. 1884. 26 x 21¼". Private collection, Chicago

La Roche-Guyon (Houses). 1885. 19 x 22″. Aberdeen Art Gallery and Museums

In late August, Renoir returned briefly to Paris and brought Durand-Ruel two recently completed La Roche-Guyon landscapes, which the dealer did not like. His subsequent letters to Durand-Ruel reveal his anxiety and fear lest he not please him:

I think that this time you will be pleased. I've taken up again, and this time for good, the old sweet and light way of painting. I want to come back only with a series of canvases, because, without hunting any more, I'm making progress on each one. It's completely different from my last landscapes [of La Roche-Guyon] and from the dull portrait of your daughter [*Mlle. Durand-Ruel Sewing*, 1882]. It's the fisherwoman [*Woman Fishing*] and the woman with the fan, with a slight difference caused by a tone that I couldn't find and that I did finally manage to lay my hands on. It's nothing new, but it's a sequel to 18th-century paintings. I'm not speaking of good ones. This is to explain to you more or less my new, latest technique (Fragonard but not so good).

I've just finished a girl sitting on a slope [*La Toilette*], with which I think you'll be pleased.

157

Woman Fishing. 1885. Pencil on paper, 24½ x 19½″. Private collection

Woman with Fan. d. 1886. 22 x 18″. The Barnes Foundation,
Merion Station, Pa.

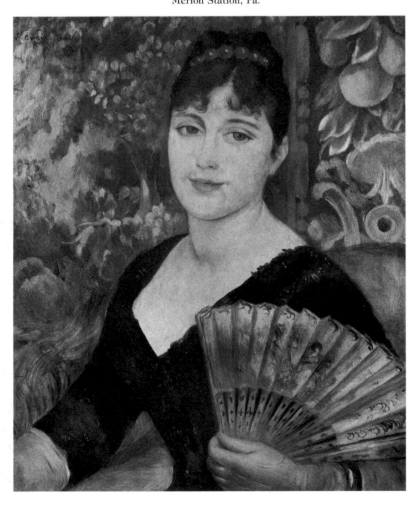

Believe me, I'm not comparing myself to an 18th-century master. But I have to explain to you in what direction I'm working. Those people who seem not to do nature knew more about it than we do.[36]

Renoir's quest for a light tone resembled his studies in Italy. His palette had become pale and dry and his surface chalky, smooth, and frescolike, despite the liquid pigment. In its subdued color, *Woman with Fan* recalls the ornamental and artificial hues of rococo decoration. Its model, as well as the model for *Girl Braiding Her Hair* and for *Bather Arranging Her Hair,* was Suzanne Valadon.

In September and October, Renoir stayed with Aline and Pierre in Essoyes. From there on October 4, he wrote to Bérard: "I've gone back to work with no enthusiasm because I'm completely alone, and I'm very much afraid of being broke this winter. Fortunately, I've spent others like it and this one will pass too."[37] He told Durand-Ruel: "I'm working and I have things in progress in the style of the Woman with Fan. I've had some pretty girls and children. I've started some washerwomen and two heads. A girl putting a very blond kid to sleep. I think it will work this time. It's very sweet and colorful, but light. I expect to bring it to you at the end of the week, and if that one goes, I have a flock of others to do."[38]

A subject that was to preoccupy Renoir for much of the remaining thirty-five years of his life—maternity and the relationship between mother and child—came to the fore between the fall of 1885 and the spring of 1886, when Renoir worked on three paintings of Aline nursing Pierre. He began by drawing small pencil studies of his son nursing, yawning, sleeping, and sitting. After Berthe Morisot came to visit him at 37 rue Laval in early 1886, she wrote in her diary:

Girl Braiding Her Hair. 1885. 22 x 18½″. Private collection

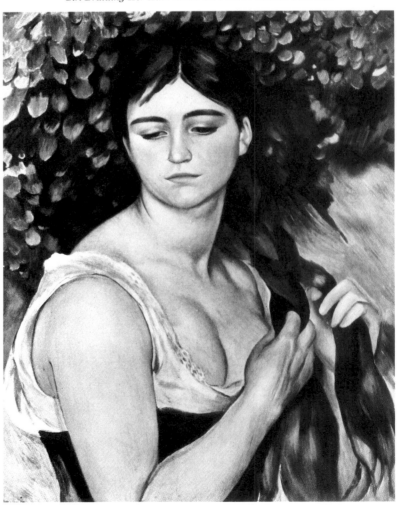

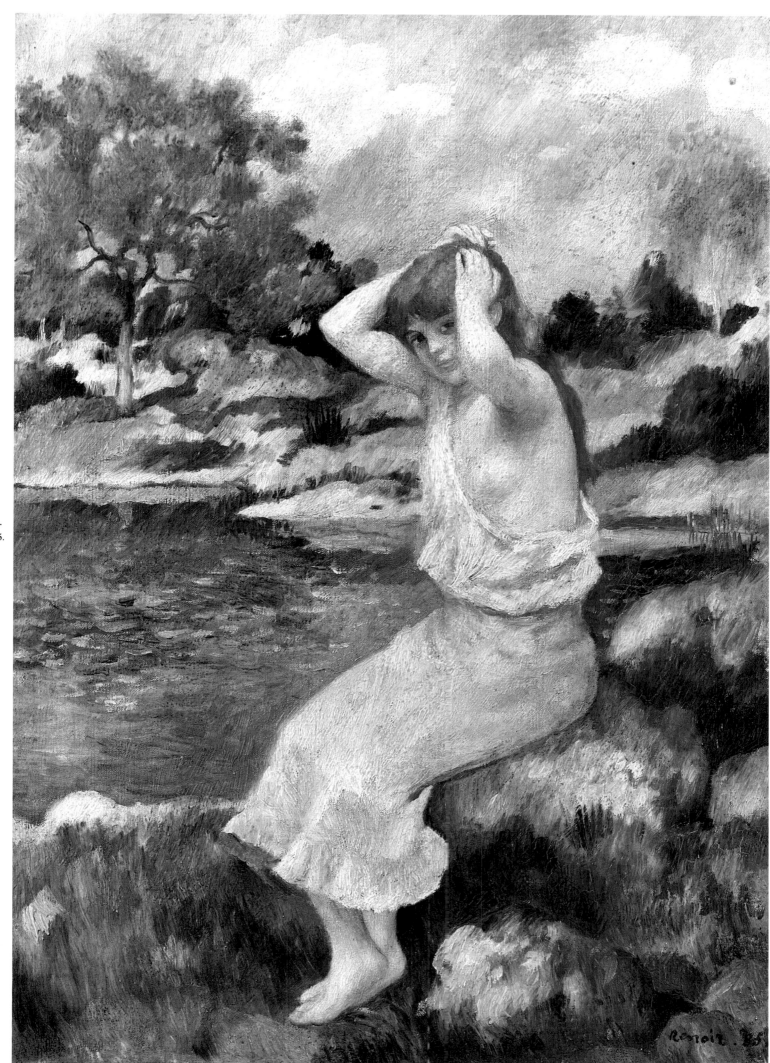

Girl Fixing Her Hair
(La Toilette). d. 1885.
20¼ x 14½".
Private collection

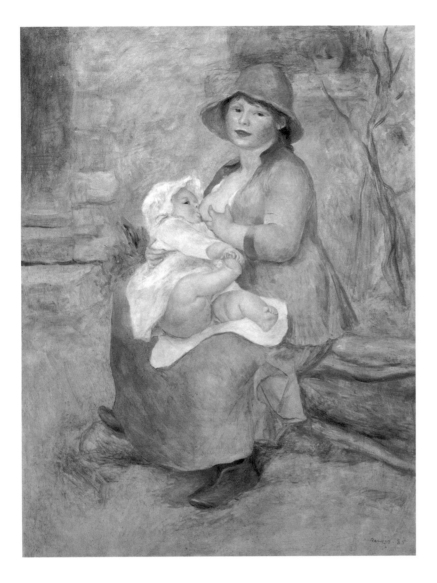

Visit to Renoir. On an easel, a drawing in red pencil and in chalk of a young mother nursing her child; charming in its grace and subtlety. Since I admired it, he showed me a series of them with the same model and almost in the same position. He is a first-class draftsman; all these preparatory studies for a painting would be interesting to show to the public, which generally imagines that the Impressionists work in a free and easy manner. I don't think that one can go further in the rendering of form.[39]

In these intimate drawings, he expressed his tender fatherly feelings more sensitively than in the paintings, where he focused on Aline's exposed breast and on Pierre's naked bottom, portraying the physical rather than the emotional relationship of nursing.

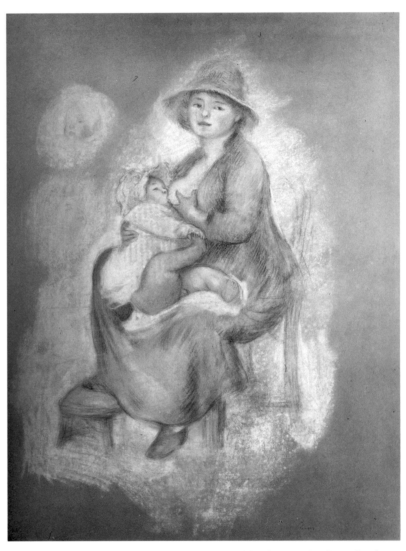

Nursing Composition with Two Infant Heads. 1886. Sanguine heightened with white chalk on beige prepared canvas, 36¼ x 28¾".
Musée de Strasbourg, France

The first painted version, which Renoir kept for himself, is the most rustic, with Aline seated on logs in front of a farmhouse with the rough-hewn stones for the doorstep and windowsill. Its light tints of earth tones suggest the delicacy of watercolor washes.

Between this version and the two later ones, Renoir made several

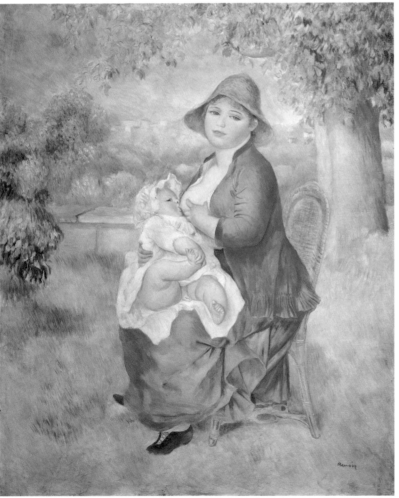

LEFT, ABOVE:
Nursing (first version). d. 1885. 32 x 25½". Private collection

LEFT:
Nursing (Aline Nursing Her Son, Pierre) (second version). 1886.
31½ x 25½". Private collection, Tokyo

OPPOSITE:
Nursing (Aline and Her Son Pierre) (third version). d. 1886. 29 x 21¼".
Anonymous loan to the Museum of Fine Arts, St. Petersburg, Florida

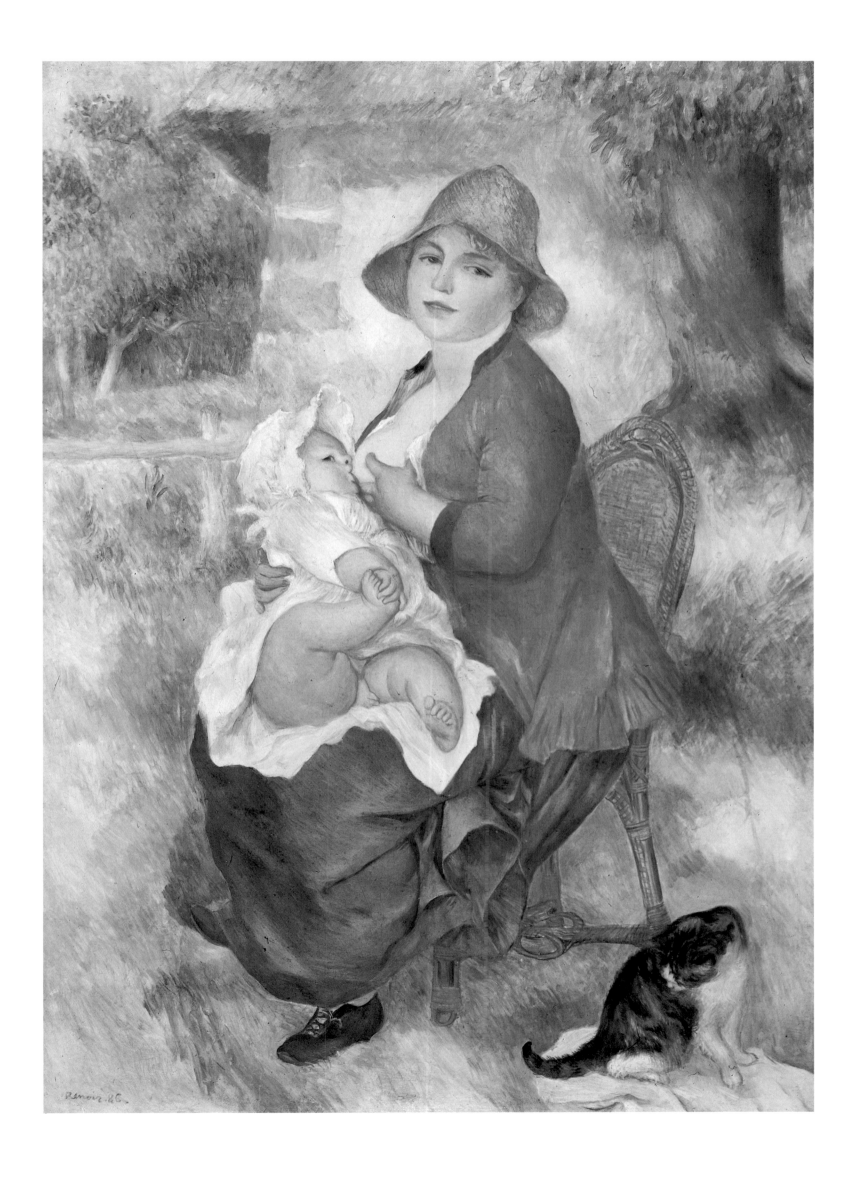

large compositional studies in which he introduced a wicker chair. In one he replaced the rock of the first painting with a rectangular footstool, perhaps inspired by Ingres's drawing of *Mme. Lethière.*

The second and third nursing scenes have an effect of the dry paint surface of fresco. The third, the most detailed of all, was completed in time for the important Exposition Internationale de Peinture et de Sculpture at the Galerie Georges Petit in Paris in June 1886. Consistent with his theory of Irregularity, Renoir here provides striking contrasts within the image: the idealized bodies of mother and child with their strong linear rhythm, smooth sculptural surface, and Classical pyramidal arrangement; the realistic details of cat fur, thatched roof, wicker chair, tiny toes and nails; the Impressionist landscape of trees and grasses with visible strokes and pervasive light. Yet the final effect is contrived and overworked. He gives evidence of sources ranging from Bouguereau's *Alma Parens* from the Salon of 1883 to Italian Renaissance portrayals of the Madonna and Child. The result is a jigsaw puzzle whose pieces do not quite fit.

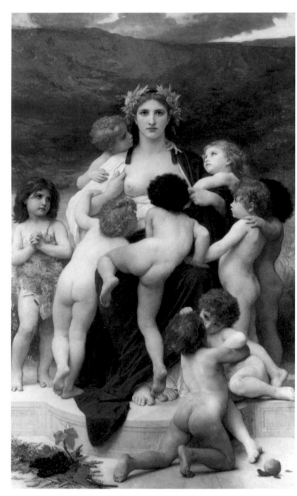

Adolphe-William Bouguereau. *Alma Parens.* d. 1883. 90¾ x 55″.
Collection Stuart Pivar, New York

The change from the key exhibition piece of 1876—*Moulin de la Galette*—to the key exhibition piece of 1886—*Nursing*—is and is not a quantum leap of style. The change in subject matter parallels Renoir's change from a carefree bachelor who celebrated modern Parisian life to a father isolated with his family in the country. The change in the treatment of the body reflects Renoir's growing interest in drawn and sculptural form—a gradual change beginning in 1878 with *Mme. Charpentier and Her Children* and continuing through the 1883 dance panels. While these are decidedly non-Impressionist directions of change,

in other ways Renoir sought to become more Impressionist—namely in the treatment of light. Throughout this decade, 1876–86, Renoir persisted in his earlier Impressionist concerns—the intense scrutiny of light and color in nature—the acknowledged and dominant element of Impressionist activity. Renoir's search was a constant theme in his letters of this period. He wanted to reproduce the brilliant light of nature in his canvases. In his search, he studied natural light and traditional art. Renoir saw no contradiction here between studying plein-air painting and museum study; indeed, he felt that the two methods complemented each other.

In a general way, Renoir's development paralleled Pissarro's at this same period. For four years, from late 1885 until 1890, Pissarro sought a lighter and brighter palette. His means of achieving this were very different from Renoir's. He allied himself with the younger artists Seurat, Signac, his son Lucien, and others, and embraced the somewhat scientific pursuit of Neo-Impressionism. He tried to enhance the luminosity of his paintings through a more regular brushstroke—the dot—and through a more systematic technique.

It is as if both Pissarro and Renoir, during roughly the same period, explored in a deliberate and self-conscious manner a mode that appeared to be quite different from their earlier concerns. Each artist disliked the new style of the other. Renoir's Irregularism differs in all respects from Pissarro's Pointillism except for the common striving to reproduce brilliant natural light within their canvases. By 1890, both Renoir and Pissarro had moved beyond their respective styles of the mid- and late 1880s. Hereafter, each artist combined his new explorations with his earlier style and arrived at a less strained compromise style. Neither artist had rejected—but both had transformed—Impressionism.[40]

Renoir returned to Paris late in October. He was feeling his age and did not sound like his former gregarious self when he wrote to Bérard: "I am frightened at how fast time goes by when one gets to be our age.... I haven't seen Deudon.... One should not neglect friends, who are becoming scarce, and I assure you that those I have mean a lot to me, and I don't much feel like making new acquaintances. There comes a time when it's impossible to be comfortable with new faces. One must study the newcomers, and that's tiring. What's good is to know each other's faults and to forgive them and even like them. I'm speaking of other people."[41]

Living expenses in the capital were high, and Renoir's income was low. Pissarro, Monet, and Sisley were all similarly destitute. Durand-Ruel, close to ruin, could not get a loan. At this disastrous juncture, the dealer's judgment was called into question. He accused his rival, Georges Petit, of exhibiting a forged Daubigny painting. When Petit asserted that he had bought it from the artist, Durand-Ruel retracted his statement. Ironically, the painting soon proved not to be by Daubigny, but doubt regarding Durand-Ruel's competence lingered. In the same letter to Bérard, Renoir wrote: "Durand-Ruel is in more trouble than ever, ganged up on by the other art dealers.... Durand's death agony is protracted and painful. I don't dare to leave the premises, but I'm not saying that I won't drop in on you one day next week. I hope so without daring to believe it. I'd also like to see Goujon first."[42]

Dr. Étienne Goujon, senator from Ain, had commissioned portraits of his four children. Renoir gave each of the two older boys, eleven-year-old Léon and ten-year-old Pierre, a sculptural masklike expression reminiscent of Cézanne's head of *Louis Guillaume.* He also painted nine-year-old Marie and five-year-old Étienne. In these out-

door portraits he again contrasted a linear, sculptural, and Realist figure with an Impressionist landscape. The pale, chalky colors give the children a dull solemnity. These are timeless icons, immortalizing the children of wealth.

In early November, Renoir visited Bérard at Wargemont, where the friends discussed Durand-Ruel's published statement about the false Daubigny.[43] "I have such a fear of the power of the press," Renoir wrote Durand-Ruel, "that I was afraid out of friendship for you, knowing the way that words can be twisted." He assured him of his support and expressed his appreciation for the dealer's "true quality, the love of art, and the defense of artists before they die. In the future this will be your glory, since you are the only one to have thought of this natural thing."[44]

Renoir continued to have money problems. In January 1886, Pissarro wrote to Lucien: "I don't understand anything any more, Renoir and Sisley are penniless."[45] A few days later he related that Durand-Ruel had "not even 20 francs to give me.... I know that Monet, Sisley, and Renoir don't get any more than I do."[46]

In a desperate effort to earn something, Renoir agreed to send paintings to three exhibitions in 1886. (However, he did not participate in the eighth Impressionist group show, which took place from May 15 to June 15, 1886.) The works he chose confirmed his long-held opinion that it was safest to exhibit old work, preferably pictures that had already been shown or that were in prominent collections.

The first exhibition, in February, in Brussels, was with Les Vingt, an avant-garde group that included James Ensor and Théo van Rysselberghe. Others invited included Monet, Whistler, Odilon Redon, and from America, William Merritt Chase. In the course of four letters to Octave Maus, the secretary of the group, Renoir proposed slightly different selections of paintings, primarily portraits. He never suggested any still lifes or landscapes. The eight works that he finally sent were *Mme. Charpentier and Her Children* from the 1879 Salon; *Yvonne*

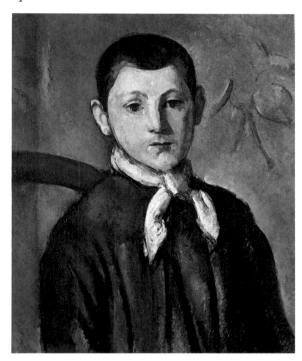

Paul Cézanne. *Louis Guillaume.* c. 1882. 22 x 18⅛".
The National Gallery of Art, Washington, D.C.
Chester Dale Collection

Grimprel from the 1882 Salon; *City Dance* and *Country Dance* from the 1883 Durand-Ruel show; *Among the Roses (Portrait of Mme. Clapisson)* of 1882; an unidentified nude; and Margot Bérard as a fishergirl

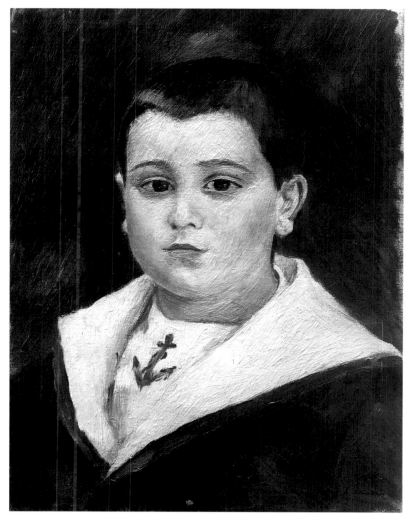

Pierre Goujon. 1885. 16⅛ x 13". Private collection

(1879). At the last minute he decided to include one work in his new style, the 1884 portrait of Lucie Bérard.[47]

The Belgian press gave little coverage to Renoir's work. Two critics were negative: "One glance at his paintings is enough...to see how meager this gaudy palette is"; and "M. Pierre-Auguste Renoir is not the one who will save the rest of them."[48]

In October 1885, Durand-Ruel was planning his New York show for the following spring. Renoir had little hope for its success and advised his dealer: "I want to tell you that it might be better to send the Americans some things a little older than these panels [the 1883 dance panels], such as the Boaters [*The Boating Party*], the Loge [*At the Concert*], and the Mussel Fishers [*Mussel Fishers at Berneval*]. That might produce more of an effect since there must be a jury there too, perhaps no more intelligent than the one in our own blessed country."[49] Durand-Ruel did choose mostly older works, including those that Renoir suggested.

The New York show—"Works in Oil and Pastel by the Impressionists of Paris, 1886"—opened on Madison Square South on April 10.[50] It contained the largest number of Impressionist works ever assembled anywhere before: 310 by 32 artists, including 50 paintings by Monet, 42 by Pissarro, and 38 by Renoir. Most of Renoir's paintings were from Durand-Ruel's stock: 14 genres, 6 nudes, 8 portraits, 6 still lifes, and 4 landscapes. The catalogue, written by Duret, included reprints of favorable reviews about the artists, among them Octave Mirbeau's article about Renoir of December 1884, where Mirbeau wrote: "I don't understand why all women don't have their portrait painted by this ex-

163

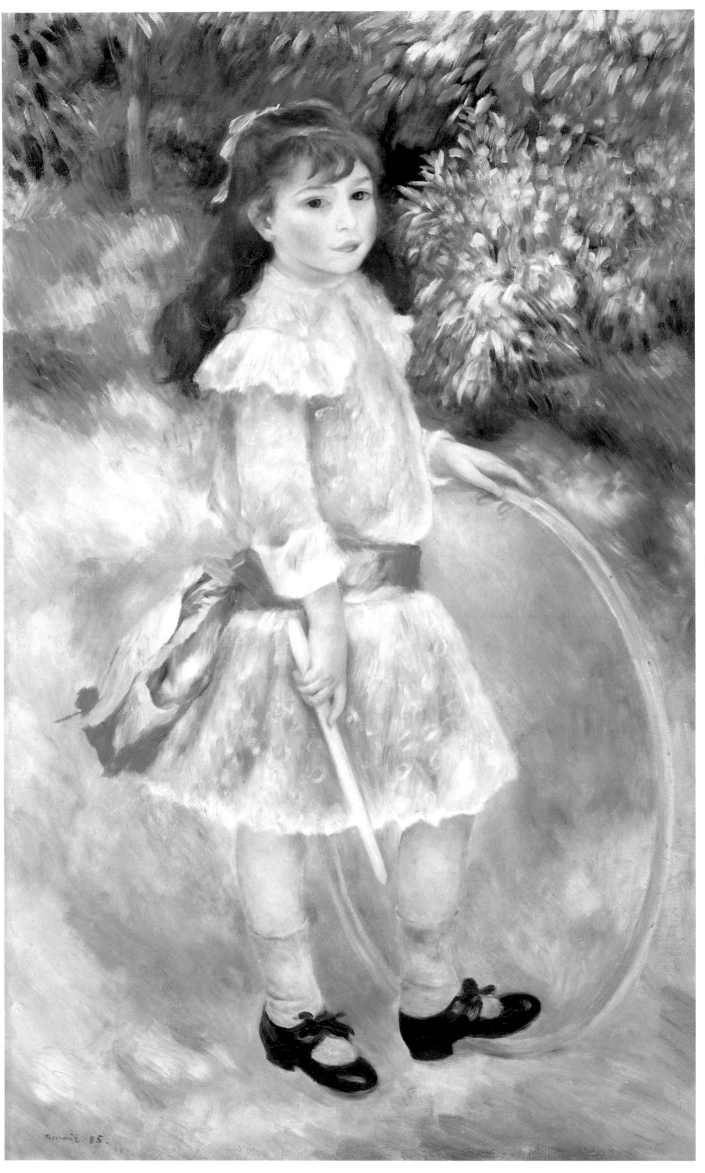

Girl with a Hoop (Marie Goujon).
d. 1885. 49½ x 30⅛".
The National Gallery of Art,
Washington, D.C.
Chester Dale Collection

quisite artist, who is also a keenly sensitive poet."[51] Because of the show's popularity, Durand-Ruel arranged for it to reopen on May 25 for a second month, at the National Academy of Design.

It prompted many reviews in the New York press. Reactions to Renoir's works were mixed, as in the *New York Times*: "There is Renoir's 'Déjeuner à Bougival' [*The Boating Party*], a capital study of French faces and forms, and half a dozen works of the same artist, in which the conventional Frenchman and Frenchwoman are depicted with fidelity and comparative sobriety of color.... [Renoir's] drawing in 'Au Cirque' [*Two Little Circus Girls*] is as bad as his color is unnatural and ugly, and... [his] portrait of Wagner is more suggestive of a possible chromo-lithographic frontispiece to the song of 'Grandfather's Clock' than of the great composer."[52]

By the close of the show, Durand-Ruel had sold six of Renoir's paintings for 9,900 francs (equivalent to about $1,980). Two American collectors were interested in Renoir's work. A. W. Kingman bought four still lifes: *Gladioli* (1884) for 600 francs, *Flowers and Cats* (1881) for 2,500 francs, and two others, probably *Peonies* and *Flowers*, for 500 and 800 francs, respectively. Albert Spencer bought two figure paintings: *After the Bath* (an unidentified nude which Renoir referred to as "a naked woman crouching")[53] for 2,500 francs and *Among the Roses (Portrait of Mme. Léon Clapisson)* for 3,000 francs. To Durand-Ruel and to Renoir, these sales were most encouraging, even though they fell far short of prices obtained by Bouguereau, whose figure paintings had sold in New York in 1886 for $9,000, $6,500, and $3,050.[54]

Durand-Ruel reported to Fantin-Latour: "Do not believe that the Americans are savages. On the contrary, they are less ignorant and less conservative than our French art lovers. I have been very successful with paintings that took me twenty years to get people to appreciate in Paris."[55] He planned a second New York show for December, and opened a branch of his gallery there in 1888.

The 1886 show in New York proved to be a turning point in Impressionist sales, and the United States market was soon increasingly important. It is ironic that the Impressionists' first successes occurred in America; it was not until around 1890 that the French market began to value Impressionist art.

Despite his New York sales, Renoir continued to be short of money. In the fall of 1886, to save money on rent, he moved his Paris studio from 37 rue Laval to 35 boulevard Rochechouart near the Sacré-Coeur. "I have moved and... I'm delighted. 1,200 [francs] instead of 3,000," he exulted to Bérard.[56]

As the New York show was coming to a close, Georges Petit's fifth Exposition Internationale de Peinture et de Sculpture opened on June 15 in his elegant Paris gallery at 8 rue de Sèze. Even though Monet was exhibiting, Renoir felt uncomfortable about participating. When he asked Bérard to lend the portraits of Mme. Bérard (1879) and of Lucie (1884), he mentioned that he was taking part "unenthusiastically," because he found it "ridiculous at this moment."[57] Renoir's embarrassment was threefold: Petit was Durand-Ruel's chief rival, so Renoir felt disloyal to his dealer; Petit's international exhibitions were the sanctuary of academic painters, such as Raffaëlli, Jean-Charles Cazin, and Albert Besnard (yet these were members of the academic avant-garde); and *Mme. Charpentier and Her Children* was again to be displayed. Renoir wrote Mme. Charpentier in the spring: "I have just learned from Monet that I am part of the exhibition at Petit's for which you made so many efforts on my behalf, which means that your portrait is going to be taken down again since it is the only thing

that got me accepted."[58] Besides these three portraits and the portrait of *Mme. Clapisson* from the Salon of 1883, he included one recent painting, the third version of *Nursing*, done in his new Irregularist style.

This new style received good and bad reviews. Mirbeau was favorable: "Admire his *Woman and Child*, whose originality evokes the charm of the Primitives, the precision of the Japanese, and the mastery of Ingres."[59] Two days later Renoir thanked Mirbeau: "I have just read your courageous article on the front page of *Le Gaulois*. You do me the honor of putting me next to the two greatest artists of the period [Rodin and Monet]. I'm not being a smart aleck. I am very proud of it and very grateful to you for the renewed courage you give me to prove to everybody at the next exhibition that you are right."[60] (Renoir was already working in a similar manner on *The Bathers* for Petit's show of the following year.)

While Mirbeau was complimentary about Renoir's Irregularism, Fénéon was not: "Renoir... should have kept [the style of] his good canvases... [from his] previous exhibitions."[61]

Most important, Durand-Ruel also disliked the style of *Nursing* (third version). Soon after he returned from New York on July 18, he visited Petit's. Pissarro reported his reaction: "Durand has been to Petit's, he has seen the Renoirs, and he doesn't like his new style at all, but not at all."[62]

Presumably, Durand-Ruel conveyed his opinion to Renoir. Nonetheless, he asked him to prepare new figure paintings for the second New

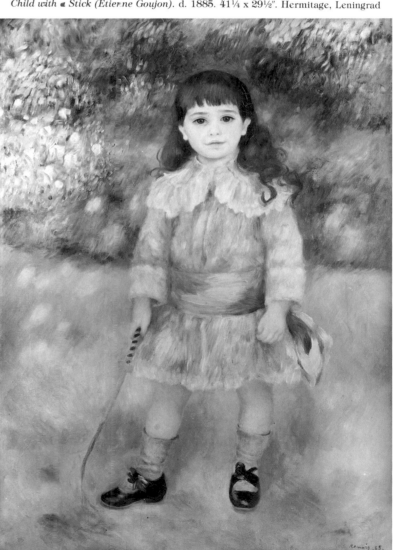

Child with a Stick (Étienne Goujon). d. 1885. 41¼ x 29½". Hermitage, Leningrad

York show that he was planning for December. Even though Renoir preferred to exhibit older works, he complied with his dealer's request. In September, he wrote from La Chapelle-St.-Briac: "I am going to try my best to give you something before you leave. As soon as I have the exact measurements, I'll let you know them for the frames,"[63] and again, "I'm in the process of finishing 2 paintings with figures for you... so that you can take them."[64]

When Renoir brought these new paintings to Durand-Ruel, on his return to Paris in October, the dealer did not like them. This, combined with his own doubts, led Renoir for the first and only time in his life to destroy a body of his work—all the paintings that he had done during the past few months. On October 15, he explained to Monet: "When I got to Paris, I scraped everything off the canvases over which I'd grown old and where I thought I had found great art like Pissarro [a sarcastic reference to Pissarro's Neo-Impressionism]. In spite of it, I'm happy, especially to be in Paris. I think Montmartre will be less cruel to me than the sea, and that in spite of all my disasters I'll have a fine exhibition [at Petit's in 1887]."[65] Surprised by Renoir's rash deed, Monet wrote to his wife: "Once he was back in Paris, he [Renoir] scraped off everything he had brought back from Brittany."[66] A few days after he wrote to Monet, Renoir related to Bérard: "I'm working ...since Durand keeps telling me canvases, canvases...canvases, and the canvases don't come because I scraped everything off. Nevertheless I believe I'm going to beat Raphael and that people in the year 1887 are going to be amazed."[67]

There is no evidence that Durand-Ruel took any recent Renoir works to his second New York show, which was postponed from December to May 25, 1887. Of the seven Renoirs listed in the catalogue, three were from his travels: *Algerian Girl* (1881), *Young Algerian Girl,* and *Fruits of the South.* The other four appeared under vague titles that make it difficult to identify them: *Child with Orange, Head of Young Woman, Near the Lake,* and *Old Songs.* But this was not essentially an Impressionist exhibition; it included a broad range of French artists, including past masters (Delacroix, Courbet, Théodore Rousseau), Salon artists (Cot, Henner, Meissonier, Jean-Léon Gérôme), and nonacademic masters (Puvis de Chavannes, Monet, Pissarro, Sisley, and Renoir). Eclectic as it was, this New York show drew many visitors, but because of problems of tax exemptions, Durand-Ruel was forbidden to sell any of the works on exhibit.[68]

Renoir's expectations for success at Petit's 1887 show back in Paris rested on *The Bathers* of that year.[69] He had told Mirbeau in June 1886 that he expected "to prove to everybody at the next exhibition that you are right,"[70] and in his October 18 letter to Bérard, he jokingly outlined his goal: to "beat Raphael."[71] *The Bathers* was important to him because it represented his most deliberate and most ambiguous stylistic change of direction to date and exemplified his cherished theory of Irregularism. With its new and transitional elements and its echoes of the past, it is a pivotal work.

Like *Le Moulin de la Galette* and *The Boating Party, The Bathers* was conceived as a large-format exhibition piece of many figures outdoors. And like them, it was a culminating work, the most ambitious painting in a style he had been working in for several years. Also as he had done for these past masterpieces, Renoir lavished a great amount of time on its preparation. More than twenty extant preparatory drawings suggest that he struggled for a long time with posture, form, composition, and technique. The studies executed after light-haired Aline and dark-haired Suzanne Valadon attest to much experimentation in medium,

support, dimensions, and number of bathers. In addition, he made drawings of the foreground tree and of the drapery under the left nude.

The dominant characteristic of *The Bathers* is its realistic treatment. The middle-class patrons at Petit's encouraged this direction. As Pissarro remarked to his son two months before the exhibition: "Duret... said to me: 'A-ha, so you're going to exhibit [at Petit's]. But, you know, you should consider it as a business matter. It's a stupid, stupid milieu! Concessions, make concessions.'"[72] Just before the opening he wrote: "I've had a lot of trouble with this damned exhibition, which stinks of the bourgeoisie.... But you have no idea how one is a slave in that milieu, and how easy it is for the powerful to interfere with the freedom of others."[73] Renoir tried to satisfy this taste with the two figures at left, which are reminiscent of such academic nudes as Bouguereau's *Nymphs and Satyr* in the minute realism of form, the artificial and complicated posture that calls attention to the breasts, the intricate composition, and the glossy, meticulous execution.

The obvious eclecticism of *The Bathers* also ties it to contemporary taste. Like Renoir's Salon submissions of the mid-1860s through the early 1870s, it refers to well-known artwork—here specifically to famous groups of nudes. Another important source for *The Bathers* was François Girardon's *Nymphs Bathing,* an iron bas-relief in the Allée des Marmousets at Versailles. It inspired two of Renoir's large preparatory studies: the pastel study *Nine Nude and Clothed Bathers* and the oil *Four Nude and Clothed Bathers.* In the final painting, an echo of Girardon remains in the theme, postures, and composition.

Ingres's nudes were also important models for *The Bathers* in the precise outline that separates the figures from their setting, in the play of shapes (especially the areas under the arms, necks, and legs), and in the combination of linear, Classical, and Realist form. The postures of Renoir's bathers are calculated to draw attention to the edges of the form: the reclining nude seems derived from *La Grande Odalisque,* while the light-haired bather resembles *La Source.* The contrived postures of the two bathers on the left may also have been inspired by the two foreground nudes of Ingres's *The Turkish Bath.*

Often Ingres distorted the anatomy of his nudes to create a graceful arabesque; in like manner, Renoir contorted the back and feet of the left bather and attenuated the right leg of the central figure, giving abstract decorativeness precedence over representational accuracy and creating rhythmical silhouettes that are effective as surface design.

A similarity in drawing technique is also apparent between Ingres's *Preparatory Drawing for The Grande Odalisque* and Renoir's *Sheet of Studies Related to the Reclining Left Nude.* In fact, after Renoir showed Morisot drawings of bathers in January 1886, she remarked in her diary, "Two drawings of nude women going into the sea delight me as much as those of Ingres."[74]

Still another goal Renoir had for *The Bathers* was to capture some of the qualities that he had admired in the Raphael and Pompeian frescoes, where a study of "sunlight" helps bring out "the great harmonies" and the feeling he was seeking of "grandeur and simplicity."[75] He wanted it to resemble a fresco. But Renoir was not interested in the actual fresco technique. Here, as in other works of the mid-1880s, he did not use a white plaster undercoating,[76] as he had with the MacLean cement in 1877. Instead, he began with a white lead oil ground, then he painted the porcelain-smooth flesh tones, and finally, he added the Impressionist landscape background. Renoir did achieve a dry, light surface, yet in the process, he created a pervasive anemic orange tone, which has often been referred to as "acid" or "sour."

THE BATHERS

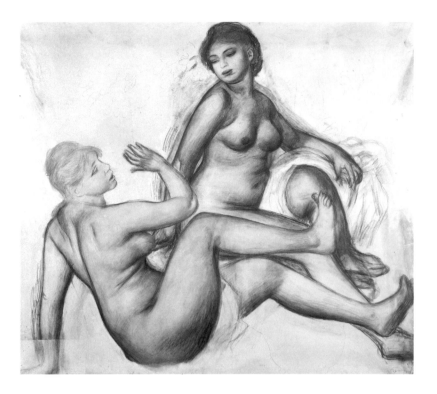

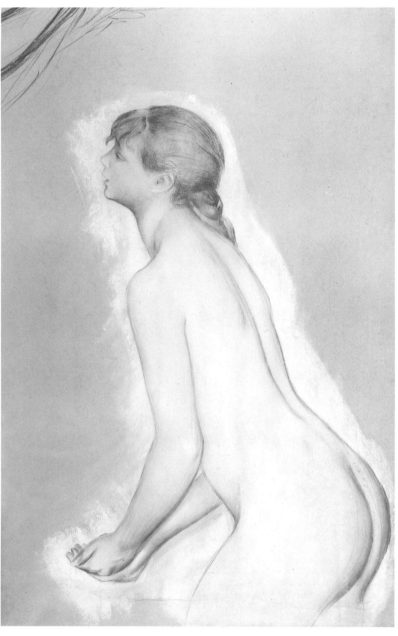

Study of Splashing Nude. c. 1886–87. Pencil, black, red, and white chalk touched with wash on brown cardboard, 38¾ x 25¼".
The Art Institute of Chicago. Bequest of Walter and Kate S. Brewster

RIGHT, ABOVE:
Study of Two Left Nudes (originally connected to next drawing). c. 1886–87.
Red chalk on yellowish paper, 49¼ x 55⅛". The Fogg Art Museum, Harvard
University, Cambridge, Mass. Bequest of Maurice Wertheim

RIGHT:
Study of Three Right Nudes with Part of Foot of Reclining Left Nude (originally
connected to preceding drawing). c. 1886–87. Red and black chalk heightened
with white on yellowish paper, 34½ x 20½". Private collection

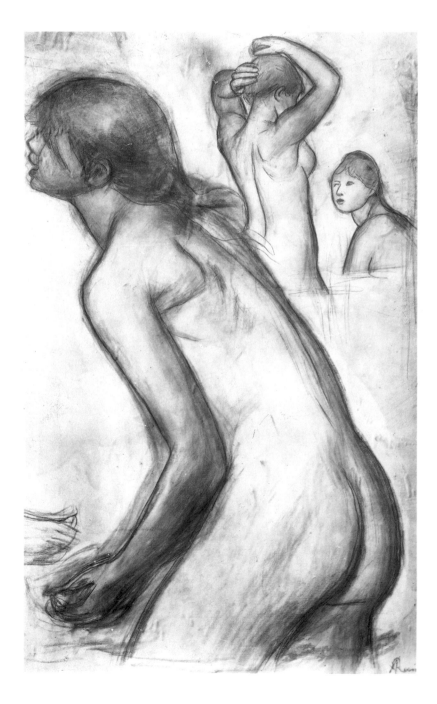

Study of Nine Nude and Clothed Bathers. c. 1886–87. Pastel, 25½ x 38½".
Private collection

Study of Four Nude and Clothed Bathers. c. 1886–87. 24⅔ x 37⅝".
Private collection

Sheet of Studies Related to the Reclining Left Nude (thigh, drapery, head, and
shoulders). c. 1886–87. Pencil on paper, 8⅜ x 13⅝". Private collection

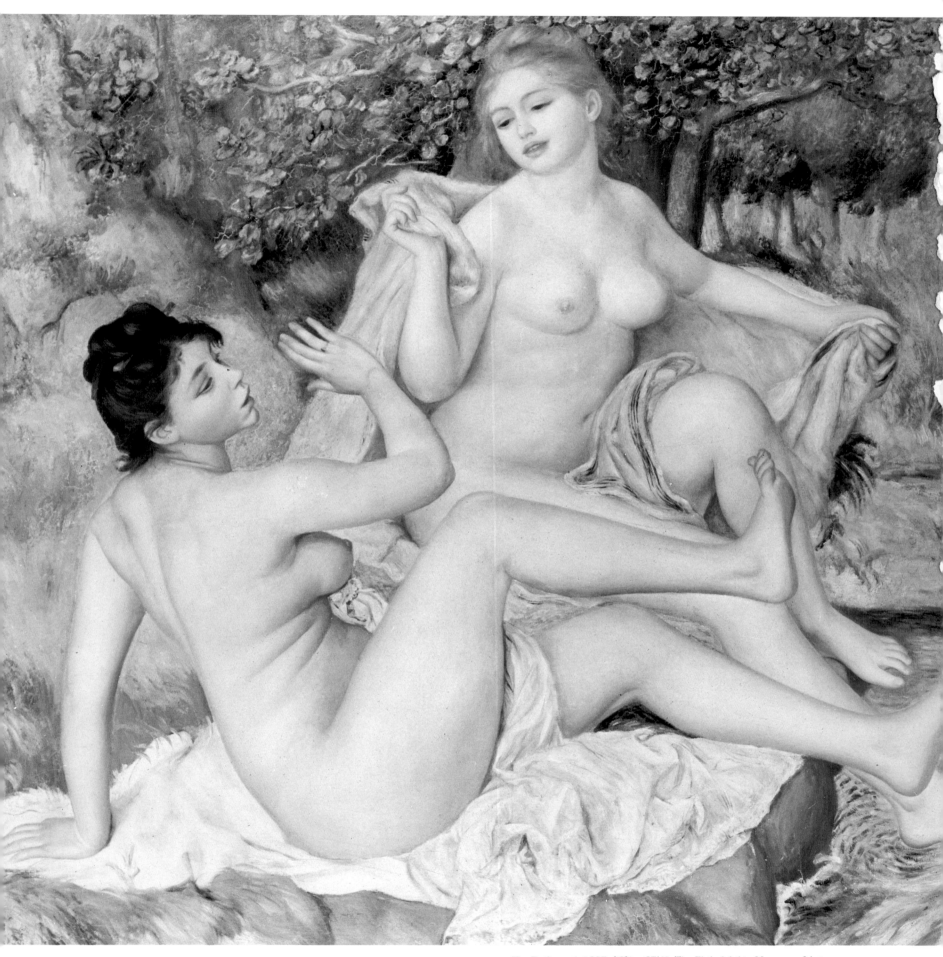

The Bathers. d. 1887. 46⅜ x 67¼". The Philadelphia Museum of Art.
Bequest of Carroll S. Tyson, Jr.

Study of Flowering Tree over Central Nude. c. 1886–87 India ink on canvas,
21¼ x 25½". Private collection

François Girardon. *Nymphs Bathing.* 1668–70. Iron bas-relief.
Allée des Marmousets, Versailles

In his attempt to capture the effect of a fresco, he may have been inspired by the frescolike techniques used by Puvis in his oil painting *The Sacred Wood Dear to the Arts and the Muses.* This mural had been a success at the Salon of 1884.[77] In subtitling *The Bathers* "Attempt at Decorative Painting," Renoir seems to have been looking for a mural commission himself.

The Bathers is a compendium too of Renoir's own earlier treatment of nudes. For over twenty years the nude had been a minor theme in his art, but henceforth it would become one of his favorite subjects. After Renoir's visit in January 1886, Morisot recorded in her diary, "He tells me that the nude seems to him to be one of the indispensable forms of art."[78] In *The Bathers,* Renoir's first group composition of nudes, many figures seem to echo past paintings: the two bathers at the left recall *Diana* (1867); the swimming midground figure and landscape, *Nude in the Sunlight* (1876); the central foreground nude, *Blond Bather* (1881); and the left foreground nude and midground standing nude, *Bather Arranging Her Hair* (1885).

Jean-Auguste-Dominique Ingres. *The Turkish Bath.* d. 1862. Diameter 42½″. Musée du Louvre, Paris

Finally, in *The Bathers,* Renoir attempted to carry out his 1884 credo of Irregularity. Although the style is close to the third version of *Nursing,* his problem here was more complex. In order to relate five figures in two planes, he established contrasts on left and right as well as near and far. The forms on the left side and foreground are linear, realistic, and Classical; on the right side and in the distance they are Impressionist. But the figures do not relate to one another or to their setting in a natural or comfortable fashion. He also varied the landscape: the leaves of the nearer trees are precisely defined while the remote trees are sketches.

With such complex intentions, it is no wonder that, in the end, Renoir created a stilted, labored exercise that lacks stylistic unity. Among his great exhibition pieces, it is the least successful work. It failed because Renoir tried to do too much: to satisfy the bourgeois audience at Petit's, to follow traditional masterpieces, to sum up his earlier ways of treating the nude, and to follow his credo of Irregularity.

At first Renoir thought that *The Bathers* was a success. On May 12, 1887, four days after Petit's show opened, he wrote Durand-Ruel, who was in New York: "The Petit exhibition ... is quite successful, they say. Because it's hard to find out for yourself what's going on. I believe I've

made a step forward in the public esteem, a small step. But it's still something.... In short, it looks like the public is coming. I may be wrong, but that's what they're saying on all sides. Why this time and not the others? It's impossible to understand."[79]

A few of Renoir's friends applauded. The next day Monet wrote Durand-Ruel: "Renoir has done a superb painting of his bathers, not understood by everybody, but by many."[80] Wyzewa probably personally complimented him when they met at one of Morisot's dinners. Two years later he wrote: "*The Bathers* ... will remain a testimony of these years of experiment and hesitation. I cannot forget the supernatural emotion that was aroused in me by this painting, simultaneously sweet and strong, this delicious mixture of vision and dream. The effort of so many years leads to a triumph. M. Renoir finally grasps, never to let it go, this pure and knowing beauty of form, whose secret he is the only one among us to know."[81]

However, Renoir soon learned that unfavorable opinions were numerous. Pissarro implied that Renoir had again painted in the inferior style of the third version of *Nursing*: "As for Renoir, the same lapse—I

Jean-Auguste-Dominique Ingres. *Preparatory Drawing for The Grande Odalisque* (detail). c. 1814. Pencil on paper, Musée du Louvre, Cabinet des Dessins, Paris

am well aware of all the effort involved; it's very good not to want to stay in the same place, but he has only cared to be concerned with line, the figures stand out one against another without taking their relations into account, and so it is incomprehensible. Renoir, not having the gift of drawing and without the pretty colors that he used to feel instinctively, becomes incoherent."[82] On the following day, Pissarro wrote that Bracquemond "has been, however, a little harsh on Renoir, but still he finds some bits of his large painting very well drawn—I agree with him about these bits; what is faulty is the whole, the synthesis, and this is what they [Renoir, Monet, and Wyzewa] don't want to understand!"[83]

Four critics were negative: Jules Desclozeaux wrote about "M. Renoir's *simplistic* works";[84] Alfred de Lostalot mentioned "some Bathers that one would think copied from an old tapestry";[85] Astruc "fulminated against the backsliding of the Renoirs;"[86] and Huysmans called Renoir "old-fashioned."[87]

All these poor evaluations caused Renoir to question the new direction of his work. With so much of himself invested in *The Bathers,* he was devastated by the lack of appreciation it elicited. Nor did he achieve the financial rewards of which he dreamed. *The Bathers* did not sell until 1889, when Jacques-Émile Blanche bought it for a mere 1,000 francs. With his expectations once again dashed, Renoir soon changed his style. In late 1887 and during 1888 and 1889, he slowly

moved away from his hard-sought Irregular style; he dropped the realistic aspects and eliminated the affected postures.

In June 1887, as in January of the year before, Pissarro continued to complain from Éragny to Lucien in Paris about his own lack of money and to declare: "It is beyond me how Sisley and Renoir get along."[88] Feeling destitute, Pissarro, Monet, and Sisley decided to sell their paintings to Durand-Ruel's competitors. Renoir wrote to Bérard in September: "Everyone is selling paintings to [Adolphe] Goupil, even Pissarro. I am dead set against it, I don't know whether I'm right or wrong."[89] He continued, "I'd rather wait.... Besides, I'm feeling very good. Life is much more fun when you have to worry about money coming in. It stirs you up. You don't have time to get bored."[90] In spite of his poverty, Renoir remained faithful to Durand-Ruel—the only major Impressionist who did[91]—and he also maintained a very close personal relationship with him.

His dwindling popularity meant that Renoir had few portrait commissions at this time. The only one in 1886 was the pastel *Young Girl with a Rose*. In 1887 he made a pastel of Madeleine Adam. He was also commissioned by Berthe Morisot to do an oil of her eight-year-old daughter, Julie Manet, during the summer of 1887 in her Paris house on rue Villejust (now rue Paul Valéry). Since Renoir gave Morisot the complete set of five preparatory drawings, we can reconstruct the transformations of the young girl's appearance. He began by recording his direct observation; the rounded shapes are presented straightforwardly and simply. By the fourth drawing, he arrived at the formalized abstraction that appears in the painting. He purposely modulates the

Madeleine Adam. d. 1887. Pastel on paper, 23⅝ x 18⅞". Private collection

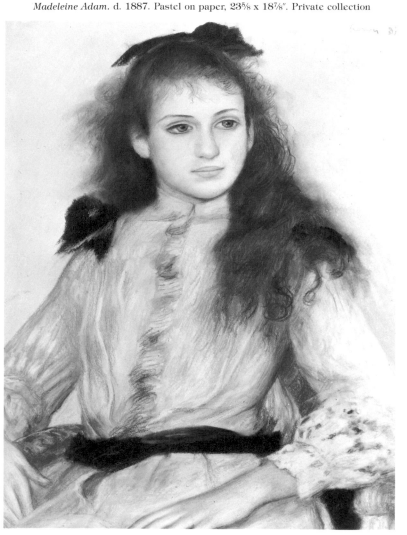

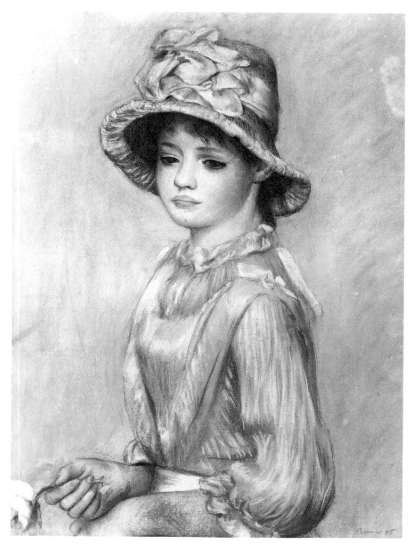

Young Girl with a Rose. d. 1886. Pastel on paper, 23½ x 17¼".
Private collection

size, shape, and direction of every line so that there is rich variation from the heart-shaped face, to the angular area between the two points of her collar, to the tapered shape of her neck.

In 1963, eighty-five-year-old Julie Manet Rouart recalled the steps in the painting of her portrait. First Renoir primed the canvas with a white lead ground. Once the ground was dry, he took the tracing and applied sanguine on the reverse side of the traced outlines. Next he placed the tracing in its correct position on the dry canvas, sanguine side down. Now he followed the outline of his drawing with a hard pencil. In this manner, he was able to transfer the exact silhouette of the face and collar from the last preparatory drawing onto the primed canvas. This new and direct use of the preparatory drawing in the procedure did not allow for spontaneity since Renoir retained the exact linear relationships that he first worked out in the drawings.

Mme. Rouart recalled that Renoir painted her portrait with oils "bit by bit, one day my head and a little of the background, another day my dress and the cat." This controlled procedure resulted in a separation of hue areas. She recalled that to retard drying during the execution he used to leave the painting in their damp cellar overnight. Renoir's Ingrist procedure did achieve the transparent and muted effect he sought. Unfortunately, the underpainting began to crack some time after the work was completed.[92]

Renoir also painted his family. *Aline and Pierre (Washerwoman and Baby)* shows Aline kissing their son while friends hang out laundry. (A

Julie Full Face. 1887. Charcoal and pencil on paper, 23 x 17″. Private collection

Julie, Cat, and Background. 1887. Crayon on paper, 24 x 18¼″.
Private collection

pastel and a painted version exist in identical sizes. Here the drawing is more carefully finished than is the painting.) In *Garden Scene,* Aline sews, Pierre stands nearby, and a second woman comes home from market. Renoir's colors are no longer pale and dull. Instead, he has returned to the rich and liquid palette of 1881–83. Black outlines around some of the rose leaves and some of the pears recall the foreground tree of *The Bathers. Artichokes and Tomatoes* (p. 184) has similarly precise definition of individual pointed leaves and a vibrant color scheme.

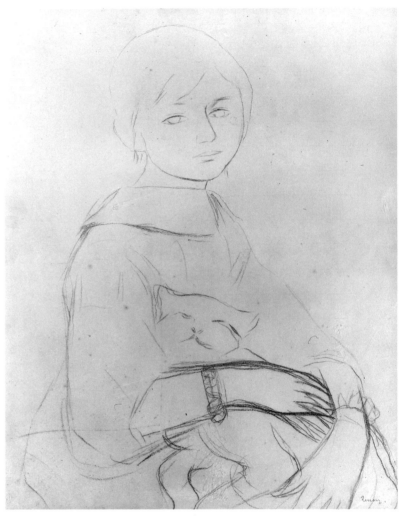

Julie Three-Quarters with Cat. 1887. Charcoal and pencil on paper, 24 x 19″.
Private collection

In June 1887, Pierre, then two years old, had a foreskin operation. Renoir expressed concern for his son in a letter to his old friend Dr. de Bellio, who had treated Margot eight years before: "I am worried about the time that it's taking [to heal] and perhaps you can give us some advice. My cleaning woman is bringing you this letter."[93] To Murer, he reported: "As for my kid, everything is going well, even though it's still not over, because it is necessary to wait till the stitches fall out by themselves, which takes a long time."[94]

In September, Renoir happened to meet Pissarro while on a visit to the Murers with Aline and Pierre. The two artists had been at odds for quite a while, partly because neither liked the other's recent style. Pissarro related to Lucien: "Big argument about dots [i.e., Pointillism]! . . . Renoir added: 'You've given up dots, but you don't want to admit that you were wrong!' I answered Renoir, very agitated . . . 'My dear fellow, I haven't reached that degree of senility. . . . As for you, Renoir, you follow your whims, but I know what I'm doing!' . . . I had thought

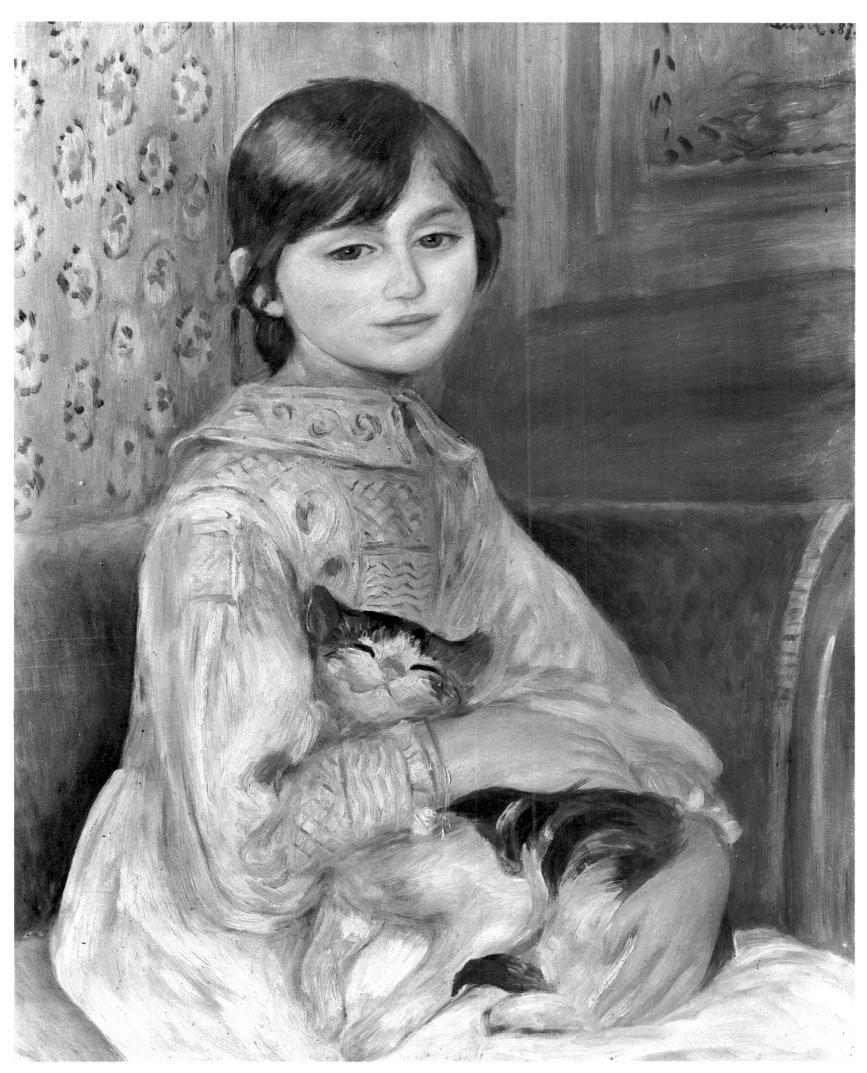

Julie Manet. d. 1887. 25½ x 21″. Private collection

they knew something, however little, about our movement, but nothing, they don't understand anything about it."[95]

Later in the fall, Renoir was still acutely depressed about the failure of *The Bathers*. He told Bérard: "Here I am in the dumps. I will wait till I'm in a better mood, which will be difficult since I've really wasted my year. I'm unable to start painting. I've reached the point of waiting impatiently for winter so as to be in my studio, since the outdoors are no good for me this year, but I don't want to go on crying on your shoulder, because a little sunshine would make me forget all my troubles very quickly, but it doesn't want to come. I'll write you when I feel more levelheaded."[96]

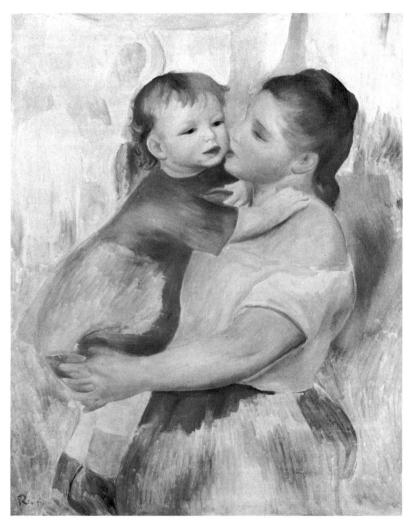

Washerwoman and Baby. c. 1887. 32 x 25¾". The Barnes Foundation, Merion Station, Pa.

Traveling back and forth between the country and Paris, Renoir attended Morisot's weekly dinners as often as possible. He enjoyed the company there: Degas, Cassatt, Monet, Sisley, Rodin, Redon, Whistler, Fantin-Latour, Puvis, Brown, and Rouart. He also met two artists who were good friends of Degas—Henry Lerolle and Paul-Albert Bartholomé. Writers also came: Mallarmé, Wyzewa, Astruc, Mirbeau, Édouard Dujardin, and occasionally Henri de Régnier and Oscar Wilde.

In December, Mallarmé asked Renoir, Morisot, Degas, Monet, and Brown to illustrate an edition of his poems.[97] Only Renoir went ahead with the work. Early in 1888 he executed three pencil and India ink drawings of Venus for the poem "Le Phénomène futur" ("The Phenomenon of the Future") (p. 185). They seem to correspond to the lines: "Instead of a useless garment, she has a body; and her eyes, like rare stones, are not as valuable as that look that comes from her happy

178

flesh: from firm breasts filled with an eternal milk, the nipples toward the sky, to the smooth legs that retain the salt of the primal sea."[98]

It was probably in 1889 that Mallarmé persuaded Renoir to make his first etching based on one of these drawings. A year later, when Durand-Ruel asked Renoir for graphic work to be included in a show of *peintre-graveurs* (painters who were also engravers) Renoir suggested this etching[99] and then wrote to Mallarmé: "Dear Poet, May I exhibit the only etching that I've done and which you own? I am having an exhibition in which an etching is obligatory, it is not to be sold, only exhibited. Would you be kind enough to tell me simply yes or no.... I have only that unique copy of it. R."[100]

The etching appeared in 1891 as the frontispiece to the first edition of *Pages*.[101] It prefigures the Classical nude that Renoir would develop in his painting, graphics, and sculpture for the following thirty years. This relaxed, voluptuous woman is small-breasted and large-hipped. She has a defined silhouette and yet seems massive.

At the same time that Renoir's conception of the goddess Venus was Classical, his landscapes continued to be Impressionist. For example, *Red Boat, Argenteuil* (p. 184) could be mistaken for a scene of 1881–83 because of its pure hues, bright light, visible strokes, and rich impasto. What is different are the solid, undissolved forms and the clear contours.

Renoir continued to travel extensively. In February 1888, he, Aline, and Pierre spent several weeks with Cézanne at Jas de Bouffon, but they soon had to depart, as Renoir explained to Monet: "I've had plenty of trouble ... wandering in cheap hotels and with no money. We had to leave Mother Cézanne all of a sudden because of the dismal stinginess prevailing in that house. In short, I'm now at Les Martigues."[102] From the same place Renoir wrote Bérard: "Still I'm very pleased with myself. ... I have some interesting things started, and I'm determined to finish them. Besides, it has forced me to use watercolor, which will be extremely useful to me, being now familiar with this kind of painting for young boarding-school students."[103]

Renoir's stay in Provence was interrupted in March by news that his mother was ill from "an inflammation of the lungs."[104] He went to Louveciennes to be with her. When she was out of danger, he returned south to complete some landscapes, including the watercolor *Fishermen's Houses at Les Martigues* (p. 186).

In 1888, Durand-Ruel opened a Manhattan branch of his gallery. Renoir had been opposed to this move in May of 1887, shortly before Durand-Ruel's second show in New York. He cautioned his dealer: "I am afraid to see you lose the substance for the shadow with your America.... To give up Paris in order to find the same difficulties somewhere else seems to me unwise."[105] But with the good attendance at the 1887 show, Renoir's hopes for the American market may well have risen. In any event, his mood seems to have steadily improved in spite of the fact that sales of his figure paintings were still sluggish. In 1888, he wrote his old friend the poet Catulle Mendès, "There's something good about figure paintings, they're interesting, but nobody wants them."[106] In order to have a portrait group for Durand-Ruel's spring 1888 show in Paris, he made a large painting of Mendès's three stepdaughters. The eldest, Huguette, is seated at the piano against which the youngest, Helyone, leans. The middle girl, Claudine, holds a violin. Though the form is softened somewhat, the group resembles the

Aline and Pierre (Washerwoman and Baby). c. 1887. Pastel on paper on composition board, 32 x 25¾". Jointly owned by The Cleveland Museum of Art and an anonymous collector

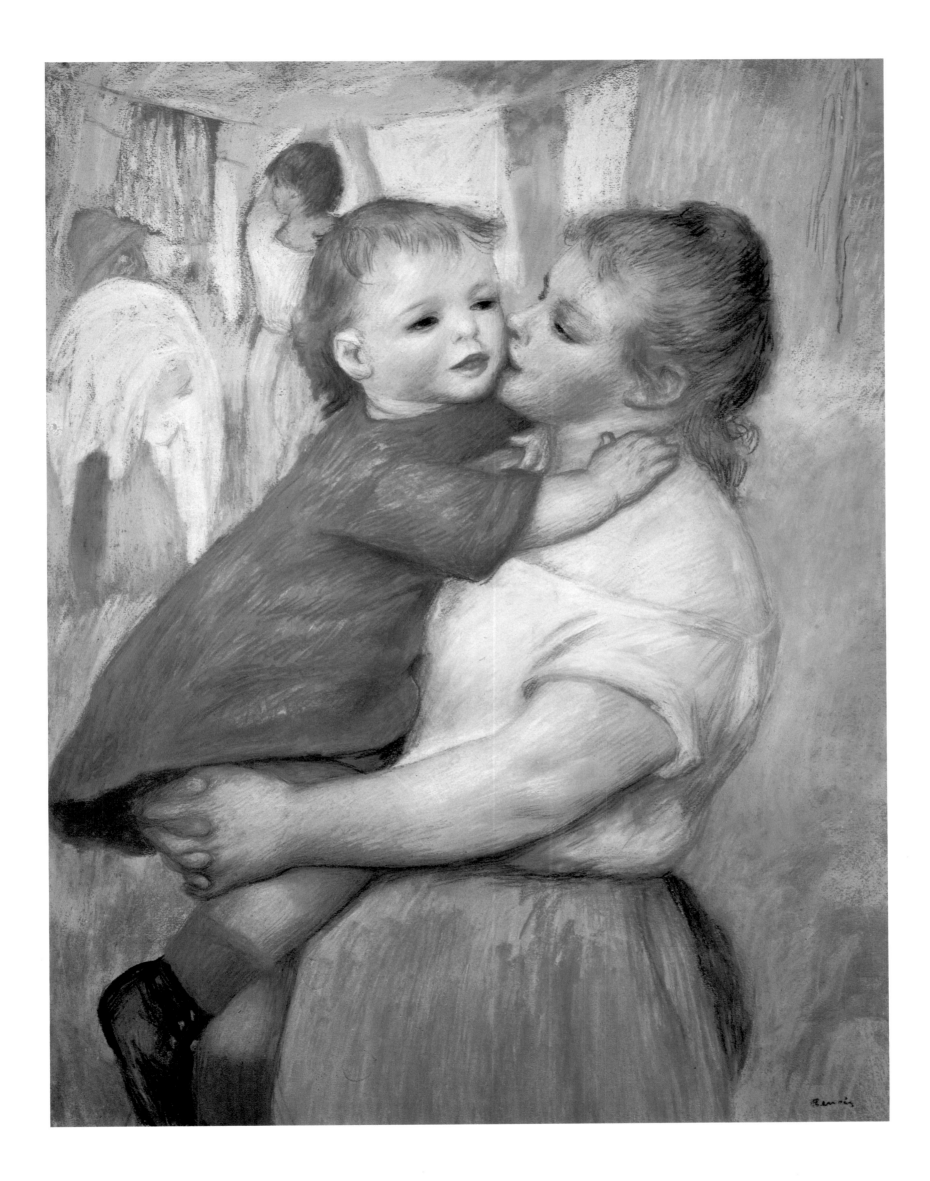

Garden Scene. c. 1887. 21¼ x 25¾".
The Barnes Foundation, Merion Station, Pa.

The Daughters of Catulle Mendès. d. 1888. 63⅞ x 51⅛″.
Collection Mr. and Mrs. Walter H. Annenberg, Palm Springs

After the Bath. d. 1888. 25½ x 21¼″. Private collection, Tokyo

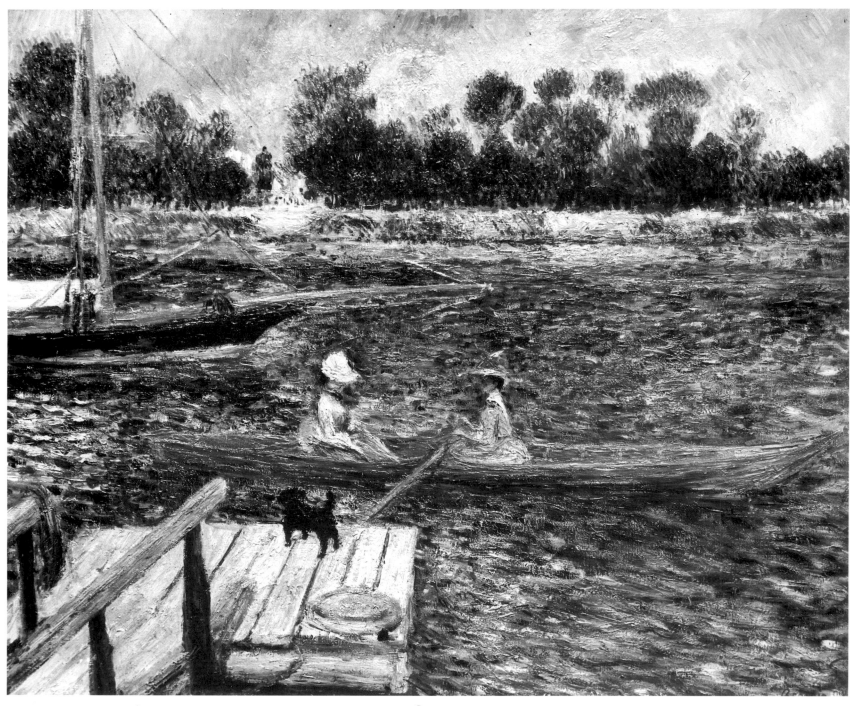

Red Boat, Argenteuil. d. 1888. 21¼ x 25½". The Barnes Foundation, Merion Station, Pa.

RIGHT:
Artichokes and Tomatoes. d. 1887. 18 x 21¾". Private collection

large painting *The Afternoon of the Children at Wargemont* in the static feeling, arrested movement, and almond eyes of the girls.

Renoir did not ask his impoverished friend Mendès for money until late November, five months after the painting was exhibited, when he wrote from Essoyes: "Watch out. You've got to pay up. . . . If in the meantime you have a 100-franc bill, you'll make me very happy."[107]

Another work that Renoir completed in 1888 in time for the Durand-Ruel exhibition was *After the Bath.* The realism and dependence on Ingres in *Bather Arranging Her Hair* have disappeared, and the hard linear edges have softened into a more supple, flowing arabesque. However, the figure still has a certain stiff and serious demeanor.

Renoir encouraged Morisot to exhibit at the Durand-Ruel show,[108] and she did take part, as did Whistler, Sisley, Pissarro, Caillebotte, Boudin, Brown, and Stanislas Lepine. Renoir sent nineteen paintings and five pastels and gouaches. Besides the 1888 group portrait and

184

Three Drawings for Venus ("Le Phénomène futur"). 1888. Left drawing: pencil on paper, 2⅝ x 1⅜"; middle drawing: pencil and India ink on paper, 2½ x 2"; right drawing: pen on paper, 2⅝ x 1¼". Musée du Petit Palais, Paris

LEFT:
Venus ("Le Phénomène futur"). 1889. Etching, 6¾ x 4½". Bibliothèque Nationale, Paris

nude, he included the recent portrait of Julie Manet and *Woman with Fan* (1886).

The exhibition ran from May 25 through June 25, but attracted little attention from the press or public. As Morisot explained to Monet in June: "As you know, it's a complete failure . . . but all this is incomprehensible to the public."[109] After the show closed, Durand-Ruel bought a small oil, *Woman Reading* (1877), for the tiny sum of fifty francs.[110]

In July, Claude Roger-Marx, a collector, critic, and journalist, began organizing the contemporary art section of the Paris World's Fair for the spring of 1889. Victor Chocquet tried to persuade him to include the works of his two favorite painters, Cézanne and Renoir, but when Renoir learned of this he wrote directly to Roger-Marx on July 10: "If you see M. Chocquet, I would be very grateful if you wouldn't listen when he talks about me. When I have the pleasure of seeing you, I'll explain to you what is very simple, that I find everything I have done bad and that it would be very painful for me to see it exhibited."[111] As early as April 25, Mallarmé had written Whistler that "Renoir [is showing no sign] of enthusiasm for the international exhibition, that Solemnity where you were supposed to appear again, weren't you?"[112] (Whistler had exhibited at the Munich World's Fair in 1888.) Renoir remained adamant about his refusal to participate, even though Cézanne, Monet, Pissarro, and Whistler did show at that epochal event. That Renoir would pass up this opportunity indicates how unhappy he felt about his work at this time.

On October 1, 1888, Pissarro, in a rather sympathetic manner, accounted for Renoir's discouragement in a letter to Lucien: "[Renoir] admitted to me that everybody, Durand, his old collectors, were after him, deploring his efforts to get out of his romantic period [presumably the work of the years 1869 through 1883]. He seems to be very

Fishermen's Houses at Les Martigues. 1888. Watercolor, 5⅛ x 9⅛". Musée du
Louvre, Cabinet des Dessins, Paris

RIGHT:
The Washerwomen. c. 1889. Watercolor on paper, 8¼ x 6¾". The Baltimore
Museum of Art. The Cone Collection, formed by Dr. Claribel Cone
and Miss Etta Cone of Baltimore, Md.

sensitive to what we think of his show. I told him that for us the search
for unity was the goal at which any intelligent artist must aim, and that
even with great defects it was more intelligent, more artistic, than to
mark time in romanticism. —He hasn't had any portraits to do since!
. . . No wonder!"[113]

Renoir's other friends were concerned about him. Mallarmé wrote to
Morisot that when he had seen Jacques-Émile Blanche, "He told me
about Renoir's being anguished and discouraged, according to a let-
ter."[114] She, however, retorted: "I saw Renoir the day after I left, not
sad at all, very talkative and fairly pleased with his work; he is sup-
posed to come and see us on a tricycle!"[115]

In November and December, Renoir and his family were at Essoyes.
When Morisot and her husband invited Renoir to come south to visit
them, he declined and wrote: "I am in the process of being rusticated
[here] in Champagne in order to escape the expensive models in Par-
is. I am doing some laundresses, or rather washerwomen, on the
banks of the river . . . since I promised to bring something back."[116] In
The Washerwomen, five-year-old Pierre is talking with Aline behind
the two figures working along the riverbank. Although some stiffness
of posture remains, the figures are distinctly more comfortably inte-
grated into the landscape than in paintings of 1885–87.

In December 1888, Renoir wrote to Eugène Manet: "I'm becoming
more and more of a countryman. . . . I'm returning reluctantly to Paris,
where the stiff necks forgotten for months are going to start getting on

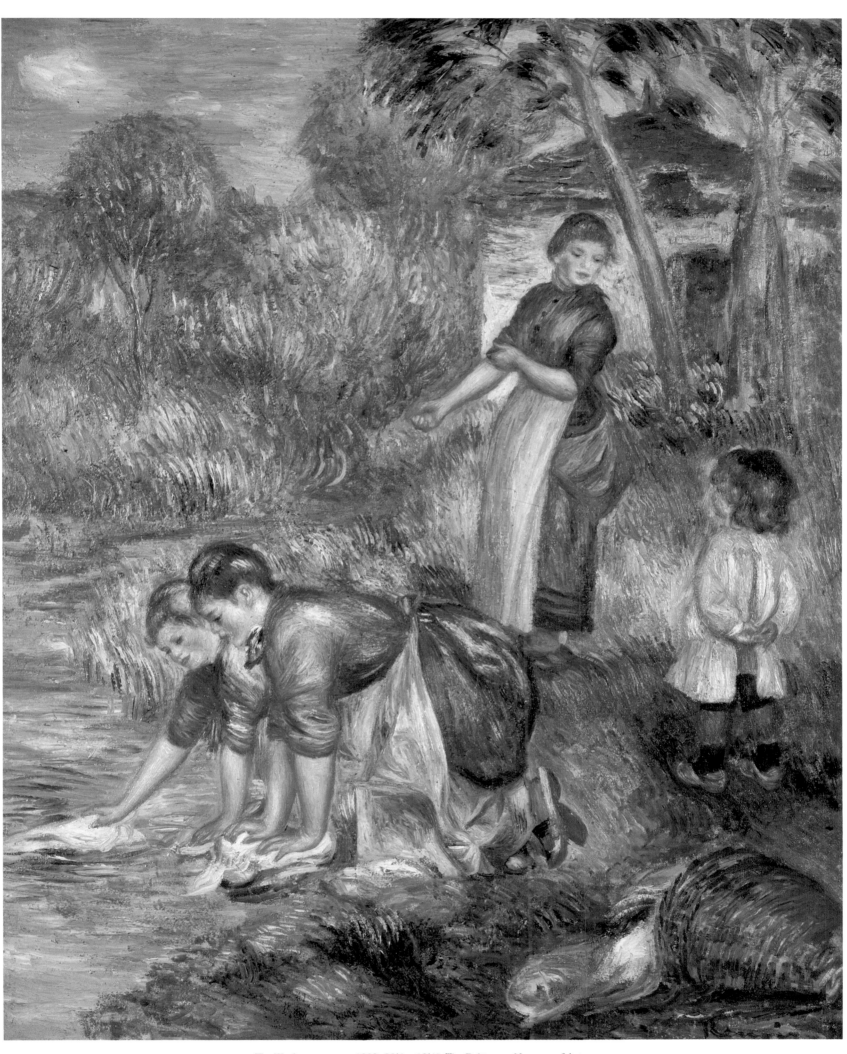

The Washerwomen. c. 1889. 22¼ x 18½". The Baltimore Museum of Art.
The Cone Collection, formed by Dr. Claribel Cone and
Miss Etta Cone of Baltimore, Md.

Mont Ste.-Victoire. d. 1889. 21½ x 25¾″. The Barnes Foundation,
Merion Station, Pa.

my nerves again, but I'm not planning to stay there long enough to re-
sume those sufferings. The blue sea and the mountains attract me con-
stantly; it's only if my means won't allow it that I will shut myself up in
the stuffy studio, unless there should be important commissions for
portraits, which would surprise me a lot."[117]

Late that month Renoir was stricken with his first serious attack of
rheumatoid arthritis. The disease began with facial paralysis, prob-
lems with his eyes, teeth, and ears, a manifestation known as Sjögren's
syndrome. He described his condition to Eugène Manet:

I'm stuck; I caught a cold in the country and I have a facial paralysis, local,
rheumatic, etc.... In short, all one side of my head can no longer move, and
just for fun I'm to have a two-month treatment by electricity. Going out and
catching cold again are forbidden. Nothing serious, I guess, but so far nothing
moves; needless to say, I feel very bored being nailed down with dark and foggy
weather; I'll let you know when I feel better; that will be my consolation. Other-
wise, I'm doing all right; no pain whatsoever, so I waited a little to give you this

piece of news, hoping to find a man of science who could get me out of it. I've
been disappointed in my hopes; I'm now obliged to let you know; it's the least I
can do.[118]

"I'm pinched by awful neuralgia,"[119] he explained to Georges Char-
pentier, and to Durand-Ruel: "It's as though half of my face were para-
lyzed. I can neither sleep nor eat."[120]

By mid-February, Renoir's health was improving. Monet wrote Mori-
sot: "Poor Renoir has been quite stricken, they were afraid it was a
facial paralysis, but he's much better and fortunately he didn't pan-
ic."[121] Two days later, Mallarmé reported to her: "Renoir is better,
they tell me, will you see him? and a painful state of health that one
could have thought permanent will only have been a dirty trick from
the cold, without consequences."[122] However, Renoir continued to
suffer, as he wrote to Dr. Gachet in April: "I'm getting slowly better,
but this better is certain."[123]

Renoir's financial worries continued. "The works of Pissarro, Gau-

guin, Renoir, Guillaumin don't sell,"[124] Theo van Gogh wrote his brother Vincent on May 21. By contrast, later in 1889, Pissarro told Lucien: "Theo van Gogh has sold a Monet to an American for 9,000 francs."[125] So there was hope for Renoir and his friends from American collectors. During that year Durand-Ruel sold to Bertha Honoré (Mrs. Potter) Palmer of Chicago her first Renoir, *Aline at the Gate (Girl in the Garden),* for an undisclosed sum.

In the summer of 1889, Renoir, Aline, and Pierre returned to Provence. This time they rented a house in Montbriant from Cézanne's brother-in-law, Maxime Conil. Renoir made watercolors and paintings of Cézanne's favorite mountain, Mont Ste.-Victoire. Unlike Cézanne's stark and desolate landscape, Renoir's painting is soft and inviting, with its decorative parallel brushstrokes and small midground figures.

In the fall, Renoir again had problems with his teeth, which may have been related to his arthritis, and he was fitted with dentures. He wrote Bérard from Paris October 9:

I should have written to you yesterday but I was still in great pain from the sessions at the dentist. Today I feel less brutalized. I was able to enjoy the little masterpiece that you enclosed with your letter while adding that it shears dogs and trims cats painlessly and without shedding any blood. Working only for a prince.

. . . After having suffered the torments of the damned from my teeth and from hunger because of their absence, I'm going to have a brand-new set, and if my health comes back, to resume working. I think that my capacity for work is improving, and it's time to be serious. I must, unless I'm making too much out of it, take advantage of it this time, because later on I would be a little too decrepit. In short, I'm working with enthusiasm again.[126]

In November, Octave Maus invited Renoir to exhibit at the show of Les Vingt in Brussels, as he had three years before. His first response

Still Life—Flowers and Fruits. d. 1889. 25½ x 21¼". Private collection

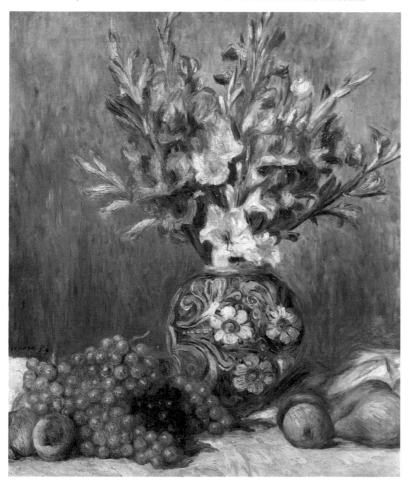

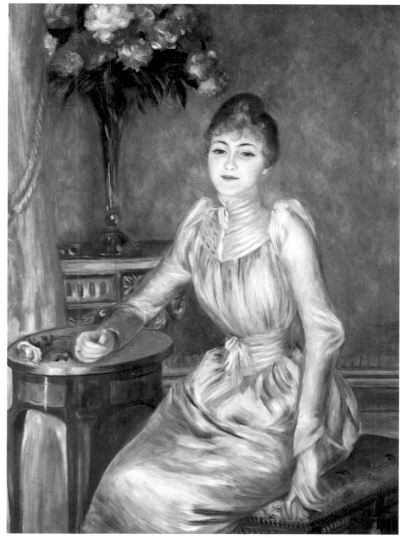

Mme. de Bonnières. d. 1889. 46⅛ x 35". Musée du Petit Palais, Paris

was similar to his earlier reaction to Roger-Marx. He wrote to Maus, "Flattered as I am by your kind invitation, I am obliged to refuse it, not having anything interesting enough to show to a public accustomed to seeing beautiful things."[127] In December, when Wyzewa learned of this letter, he wrote independently to Maus: "There has been a misunderstanding and Renoir, or rather his maid, sent you a letter prior to our first conversation. He had already prepared the things he is going to send you, Bonnières too. You will receive all this one of these days. Renoir is very sorry about what happened: he had left that letter on the table long before and his maid mailed it ten days later."[128]

With Wyzewa's prodding, Renoir agreed to show five works. Robert de Bonnières, a writer for *Le Figaro* and a friend of Wyzewa's, sent three from his collection: *After the Bath,* which he had purchased after the spring 1888 Durand-Ruel exhibition; *Still Life—Flowers and Fruits;* and the portrait of his wife, Henriette.

By late December 1889, the future was looking up for Renoir. The American market was promising, a new Paris patron had come forward, and Durand-Ruel was optimistic. Renoir's letters rarely express unhappiness. At the same time, he was softening his hard linear form, eliminating his stiff figures, and introducing more space around them. At the end of the year, he wrote Bérard: "Painting would go wonderfully if I could work, but this dark weather makes it necessary to start all over the next day whatever you've done the day before. . . . I'm in demand again on the market and I worked a lot in the spring; if nothing happens to disturb my work, it will go like clockwork."[129]

189

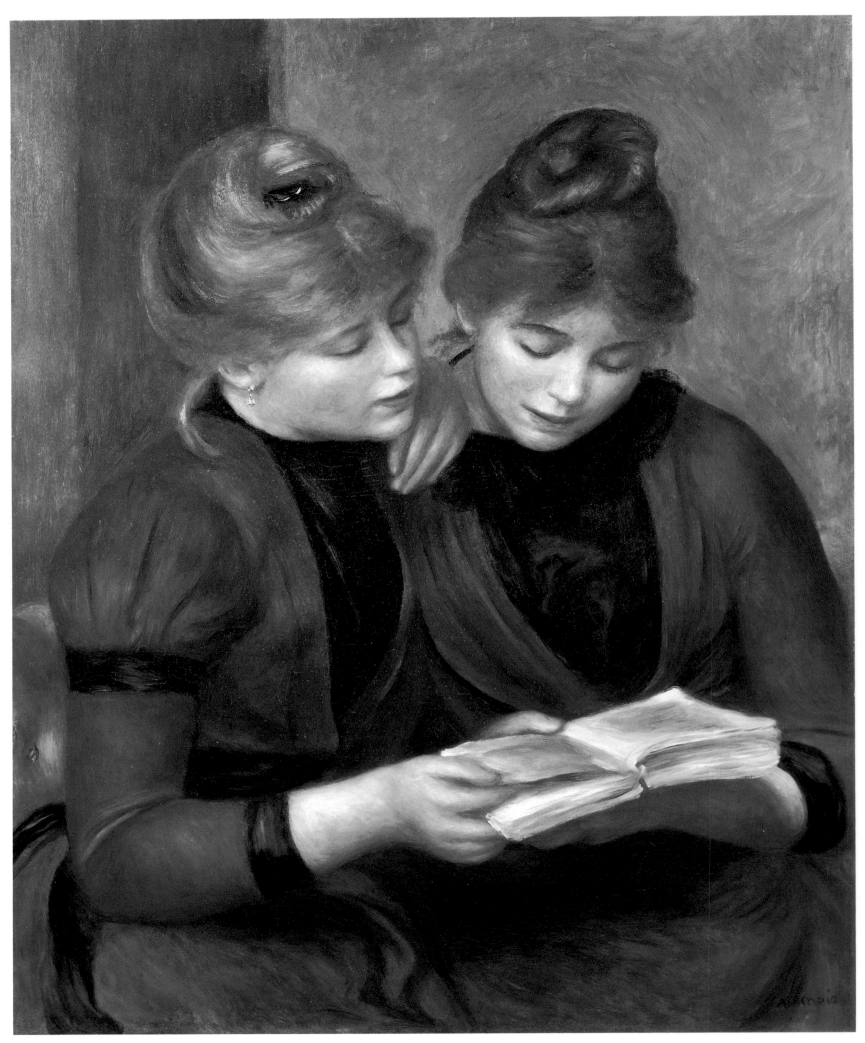

Young Girls Reading. c. 1889. 26 x 22¾".
Collection Mr. and Mrs. Robert J. Arnold

THE YEAR 1890 marked a dramatic turning point in Renoir's financial situation. After selling *Young Girls Reading* for 2,100 francs, Durand-Ruel became markedly more interested in buying his work. While he had bought two figure paintings in 1889, he bought seventeen in 1890, the most expensive being *Girl with a Basket* of 1888, for which he paid 1,500 francs.

The quality of Renoir's paintings improved from that of his Irregularist works of 1884 through 1889. However, the rheumatoid arthritis that gradually deformed and ossified his hands brought about a progressive lack of manual dexterity and control, which necessitated broader and less detailed forms. In contrast to the preceding twenty-five years, when he experimented in many different modes and changed styles every six or seven years, during the last three decades of his life, until his death in 1919, his style changed little. Feeling prematurely old and ill, he painted in a way that was most comfortable to him; it was also a mode of expression that was appreciated by his public. Because of his illness, Renoir was never able to regain the heights of genius, diversity, and innovation apparent in his greatest paintings of 1872 through 1883. Nonetheless, despite what could have been regarded as a devastating incapacity, the heroic Renoir was able to cope with and transcend his illness by sustained creative work. In this light, the paintings of his last thirty years are courageous and, toward the end, miraculous.

In 1890, buoyed by his new popularity, Renoir risked submitting again to the Salon, which he had shunned since 1884. Although the portrait of Catulle Mendès's daughters was accepted, he was once again disappointed and later recalled, "When I sent the little Mendèses, they were put under the awning where no one saw them."[1] He never again submitted a work to the official spring Salons.

To be snubbed by the Salon was almost predictable, in spite of his new-found success with collectors. Moreover, Monet's work was more popular than Renoir's and was selling for higher prices. This brought new friction between the old friends. On May 12, Monet wrote to Caillebotte with marked sarcasm: "As for Renoir, I congratulate him for not wanting to be decorated; true, it would have been useful to him, but he must succeed without it, it's more chic."[2]

Duret commented to Caillebotte: "I was sorry to read what you had written me about the quarrel between Monet and Renoir. Men who as friends had endured misfortune and who break up as soon as success comes to them unequally!"[3] Happily, the estrangement between Renoir and Monet disappeared by the fall of 1891. "We are resuming our monthly dinners," Caillebotte informed De Bellio. "See you Thursday at 7, Café Riche, Monet and Renoir will come."[4] The all-male monthly dinners continued throughout the next two years. The regulars included, in addition, Pissarro, Sisley, Duret, Mirbeau, Mallarmé, and Geffroy.[5]

Because of increasing sales in 1890, as he neared fifty, Renoir felt increasingly optimistic about his ability to support himself and his family, and he decided to marry Aline. The ceremony was held in the ninth arrondissement town hall in Paris on April 14, 1890, in front of

four witnesses who had been friends for the last twenty years: Lhote, Lamy, Lestringuez, and Federico Zandomeneghi. The marriage license stated that Aline and Auguste had "declared that they acknowledge Pierre as their son, in view of the legitimation that would result from their marriage." Renoir's address was given as his studio, 11 boulevard de Clichy, and Aline was recorded as "seamstress, domiciled in Paris, 15 rue Bréda, with her mother."[6] Aline's address was a decorous fiction since Renoir's letters and his paintings indicate that Aline had been his common-law wife for five years. In July, the three went to Essoyes, where Renoir made a sanguine of Aline and Pierre in preparation for a series of three paintings of *The Apple Seller,* in which they are the central figures. Unlike the *Nursing* series of five years before, the figures are now integrated into nature and interact unselfconsciously with one another.

Back in Paris in the fall, Renoir, Aline, and Pierre moved to 13 rue Girardon, near the place des Abbesses in the Butte Montmartre, up on the hill near the Moulin de la Galette. The large house had a garden fifty by seventy-five feet. A drawing room, a dining room, a kitchen, and a butler's pantry were on the ground floor above a large cellar. Upstairs were the bedrooms of Aline, Pierre, and a servant, as well as a rather primitive bathroom. Another flight led to the rooms of Renoir, other servants, and guests. Above this was the attic, which served as a second studio when Renoir did not feel well enough to leave the house.[7]

In the fall, Aline was pregnant again. On September 17, when she became sick but was resisting all medical help, Renoir complained to Dr. Gachet: "With women you can't be sure of anything; when it comes to their health, you'll never get them to take care of themselves at the right time and place, and there's nothing I can do to change them."[8] She soon had a miscarriage.[9]

Beginning in 1891, as his arthritis worsened, Renoir tried to spend half the year in a more moderate climate. He usually left Paris when it was cold (January–March) and when it was hot (July–September). He spent the first three months of 1891 in the south, in Provence—Toulon, Tamaris-sur-Mer, Les Martigues, Le Lavandou, and Nimes. Part of the time he was alone, and sometimes he was accompanied by Aline, Pierre, and Wyzewa. His letters to Durand-Ruel reveal reasons other than health for his travels: "I had a [free railroad] pass that couldn't wait. I took advantage of it."[10] "I have landscape subjects to spare. I'm preparing a show.... I'll accomplish more here, and more interesting things, in peace and quiet than I could at great expense in Paris."[11] "I am cramming myself with sunlight."[12] "I'm working. I'm having magnificent weather.... I'm trying very hard to succeed without groping my way any more. Four days ago, I turned fifty, and if at that age one is still searching, indeed, it's a little old. I do what I can, that's all I can say."[13] "I am making some progress.... This landscape painter's craft is very difficult for me, but these three months will have taken me further than a year in the studio. Afterward I'll come back and be able to take advantage at home of my experiments... to do a lot of figures for you."[14] And before his return: "I think that I've made

Renoir's residence at the Château des Brouillards,
13 rue Girardon, Paris, c. 1890

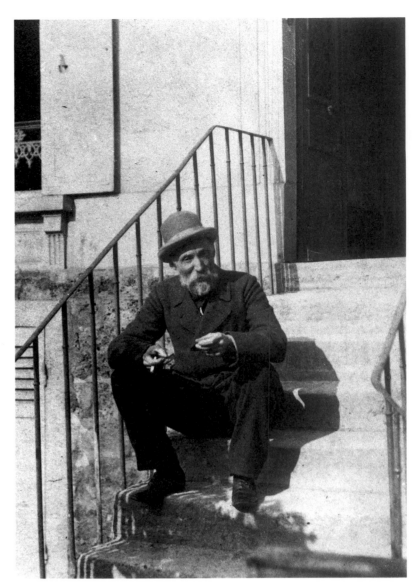

Renoir smoking on the steps of his residence at the Château des Brouillards,
c. 1890

some progress and will be able to work in the studio productively."[15]

As he had planned, he had an exhibition in July 1891 at Durand-Ruel's Paris gallery. Pissarro described it to his son: "his paintings of 1890–91... don't seem to be causing much of a stir."[16]

That summer Renoir made several visits to Morisot and her family at their country house in Mézy. "Above all, finish the canvas with the cherry trees.... I send you all my wishes for success. Give my greetings to the girls and to Manet."[17] Morisot was working on *Cherry Pickers* (which she completed the following year) at the same time that Renoir was painting *Picking Flowers*. The preliminary models for both paintings were the "young ladies": thirteen-year-old Julie Manet and her cousins Jeanne and Paule Gobillard (daughters of Morisot's sister Yves). During this period, the styles of Morisot and Renoir have in common graceful forms bound by a supple arabesque.

On August 25, Durand-Ruel purchased three major works from Renoir—*City Dance, Country Dance,* and *Dance at Bougival*—for 7,500 francs apiece. These sums, the largest Renoir had yet received, were further evidence of Durand-Ruel's commitment to him. That year the dealer bought sixteen more figure paintings for an additional 11,350 francs; still lifes and landscapes brought Renoir additional income.[18]

The year 1892 was even better for Renoir. His financial success reached a level that he had previously enjoyed briefly—during the two

years following the 1879 Salon success of *Mme. Charpentier and Her Children*. Of the twenty-nine figure paintings sold that year, the Chicago socialite Mrs. Potter Palmer bought eight works of 1874–91 from Durand-Ruel. She paid $8,000 to his New York gallery for *Two Little Circus Girls* (1879) and 10,000 francs to his Paris gallery for *In the Meadow* (1890-92). She also bought *Mother and Children* (1874) and *Mother and Child* (1881).

Between February and April 1892, Renoir painted Mallarmé's portrait, with interruptions caused by the artist's poor health. "Dear Poet," he wrote, "I wanted to talk to you about your portrait, to tell you that I haven't forgotten you but I have a toothache. For two days I have been having chills and fever.... Inflammation. Head like wood."[19] Renoir gave Mallarmé the painting and inscribed it to him. In it he captured the serious demeanor and sharp features that are apparent in a photograph taken by Degas[20] at one of the Wednesday evenings on which Mallarmé often invited Renoir and Degas to his home. Other artists and writers were also guests: Monet, Whistler, Gauguin, Redon, Verlaine, Claudel, Valéry, and Gide, as well as De Banville, Duret, Zola, Villiers de l'Isle-Adam, Huysmans, Mirbeau, Moore, Fénéon, and Henri de Régnier, who described Renoir at one of these gatherings:

It was in the house of Stéphane Mallarmé that I encountered Renoir for the

first time. He was seated on a small sofa on which Whistler and Redon had often sat. . . . Renoir was neither silent like Redon nor a conversationalist like Whistler. His features and body were thin and he appeared extremely nervous, his face twitching and intelligent, refined and with watchful eyes. . . . With a somber mien and simple movements, Renoir had just sketched a little portrait of Mallarmé. . . .

I met him again at Berthe Morisot's . . . in a strange milieu of rare distinction . . . Eugène Manet, nervous and hard pressed, Berthe Morisot of a lofty and cool courteousness, of a distant elegance beneath her white hair, her glance sharp and sad, and little Julie, a silent but wild child. . . . Renoir partook of his meal with provincial, rustic gestures, his hands already deformed.[21]

On April 13, Eugène Manet died, leaving Berthe Morisot a widow at fifty-one and fourteen-year-old Julie fatherless. As Julie later observed, "[Mallarmé] and M. Renoir were the two great friends of Papa and Mama,"[22] and they became the two closest friends of Berthe and Julie. Renoir saw his "role as family adviser."[23] Several months before Eugène's death, Morisot had planned her first large one-woman show to be held in late May at the Boussod & Valadon Gallery in Paris. Because she was then in mourning, she left the capital before it opened. Renoir reported to her on May 25: "Your comrade is happy to tell you that the utter failure you were anticipating didn't materialize. It was very successful and sold the ducks, the large painting . . . *The Veranda,* and some watercolors. In short, everybody is happy and I congratulate you on it."[24] When Berthe and Julie moved to a more modest apartment in the fall, Renoir wrote to Berthe: "It must look strange to you, and I won't yet find you at your best. It will take some time. I will come

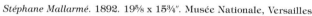

Stéphane Mallarmé. 1892. 19⅝ x 15¾". Musée Nationale, Versailles

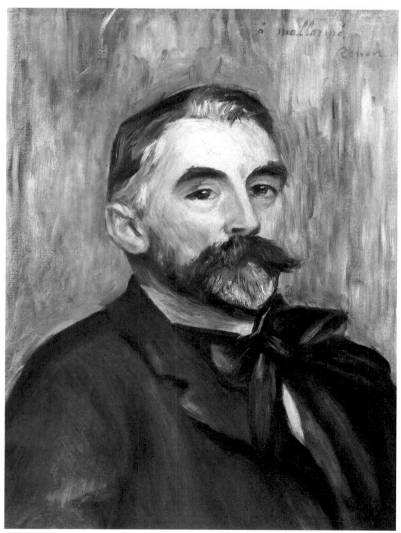

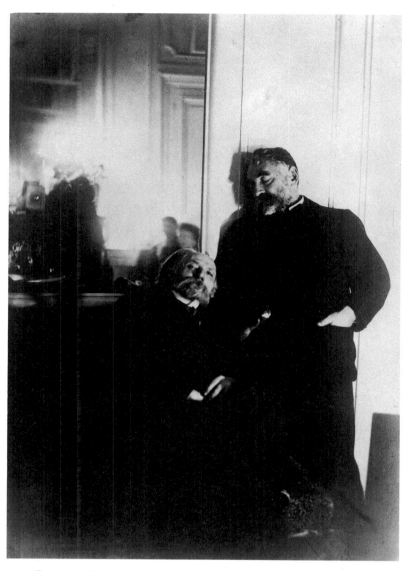

Renoir and Mallarmé, in the mirror Degas and Mme. Mallarmé, in Berthe Morisot's salon, c. 1892. Photograph by Edgar Degas

tomorrow afternoon around five to say hello, because I'll come to dinner some other time. . . . I'll come then to see how you look, not how the place is, but you'll see, one gets used to it."[25]

Shortly before Morisot's show, Renoir had had his largest one-man exhibition at Durand-Ruel's Paris gallery. The 110 paintings on view from May 7 to 21 spanned twenty years.[26] Works were lent by nineteen prominent collectors including Bérard, Caillebotte, Monet, and Charpentier. The catalogue contained a long preface by Arsène Alexandre, an eminent critic and collector, who wrote: "As for his drawing . . . it is the drawing of a master painter who has kept, throughout the disappointments of life and the anxieties of art, all the candor and lively impressions of a twenty-year-old."[27]

Many favorable reviews appeared. One was by the painter Maurice Denis, then twenty-two, who was to become a close friend of Renoir's: "A whole life of silent and unpretentious work, the beautiful and honest life of a true painter. Idealistic? Naturalistic? As you like. He has been able to limit himself to conveying his own emotions, all of nature and all of his dream by his own methods: with the joys of his eyes he has composed marvelous bouquets of women and flowers. And since his heart is big and his will upright, he has only done very beautiful things."[28] However, less favorable articles also appeared, such as an anonymous review in *Le Temps*: "The artist has an uneven temperament. . . . Be that as it may, all this work, despite the weaknesses that

193

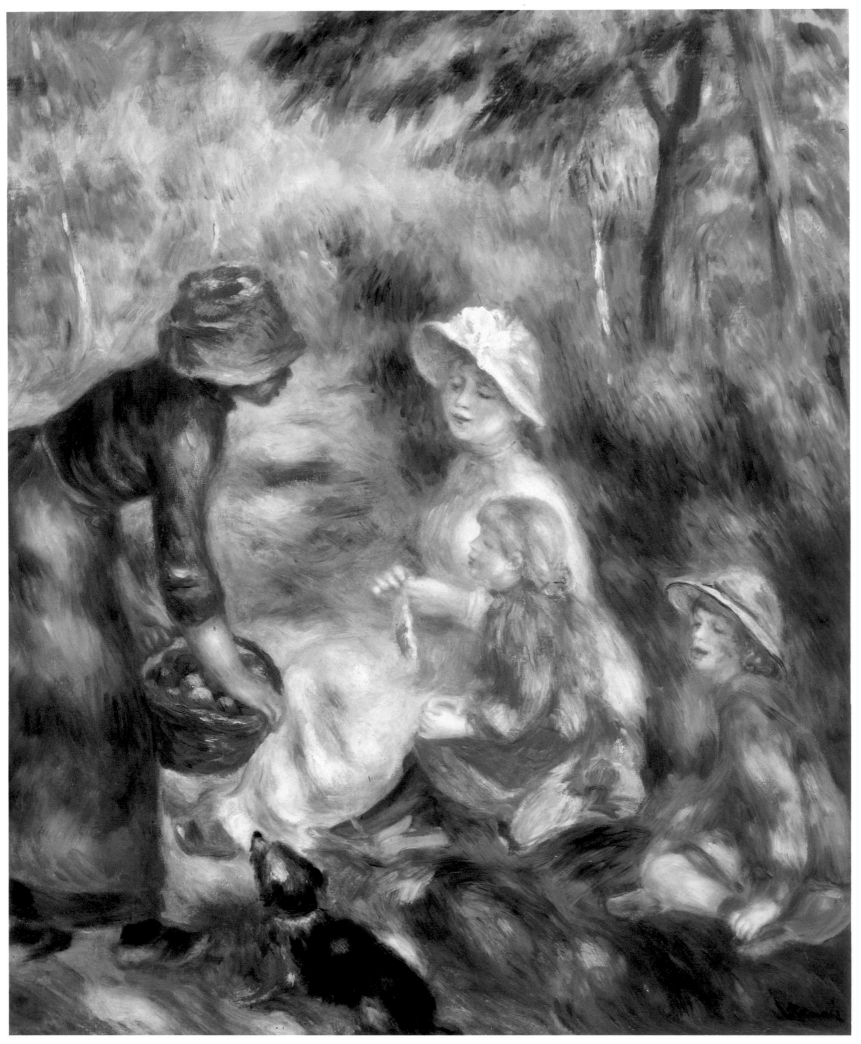

The Apple Seller. 1890. 25⅞ x 21⅜″. The Cleveland Museum of Art.
Leonard C. Hanna Jr. Collection

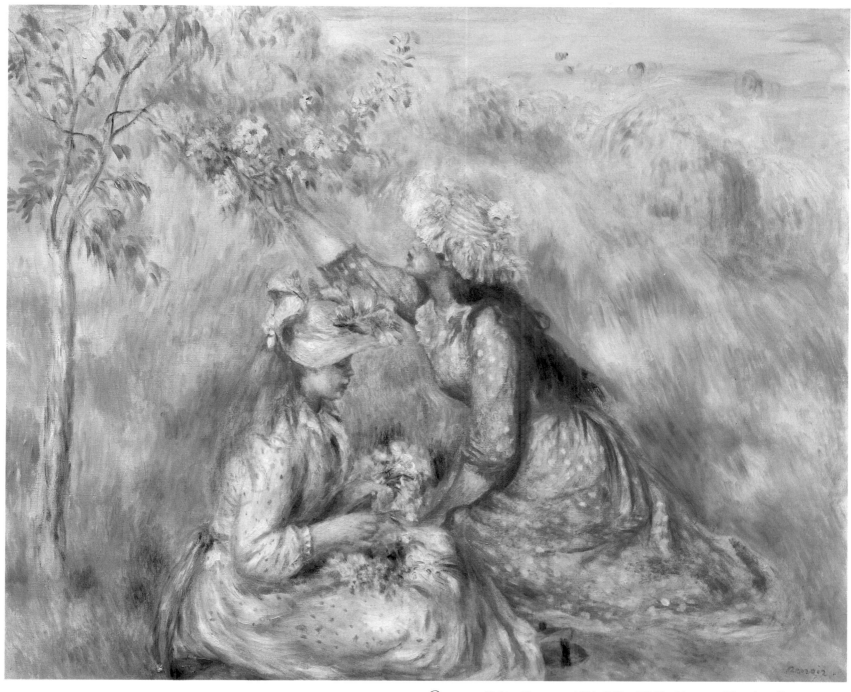

Picking Flowers. c. 1891. 25¾ x 32". The Museum of Fine Arts, Boston.
Juliana Cheney Edwards Collection. Bequest of Hannah Marcy Edwards
in memory of her mother

one can see in it, is that of a born artist, but an artist basically too un-
decided, too far below his own level, for him to be properly ranked
among the masters."[29]

Despite this devastating comment, evidence that Renoir had achieved
official recognition was on hand at this exhibition. Earlier in the spring
Mallarmé and Roger-Marx had persuaded their friend Henry Roujon,
recently appointed director of fine arts, to purchase a Renoir painting.
At age fifty, Renoir finally saw his first government purchase. On April
4, Mallarmé had written to Roger-Marx: "My dear accomplice . . . I went
twice to the [Ministry of] Fine Arts; I even spent an afternoon waiting
for Roujon, who had been taken somewhere by the minister. Renoir
has taken advantage of it to paint the same picture again alongside it,
and you will have trouble choosing."[30] On April 25, Roujon had stated
in an official document: "Purchase from M. Renoir, for the price of
4,000 francs, one painting: *Girls at the Piano.*"[31] On May 2, an official
order stated, "The State has purchased it by decree."[32] Ten days later,

Mallarmé thanked Roujon "in Renoir's name" for permitting the paint-
ing to be exhibited at Durand-Ruel's. "He very discreetly contrived to
make use of this painting, one of his perfect ones, by displaying it sepa-
rately on an easel in a special room. As for myself, I couldn't, and
according to the unanimous impression gathered from all sides, con-
gratulate you enough for having chosen for a museum this definitive
canvas, so calm and so free, a work of maturity. I see it, once the damp-
ness has gone and the painting is done, after a few months, like a
feast in the Luxembourg, and completely accessible to visitors."[33]
In November, the painting entered the Luxembourg Museum.[34]

Renoir's former collectors, though willing to lend paintings, were not
interested in purchasing his recent work. However, new patrons came
forth. Around 1891, Paul Gallimard, owner of the Théâtre des Variétés
in Paris, bibliophile, and friend of many authors, bought the first of
many Renoirs, and in a dozen years built up one of the largest collec-
tions.[35] He and Renoir became close friends and voyaged to Spain to-

gether during the summer of 1892.[36] That same year Renoir painted a portrait of Gallimard's wife.

In August, September, and October 1892, Renoir traveled extensively in Brittany, visiting Pont-Aven, Noirmoutiers, and Pornic (p. 199). Yet from Pornic he complained to Morisot: "Landscape is getting more and more to be pure torture for me, especially because it's a duty; of course, it's the only way to learn a little about one's craft, but to stand outdoors like an acrobat, I can't do it any more."[37]

On September 18, Paul Durand-Ruel's twenty-seven-year-old son, Charles, died. Morisot told Mallarmé: "I saw Renoir at the funeral of

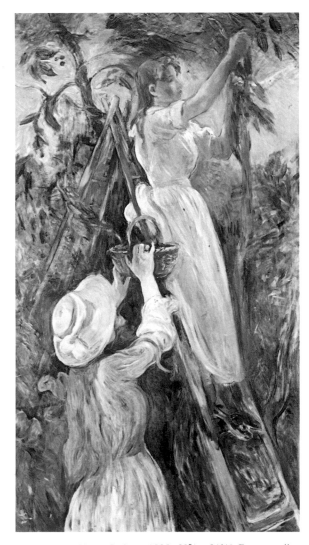

Berthe Morisot. *Cherry Pickers*. 1892. 60⅝ x 31½". Private collection

that poor little Durand. He was coming from Noirmoutiers and was supposed to go back next day. His wife and son are bathing with delight and he is bored to death."[38]

A month later, Renoir moved to a new studio at 7 rue Tourlaque. He did a series of paintings of the nearby place de la Trinité (p. 202) that recall his Impressionist cityscapes of the 1870s and early 1880s. His figure paintings, on the other hand, were becoming more Classical. On April 27, 1893, from Beaulieu in Provence, he told Bérard that he was working on "some terrific Jean Goujons."[39] He may have been referring to the *Reclining Nude,* a panel intended to go above a door, which resembles Goujon's carved reliefs for the Fountain of the Innocents (1548–49); Renoir even simulated a marble frame. This nude, like traditional portrayals of a mythological goddess, rests her head on her hand and evokes an Arcadian age.

196

Renoir's ease in depicting the nude is also apparent in *Bather Arranging Her Hair* (1893). A glance at the 1885 painting of the same subject reveals his new interest in portraying voluptuous figures in a warm atmosphere of pearly, iridescent strokes. The nude is both comfortably part of her environment and intimately close to the observer.

Around this time, Renoir experimented with graphics and did his first lithograph. From 1893 through 1895, the journalist-critics André Marty and Claude Roger-Marx published a series of prints in three portfolios titled *L'Estampe originale.* Renoir's etching *Two Bathers* and his lithograph *Pierre Renoir*—shown as a baby, but published in October 1893, when he was eight—(p. 201) were included. As Renoir explained his procedure: "I won't work on my plate until Saturday morning, my drawing is done but I still have to look at it before transferring it without trouble for M. Marty. Be sure to tell him that he'll have his plate Saturday afternoon."[40]

For the month of June, Renoir stayed with Gallimard in Normandy. Aline regretted not being with her husband, especially because, as Renoir affirmed, "My wife . . . has a passion for traveling."[41] From Paris she wrote one of the few extant letters to her husband:

The leak in your studio is not yet fixed. The workmen were supposed to come on Monday, but there was a wedding. Tuesday was a holiday. Today it rained all day and now they are waiting for the weather to clear up. Still I hope it will be finished by the time you get back. I showed the drawing of your bed to M. Charles. He will do it when you are back. He has some comments to make to you. You know how stubborn he is. I don't know what it is he finds too high. You will settle that together.

I don't know if I will have enough money to wait until the end of the month because we have to buy more linen. There is not enough to make the big curtains

Mme. Gallimard. d. 1892. 31½ x 25". Collection Mrs. Robert Mayer, Chicago

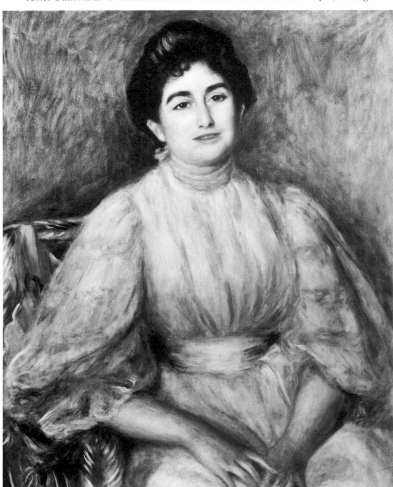

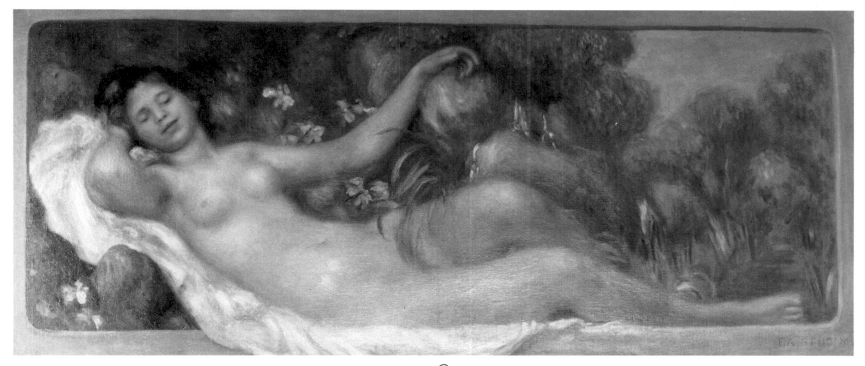

Reclining Nude. c. 1893. 25¾ x 61¼″. The Barnes Foundation, Merion Station, Pa.

next to the biggest window where the sun comes in the most. It's west, I think. M. Charles had not understood that they were needed there. Isn't that what you explained to him? The calico curtains on one side of the beam and the linen ones on the other.

I can buy exactly the yardage we'll need. I found a dealer who sells it retail. The only thing is since I've already spent forty francs for you, I'm afraid of not having enough money to buy the linen. If you're not coming before the end of the month, please send me some money.

Tell me, my poor darling, whether you aren't cold in Dieppe. In Paris we are freezing.

Are you working a lot? Will your portraits be finished soon? A month is such a long time! Our trip last winter felt shorter than these two weeks I have just spent.

Write me a lot and tell me about your health.

Love.[42]

In July, Renoir received a painting commission through his old friend Maître, who continued to be active in Paris musical circles. Paul-Alfred Chéramy, a lawyer, collector, and music lover, had seen the portrait of Wagner at Renoir's 1892 exhibition, where it was on loan from Bonnières, and he wanted to have a copy made. Renoir replied to Maître in mid-July: "In short, I have no objection to what you ask, the whole thing is to find out if Bonnières is in Paris in order to get hold of that portrait. As for the price, what the devil can I ask? Say between 500 and a thousand, as you like. You understand that it will take me a day to do the thing, what takes longer is to get the original, but I'll ask Wisewa [*sic*], if he's in Paris, and he will do it for me with no trouble.

"So, to sum up, the price that M. Cherami [*sic*] will agree to, what I'm telling you, is just a suggestion. If it's too much, lower it, take care of it yourself."[43] On the reverse of Renoir's letter, Maître advised Chéramy: "I send you *sub rosa* the answer I have just received from Renoir. It seems to me that if you were to offer him 600 francs, you would satisfy his soul. By the way, you can contact him directly from now on: he is a shy man, but I know of no one more unselfish or more reliable."[44]

Bonnières was not in Paris, but in September, Renoir was able to borrow the portrait.[45] The sketchy version that he made for Chéramy,

which is smaller than the original, is a close-up of the head.

On December 7, Renoir lamented to Bérard from Paris: "I am surrounded by sick people and I don't know if it's this circle of friends that is getting on my nerves but I'm visibly deteriorating. First I have my

Bather Arranging Her Hair. 1893. 36⅜ x 29⅛″. The National Gallery of Art, Washington, D.C. Chester Dale Collection

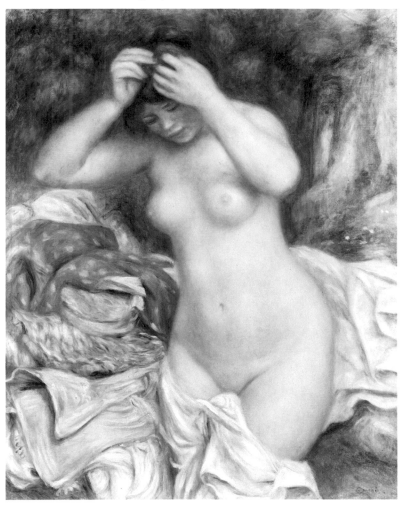

197

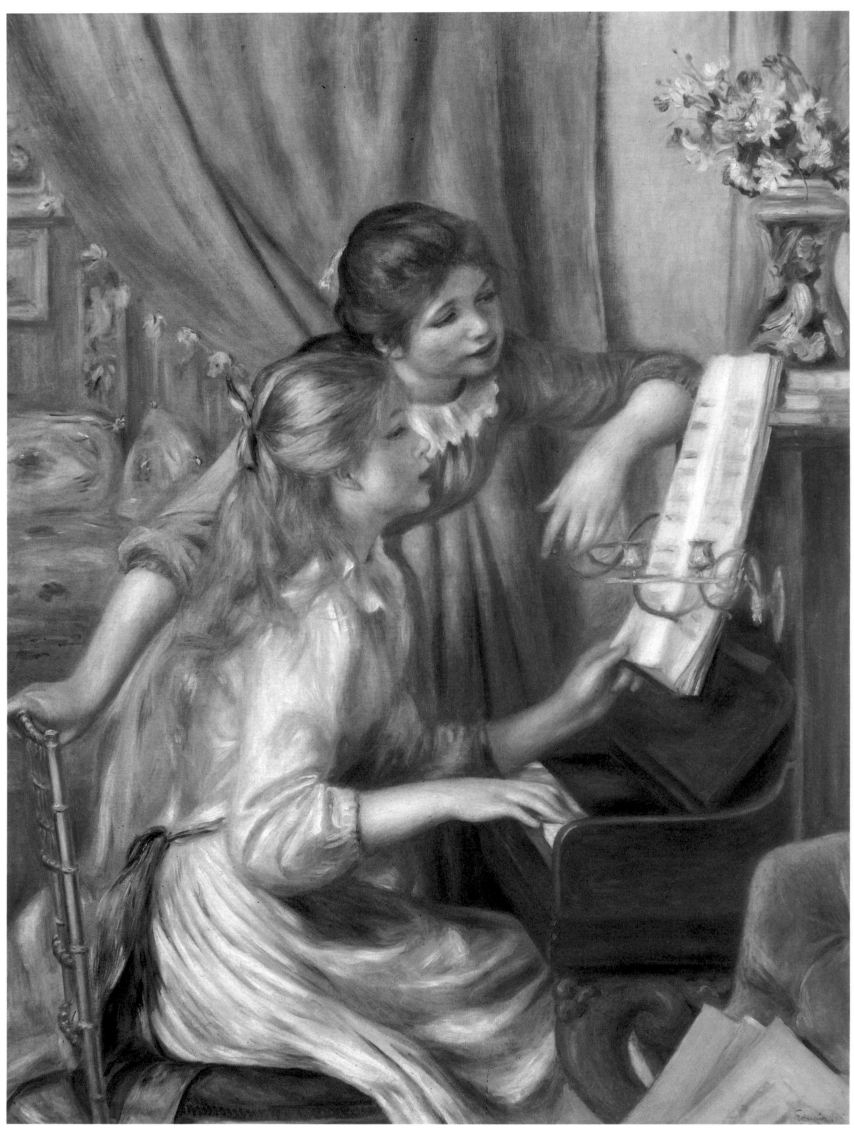

Girls at the Piano. 1892. 45⅝ x 35½". Musée d'Orsay,
Galerie du Jeu de Paume, Paris

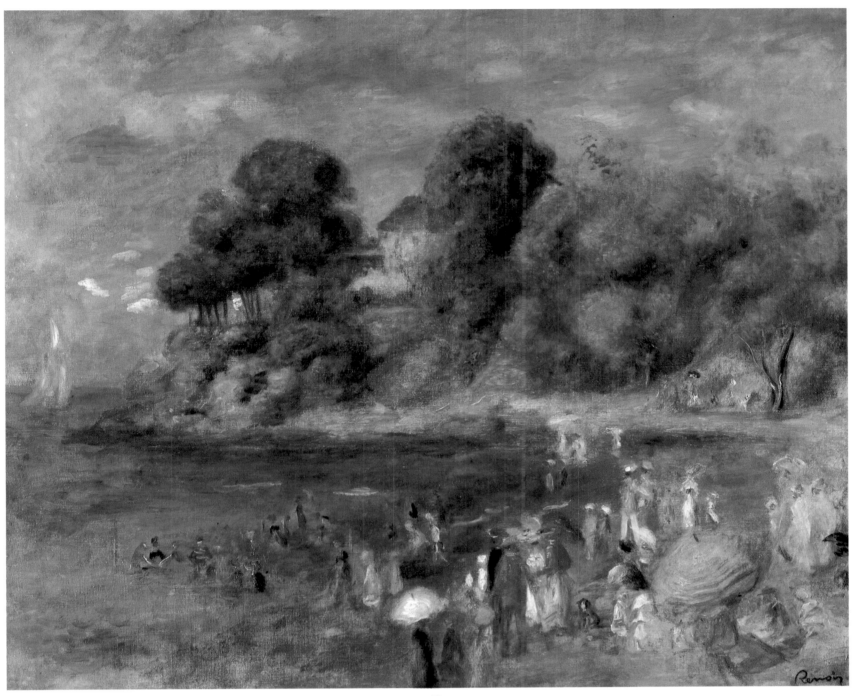

The Beach at Pornic. 1892. 26 x 32″. Private collection

friend Maître. It's frightening. Caillebotte is in a bad way. Bellio, etc. . . . and the dismal weather. I was forgetting Chabrier, so strong, who's now in terrible shape. That leaves Monet, still in excellent health."[46]

In 1894, three of these ailing friends died: De Bellio, Chabrier, and Caillebotte. Caillebotte's will stipulated that Renoir was to be the documentary executor of his estate. In recompense he was to accept one important work from the collection, which contained sixty-seven paintings and drawings: eighteen Pissarros, sixteen Monets, nine Sisleys, eight Renoirs, seven Degases, five Cézannes, and four Manets.[47] Renoir chose his own *Moulin de la Galette,* but when Caillebotte's brother Martial refused to permit it to leave the collection, he decided upon Degas's pastel *Dance Lesson.* Caillebotte's will stated further: "I give to the State the paintings I own, except that I want this gift to be accepted and in such a way that these paintings go neither to a store-room nor to a provincial museum, but to the Luxembourg and later to the Louvre."[48]

It took three full years before the Caillebotte bequest was displayed at the Luxembourg. During this time, Renoir defended Impressionist painting against the opposition of Jean-Léon Gérôme, an Academic Realist painter and professor at the École des Beaux-Arts, who had assumed Albert Wolff's role after his death in 1891.

By 1894, Impressionism was no longer the avant-garde. The style had been in existence for twenty-five years, and the painters were beginning to sell their works for high prices. Even the Luxembourg had begun to buy their paintings. Nonetheless, the Caillebotte bequest brought forth the ultraconservative opposition in what turned out to be the last battle the Impressionists had to wage for recognition.

In mid-March, Renoir met with "the Advisory Committee for the Museums." As he explained to Monet: "I just left the commission. There

was an admiral and the curator of Egyptian antiquities, among others. They left without saying anything after a closed-door session. . . . There must have been about twenty of them."[49]

Renoir concurred in the committee's decision to accept only part of the total bequest. In an interview in *Le Matin,* he said: "People go around shouting that the collection consists only of masterpieces. . . . But there are many sketches in the whole lot, studies that are not museum pieces, and which we would be the first to be sorry to see misrepresented in advance as masterpieces. The day the public would be admitted to see them, they would make fun of us."[50]

The following month, Gérôme stated in the *Journal des Artistes:* "There are some paintings in it by M. Monet, aren't there? And by M. Pissarro and others? . . . For the State to have accepted such excrement, there must be very great moral blight. . . . There is anarchy everywhere and nothing is done to repress it. . . . There is no adequate expression to condemn such madness. . . . These people paint like mental patients of Dr. Blanche. . . . They are unable to control their bowels."[51]

The review *L'Artiste* circulated a questionnaire to its readers and found that the Caillebotte bequest was considered "a pile of excrement whose exhibition in a national museum publicly dishonors French art."[52]

Nonetheless, on July 27, 1895, Léonce Bénédite, curator of the Luxembourg Museum, officially accepted thirty-eight works: eight Monets, seven Pissarros, seven Degases, six Sisleys, six Renoirs, two Manets, and two Cézannes.[53] Two years later, in February 1897, the Caillebotte collection was opened to the public in a newly constructed annex to the Luxembourg.

Gérôme continued to rail. In an interview in *L'Éclair* of March 9, 1897, he stated: "And is there not also a M. Renoir—yes, noir [black] he is well called; and he never knew how to hold a pencil!"[54] Pissarro wrote to his son: "That idiot [Gérôme] made himself ridiculous as well as the Institute. We don't feel sorry about it. Deep down, they are angry and we are in the right. . . . [I] am convinced that this has done us a lot of good."[55] Pissarro was correct; after 1897, Impressionism stirred very little controversy.

Throughout the Caillebotte deliberations, Renoir saw Berthe Morisot often. He invited her on March 31, 1894: "Next Wednesday Mallarmé is giving me the pleasure of coming to dinner in Montmartre. If climbing up here in the evening is not too arduous for you, I thought he might enjoy meeting you here. There will also be Durand-Ruel, and I am going to write the above-mentioned poet to ask him to invite de Régnier for me. P.S.—I don't mention the sweet and lovely Julie; it goes without saying, and I think that Mallarmé is bringing his daughter. I wanted to ask Degas but confess I don't dare."[56] Renoir's painting of Julie at sixteen, at ease and pensive, forms a striking contrast with her portrait at nine, when Renoir had depicted her as stiff and self-conscious. In April, when he offered to paint her again, he suggested: "If it is not too unpleasant for you, I would like, instead of doing Julie alone, to do her with you. But here is the drawback; it is that if I go to your place, there will always be something to prevent me, but if you were willing to give me two hours, which means two mornings or afternoons a week, I think I'd be able to do the portrait in six sittings at the most. Tell me yes or no."[57] Morisot agreed, and she and Julie posed at Renoir's studio, first for a pastel preparatory study. In the painting, Renoir captures the same sensitive expression that Julie shows in a contemporary photograph but rounds off the high cheek-

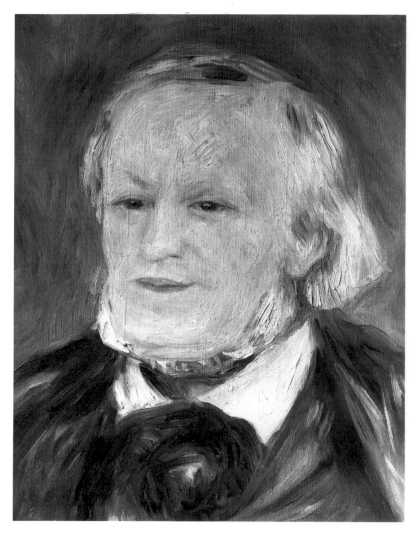

Wagner. d. 1893. 15¾ x 12¼". Musée de l'Opéra, Paris. Bequest of Paul-Alfred Chéramy

bones. Morisot, still in her widow's black, has a cool, sad aloofness.

By June, with Morisot's careful intercession, Renoir became more friendly with Degas. A postcard from Renoir to Mallarmé reads: "Mme. Manet agrees to have dinner at Degas's, and so do I."[58]

On September 15, 1894, Aline, thirty-five years old, gave birth to a second son. With Renoir at the time was the caricaturist Abel Faivre, who made a profile sketch of the expectant father; at fifty-three, Renoir looked frail and elderly.

Elated about his son's birth, Renoir wrote to two women friends. To Berthe Morisot, who had predicted a girl: "I must announce to you something completely ridiculous, but contrary to the letter that you sent me and which I received today: it's the arrival of a second son, whose name is Jean. Mother and child are doing wonderfully well. Greetings to the sweet and charming Julie and to the no less pleasing Mama Manet"[59] (p. 204). To Murer's sister, Marie Meunier: "A big boy. Everybody fine."[60] The godfather was twenty-eight-year-old Georges Durand-Ruel. The godmother was Renoir's painting student seventeen-year-old Jeanne Baudot, whom Renoir had met in 1893 and whose physician father was a close friend of Gallimard's.

Aline's fifteen-year-old cousin, Gabrielle Renard, came to Paris to be Jean's nursemaid. In the summer of 1894, shortly before Jean's birth, Renoir painted the first of scores of portraits of her (p. 205). His enthusiasm for this new young model revived some of his earlier Impressionist verve, but a new Classical tangibility is also apparent.

In 1895, Gallimard took Renoir to visit Holland and England. From London, Renoir wrote Bérard that despite the poor weather he liked

"these horizons in the fog through which comes some filtered sunshine." In spite of "backache, in spite of the beer and alcohol, the tea, etc.," he had seen sights that were "superb, ugly but immense monuments, restaurants like factories. Everything is extraordinary but artificial, even the potatoes."[61]

During the same year, Renoir made theatrical decorative paintings of the Classical tale of Oedipus and Jocasta for Gallimard's Normandy home. They were to be installed into Louis XVI paneling, and the style recalls both Pompeian frescoes and seventeenth-century decorations. Gallimard decided not to use the two panels, so they remained in Renoir's studio along with a dozen related drawn and oil studies.

On March 2, Berthe Morisot died of pneumonia at the age of fifty-four. Years later, Julie recorded Renoir's reaction: he was "in the midst of painting alongside Cézanne when he learned of Mother's death, he closed his paintbox and took the train—I have never forgotten the way he came into my room on the rue Weber and took me in his arms—I can still see his white flowing necktie with red polka dots."[62] He alerted his old friend Alphonse Portier, a dealer: "We have just lost a dear friend, Berthe Manet. We are taking her to her last resting place, friends only, Tuesday morning at 10."[63]

In her will, Morisot named Renoir as Julie's guardian.[64] Julie, aged sixteen and a half, went to live with her two orphaned cousins, Jeanne and Paule Gobillard. Renoir, caring, generous, and gregarious, invited the three girls to spend August and September with his family (Pierre, Jean, Aline, and Gabrielle) in Brittany. Julie's diary calls attention to Renoir's kindness: on August 8, he left his family in the country to accompany the girls en route from Paris to Brittany.[65] During their visit, he gave Julie, Jeanne, and Paule painting lessons and was open to them about his work. Julie wrote how Renoir "is doing a ravishing study [perhaps *Tréboul near Douardenez, Brittany*, p. 206] under the

Two Bathers. c. 1893. Etching, 10¼ x 9½". The National Gallery of Art, Washington, D.C. Rosenwald Collection

trees, all the richness of color underneath trees on a very hot day can be seen in it, and in the background the sea shines with an intense blue."[66]

On October 4, Julie recorded: "We are leaving the Renoirs, M. Renoir who has been so kind and charming all summer; the more one

Pierre Renoir. 1893. Lithograph (brown ink), 11½ x 9½". The National Gallery of Art, Washington, D.C. Rosenwald Collection

sees of him, the more one finds him an artist, fine and of an extraordinary intelligence, but on top of that with a sincere simplicity."[67] In the fall, Renoir continued to see Julie often, as when they met at a dinner at Degas's and at lunch at Renoir's, where Julie admired his portrait of Jean with Gabrielle[68] (p. 205).

In November, Julie also accompanied Renoir and Degas to Cézanne's show at Ambroise Vollard's gallery. At Morisot's urging, the twenty-seven-year-old dealer had introduced himself to Renoir earlier in the fall. Julie related in her diary: "M. Degas and M. Renoir drew lots for a magnificent still life of pears in watercolor."[69] Pissarro also wrote about this to Lucien: "Degas and Renoir are enthusiastic about Cézanne's works. Vollard showed me a drawing of some fruits for which they drew lots to see which of them would be the happy owner."[70] Degas had the lucky draw and acquired Cézanne's *Three Pears*. Pissarro explained to Lucien: "My enthusiasm is nothing compared to Renoir's.... As Renoir very rightly said to me, there is somewhat of a similarity with the things of Pompeii, so rough and so admirable."[71] Renoir eventually acquired other Cézannes (four paintings and two

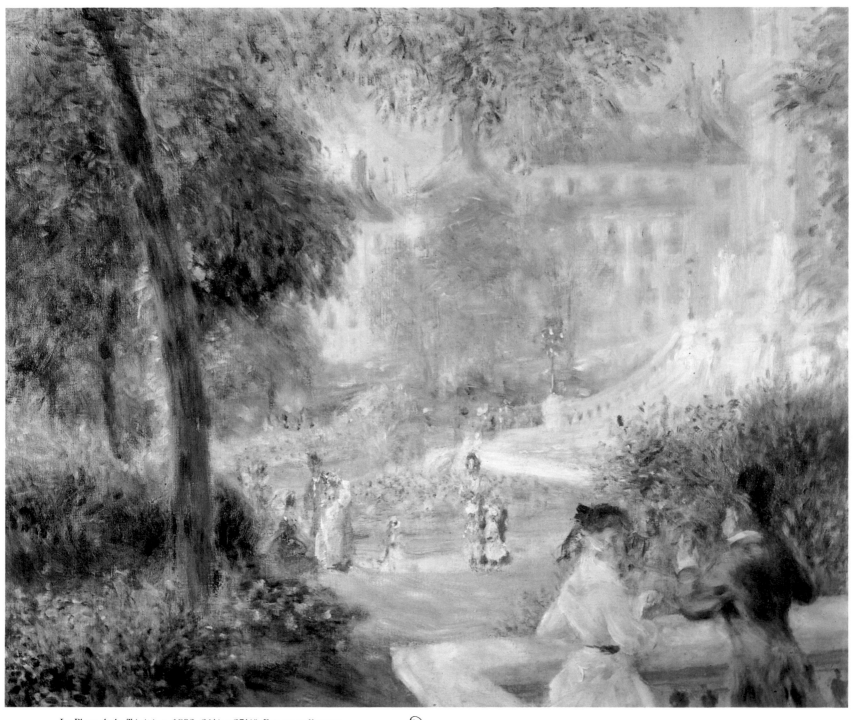

La Place de la Trinité. c. 1892. 21½ x 25½". Private collection

watercolors).[72] At the same time, he strongly disliked Gauguin's art. Of a Gauguin show in November 1893, Pissarro wrote, "Monet and Renoir find all this frankly bad."[73]

Renoir continued to oversee Julie's activities. In 1896, just seventeen years old, she organized a three-hundred-work retrospective exhibition of her mother's art, which took place March 5–23 at Durand-Ruel's Paris gallery. Nine letters from Renoir to Julie give detailed advice for this major undertaking.[74] Although he was in poor health, he assisted at the hanging of the show. On March 4, Julie recorded in her diary, "M. Renoir is very fond of this painting [*La Mandoline*], as well as the one next to it."[75] An excellent review by Geffroy on March 6 prompted Renoir to write to the critic: "Everyone agrees in finding excellent writing in your article on Berthe Morisot. As for me, I agree with everyone, with however something more (even more so)."[76]

A few days after the opening, Renoir congratulated Julie "on the success of the exhibition, and of the articles.... Beside Arsène Alexandre,

202

Geffroy did a very fine one in *Le Journal* of the 6th, and I know there are others. It would be interesting to have them."[77]

Renoir's admiration and persistent support for Morisot's painting contrast strangely with a statement of April 8, 1888, that he provided in response to an inquiry by his old friend Philippe Burty about his opinion of feminism: "I consider women writers, lawyers and politicians, [the two women writers] George Sand, Mme. [Juliette] Adam, and other bores as monsters and nothing but five-legged calves. The woman artist is merely ridiculous, but I am all in favor of the female singer and dancer. In Antiquity and among simple peoples, the woman sings and dances and does not therefore become less feminine. Gracefulness is her domain and even a duty. I'm well aware that today things have gone bad, but what can be done? In ancient times, women sang and danced for nothing, for the pleasure of being pleasant and graceful. Today it's paid too much, and that takes away the charm."[78] Morisot was an exception to the way that Renoir felt about women in

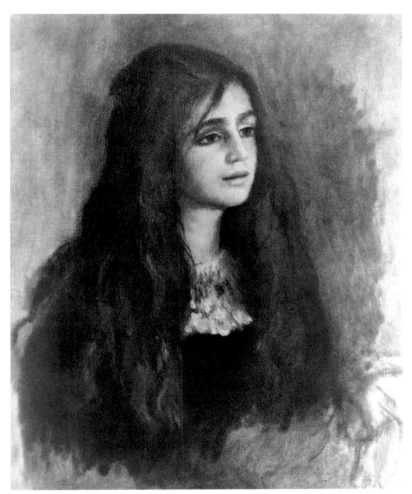

Mlle. Julie Manet. 1894. 22 x 18⅛". Private collection

Berthe Morisot and Her Daughter, Julie. 1894. 32 x 25¾". Private collection

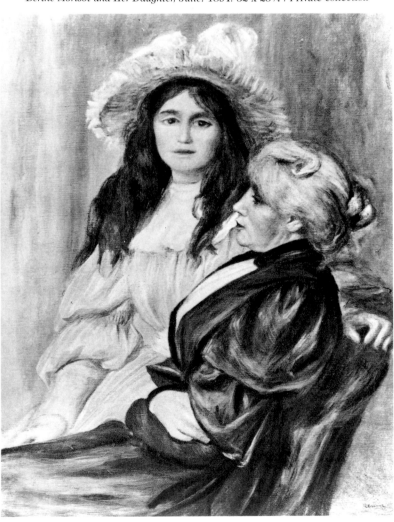

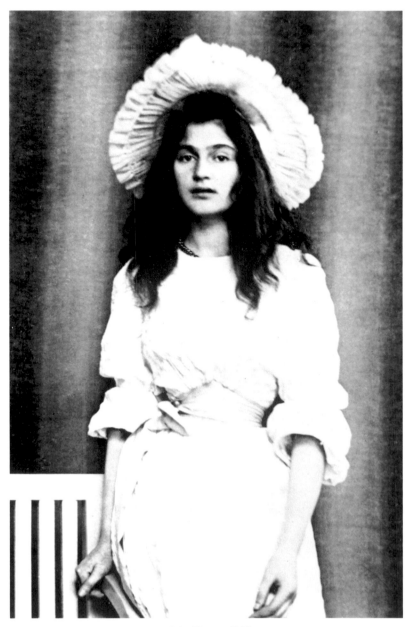

Julie Manet, 1894

Abel Faivre. *Profile of Renoir.* 1894. Pencil on paper, 6⅝ x 3⅝".
Private collection

Chère Madame

J'ai a vous annoncer une nouvelle complètement ridicule mais contraire a la lettre que vous m'avez envoyé et que j'ai reçu aujourd'hui. C'est l'arrivée d'un second fils. qui s'appelle Jean. Mère et enfant se portent à merveille.

Je vous écrit 40 rue Weber ne sachant si vous êtes toujours en Bretagne J'ai du reste perdu l'adresse

Amitié a la douce et charmante Julie et a la non moins agréable qui au ai. Manet.

amitiés
Renoir

13. rue Girardon.

Lundi 1er Septembre.

general. Late in 1896, Julie noted in her diary that Renoir spoke of her mother "of the charming way that she entertained friends, of her talent, etc., 'another woman with all that she had would find the way to be unbearable.'"[79]

Renoir here displayed the typical late nineteenth-century attitudes of most men and women toward professional women: that men held exclusive rights to be intellectuals, decision makers, and artists, and that women should be sources of pleasure for men. Yet despite his declaration that women artists were ridiculous, he gave Morisot's art the same respect that he gave the work of Monet, and he gave her the same encouragement that he gave his male colleagues.

After the close of the Morisot show, Renoir began preparing his own exhibition of forty-two recent works to be displayed at Durand-Ruel's gallery from May 28 through June 20, 1896. The centerpiece was the life-sized *The Artist's Family*. Like *The Bathers* (1887), this outdoor, many-figured painting was intended as an exhibition piece, yet because it has unity of style, it is neither complex nor overworked. Presenting a scene of daily life carried on with evident physical well-being, it recalls *Le Moulin de la Galette, The Boating Party,* and the dance panels. Abandoning his secretive attitude of a decade earlier, Renoir now proudly displays his family as full-fledged members of the bourgeoisie. He camouflages the "frankly stout and peasant"[80] Aline, painting her instead as a stylish woman (her costume resembles a contemporary fashion advertisement) presiding over this affectionate family in the garden of their Montmartre residence. She links arms with eleven-year-old Pierre. Gabrielle, in a maid's uniform, crouches to support two-year-old Jean. The young girl at the right, a neighbor, seems a substitute for Renoir himself as the artist calls attention to her hands; his joints, as a photograph shows, were already deformed by arthritis.

Thadée Natanson wrote a favorable review of the show in his *La Revue Blanche,* where he noted Renoir's "religious enthusiasm for the ancients, his warm reverence for the eighteenth century."[81] Geffroy also wrote favorably in *Le Journal,*[82] but Frantz Jourdain, a former supporter of the Impressionist cause, belittled Renoir in *La Patrie,* bemoaning "about thirty frames of dismaying weakness." He continued: "These chalky women, these heavily modeled bodies, these feet and hands resembling pieces of bloody meat, these everlastingly crushed profiles, these seas of tin, these rocks of mauve oakum, these arrangements of an unwitting childishness make a laudatory appreciation, or even a sincere and convinced defense, impossible. A few canvases, the portrait of Mme. Manet [*Berthe Morisot and Her Daughter, Julie,* 1894], for example, evoking the memory of the luminous and exquisite painting of the past, can still be found, but—alas!—these canvases are scarce in the rue Laffitte exhibition."[83]

In July, Renoir moved from Montmartre closer to the center of Paris, near the place Pigalle. His apartment was on the fifth floor at 33 rue de La Rochefoucauld and his studio (which Julie Manet called "superb")[84] was at number 64.

Later that summer, Martial Caillebotte accompanied Renoir to the Wagner operas in Bayreuth, Germany. Julie later wrote in her diary: "M. Renoir says he was very bored this summer, he was never able to sit through the four days of performances in Bayreuth."[85]

On November 12, Renoir's mother died at the age of eighty-nine. Despite his heritage of longevity,[86] his own health was increasingly frail. Odilon Redon, who had first met him in the mid-1880s, described Renoir in 1896 as "timid, anxious, and without any charm. He must have

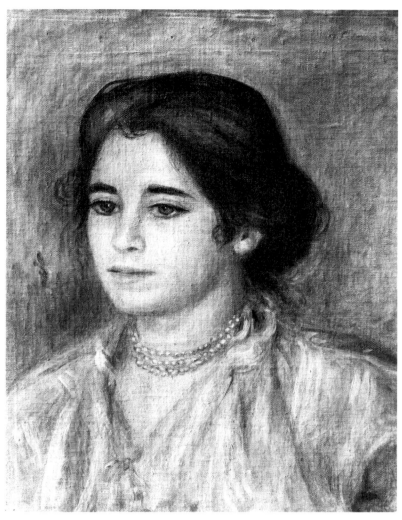

Gabrielle with the Necklace. 1894. 15¾ x 12⅝". Kunstmuseum, Basel. Rudolf Staechelin Foundation

Gabrielle and Jean. 1895. 25⅝ x 21¼". Orangerie des Tuileries, Paris. Walter-Guillaume Bequest

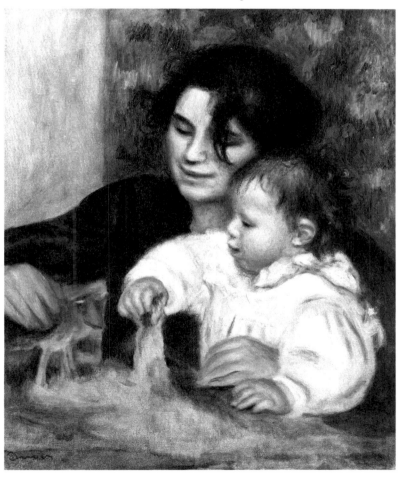

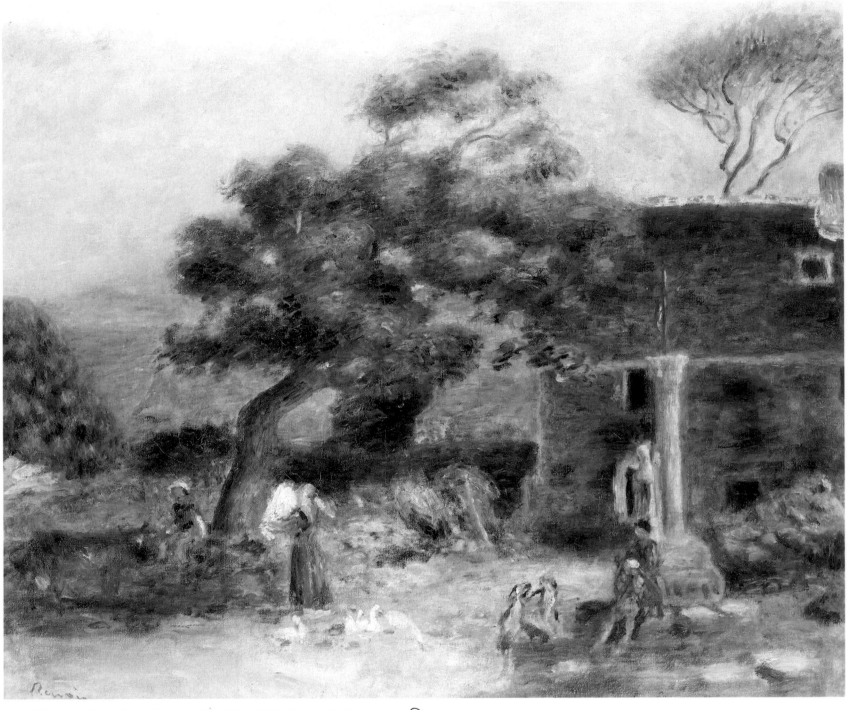

Tréboul near Douardenez, Brittany. 1895. 17¾ x 21½". Private collection

suffered a lot. With him you must make the first move; he deserves it. He is plain-spoken; we got on well together. He kept all his tenderness inside, but one guesses it."[87]

In September 1897, while in Essoyes, Renoir fell off his bicycle onto a pile of rocks and broke his right arm, the same arm he had fractured in 1880. Again he had to rely on his ability to paint with his left hand.[88] Pissarro later exclaimed: "Didn't Renoir, when he broke his right arm, do some ravishing paintings with his left hand?"[89]

While his arm was still in a cast, Julie came to stay with the Renoirs from September 14 through October 17. In her diary she elaborated on Renoir's conservative viewpoint: "M. Renoir attacks all the new machines, saying that we are in decadence when people think of nothing else but traveling many kilometers an hour, that this is pointless, that the automobile is an idiotic thing, that we don't need to go so fast, that all this will be a cause for distraction, that joining together in a single direction is required for work and trade."[90]

206

Back in Paris late in 1897, Renoir resumed giving painting lessons to Julie Manet, her cousins Jeanne and Paule Gobillard, and Jeanne Baudot, daughter of the doctor. As he had copied at the Louvre in the 1860s, he now taught this same way. Every other week he met his students there to criticize their copies of the old masters and to study works by Egyptian and Pompeian artists as well as by Delacroix, Ingres, and Corot.[91] Around this time he himself made a copy, which he inscribed: "Renoir d'après Corot."

Renoir's conservative work of 1897 drew both on great masters and on his own earlier art. *Landscape at Beaulieu* (p. 210) is an ordered scene that calls to mind both Poussin and Corot landscapes, yet the impasto, space, and light are Impressionist. *Bathers in the Forest* recalls Girardon's *Nymphs Bathing* at Versailles, which had influenced *The Bathers* (1887). Renoir again tackled the theme of nudes romping in nature. Now, however, the figures are well integrated in their setting and relate to one another with easy harmony. In his preparatory

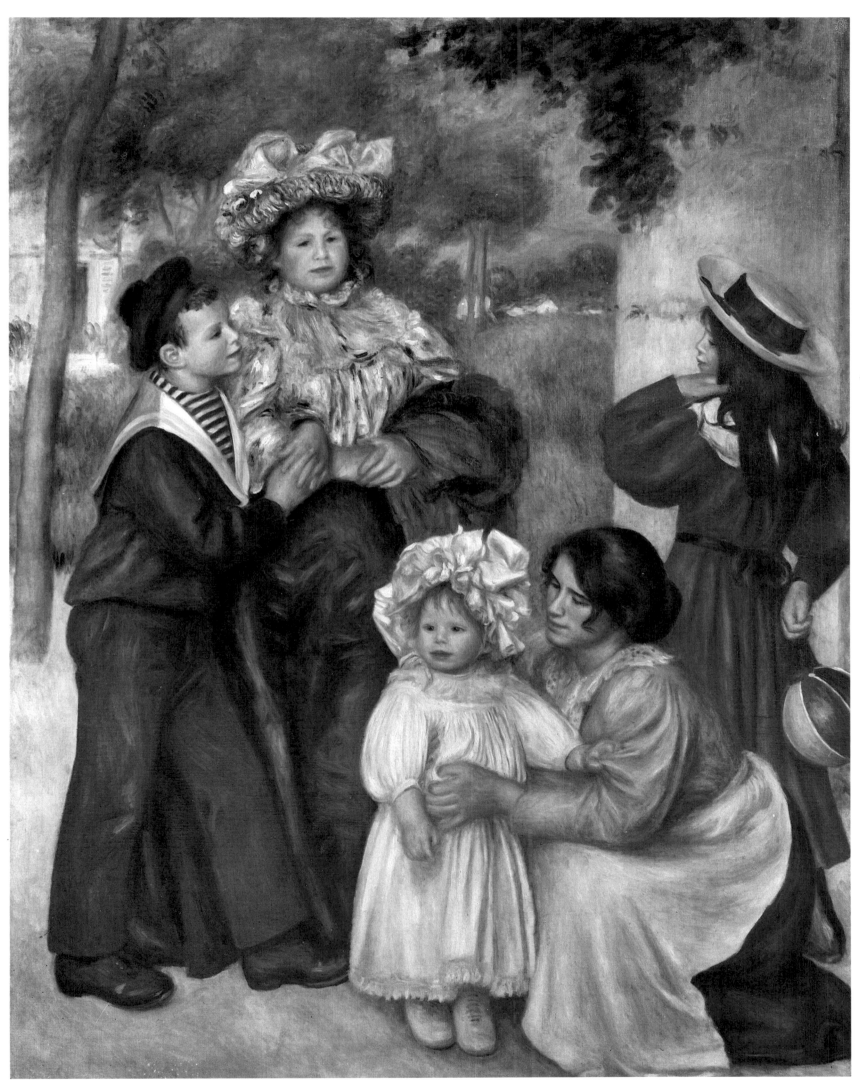

The Artist's Family. d. 1896. 68 x 54". The Barnes Foundation,
Merion Station, Pa.

drawing, he continued the traditional practice noted by Maurice Denis: "Renoir draws on tracing paper and modifies his painting by means of successive tracings."[92]

At the same time, Renoir also returned to scenes of daily sociability that he had not portrayed since 1883: friends' homes, the theater, and his own home, filled with fashionably dressed women. Unlike works of the 1870s and early 1880s, however, the figures have clearly defined silhouettes and are solid. Men now appear rarely, usually in the backgrounds or at the sides of the image. Gone are the romance and flirtation of Renoir's bachelor years; now he celebrates the stability and comfort of middle-class life.

In the late 1890s, Yvonne and Christine Lerolle posed for Renoir at the piano in their home. Their father, Henry Lerolle, a painter and collector, had met Renoir in the mid-1880s at Morisot's dinners. Behind the daughters are works in Lerolle's collection, Degas's *Jockeys* and *Dancers*. In another painting, Christine embroiders while Renoir's old friend the painter, industrialist, and collector Henri Rouart and the sculptor Louis-Henry Devillez scrutinize two Degas works and a Renoir of 1890.[93]

As a guest of Gallimard, Renoir often went to the Théâtre des Variétés,[94] where he found themes similar to those that had attracted him in the 1870s and early 1880s. On January 8, 1898, Julie visited his studio and admired the painting of Mlle. Diéterle: "A ravishing

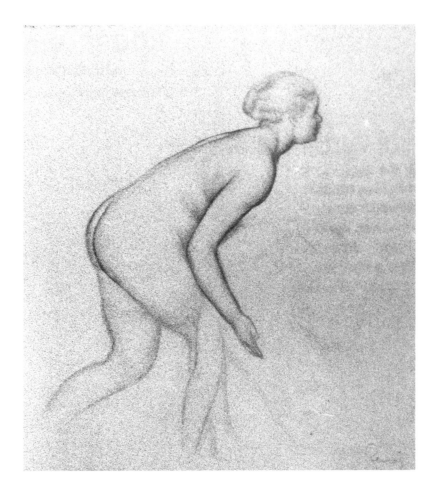

Study for Two Left Midground Nudes in Bathers in the Forest. c. 1897. Private collection

portrait of an actress from the Variétés in a Directoire costume with a large gray [*sic*] hat and roses [p. 211]; then he began a box at the Variétés [p. 214]."[95]

In the summer of 1898, thirteen-year-old Pierre was home on vacation from boarding school, and Renoir appropriated him as a model. *Breakfast at Berneval* (p. 215) shows the boy reading while Jean talks to Gabrielle. The compositional juxtaposition of near and far recalls *Mlle. Christine Lerolle Sewing* of two years earlier. Along with these

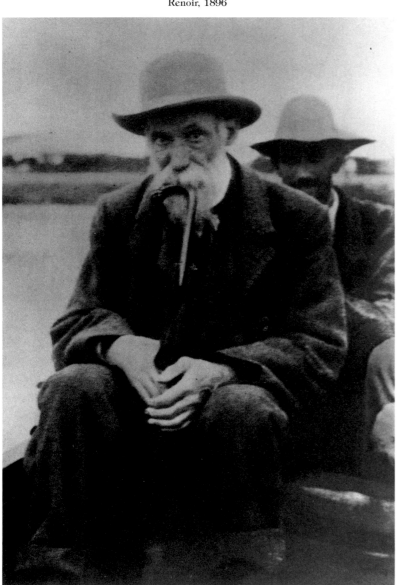

Yvonne and Christine Lerolle at the Piano. c. 1898. 29 x 36". Orangerie des Tuileries. Walter-Guillaume Bequest

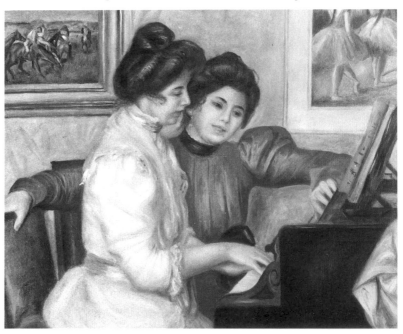

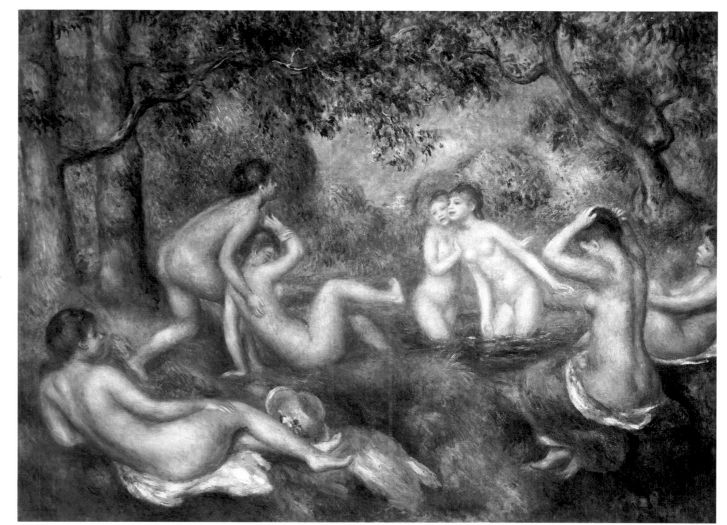

Bathers in the Forest.
c. 1897. 29 x 39¼".
The Barnes Foundation,
Merion Station, Pa.

Interpretation of Corot.
c. 1897. 15¾ x 21¾".
Private collection

Landscape at Beaulieu. d. 1897. 25⅝ x 31⅞". The Fine Arts Museums of San Francisco. Mildred Anna Williams Fund

interior scenes, he continued to paint still lifes such as the boldly composed triangular bouquet in *Flowers in a Vase.*

Later that summer, Renoir bought a house in Essoyes, Aline's birthplace. From then on he spent part of every year there. Besides this evidence of his comfortable lifestyle, he also painted an elegant portrait of Jean (dressed as a girl, as was Mme. Charpentier's son) that he proudly displayed in his home. As Julie noted in her diary on June 16, 1898: "Jean's portrait in black velvet with a lace collar and a hoop in his hand hangs in the drawing room, it looks very good, you would think it was the portrait of a little prince."[96]

In his old age Jean wrote angrily: "Why my father had insisted on showing me in this outfit that I hated I don't know. It may have been an affectionate thought for Van Dyck. . . . I suppose that the lace collar, in my mind, added still more to the 'girlish' look of my hair. As a reaction against this unfortunate hair style, I liked only coarse materials, heavy shoes, whatever seemed masculine to me."[97] (Renoir painted another

portrait of Jean before he had his hair cut, which he presented as a gift to the museum of Limoges, his birthplace.)[98]

On September 9, 1898, Mallarmé died at his summer home in Valvins, near Fontainebleau. Renoir took Julie, Jeanne, and Paule to the funeral.[99] Afterward he went to Thadée Natanson's house for lunch, along with Vollard, Mirbeau, Henri de Toulouse-Lautrec, Édouard Vuillard, Félix Vallotton, and Pierre Bonnard.

In 1898, at the height of the Dreyfus affair, Renoir had no qualms about eating at the home of Natanson, a Jew. He also kept up his friendship with other Jews—Charles Ephrussi, Catulle Mendès, Arsène Alexandre, Claude Roger-Marx, Pissarro, and his brother Henri's wife, Blanche David. Nonetheless, he was staunchly anti-Dreyfus and believed with Cézanne, Degas, and Forain that the Jewish Captain Alfred Dreyfus had supplied the Germans with military secrets. Monet, Pissarro, Charpentier, and Mirbeau were pro-Dreyfus, as was Zola, who published "J'accuse" in *L'Aurore* on January 13, 1898, in which

Mlle. Christine Lerolle Sewing. c. 1896. 32 x 25⅛″.
Collection Dr. and Mrs. Howard D. Sirak, Columbus, Ohio

RIGHT, BELOW:
Flowers in a Vase. c. 1898. 21⅝ x 17⅛″. Orangerie des Tuileries, Paris.
Walter-Guillaume Bequest

Mlle. Diéterle in the White Hat. 1898. Private collection

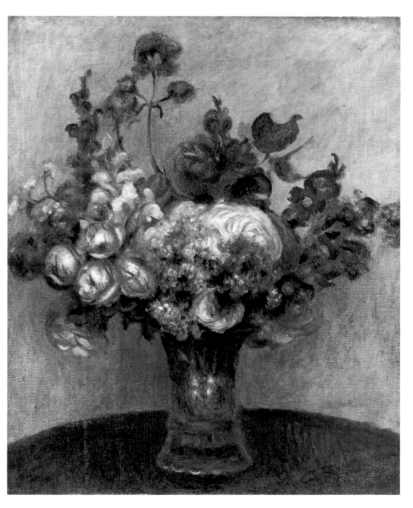

he charged French generals and statesmen with convicting an inno-
cent man and—the worst crime—upholding the verdict through lies
and suppression of evidence, once they knew that Dreyfus was not
guilty.[100]

Renoir's anti-Dreyfus position was linked to his conservatism and
fear of anarchism. As Julie recorded in her diary: "We also talked
about the Natansons: M. Renoir says that it is very dangerous to sup-
port anarchists like Fénéon, who write while waiting to launch them-
selves in politics and who will end up doing something bad. Isn't he
right? The literary men support bad characters too much, painters
have healthier minds. Still Pissarro is an anarchist."[101]

Julie related several conversations in 1898 in which Renoir voiced
anti-Dreyfus and anti-Semitic remarks. On January 15: "In Renoir's
studio where they were talking about the 'Dreyfus case' and against
the Jews, ' They come to France to make money and then when there is
fighting they go and hide behind a tree.' M. Renoir says, ' There are
plenty of them in the army because the Jew likes to walk around wear-
ing officers' ornaments. If they get kicked out of all countries, there is
a reason for it, and they shouldn't be allowed to become so important
in France. People ask that the Dreyfus trial be reviewed, but there are
things that can't be said, they don't want to understand that.' M. Re-
noir starts on Pissarro too, 'a Jew' whose sons are of no country and
don't do their military service anywhere. ' This Jewish race is tena-

cious, Pissarro's wife is not one and all the children are even more Jewish than their father.'"[102]

Six months before Mallarmé's death, Julie described a visit he and Renoir had paid her during which the two men "resume the endless discussion about the Dreyfus case, they repeat the same things all over again, M. Renoir says, which is true, that the characteristic of the Jews is to cause dissension, etc. . . . They may be very interesting but really we've had enough of this case . . . these two men discussing seriously; one, M. Renoir, very excited; and three people . . . listening to them without opening their mouths."[103] Like his antifeminism, Renoir's anti-Dreyfus stance and anti-Semitic remarks reflected common stereotypical beliefs to which he made numerous exceptions.

Late in 1898 and in 1899, Renoir's health continued to deteriorate. Nonetheless, accompanied by Faivre, Bérard, and Joseph Durand-Ruel, he visited museums in Holland in October 1898.[104] Three months later, Julie reported, "He can neither work nor go out, and his arthritis does not improve."[105]

From Cagnes, on the Riviera, where he spent from mid-February to mid-April, he wrote to Joseph's father, Paul: "At any rate, I am outdoors all day long roasting in the sun, something I can't do in Paris. What keeps me from moving around is my feet, where the swelling doesn't want to go down. . . . All goes well except for this troublesome rheumatism."[106] And again: "I haven't mentioned my health because it's a little difficult. One day bad, one day better; in short, I think I'll have to get used to living this way. Still my feet, where the swelling doesn't want to go down. I had foreseen for a long time that as soon as I was mature in myself for my painting, things would no longer work. I shouldn't complain, it could have been worse."[107] Two months later, "The doctor here warns me that it may last at least eighteen months if I take good care of myself."[108]

In spite of these infirmities, Renoir continued to lead an active social life. He rented a house for the summer at 39 rue Gounod in St.-Cloud. From July 29 through August 12, when Aline and the children went to Essoyes, he invited Julie, Jeanne, and Paule to stay with him. Yet, as Julie remarked in her diary on August 4: "M. Renoir's health changes every day, sometimes he looks fine, but then his feet and hands swell; this disease is really very annoying, and he, so nervous, puts up with it with a lot of patience."[109] A few days later, she lamented: "It is so painful to see him in the morning not having the strength to turn a doorknob. He is finishing a self-portrait that is very nice, at first he had made himself a little stern and too wrinkled; we absolutely insisted that he remove a few wrinkles and now it's more like him. 'It seems to me that those calf's eyes are enough,' he says."[110]

In mid-August, Renoir agreed to go to Aix-les-Bains for about two weeks to try the curative powers of the baths. He reported to Durand-Ruel on August 29, "I was very tired and the treatment was making me even more nervous than usual."[111] Although they rarely saw one another, Monet was concerned about Renoir's health and wrote Durand-Ruel on November 25, when Renoir had gone to Cagnes, "I am sorry about what you tell me of Renoir and I'd be happy to know if he feels better in the south."[112]

Renoir's tie to Durand-Ruel remained very strong. While Monet, Pissarro, and Sisley had sold to other dealers from the late 1880s on, Renoir loyally offered Durand-Ruel all his new work. Alexandre,

Self-Portrait. 1899. 16¼ x 13¼". The Sterling and Francine Clark Art Institute, Williamstown, Mass.

Renoir's house at Essoyes

Josse, and Gaston Bernheim of Bernheim-Jeune & Cie.; Léonce and Paul Rosenberg of Rosenberg & Co.; and Ambroise Vollard were trying to acquire his works. But they could obtain only what Durand-Ruel

At Le Relais, home of Thadée and Misia Natanson, after Mallarmé's funeral, September 10, 1898. *Left to right:* Pierre Bonnard, Cyprien Godebski (Misia's half-brother), Ida Godebski (his wife), Thadée and Misia Natanson, and Renoir

213

A Loge at the Théâtre des Variétés. 1898. 26 x 32¼″. Private collection

turned down or older paintings from former collectors or from estates. Renoir, however, sometimes accepted commissions from them.

Durand-Ruel continued his practice of promoting Renoir and other Impressionists internationally in a series of exhibitions. A dozen Renoirs were shown in January and February 1899 in St. Petersburg, four in February in Dresden, and forty-one in April at Durand-Ruel's Paris gallery (the first major joint exhibition in Paris since 1882 of works by Renoir, Monet, Pissarro, and Sisley).

Sisley had died on January 29, 1899. Renoir and Sisley had not been friendly since Édouard Manet's death in 1883,[113] but Renoir contributed a painting to "a sale for the benefit of the Sisley children."[114]

Three days later, in Paris at the sale of the collection of Count Armand Doria, ten Renoirs were offered. Durand-Ruel paid 22,100 francs for *Girl Thinking* (1877). This was a record price for a Renoir painting, surpassing the 13,000 francs paid by François-Félix Depeaux in 1894 for *Dance at Bougival*. Renoirs also brought high prices at the Chocquet sale on July 1, including 20,000 francs paid by Durand-Ruel for *At La Grenouillère* (1879).

Renoir, of course, received no money from these impressive resales. Although Durand-Ruel was buying many of his recent works, the artist was short of money. His living expenses were high: he had an apartment and two studios in Paris and a house in Essoyes; he traveled a good deal, and because of his poor health, he was under the constant care of several doctors and dentists. He employed several servants and models, entertained guests for weeks at a time, and was sending Pierre to boarding school at Notre-Dame-de-Ste.-Croix in Neuilly. His need for money probably explains why he sold the Degas pastel he had acquired from the Caillebotte estate.

On November 16, 1899, Julie wrote in her diary: "Yvonne [Lerolle] tells us of the break between M. Degas and M. Renoir. It is upsetting to hear that these two friends have broken up. M. Degas went a little too far after all when he wrote an insolent letter to M. Renoir because he sold one of his pastels, and it looks serious this time; for they have broken up many times before, but not as seriously. It was in fact by meeting each other in the past at home at the Thursday dinners that they were reconciled."[115]

Breakfast at Berneval. 1898. 31⅞ x 25⅝". Private collection

I N JANUARY 1900, Renoir learned that Julie Manet had become engaged to Ernest Rouart, son of his old friend Henri. "A thousand Bravos!!!!" he wrote. "My dear Julie, this is a piece of good news that fills my wife and me with joy. Now I can tell you that he was the fiancé of our dreams. My wife had spoken of it to Degas while coming back together from a dinner at your house. Our wish has been fulfilled, again Bravo!! And to dispel the only cloud that darkens your happiness, as the old man of the mountain, I send you this old saying: When happiness comes into the house, you must count to three. We kiss you all, my wife and I, and I'm ordering a new suit."[1] In June, in a double ceremony, Julie married Ernest, and Jeanne Gobillard married the poet Paul Valéry.

Renoir felt optimistic about his health. In March, he explained to Bérard from Grasse: "I keep getting along well without any medication, only rubbing in the morning with water and eau de Cologne and as many walks as possible."[2] Although in the same month he told Jeanne Baudot that "the doctor here told me that I was too anemic to take the waters at this time," nevertheless, at the end of the letter he drew a cartoon of himself inscribed, "My portrait in the month of May as I entered the Folies-Bergère."[3] He looks considerably more vigorous here than in contemporary photographs.

By 1900, his paintings had soared in value to over 22,000 francs,[4] far beyond the prices his friends' canvases were fetching. Cézanne's paintings were selling for up to 6,000 francs; Pissarro's, 8,500 francs; Sisley's and Monet's, 10,000 francs.[5] Renoir had five exhibitions that year: from late January through mid-February, Bernheim-Jeune displayed fifty-nine works; in April, Durand-Ruel exhibited twenty-one in New York, and sent others to Berlin and Glasgow; from April through June, eleven were shown at the Exposition Universelle in Paris.

On August 16, Renoir's eminent accomplishment received official recognition; he was named a *chevalier* of the Legion of Honor. His letter of acceptance states: "I am choosing M. Paul Bérard, *chevalier* of the Legion of Honor, 20 rue Pigalle, Paris, to represent me and to deliver to me the insignia of *chevalier* of the Legion of Honor. He will deliver to you my birth certificate and service documents, which consist in having exhibited since 1864 at the official Salons and finally at the 1900 Centennial."[6] Four days later, he informed his dealer: "Yes, my dear Durand-Ruel, I am the culprit. So I hope that the firm of Durand-Ruel will take up a collection to buy me an honorary potty-chair."[7]

To Mme. Charpentier he composed a brief note signed, "the member of the Institute, Renoir."[8]

RIGHT:
Study for Claude and Renée. 1903–4. Pencil on paper, 24 x 18".
Private collection

OPPOSITE:
Claude and Renée. 1903–4. 31 x 25". The National Gallery of Canada

Renoir knew that Monet spurned anyone who would accept such an honor. In two letters to him, Renoir expressed his concern: "I let them decorate me. Be assured that I am not letting you know to tell you whether I am wrong or right, but so that this little piece of ribbon does not become an obstacle to our old friendship. So call me dirty names, the most unpleasant words, it's all right with me, but no joking, whether I made a fool of myself or not. I want your friendship; as for the others, I don't give a damn."[9] Three days later: "I realized today, and even before, that I wrote you a stupid letter. I was feeling ill, nervous, tense. One should never write at such times. I wonder what difference it makes to you whether I'm decorated or not. *You* are admirably consistent in your behavior, while *I* have never been able to know the day before what I would do the next. You must know me better than I do myself, just as I very probably know you better than you do. So tear up this letter and let's not talk about it any more, and *vive l'amour!*"[10] Their friendship did continue.

In Grasse, during the winter of 1899–1900, Renoir complained to

Gallimard: "I lack company. It's a little monotonous in the evening."[11] However, when he returned south for the winter of 1900–1901, several young artists, among them Louis Valtat and Georges d'Espagnat, came to spend time with him. Odilon Redon also visited Renoir and reported to Paule Gobillard on February 26 that he had seen him "suffering from his pain, and very splendid in his wonderful pride! He was surprised by my visit, and touched at the same time; he expressed it to me gently, with something in the tone of his voice in which I perceived all his sensitivity, which is exquisite. . . . This is how a man, in certain conditions of loneliness, reveals himself and shows himself better."[12]

Dealers and collectors continued to be enthusiastic about Renoir's work. Nine Renoirs were included in a group show at the Hanover Gallery in London organized by Durand-Ruel—to whom Renoir confessed in April from Cannes: "I was weak enough to be unfaithful to you with the Abbé [Gauguin, a collector], although what I gave him you had turned down and found horrible, which after all is true. But if I sold only good things, I would starve to death, and I thought afterward that he would keep those horrors longer. For 4 years he had been asking me for a view of the south. It was a commission that for a long time I refused to do. Finally I dashed off a Palace of the Popes, and that's it. But I've had enough of collectors and I will no longer let myself 'give in.' . . . Please forgive me my weaknesses."[13]

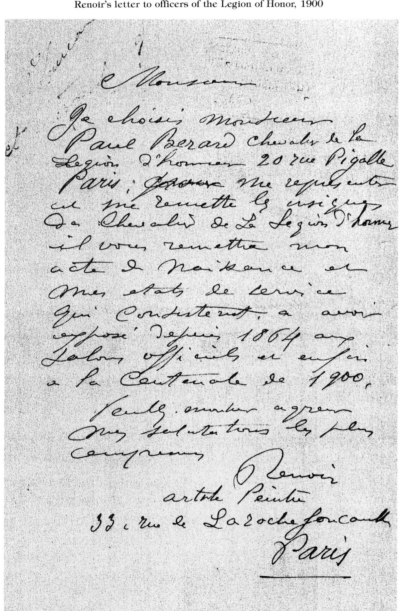

Cartoon at the end of Renoir's letter to Jeanne Baudot, mid-March 1900

In 1901, Paul Cassirer, the German art dealer and publisher, began collecting Renoirs and acquired *Lise* (1867). He exhibited it along with twenty-two other Renoirs in a group show in Berlin from October 16 through December 1, 1901.

Ambroise Vollard and Renoir had developed a lighthearted, bantering friendship. Writing to Vollard from the health spa at Aix-les-Bains, Renoir reveals the warmth the sixty-year-old artist felt for this dealer just over half his age. On May 3:

I've come back to my little Hôtel de la Paix, where I am alone and very coddled. They make me little gourmet meals that that glutton Vollard would be happy to taste. In short, since I didn't know what to do, I said to myself, let's write to Vollard, but what can I say to him since I have nothing interesting!!! Bright idea, let's ask him for money. I know he loves that. 500 francs, in case the burglars should penetrate his sanctuary, that much at least would be saved, and that's why I thought of you, my dear Vollard.[14]

Two days later:

I received the 500 francs, for which I thank you, and I'm especially happy that business allows you to play the rich collector, at least until they hang them. I'll know where to find one. I will be back at the end of the month, and we'll go and see that restaurant and taste the famous fish. I don't think that you're one of them [a fish or a collector], you would be a little tough. Greetings and thanks. RENOIR.
3 more weeks of massage or baths. I'll come back, if not cured, completely brutalized. R.[15]

Another important Paris dealer whom Renoir knew was Alexandre Bernheim and his twin sons, Josse and Gaston (who changed their last names to Bernheim-Dauberville and Bernheim de Villers). In 1901, the twins, then thirty-one, commissioned Renoir to paint portraits of their fiancées (and cousins), Mathilde Adler and her sister Suzanne. From Fontainebleau, Renoir informed Georges Durand-Ruel on September 7: "I am staying with the Bernheims or rather at Adler's, 4 rue St.-Honoré, for about ten days."[16] A photograph shows him outdoors painting Mathilde, whose position straddles the threshold between inside and outside. The final portrait had an indoor setting. During this short visit, he also painted Mme. Charles Fray, a painter who exhibited under the name "Val," who was a first cousin to the Bernheims and

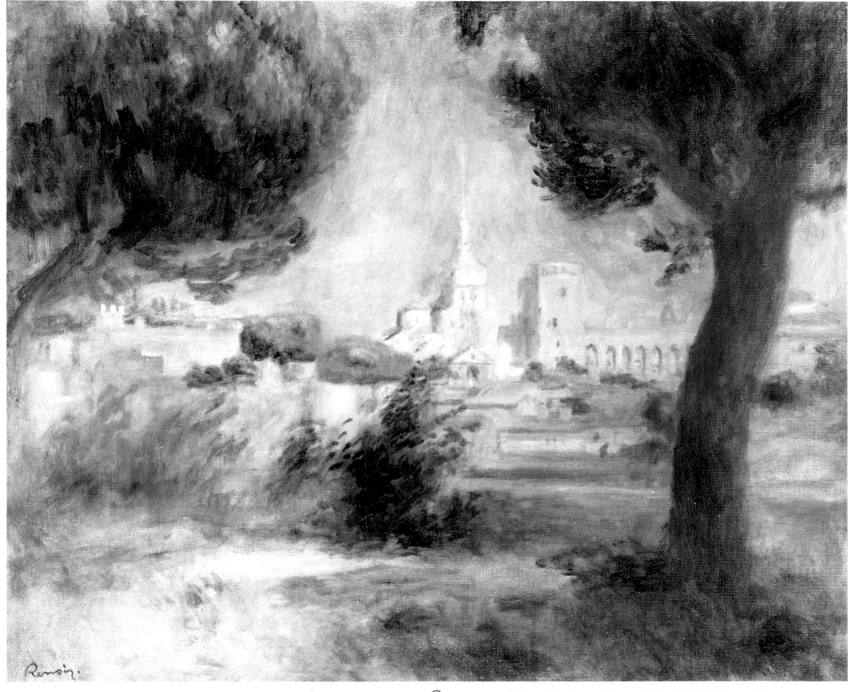

Palace of the Popes, Avignon. 1901. 18 x 22″. Private collection

Adlers. Despite his earlier pronouncement that "the woman artist is merely ridiculous,"[17] this is a dignified portrait, reminiscent of his 1876 self-portrait with brushes.

During this first decade of the twentieth century, Renoir's style continued to develop as it had during the previous decade in an integration of Classicism and Impressionism. He continued painting portraits, nudes, mothers, children, young girls, daily life, landscapes, and still lifes. Tangible forms are surrounded by a warm atmosphere created by expressive brushstrokes of vibrant color and sparkling light. Classical feelings of weightiness and universality are blended with Impressionist feelings of movement and joyfulness.

A month before he executed the Bernheim commissions, Renoir had become a father again: Claude (Coco) was born in Essoyes on August 4. Renoir was then sixty and in increasingly poor health. He walked with a cane. A nerve in his left eye had partially atrophied. His hands were ossified and deformed, his knuckles stiff and swollen, and his fingers

twisted.[18] Because of his frail condition, he often caught colds. Aline, forty-two, was obese and frequently ill with bronchitis and other respiratory problems.

Three days after his son's birth, Renoir wrote a condolence letter to Téodor de Wyzewa, whose wife had died: "Despite the daily and rather strong attacks of rheumatism that I have suffered here, I had been hoping, nonetheless, to be near you during your sad ceremony. But at the same time, my wife had a third boy, and she was pretty ill. Fortunately, today everything is fine; we have re-entered the calm. She asks me to tell you how much she was affected by this sad end, and to express to you her strongest feelings of friendship. As soon as I am a little better, I will come to see you, but until then, I shall have to stay still."[19]

Renoir enjoyed family life more and more. Becoming a father in his old age and sickness brought him tremendous joy, for he saw the baby's growth and health as an affirmation of the power of life itself. Coco became one of his favorite models, but the other sons were not dis-

219

placed. In 1901, he painted Jean drawing; the seven-year-old now has a boyish haircut and suit.

The climb up the four flights of stairs to the rue La Rochefoucauld apartment became too difficult for Renoir, and in October the family moved to a second-floor apartment at 43 rue Caulaincourt. He rented a studio nearby at number 73.[20] Later in the fall the young artist Albert André painted Renoir at work there, wearing his ever-present hat, accompanied by Coco on Gabrielle's lap, Jean dressed as a clown, and Aline.

André joined Renoir in the south early in 1902. As Renoir explained to Durand-Ruel from Le Cannet, a suburb of Cannes: "A slight attack is keeping me in my room, one foot swollen.... I have everything here that I need: a large room to work in and company. Albert André is extremely pleasant, and we help each other to work better."[21]

In 1902, prices for his paintings continued to rise. The Bernheims paid 23,500 francs for *Girl Thinking* (1877).[22] On March 9, Renoir counseled Durand-Ruel from Le Cannet about the forthcoming June exhibition at his Paris gallery: "I would rather when I get back give you some canvases that are not new, because they never look good when they're too fresh, but at least from last year.... Besides, small exhibitions with few paintings carry more weight, in my opinion. I find that exhibitions of figures that are too large give the impression that they have been done too easily, which removes the stamp of rarity from them. This reproach is leveled at the Impressionists, who exhibit too often. It looks like they lay paintings like eggs. This has or will later have a very bad effect."[23]

The treatment for rheumatoid arthritis in the 1890s and early 1900s depended largely on the application of heat and mineral waters in various forms, both internally and externally, at spas. The doctors Renoir consulted also prescribed sun, walks, rubdowns, baths, and purges.

Louis Valtat, Georges d'Espagnat, and Renoir at Magagnosc, near Grasse, 1901

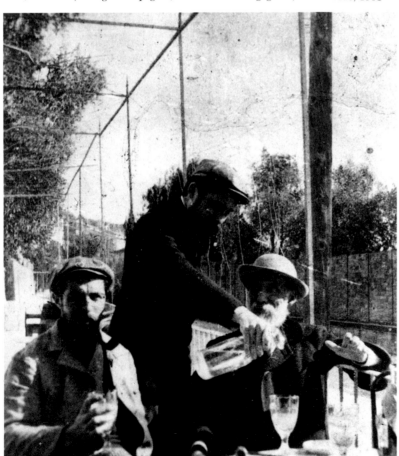

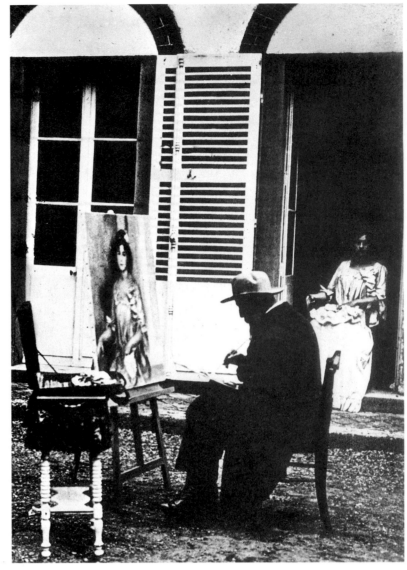

Renoir painting the portrait of Mathilde Adler at Fontainebleau, 1901

Renoir took large quantities of antipyrine (a substance similar to aspirin, which had been introduced in 1899) and other drugs, and ate very sparingly.[24] Attacks during which he could not paint at all were followed by remissions, when he could work, but each crisis left him progressively more debilitated and deformed.

Renoir's usual departure from Paris to the Midi was delayed in 1902 beyond the onset of cold weather. He explained to Durand-Ruel in mid-January that he had "frozen feet, even when I warm them up. My trip is again delayed: they are going to stick me with fiery needles, etc."[25]

When his foot treatment was over, Renoir went to Le Cannet,[26] but he began to feel it was too isolated. In April, he rented a house near the post office (known as the Villa de la Poste) in Cagnes-sur-Mer, where he painted many landscapes. He and his family stayed here periodically from 1903 through 1908. A photograph around this time shows him with gnarled hands painting a beach scene with a boat.

Renoir returned north for the summer and early fall. He was traveling to Cagnes via Marseilles in mid-November[27] when he learned that Pissarro had died (on November 13). Despite his poor health, he took the train back to Paris to be at the funeral.[28]

He had been concerned for some time about eighteen-year-old Pierre, who was interested in an acting career. He wrote to André: "I nag Pierre from time to time trying to get him to keep on the lookout for a career. It's difficult, but I'd be so happy to see him get excited about something other than being a ham actor."[29]

The previous spring, Vollard had commissioned a replica of *The Bathers* (1887), which he had seen on loan from Jacques-Émile Blanche at Bernheim-Jeune's 1900 exhibition. "I would be much obliged if you would send me the thousand francs," Renoir wrote to him on April 25. "Put *'Artiste-Peintre'* in case there may be two Renoirs in Cagnes."[30] Renoir began by making a full-size drawing on brown paper, which he used to trace the contours onto the final canvas. Although the new version (p. 228) is close in size to the 1887 painting, it has none of the artificiality and Irregularism of the earlier work; naturalism and unity prevail. The nudes are more fleshy, weighty, and massive, the crisp outline has given way to a flowing arabesque, and the hard, smooth form has been softened by overall brushstrokes. Two figures (the central blond bather and midground standing bather) move forward so that all the figures interact as a group. The color has changed from pale acid tones to warm, pleasing hues.

Here and elsewhere, in the last twenty-five years of his life, red and its nuances became more prominent. His palette contained four reds (superfine carmine, Venetian red, French vermilion, and madder lake), three yellows (antimony or Naples yellow, yellow ocher, and raw umber), emerald green, cobalt blue, ivory black, and white lead.[31] He now used twice as many reds as he did in the late 1870s, eliminated two greens, one yellow, and one blue, and added a black.

Throughout 1903, Durand-Ruel continued sending Renoir's paint-

RIGHT, ABOVE:
Mme. Josse Bernheim-Dauberville (née Mathilde Adler). d. 1901. 36⅝ x 28¾". Private collection

RIGHT, BELOW:
Mme. Charles Fray. d. 1901. 25½ x 21¼". Glasgow Art Gallery and Museum

Mme. Gaston Bernheim de Villers (née Suzanne Adler). d. 1901. 36⅝ x 28¾". Musée d'Orsay, Galerie du Jeu de Paume, Paris

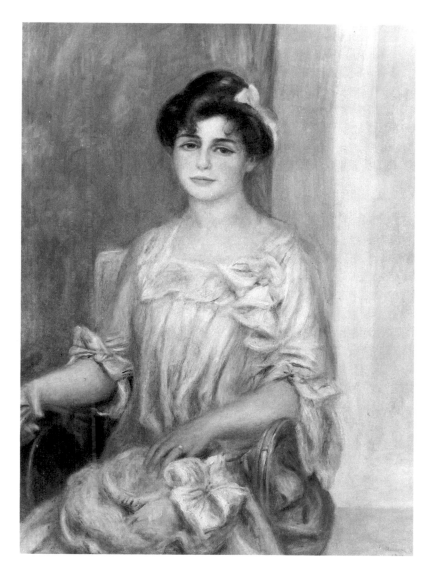

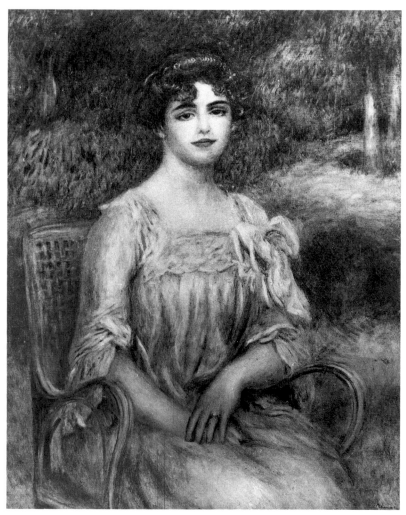

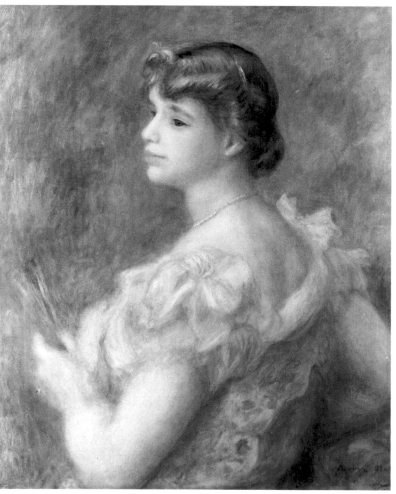

ings abroad, this year to group shows in Vienna and Budapest. In answer to his dealer's inquiry about available canvases, Renoir replied: "I don't very well see who can have 30 canvases. Those who have the most, [Dr. Georges] Viau [who had bought many paintings from Murer in 1896] and Gallimard, don't have as many as that. There is also De Bellio's son-in-law [E. Donop de Monchy]. I can't think of anyone else. For me, it's not possible, unless it would be only some little things not worth bothering about."[32]

Once disgruntled at low prices for his work, Renoir was now anxious about the inflated art market. He wrote Jeanne Baudot in April: "I am fed up with painting. These ridiculous high prices have made everyone lose their minds and everyone is selling, including my multimillionaire friend Bérard. This is what the Bernheims were hoping for, and they're going to kill the goose that lays the golden eggs. I don't give a damn, but I'm fed up with it."[33]

He was also troubled by a new problem: forged Renoirs and false signatures on real Renoirs. He wrote to Durand-Ruel on November 24: "All this must end or it means ruin for us both."[34] Writing on Christmas Eve, he explained to André: "The paintings that are in my house are seldom if ever signed, but the sketches never. Therefore, the paintings at Viau's have false signatures."[35] From late 1903 to early 1904, Durand-Ruel mailed Renoir paintings and photographs for authentication. After one such shipment, Renoir wrote: "There was no need to examine them carefully, it is ridiculously stupid. The woman reading, false even to the signature. The woman full face, much touched up, the costume finished and the signature false, but so blatantly false."[36]

January 1, 1904, Renoir sent a complaint to a public attorney.[37] A month later he reported to Durand-Ruel: "I had a long discussion with a very good lawyer, who advised me not to file that second complaint, which would bring very great trouble down on me. There is a forger and we must attack him directly, so it is either the police court and *nasty,* or send for the man and give him a warning, the rest is useless. . . . Besides, he thinks that all the talk about false paintings is rather bad than good, that it can only scare off buyers."[38]

Because he thought the issue so important, Renoir returned to Paris on February 15 for a few weeks to deal directly with the problem. In his letters from there to Aline in Essoyes with Coco, he does not mention the forgeries but talks exclusively about family issues:

Dearest,

I'm very glad that Renée [a maid who had recently posed with Coco for a preparatory study inscribed to Roger-Marx and for a large painting, pp. 216–17] is getting married. I tried to take her back on principle but without really wanting to. I'm very glad to know that Cloclo [Claude] is doing so well. He should have the milk he likes. I will leave on Wednesday. Tomorrow Gabrielle is going with Mlle. [Marguerite] Cornillac [André's fiancée, nicknamed Maleck] to see a specialist about her pimples. I preferred to delay so as not to have to come back for that if she were sick. In the south it would be no fun. I think it's better to leave me there alone until Easter. Jean [in boarding school] is doing well, but his voice is still hoarse and his throat red. [It's] not serious, but it's a good thing that you are not far away in case of need. I don't think it's worthwhile returning to Paris on Saturday. If Jean doesn't go, Pierre will write you. Coming back from Essoyes is not much, but since you are well, stay there for Cloclo. As soon as I get there, I'll send you a telegram to Essoyes. . . .

Love to you and Cloclo. Renoir.[39]

In the spring of 1904, Renoir received several visitors, among them Maurice Denis and his wife, Marthe, who stopped in Cagnes on their

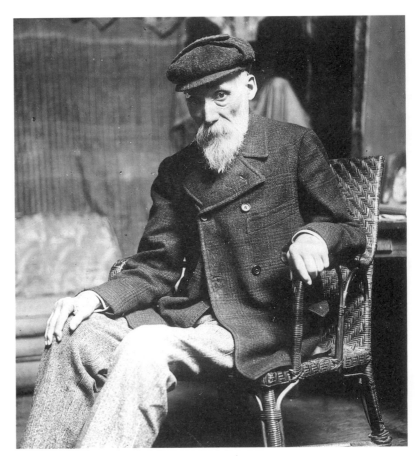

Renoir, 1901–2

Renoir. Photograph by Albert André, 1901–2

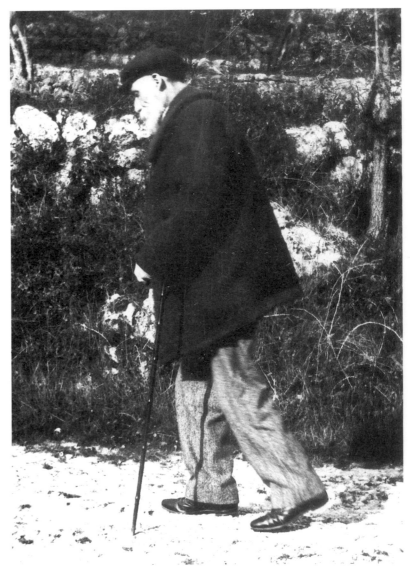

Mme. Renoir, Coco, and Pierre, 1901–2

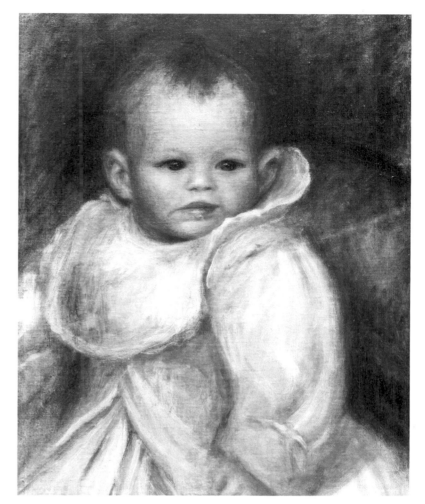

Claude. 1901–2. 16 x 12½″. Art Gallery of Ontario, Toronto

return from a trip to Italy. Renoir painted an elegant portrait of Marthe (p. 226). (Denis visited again in 1906, when he wrote in his diary: "Dined at Renoir's. His wife never stops telling funny stories.")[40]

In May 1904, en route from Cagnes to Paris, Renoir visited André in Laudun, and made an oil sketch of Maleck reading (p. 226). A photograph shows him walking with extreme difficulty (p. 227).

Once in Paris, his health continued to deteriorate. On Bastille Day, he complained to his friend Ferdinand Deconchy, a painter who was the mayor of Cagnes, of "a violent attack. I can't budge a single finger."[41] By mid-August he was so paralyzed that his only hope was a cure at a spa.

For a month beginning on August 12, he went to Bourbonne-les-Bains, in eastern France, accompanied by Aline, Jean, Coco, and Gabrielle.[42] The family stayed at the Grand Hôtel de l'Établissement Thermal, whose stationery boasted, "Opposite the Civic Baths and the

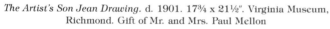

The Artist's Son Jean Drawing. d. 1901. 17¾ x 21½″. Virginia Museum, Richmond. Gift of Mr. and Mrs. Paul Mellon

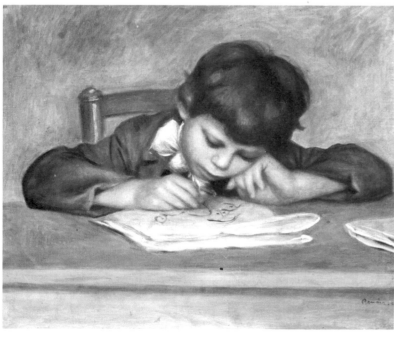

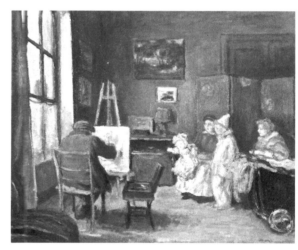

Albert André. *Renoir Painting His Family at His Studio, 73 Rue Caulaincourt, Paris.* d. 1901. 19⅝ x 15¾″. Musée Renoir, Les Collettes, Cagnes-sur-Mer

Casino / Telephone / Electricity / Garage for Automobiles."[43]

Renoir's paralysis was so unremitting that although he started a landscape, he could not complete it.[44] He wrote to André on August 16: "Not being able to move any more and incapable of working, I gave in and am here taking the waters."[45] When André volunteered to keep him company, Renoir replied: "It's very nice of you, but I can't accept this sacrifice. . . . At the hotel, the women look like target dolls in a funfair game. It's hopeless, and anyway I've got in the habit of being bored. In short, you have better things to do.[46] On September 4, Renoir described his torments to his dealer: "What bothers me the most at this moment is not being able to remain seated because I'm so skin-

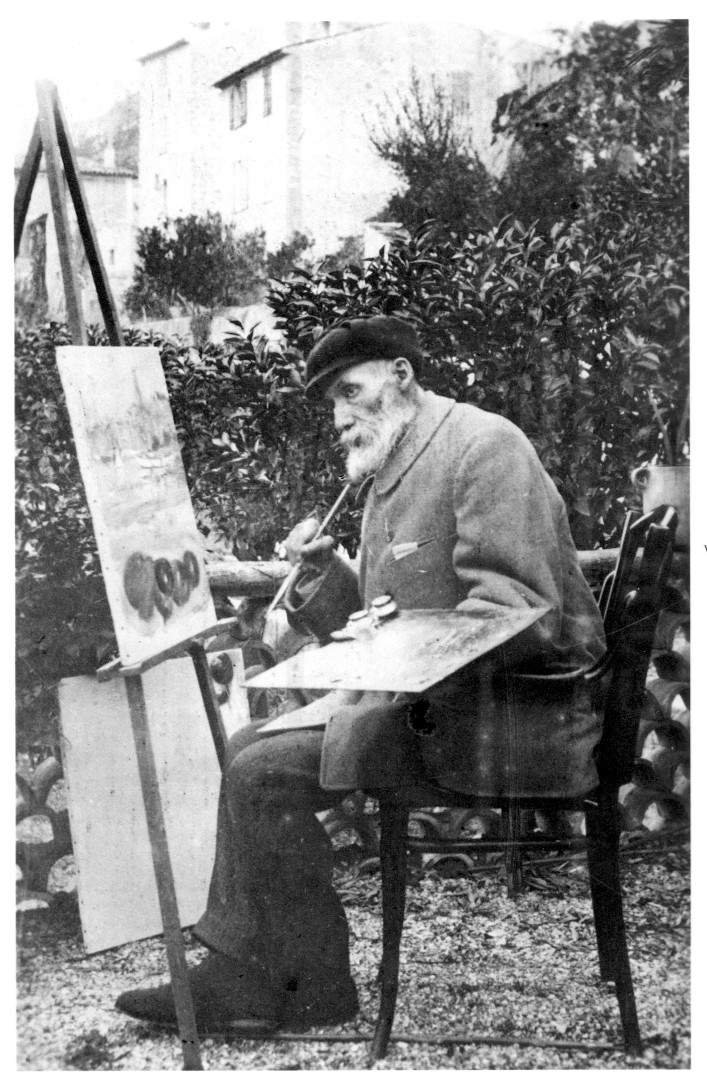

Renoir painting in front of the
Villa de la Poste at Cagnes, 1903

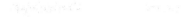

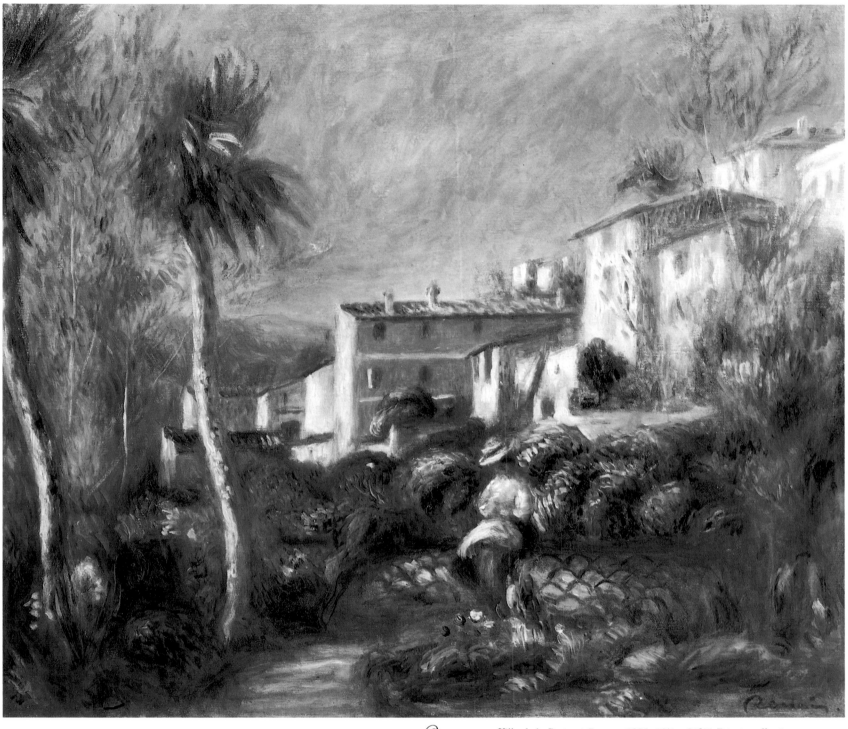

Villa de la Poste at Cagnes. 1903. 18¼ x 21¾". Private collection

ny: 97 pounds. That's not fat. The bones go through the skin and after a while I can't bear to sit. My appetite, however, is good. Let's hope that by trying hard I'll put on a little fat."[47] In a poignant letter to Bérard, he wrote September 8: "I've suffered a lot this summer."[48] He continued: "Are you satisfied with life as much as it is possible to be satisfied in this world?"[49]

By September 18, Renoir was back in Essoyes. He was profoundly discouraged, he explained to Durand-Ruel: "I can hardly move and I really think things are all botched up for Painting. I won't be able to do anything any more. You must understand that under the circumstances nothing interests me."[50] Five days later, he told Julie Rouart: "I still don't see any effect from the waters. I've seen a lot of people arrive crippled and go away cured, so it's tiresome not to be like anyone else. I must get used to it. I'm trapped, it's going slowly but surely; next

year I'll be a little worse and so on. It's a habit I must get into, that's all, let's not talk about it any more."[51]

During this year, when Renoir's health reached its lowest ebb, Durand-Ruel sent two paintings to St. Louis, several to Paul Cassirer's Berlin show, twelve to Brussels, and thirty-five to a special Renoir room at the second Paris Salon d'Automne. On October 15, the day the Paris exhibition opened, an interview with Renoir by C.-L. de Moncade appeared in *La Liberté*. Moncade had asked:

And now, will you exhibit [at the Salon d'Automne] regularly?

[Renoir]: I really don't know. To tell you the truth, I'm not the one who's exhibiting, it's Durand-Ruel.... I'm a little tired of sending things.... This Autumn Salon seems to me fairly useless. Certainly I'm in favor of Salons, they're an excellent lesson in painting. One thinks one has a marvel which is going to bowl everyone over. In the studio, it's enormously effective, and your friends

225

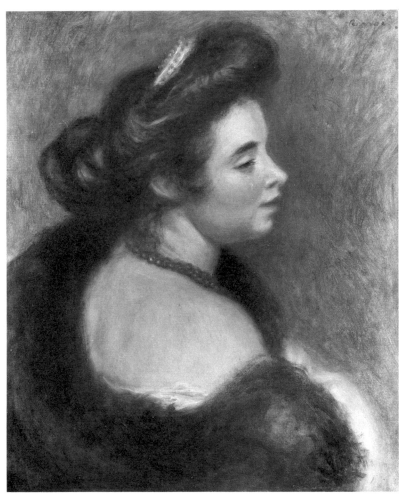

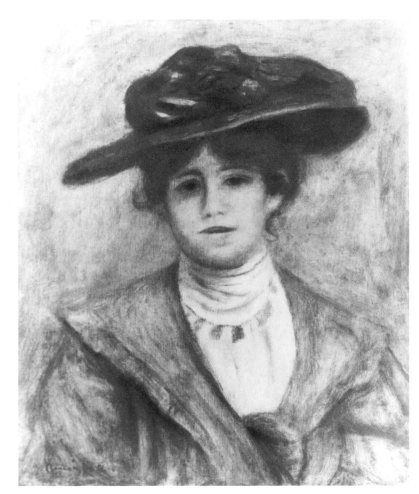

Marthe Denis (Mme. Maurice Denis). d. 1904. 21⅝ x 17¾″. Private collection

Jeanne Gobillard (Mme. Paul Valéry). 1904. 21½ x 18⅛″. Private collection

Maleck Reading. 1904. 11 x 12¼″. Whereabouts unknown (stolen from the
Musée de Bagnols-sur-Cèze, France, in 1972)

Misia Natanson Reading. c. 1904. 21¾ x 18½″. The Tel Aviv Museum.
Gift of Dr. Herman Lorber, New York

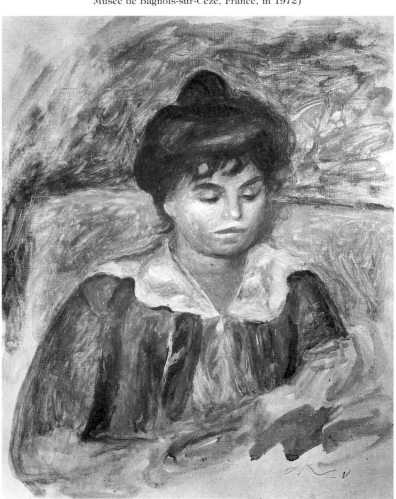

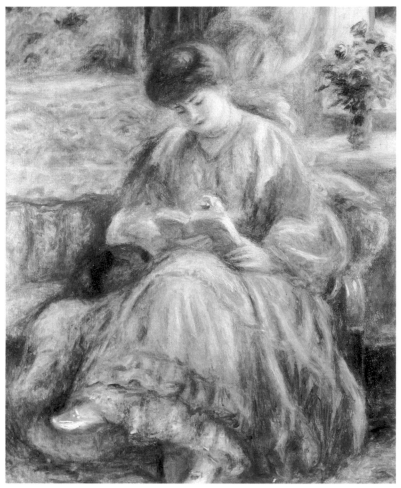

Gabrielle, Maleck, and Renoir in Laudun, 1904

RIGHT, ABOVE:
Louis Valtat. 1904. Lithograph (black ink) on paper, 11¾ x 9½". The National Gallery of Art, Washington, D.C. Rosenwald Collection

RIGHT, BELOW
Jean-Louis Forain. *Renoir.* 1905. Lithograph (black ink) on paper, 13¾ x 10¾". Musée de Bagnols-sur-Cèze, France. Gift of Albert André
Louis Valtat. *Renoir* 1904–5. Wood engraving, 13 x 10".
Musée de Bagnols-sur-Cèze, France. Gift of Albert André

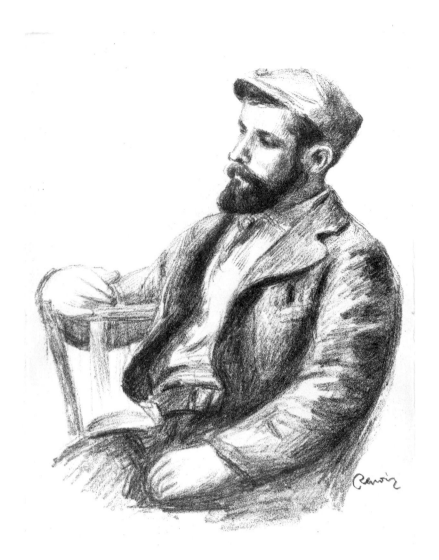

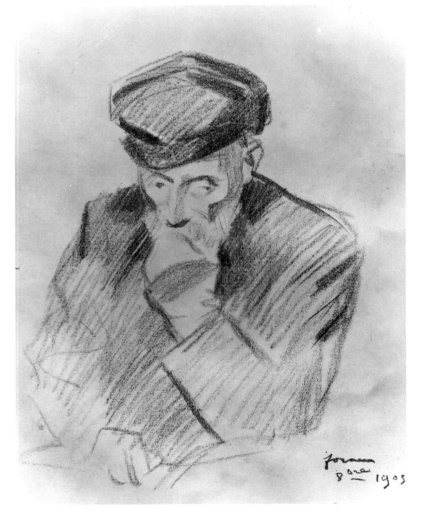

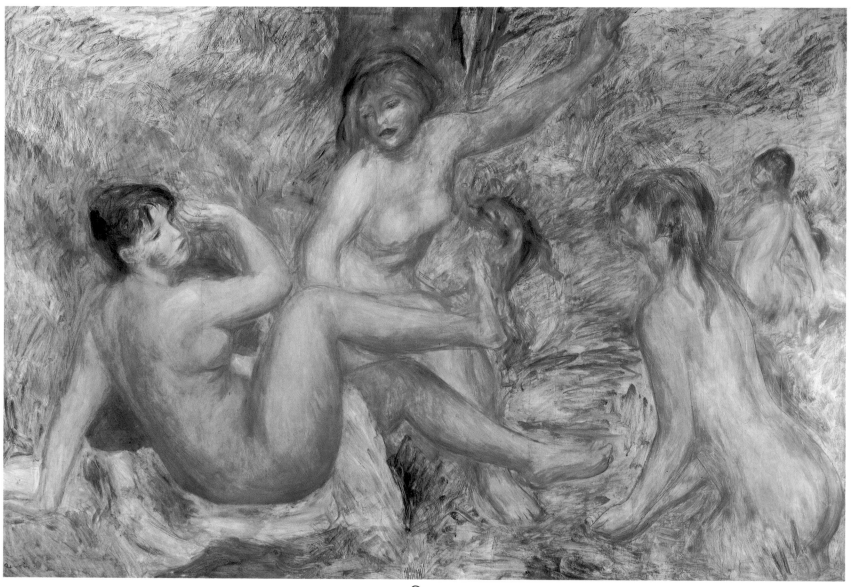

Variant of The Bathers. 1903. 44 x 65½".
Musée des Beaux-Arts Jules Chéret, Nice

come and pronounce it a masterpiece. Once in the Salon among the other canvases, it's not at all the same thing any more, and it doesn't bowl anyone over. So it's also a lesson in modesty. But there really are too many exhibitions and it seems to me quite sufficient to bother the public once a year.[52]

Many favorable reviews of the Salon d'Automne appeared, including

Study for Variant of The Bathers. 1903. Brown, white, and red chalk on brown paper, 41 x 64". Musée du Louvre, Cabinet des Dessins, Paris

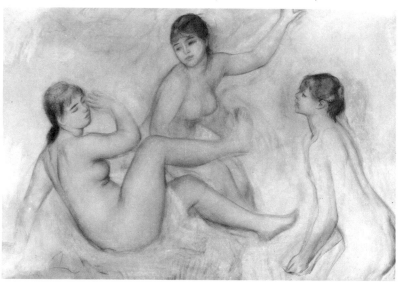

228

one by Gustave Babin that compared Renoir with Fragonard, Watteau, and Lancret.[53]

Around this time, Gallimard brought Maurice Gangnat, a retired industrialist, to Renoir's studio. He soon became a devoted companion and frequent house guest at Cagnes. Like other close friends, he purchased directly from the artist.[54] His first acquisitions, in 1904, were twelve paintings, for which he paid 26,000 francs. For the next fifteen years, Gangnat was the most important collector of his new works.[55]

In spite of Renoir's dire predictions, during his paralysis in August and September, that his career was over, by November he was painting again. On November 27, he asked Jeanne Gobillard Valéry to come for a portrait sitting in his Paris studio: "Would you care to come starting Tuesday morning if there's not too much fog? You will stay for lunch. That will be easier."[56] And on December 24: "You'll have to sacrifice yourself and come and get your slice of bread and butter (read portrait)."[57]

It is poignant that once Renoir was able to paint again after months of paralysis, he created the most sensual nudes of his entire career—voluptuous women who lift their hair to reveal their bodies or lie alluringly in bed. *Nude in the Sunlight* (1875–76) has been transformed by 1905 from the elusive woman of Renoir's youth, whose presence is like a whiff of perfume, into *Bather: The Source*, the tangible, rich-fleshed nude of his old age.

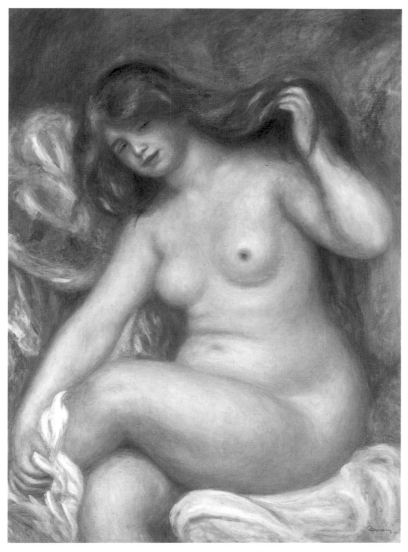

Bather. 1905. 38¼ x 28¾".
Collection Mr. and Mrs. R. Meyer de Schauensee, Devon, Pa.

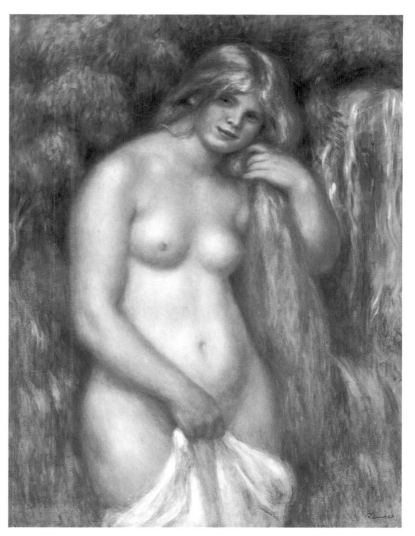

Bather: The Source. 1905. 36¼ x 28¾".
Foundation E. G. Bührle Collection, Zurich

Like figures painted by the aged Titian or Rubens, these nudes of late 1904 through 1906 capture a powerful sexuality, a metaphor of life itself in the contrast between the artist's physical deterioration and his figures' increased sensuality. He compensated for his own sickness, emaciation, and paralysis by brilliantly expressing health, corpulence, and vitality. His powerfully optimistic nudes express his resilient defiance.[58]

Reclining Nude. 1905–6. 25½ x 61⅛". Private collection

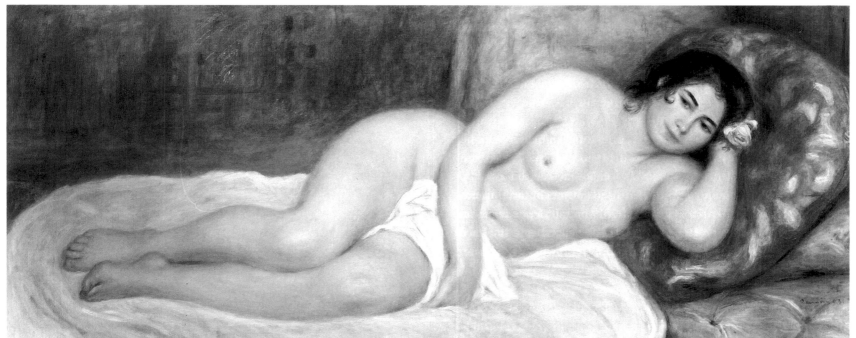

By 1904, Renoir accepted a commission from Vollard to execute a series of twelve lithographs, including portraits of Vollard and Valtat.[59] Around the same time, both Valtat and Forain did graphic studies of Renoir.[60]

Also in 1904, he was commissioned to do two portraits of Misia Natanson; by then she had divorced Thadée and was living with Alfred Edwards, the financier and founder of the newspaper *Le Matin*. Two years later, Renoir invited Misia (now Mme. Edwards) to come to pose: "Also in the third portrait I will try to make you even more beautiful. As for me, I am well and I will be even better if you can come and see us in Essoyes this summer. . . . I'll try my best to show you some amusing things. . . . I have seen Pierre as a soldier [in the reserves], it suits him very well."[61]

Although Misia was unable to accept this invitation, she visited Renoir in Cagnes the next summer and sat for a final portrait. Bonnard wrote her there: "Our friends tell me that you are near Nice, as you had planned and that you have been seeing the good, the great Renoir who has become your happy portraitist. They say the results are marvels. I can well believe it. It must also interest you to hear him chatter away. At least he's a man who knows what he likes."[62]

Renoir was in good spirits in mid-February 1905 when he wrote André about his son Pierre's promising acting career: "I've just received a letter from Pierre, who is launching himself in society. I am delighted to know that he's busy. My wife's sprained ankle is much better. She could have been badly hurt, but fortunately it will be nothing. With me, always something wrong. Nevertheless I'm working, having decided to rent an automobile by the month, since my legs refuse to obey me. I am even fairly happy. I am thinking of doing a few landscapes that I couldn't do otherwise (don't say anything about it to Durand-Ruel, who is against landscape)."[63] However, his condition was worse late in the year when he reported to Rivière: "My hands hurt very badly. . . . I have only my thumb, which keeps me from writing."[64]

In January and February 1905, Durand-Ruel sent 315 paintings to the Grafton Galleries in London for a monumental group exhibition of Impressionist works. The fifty-nine Renoirs included *La Loge* and *The Dancer* (both 1874) and *City Dance* and *Country Dance* (both 1883). Twelve thousand people attended the show, but fewer than ten sales were made and no important Renoirs were among them. Although by now French, American, and German collectors were eager to buy Impressionist paintings, the English were still not interested.[65]

In March, Renoir's good friend Paul Bérard died at the age of seventy-two. Two months later, part of his collection, including eighteen Renoirs, was auctioned off at Petit's gallery. *The Afternoon of the Children at Wargemont* (1884) was sold to Bernheim-Jeune for 14,000 francs.

The following year, Renoir's paintings brought even higher prices.[66] In late May, at the sale following the death of the Rouen collector Francois-Félix Depeaux, *Dance at Bougival* (1883) was sold to Depeaux's brother-in-law, Edmond Decap, for 47,000 francs. This was almost double the previous high of December 1905, when the Paris politician and journalist Adrien Hébrard had bought *After the Concert* (c. 1877) from Durand-Ruel for 24,000 francs. In 1906, Hébrard acquired seven

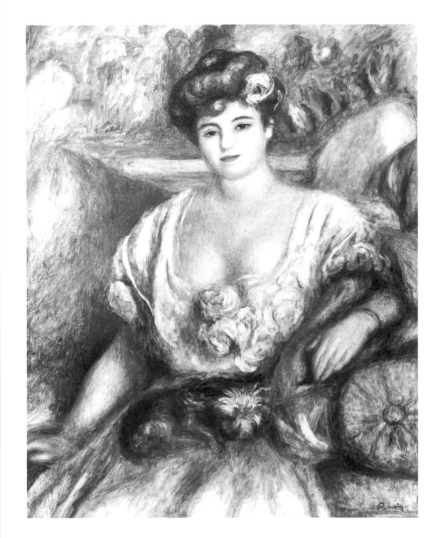

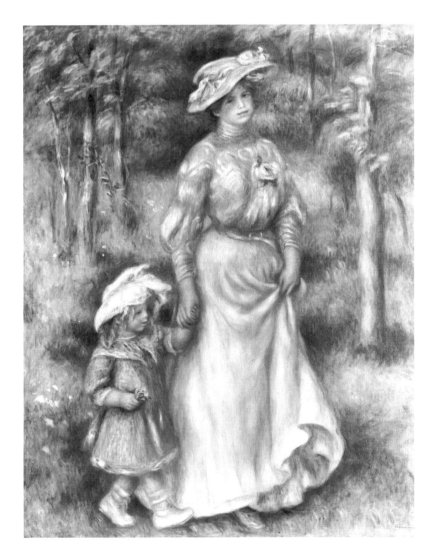

RIGHT, ABOVE:
Misia Edwards. 1907. 36¼ x 29″. The Barnes Foundation, Merion Station, Pa.

RIGHT:
Promenade. c. 1906. 64¾ x 50¾″. The Barnes Foundation, Merion Station, Pa.

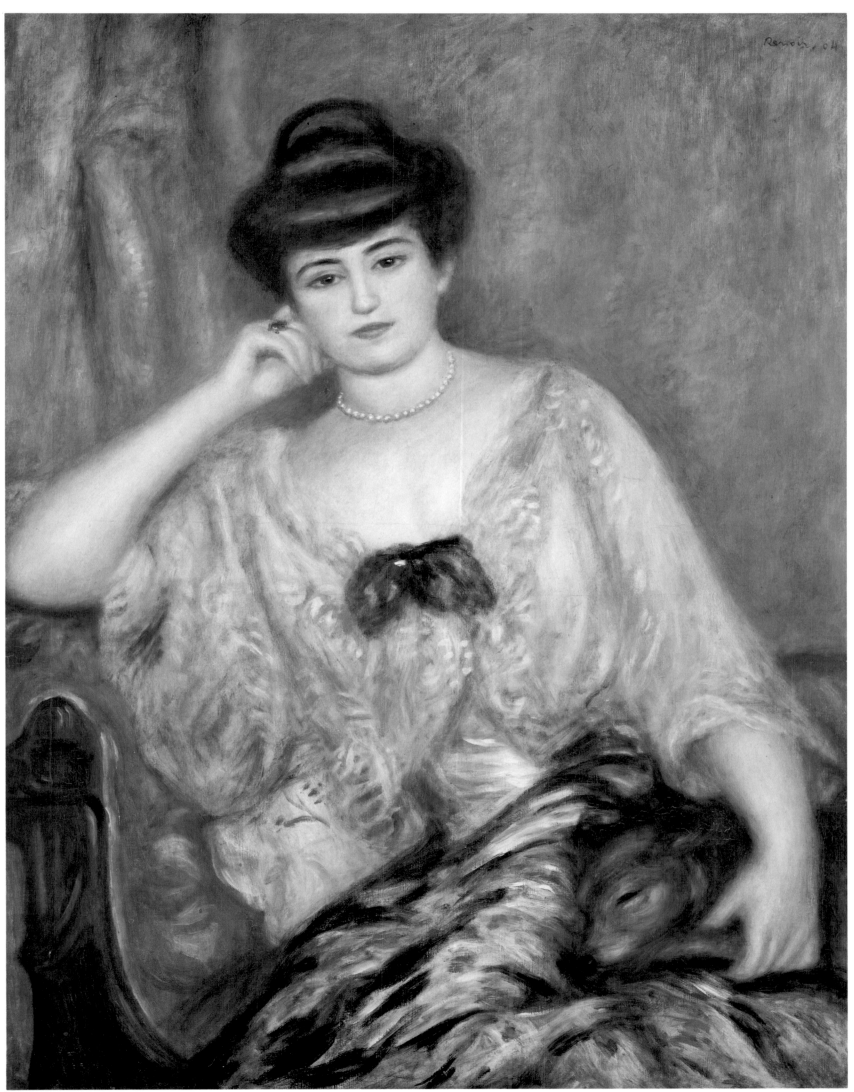

Misia Natanson. d. 1904. 36¼ x 23⅜″. The National Gallery, London

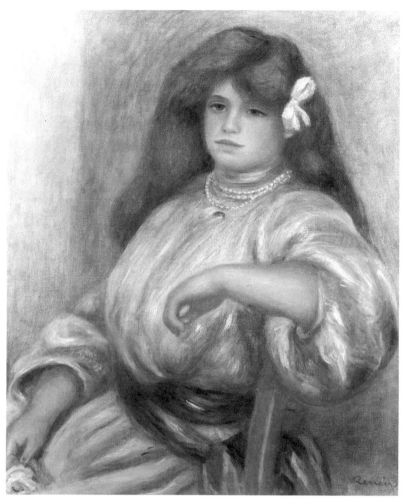

Girl with Rose. 1907. 25¾ x 21½″. Private collection

Ambroise Vollard. d. 1908. 31¾ x 25½″. Courtauld Institute Galleries, London.
Courtauld Collection

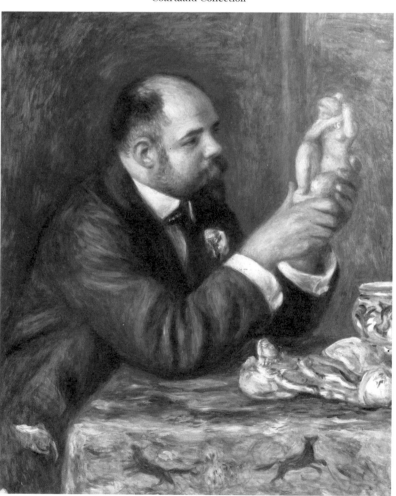

Plums. 1907. 9 x 17¼″. Private collection

other Renoirs from Durand-Ruel, including *Nursing* (second version, 1886) for 10,000 francs and *After the Bath* (1888) for 1,500 francs. In New York, American collectors were also buying from Durand-Ruel; for example, in February 1906, Arthur Brewster Emmons bought *Picking Flowers* (c. 1891) for $5,400.

That same month Julie Rouart (one of the models for *Picking Flowers*) gave birth to Clément Rouart. Jeanne Gobillard Valéry was also expecting a baby. Renoir wrote to Paule Gobillard from Cagnes on February 4: "We were a little anxious about the delay in this event. By the way, my wife, on account of the delay, had predicted a boy. So we are very happy to learn that in spite of tiresome moments, everything has ended to everyone's joy. We congratulate the mother and hope it goes on, as now it no doubt will. That's one—now we await the others."[67] Soon Agathe Valéry was born.

Shortly thereafter Renoir informed his dealer, "We are having magnificent weather and I'm working."[68] At this time he painted *Gabrielle and Coco taking a stroll in Cagnes* (p. 230).

Back in Paris in June 1906, Renoir learned that Rodin (whom he had known since 1886) wanted to visit his studio. Renoir eagerly wrote the sculptor on June 20: "I am overjoyed that you are willing to sacrifice a few moments of your precious time and I am grateful to you for it. I will be expecting you next Saturday morning around ten o'clock, 43 rue Caulaincourt."[69]

A few years before, Renoir had resumed his friendship with Georges Rivière, who still worked in the Ministry of Finance. They had drifted apart in the 1880s—perhaps because Rivière disliked Renoir's Irregularist style.[70] In the interim, Rivière had married and fathered Hélène, born in 1882, and Renée, born in 1885. Once the old camaraderie was reestablished, Rivière, now a widower, and his daughters were frequent guests at Renoir's home. In August of 1906, he announced to Rivière that he was again traveling. "I am here not to take shower baths but to finish a landscape that was begun 2 years ago," he wrote Rivière from Bourbonne-les-Bains. "As soon as it is finished, I'll return as quickly as possible to Essoyes. I left my wife very sick with bronchitis and emphysema. This in the long run will wind up being very serious, but to make a woman take care of herself is beyond human capacity. I am delighted to know that you are out of politics for a while. Love to your daughters and see you soon."[71] Rivière soon visited Essoyes along with his daughters, and Renoir painted them enjoying tea in the garden. He also did the robust yet delicate *Lady with a Fan,* an interior portrait with the freshness and lightness of the summer flowers in *The Cup of Tea.*

Aristide Maillol also came to Essoyes, to execute a statue of Renoir commissioned by Vollard. Renoir informed Vollard on September 12, 1906: "My bust is going splendidly."[72] Maillol later told his biographer Henri Frère:

I went to see Renoir in Essoyes in the Aube....

I was working on Renoir's bust mornings and evenings. He didn't paint. I told him, "You can work, you know." He answered, "No, I want to do this seriously." He didn't touch his brushes. He would pose mornings and evenings. He liked that portrait very much. He would observe its progress. He would say to me, "It's becoming very lifelike." On the last day, the bust collapsed. It made him very sad. It happened during the night. I must have wetted it too much. That happens. When we came into the studio, he was more sorry than I was. He was very upset. I raised the bust and redid it. But it was no longer the same. It wasn't as good....

He had given me a tremendous amount of trouble. It was an impossible face.

Medallion of Coco. 1908. Plaster, diameter 8½". Musée Marmottan, Paris

Aristide Maillol. *Bust of Auguste Renoir.* 1906. Bronze, height 12". The Fogg Art Museum, Harvard University, Cambridge, Mass. Bequest of Maurice Wertheim

It was all sick and deformed. There was nothing in it; there was only the nose. When I got there and saw him, I was perplexed. He had no mouth, he had drooping lips. It was awful. I had seen an old portrait and thought he had a fine beard. But he had shaved off his beard. Oh, did I have trouble!... Still I managed just the same.[73]

A month later, on October 22, Cézanne died in Aix. Irascible in his old age, Cézanne had written: "I despise all living painters, except Monet and Renoir."[74] Several years after his death, Renoir wrote Monet that his idea for a tribute to Cézanne's memory was: "A bust of Cézanne in the room of the museum (the museum in Aix is very nice) and especially a painting. It would be honorable and it wouldn't disturb anyone."[75]

Inspired by Maillol's sculpture and by Cézanne's volumetric images, Renoir's painting in 1907 became even more monumental. "I keep

looking for the secrets of the masters," he wrote to Paule Gobillard. "It's a sweet madness, which I'm not alone in having."[76] *Girl with Rose* has the breadth of a Rembrandt or a Rubens. Even the small still life *Plums* has weight, relief, and volume.

Bust of Coco. 1908. Bronze, height 11". The National Gallery of Art, Washington, D.C. Gift of Sam A. Lewisohn

The Judgment of Paris. d. 1908. 32¼ x 40″. Private collection

LEFT:
Study for The Judgment of Paris. 1908. Red chalk heightened with white chalk on paper, 18⅝ x 24⅛″. The Phillips Collection, Washington

Peter Paul Rubens. *The Judgment of Paris.* c. 1638–39. 6′6⅜″ x 12′5¼″. Museo del Prado, Madrid

View of Cagnes from Renoir's house at Les Collettes

Renoir's house at Les Collettes, Cagnes-sur-Mer

239

Renoir's outdoor studio at Les Collettes

Cagnes, Renoir wrote to Vollard: "Come whenever you like. Now I'm all set to work."[78] Renoir shows him holding and admiring a statuette by Maillol.

On this visit, Vollard encouraged Renoir to try doing soft-wax sculpture, which even his arthritic hands could manage. He made two small pieces: a medallion profile of Coco, which was later copied in white marble in the mantel of the dining-room fireplace at Cagnes, and a bust of Coco. These are the only pieces of sculpture by Renoir's own hands. Both were later cast in bronze.[79]

Along with this interest in doing sculpture, he was attracted to Rubens's sculpturesque late nudes of *The Judgment of Paris*. Renoir made his own version, which depicts a later moment when Paris offers the apple to Aphrodite. In a red-and-white-chalk drawing, he worked out the broad flow of rhythms between the figures. He made several painted versions as well as a lithograph of this subject. When he began the project, the actor Pierre Daltour posed for Paris. Later, Gabrielle and other models—Marie Dupuis, nicknamed La Boulangère (the Baker), and Georgette Pigeot—posed for the shepherd as well as for the goddesses.[80]

After many years of renting villas in Cagnes, Renoir decided in 1907 to buy property there of five and three-quarter acres, with 145 olive trees, plus orange trees, rosebushes, and a farm, in an area called Les Collettes. The contract was signed June 28, and Renoir commissioned construction of a villa, which took over a year to complete.

Nine months later, in March 1908, he wrote to Julie Rouart:

We are in the process of planting like La Fontaine's old man. An old man was planting, planting at this age . . . which is no fun for the old man but a lot of fun for his wife. The green peas are doing well, and so are the potatoes. So for the moment it's perfect bliss. If all of Cagnes had not befriended me because of my rich estate, everything would be fine, but here I am, an esteemed gentleman in Cagnes, where nobody paid any attention to me last year.

When I become general councilor, I'll back the Agricultural Award, now there's a delusion of grandeur. We have had many friends this year. Renée [Rivière] sings all day long and is rapidly improving. As you can see, we have the trilogy of painting, music, and architecture. Cagnes is becoming an intellectual center. It's Paris that is provincial, so there.[81]

On May 13, 1908, he sent a note to Rivière: "At the moment my head is confused by my architects, builders, etc. . . . Renée sings a lot and we like it very much, believe me. . . . I hope that someday this house will be finished. It gives me a headache."[82]

Les Collettes, into which Renoir moved at sixty-seven in the fall of 1908, completed his transition from his modest origins to upper-class comfort. Besides bedrooms for his family, servants, and guests, the handsome villa had two studios for indoor painting, a dining room, a living room, a kitchen, and an office. There were modern conveniences such as central heating and plumbing. A terrace on the second floor provided spectacular views of the Mediterranean, Cap d'Antibes, and the town of Cagnes. A short distance away, he constructed a glass studio amid the trees, where he could paint sheltered but outdoors.

One of Renoir's expectations in building Les Collettes was to have a comfortable place for guests to stay. "Monet is within our walls," he informed Paule Gobillard.[83] André was one of the most frequent visitors. When André came, he and La Boulangère transported Renoir in a carrying chair to his outdoor studio. January 2, 1909, Renoir wrote warmly to André in a handwriting that shows the extent to which he retained control: "Excuse me for taking so long to write you, and don't

Albert André and La Boulangère carrying Renoir in his portable chair at Les Collettes, c. 1909

read anything into it but extreme laziness. I am a poet. So I am told every day. Poets dream. The sun, the atmosphere, the distant sea, what do I know? I growl at Gabrielle. One can't do everything"[84] (p. 242).

Yet he very nearly could. He still occasionally executed large paintings such as *Dancer with Castanets* and *Dancer with Tambourine*, both for Maurice Gangnat's dining room. On the whole, however, he was impatient with his diminished productivity. On February 11 he complained to Durand-Ruel: "The older I get, the longer it takes me to work. I admire Monet for being able to do such interesting things in so short a time. He has an energy that I am far from having. I'm glad to know that the collectors are being less recalcitrant. Better late than never. But that won't keep me from going on with my little routine as though nothing had happened."[85]

241

Mon cher André

Excusez moi de mettre
si longtemps à vous
donner des nouvelles
ne voyez la dedans
qu'une extrême paresse
Je suis poète. on me
le dit tous les jours
les poètes rêvent. le
soleil. les effluves. la
mer lointaine. que
fais-je. J'engueule Gabrielle
on ne peut tout faire.
Tous les bonheurs à vous
les deux. amitié

Renoir

Cagnes 2 janvier 09.

Letter from Renoir
to Albert André, January 2, 1909

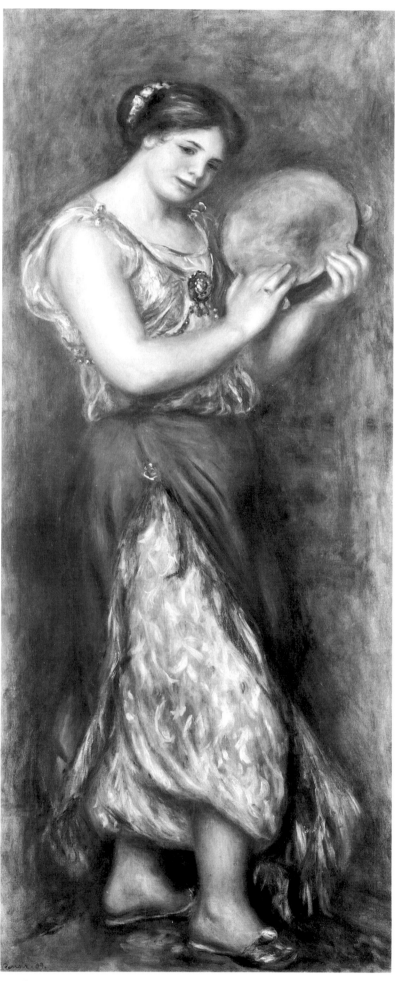

Dancer with Tambourine. d. 1909. 61 x 25½". The National Gallery, London

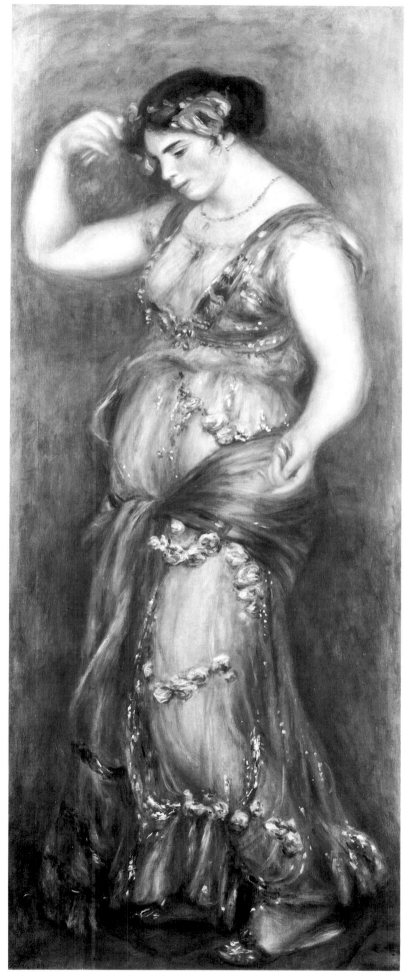

Dancer with Castanets. d. 1909. 61 x 25½". The National Gallery, London

RENOIR'S love of his work was his best medicine. He told André in early 1910: "I am so lucky to have painting, which even very late in life still furnishes illusions and sometimes joy."[1]

Jean Renoir described his father at seventy:

What struck outsiders coming into his presence for the first time were his eyes and hands. His eyes were light brown, verging on yellow. His eyesight was very keen. Often he would point out to us on the horizon a bird of prey flying over the valley of the Cagne, or a ladybug climbing up a blade of grass lost among other blades of grass.... So much for the physical aspect of his eyes. As for their expression, imagine a mixture of irony and tenderness, of joking and sensuality. They always looked as though they were laughing, as though perceiving the ludicrous side first. But this laugh was a tender laugh, a loving laugh. Perhaps it was also a mask. For Renoir was extremely modest and did not like to reveal the emotion that overwhelmed him while he was looking at flowers, women, or clouds in the sky, the way other men touch and caress.

His hands were terribly deformed. Rheumatism had cracked the joints, bending the thumb toward the palm and the other fingers toward the wrist. Visitors who weren't used to it couldn't take their eyes off this mutilation. Their reaction, which they didn't dare express, was: "It's not possible. With those hands, he can't paint these pictures. There's a mystery!" The mystery was Renoir himself.[2]

Although his fingers were paralyzed, he retained the ability to move his wrists and arms. Jean explained: "His hands, with the fingers curled inward, could no longer pick up anything. It has been said, and written, that his brush was fastened to his hand. That is not entirely accurate. The truth is that Renoir's skin had become so tender that contact with the wooden handle of the brush injured it. To avoid this difficulty, he had a little piece of cloth inserted in the hollow of his hand. His twisted fingers gripped rather than held the brush. But until his last breath, his arm remained as steady as that of a young man."[3]

In late photographs, linen strips can be seen on both hands. Renoir sometimes painted with the brush positioned between his two hands. Family, models, and maids prepared his palette and brushes, and by means of a screen mounted on rollers, large canvases could be wound to the spot where he wanted to work. "One is always flabbergasted, astonished, at seeing the skillfulness and precision with which his tortured hand operates," André wrote. "He can no longer change brushes in the course of his work. The brush, once chosen and gripped between his paralyzed fingers, moves speedily from the canvas to the turpentine can, where it is rinsed, and goes back to the palette to take a little paint and carry it once more to the canvas. When his hand is numbed

Study for Venus Victorious. 1914. Watercolor on paper, 12 x 9".
Musée du Petit Palais, Paris

by fatigue, we must remove the brush from his fingers, which cannot open themselves."[4]

In 1910, Renoir painted a number of portraits. As in the past, his portrayals are both truthful and idealized. His portrait of his devoted spouse, prematurely aged at fifty-one, is full of gentle compassion. And the sleepy, trusting puppy, Bob, on her lap enhances her maternal character (p. 252).

Around the same time he made two self-portraits. Although the frontal one, which he kept for himself, recalls the self-portrait of 1899 in costume and pose, it has an anguished, frozen expression that his son Jean described as "fixed."[5] He gave the profile portrait to Durand-Ruel.

Renoir also painted his dealer—now seventy-nine—in regal gold, black, and crimson (p. 253). In December, he urged the dealer to visit him at Les Collettes, arguing persuasively: "You have sons working for you, at least take advantage of it and get a little rest, which you well deserve. There is an age when one must know how to work, but there is another when one must know how to rest. So I hope to see you soon. ...And above all, don't come alone. You have daughters to accompany you."[6] Durand-Ruel seems to have come early in the new year.[7]

In June 1910, Durand-Ruel and his sons held a large Impressionist show in Paris that included thirty-four Renoirs. They sold *After Lunch* (1879) to the Städelsches Kunstinstitut in Frankfurt for 125,000 francs, a new record price for a Renoir. It was in 1911 that Paul Durand-Ruel, now eighty, turned over his Paris and New York galleries to his sons, Georges and Joseph, though he continued to be involved in the business.

Toward the end of the summer of 1910, the entire family—Renoir, Aline, Pierre, Jean, Claude, and Gabrielle—accepted an invitation from Dr. Franz Thurneyssen to come to Wessling, a suburb of Munich, so that Renoir could paint Frau Thurneyssen and her daughter. What attracted Renoir more than the commission were the fifty-odd Rubens paintings at the Alte Pinakothek in Munich.[8] Among the works that he studied was the late portrait *Helena Fourment with Her Son,* which influenced *Frau Thurneyssen and Her Daughter* (p. 253), notably in the transparent washes of vibrant color. The following year, he painted her son Alexander as a shepherd (p. 250), in a posture that calls to mind the Dionysus of the Parthenon pediment. From Munich, Gabrielle enthusiastically described the painting in a note on the back of a letter from Renoir to Gangnat: "The boss is better, he has made good progress on his portrait. I wish you could see how nice it is. Mme. Thurneyssen in a pink and white dress, very open, and her little girl in her lap. The child is blond and all curls. She is not pretty but the boss has made something beautiful out of her."[9]

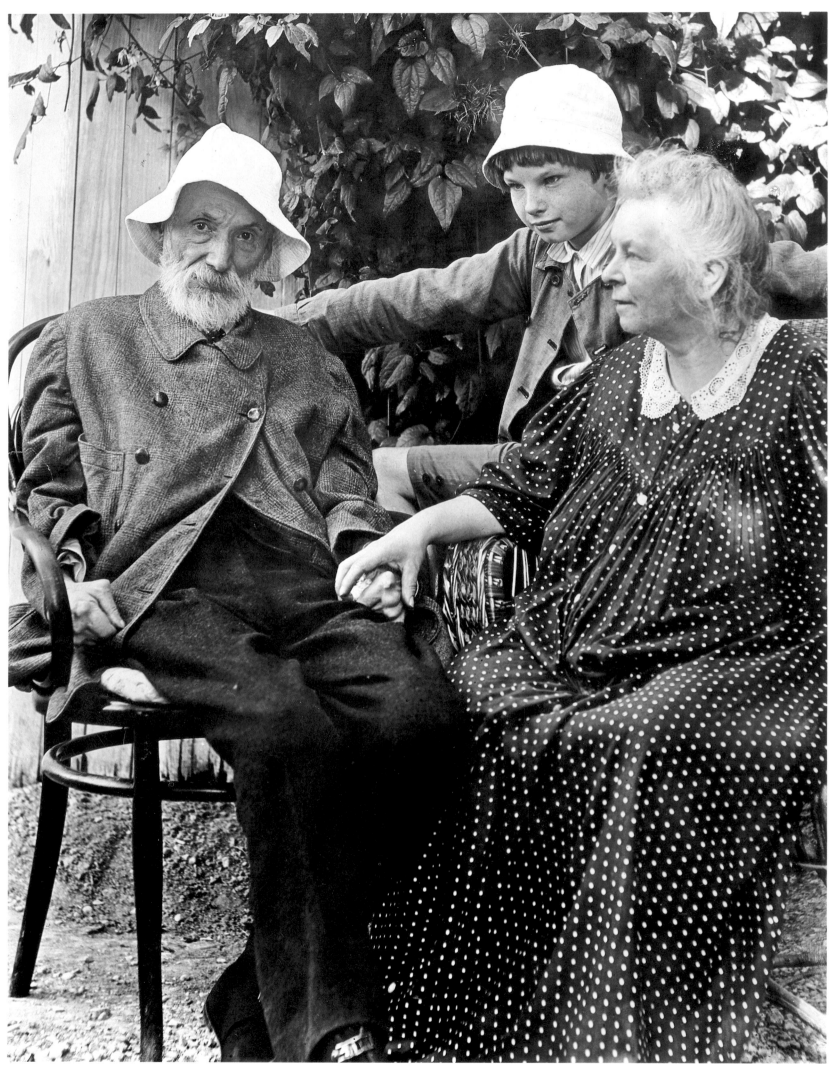

Renoir, Aline, and Coco, 1912

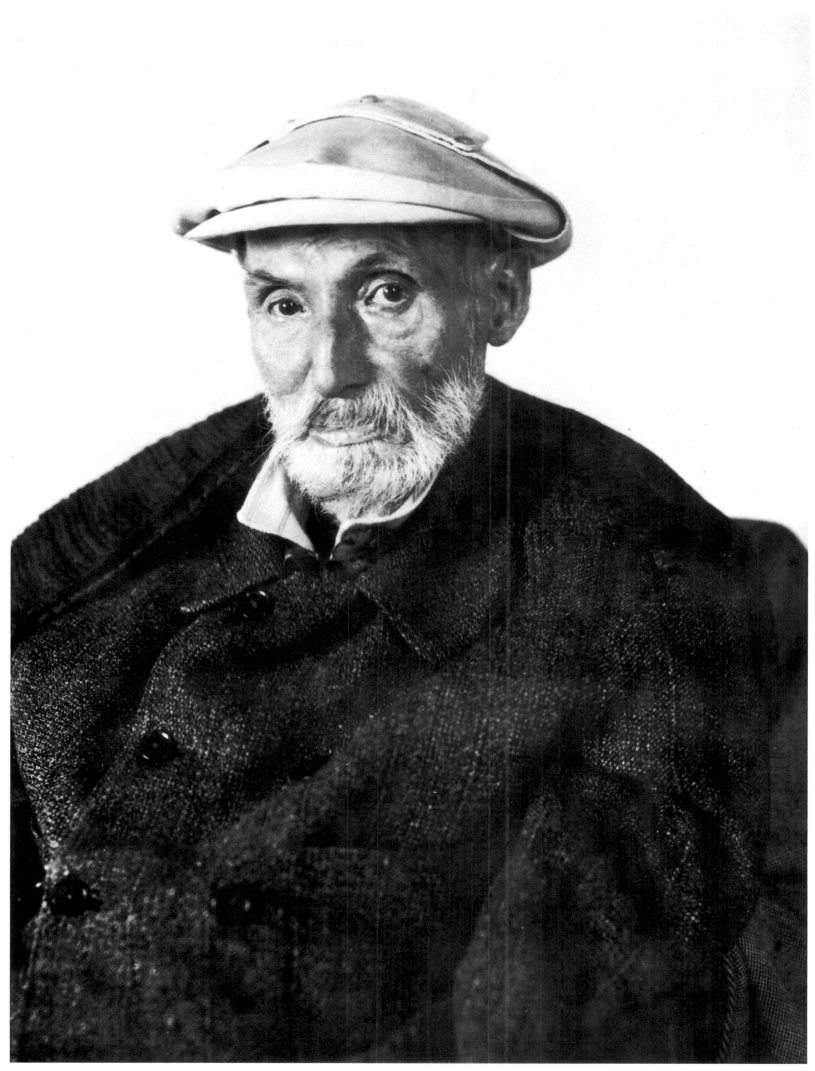

Renoir, 1914

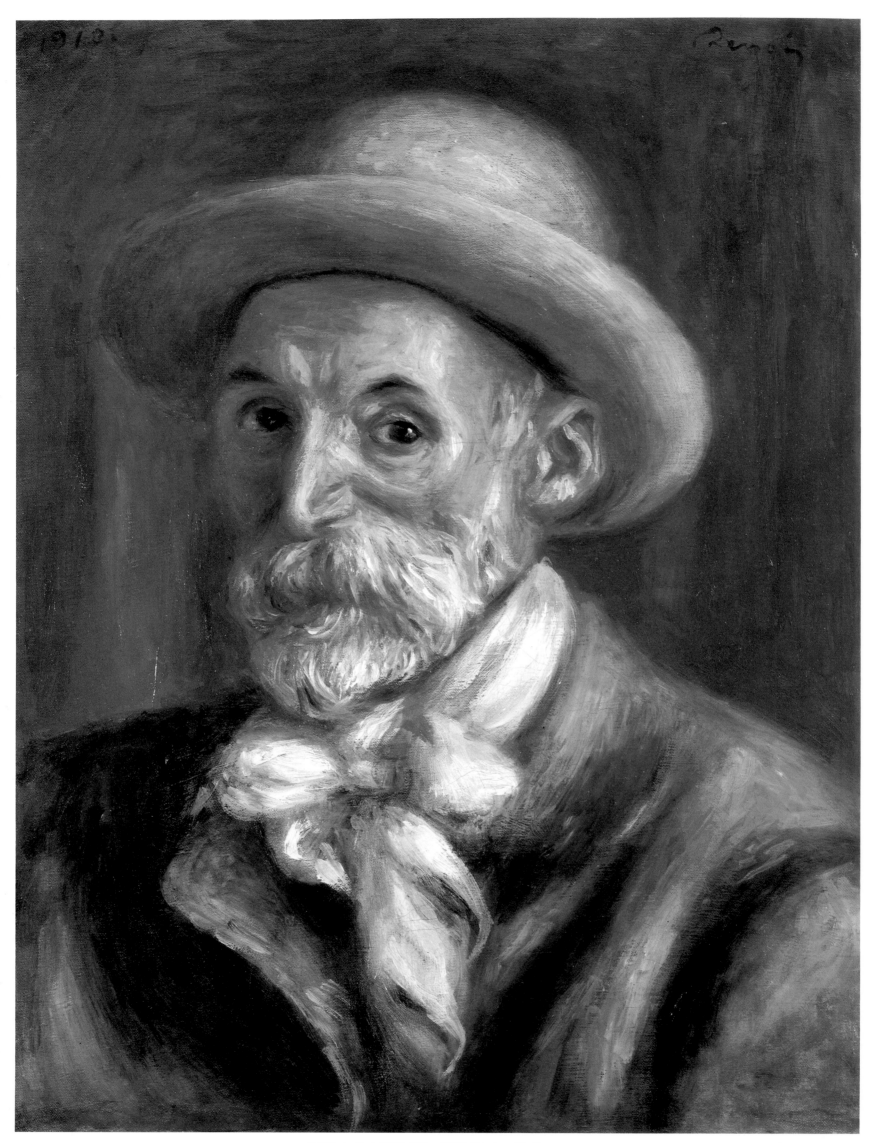

Self-Portrait. d. 1910. 18½ x 15⅜". Private collection

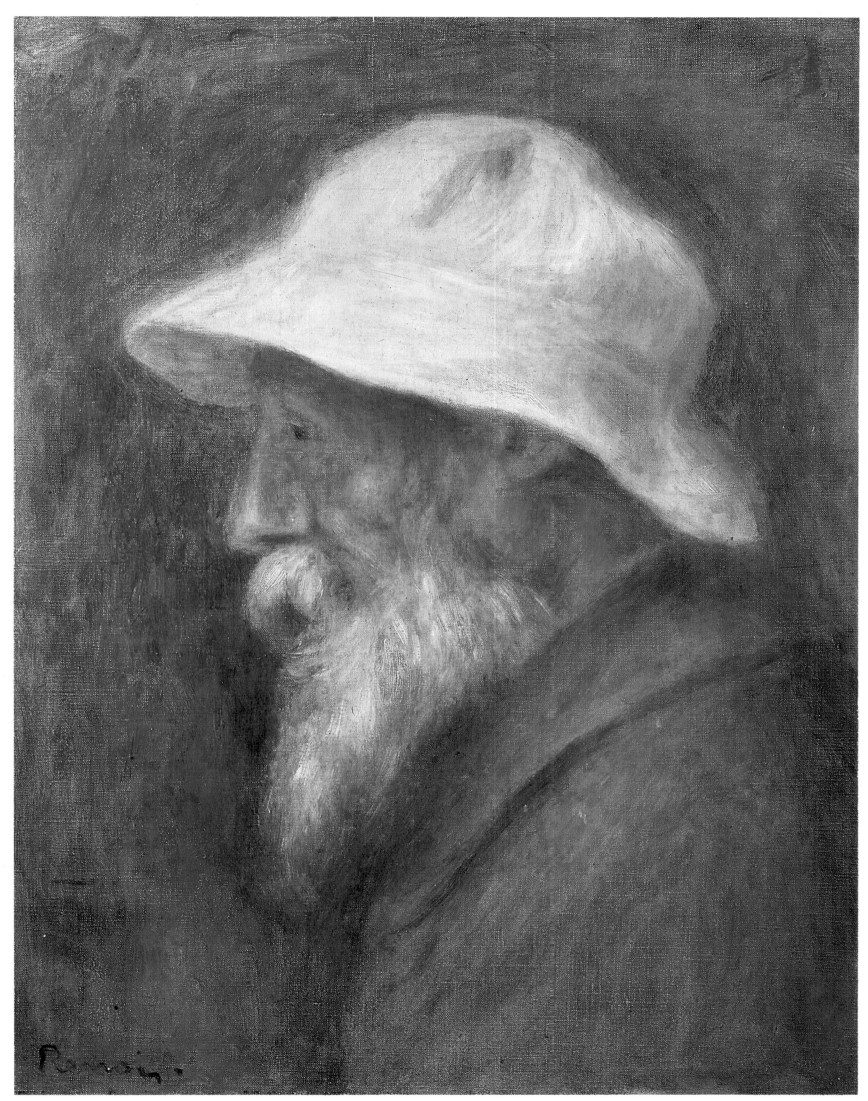

Self-Portrait. 1910. 16½ x 13″. Private collection

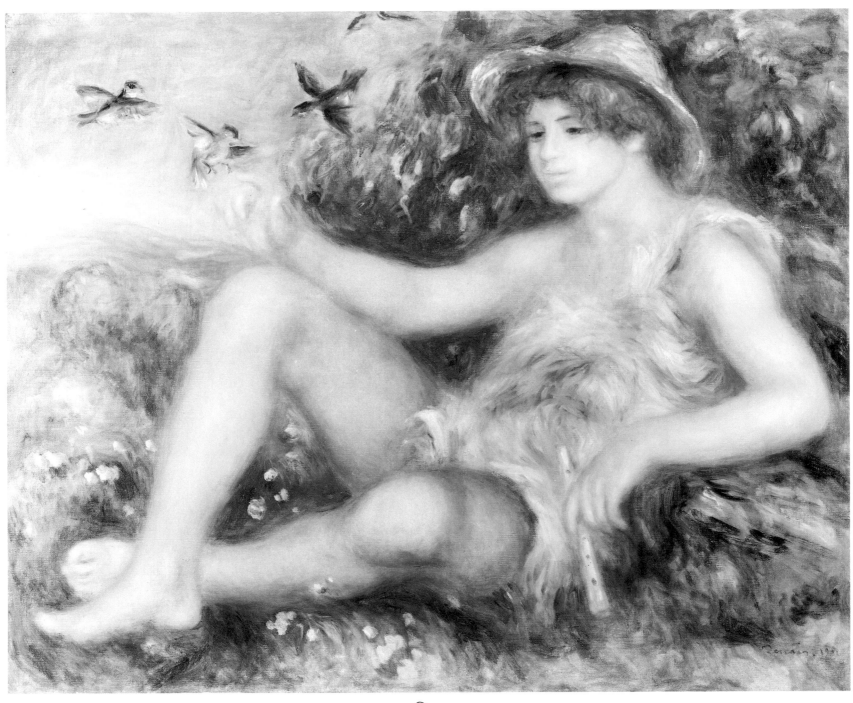

Alexander Thurneyssen as a Shepherd. d. 1911. 29⅝ x 36⅝".
Museum of Art, Rhode Island School of Design, Providence.
Museum Works of Art Fund

When Renoir returned to Paris, he continued to work on a literary project—a preface for the reissue of a French translation of the fifteenth-century *Il Libro delle'Arte* (*Craftsman's Handbook*), by Cennino Cennini. Cennini was a late fourteenth–early fifteenth-century artistic descendant of Giotto. *Il Libro delle'Arte* contains both medieval and Renaissance art-workshop precepts. In 1858, the painter Victor Mottez, a former pupil of Ingres who was particularly interested in frescoed architectural decoration, translated Cennini's book. Mottez had died in 1897, and his son, Henri, and Renoir had decided in July 1909 to reissue the work as an homage[10] and for Renoir to write a preface.[11] Since Maurice Denis was a respected theoretician and author as well as an important painter, Renoir asked him to check his manuscript before he submitted it for publication. In March 1910 Denis visited Mottez in Nice and Renoir in Cagnes and they discussed the essay.[12] On this visit, Denis also made a tiny painting of Renoir and Jeanne

Baudot that captures the old man's gentleness and sensitivity.[13] In August, Denis sent Renoir's eight-page preface (transcribed by Rivière because writing was difficult for Renoir)[14] to Albert Chapon, an editor at the Bibliothèque de l'Occident.[15] In November, Renoir instructed Chapon: "You will send the proofs to M. Georges Rivière, who will take it upon himself to see if there are any changes to be made and give you the go-ahead to print."[16] The book was published in 1911.

Renoir's essay expounds many of his long-held Classical beliefs, which became even more conservative and traditional as he aged. He wrote about his respect for craftsmanship in painting and its validity in the twentieth century. Particularly interesting is Renoir's explanation of the faith that sustained him. No extant Renoir letter mentions God, religion, or church. (As Jean commented, "Renoir seldom, if ever, set foot in a church.")[17] Nonetheless, the preface affirms an al-

most religious faith that underlies Renoir's lifelong idealism:

All painting, from that of Pompeii, done by Greeks, to Corot, through Poussin, seems to have come from the same palette. All of them formerly learned this way of painting from their teachers; their genius, if they had any, would take care of the rest....

But in order to explain the general value of the art of the past, one must remember that over and above the instruction of the teacher, there was something else that has disappeared...religious feeling, the most fertile source of this inspiration. This is what gives all their works that character of nobility and at the same time of candor that we find so charming. To sum it up, there was then a harmony between men and the environment in which they moved, and this harmony came from a common belief. This can be explained if one acknowledges that the concept of the divine among advanced peoples has always involved ideas of order, hierarchy, and tradition....

Abandoned by the masses, Catholicism seems to many people to be dying and nothing is appearing on the horizon to replace it. Gods are no longer wanted and gods are necessary for our imagination. We must admit that modern rationalism, while it may satisfy scientists, is a way of thinking incompatible with a conception of art. It is, in fact, a religion for some people who would have made the Gallery of Machines their temple (all the same, less beautiful than Notre-Dame), but it does not have the qualities required to stimulate sensibility, even assuming that such sensibility is not proscribed in the name of reason....

Whatever the importance of these secondary causes for the decline of our crafts, the chief cause, in my opinion, is the lack of an ideal. The most skillful hand is never more than the servant of thought. So I am afraid that efforts aimed at making us into craftsmen like those of the past will be in vain. Even if we were to succeed in producing in professional schools skilled workmen knowing the technique of their craft, we will achieve nothing with them if they do not have within them an ideal to give life to their work.[18]

At the time that Renoir was involved with the Cennini project, he had a series of talks with a young American writer, Walter Pach, then living in Paris. Pach first met Renoir in 1908, when he was twenty-five years old, and he visited him for the next four summers. With Gertrude Stein's help, he wrote an article based on these conversations. When he sent it to Renoir for approval, the artist replied that he was flattered by the aesthetic criticism, but that he objected to parts of the interview that he felt were too personal:

For example, I mention Saint-Saëns in relation to Wagner. Saint-Saëns is a man of great talent and *alive* besides; it would be very offensive for me to seem to be critical of him since I know very little about music. I probably picked his name at random, not having anyone to contrast to Wagner.

...But above all avoid any personality (Gauguin, for example)....

To summarize: interviews are not literature, they are journalism. Besides, I don't see what interest there is in knowing whether a man ate lentils or beans, whether he was rich or poor. The interest lies in knowing the importance of any art. For example, I don't know whether Homer ate beans or lentils, and he remains nonetheless Homer.[19]

Pach forwarded a copy of Renoir's letter to Stein with a note thanking her for her help.[20] A year later, in May 1912, "Pierre Auguste Renoir" appeared in *Scribner's Magazine*. Pach had removed the personal parts of the interview but had retained the more objective statements such as:

[Renoir]: Nowadays they want to explain everything. But if they could explain a picture it wouldn't be art. Shall I tell you what I think are the two qualities of a work of art? It must be indescribable, and it must be inimitable....

The work of art must seize upon you, wrap you up in itself, carry you away. It is the means by which the artist conveys his passion; it is the current he puts forth which sweeps you along in his passion. Wagner does this, and so he is a great artist; another composer—one who knows all the rules—does not do this, and we are left cold and do not call him a great artist.

Cézanne was a great artist, a great man, a great searcher....

I so much like a thing that Cézanne said once: 'It took me forty years to find out that painting is not sculpture.' That means that at first he thought he must force his effects of modelling with black and white, and load his canvases with paint, in order to equal, if he could, the effects of sculpture. Later, his study brought him to see that the work of the painter is so to use color that, even when it is laid on very thinly, it gives the full result. See the pictures by Rubens at Munich; there is the most glorious fullness and the most beautiful color, and the layer of paint is very thin....

There is nothing outside of the classics. To please a student, even the most princely, a musician could not add another note to the seven of the scale. He must always come back to the first one again. Well, in art it is the same thing. But one must see that the classic may appear at any period: Poussin was a classic; Père Corot was a classic.[21]

On October 20, 1911, Renoir was promoted to the rank of *officier* of the Legion of Honor. Monet wrote Paul Durand-Ruel: "He's an officer now, he must be happy. Congratulate him for me."[22] On October 21, Paul Signac, the Neo-Impressionist painter and writer, became a *chevalier* and asked Renoir to be his representative. Even though Renoir abhorred Neo-Impressionism, he agreed tactfully: "I have always held the conscientious artist that you are in high esteem."[23] Two days later he notified Signac: "This morning I received the insignia of *chevalier* of the Legion of Honor....Come to lunch...potluck."[24]

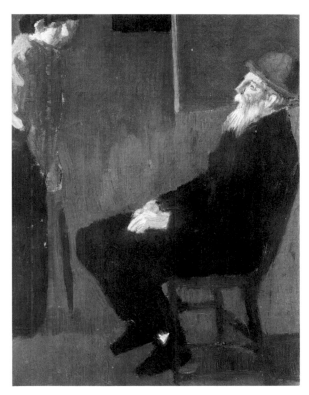

Maurice Denis. *Renoir and Mlle. Jeanne Baudot.* 1910. Oil on cardboard, 10⅝ x 8¼″. Private collection

The first monograph on Renoir appeared in 1911, written by Julius Meier-Graefe, a German critic and organizer of exhibitions who had long supported Impressionism. Illustrated with one hundred works, the German edition was followed by a French version a year later. Meier-Graefe proposed the influence of traditional art as the reason for Renoir's stylistic changes.[25] While there is no mention of the biography in any of Renoir's extant letters, he must have been pleased

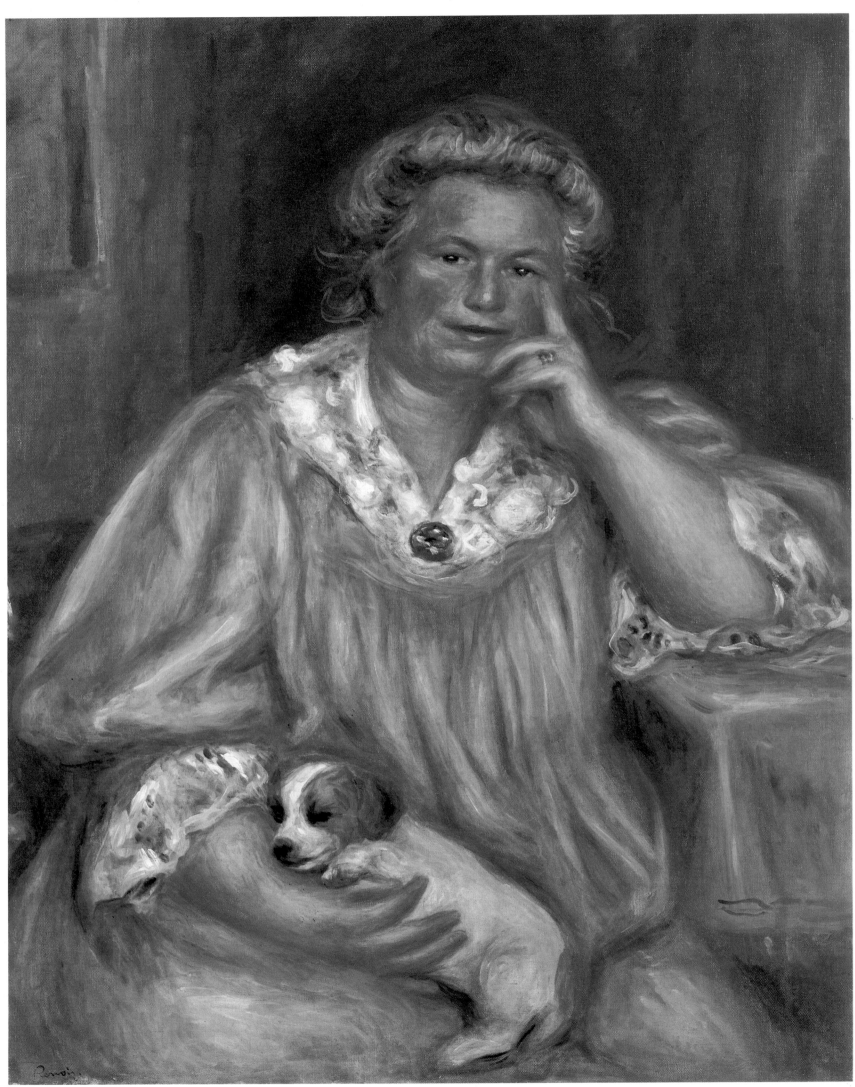

Mme. Renoir. 1910. 32 x 25⅝″. The Wadsworth Atheneum, Hartford, Conn.
The Ella Gallup Sumner and Mary Catlin Sumner Collection

since it was the first book-length biography of any Impressionist.

Monet, too, had become world-famous, and he and Renoir, both now in their seventies, saw each other about once a year. In 1911, Monet wrote to Paul Durand-Ruel: "I was very happy to spend a few moments with Renoir, whom I found looking better than when he came last year, and I will be glad to know from you if his trip back went well and if he didn't feel tired from it. Since I don't want to oblige him to answer me, would you be kind enough to let me know, and please tell him how happy his visit made me."[26]

During these years, Monet continued to inquire about Renoir's condition in letters to Durand-Ruel. On June 26, 1913: "I am told that Renoir is not well, would you be kind enough to let me know what it's all about."[27] On December 14 of the same year: "I felt all the more sorry because I had learned the bad news about Renoir, and I would have liked to know from you what his exact condition was, what I had been told being scarcely reassuring. So I would be very grateful if you would give me the latest news."[28]

In the fall of 1911, Renoir and Aline moved to a large apartment at 57 bis boulevard Rochechouart in the ninth arrondissement, so that his residence and studio could be on one floor.[29]

In Cagnes, he continued undergoing treatment for rheumatoid nodules. He explained to Rivière: "I have just been scratched again by a surgeon. I will see him again in a week, and again, and again."[30] To another friend: "The role of the surgeon consists of getting rid of my growths. It doesn't hurt, but it's a long and bothersome process. . . .

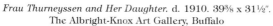

Frau Thurneyssen and Her Daughter. d. 1910. 39⅜ x 31½". The Albright-Knox Art Gallery, Buffalo

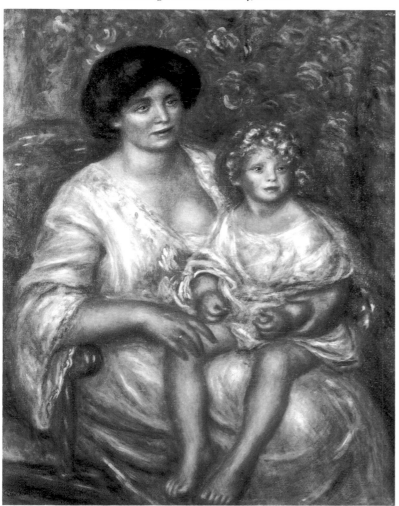

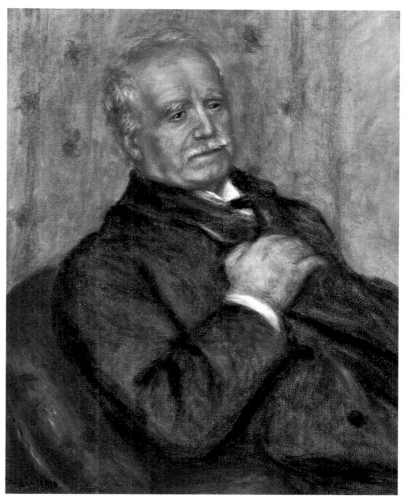

Paul Durand-Ruel. d. 1910. 25⅝ x 21¼". Private collection

I had to rent an apartment in Nice so that the children can get to school more easily."[31] Nice was also closer to his doctors.

Early in 1912, Mary Cassatt, an old friend from the 1870s, who lived in Grasse, confided to Durand-Ruel: "Seeing that poor Renoir really made me sad. If only something could be done for him! I'm afraid he is not getting proper care."[32] In February, Renoir complained to Rivière: "I am not much better but the surgeon and my wife are pleased. Are they right? In the battle, I have *lost my legs.* I am *unable to get up,* sit down, or take a step without being helped. Is it forever??! That's it. I sleep badly, tired out by my bones, which tire the skin. That's how skinny I am."[33] To Renée Rivière he wrote: "Unfortunately my rheumatism makes me suffer constantly. Every night I have feet like an elephant."[34]

Later in the spring Renoir had a stroke that left him unable to move his arms. Yet by June 15, Aline reported: "He is beginning to be able to move his arms, but the legs are still the same. He is unable to stand up, but he is much less discouraged. He is getting used to his immobility. It is very distressing to see him in this condition."[35] Gradually Renoir regained mobility in his arms. In December, the aged Paul Durand-Ruel visited and reported: "Renoir is in the same sad condition, but still amazing for his strength of character. He is unable to walk or even to get up from his armchair. He has to be carried everywhere by two people. What torture! And still the same good humor, the same happiness when he can paint. He has already done several things, and yesterday during the day a whole torso that he began in the morning. Sketchy but superb."[36]

A photograph shows Aline holding her husband's gnarled hand while little Coco, wearing a hat like his father's, stands behind (p.246). An-

After the Bath. 1912. 26½ x 20½". Kunstmuseum, Winterthur

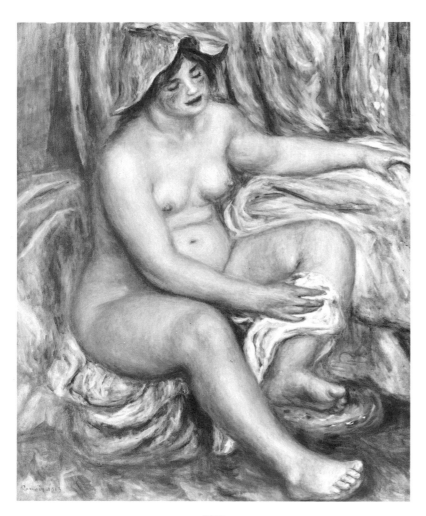

Female Nude. d. 1913. 39½ x 31½". Oskar Reinhart Collection, Am Römerholz, Winterthur

other photograph of 1912 was inscribed by Renoir to Vollard (p. 256). It was widely reproduced after the artist's death, and Picasso made a drawing from it, giving special attention to the piercing eyes and pitiful hands (p.256).

A nude of 1912 forms a striking contrast with these photographs. Her body is of superhuman proportions, and every part of it is active—her head turns, her arms and legs move, even her back twists. Evoking sexuality, maternity, and comfort, she is a fertility goddess—Mother Nature or Mother Earth—symbol of the continuity of life.

Even Guillaume Apollinaire, "the main impresario of the avant-garde,"[37] had the highest praise for Renoir's painting: "While the aged Renoir, the greatest painter of our time and one of the greatest painters of all times, is spending his last days painting wonderful and voluptuous nudes that will be the delight of times to come, our young artists [Futurists] are turning their back on the art of the nude, which is at least as legitimate an art as any other. They are doubtless prompted by a desire to go beyond humanity, as it were, and not consider it, and it alone, as the criterion of beauty."[38]

Renoir's paintings were widely exhibited in 1912. At least 266 canvases were displayed in four one-man shows and seven group exhibitions—from Paris to St. Petersburg to New York.[39] Sales proliferated. Dr. Albert C. Barnes of Philadelphia, the millionaire art collector who patented the antiseptic Argyrol, sent the painter William Glackens to Paris to purchase Impressionist works. Barnes soon became enamored of Renoir's work and eventually acquired 180 paintings for his home in Merion Station, outside of Philadelphia.[40] This is the largest collection of Renoirs in the world.

Renoir's works also sold well in public auctions. In December, at the estate sale of Henri Rouart, the once-denigrated *A Morning Ride in the Bois de Boulogne* (1873) went to Paul Cassirer for 95,000 francs, and *Parisian Lady* (1874) sold to the Knoedler Gallery in Paris for 56,000 francs. Monet's works were fetching considerably lower prices in 1912. *The Banks of the Seine at Argenteuil* (c. 1873–74) went to the Bernheim-Jeune Gallery for 27,000 francs, and in 1913 *Terrace at Ste.-Adresse* (c. 1866–67) went to Durand-Ruel for the same price.[41] (In 1967, the Metropolitan Museum of Art purchased the painting for $1,411,200.) When Renoir learned the results of the Rouart sale, he was naturally pleased at the increased esteem and money it promised for him, but he also congratulated Paule Gobillard, whose cousin, Julie Manet, had married one of Henri Rouart's sons: "You must be all excited about this sensational sale, which is upsetting the world and that must be thrilling, it is the triumph of Papa Rouart's taste."[42]

In February 1913, Denis visited Renoir and drew his portrait, in which he wears the same hat as in the 1912 photograph. Denis reported to Jeanne Baudot, "He is in very good form,"[43] and recorded in his diary: "Had lunch with Renoir.... Jean Renoir, who is going to enlist in the dragoons, tall, well built, drives the automobile.... Renoir pestered by dealers. 'Do you like sole?' The Bernheims send him twenty soles at a time. Melons, etc. D[urand-]R[uel] says: 'Why don't you have a young man to do your paintings for you—you would just have to sign.' He protests all the time and lets people do what they want with him."[44]

Renoir never took a painting assistant and never permitted the suffering he described in his letters to enter his paintings; the carefree

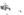

The Judgment of Paris. 1913. 28⅜ x 36¼". Hiroshima Museum of Art

bather drying her leg of 1913 seems to inhabit a different planet from that of the gaunt, deformed artist.

Despite the imminence of war, Renoir's work was shown widely in 1913, especially in Germany, where there were five exhibitions, including a one-man show of forty-one paintings at the Thannhauser Gallery, Munich. There were also five works on view at the New York Armory Show in 1913.

The most important exhibition of the year was in March at the Bernheim-Jeune Gallery—an extensive retrospective with fifty-two works spanning the years 1867 through 1913. On view were *Diana* (rejected for the 1867 Salon); *Bather* (1870 Salon); *The Harem (Parisian Women Dressed as Algerians)* (rejected for the 1872 Salon); *Mlle. Yvonne Grimprel with the Blue Ribbon* (1882 Salon); *Pink and Blue: Alice and Élisabeth Cahen d'Anvers* (1881 Salon); and *The Bathers* (Petit's 1887 Exposition Internationale). The gallery published an accompanying book which contained fifty-eight critical pieces about Renoir from the mid-1870s. Octave Mirbeau contributed the preface in which he pro-

claimed: "So his whole life and his work are a lesson in happiness. He has painted with joy, with enough joy not to cry out this joy of painting with all the echoes that the sad painters proclaim lyrically.... Renoir may be the only great painter who has never painted a sad picture."[45] The writings included earlier reviews by Wolff, Burty, Castagnary, Huysmans, and Geffroy—and statements written for the occasion by Maus, Natanson, Bonnard, the sculptor Antoine-Émile Bourdelle, and the collector and art historian Achille Segard.

Renoir was upset by Segard's article. He wrote André on March 19, 1913, that he objected to "an article by your friend S[egard], who feels obliged, poor man, to tear down Monet in order to build me up. I told him about it, I don't know if he will be very pleased with my letter."[46] Segard's article asserted that "Renoir occupies a place in contemporary art completely apart. He is a discoverer. He owes nothing except to himself and to his genius. He is inimitable. One can perhaps imagine painters who could imitate Claude Monet. Woe to those who try to imitate Renoir. He is a force of nature. It is instinct much more than

255

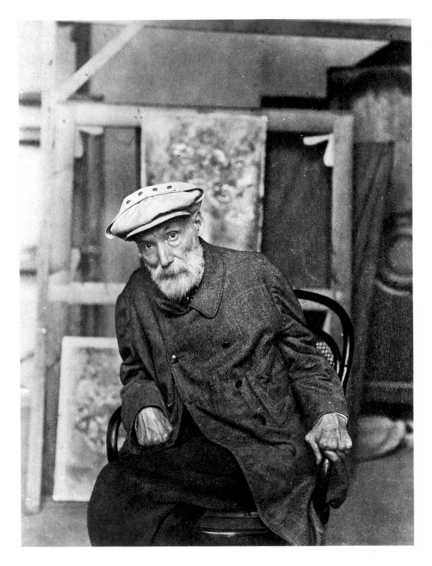

Maurice Denis. *Renoir.* d. 1913. Watercolor on sketchbook page, 6⅝ x 4″.
Private collection

Richard Guino. *Medallion of Renoir* and *Bust of Renoir*. Both 1913.
Bronze. Musée Renoir, Les Collettes, Cagnes-sur-Mer

RIGHT, ABOVE:
Albert André. *Renoir*. d. 1914. Charcoal on paper. Musée Renoir,
Les Collettes, Cagnes-sur-Mer

RIGHT:
Pierre Bonnard. *Renoir*. 1916. Etching, 10⅝ x 7⅞″.
Bibliothèque Nationale, Paris

Standing Venus. 1913.
Bronze, height 23½″.
The Baltimore Museum
of Art. The Cone Collection,
formed by Dr. Claribel Cone
and Miss Etta Cone
of Baltimore, Md.

Venus Victorious. d. 1914. Bronze, height 72″.
The Tate Gallery, London

reason. And this instinct is disciplined, ordered, and sharpened by a sort of natural affiliation with the great old masters."[47]

Apollinaire's review of the show was favorable: "Renoir is an artist who is constantly growing. His latest pictures are always the most beautiful and also the youngest.... These last works are so calm, so serene, and so mature that I do not believe he can surpass them."[48]

In April, Vollard came to Cagnes[49] with an interesting proposal: he suggested that Renoir collaborate on sculpture with Richard Guino, a twenty-three-year-old Spaniard who had been Maillol's assistant from 1910 to 1913. Vollard proposed that Guino translate paintings or drawings by Renoir into sculpture. The plan was that he would work under Renoir's direct supervision; Renoir would make all the critical decisions, such as size and style. Vollard would pay Guino, and Renoir would get the sale price less Vollard's commission. When Renoir was satisfied with a piece, his name would be affixed to the sculpture.[50] He would authorize Vollard in writing to cast the pieces, and Vollard would hold exclusive casting rights.

Vollard's motives are not hard to understand. Since 1895, when he had met Renoir, he had had trouble competing with Durand-Ruel, who still had almost exclusive rights to all new works. Now, in 1913, the Bernheims were also active Renoir dealers. To date, Vollard had been able to commission only some portraits and prints. With the Guino scheme, he would establish himself as the exclusive agent for Renoir's sculpture.

It is not precisely clear why Renoir agreed to the venture. He had

Clock Project (Hymn to Life). d. 1914. Bronze, height 28½".
National Gallery of Ireland, Dublin

been interested in sculpture since 1906; he may have feared total paralysis and wanted an ongoing collaboration to keep his mind occupied. In a letter to André from Cagnes on April 28, he explained: "Everything is chance in life, and when Vollard spoke to me about sculpture, at first I told him to go to hell. But after thinking it over, I let myself be persuaded in order to have some pleasant company for a few months. I don't understand much about that art, but I made fast progress in three-handed dominoes by working hard at it."[51]

The first two works Guino made were portraits of the artist: a bust and a medallion (p. 257). Renoir's own first idea was a series of works based on the Judgment of Paris theme. He painted a new, smaller version of his 1908 *The Judgment of Paris* (p. 255), in which he introduced a flying Mercury, changed the stances of the two lefthand nudes, and made all three women heavier and more three-dimensional. Of the fourteen statues in the Guino-Renoir partnership, half are related to this 1913 painting: two small statuettes and one large statue of *Venus Victorious* (p. 259); a small low relief and a large high relief of *The Judgment of Paris*; and two busts of the head of Paris.[52]

One of Renoir's earliest ideas for the statue of *Venus Victorious* appears in a watercolor that he gave to Vollard (p. 244). In the upper left corner, he wrote instructions for the setting: "Let the base of the statue be at the level of the water with small rocks and aquatic plants."[53]

In the spring and summer of 1913, in Cagnes and Essoyes, the statuette of *Standing Venus* (p. 258) was made. Not quite two feet tall, it depicts the goddess holding the golden apple bestowed on her by Paris. The proportions of the heavy, unself-conscious nude resemble the painted version: sloping shoulders, small breasts, long waist, large thighs, and wide hips.

261

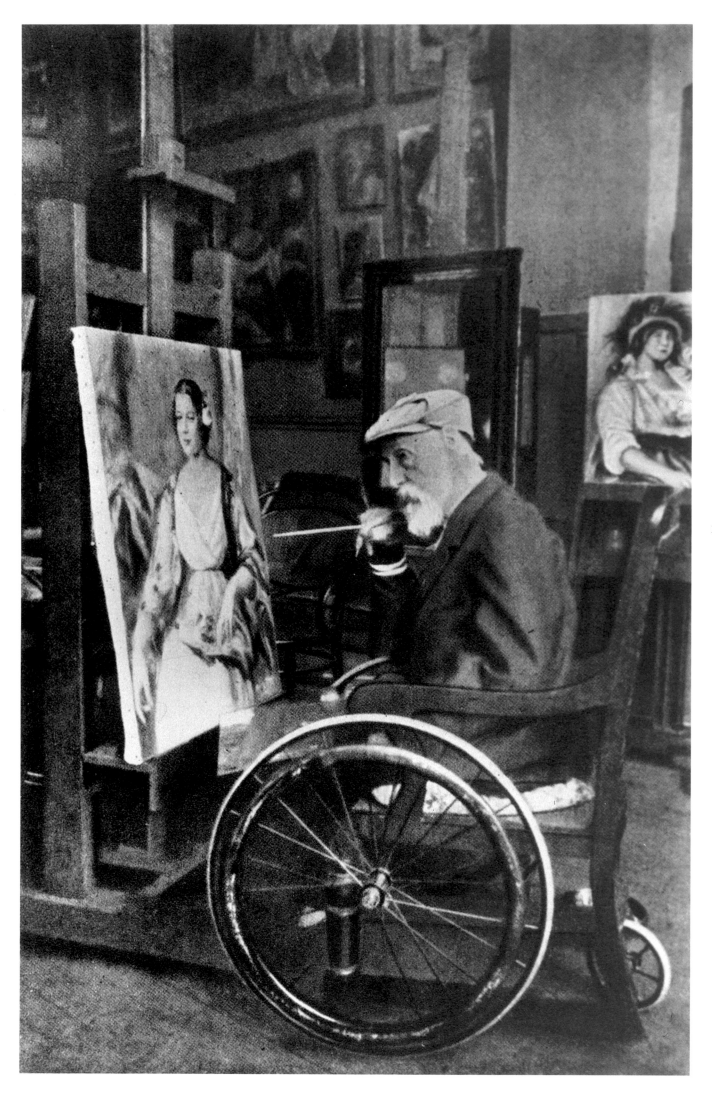

LEFT:
Renoir painting Tilla Durieux,
1914

OPPOSITE:
Renoir and Dédée, 1915

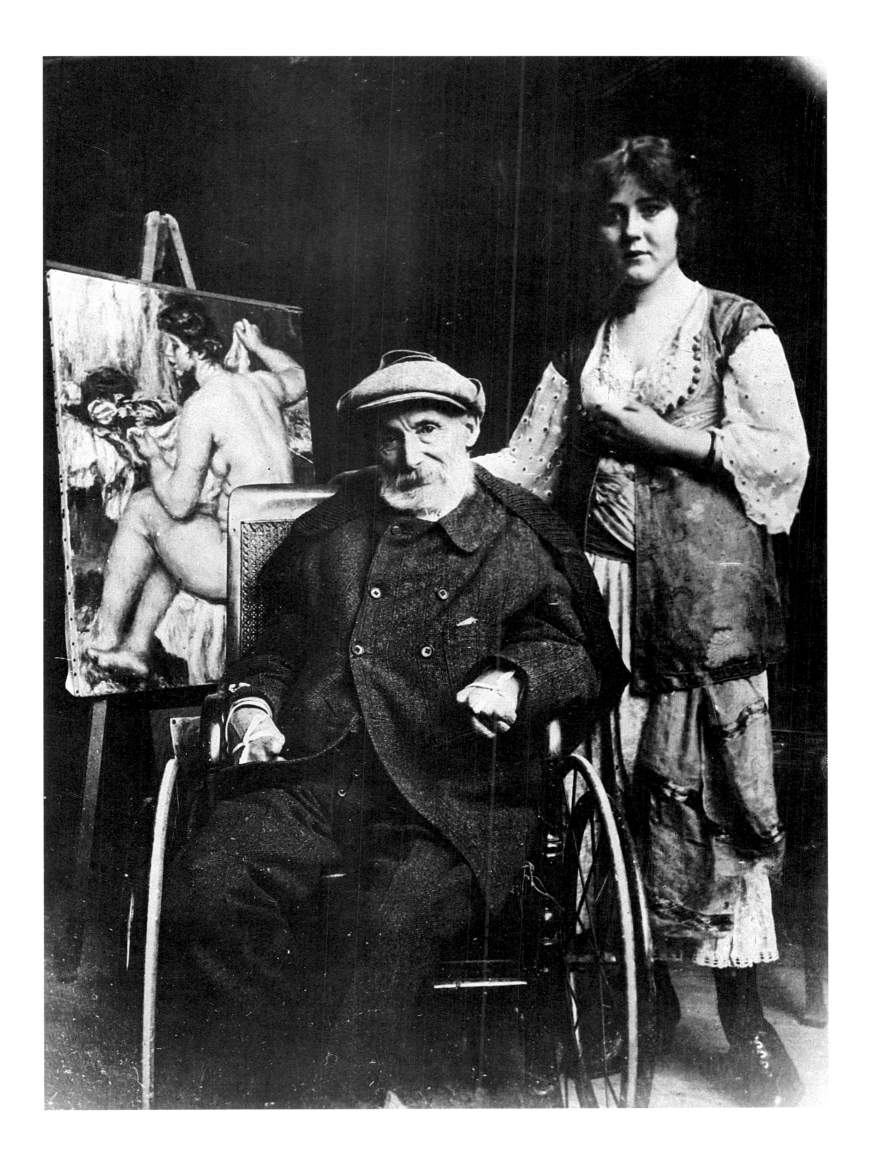

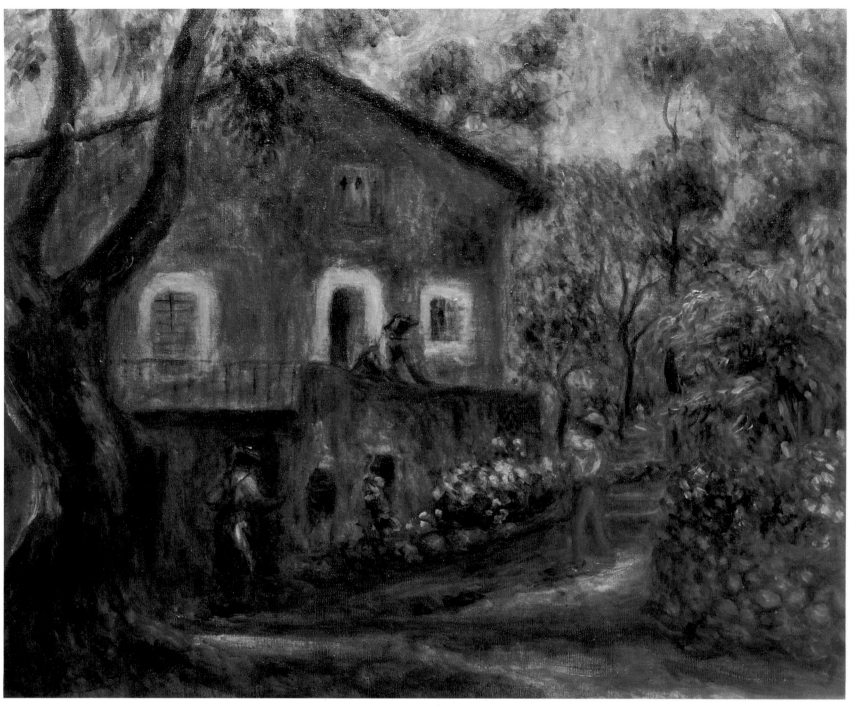

House at Cagnes. d. 1914. 21¼ x 25½″. Formerly collection of Alvan T. Fuller

Even though Guino would be working from Renoir's *Judgment of Paris* painting, Renoir also hired models to pose for him. On January 25, 1914, Renoir told Vollard that he was ready to receive Guino in Nice: "I have here two models, male and female, quite nice, and that is why I advise him not to delay."[54] "If the large statue won't come off, he can handle the clock. He will not be short of work. I am not going to interfere in all that."[55]

Before beginning work on the "large statue," *Venus Victorious,* Renoir requested a favor of André: "There is something boring you could do for me. I don't even know how it can be done. It would be to find out the exact height from the heel to the top of the head of a Greek statue of a woman, not the Venus de Milo, who is a big gendarme, but for example the Venus of Arles or the Medici or some other. One can get this information, I think, from the casts in the Louvre. If through someone or other you can write me this information, let me know as soon as possible. If it's impossible, I'll do without it, that's all."[56]

Inspired by the larger than life-size Classical statues, Renoir decided on a height of seventy-two inches for his Venus. However, her head, proportions, and swollen belly (suggestive of early pregnancy) are entirely different from those of the ancient statues. "The big statue is progressing,"[57] Cassatt reported to Paul Durand-Ruel from Grasse in the spring of 1914.

At the same time, as he had mentioned to Vollard, he was working with Guino on a clock design (p. 260) that utilized a related subject, a hymn to life or triumph of love. A nude man and woman look up to the figure of an infant, seated on top of the globe of the world and firmly grasping a flaming torch. This theme of the continuity of life through procreation and its related subject, the immortality of the artist through creativity, were part of his optimistic bequest to posterity.

On April 19, Renoir sent Vollard a warrant: "I authorize Ambroise Vollard, picture-dealer, owner of my three sculpture models: small statue with base *Jugement de Paris,* large statue with base *Jugement*

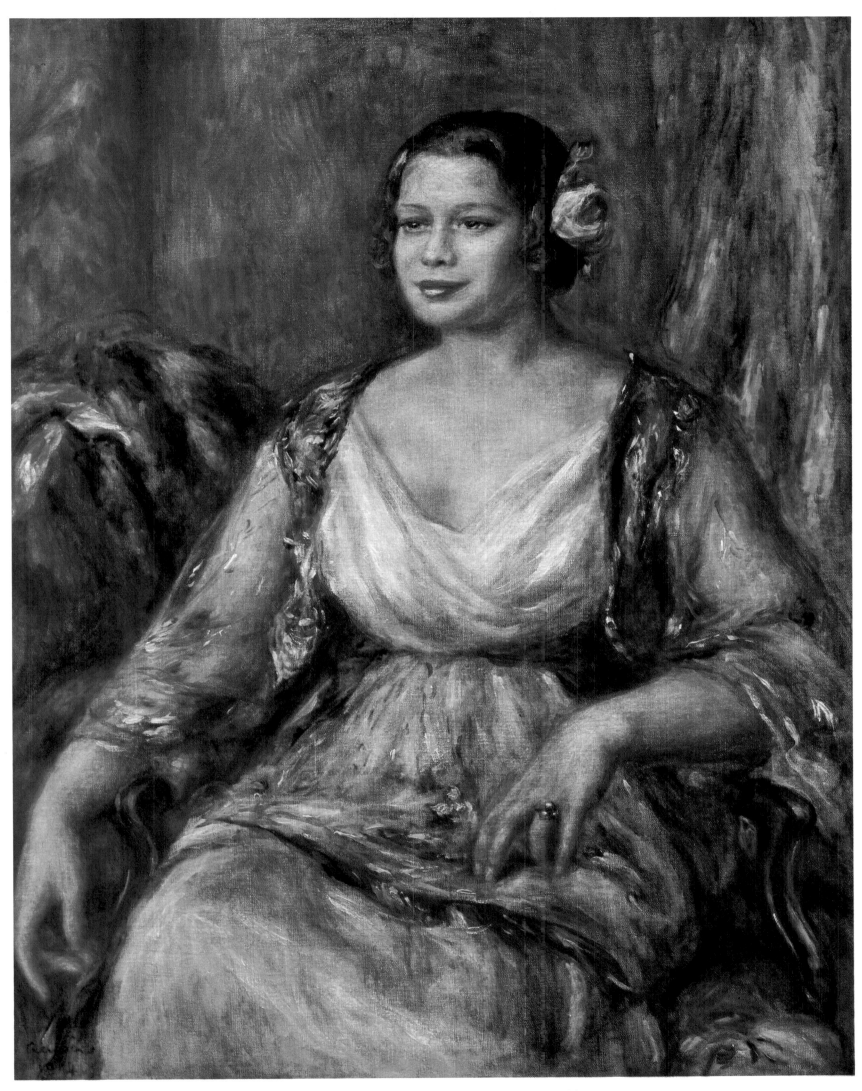

Tilla Durieux. d. 1914. 36¼ x 29". The Metropolitan Museum of Art,
New York. Bequest of Stephen C. Clark

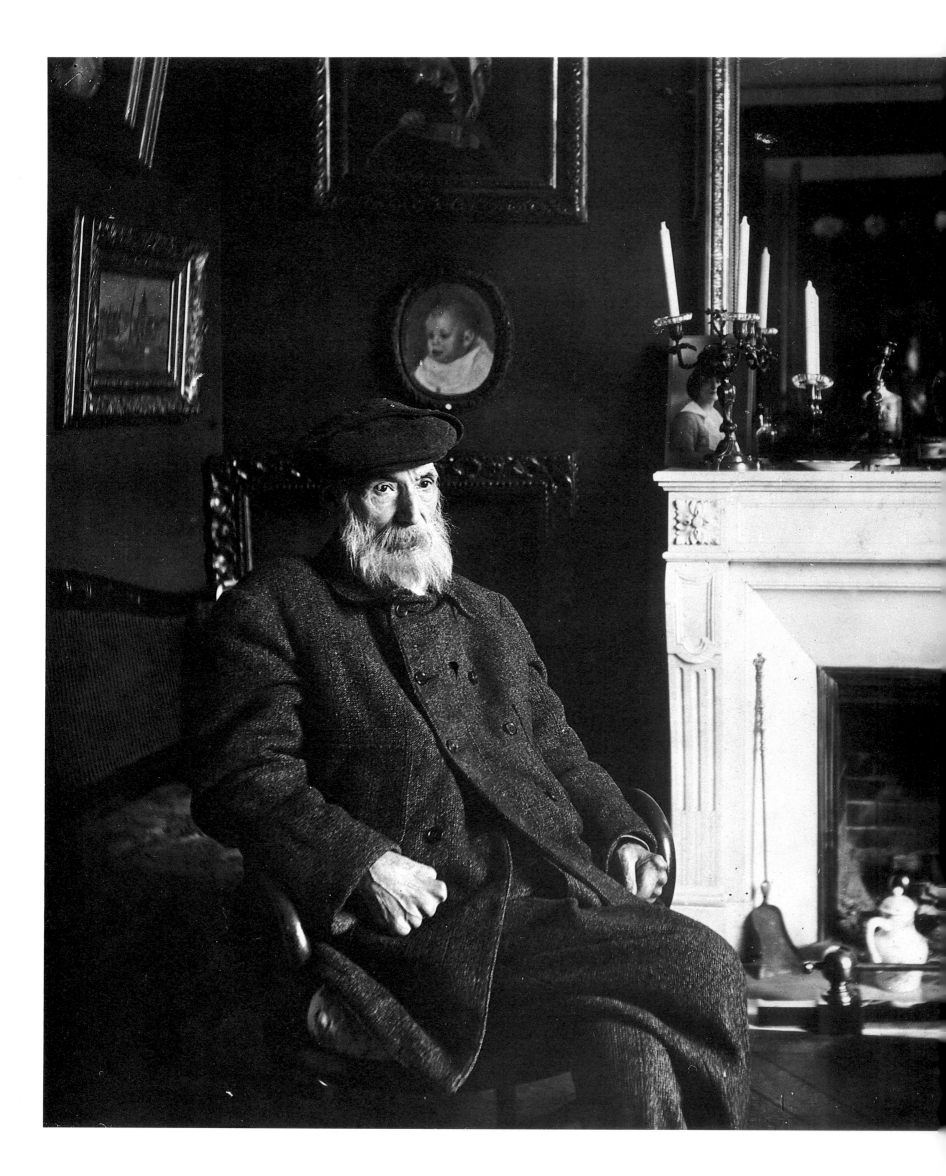

Renoir, 1915

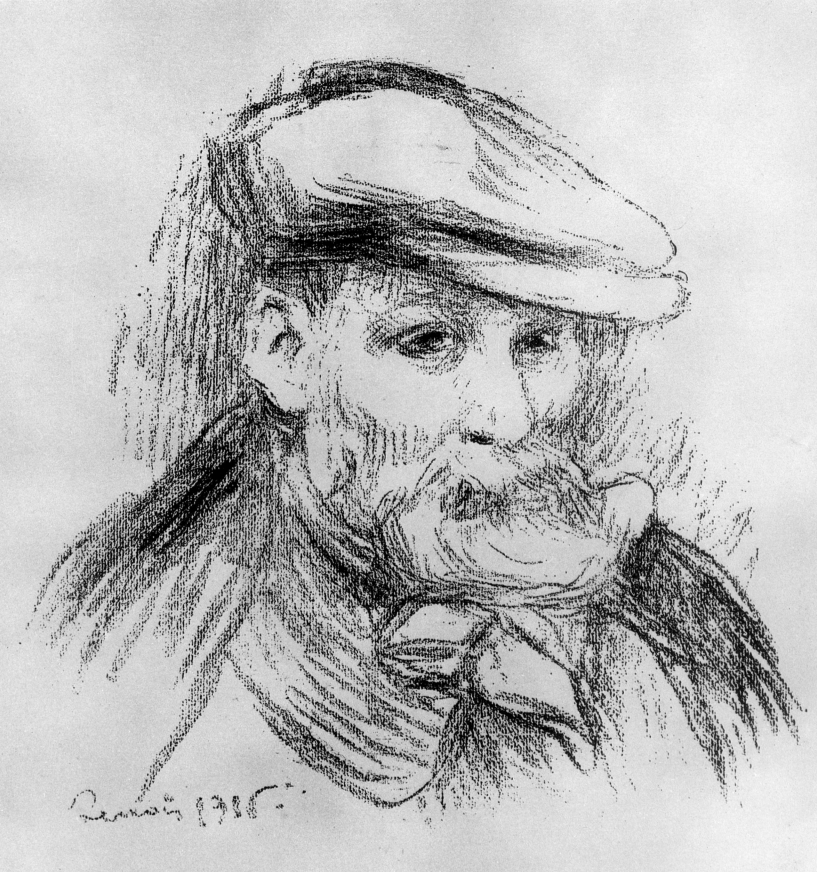

Mon cher Vollard

J'aurais eu besoin
de vous pour l'inventaire
qui se fera a Paris et
impossible d'avoir de
vos nouvelles étés vous
malade ou mort.
Je suis embêté avec
mon notaire de Cagnes
et je n'ai personne
pour me conseiller
Je vais m'adresser
a Durand Ruel. ne
recevant aucune nouvelle
de personne

à vous

Renoir

25 Décembre 1915

de Paris and the clock *Triomphe de l'amour,* to reproduce them in any material."[58] (A cast of the *Venus Victorious* was exhibited at the Paris Triennale in March and April 1916.)[59]

The clock still was not completed by summer. On June 16, from Paris, Vollard wrote to Guino: "Renoir has arrived. Could you bring the clock? If you could finish it at his place, he is entitled to the best."[60] Shortly thereafter Vollard added: "I have reached an agreement with M. Renoir; he will have nothing to do with your work. You will deal with me as you did in the past."[61]

Early in 1914, Gabrielle, then thirty-five years old, married an American painter, Conrad Slade, and left the Renoir household, although she remained a close friend. She had been a part of the family for twenty years and had posed for Renoir more than had any other model. In the circumstances of Renoir's failing health, this event might have been daunting. Yet Renoir continued to paint. "It is unbearable," he told Vollard, "especially at night, and I am still obliged to take drugs, useless at that. Apart from this inconvenience all is well and I work a little to forget my sufferings."[62] Among the paintings was *House at Cagnes* (p. 264). Albert André visited and drew a portrait of Renoir that he signed "Cagnes 1914" (p. 257).

In March of 1914, Renoir wrote Rodin in the Midi: "I hope that the indisposition that prevented you from coming to see me will be of short duration."[63] Later that month, the sculptor came and posed for this portrait, which had been commissioned by the Bernheims the previous November.[64] "There is the drawing of Rodin's head," Renoir wrote Gaston Bernheim from Cagnes. "It is one thousand francs"[65] (p. 286).

War concerns were now on Renoir's mind especially since Pierre and

Mme. Renoir. 1915. Bronze, height 23½". Hirshhorn Museum and Sculpture Garden, Smithsonian Institution, Washington, D.C.

270

Mother and Child. 1915. Bronze, height 21⅛". The Baltimore Museum of Art. The Cone Collection, formed by Dr. Claribel Cone and Miss Etta Cone of Baltimore, Md.

Jean were in the active reserves. From Nice, on January 27, Renoir had written Paul Durand-Ruel: "Jean's regiment is definitely going to the Vendée. The poor boy and we are very upset."[66] On February 3, from Cagnes, he told Rivière: "It looks like Jean's regiment is going very far away, since it's a clerical regiment and it is Clemenceau, always Clemenceau, who is responsible for sending a regiment where there is no barracks and where there is no need for it to be.... Pierre for the moment is in Cagnes."[67]

On May 22, Renoir wrote Rivière from Cagnes: "As for Jean, I think that something must be done before the change of government. How much can be done, I don't know. The thing is not to give up a bird in the hand, so it's very tricky. All the same, I'd be very pleased if he were less far from Paris. Arrange things with him. Do your best. That's all I can say."[68]

With the war imminent, fewer exhibitions were planned. Nonetheless, Durand-Ruel showed thirty Renoir paintings in New York in February. His works also appeared in group shows: ten at the Grosvenor House in London, twelve at the Art Museum in Copenhagen, eight in the Art Hall in Bremen, as well as at the Arnold Gallery in Dresden, and two at Bernheim-Jeune in Paris. Sales and prices declined, however, because of the political unrest.

Medallions of Rodin, Ingres, Monet, Delacroix, Corot, and Cézanne. 1916–17.
Each bronze, diameter 30½". Chrysler Museum, Norfolk, Va.
Gift of Walter P. Chrysler, Jr.

Apollinaire reiterated his effusive praise of Renoir in several reviews in the *Paris-Journal.* On May 6, 1914: "Renoir . . . is the greatest living painter."[69] On July 23: "Modern art is in danger of industrialization. . . . Renoir, the greatest living painter, whose least production is hungrily awaited by a whole legion of dealers and collectors, is far from industrializing his art. Rather, he likes to relax by decorating tiny pots, thus preserving all his freshness for his paintings."[70]

What Apollinaire was referring to was the fact that around 1913, at the same time that he became involved in making sculpture with Guino, Renoir had a kiln constructed in his garden at Cagnes. He made oil studies first (p. 261) and then decorated plates and pictures. Besides being physically easier, this work may also have reflected a desire for another try at his first craft—decorating porcelain.

Renoir and Aline returned north in mid-June 1914, when again Renoir saw much of Paule Gobillard, now a painter, and her sister Jeanne Gobillard Valéry, the mother of three,[71] as well as Julie Manet Rouart, who also had three children. Pierre and Jean were far from Paris. Pierre's companion, the actress Véra Sergine, had just given birth to their son, Claude. Aline invited Véra and the baby to stay at Les Collettes, which they often did in the following years.[72]

Soon after he arrived back in Paris, Renoir painted the stage star Tilla Durieux, wife of the German dealer Paul Cassirer (pp. 262 and 265). In her memoirs, Durieux described how she posed in his studio morning and afternoon for two weeks. She wore a costume from George Bernard Shaw's *Pygmalion.*[73]

Germany declared war on France on August 3. Pierre, twenty-nine, was in a reserve unit of the artillery; Jean, twenty, was a noncommissioned officer in the cavalry. In order to keep better track of their sons' whereabouts, the Renoirs decided to stay in Paris. However, on September 2, the Germans began to advance until they were only thirty miles from the city. The French government abandoned the capital and took refuge in Bordeaux. The next day Renoir and Aline were driven to Cagnes, where they soon received bad news: "PIERRE seriously wounded—JEAN too, but much less."[74] Renoir wrote in detail to André: "Pierre, wounded in the right arm, is in the Carcassonne hospital. The radius broken by a bullet that went through the arm. . . . Jean . . . after many vicissitudes received a kick, sheltered by a good butter dealer, he was in the Amiens hospital during the German occupation. Those Germans having run off, he was able to get out but he lost his regiment. So he was able to go to Paris and see Vollard and he is going back to Luçon.'[75]

In October, Renoir related, the French army "commission came to

271

see to the properties in Cagnes." He reported that they decided to stop at another location, and added, "which would be perfect."[76] Shortly thereafter his grounds were used: "We had 60 soldiers billeted on us, all fathers of families, they went away this morning, sorry to leave Les Collettes—they are sad but full of courage, poor fellows."[77]

On October 29, he told Paul Durand-Ruel: "You must have received the letter in which I told you about Pierre and Jean. My wife is leaving on Saturday to go and see them, one in Carcassonne, the other in Lu-

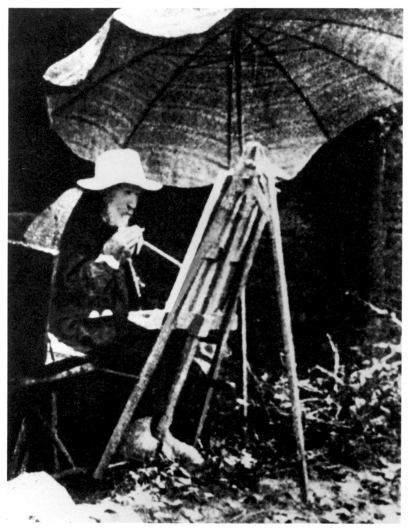

Renoir, 1916

çon, a tiring trip and above all long, but they will be happy to see their mother a little. I am sorry not to be able to go too."[78] On November 17 he wrote André: "My wife is reluctantly leaving Jean tomorrow. Although he is very happy for the time being, he is always impatient to go back and join his comrades at the front. But in the meantime, he is at the infirmary, no longer as a patient but as a secretary. Pierre writes me this morning that he is still waiting for the bone scraping that is supposed to take place one of these days. As for me, I'm painting, if you can call it painting. Just to kill this damned time, which gets old but like the old guard doesn't die. I keep rotting here like an old cheese."[79]

In 1915, few exhibitions took place. A Renoir painting was on view in San Francisco and several appeared in a Paris show. Sales were minimal, although Barnes bought some works.

Early in the year Renoir took on a new model, sixteen-year-old Andrée Heuschling, called Dédée. She posed for at least a hundred paintings, an astonishing number for Renoir to have undertaken in the

fewer than five years that remained in his life. A photograph shows her standing next to Renoir; on the easel is a painting for which she had posed—*Seated Nude,* of about 1915 (p. 263). It was in the collection of Jean Renoir, whom she married after his father's death.[80]

Aline, who suffered from diabetes, was in poor health. Two years earlier, Cassatt had expressed concern to Durand-Ruel about her refusal to follow her doctor's advice.[81] Now she reported to him on February 17, 1915, from Grasse: "I saw Renoir this afternoon, very well and painting and a nice color, no more red. Madame was not there, having gone to Nice. He told me that she was very well too. The cook [Grand'Louise] told me...that no, she [Aline] was not herself and that she [the cook] thought that the diabetes was going to her head. This woman has been in her service for a very long time. Now she [Aline] does not want to follow any regular diet, but they say that if one goes regularly to Vichy, it's not necessary."[82]

On March 25, from Cagnes, Renoir informed Georges Durand-Ruel: "Here is Jean's address: second lieutenant in the 6th Alpine Infantry, 2nd Company, in Nice. Forward to the front....As for me, I am aging here peacefully, as much as the constant anxiety of this ridiculous war allows me to, and I work a little so as not to think about it. That much at least is gained. Coco is in Cannes at a teacher's, in order to make up for lost time, which makes the house a little too peaceful....Pierre is supposed to be operated on today by [Dr.] Gosset."[83] A month later Renoir told André: "Pierre is going to be operated on again one of these days in a week or so. He is doing well."[84] That same day, April 16, Jean was seriously injured by a bullet in the thigh. He was sent to a hospital at Gérardmer near Besançon in northeast France. Renoir wrote to Rivière: "You must have known before me that Jean has been

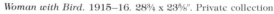

Woman with Bird. 1915–16. 28¾ x 23⅝". Private collection

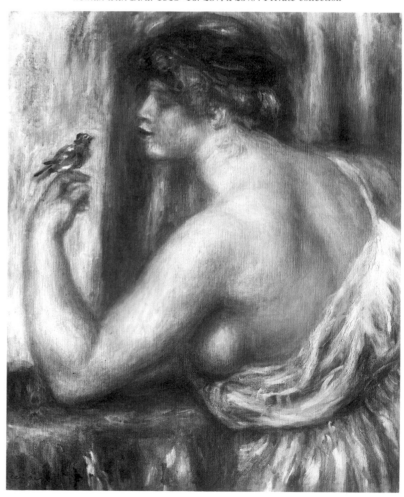

wounded. My God, when will we ever get rid of these brutes with poison gas. You who know people in Paris, try to get them to try cartridges like hunters, or small bullets: glass ground into a powder, cayenne pepper, or snuff. That can be made immediately, costs nothing, and puts hundreds of men out of action. But people in France are too bright. They'll laugh."[85]

Monet asked Georges Durand-Ruel on May 28 from Giverny: "Would you be kind enough to give me . . . news . . . of Jean Renoir . . . and also the results of the operation on Pierre Renoir."[86]

Eager to see Jean, Aline traveled to the Gérardmer hospital. When she learned that the doctors wanted to amputate his gangrenous left leg, she opposed the operation. Another doctor tried a different cure, circulating distilled water through the leg; this worked. Later, Jean learned that an amputation might have meant the loss of his life.[87] After his mother left, he was transferred to a hospital in Besançon.

On June 26, Renoir wrote to André's wife, Maleck: "I am in Nice. My

wife being very sick, I am stuck here. I cannot go to see Jean in Besançon. The poor boy is expecting us every day. She [Aline] is feeling a little better this evening."[88]

The next day Aline suffered a heart attack and died. She was fifty-six. Renoir wrote to Paul Durand-Ruel almost at once: "My wife, already sick, came back from Gérardmer very upset, and she was unable to recover. She died yesterday, fortunately without knowing it."[89] Renoir, an invalid of seventy-four, had lost his companion of thirty-six years. Their relationship had been respectful and tender. He considered Aline an ideal wife and mother, who took good care of him and their three sons and capably supervised their households at Cagnes, Nice, Essoyes, and Paris.[90] Aline was buried in Essoyes.

Because of his health, Renoir was unable to leave Cagnes for a few weeks, and Véra Sergine went to the Besançon hospital to tell Jean the sad news. On July 3, Renoir thanked Maleck for also having gone to see Jean at the hospital: "I must thank you very much for that mad

273

Mon cher Gaston

Pour la femme à l'oiseau
il faut une marge comme
pour un pastel, c'est à dire
une planche mince deux ou
trois millimètres d'épaisseur
peinte comme une porte
blanc et une pointe de
noir, le tableau grandira
si vous voulez emplir
le fond comme vous
voulez le faire la
figure perdra toute sa
valeur mettre le
nom du peintre sur
un carton doré sur
la marge en bas.

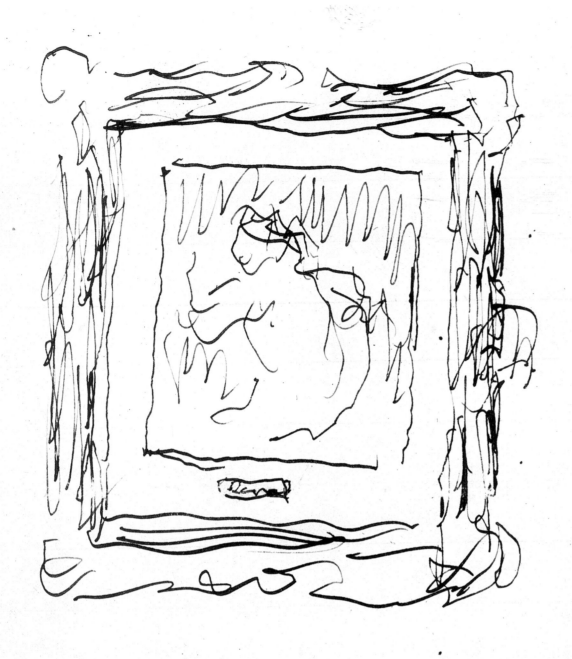

Letter from Renoir
to Gaston Bernheim
de Villers, 1918

Bien à vous

Renoir

1918

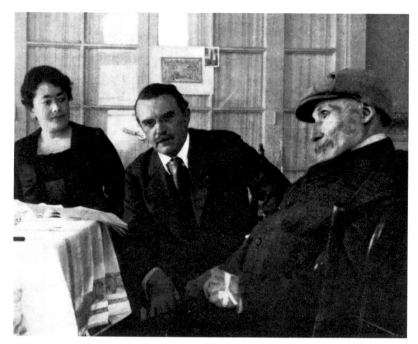

Adèle Besson, Albert André, and Renoir. Photograph by Georges Besson, 1918

dash to Besançon. You did me a great favor, very great. . . . Jean writes me not to go to Besançon, that he is being evacuated to Paris. So I'm waiting here, not knowing what to do."[91] Five days later, Renoir again wrote to Maleck: "My trip postponed again, indigestion, fever, etc. . . . Jean, Hotel Ritz [being used as a military hospital] in Paris. . . . The doctor will tell me when I'll be able to escape this torrid temperature."[92]

Later in July, Renoir went to Paris. He was too ill to go to Jean. Instead, Jean left the hospital on crutches to visit with his father at the boulevard Rochechouart apartment. Years later, in the opening paragraph of his biography of his father, he wrote: "My mother's death had destroyed him completely and his physical condition was worse than ever."[93] In a photograph taken at this apartment, Renoir's whole body seems overwhelmed by grief and anguish (p. 266).

Renoir soon went to Essoyes to plan a monument for Aline's grave. His first idea was to commemorate her as a loving mother nursing her baby. He decided on a small statue based on the first version of *Nursing* (1885), which he still owned. He made a small oil version and then asked Guino: "Could you come as soon as possible to join me in Essoyes? I have a study showing my wife seated. I would like you to do a bust in clay from this painting. I'm counting on you."[94] Guino made a statuette, but Renoir changed his mind and decided on a bust-length portrait (p. 270). He commissioned Guino to execute one after the 1885 portrait, also in his collection, and this statue went over her tomb. Copies of both statues, in polychromed cement, were placed in Renoir's garden at Les Collettes.

Renoir returned to Paris to be close to Jean until November, when he went back to Cagnes and Jean was sent to a hospital in Nice. At this time, Renoir taught both Jean, twenty-one, and Coco, fourteen, to make pottery in the kiln and to decorate plates.

On November 1 he related to Rivière:

Jean has gone before the great medical inspector De Lorme. He came through Nice and found everybody fit. Jean like the others. But he admitted that he would be better off in something other than the Alpine infantry, which has to climb walls and mountains. Since then he has gone before another commission and was denied an extension of convalescence. So he'll probably leave for the

front since they consider him fit. In the next three or 4 days, since his commander cannot go against the decisions of the commission. I am very upset, not knowing what to do. The thing would be for his application for armored cars to be accepted. Otherwise it's a death sentence, not being able to protect himself since he walks very badly. Tell me what I should do. What you think best.

On the back of Renoir's letter, Jean added a note:

Dear M. Rivière, My father has also written to Élie Faure [the writer], 147 blvd. St.-Germain. He asks me to tell you so as to keep you informed of all endeavors. With my respectful greetings. Jean Renoir.[95]

In 1915, Jean obtained a pilot's license. Pierre, whose arm was permanently damaged, was discharged from the army. He resumed his acting career and stayed at the Paris apartment. In mid-December, Renoir, ill at Cagnes,[96] was obliged to provide an inventory of his paintings as part of the assets that he and Aline had shared. He gave Vollard the job of drawing up a list of works in the Paris apartment. On December 25, Renoir wrote to Vollard: "I need you for the inventory that will take place in Paris and it's impossible to get a word from you. Are you sick or dead?"[97] (p. 269). In a similar vein, he inscribed a self-portrait drawing of 1915, "To Vollard, my nice bore." Renoir also asked Paul Durand-Ruel to help in the inventory.[98] Over the years, all the paintings that Renoir could not sell or wanted to keep for himself went into his private collection.[99]

On January 2, 1916, Renoir lamented to André from Cagnes: "I would rather see you than write to you. Since my wife's death I have not had a moment's peace: 2 notaries, a lawyer, inventories, and a large sum to pay for the paintings that are left and the rest. Well, I shouldn't complain too much. I am still more or less on my feet (in a

Adèle Besson. d. 1918. 16⅛ x 14½". Musée des Beaux-Arts et d'Archéologie, Besançon. Gift of Georges and Adèle Besson

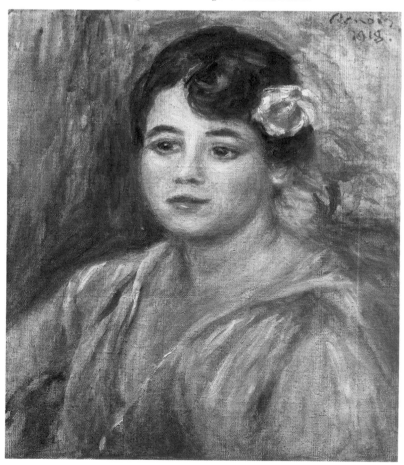

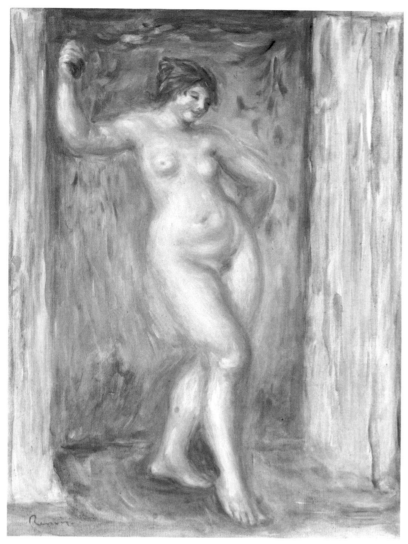

Nude with Castanets. 1918. 21 x 16″. The Barnes Foundation, Merion Station, Pa.

noir, seventy-five years old, wrote a letter to Monet, then seventy-six: "I'm delighted to hear that you have some large decorations [waterlilies], they will be additional masterpieces for the future. As soon as I'm in Paris, around May I think, I'll drop you a note. It will be a real pleasure to share a bite with you. Just thinking about it makes my mouth water in anticipation. Stay well, it's the best thing I can wish everybody. Best, your friend."[103] The old friends did not see one another again.

The war meant sparse sales, low prices, and few shows for most artists; however, Renoir continued to do well. In October and November, in neutral Switzerland, twenty-six Renoirs were on view in Winterthur, in an exhibition of French paintings; Duret wrote the catalogue.

Back in Cagnes on November 29, Renoir complained to Georges Durand-Ruel: 'As for me, I am in very, very bad shape. I have a mass of afflictions that make my life unbearable, loss of appetite, pains in the lower back, troubles I can't get rid of. It's now five weeks since I've set foot outside my room, and that's not funny."[104] However, on December 13, Monet marveled to Georges Durand-Ruel: "As for Renoir, he's still astonishing. He is said to be very sick and then all of a sudden you hear that he's working and forging ahead all the same. He is quite simply marvelous."[105] A photograph of 1916 (p. 272) shows Renoir painting outdoors, working on *Bathing Group* (p. 273), another celebration of the pleasures of nature and friendships.

In 1917, several exhibitions, primarily held in countries not at war,

Dancer with a Tambourine. 1918. Terracotta, 24 x 16⅛″. Private collection

manner of speaking). . . . Excuse me if I don't talk about this stupid war, which makes no sense but will never end. Jean is still in Nice, expecting to leave every day for the air force. Coco is fine. He is the happiest. He does nothing but run in the countryside. Well, let's hope that we'll see each other again, but when?"[100]

Before Jean left to serve as a pilot, Pierre Bonnard came to visit. He took a photograph of father and son, from which he later made an etching (p. 257). Years later he recalled Renoir's asking: "Isn't it true, Bonnard, that we must beautify?" and Bonnard went on to explain: "Renoir had made a magnificent universe for himself. He worked from nature and was able to project onto a model and light that were sometimes a little dull, the memory of more enthusiastic moments."[101]

In 1916, Renoir directed Guino to execute six medallions as a personal hall of fame of great artists of the present and past: Rodin, Ingres, Corot, Delacroix, Monet, and Cézanne (p. 271). Guino based the portraits of the contemporaries on Renoir's drawings: the 1881 drawing of Cézanne for Chocquet, a drawing now lost of the elderly Monet, and the 1914 drawing of Rodin for Bernheim-Jeune. Ingres and Corot were portrayed from photographs, and Delacroix from a self-portrait. A seventh medallion (now lost), which was halted at the rough stage and lacked its garland, was of Wagner, based on the 1882 portrait.

Throughout 1916, Renoir's health continued to deteriorate. On January 17, Monet wrote to Georges Durand-Ruel, "Only the news about Renoir was disturbing."[102] Two months later, on March 24, Re-

277

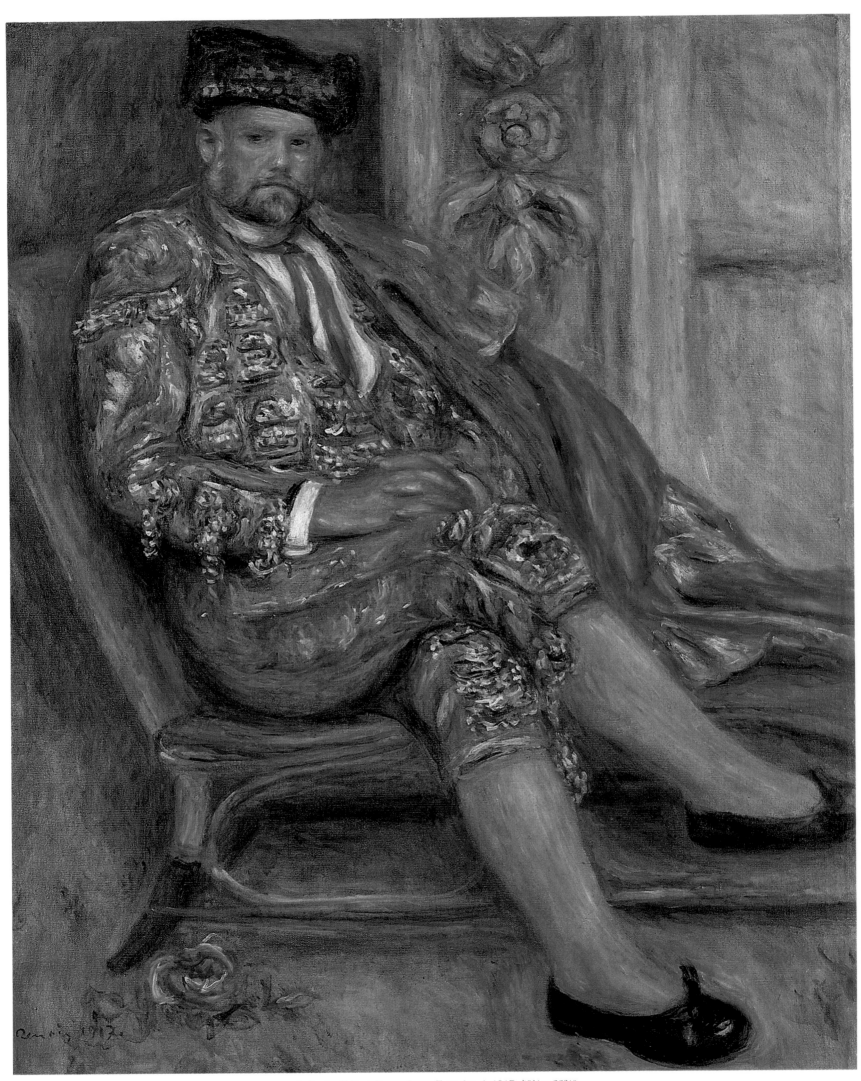

Ambroise Vollard Dressed as a Toreador. d. 1917. 40¼ x 32¾".
Collection Nippon Television Network Corporation, Tokyo

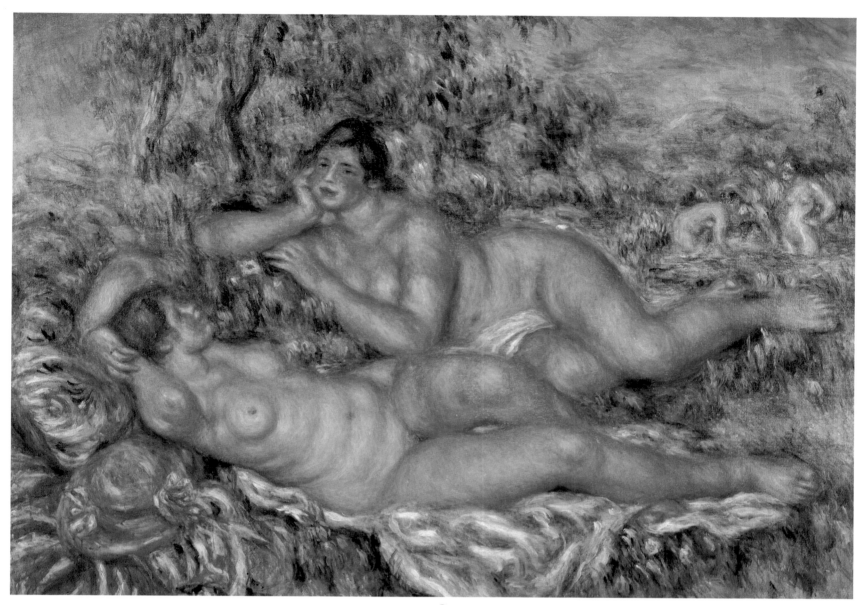

The Great Bathers. 1918–19. 43¼ x 63″. Musée d'Orsay, Galerie du Jeu de Paume, Paris

included works by Renoir. At the Kunsthaus in Zurich in a large show of modern French art, fifty-seven paintings and three bronzes were shown. Exhibitions were held also at the Nationalmuseum in neutral Stockholm, and in neutral Barcelona. In New York City, eighteen Renoirs were displayed at Durand-Ruel's gallery before the United States entered the war on April 6. In Paris, at Rosenberg & Co., sixteen Renoirs were shown for the benefit of the war wounded.

Sales were also active. On March 31, Durand-Ruel sold two paintings of *Scenes from Tannhäuser* (1879), to Dikran K. Kelekian for 50,000 francs each.[106] On April 2, the Bernheims bought fifteen Renoir paintings at a sale for the benefit of artists in the armed forces. Renoir later advised Gaston Bernheim de Villers: "For the woman with the bird [p. 272], a mat as for a pastel is needed, namely a thin board, two or three millimeters thick, painted like a door, white with a touch of black. The painting will grow if you want to fill the background the way you wanted to. The figure will take on all its value. The name of the painter should be put on a gilded placard on the bottom edge."[107] Renoir went on to sketch how the framed painting would look (pp. 274-75).

On January 28, 1917, Renoir informed Georges Durand-Ruel from Cagnes: "I think Jean will have a leave at the end of the month. The

Andrés are here keeping me pleasant company."[108] A few days later he wrote Jeanne Baudot's father: "Here nothing is happening, except that Jean has a week's leave but that is going to end and it makes me even sadder. . . . There shouldn't be people who are too happy when there are some who are so unhappy."[109] The next month to Georges Durand-Ruel: "I am very tired and work less and less, it being impossible for me to move my arms. Still I'm as well as I can be, considering my rheumatism."[110] And again to Georges on May 21: "I am well but I got old faster than is customary."[111]

Renoir returned to Paris in mid-July for a brief stay before settling in Essoyes for the summer. At this time, he received an unusual tribute. His painting *The Umbrellas* (c. 1883) had been purchased in 1907 by the Irish collector Sir Hugh Lane. After Lane died on the *Lusitania* in 1915, his will stipulated that his modern paintings should go to the National Gallery in London. When the painting was hung, about a hundred English artists and collectors signed a letter to Renoir: "From the moment your picture was hung among the famous works of the old masters, we had the joy of recognizing that one of our contemporaries had taken at once his place among the great masters of the European tradition."[112] This testimonial was especially moving because the English had been so slow to appreciate his work.

In August, Vollard visited Renoir in Essoyes and sat for a portrait dressed in a toreador's outfit that he had recently bought in Barcelona. As in many of Renoir's late works, the head seems small and the body elongated, almost Mannerist in proportions. The thin veils of golden reddish color have the sparkling luminosity of a stained-glass window.

Renoir returned in September to Cagnes, where he learned of Degas's death. On September 30, Renoir sent a note to Georges Durand-Ruel: "I have received a letter and a telegram informing me of Degas's death. It's fortunate for him and for the people around him. Any conceivable death is better than living the way he was."[113] (Degas had become blind and could not work during his last years.) Both Rodin and Wyzewa also died that year.

In December the four-year collaboration with Guino ended. What precipitated the termination is not known, for Renoir the next month praised his assistant to Vollard: "First of all, Guino has an incomparable ability as a modeler and he is very serious. Besides, since I am extremely tired—very, very tired, I wouldn't mind taking a little rest for the time being, feeling as bad as I do, life too complicated for my age, and I reach the point where I no longer do either painting or sculpture or pottery while I want to do everything. Guino is a charming man whom I wouldn't want to hurt for all the world and who does everything he can to please me. This is why I am giving you this tip, which may help me out without hurting anyone."[114]

In his late years, Renoir was surrounded by family: Coco, Jean, Pierre, Véra, his grandson, Claude, and by friends: Rivière, the Durand-Ruels, Vollard, Gangnat, André, Maleck, Paul Cézanne, Jr., and his wife, Renée Rivière, and Edmond Renoir, Jr., and his wife, Hélène Rivière. Renoir's bustling household included models Dédée, La Boulangère, and Madeline Bruno; the cook, Grand'Louise; the maid, Nénette; the chauffeur, Bistolfi; the gardener, Old Jean; and a trained nurse.

In December 1917, Matisse, then forty-eight, was wintering in Nice and visited Renoir at Les Collettes.[115] He had been asked to write about Renoir for the catalogue of an exhibition in Oslo where thirteen paintings would be on view early the following year. His text reads in part: "Renoir's spirit, by its modesty as well as by its confidence in life, once the effort is made, has allowed him to reveal himself with all the generosity with which he has been endowed and undiminished by second thoughts. The appearance of his work lets us see an artist who has received the greatest gifts, which he has been grateful enough to respect."[116]

In 1918, Jean, who had completed his duty in the air force, was transferred back to Paris for less dangerous assignments. He lived with Pierre and his family in the boulevard Rochechouart apartment. On January 20, Renoir, in Cagnes, asked Joseph Durand-Ruel "to be kind enough to give Jean the small sums of money he will need."[117] In January, André and Maleck visited Cagnes along with Georges Besson, an art critic, and his wife, Adèle. Besson photographed Renoir with André and Adèle (p. 276). The resemblance between the photograph and Renoir's portrait of Adèle is striking.

The following month, André mailed Renoir the preface to a book of forty Renoir paintings that was to be published in Paris by Crès. Renoir commented: "I'm writing you only to give you carte blanche. I will not be like Courbet in the preface written for him by Proudhon. He ended by saying, no matter what I say about Courbet, Gustave will not be pleased."[118]

Shortly thereafter Renoir received the reproductions for the first volume of Vollard's *Tableaux, Pastels et Dessins de Pierre-Auguste Renoir*, which contained 667 illustrations. (The second volume would have 192 plates.) Renoir congratulated Vollard on March 3: "I have received the reproductions that you made for your book about me and I am happy to be able to tell you that I find them perfect. I am delighted."[119] This letter was printed in the first volume, which was published later in 1918.

Renoir's health continued to deteriorate.[120] In May, he wrote to Jeanne Baudot from Cagnes: "Since my feet are swollen, it's impossible to go to sleep, even the sick part."[121] He remained in Cagnes longer than usual, explaining in July to Georges Durand-Ruel: "It's painful enough and often I suffer a lot from my foot, the heat, the flies and mosquitoes. Otherwise all is well, but it's impossible to do anything. Too many bugs in the eyes, in the nose, and no appetite. I am less and less plump. I hope that all your family is well and that Papa is bravely putting up with the excessive heat."[122]

In September, Renoir took on another sculpture assistant, Louis Morel, a thirty-one-year-old native of Essoyes. He wrote Morel from Cagnes on September 3: "If by any chance you should feel like coming in this direction, I can offer you hospitality and the expenses of the trip. Here you will find everything needed for sculpture. I mean the desire or the possibility."[123] Vollard had no part in this arrangement. Again Renoir began with oil studies, such as *Nude with Castanets* (1918), and *Dancer with Tambourine*, which Morel made into high-relief terracottas. Later the Paris firm of Renou and Colle cast in bronze the three high-relief terracottas that resulted from the collaboration.[124]

Renoir was in Cagnes on November 11, 1918, when the Armistice was signed. His joy at the return of peace inspired him to create a large new work, *The Great Bathers*—his final masterpiece. Its dimensions suggest that it was made as an exhibition piece for eventual museum—rather than private—acquisition.[125] Renoir here summed up his experiments of the past few years through his synthesis of Classicism in the form and composition and Impressionism in the brushwork and light.

The Great Bathers calls to mind earlier pivotal works: *At the Inn of Mother Anthony, Marlotte* (1866), *Le Moulin de la Galette* (1876), *The Boating Party* (1881), the dance panels (1883), *The Bathers* (1887), *The Artist's Family* (1896), and *Variant of The Bathers* (1903). Each of these paintings is unusually large, over five feet; each recapitulates his work of the previous few years and serves as a springboard for further research.

When Renoir was working on *The Great Bathers*, he was suffering, emaciated, immobile, near death, yet he could still embody his ideals and fantasies in healthy, relaxed, convivial figures basking in a sunny rural setting. The quintessence of beauty for him was still sensuousness, best expressed through plump young women who are the link between the cycle of life and artistic creativity.

In his last year, Renoir painted *Girl with a Mandolin* and *The Concert*, with monumental figures majestically filling the space. The surfaces sparkle with thin washes of red ocher, vermilion, burnt and raw umber, and golden red. He also painted charming small still lifes such as *Chrysanthemums in Vase*.

With the war just over in 1919, the art market remained slow. Among the few shows were one at Durand-Ruel's New York gallery and one at the Petit Palais in Paris. However, the Durand-Ruels, Cassirer, and several collectors were buying up Renoirs in resales.

Cagnes Mai 1919

Mon cher ami
En lisant votre
préface je n'y ai
vu qu'une chose
et écrit avec amour
assez de l'amitié
tout le monde ne
peut en dire autant
vous me voyez
au travers de
vapeurs roses et dorées
mais vous me
voyez ainsi, ce n'est
pas moi qui me
plaindrai que la
mariée est trop belle
Renoir

Letter from Renoir to Albert André,
May 1919

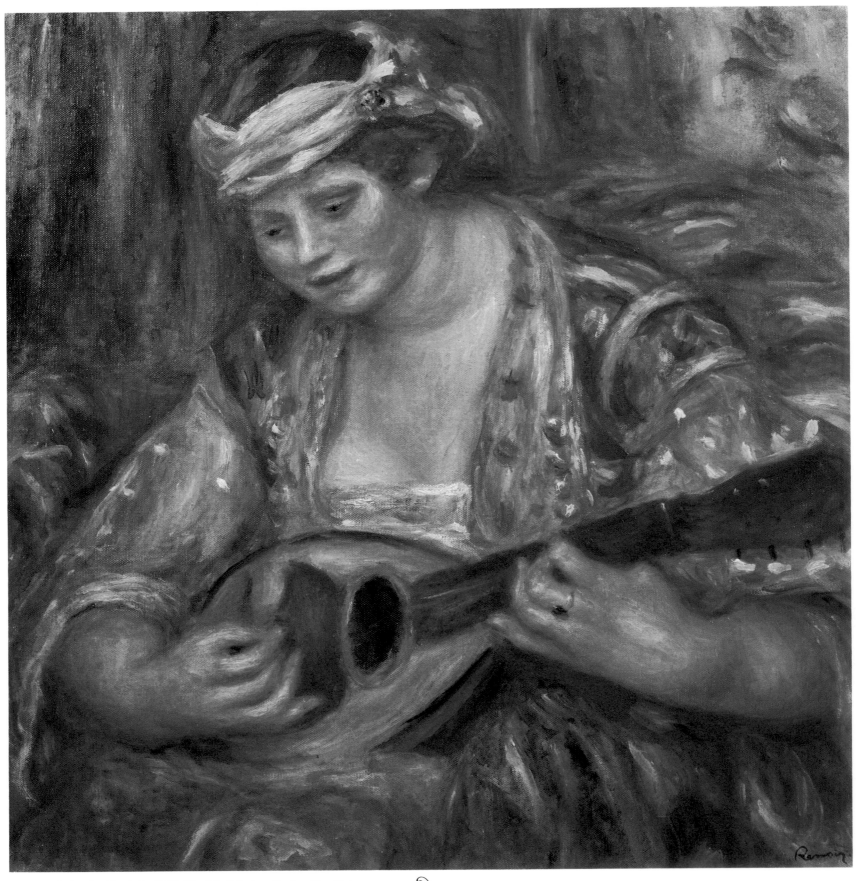

Girl with a Mandolin. 1919. 22 x 22″. Private collection, New York

On February 19, Renoir was promoted to the rank of *commandeur* of the Legion of Honor. His letter of acceptance was written by someone else, but signed by himself.[126] Durand-Ruel, then eighty-eight, wrote to congratulate him. Renoir dictated this reply: "I was very moved by your going to the trouble to write to me yourself, considering the pain it gives you. That proves to me all the affection you have for me. . . . You have been able to write me, but I'm not able to do the same to you. It is impossible for me."[127] Yet three months later, Renoir was able to

write again. When André's book appeared in May, Renoir wrote in a shaky, poorly coordinated script: "My dear friend, While reading your preface, I saw in it only one thing: it is written with love and also out of friendship. Not everybody can say the same. You see me through pink and golden mists. But that's how you see me. I won't be the one to complain when the bride is too beautiful."[128]

Before his trip north for the summer, Renoir made arrangements for the maintenance of Les Collettes: "While I am away, my farmer may

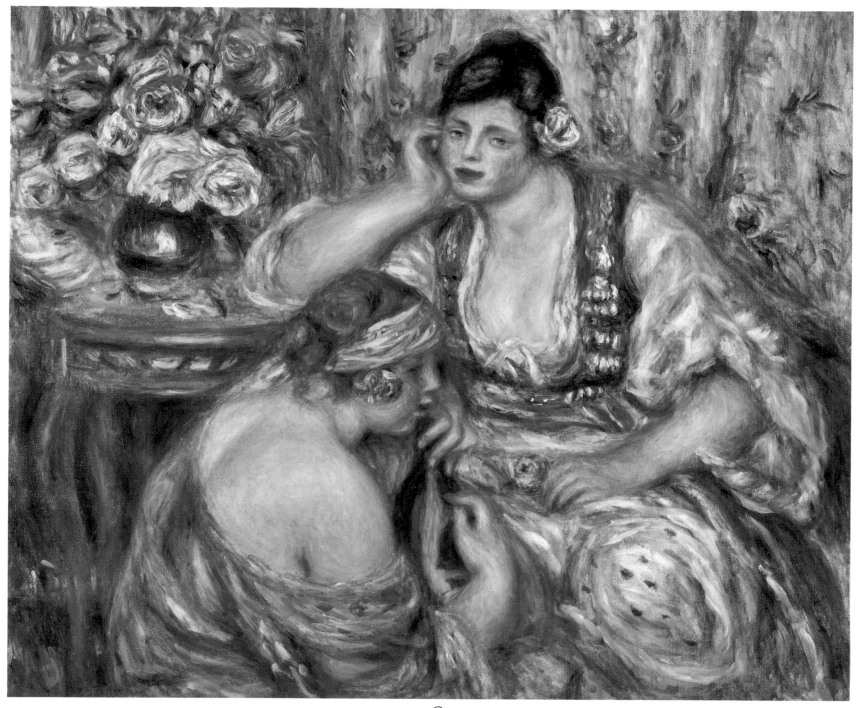

The Concert. 1919. 29¾ x 36½″. The Art Gallery of Ontario, Toronto.
Gift of Ruben Wells Leonard Estate

have to go to Italy. In that case, Old Jean must sleep at the farm . . . and watch over the property. I want him to be paid even if he is sick."[129]

In late July, he went with his sons to Essoyes, where Rivière spent a few days with him. "I found him even thinner, although at first that seemed impossible," Rivière wrote. "His voice had become so weak that at times he could hardly be heard. Although he kept painting every day, the work was costing him more and more suffering and the sittings were interrupted by very frequent breaks. He was aware of his decline and realized the seriousness of his condition, but generally he wouldn't talk about it."[130]

Back in Paris in August, Renoir began to feel better. He learned that the Society of Friends of the Luxembourg had bought *Mme. Georges Charpentier* (1876–77) for the Louvre. When he expressed interest in seeing it, a special visit was arranged and he was carried through the galleries in his sedan chair, accompanied by curators and André.[131]

Soon thereafter, Renoir left Paris for the last time and returned to Cagnes. Dissatisfied with the work of Morel, he had hired a twenty-three-year-old sculptor, Marcel Gimond, who began working on a bust portrait of Renoir. They also talked of plans for a temple of love, reminiscent of the Temple of Love in Versailles, to be erected in the garden at Les Collettes.[132] This project was never realized.

Renoir died on December 3, 1919, at the age of seventy-eight. Félix Fénéon, the critic and artistic adviser to the Bernheims, who was at Les Collettes at the time, wrote a letter to the editors of the newspaper *Le Bulletin de la Vie Artistique,* which was published on December 15:

A month ago . . . [Renoir] may have caught cold while painting a landscape in his garden in Cagnes. He had pneumonia, during which he happened to mention, but without complaining, his probable death. "I am finished," he would say. He did not die, however, directly of his pneumonia. He had a heart attack (his heart had always been very delicate), and so he avoided the painful congestion customary in fatal pneumonia.

283

Tombs of Pierre-Auguste Renoir, Pierre Renoir, and Aline Renoir,
Essoyes cemetery

On November 30, he was still painting: he had begun a small still life—two apples. Then the death throes came.

He was being treated by Dr. Prat, a surgeon, and Dr. Duthil, two physicians from Nice. The latter was still at his bedside at midnight, two hours before his death. This Dr. Duthil had killed two woodcocks and had told the patient about his exploit. In his delirium, those birds stubbornly came back and, combined with ideas of painting, were his last concern. "Give me my palette.... Those two woodcocks.... Turn the head of that woodcock to the left.... Give me back my palette.... I can't paint that beak.... Quick, some paints.... Move those woodcocks...." He died at two o'clock in the morning, on Wednesday, December 3.

His son Pierre, the actor, was unable to arrive until Wednesday during the day. His sons Jean and Claude were present at the end.

In his room on the second floor of the villa Les Collettes, whose windows open on the trees and sea, he lies on a bed that is covered with his favorite flowers, a trellis of yellow and pink roses. Face pure and emaciated, but not hard; mouth half open.[133]

Renoir was buried next to Aline in Essoyes. He shares his plot with his son Pierre, whose name is also on the tombstone. Guino's 1913 bust rests atop the stone. A year after Renoir's death, Georges Rivière, his friend since the early 1870s, wrote this poem:

SONNET TO RENOIR

Friend, death has taken you by her rude gesture,
She did not surprise your serene wisdom;
Too often the alert shrew had appeared
On the threshold of your dwelling, spying out your weakness.

In your body heavy with years, weary with countless pains
Your soul had kept the flower of your youth
And, deaf to vanities, your choice spirit
Scorned, by reason, glory and wealth.

Your art renewed the spell of Greece,
You animated it again with all your tenderness,
Laying bare in your work your noble heart.

You could, O Renoir, leave us without sadness:
The treasures generously sown by your brush
Will make your name live long after you have gone.

December 1920 [134]

AFTERWORD

Several weeks after Renoir's death, Monet wrote to Joseph Durand-Ruel: "Poor [Renoir], so now he's gone. It's a very great loss and real grief for me, and for you too."[1] Many of Renoir's companions were there to the end. Besides Monet, Paul Durand-Ruel, Georges Rivière, there were young friends who carried on his living memory: André, Vollard, Jeanne Baudot, Julie Manet Rouart.

At his death, Renoir left seven hundred and twenty paintings.[2] His estate, valued at five million francs, was divided among his children.[3] In spite of his chronic illness, Renoir was an exceptional father, and each son grew up to become productive and successful in his own field: Pierre was a highly regarded actor; Jean, a world-famous film-maker and writer; and Claude, a skillful ceramist.

The year after Renoir died, three important exhibitions of his art took place. In Paris, Durand-Ruel exhibited sixty-three paintings, thirteen pastels, and some drawings, and in New York he showed forty-one paintings. The Salon d'Automne mounted a show of thirty-one Renoirs of 1915–19. From 1921 through 1929, his works were exhibited in fifty-seven shows, of which twelve were one-man shows. Throughout the next decades, his popularity remained high, although not as dramatically so as in the twenties. In every decade from the 1930s through the 1960s, except for the wartime forties, his works were included in at least twenty shows, at least half of them devoted solely to his work.[4] In 1973, a major retrospective was held at the Art Institute of Chicago and an international Renoir exhibition took place in London, Paris, and Boston in 1985.

Throughout the last six decades critical reaction to Renoir's painting has been generally favorable. However, some negative opinions have appeared. For example, of The Great Bathers (1918–19), Mme. Gérard d'Houville wrote in Le Figaro in 1933: "A group of Pomonas—in-flated pneumatic figures, smeared with a sort of reddish oil—are reclining in an orchard, where they appear to be ripening, and are wholly resigned to their fate of becoming monsters prior to being eaten."[5] Yet in the same year, Paul Jamot described these very bathers as: "nymphs and goddesses...[who] can lay claim to a...[fine] patronage—that of Corot, Titian, and Giorgione."[6]

The prices of Renoir's works have continued to spiral. Shortly after his death, The Pont Neuf, Paris (1872), which had been sold for 300 francs in 1875, brought 93,000 francs. In 1923, Durand-Ruel sold Luncheon of the Boating Party (1881) to Duncan Phillips for $125,000. In 1982, The Boating Party was insured for $10,000,000 while in a traveling exhibition.[7] In 1925, the auction of Maurice Gangnat's 160-painting collection brought more than 10,000,000 francs. The Pont des Arts, Paris (1867) fetched 200 francs in 1872. In 1932, it sold for 133,000 francs. In 1968, it went for $1,550,000. This represents a twelve-thousandfold increase in ninety years.[8]

Today paintings by Renoir are found in museums throughout the world. In addition to the unparalleled Barnes Foundation collection, in Merion Station, Pennsylvania, there are many major museums in North and South America, Europe, the U.S.S.R., Africa, Australia, Japan, and the Middle East where his work is prized and admired.[9]

Renoir was truly the last great painter of the ideal sensuous figure. His forebears were the Pompeian fresco artists, Raphael, Rubens, and Ingres. His art influenced Bonnard, Denis, Maillol, Matisse, Picasso,[10] and other twentieth-century artists whose work is permeated with the freedom and joie de vivre of the Impressionists, fused with a Classical search for balanced compositions and form that is substantial and monumental.

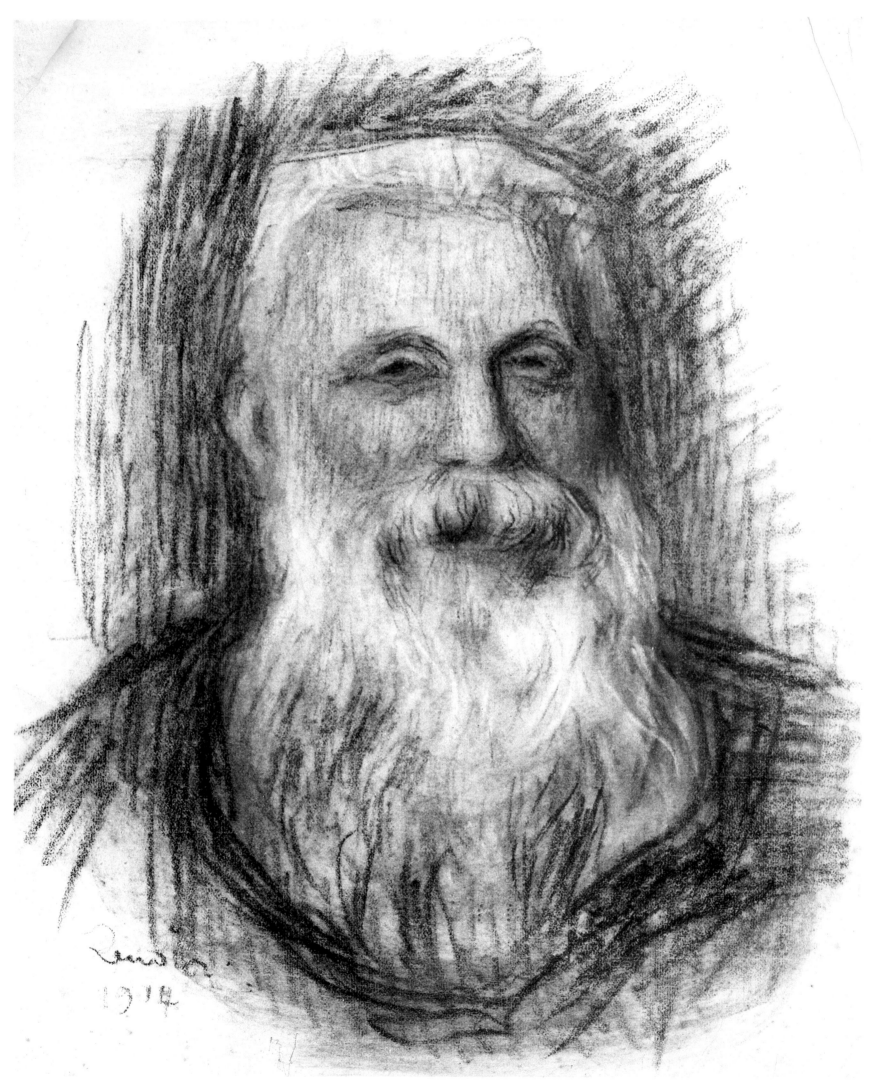

Auguste Rodin. d. 1914. Sanguine on paper, 21¼ x 17¾". Private collection

Many of the previously published letters and reviews cited have been newly translated from the original French sources, which are listed in the Notes and Bibliography. Mistakes in Renoir's spelling and punctuation have generally been corrected. All dates and locations in the text and notes are as Renoir gave them. Bracketed dates or locations are inferred from a letter's content or are deduced from the similarity of the letter to other correspondence.

Shortened forms are used in most references; complete information about each source is given in the Bibliography. If a review appears only once, it is cited in full in the Notes and is not in the Bibliography.

ABBREVIATIONS

Daulte, *Renoir* = *Auguste Renoir: Catalogue raisonné.* Vol. 1.
Coll. D.-R. = Collection Durand-Ruel, Paris
Marandel and Daulte, *Bazille* = *Frédéric Bazille and Early Impressionism*
Rewald, *Impressionism* = *The History of Impressionism*
Venturi, *Archives* = *Les Archives de l'Impressionnisme*
C.P. = Camille Pissarro
L.P. = Lucien Pissarro
n.l. = no location
no. = number or lot number
P.A.R. = Pierre-Auguste Renoir

PREFACE

1. Albert André, *Renoir* (1923); Théodore Duret, *Renoir* (1924); Georges Rivière, *Renoir et ses Amis* (1921); Ambroise Vollard, *Auguste Renoir* (1920); Georges Besson, *Renoir* (1929); Claude Roger-Marx, *Renoir* (1937); Jeanne Baudot, *Renoir: Ses Amis, ses modèles* (1949), which includes some Renoir letters; Walter Pach, *Renoir* (1950); and Jean Renoir, *Renoir* (1962).
2. White, "Renoir's Development from 1877 to 1887," 9–33.

1841–1870 § BOHEMIAN LIFE

1. Hugon, "Les Aïeux de Renoir et sa maison natale," 453–55.
2. Edmond Renoir, "Cinquième Exposition de 'la Vie Moderne'" (June 19, 1879); in Venturi, *Archives,* 2:335. See also Rewald, "Auguste Renoir and His Brother," 174–75.
3. Edmond Renoir, "Cinquième Exposition"; in Venturi, *Archives*, 2:335.
4. Around this time, in the years 1861–64, Renoir's three older siblings married and left home. By this time Pierre-Henri was a metal engraver who did gold and heraldic work; he married Blanche David. Marie-Élisa married Charles Leray, a book and fashion illustrator. Léonard-Victor, who followed his father in becoming a tailor, married in Russia.
5. Reff, "Copyists in the Louvre, 1850–1870," 556, 559.
6. Bellony-Rewald, *The Lost World of the Impressionists,* 8.
7. Letter to Durand-Ruel, [Algiers, Mar. 1882]; in Venturi, *Archives*, 1:115. While Venturi dates this letter March 1881, the content of the letter makes March 1882 more likely.
8. Boime, *The Academy and French Painting in the Nineteenth Century,* 63.
9. Moncade, "Le Peintre Renoir et le Salon d'Automne" (interview Oct. 15, 1904); in White, ed., *Impressionism in Perspective,* 22.
10. Rey, "Renoir à l'École des Beaux-Arts" (1926), 33–37, and Rey, *La Renaissance du sentiment classique,* 45–46.
11. Shikes and Harper, *Pissarro: His Life and Work,* 61.
12. Edmond Renoir, "Cinquième Exposition"; in Venturi, *Archives*, 2:336.
13. Ibid., 1:21.

14. N.1. [1864]; in Marandel and Daulte, *Bazille,* 195; n.1. [1864]; in ibid., 196.
15. Paris, July 3, 1865; in Daulte, *Frédéric Bazille et son temps,* 47. Bazille did not join Renoir.
16. Cooper, "Renoir, Lise and the Le Coeur Family," 163–71, 322–28.
17. Unidentified recipient, n.1., Mar. 29, 1866; in *Cahiers d'Aujourd'hui,* n.p.
18. Unidentified recipient, n.1., Apr. 6, 1866; in ibid.
19. N.1., n.d.; in Poulain, *Bazille et ses amis,* 101.
20. N.1. [1866]; in Marandel and Daulte, *Bazille,* 203.
21. Letter, n.1. [1866]; in ibid., 204.
22. Sisley's still life is illus. in Rewald, *Impressionism,* 182.
23. Cooper, "Renoir, Lise, Le Coeur Family," 171 n.47.
24. N.1. [Spring 1867]; in Marandel and Daulte, *Bazille,* 205.
25. Bazille to his mother, n.1. [1867]; in ibid., 207. Letter incorrectly dated 1869 in source. The dozen young artists included, besides Renoir and Bazille, Cézanne, Félix Bracquemond, Armand Guillaumin, Antoine Guillemet, Henri Fantin-Latour, Manet, Monet, Berthe Morisot, Pissarro, Sisley, and possibly Edgar Degas; Rewald, *Impressionism,* 172–73.
26. [Paris, May 20, 1867]; in Wildenstein, *Claude Monet: Biographie et catalogue raisonné,* 1:423.
27. Letter, n.1. Aug. 23, 1867; in Daulte, *Bazille,* 64.
28. Venturi, *Archives,* 2:281.
29. *Le Siècle;* in Monneret, *L'Impressionnisme et son époque,* 1:115.
30. *La Presse,* June 23, 1868; in Lethève, *Impressionnistes et Symbolistes devant la presse,* 50.
31. *L'Opinion nationale,* June 20, 1868; in ibid.
32. Cooper, "Renoir, Lise, Le Coeur Family," 326. Renoir's murals were destroyed in 1911 when the Bibesco town house was demolished.
33. N.1., n.d.; in Cooper, "Renoir, Lise, Le Coeur Family," 326–27.
34. Professor Meyer Schapiro has pointed out that a possible source for the couple's pose is the photograph of Prince Richard and Princess Pauline de Metternich taken around 1860 by André-Adolphe-Eugène Disdéri and widely reproduced. Lecture, Columbia University, New York, 1961.
35. Rewald, *Impressionism,* 197ff. Also see Baird, ed., *Pre-Impressionism: Selected Essays on French Art and Culture, 1860–1869.*
36. Thiébault-Sisson, "Claude Monet" [interview] (Nov. 27, 1900); quoted in Rewald, *Impressionism,* 197.
37. To Edwards n.1., June 15, 1871; quoted in ibid., 205, 236 n.21. In the painting, from left to right, are: Otto Scholderer (a German painter), Manet (seated), Renoir Astruc (seated), Zola, Maître, Bazille, and Monet.
38. St.-Michel, Aug. 9 [1869]; in Poulain, *Bazille,* 157.
39. [Ville-d'Avray, late Aug. 1869]; in ibid., 153–54.
40. N.1. [late Aug.–early Sept. 1869]; in ibid., 155–56.
41. N.1. [Oct. 1869]; in ibid., 156–57.
42. Shikes and Harper, *Pissarro,* 78, argue convincingly: "A tragedy of Pissarro's career is that his place as one of the founders of Impressionism has been obscured by the destruction of almost all of his paintings of that year [1869]." Also see ibid., 78–81. Soon thereafter Sisley began to paint Impressionist landscapes; see François Daulte, *Alfred Sisley: Catalogue raisonné de l'oeuvre peint,* figs. 15–18.
43. [St.-Michel] Sept. 25, 1869; in Poulain, *Bazille,* 161–62.
44. In K. Bertrand, "Le Salon de 1870," *L'Artiste,* 9th ser. 13 (1870): 319–20; in Sloane, *French Painting Between the Past and the Present,* 203.
45. [Méric] Aug. 2, 1870; in Daulte, *Bazille,* 81 n.1.
46. [Paris, mid-Aug.]; in Poulain, *Bazille,* 184.
47. Rewald, *Impressionism,* 254, 260, 269 n.42.

1. Vic-Bigorre, Mar. 1, 1871; in Cooper, "Renoir, Lise, Le Coeur Family," 327.

2. Letter Renoir to Duret, Celle-[St.-Cloud, 1871]; in Florisoone, "Renoir et la famille Charpentier," 39.

3. [Marlotte], Aug. 13, 1871; in Cooper, "Renoir, Lise, Le Coeur Family," 325.

4. Durand-Ruel exhibited *The Pont des Arts, Paris* in London two months after he had bought it.

5. Also see Rewald, "Auguste Renoir and His Brother," 181.

6. When Lise retired from modeling for Renoir, he gave her at least four paintings: *Landscape with Two Figures* (1865–66), a landscape of 1866 (illus. Cooper, "Renoir, Lise, Le Coeur Family," 169, fig. 6), and two paintings in which she appears: *Lise Sewing* (1866), and the 1872 *Lise with a White Shawl* (illus. Daulte, *Renoir,* vol. 1, figs. 16, 88).

7. Others who attended included Ernest Hoschedé, a collector close to Monet; Jules Champfleury, a writer; and Eugène Gru, a pastry cook who was also a Socialist writer with connections among journalists and bohemians.

8. "Salon de 1873, XIII—Le Salon des Refusés," *L'Art et les artistes francçais contemporains* (Paris, 1876), 162; quoted in Rewald, *Impressionism,* 308, n.31.

9. *Paris-Journal* (May 17, 1873); quoted in Perruchot, *La Vie de Renoir,* 85.

10. Shikes and Harper, *Pissarro,* 105.

11. White and White, *Canvases and Careers,* 124, 150–51, 155–61.

12. Argenteuil, Sept. 12, 1873; in Wildenstein, *Monet,* 1:429.

13. Rivière, *Renoir et ses amis,* 61ff.

14. New writer friends also joined their ranks: George Moore and Auguste, comte de Villiers de l'Isle-Adam. Other artists who frequented the Café de la Nouvelle-Athènes included Federico Zandomeneghi and Henri Guérard. Later, the younger artists Jean-François Raffaëlli and Henri Gervex also attended.

15. Signac saw the painting at Henri Rouart's collection on Feb. 16, 1898; quoted in Callen, *Renoir,* 53.

16. Moncade, "Renoir et le Salon d'Automne," (interview Oct. 15, 1904); in White, ed., *Impressionism in Perspective,* 22.

17. In Rewald, *Impressionism,* 312–13, 394.

18. Unpublished letter to Burty, [Paris, 1874]; in Bibliothèque Centrale du Louvre, Paris.

19. Lethève, *Impressionnistes devant la presse,* 64–67.

20. Favorable reviews include Jean Prouvaire (pseudonym for Catulle Mendès), "L'Exposition du boulevard des Capucines," *Le Rappel* (Apr. 20, 1874); Ernest d'Hervilly, "Exposition du boulevard des Capucines," *Le Rappel* (Apr. 17, 1874); Léon de Lora [pseud. for Alexandre Pothey], "Petites nouvelles artistiques, Exposition libre des peintres," *Le Gaulois* (Apr. 18, 1874); Philippe Burty, "Exposition de la Société anonyme des artistes," *La République française* (Apr. 25, 1874); Jules Castagnary, "Exposition du boulevard des Capucines: Les impressionnistes," *Le Siècle* (Apr. 29, 1874); Ernest Chesneau, "Le Plein Air, Exposition du boulevard des Capucines," *Paris-Journal* (May 7, 1874); Marc de Montifaud (pseudonym for Émilie Chartroule de Montifaud), "Exposition du boulevard des Capucines," *L'Artiste* (May 1, 1874). These reviews are reprinted in Adhémar and Gache, *L'Exposition de 1874 chez Nadar,* n.p.

21. Leroy, "L'Exposition des Impressionnistes," *Le Charivari* (Apr. 25, 1874); in Rewald, *Impressionism,* 318.

22. In ibid., 591.

23. Daulte, *Renoir,* 69–74.

24. N.1. [1874]; in Florisoone, "Renoir et la famille Charpentier," 39.

25. N.1. [1874]; in ibid.

26. Cooper, "Renoir, Lise, Le Coeur Family," 328.

27. Letter Monet to Joseph Durand-Ruel, Giverny, May 4, 1926; in Venturi, *Archives,* 1:465.

28. Unpublished letter, n.1. [c. Jan. 1875]; in Bibliothèque d'Art et d'Archéologie, Paris.

29. N.1., n.d.; in Florisoone, "Renoir et la famille Charpentier," 39.

30. N.1. [dated 1875 by Duret]; in *L'Oeuvre* (Apr. 6, 1933); letter now in The Pierpont Morgan Library, New York.

31. Unpublished letter, n.1., n.d.; in Collection Pierre F. Simon, New York.

32. This and the two preceding letters to Duret in Florisoone, "Renoir et la famille Charpentier," 39. No dates or locations are given.

33. See Burty's account in *La République Française* (Mar. 26, 1875); excerpt in Lethève, *Impressionnistes devant la presse,* 75.

34. Moncade, "Renoir et le Salon d'Automne," (interview Oct. 15, 1904); in White, ed., *Impressionism in Perspective,* 23.

35. In Geffroy, *Claude Monet: Sa Vie, son oeuvre,* 1:77. Also see Monneret, *L'Impressionnisme,* 3:91. Wolff wrote under the pen name Masque de Fer.

36. For other reviews see Geffroy, *Monet,* 1:75–78, and Monneret, *L'Impressionnisme,* 1:277.

37. Robida, *Le Salon Charpentier et les impressionnistes.*

38. Unpublished letter, [Paris], n.d.; in Bibliothèque Centrale du Louvre, Paris.

39. [Paris, Feb. 1876]; in Varnedoe and Lee, *Gustave Caillebotte: A Retrospective Exhibition,* 44 n.12.

40. May 6, 1876; in Perruchot, *Vie de Renoir,* 119. Other favorable reviews by past supporters were: Silvestre, "Exposition de la rue Le Peletier," *L'Opinion,* Apr. 2, 1876; in Venturi, *Archives,* 2:286–87. Also Rivière, "Les Intransigeants de la peinture," *L'Esprit Moderne,* Apr. 13, 1876; cited in Rewald, *Impressionism,* 396 n.38.

41. Mar. 31, 1876, in Venturi, *Archives,* 2:303.

42. June 1876; in *Émile Zola—Salons,* 196.

43. Rewald, *Impressionism,* 372–73.

44. May 13, 1876; in White, ed., *Impressionism in Perspective,* 32–33.

45. April 3, 1876, *Le Figaro;* in Perruchot, *Vie de Renoir,* 115.

46. April 8, 1876, in Lethève, *Impressionnistes devant la presse,* 79.

47. April 8, 1876, in ibid., 79. Other unfavorable reviews: Georges Maillard, *Le Pays* (Apr. 4, 1876); in ibid., 80; Charles Bertall, *Le Soir* (Apr. 15, 1876); cited in ibid., 80; and Arthur Baignières, *Echo Universel* (Apr. 13, 1876); in Venturi, *Archives,* 2:304–305.

48. N.1., n.d.; in Florisoone, "Renoir et la famille Charpentier," 32.

49. N.1., n.d.; in ibid., 39.

50. Rivière, *Renoir et ses amis,* 130–31.

51. Edmond Renoir, "Cinquième Exposition"; in Venturi, *Archives,* 2:336.

52. Rivière, *Renoir et ses amis,* 136.

53. Ibid., 136–37.

54. Rivière, "L'Exposition des Impressionnistes," *L'Impressionniste* (Apr. 6, 1877); in Venturi, *Archives,* 2:308–309, and in White, ed., *Impressionism in Perspective,* 8.

55. Paris, Nov. 3, 1876; in Varnedoe and Lee, *Caillebotte,* 220.

56. N.1., n.d.; in Galerie Braun, *L'Impressionnisme et quelques précurseurs,* 10.

57. Paris, Feb. 24, 1877; in Gachet, *Lettres impressionnistes,* 72–73.

58. The journal was published at 22 rue Lafitte, in the offices of Legrand's art gallery.

59. April 6, 1877; in Rivière, "L'Exposition des Impressionnistes"; in White, ed., *Impressionism in Perspective,* 9.

60. In Venturi, *Archives,* 2:310.

61. G.R. [Georges Rivière], "Aux Femmes," *L'Impressionniste* (Apr. 21, 1877); in Venturi, *Archives,* 2:322.

62. "Les Impressionnistes," *Courrier de France* (Apr. 6, 1877); in Venturi, *Archives,* 2:330.

63. Ph. B. [Philippe Burty], "Exposition des Impressionnistes," *La République Française* (Apr. 25, 1877); in Venturi, *Archives,* 2:292.

64. Baron Grimm [pseud. for Albert Wolff], *Le Figaro* (Apr. 5, 1877); in Lethève, *Impressionnistes devant la presse,* 82.

65. Georges Maillard, *Le Pays* (Apr. 9, 1877); in Florisoone, *Renoir,* 163.

66. Louis Leroy, *Le Charivari* (Apr. 11, 1877); in Lethève, *Impressionnistes devant la presse,* 85.

67. Barbouillotte, *Sportsman* (Apr. 7, 1877); in Florisoone, *Renoir,* 163.

68. Roger Ballu, *Chronique des arts* (Apr. 13, 1877); in Florisoone, *Renoir,* 163.

69. Apr. 15, 1876, *Le Charivari,* in Lethève, *Impressionnistes devant la presse,* 86.

70. Paul Mantz, *Le Temps* (Apr. 22, 1877); in ibid., 84–85.

71. In Rewald, *Impressionism,* 394, 397 n.74.

72. N.1., n.d.; excerpt in *Archives de Camille Pissarro,* Hôtel Drouot sale cat. Nov. 21, 1975, no. 159 (holograph illus.).

73. Gachet, *Lettres impressionnistes,* 88.

74. Rough draft of C. P. letter to Murer, n.l. [1878]; in *Correspondance de Pissarro*, 1:115. The actual letter is similar; see Tabarant, *Pissarro*, 39.

75. N.l. [1877]; in Tabarant, *Pissarro*, 39–40.

76. Bodelsen, "Early Impressionist Sales 1874–94 in the Light of Some Unpublished 'Procès-Verbaux,' " 336.

77. *Correspondance de Pissarro*, 1:118–19 n.5; also see Rivière, *Renoir et ses amis*, 35.

78. "Un peintre" [P.A.R.], "Lettre au directeur de 'L'Impressionniste,' " *L'Impressionniste* (Apr. 12, 1877); in Venturi, *Archives*, 2:321–22. "Un peintre" is identified as Renoir in ibid., 2:306. Rivière may well have rewritten Renoir's statements, but there is no extant proof of this.

79. "Un peintre" [P.A.R.], "L'Art décoratif et contemporain," *L'Impressionniste* (Apr. 28, 1877); in Venturi, *Archives*, 2:326–29.

80. N.l., n.d.; quoted in Florisoone, "Renoir et la famille Charpentier," 32–34.

81. N.l., n.d.; in ibid., 34.

1878–1880 § TRIUMPH AT THE SALON

1. Paris [1878]; in *Correspondance de Pissarro*, 1:116.

2. Letter, Pontoise [1878]; in ibid., 1:110.

3. Émile Zola, "Le Naturalisme au Salon," *Le Voltaire* (June 19, 1880); in *Zola—Salons*, 239.

4. The implications of the distinction are discussed by Joel Isaacson in *The Crisis of Impressionism, 1878–1882*, 27: "Without Degas, Impressionism was, within its mission to renew the art of painting, reduced in its essentials to a mode of plein-air and coloristic experimentation coupled with a more or less identifiable style of free and broken brushwork. Restore Degas to the group and the definition of Impressionism is immediately expanded: Impressionism becomes a broadly experimental painting that includes a wider range of subject matter, a more diverse approach to the possibilities of the sketch and the revaluation of line and color, an enhanced investigation of the space of painting and the compositional possibilities offered by the investigation of new points of view, and a more dynamic investigation of time and change as constituent elements of our experience of the modern world." His essay as a whole (2–47) contains a valuable history of the movement and of Renoir's part in it.

5. [Algiers, Mar. 1882]; in Venturi, *Archives*, 1:115. While Venturi dates this letter Mar. 1881, the content of the letter makes 1882 more likely.

6. See Rivière, "L'Exposition des Impressionnistes," *L'Impressionniste* (Apr. 14, 1877); in Venturi, *Archives*, 2:315–17.

7. Duret, *Les Peintres impressionnistes* (1878); reprinted in Duret, *Histoire des peintres impressionnistes*, 27–28.

8. Unpublished letter, [Paris] Oct. 15, 1878; in The Pierpont Morgan Library, New York (Collection d'autographes Tabarant).

9. N.l., n.d.; in Florisoone, "Renoir et la famille Charpentier," 39.

10. In Edmond Renoir, "Cinquième Exposition"; in Venturi, *Archives*, 2:336–37.

11. Unpublished letter, [Paris, postmarked] Oct. 15, 1878; in The Pierpont Morgan Library, New York (Collection d'autographes Tabarant).

12. White and White, *Canvases and Careers*, 130–31.

13. N.l., n.d.; quoted in Florisoone, "Renoir et la famille Charpentier," 35.

14. N.l., Nov. 30 [1878]; quoted in ibid., 35.

15. L'Estaque, Feb. 7, 1879; in *Paul Cézanne, Correspondance*, 159.

16. Moncade, "Renoir et le Salon d'Automne," [interview] (Oct. 15, 1904); in White, ed., *Impressionism in Perspective*, 22.

17. In Lethève, *Impressionnistes devant la presse*, 106.

18. "Le Salon de 1879," *Le Siècle* [n.d.]; in Mirbeau, Preface, *Renoir*, 3–4.

19. *La République française* (May 27, 1879); in ibid., 3.

20. Baignières in *Gazette des Beaux-Arts* and Bigot in *Revue bleue*; both in Lethève, *Impressionnistes devant la presse*, 106.

21. In ibid.

22. Pontoise, May 27, 1879; in *Correspondance de Pissarro*, 1:133.

23. N.l. [late May 1879]; in Berhaut, *Caillebotte: Sa Vie et son oeuvre*, 245.

24. N.l., n.d.; in Florisoone, "Renoir et la famille Charpentier," 34.

25. N.l., n.d.; in ibid.

26. See P.A.R.'s letter to Mme. Léon Riesener, n.l., May 8, 1879; in Viallefond, *Le Peintre Léon Riesener (1808–1878)*, 41.

27. Letter, n.l , n.d.; in Florisoone, "Renoir et la famille Charpentier," 34.

28. Edmond Renoir, "Cinquième Exposition"; in Venturi, *Archives*, 2:337–38.

29. Letter, n.l., June 12, 1879; quoted in Florisoone, "Renoir et la famille Charpentier," 35.

30. Letter [Paris, Jan. 1879]; in Gachet, *Lettres impressionnistes*, 81.

31. [Paris, Jan. 1879]; in ibid., 81–82.

32. N.l., [Jan. 1879]; in ibid., 82–83.

33. N.l., [Jan. 1879]; in ibid., 83.

34. N.l., [Jan. 1879]; in ibid., 83–84.

35. Letter, n.l. [Jan. 1879]; in ibid., 84–85. The head in De Bellio's collection is *The Milliner* (1875), now in the Oskar Reinhart Collection Am Römerholz in Winterthur, Switzerland.

36. [Postmarked Paris, Feb. 25, 1879]; in Gachet, *Lettres impressionnistes*, 85.

37. Unpublished letter, Renoir to Murer, Wargemont [Aug. 1879]; in The Pierpont Morgan Library, New York (Collection d'autographes Tabarant).

38. See Bérard, *Renoir à Wargemont*, and Bérard, "Un Diplomate Ami de Renoir," 239–45.

39. [Wargemont, 1879]; in Florisoone, "Renoir et la famille Charpentier," 35.

40. Dieppe, Sept. 1879; in Blanche, *La Pêche aux souvenirs*, 440.

41. Same letter, ibid., 440–41.

42. Letter from Charles Durand-Ruel to author, Paris, Aug. 27, 1981.

43. Unpublished document, Renoir and Aline's marriage license of Apr. 14, 1890, Paris, Mairie du 9ᵉ Arrondissement.

44. N.l., Feb. 13, 1880; in Galerie Braun, *L'Impressionnisme*, 11.

45. See Weisberg, "Jules Breton, Jules Bastien-Lepage and Camille Pissarro in the context of 19th-Century Peasant Painting and the Salon," 115–19. See Bezucha, "Being Realistic about Realism," 1–13. In Weisberg, ed., *The Realist Tradition: French Painting and Drawing 1830–1900*. And see Weisberg, "Jules Breton in Context," in H. Sturges, *Jules Breton and the French Rural Tradition*, 30–42.

46. N.l., n.d.; in *Cézanne, Correspondance*, 171.

47. [Paris] May 10, 1880; in ibid., 169–70.

48. Zola's four articles, "Le Naturalisme au Salon," appeared in *Le Voltaire* (June 18–22, 1880); in *Zola—Salons*, 245–46.

49. N.l., [May 1880]; in Gachet, *Lettres impressionnistes*, 91–92.

50. Although Renoir specified 1880, since this was written in May 1880, he must have been thinking of the Salon for the spring of 1881.

51. [Paris, May 1880]; quoted in Gachet, *Deux Amis des impressionnistes*, 166–67.

52. [Paris] July 4, 1880; in *Cézanne, Correspondance*, 173.

53. Letter to unidentified model, [Chatou] Sept. 17, 1880; excerpt in Hôtel Drouot sale cat. Dec. 18, 1959, no. 150.

54. [Chatou, 1880]; in "Lettres de Renoir à Paul Bérard," 4.

1881–1883 § TRAVELS ABROAD

1. Letter to Duret, Algiers, Mar. 4, 1881; in Galerie Braun, *L'Impressionnisme*, 11.

2. It is difficult to determine the exact dates of this first Algerian trip. A letter asking Ephrussi to send to the Salon the Cahen d'Anvers portrait and a pastel of Jeanne Samary is dated Algiers, February 28. Unpublished letter, Algiers, Feb. 28, 1881; in Musée du Louvre, Cabinet des Dessins, Paris. (The pastel was also accepted at the May Salon.) Another letter establishes that he was back in Paris in mid-April. Letter to Duret [Chatou], Easter Monday [April 18], 1881; in Florisoone, "Renoir et la famille Charpentier," 40. His sketchbook is inscribed on the cover: "1881. March April—Algiers—with Cordey."

3. Algiers [n.d.]; in Joëts, "Lettres inédites: Les Impressionnistes et Chocquet," 121. See *Renoir: Carnet de Dessins—Renoir en Italie et en Algérie (1881–1882)*, n.p.

4. Algiers [n.d.]; in "Lettres de Renoir à Bérard," 5.

5. Algiers, Mar. 4, 1881; in Florisoone, "Renoir et la famille Charpentier," 36.

6. Unpublished letter, Mustapha [Algeria] [Mar. or early Apr. 1881]; in Collection Charles Durand-Ruel, Paris.

7. Letter, Algiers, Mar. 4, 1881; in Galerie Braun, *L'Impressionnisme*, 11.

8. [Chatou] Easter Monday [April 18] 1881; in Florisoone, "Renoir et la famille Charpentier," 40.

9. [Chatou, Sept. 1880]; in "Lettres de Renoir à Bérard," 3.

10. Dieppe, July 20, 1881; in Blanche, *Le Pêche aux souvenirs*, 443–44.

11. Dieppe, July 20, 1881; in ibid., 444–45.

12. L'Éstaque, Feb. 19, 1882; in Schneider, "Lettres de Renoir sur l'Italie," 99.

13. The exact dates of his Italian sojourn are not known. The envelope of a letter to Bérard is postmarked "Paris October 1881"; excerpt in Drouot sale cat., Feb. 16, 1979, no. 80(1). An early letter from Venice (also to Bérard) is dated Nov. 1; excerpt in ibid., no. 69. A letter to Durand-Ruel specifies that he left Italy in late Jan.; L'Éstaque, Jan. 23, 1882; in Venturi, *Archives*, 1:118.

14. Naples [Dec. 1881]; in Schneider, "Lettres sur l'Italie," 97, or White, "Renoir's Trip to Italy," 347–48.

15. Capri, Dec. 28, 1881; in Moreau-Nélaton, *Manet, raconté par lui-même*, 2:88, or White, "Renoir's Trip to Italy," 348.

16. Douardenez, Sept. 19, 1895; in Manet, *Journal (1893–1899)*, 66.

17. Further evidence that Renoir was not alone in Italy is given by his son Jean, who recalled that his mother used to tell him about her trip to Sicily and Italy with his father; in Jean Renoir, *Renoir*, 231.

18. Venice, n.d.; excerpt in Drouot sale cat., June 22, 1979, no. 118.

19. Venice, Nov. 1, 1881; excerpt in Drouot sale cat., Feb. 16, 1979, no. 69.

20. Letter, Naples [Dec. 1881]; in Schneider, "Lettres sur l'Italie," 97, or White, "Renoir's Trip to Italy," 348.

21. [Venice] n.d.; in Schneider, "Lettres sur l'Italie," 96–97, or White, "Renoir's Trip to Italy," 347.

22. Letter, Venice, n.d.; in Florisoone, "Renoir et la famille Charpentier," 36, or White, "Renoir's Trip to Italy," 346.

23. Naples, n.d.; excerpt in Drouot sale cat., Feb. 16, 1979, no. 71.

24. [Renoir], "L'Art décoratif et contemporain"; in Venturi, *Archives*, 2:327.

25. Venice, n.d.; in Florisoone, "Renoir et la famille Charpentier," 36, or White, "Renoir's Trip to Italy," 346.

26. [Venice] n.d.; in Schneider, "Lettres sur l'Italie," 96–97, or White, "Renoir's Trip to Italy," 347.

27. Naples, Nov. 21, 1881; in Venturi, *Archives*, 1:116–17, or White, "Renoir's Trip to Italy," 347.

28. L'Éstaque, n.d.; in Florisoone, "Renoir et la famille Charpentier," 36, or White, "Renoir's Trip to Italy," 350.

29. [Monaco, Dec. 1883]; in Schneider, "Lettres sur l'Italie," 98, or White, "Renoir's Trip to Italy," 350.

30. Naples, Nov. 21, 1881; in Venturi, *Archives*, 1:116, or White, "Renoir's Trip to Italy," 347.

31. Naples, Nov. 23, 1881; in Venturi, *Archives*, 1:117, or White, "Renoir's Trip to Italy," 347.

32. Naples [Nov.] 26 [1881]; excerpt in Drouot sale cat., Feb. 16, 1979, no. 70.

33. Naples [Dec. 1881]; in Schneider, "Lettres sur l'Italie," 97, or White, "Renoir's Trip to Italy," 347–48.

34. Naples [Nov.] 26 [1881]; excerpt in Drouot sale cat., Feb. 16, 1979, no. 70.

35. Naples [Dec. 1881]; in Schneider, "Lettres sur l'Italie," 97, or White, "Renoir's Trip to Italy," 347–48.

36. Letter to Bérard, Naples [Nov.] 26 [1881]; excerpt in Drouot sale cat., Feb. 16, 1979, no. 70.

37. Naples [Dec. 1881]; in Schneider, "Lettres sur l'Italie," 97–98, or White, "Renoir's Trip to Italy," 348.

38. [L'Éstaque, late Feb. 1882]; excerpt in Loliée sale cat. 61, 1936, no. 445.

39. Letter, Capri, Dec. 26, 1881; excerpt in Drouot sale cat., Feb. 16, 1979, no. 72.

40. Ibid.

41. Capri, Dec. 28, 1881; in Jöets, "Les Impressionnistes et Chocquet," 121, or White, "Renoir's Trip to Italy," 348.

42. Ibid.

43. Capri, Dec. 28, 1881; in Moreau-Nélaton, *Manet, raconté par lui-même*, 2:88, or White, "Renoir's Trip to Italy," 348.

44. The letter is apparently misdated; it must have been written January 15 or later.

45. Renoir is confused here: the opera was by Daniel-François Auber.

46. [Palermo, mid-Jan. 1882]; in Drucker, *Renoir*, 132–34, or White, "Re-

noir's Trip to Italy," 348–50. Originally published in *L'Amateur d'Autographe*, Paris, 1913, 231–33.

47. N.l., n.d.; in Florisoone, "Renoir et le famille Charpentier," 38. The Charpentiers rejected the portrait. Renoir exhibited it the following year from his own collection.

48. Naples, Jan. 17, 1882; in Venturi, *Archives*, 1:117–18, or White, "Renoir's Trip to Italy," 350.

49. L'Éstaque, Jan. 23, 1882; in Venturi, *Archives*, 1:118.

50. [L'Éstaque] Feb. 14, 1882; in ibid.

51. [L'Éstaque, Feb. 19, 1882]; in Schneider, "Lettres sur l'Italie," 99.

52. N.l., Jan. 24, 1881; in Berhaut, *Caillebotte*, 245–46.

53. Paris, Jan. 27, 1881; in ibid., 246.

54. N.l., Jan. 28, 1881; in ibid.

55. L'Éstaque, Feb. 24, 1882; in Venturi, *Archives*, 1:119–20.

56. L'Éstaque, Feb. 26, 1882; in ibid., 120–21.

57. [L'Éstaque, Feb. 26, 1882]; in ibid., 122.

58. Letter, n.l., n.d.; excerpt in Loliée sale cat. 61, no. 446.

59. Algiers [Mar. 1882]; in Venturi, *Archives*, 1:123.

60. L'Éstaque, Mar. 2, 1882; in Jöets, "Les Impressionnistes et Chocquet," 121–22.

61. "Quelques Expositions," *Le Figaro* (Mar. 2, 1882), 1.

62. Algiers [Mar. 1882]; in Venturi, *Archives*, 1:124.

63. Unpublished letter, Algiers [Mar. 1882]; in Collection Christian Renaudau d'Arc, Wargemont.

64. Letter to Berthe Morisot, [Paris, Mar. 1882]; in *Correspondance de Berthe Morisot*, 104.

65. Letter, Pontoise, Mar. 26, 1882; in *Correspondance de Pissarro*, 1:162.

66. Unpublished letter, [Algiers, Apr. 1882]; in Collection Maurice Bérard, Paris.

67. Unpublished letter, [L'Éstaque] n.d.; in Coll. D.-R.

68. [Marseilles, early Mar. 1882]; excerpt in Drouot sale cat., June 22, 1979, no. 113.

69. Unpublished letter, Algiers [Mar. 1882]; in Collection Christian Renaudau d'Arc, Wargemont.

70. Algiers, Mar. 14, 1882; excerpt in Stargardt sale cat. 620, no. 669.

71. Unpublished letter, [Algiers, Apr. 1882]; in Collection Maurice Bérard, Paris.

72. Letter, Algiers, [late Apr.]; in Librairie de l'Abbaye, sale cat. 26, n.d., no. 254.

73. Algiers [Mar. 1882]; in Venturi, *Archives*, 1:124–25.

74. Unpublished letter, n.l., [early Apr. 1882]; in Collection Maurice Bérard, Paris.

75. Unpublished letter, n.l., [Apr. 1882]; in ibid.

76. Unpublished letter, [Paris, July 1882]; in ibid.

77. Unpublished letter, n.l., [June 1882]; in Bibliothèque Nationale, Paris.

78. Dieppe, Aug. 15, 1882; in Blanche, *La Pêche aux souvenirs*, 441.

79. Unpublished letter, [Paris, Fall 1882]; in Coll. D.-R. Clapisson did acquire *Mosque at Algiers*, *Old Arab Woman*, and *Ali, the Young Arab*.

80. N.l., n.d.; in "Lettres de Renoir à Bérard," 3.

81. Unpublished letter, [Paris, Oct. 1882]; in Coll. D.-R.

82. Tabarant, "Suzanne Valadon et ses Souvenirs de modèle," 627.

83. Letter to the *Standard*, Apr. 25, 1883; in Cooper, *The Courtauld Collection*, 26 n.3. Both the exhibition catalogue and reviews of the show discuss two dance panels on view. See Jules de Marthold, "A. Renoir," *La Ville de Paris* (Apr. 3, 1883), and Henry Morel, "P. A. Renoir," *Le Reveil* (July 2, 1883).

84. N.l., n.d.; excerpt in Drouot sale cat., June 22, 1979, no. 119.

85. N.l., Sept. 5, 1883; in Venturi, *Archives*, 2:97.

86. Letter P.A.R. to Caillebotte, n.l. [1883]; in Berhaut, *Caillebotte*, 247.

87. Letter P.A.R. to Murer, n.l., n.d.; in Gachet, *Lettres impressionnistes*, 92.

88. Letter P.A.R. to Cézanne, [Aix-en-Provence] Mar. 10, 1883; in *Cézanne, Correspondance*, 192.

89. [Apr. 1883]; in Drucker, *Renoir*, 177.

90. N.l., n.d.; in Florisoone, "Renoir et la famille Charpentier," 40.

91. Osny, Apr. 10, 1883; in *Pissarro: Lettres*, 38.

92. May 5, 1883; in Cooper, *The Courtauld Collection*, 26.

93. Apr. 28, 1883; in ibid., 25.

94. Apr. 25, 1883; in ibid.

95. "À l'Exposition d'Édouard Manet," *La Libre Revue* (Apr. 1884); in Rewald, *Impressionism*, 478.

96. Letter to L.P., Osny, Dec. 28, 1883; in *Pissarro: Lettres*, 73.

97. Paris, Aug. 1 [1883]; excerpt in Drouot sale cat., June 22, 1979, no. 117.

98. Paris, Nov. 20, 1883; in Varnedoe and Lee, *Caillebotte*, 220.

99. Unpublished letter, Yport, Aug. 21, 1883; in Collection Maurice Bérard, Paris.

100. Huth, "Impressionism Comes to America," 229–31.

101. Letter, Rouen, Oct. 31, 1883; in *Pissarro: Lettres*, 65.

102. N.l., Sept. 5, 1883; in "Lettres de Renoir à Bérard," 4.

103. Guernsey, Sept. 27, 1883; in Venturi, *Archives*, 1:125–26.

104. Letter Monet to De Bellio, [Paris] Dec. 16 [1883]; in Wildenstein, *Monet*, 2:232.

105. Letter Cézanne to Zola, Aix-en-Provence, Feb. 23, 1884; in *Cézanne, Correspondance*, 197.

106. [Genoa?, Dec. 1883]; in Venturi, *Archives*, 1:126–27.

107. Letter, Monte Carlo [Dec. 1883]; excerpt in Thierry Bodin sale cat., no. 276.

1884–1889 § FATHERHOOD AND MIDDLE AGE

1. [Genoa?, Dec. 1883]; in Venturi, *Archives*, 1:126.

2. Letter, Giverny [Jan. 12, 1884]; in ibid., 267–68.

3. Letter, Bordighera, Italy, Jan. 28, 1884; in ibid., 271.

4. [Paris, late Jan.]; in Geffroy, *Monet*, 2:24–25.

5. Monneret, *L'Impressionnisme*, 3:11–12.

6. Letter to Mme. Charpentier, Paris, Oct. 29, 1894; in Florisoone, "Renoir et la famille Charpentier," 38.

7. N.l., May 1884; in Venturi, *Archives*, 1:127.

8. N.l. [May 1884]; in ibid., 127–29; and in White, ed., *Impressionism in Perspective*, 19–20. Also see "Notes d'Auguste Renoir"; in Jean Renoir, *Renoir*, 232–36.

9. Letter, Paris, May 13, 1884; in *Correspondance de Pissarro*, 1:299.

10. N.l., May 23, 1884; in ibid., 300n.

11. Letter, n.l., n.d.; in ibid.

12. Letter, Paris [1884]; excerpt in Drouot sale cat., June 11, 1980, no. 96 (letter incorrectly dated there).

13. [La Rochelle, Summer 1884]; in Venturi, *Archives*, 1:129–30.

14. White, "Renoir's Sensuous Women," 175–77.

15. Unpublished document, Ville de Paris, 18ᵉ Arrondissement, Mar. 23, 1885. "Extrait des minutes des actes de naissance, no. 155/1324." Obtained through the courtesy of P. Stouvenot.

16. Letter to Murer, Essoyes [Dec. 1886]; in Gachet, *Lettres impressionnistes*, 98.

17. Essoyes, Sept. 14, 1898; in Manet, *Journal*, 188.

18. Letter Morisot to Mallarmé, [Mézy, early Oct. 1890]; in *Correspondance de Morisot*, 156.

19. Letter Morisot to Mallarmé, [Mézy] July 14, 1891; in ibid., 160.

20. [Mézy, early Oct. 1891]; in ibid., 163.

21. N.l. [Sept. 1887]; in Gachet, *Lettres impressionnistes*, 95.

22. [Chatou, Apr. 18] 1881; quoted in Florisoone, "Renoir et la famille Charpentier," 40.

23. Éragny [Feb. 23, 1887]; in *Pissarro: Lettres*, 134.

24. Letter C.P. to L.P., Éragny [Sept. 20, 1887]; in ibid., 162–63.

25. Jaques, "Death and the Mid-Life Crisis"; and Levinson, *The Seasons of a Man's Life*, 191ff.

26. Schapiro, "The Nature of Abstract Art"; Dorival, *Les Étapes de la peinture française contemporaine*, 1:24–30; Lövgren, *Genesis of Modernism: Seurat, Gauguin, Van Gogh, and French Symbolists in the 1880s*, xii.

27. *Puvis de Chavannes* (1894); quoted in Rewald, *Post-Impressionism from Van Gogh to Gauguin*, 163. Wyzewa's real name was Téodor de Wyzewski.

28. In the mid-1880s, this "culte wagnérien" expounded an aesthetic that was "un retour vers l'idéalisme, une révolte contre le naturalisme et le positivisme"; see Wyzewska, *La Revue Wagnérienne: Essai sur l'interprétation esthétique de Wagner en France*, 2–3. In 1885, the two editors of *La Revue Wagnérienne*, Wyzewa and Édouard Dujardin, included Renoir's name in a list of "Wagnerian painters"; see Lockspeiser, "The Renoir Portrait of Wagner," 16.

29. "L'Impressionnisme," June 15, 1885 [Brussels]; in Verhaeren, *Sensations*, 179ff., and in Muchsam, ed., *French Painters and Paintings from the Fourteenth Century to Post-Impressionism*, 512.

30. Letter Cézanne to Zola, La Roche[-Guyon], July 6, 1885; in *Cézanne, Correspondance*, 203.

31. Schapiro, *Paul Cézanne*, 12.

32. Éragny-sur-Epte par Gisors [early July 1885]; in *Correspondance de Pissarro*, 337–38.

33. Giverny, July 9, 1885; in Wildenstein, *Monet*, 2:260.

34. Rewald, "Auguste Renoir and His Brother," 188. In an interview between the author and Edmond Renoir, Jr., in 1978, M. Renoir said that his father and uncle were not friendly, but that his uncle had always been extremely kind and warm to him. He explained the rift between the brothers as the result of the fact that his father had sold off the paintings that Pierre-Auguste had left in the apartment at 35 rue St.-Georges.

35. La Roche-Guyon [Aug. 17, 1885]; excerpt in Drouot sale cat., Feb. 16, 1979, no. 74.

36. Essoyes [Sept.–Oct. 1885]; in Venturi, *Archives*, 1:131–32.

37. [Essoyes] Oct. 4, 1885; excerpt in *The Collector*, Walter R. Benjamin sale cat. 718, no. 3691.

38. Letter, Essoyes [Oct. 1885]; in Venturi, *Archives*, 1:133–34.

39. [Paris] Jan. 11, 1886; in *Correspondance de Morisot*, 128.

40. Rewald, *Post-Impressionism from Van Gogh to Gauguin*, 86, 89, 418, 434, n.61.

41. Unpublished letter, [Paris], Oct. 29, 1885; in Coll. D.-R.

42. Ibid.

43. Durand-Ruel's statement in his defense had appeared in *L'Événement* (Nov. 5, 1885).

44. Wargemont [Nov. 1885]; in Venturi, *Archives*, 1:134.

45. Paris [Jan. 21, 1886]; in *Pissarro: Lettres*, 90.

46. Paris [Jan.] 1886; in ibid., 91.

47. Renoir's letters to Maus, all Paris, Jan. 3, Jan. 5, [Jan. 5–10], Jan. 21, 1886; in Venturi, *Archives*, 2:227–29.

48. Both quoted in Maus, *Trente Années de lutte pour l'art*, 44.

49. [Essoyes, Oct. 1885]; in Venturi, *Archives*, 1:133.

50. See Huth, "Impressionism Comes to America," 238–47.

51. "Notes sur l'art: Renoir," *La France* (Dec. 8, 1884); in Mirbeau, *Renoir*, 7–8.

52. "French Impressionists," *The New York Times*, May 28, 1886.

53. Letter to Monet, St.-Brice [Aug. 1886]; in Geffroy, *Monet*, 2:23.

54. Eudel, ed., *Hôtel Drouot* (1882–91), 6:224.

55. Paris, Aug. 21, 1886; in Venturi, *Archives*, 2:252.

56. [Paris] Oct. 18, [1886]; in "Lettres de Renoir à Bérard," 6.

57. Letter, n.l. [Apr. 1886]; excerpt in Drouot sale cat., Feb. 16, 1979, no. 66.

58. N.l. [Spring 1886]; quoted in Florisoone, "Renoir et la famille Charpentier," 38.

59. Mirbeau, "Impressions d'art," *Le Gaulois* (June 16, 1886).

60. N.l., June 18, 1886; excerpt in Drouot sale cat., June 19, 1970, no. 138.

61. Fénéon, *Les Impressionnistes en 1886*; in Fénéon, *Au-delà de l'Impressionnisme*, 69.

62. Letter C.P. to L.P., Paris [July 27, 1886]; in *Pissarro: Lettres*, 108.

63. St.-Briac [Sept. 1886]; in Venturi, *Archives*, 1:137.

64. St.-Briac [Sept. 1886]; in ibid.

65. Paris, Oct. 15, 1886; excerpt in Charavay sale cat., no. 38792.

66. Kervilhouen, Oct. 17, 1886; in Wildenstein, *Monet*, 2:281. Monet's common-law wife was now Alice Hoschedé (whom he married in 1892).

67. Letter P.A.R. to Bérard, [Paris] Oct. 18 [1886]; in "Lettres de Renoir à Bérard," 6.

68. Huth, "Impressionism Comes to America," 248. "Celebrated Paintings by Great French Masters" was held from May 25 to June 30, 1887, at the National Academy of Design, New York. Monneret, *L'Impressionnisme*, 1:188.

69. Renoir's other submissions were small works: the pastel *Young Girl with a Rose*, a pastel *Portrait of Mme. X...*, *Portrait of a Child*, *Washerwomen*, and a *Head*. The following discussion of *The Bathers* is based on White, "The *Bathers* of 1887 and Renoir's Anti-Impressionism," 106–26.

70. Letter to Mirbeau, n.l., June 18, 1886; excerpt in Drouot sale cat., June 19, 1970, no. 138.

71. [Paris] Oct. 18 [1886]; in "Lettres de Renoir à Bérard," 6.

72. Letter C.P. to L.P., Paris, Mar. 17, 1887; in *Pissarro: Lettres*, 139.

73. To L.P., Paris, May 8, 1887; in ibid., 144.

74. [Paris] Jan. 11, 1886; in *Correspondance de Morisot*, 128.

75. Letter to Mme. Charpentier, L'Éstaque, n.d.; in Florisoone, "Renoir et la famille Charpentier," 36; and letter P.A.R. to Durand-Ruel, Naples, Nov. 21, 1881; in Venturi, *Archives*, 1:116–17.

76. Mr. Theodor Siegl, formerly conservator of the Philadelphia Museum of Art, examined *The Bathers* for me. Examination of the back of other canvases of 1884–87 also showed no use of gesso or plaster: *Aline* (1885), Philadelphia Museum of Art, examined by Mr. Siegl; *Julie Manet* (1887), formerly collection Denis Rouart, Paris, examined by M. Rouart; *Washerwoman and Baby* (c. 1887), *Woman with Fan* (1886), and *Garden Scene* (c. 1887), Barnes Foundation, Merion Station, Pa., examined by Miss Violette de Mazia; *Lucie Bérard* (1884), formerly collection Maurice Bérard, Paris, examined by M. Bérard; *Nursing* (first version) (1885), formerly collection Philippe Gangnat, Paris, examined by M. Gangnat; *Bather Arranging Her Hair* (1885), Clark Art Institute, Williamstown, Mass., examined by the author with Mr. G. L. McManus; *Still Life: Flowers* (1885), The Solomon R. Guggenheim Museum, New York, examined by Mr. Orrin Riley.

77. Suzanne Valadon modeled for this painting, thereby providing an interesting link between Puvis and Renoir at this time.

78. [Paris] Jan. 11, 1886; in *Correspondance de Morisot*, 128.

79. [Paris] May 12, 1887; in Venturi, *Archives*, 1:138.

80. Giverny, May 13, 1887; in ibid., 325–26.

81. Wyzewa, "Pierre-Auguste Renoir," *L'Art dans les deux mondes* (Dec. 6, 1890); in Wyzewa, *Peintres de jadis et d'aujourd'hui*, 373.

82. Letter to L.P., Paris [May 14, 1887]; in *Pissarro: Lettres*, 146.

83. To L.P., Paris [May 15, 1887]; in ibid., 148.

84. "L'Exposition internationale," *L'Estaffette* (May 15, 1887); in *Pissarro: Lettres*, 151 n.l.

85. Alfred de Lostalot, "Exposition internationale de peinture et de sculpture, Galerie Georges Petit," *Gazette des Beaux-Arts*, 35 (1887): 526.

86. Letter C.P. to L.P., Paris [May 16, 1887]; in *Pissarro: Lettres*, 150. The collector Hoschedé also criticized Renoir's new style (letter C.P. to L.P., Paris [May 14, 1887]; in ibid., 147); as did Renoir's old friends Rivière (*Renoir et ses amis*, 199–201), and Duret (*Renoir*. 95–96).

87. "Chronique des Arts," *Revue Indépendant* [June, 1887]; in letter L.P. to C.P., Paris, June 2, 1887; cited in *Camille Pissarro—Letters to His Son*, 128.

88. Éragny [June 1, 1887]; in *Pissarro: Lettres*, 154–55.

89. [Paris] Sept. 24, 1887; excerpt in Drouot sale cat., June 11, 1980, no. 94.

90. Different excerpt from the same letter, in Librairie de l'Abbaye, sale cat. 241, Mar. 16, 1979.

91. Monneret, *L'Impressionnisme*, 1:189.

92. Interview with Mme. Ernest Rouart, Paris, summer 1963. Mme. Rouart died in 1966.

93. Unpublished letter, Boulogne [June] 25 [1887]; in Musée Marmottan, Paris; paraphrased but misdated in Niculescu, "Georges de Bellio, l'ami des impressionnistes," 257. In spite of the precariousness and insecurity of his income, Renoir, like Pissarro and Monet, aspired to a middle-class standard of living which included having a servant; see White and White, *Canvases and Careers*, 136.

94. N.l., n.d.; in Gachet, *Lettres impressionnistes*, 96.

95. Éragny [Sept. 20, 1887]; in *Pissarro: Lettres*, 162–63.

96. [Trouville, Fall 1887]; in "Lettres de Renoir à Bérard," 6.

97. Letter Morisot to Mallarmé, n.l. [Dec. 1887]; in *Correspondance de Morisot*, 133.

98. In *Oeuvres complètes de Mallarmé*, 269, 1552.

99. Letter to Durand-Ruel, n.l., Feb. 1890; in Venturi, *Archives*, 1:141.

100. Unpublished letter, n.l., n.d.; given by Henri Mondor to Bibliothèque d'Art et d'Archéologie, Paris.

101. In Renoir's copy, Mallarmé inscribed this couplet: "Offre à sa vision amie un promenoir/mainte page du livre illustré par Renoir"; in *Stéphane Mallarmé: Correspondance*, 5:76 n.l.

102. Letter, Les Martigues [late Feb. 1888]; in Baudot, *Renoir: Ses Amis, ses modèles*, 53.

103. Les Martigues, Mar. 4, 1888; excerpt in *The Collector*, Benjamin sale cat.

709, June 1951, no. W1051.

104. Letter to Durand-Ruel, Les Martigues [Mar. 1888]; in Venturi, *Archives*, 1:140.

105. [Paris] May 12, 1887; in ibid., 1:137–38.

106. N.l., [1888]; excerpt in Loliée sale cat. 85, no. 104.

107. Essoyes, Nov. 27, 1888; in Gutekunst & Klipstein sale cat. 89, no. 112 (holograph illus.).

108. N.l., n.d.; in *Correspondance de Morisot*, 135.

109. N.l., [June 1888]; in ibid.

110. Purchased July 19, 1888, see Daulte, *Renoir*, vol. 1, fig. 257.

111. N.l., July 10 [1888]; in Roger-Marx, *Renoir*, 68.

112. Paris, Apr. 25, 1888; in *Correspondance Mallarmé-Whistler*, 14–15.

113. Paris, Oct. 1, 1888; in *Pissarro: Lettres*, 178.

114. N.l., Nov. 1, 1888; in *Correspondance de Morisot*, 140.

115. N.l., [Nov. 1888]; in ibid., 141.

116. N.l., [Nov. 1888]; in ibid., 142.

117. [Essoyes, Dec. 1888]; in ibid., 142–43. Rouart's Dec. 29 date does not agree with the dates of the Charpentier and Durand-Ruel letters below.

118. N.l. [late Dec. 1888]; in ibid., 143.

119. Letter, Essoyes, Dec. 29, 1888; quoted in Florisoone, "Renoir et la famille Charpentier," 38.

120. [Essoyes, Dec. 31, 1888]; in Venturi, *Archives*, 1:140.

121. Giverny, Feb. 15, 1889; in Wildenstein, *Monet*, 3:240.

122. N.l., Feb. 17, 1889; quoted in Mondor, *Vie de Mallarmé*, 549.

123. [Paris] Apr. 24, 1889; in Gachet, *Lettres impressionnistes*, 86.

124. Paris, May 21, 1889; in Rewald, *Post-Impressionism*, 236.

125. Letter, Paris, Sept. 13, 1889; in *Pissarro: Lettres*, 184.

126. Unpublished letter, [Paris] Oct. 9, 1889; in Collection Maurice Bérard, Paris.

127. Paris, Nov. 20, 1889; in Venturi, *Archives*, 2:230.

128. Paris, Dec. 25, 1889; in ibid.

129. N.l., Dec. 23, 1889; excerpt in Drouot sale cat., June 22, 1979, no. 107.

1890–1899 § MARRIAGE, ACCLAIM, ILLNESS

1. Moncade, "Renoir et le Salon d'Automne" [interview] (Oct. 15, 1904); in White, ed., *Impressionism in Perspective*, 22.

2. Giverny, May 12, 1890; in Berhaut, *Caillebotte*, 248.

3. Letter [Paris, c. 1890]; in ibid., 247.

4. Petit Gennevilliers, n.d.; in ibid., 248.

5. See Niculescu, "Georges de Bellio," 236–38.

6. Ville de Paris, 9e Arrondissement, Apr. 14, 1890. "Extrait des minutes des actes de mariage, no. 154/339"; in White, "An Analysis of Renoir's Development from 1877 to 1887," 168–69.

7. Jean Renoir, *Renoir*, 276–77.

8. Letter [Paris] Sept. 17, 1890; in Gachet, *Lettres impressionnistes*, 87.

9. Jean Renoir, *Renoir*, 272.

10. [Tamaris-sur-Mer, Feb. 1891]; in Venturi, *Archives*, 1:142. Also see letter P.A.R. to Paul Alexis, Paris, Jan. 7, 1891; excerpt in Charavay card-index, no. 97420.

11. [Tamaris-sur-Mer, Feb. 1891]; in Venturi, *Archives*, 1:142.

12. Tamaris-sur-Mer, [Feb. 1891]; in ibid., 143.

13. Tamaris-sur-Mer, Mar. 5, 1891; in ibid., 144.

14. Tamaris-sur-Mer, Mar. 25, 1891; in ibid., 145.

15. Le Lavandou, Apr. 23, 1891; in ibid., 148.

16. Éragny, July 14, 1891; in *Pissarro: Lettres*, 259.

17. Letter to Morisot, [Paris] Aug. 17, 1891; in *Correspondance de Morisot*, 161.

18. Since only one volume of the Renoir cat. raisonné (figure paintings of 1860–90) has been published (Daulte, *Renoir*), reliable information about still lifes and landscapes is not available, nor is it for figure paintings after 1890.

19. [Paris, 1892]; in Drouot sale cat., Dec. 19, 1977, no. 177, holograph illus. Also see letter Mallarmé to Mirbeau, n.l., Apr. 5, 1892; in Mondor, *Vie de Mallarmé*, 631, where Mallarmé writes of going to Renoir's studio to pose.

20. See Paul Valéry, "A propos de Degas," *N.R.F.*, Mar. 1, 1938; in Mondor, *Vie de Mallarmé*, 684 n.l.

21. Régnier, *Renoir, peintre du nu*; in Muchsam, ed., *French Painters*, 516.

22. Diary, Valvins, Sept. 11, 1898; in Manet, *Journal*. 187.

23. Letter to Morisot, St.-Chamas [Mar. 1893]; in *Correspondance de Morisot*, 173.

24. N.l., May 25, 1892; in ibid., 168. For *Dans la Vérandah*, see Bataille and Wildenstein, *Berthe Morisot: Catalogue des peintures, pastels et aquarelles*, pl. 57 and p. 33, n.160.

25. N.l. [Fall 1892]; in *Correspondance de Morisot*, 172–73.

26. The exhibition included *La Loge* (1874); *Le Moulin de la Galette* and *The Swing* (1876); *Mme. Charpentier and Her Children* and *The Cup of Chocolate* (1878); *After Lunch* and *Mussel Fishers at Berneval* (1879); *Sleeping Girl with Cat* and *At the Concert* (1880); *The Boating Party*, *Algerian Girl*, and *St. Mark's Square, Venice* (1881); *Richard Wagner*, *Mosque at Algiers*, and *Blond Bather* (second version) (1882); *City Dance*, *Country Dance*, and *Dance at Bougival* (1883); *Girl in the Garden* (1884); *Nursing* (third version) (1886); and *The Bathers* (1887).

27. In Mirbeau, *Renoir*, 9–10. Other lenders included Bonnières, Jacques-Émile Blanche, André Mellerio, Chabrier, De Bellio, Duret, Rouart, Dollfus, and Ephrussi.

28. Published under pseudonym Pierre L. Maud, "Le Salon du Champ-de-Mars [et] l'Exposition de Renoir," *La Revue Blanche* (June 25, 1892); in Denis, *Théories, 1890–1910*, 19.

29. "Le Peintre A. Renoir et son oeuvre," *Le Temps* (May 12, 1892).

30. Paris [Apr. 4, 1892]; in *Mallarmé: Correspondance*, 5:61–62

31. [Paris] Apr. 25, 1892; in ibid., 62 n.l.

32. [Paris] May 2, 1892; in ibid.

33. Paris [May 12, 1892]; in ibid., 77–78.

34. In 1923, the American painter Robert Henri wrote about this painting in "The Art Spirit"; see Goldwater and Treves, eds., *Artists on Art: From the XIVth to the XXth Century*, 399.

35. Letter P.A.R. to Durand-Ruel, Cagnes, Apr. 18, 1903; in Venturi, *Archives*, 1:173.

36. Letter P.A.R. to Gallimard, n.l. [July 1892]; excerpt in Parke-Bernet Galleries sale cat. 2058, no. 457.

37. Letter, Pornic [Aug.-Sept. 1892]; in *Correspondance de Morisot*, 170. Also see letter P.A.R. to Bérard, Pornic, Sept. 5, 1892; excerpt in Drouot sale cat., June 22, 1979, no. 108.

38. Letter, [Paris, late Sept. 1892]; in *Correspondance de Morisot*, 171.

39. Letter, [Beaulieu-sur-Mer] Apr. 27, 1893; excerpt in Drouot sale cat., June 22, 1979, no. 110.

40. Unpublished letter to unidentified correspondent, n.l. [1893]; in Collection Georges Alphandéry, Montefavet, France.

41. Letter P.A.R. to Murer, Pont-Aven [Aug. 1893]; in Gachet, *Lettres impressionnistes*, 108.

42. [Paris, June 1893]; in Jean Renoir, *Renoir*, 309–10.

43. Unpublished letter, Dune de St.-Marcouf par Montebourg [mid-July 1893]; in Bibliothèque d'Art et Archéologie, Paris. In 1886, Renoir had sold the portrait to Bonnières.

44. Unpublished letter, Arcachon, July 21, 1893; in Bibliothèque d'Art et d'Archéologie, Paris.

45. Julie Manet diary, Paris, Sept. 9, 1893; in Manet, *Journal*, 18.

46. [Paris] Dec. 7, 1893; excerpt in Librairie de l'Abbaye sale cat. 246, no. 232.

47. Caillebotte's will, Paris, Nov. 3, 1876; in Berhaut, *Caillebotte*, 251.

48. Ibid. The Luxembourg Museum, the former government museum of modern art, was in the Palais du Luxembourg.

49. Unpublished letter, n.l. [mid-Mar. 1894]; in Collection Pierre E. Simon, New York.

50. Leroy, *Histoire de la peinture française*, 167.

51. In *Pissarro: Lettres*, 342 n.l.

52. In ibid., 341–42 n.2.

53. The Renoir paintings accepted, each valued at 5,000 francs, were: *Woman Reading* (1874), *Nude in the Sunlight* (1875–76), *Le Moulin de la Galette* (1876), *The Swing* (1876), *Banks of the Seine at Champrosay* (1876), and *Railroad Bridge at Chatou* (1881).

54. In Florisoone, *Renoir*, 164.

55. Paris, Mar. 10, 1897; in *Pissarro: Lettres*, 434.

56. Letter, [Paris] Mar. 31, 1894; in *Correspondance de Morisot*, 179. Also see *Mallarmé: Correspondance*, 6:248 n.2.

57. Letter, n.l. [Apr. 1894]; in *Correspondance de Morisot*, 179.

58. Postmarked Paris, June 1, 1894; excerpt in Drouot sale cat., Dec. 19, 1977, no. 177.

59. N.l. [Sept. 15, 1894]; in *Correspondance de Morisot*, 182.

60. N.l., Sept. 15, 1894; in Gachet, *Lettres impressionnistes*, 109.

61. [London, 1895]; excerpt in Drouot sale cat., June 11, 1980, no. 109.

62. Julie Manet Rouart's addition to her diary in Aug. 1961, when Jean Renoir visited her; in Manet, *Journal*, 75.

63. Letter, [Paris] Mar. 3 [1895]; excerpt in Drouot sale cat., June 10, 1974, no. 119.

64. Rouart, intro., *Berthe Morisot and Her Circle: Paintings from the Rouart Collection, Paris*, n.p.

65. Diary, Châteaulin, Aug. 8, 1895; in Manet, *Journal*, 57–58.

66. Diary, St.-Nicolas, Aug. 16, 1895; in ibid., 59–60.

67. Diary, Paris, Oct. 4, 1895; in ibid., 70.

68. Diary, Paris, n.d., in ibid., 71; and diary, Paris, Nov. 17, 1895, in ibid., 72.

69. Paris, Nov. 29, 1895; in ibid., 74.

70. Paris, Dec. 4, 1895; in *Pissarro: Lettres*, 392.

71. Paris, Nov. 21, 1895; in ibid., 388–90.

72. Five of the works in Renoir's collection are reproduced in Venturi, *Cézanne: Son Art et son oeuvre* (1936): *Thatched Cottages at Auvers* (1872–73), in 1:135; *Landscape* (1879–82), in 1:308; *Struggle of Love* (1875–76), in 1:380; *Turning Road at La Roche-Guyon* (1885), in 1:441; *Nude Bathers* (watercolor, 1882–94), in 1:902. A second watercolor, *Carafe and Bowl* (1879–82), is illus. in Knoedler New York, *Cézanne Watercolors*, exhibition by Columbia University, Department of Art History and Archaeology, Apr. 1963, pl. v.

73. Letter to L.P., Paris, Nov. 23, 1893; in *Pissarro: Lettres*, 317.

74. Unpublished letters, Paris, late Jan. and Feb. 1896; in Collection Denis Rouart, Paris, and Coll. D.-R.

75. Paris, Mar. 4, 1896; in Manet, *Journal*, 87. For illus. of *La Mandoline*, see Bataille and Wildenstein, *Morisot*, fig. 226 and 38, n.238.

76. N.l., Mar. 1896; complete letter in Librairie Henri Saffroy sale cat. 106, no. 9883 (holograph sent courtesy Mme. J. Naert).

77. Unpublished letter [Paris, early Mar. 1896]; in Collection Denis Rouart, Paris.

78. Cagnes, Apr. 8, 1888; in Daulte, *Renoir*, 1:53. A letter from François Daulte to author, Lausanne, Dec. 9, 1981: "Enfin, quant à la lettre citée dans mon catalogue, qui date du 8 avril 1888, elle fait partie des archives Durand-Ruel, et à part les salutations, je l'ai citée in extenso. Au moment de la parution de mon catalogue, c'était une lettre complètement inédite, protégée par le copyright de mon livre. Elle a été adressée par Renoir à son ami Philippe Burty."

79. Paris, Dec. 31, 1896; in Manet, *Journal*, 122.

80. Julie Manet, diary, Essoyes, Sept. 1897; in ibid., 130.

81. June 15, 1896; in Drucker, *Renoir*, 178.

82. June 20, 1896; in Mirbeau, *Renoir*, 12.

83. June 22, 1896; in Baudot, *Renoir*, 40, 43.

84. Diary, Paris, Oct. 18, 1896; in Manet, *Journal*, 116.

85. Paris, Oct. 5, 1896; in ibid., 113.

86. Renoir's father had lived to be seventy-five, his paternal grandfather to seventy-two, and his paternal grandmother to seventy-nine.

87. Letter to Maurice Fabre, n.l. [1896]; in Monneret, *L'Impressionnisme*, 2:177. See also ibid., 2:159.

88. Jean Renoir, *Renoir*, 347.

89. Letter to L.P., Paris, Jan. 22, 1899; in *Pissarro: Lettres*, 465.

90. Essoyes, Sept. 28, 1897; in Manet, *Journal*, 133.

91. Diary, Paris, Nov. 16, Dec. 3, Dec. 17, 1896; in Manet, *Journal*, 140–41, 143, 145.

92. Diary, n.l., June 6, 1897; in Denis, *Journal*, 1:121.

93. The Renoir, *Le Bain*, is reproduced in Daulte, *Renoir*, vol. 1, fig. 618.

94. Julie Manet diary, Paris, Dec. 30, 1898; in Manet, *Journal*, 209.

95. Diary, Paris, Jan. 8, 1898; in ibid., 147.

96. Paris, June 16, 1898; in ibid., 167.

97. In Jean Renoir, *Renoir*, 396–97.

98. Letter P.A.R. to Durand-Ruel, Grasse, Dec. 29, 1899; in Venturi, *Archives*, 1:156.

99. Letter Jeanne Gobillard to Jeanne Baudot, n.l. [Sept. 1898]; in Baudot,

Renoir, 83–84.

100. Monneret, *L'Impressionnisme*, 3:115. Major Count Walsin-Esterhazy was the actual culprit.

101. Essoyes, Oct. 11, 1897; in Manet, *Journal*, 135.

102. Diary, Paris, Jan 15, 1898; in ibid., 148.

103. Diary, Paris, Mar. 17, 1898; in ibid., 156.

104. Diary, Paris, Oct. 20, 1898; in ibid., 198.

105. Diary, Paris, Jan. 19, 1899; in ibid., 213.

106. Cagnes, Feb. 21, 1899; in Venturi, *Archives*, 1:151.

107. [Nice, Feb. 1899]; in ibid., 152.

108. Letter, Cagnes [Apr. 1899]; in ibid., 155.

109. St.-Cloud, Aug. 4, 1899; in Manet, *Journal*, 247.

110. Diary, St.-Cloud, Aug. 9, 1899; in ibid., 248–49.

111. Letter, [Acqui?] Aug. 29, 1899; in Venturi, *Archives*, 1:155.

112. Giverny, Nov. 25, 1899; in ibid., 1:370.

113. Julie Manet diary entries, Paris, Jan. 31 and Apr. 22, 1899; in Manet, *Journal*, 214–15, 227.

114. Letter C.P. to L.P., Paris, Apr. 12, 1899; in *Pissarro: Lettres*, 467.

115. Paris, Nov. 16, 1899; in Manet, *Journal*, 279.

1900–1909 § INTERNATIONAL RECOGNITION

1. Unpublished letter, Grasse, Jan. 17, 1900; in Collection Denis Rouart, Paris.

2. Letter, Grasse, Mar. 7, 1900; excerpt in Librairie de l'Abbaye sale cat. 247, no. 230.

3. [Grasse, mid-Mar. 1900]; in Baudot, *Renoir*, 87.

4. Daulte, *Renoir*, vol. 1, fig. 227. Also see letter Monet to Durand-Ruel, Giverny, Apr. 10, 1900; in Venturi, *Archives*, 1:376.

5. Shikes and Harper, *Pissarro*, 310.

6. Unpublished letter, Paris [Aug. 1900]; in Musée National de la Légion d'Honneur, Paris.

7. Letter, [Louveciennes] Aug. 20, 1900; in Venturi, *Archives*, 1:161.

8. N.l. [1900]; in Florisoone, "Renoir et la famille Charpentier," 38.

9. Louveciennes, Aug. 20, 1900; in Baudot, *Renoir*, 49.

10. N.l., Aug. 23, 1900; in ibid., 50.

11. Letter, Grasse, Jan. 28, 1900; excerpt in Charavay sale cat., Oct. 1980, no. 38784.

12. Cannes, Feb. 26, 1901; in *Lettres d'Odilon Redon, 1878–1916*, 46.

13. Letter, Cannes, Apr. 25, 1901; in Venturi, *Archives*, 1:166–67.

14. Aix-les-Bains, May 3, 1901; in Drucker, *Renoir*, 140–41.

15. Aix-les-Bains, May 5, 1901; in ibid., 141.

16. Letter to Georges Durand-Ruel, Fontainebleau, Sept. 7, 1901; in Venturi, *Archives*, 1:168.

17. See notes for 1890–1899, n.78.

18. Jean Renoir, *Renoir*, 349–50, 414.

19. N.l., Aug. 7, 1901; excerpt in The Rendells sale cat. 129, no. 370 (Rendell trans.).

20. Jean Renoir, *Renoir*, 368.

21. Letter, Le Cannet, Feb. 3, 1902; in Venturi, *Archives*, 1:168–69.

22. Daulte, *Renoir*, vol. 1, fig. 227.

23. Letter, Le Cannet, Mar. 9, 1902; in Venturi, *Archives*, 1:169–70.

24. Jean Renoir, *Renoir*, 404.

25. Letter, [Paris] Jan. 19, 1903; in Venturi, *Archives*, 1: 171.

26. Letter P.A.R. to Bérard, Le Cannet, Feb. 10, 1903; excerpt in Drouot sale cat., June 22, 1979, no. 116 (2).

27. Letter P.A.R. to Durand-Ruel, Marseilles, Nov. 13, 1903; in Venturi, *Archives*, 1:174.

28. Shikes and Harper, *Pissarro*, 316.

29. Unpublished letter [Cagnes] Dec. 8, 1903; in Fondation Custodia (Collection F. Lugt), Institut Néerlandais, Paris.

30. Unpublished letter, Cagnes, Apr. 25, 1903; in Collection Anahid Iskian, New York.

31. From unpublished notes by Albert André; in Rewald, *Impressionism*, 589 n.61.

32. Letter, Cagnes, Apr. 18, 1903; in Venturi, *Archives*, 1:173.

33. Cagnes, Apr. 25, 1903; in Baudot, *Renoir*, 100.

34. [Cagnes] Nov. 24, 1903; in Venturi, *Archives*, 1:174.

35. Unpublished letter, Cagnes, Dec. 24, 1903; in Fondation Custodia (Collection F. Lugt), Institut Néerlandais, Paris.

36. Cagnes, Dec. 26, 1903; in Venturi, *Archives*, 1:176.

37. Letter P.A.R. to Durand-Ruel, Cagnes, Jan. 1, 1904; in ibid., 177.

38. Cagnes, Feb. 10, 1904; in ibid., 179–80.

39. Unpublished letter, [Paris] Feb. 22, 1904; in Humanities Research Center, University of Texas, Austin.

40. Cagnes, Mar. 1906; in Denis, *Journal*, 2:35.

41. Letter, [Paris] July 14, 1904; excerpt in Stargardt sale cat. 570, no. 903.

42. Jean Renoir, *Renoir*, 414–15.

43. Unpublished letters P.A.R. to André, Bourbonne-les-Bains, Aug. 16, 17, Sept. 8, 1904; in Fondation Custodia (Collection F. Lugt), Institut Néerlandais, Paris.

44. Unpublished letter P.A.R. to a friend [Rivière], Bourbonne-les-Bains, Aug. 25, 1906; in Bibliothèque Municipale et Archives Anciennes, Troyes, France.

45. Unpublished letter, Bourbonne-les-Bains, Aug. 16, 1904; in Fondation Custodia (Collection F. Lugt), Institut Néerlandais, Paris.

46. Unpublished letter, Bourbonne-les-Bains, Aug. 17, 1904; in Fondation Custodia (Collection F. Lugt), Institut Néerlandais, Paris.

47. Letter, Bourbonne-les-Bains, Sept. 4, 1904; in Venturi, *Archives*, 1:182.

48. Bourbonne-les-Bains, Sept. 8, 1904; excerpt in Drouot sale cat., Feb. 16, 1979, no. 83 (3).

49. Same letter as above, different excerpt; in Librairie de l'Abbaye sale cat. 243, no. 248.

50. Letter, [Essoyes] Sept. 18, 1904; in Venturi, *Archives*, 1:183.

51. Letter, Essoyes, Sept. 23, 1904; in Roger-Marx, *Renoir*, 82–83.

52. Moncade, "Renoir et le Salon d'Automne" (interview Oct. 15, 1904); in White, ed., *Impressionism in Perspective*, 23–24.

53. "Le Salon d'automne," *L'Echo de Paris* (Oct. 14, 1904); in Mirbeau, *Renoir*, 17.

54. Letter Philippe Gangnat to the author, Paris, Feb. 2, 1983.

55. See *Catalogue des tableaux composant la collection Maurice Gangnat: 160 Tableaux par Renoir*, Drouot sale cat., June 24–25, 1925, prefs. by Robert de Flers and Élie Faure.

56. Unpublished letter, Paris, Nov. 27, 1904; in Collection Mme. A. Rouart-Valéry, Paris.

57. Unpublished letter, Paris, Dec. 24, 1904; in Collection Mme. A. Rouart-Valéry, Paris.

58. See White, "Renoir's Sensuous Women," 166–81.

59. See related Valtat drawing in Rewald, *Renoir Drawings*, pl. 80.

60. Forain's four lithographs of 1905 were made for Vollard. See Johnson, *Ambroise Vollard, Éditeur: Prints, Books, Bronzes*, 134.

61. Letter, Paris, July 3, 1906; excerpt in Librairie de l'Abbaye sale cat. 215, no. 123 (part of holograph is illus.).

62. N.l. [1907]; in Gold and Fizdale, *Misia: The Life of Misia Sert*, 108 (Gold-Fizdale trans.).

63. Unpublished letter, Cagnes, Feb. 16, 1905; in Fondation Custodia (Collection F. Lugt), Institut Néerlandais, Paris.

64. Letter, Cagnes [1905]; in Rivière, "Renoir," 5.

65. Cooper, *The Courtauld Collection*, 28.

66. Daulte, *Renoir*, vol. 1. This catalogue supplies prices from various sales.

67. Unpublished letter, Cagnes, Feb. 4, 1906; in Collection Mme. A. Rouart-Valéry, Paris.

68. Letter, Cagnes, Mar. 12, 1906; in Venturi, *Archives*, 1:186.

69. Unpublished letter, Paris, June 20, 1906; in Musée Rodin, Paris.

70. Rivière, *Renoir et ses amis*, 200–201.

71. Unpublished letter, Bourbonne-les-Bains, Aug. 25, 1906; in Bibliothèque Municipale et Archives Anciennes, Troyes, France.

72. Unpublished letter, Essoyes, Sept. 12, 1906; in Musée du Louvre, Cabinet des Dessins, Paris.

73. Frère, *Conversations de Maillol*, 237–38.

74. To Gasquet, Aix-en-Provence, July 8, 1902; quoted in Rewald, *Cézanne, Geffroy, et Gasquet: Suivi de souvenirs sur Cézanne de Louis Aurenche et de lettres inédites*, 45.

75. Cagnes, Dec. 6, 1909; in Geffroy, *Monet*, 2:26–27.

76. Unpublished letter from Cagnes, Jan. 4, 1907; in Collection Mme. A. Rouart-Valéry, Paris.

77. Cagnes, Mar. 24, 1908; in Venturi, *Archives*, 1:191.

78. Unpublished letter, Cagnes, May 7, 1908; in Collection Anahid Iskian, New York.

79. André Warnod, "M. Pierre Renoir évoque pour nous le souvenir de son père," *Le Figaro Artistique* (Oct. 23, 1934), and Haesaerts, *Renoir Sculptor*, 39.

80. Jean Renoir, *Renoir*, 355.

81. Cagnes, Mar. 20, 1908; in Galerie d'Art Braun, *Renoir*, 12.

82. Unpublished letter, [Cagnes] May 13, 1908; in Humanities Research Center, University of Texas, Austin.

83. Unpublished letter, postmarked Cagnes, 1908; in Collection Mme. A. Rouart-Valéry, Paris.

84. Cagnes, Jan. 2, 1909; in Perruchot, *Vie de Renoir*, 311.

85. Letter, Cagnes, Feb. 11, 1909; in Venturi, *Archives*, 1:194.

1910–1919 § "THE GREATEST LIVING PAINTER"

1. Unpublished letter, Cagnes, Jan. 2, 1910; in Fondation Custodia (Collection F. Lugt), Institut Néerlandais, Paris.

2. Jean Renoir, *Renoir*, 32–33.

3. Jean Renoir, "Renoir My Father," *Look*, 26 (Nov. 6, 1962): 67.

4. André, *Renoir* (1919), 32–34.

5. Jean Renoir, *Renoir*, 349.

6. Cagnes, Dec. 29, 1910; in Venturi, *Archives*, 1:199.

7. Letter P.A.R. to Paul Durand-Ruel, Cagnes, Jan. 11, 1911; in Venturi, *Archives*, 1:199.

8. See Renoir's conversation with a young unnamed German artist in notes of Dr. Ernest L. Tross, Denver, Colo., who served as interpreter; quoted in Rewald, *Impressionism*, 210 and 236 n.28.

9. Wessling, Summer 1910; in Städtische Galerie, *Auguste Renoir*, exhib. cat. 58–59. Permission also of John Slade.

10. Unpublished letter P.A.R. to Albert Chapon, Paris, July 12, 1909; in Collection François Chapon, Paris.

11. Unpublished letter from Mottez to Chapon, n.l., Nov. 19, 1909; in Collection François Chapon, Paris.

12. Denis diary entry, Siena, Mar. 21, 1910; in Denis, *Journal*, 2:118.

13. Ibid.

14. Rivière, *Renoir et ses amis*, 226.

15. Unpublished letter Denis to Chapon, Paris, Aug. 6 [1910]; in Collection François Chapon, Paris.

16. Unpublished letter, Cagnes, Nov. 9, 1910; in Collection François Chapon, Paris.

17. Jean Renoir, *Renoir*, 144.

18. "Lettre à M. Henri Mottez," preface to Cennini, *Le Livre de l'art ou traité de la peinture*, viii–x, xii.

19. Unpublished letter P.A.R. to Pach (copied by Pach), Cagnes, Mar. 28, 1911; in Collection of American Literature, Beinecke Rare Book and Manuscript Library, Yale University, New Haven, Conn. Permission also of Mrs. Walter Pach.

20. Unpublished note from Pach to Gertrude Stein (written on the previous letter), Paris, Apr. 2, 1911; in Collection of American Literature, Beinecke Rare Book and Manuscript Library, Yale University. Permission also of Mrs. Walter Pach.

21. Pach, "Pierre Auguste Renoir," 612–14.

22. Giverny, Oct. 23, 1911; in Venturi, *Archives*, 1:429.

23. Letter P.A.R. to Signac, Cagnes, Nov. 10, 1911; excerpt in Pierre Berès sale cat. 50, no. 601.

24. Cagnes, Nov. 12 [1911]; excerpt in Drouot sale cat., June 25, 1975, no. 148 (misdated 1915).

25. Meier-Graefe, *Auguste Renoir*. See White, "Renoir's Development from 1877 to 1887," 7–8, 31–33.

26. Giverny, Aug. 28, 1911; in Venturi, *Archives*, 1:428.

27. Giverny, June 26, 1913; in ibid., 437.

28. Giverny, Dec. 14, 1913; in ibid., 438.

29. Jean Renoir, *Renoir*, 422.

30. Letter to Rivière, n.l., Nov. 15 [1911]; in Rivière, "Renoir," 5.

31. Letter to unidentified correspondent, [Nice] Nov. 21, 1911; excerpt in The Rendells sale cat. 130, no. 120 (Rendell trans.).

32. Letter, Grasse, Jan. 8 [1912]; in Venturi, *Archives*, 2:128.

33. Unpublished letter, Nice, Feb. 5, 1912; in Fondation Custodia (Collection F. Lugt), Institut Néerlandais, Paris.

34. Unpublished letter, [Nice], Feb. 23, 1912; in Humanities Research Center, University of Texas, Austin.

35. Letter to Georges or Joseph Durand-Ruel, Cagnes, June 15, 1912; in Venturi, *Archives*, 1:203.

36. Letter to unidentified correspondent, n.l., Dec. 1912; in ibid., 107.

37. LeRoy Breunig, intro., *Apollinaire on Art: Essays and Reviews 1902–1918* (1972), xvii.

38. Review in *Le Petit Bleu*, Feb. 9, 1912; in ibid., 204.

39. Exhibitions were also held in Berlin, Frankfurt, Düsseldorf, and Budapest.

40. See Barnes and de Mazia, *The Art of Renoir*.

41. Wildenstein, *Monet*, 1:256 n.332 and ibid., 164 n.95. Also see François Duret-Robert. "Prices," in Jean Clay et al., *Impressionism* (Paris: Réalités-Hachette, 1973) in White, ed., *Impressionism in Perspective*, 99.

42. Unpublished letter, Cagnes, Dec. 16, 1912; in Collection Mme. A. Rouart-Valéry, Paris.

43. Letter, Cagnes, Feb. 1, 1913; in Baudot, *Renoir*, 131.

44. Cagnes [1913]; in Denis, *Journal*, 2:150–51.

45. Mirbeau, *Renoir*, [ix, xi].

46. Cagnes, Mar. 19, 1913; in Galerie Braun, *Renoir*, 13.

47. 1913 [untitled]; in Mirbeau, *Renoir*, 47.

48. "Auguste Renoir," *L'Intransigeant* (Mar. 13, 1913); in *Apollinaire on Art*, 278.

49. Letter Cassatt to Paul Durand-Ruel, Grasse, Apr. 9, 1913; in Venturi, *Archives*, 2:130.

50. In 1971, a French court declared that Guino had been a coauthor and that the Renoir-Guino collaboration should be acknowledged as teamwork for the fourteen pieces of sculpture made between 1913 and 1917. See "Renoir/Guino Case (Decision of Tribunal, dated Jan. 11, 1971, affirmed by Appellate Tribunal, Nov. 197_)" (English trans.); in Feldman and Weil, *Legal and Business Problems of Artists, Art Galleries and Museums*, 441–52. Brought to my attention by Professor Albert Elsen, Stanford University.

51. Unpublished letter, Cagnes, Apr. 28, 1914; in Fondation Custodia (Collection F. Lugt), Institut Néerlandais, Paris.

52. Haesaerts, *Renoir Sculptor*, 39–40.

53. Vollard first exhibited a cast of the *Venus Victorious* in 1915 at the Carroll Gallery in New York, yet there is no evidence that it was in an aquatic setting.

54. Letter to Vollard, Nice, Jan. 25, 1914; excerpt in Pierre Berès sale cat. 5, no. 216 (Berès trans.).

55. Same letter, different excerpt in Lucien Goldschmidt sale cat. special list 81, n.s. 4, New York, 1954, no. 105 (Goldschmidt trans.).

56. Letter, Cagnes, Feb. 16, 1914; in Roger-Marx, *Renoir*, 87.

57. Grasse [Spring 1914]; in Venturi, *Archives*, 2:135.

58. Cagnes, Apr. 19, 1914; in Johnson, *Ambroise Vollard, Éditeur*, 41.

59. Alley, *Tate Gallery Catalogues: The Foreign Paintings, Drawings, and Sculpture*, 200

60. Paris, June 16, 1914; in Haesaerts, *Renoir Sculptor*, 27.

61. N.l., n.d.; in ibid., 18.

62. Letter to Vollard, Nice, Jan. 25, 1914; excerpt in Pierre Berès sale cat. 5, no. 215 (Berès trans.).

63. Unpublished letter, Cagnes, Mar. 7, 1914; in Musée Rodin, Paris.

64. Unpublished letter, Nice, Nov. 12, 1913; in Archives Bernheim-Jeune, Paris.

65. Unpublished letter, Cagnes, n.d.; in Archives Bernheim-Jeune, Paris. The drawing was reproduced in the book *Rodin* by Gustave Coquiot, published by Bernheim-Jeune in 1915.

66. Nice, Jan. 27, 1914; in Venturi, *Archives*, 1:205.

67. Letter, Cagnes, Feb. 3, 1914; excerpt in Jacques Lambert sale cat. 27, no. 109.

68. Unpublished letter, Cagnes, May 22, 1914; in private collection.

69. In *Apollinaire on Art*, 376.

70. In ibid., 425.

71. Unpublished letter P.A.R. to Jeanne Valéry, Nice, Jan. 27, 1914; in Collection Agathe Rouart-Valéry, Paris.

72. Jean Renoir, *Renoir*, 449.

73. Sterling and Salinger, *French Paintings: A Catalogue of the Collection of the Metropolitan Museum of Art*, 3:161.

74. Letter P.A.R. to unidentified correspondent, Cagnes [late Sept. 1914]; excerpt in Morssen sale cat., no. 258.

75. Unpublished letter, Cagnes [late Sept. 1914]; in Fondation Custodia (Collection F. Lugt), Institut Néerlandais, Paris.

76. Letter to unidentified correspondent [Cagnes, Oct. 1914]; excerpt in Drouot sale cat., June 25, 1975, no. 149.

77. Letter to unidentified correspondent, Cagnes, Oct. 12, 1914; excerpt in Stargardt sale cat. 567, no. 831.

78. Letter, Cagnes, Oct. 29, 1914; in Venturi, *Archives*, 1:206.

79. Unpublished letter, Cagnes, Nov. 17, 1914; in Fondation Custodia (Collection F. Lugt), Institut Néerlandais, Paris.

80. Her marriage to Jean Renoir took place in 1920; later, she became an actress under the name Catherine Hessling.

81. Letter to Paul Durand-Ruel, Grasse, Jan. 22, 1913; in Venturi, *Archives*, 2:130.

82. Letter, Grasse, Feb. 17 [1915]; in ibid., 135–36.

83. Letter, Cagnes, Mar. 25, 1915; in ibid., 1:207.

84. Unpublished letter, [Cagnes] Apr. 16, 1915; in Fondation Custodia (Collection F. Lugt), Institut Néerlandais, Paris.

85. N.l. [late Apr. 1915]; excerpt in Rauch sale cat., no. 58.

86. Letter, Giverny, May 28, 1915; in Venturi, *Archives*, 1:442.

87. Jean Renoir, *Renoir*, 449.

88. Unpublished letter, Nice, June 26, 1915; in Fondation Custodia (Collection F. Lugt), Institut Néerlandais, Paris.

89. Cagnes, June 28, 1915; in Venturi, *Archives*, 1:207–208.

90. Jean Renoir, *Renoir*, 214–24, 238, 450–51.

91. Unpublished letter, Cagnes, July 3, 1915; in Fondation Custodia (Collection F. Lugt), Institut Néerlandais, Paris.

92. Unpublished letter, Cagnes, July 8, 1915; in Fondation Custodia (Collection F. Lugt), Institut Néerlandais, Paris.

93. Jean Renoir, *Renoir*, 9.

94. Letter, n.l., July 23, 1915; in Haesaerts, *Renoir Sculptor*, 29.

95. Unpublished letter, Cagnes, Nov. 1, 1915; in Humanities Research Center, University of Texas, Austin.

96. Letter P.A.R. to Paul Durand-Ruel, Cagnes, Dec. 12, 1915; in Venturi, *Archives*, 1:208.

97. Unpublished letter, [Cagnes] Dec. 25, 1915; in Collection Anahid Iskian, New York.

98. Letter, Cagnes, Dec. 17, 1915; in Venturi, *Archives*, 1:208.

99. André and Elder, *L'Atelier de Renoir*.

100. Unpublished letter, Cagnes, Jan. 2, 1916; in Fondation Custodia (Collection F. Lugt), Institut Néerlandais, Paris.

101. Bonnard's article, "Pierre Auguste Renoir," *Comoedia* (Oct. 18, 1941), 1. Also see Bonnard's 1943 conversation; in White, ed., *Impressionism in Perspective*, 58–59.

102. Giverny, Jan. 17, 1916; in Venturi, *Archives*, 1:443.

103. [Cagnes] Mar. 24, 1916; in Baudot, *Renoir*, 111.

104. Letter, Cagnes, Nov. 29, 1916; in Venturi, *Archives*, 1:209.

105. Letter, Giverny, Dec. 13, 1916; in ibid., 444.

106. Kelekian bought the first ceiling paintings, which had been rejected by Dr. Émile Blanche because the dimensions would have had to be adjusted. See Daulte, *Renoir*, vol. 1, figs. 315–16.

107. Unpublished letter, n.l., n.d.; in Archives Bernheim-Jeune, Paris.

108. Letter, Cagnes, Jan. 28, 1917; in Venturi, *Archives*, 1:210.

109. Cagnes, Jan. 31, 1917; in Baudot, *Renoir*, 88.

110. Cagnes, Feb. 21, 1917; in Venturi, *Archives*, 1:211.

111. Cagnes, May 21, 1917; in ibid.

112. Summer, 1917; in Bell, *Since Cézanne*, 73.

113. Cagnes, Sept. 30, 1917; in Venturi, *Archives*, 1:212–13.

114. Letter, Cagnes, Jan. 7, 1918; excerpt in Drouot sale cat., June 6, 1975, no. 45 (holograph illus.).

115. Matisse's recollections were told to Picasso and Françoise Gilot in the 1950s and recorded in Gilot and Lake, *Life with Picasso*, 269.

116. Cat. of exhib., "Den Franske Utstilling," Oslo, Norway, Nasjonalgalleriet, Jan.–Feb. 1918; in *Impressionists and Some of Their Contemporaries*, 37.

117. Letter, Cagnes, Jan. 20, 1918; in Venturi, *Archives*, 1:213.

118. Unpublished letter, Cagnes, Feb. 21, 1918; in Fondation Custodia (Collection F. Lugt), Institut Néerlandais, Paris.

119. Cagnes, Mar. 3, 1918; in Vollard, *Tableaux, Pastels et Dessins de Pierre-Auguste Renoir*, 1:[v].

120. Letter P.A.R. to one of the Durand-Ruels, Cagnes, Mar. 16, 1918; in Venturi, *Archives*, 1:213; and Monet's letters to the Durand-Ruels, Apr.–Dec. 1918; in ibid., 451–53.

121. Cagnes, May 22, 1918; quoted in Baudot, *Renoir*, 89.

122. Letter, Cagnes, July 23, 1918; in Venturi, *Archives*, 1:214.

123. Cagnes, Sept. 3, 1918; quoted in Haesaerts, *Renoir Sculptor*, 33.

124. Ibid., 43.

125. Jean Renoir, *Renoir*, 456–57. Renoir's sons gave the painting to the Luxembourg in 1923; it entered the Louvre in 1929.

126. Unpublished letter, Cagnes, Mar. 14, 1919; in Musée National de la Légion d'Honneur, Paris.

127. Cagnes, Feb. 27, 1919; in Venturi, *Archives*, 1:214.

128. Cagnes, May 1919; in Clergue, *La Maison de Renoir: Musée Renoir du Souvenir*, n.p.

129. Letter to unidentified correspondent, Cagnes, July 10, 1919; excerpt in Stargardt sale cat. 574, no. 1199.

130. Rivière's book was published in 1921, so his recollections were fairly recent; in Rivière, *Renoir et ses amis*, 263.

131. Jean Renoir, *Renoir*, 456.

132. Haesaerts, *Renoir Sculptor*, 33.

133. Félix Fénéon, letter to the editors, *Bulletin de la vie artistique* (Dec. 15, 1919), n.p.

134. Unpublished poem, Dec. 1920; in private collection.

AFTERWORD

1. Giverny, Jan. 17, 1920; in Venturi, *Archives*, 1:455.

2. André and Elder, *L'Atelier de Renoir*, 2 vols. of illus.

3. Letter from Edmond Renoir, Jr., to author, Viroflay, Mar. 7, 1980.

4. A list of exhibitions in which Renoir's work appeared from 1874 to 1970 can be found in Daulte, *Renoir*, 1:69–74. In the 1930s, his works were in thirty-four shows (seventeen one-man); in the 1940s, in sixteen shows (eight one-man); in the 1950s, in twenty-four shows (seventeen one-man); in the 1960s, in twenty-two shows (ten one-man).

5. In Florisoone, *Renoir*, 165.

6. Paul Jamot, pref. to Charles Sterling catalogue, *Renoir* (1933); quoted in Florisoone, *Renoir*, 165.

7. An article on this exhibition in *The Sunday Oklahoman*, Oct. 17, 1982, p. 8, stated: "In a press release, the Oklahoma Art Center director, Lowell Adams, is quoted as saying Pierre Renoir's 'The Luncheon of the Boating Party' was purchased by Phillips in 1923 for $125,000 and that the value of the painting has increased 100 times the original price. That would place the painting's value at 12.5 million dollars. . . . A New York art dealer and prominent art expert, Richard Feigen . . . made the following estimates on the value of several of the paintings being exhibited here: . . . Pierre Renoir's 'Luncheon of the Boating Party'— 12 million to 15 million dollars, and maybe even more—'A top piece of work.' "

8. François Duret-Robert, "Un Milliard pour un Renoir?"; in Pierre Cabanne et al., *Renoir*, 266.

9. See map in François Daulte, *Auguste Renoir*, 95. In the United States: Baltimore, Boston, Cambridge, Chicago, Cleveland, Philadelphia, Minneapolis, New York, San Francisco, Washington, and Williamstown, Massachusetts. European cities whose public collections contain many Renoirs are: Copenhagen, Limoges, Nice, Paris, Berlin, Frankfurt, Stuttgart, Edinburgh, London, Rotterdam, Leningrad, Moscow, Basel, Winterthur, and Zurich. Elsewhere, Renoirs can be found in museums in Algiers, Johannesburg, Tokyo, Melbourne, Cairo, Tel Aviv, São Paulo, and Buenos Aires. Renoir's home at Les Collettes in Cagnes-sur-Mer is open to the public.

10. White, "Renoir's Development from 1877 to 1887," 154–55.

1841: February 25: Pierre-Auguste Renoir is born to Léonard Renoir and Marguerite Merlet (sixth child) in Limoges, France

1846: Family moves to Paris

1848–56: Attends Catholic school

1856: Becomes apprentice porcelain painter at Lévy Brothers, rue des Fossés-du-Temple, Paris

1860–64: January 24, 1860: Registers for yearly passes to copy paintings at Louvre; last pass requested April 9, 1864

1861–64: Student of Gleyre at École des Beaux-Arts

1862: October–November: Monet, Sisley, and Bazille enroll in Gleyre's studio

1863: Meets Pissarro and Cézanne

Spring: Meets Courbet and Diaz in Fontainebleau Forest

Spring Salon: Submission rejected

1864: Spring Salon: Address given as 23 rue d'Argenteuil; one work accepted: *La Esméralda,* destroyed by Renoir after exhibited

1865: Frequent guest of Sisley family in Paris and of Jules Le Coeur in Marlotte, Berck, and Paris

Renoir's parents move to Paris suburb Ville-d'Avray

Spring Salon: Address given as 43 avenue d'Eylau; two works accepted: *William Sisley* (1864) and *Summer Evening*

Late 1865 or early 1866: Lise Tréhot becomes model and probably mistress through 1872

1866: Spring Salon: One work rejected, one accepted and withdrawn: *Landscape with Two Figures* (1865–66)

July: Shares Bazille's studio, 20 rue Visconti

1867: Executes first life-size figure painting *en plein air: Lise*

Spring Salon: *Diana* (1867) rejected

1868: January: Bazille and Renoir move studio to 9 rue de la Paix (Batignolles)

Spring: Does architectural decoration for Prince Georges Bibesco at request of Charles Le Coeur

Spring Salon: Address given as 9 rue de la Paix; one work accepted: *Lise* (1867)

1869: Frequents Café Guerbois, where he meets Manet, Duret, Degas, Zola, and others

Spring Salon: Address given as 9 rue de la Paix; one work accepted: *Study: In the Summer* (1868)

October: Galerie Carpentier, Paris (two works)

October: With Monet at La Grenouillère paints first Impressionist landscapes

1870: Executes first large-scale Impressionist figure painting

Mid-May: Bazille and Renoir move studio to 8 rue des Beaux-Arts

Spring Salon: Address given as chez M. Bazille, 8 rue des Beaux-Arts; two works accepted: *Bather* (1870) and *Woman of Algiers* (1870)

Mid-June: Renoir moves in with Maître, 5 rue Taranne (boulevard St.-Germain)

July 19: Franco-Prussian War begins

October 28: Renoir drafted and sent to Libourne, Bordeaux, and Tarbes

November 28: Bazille killed in action

1871: January 28: Defeat of France

March 15: Paris Commune established; civil war erupts

Late March–June: In Louveciennes

June: Rents room on rue Dragon, Paris; renews friendship with Duret

Mid-August: In Marlotte with Jules Le Coeur

Fall: Studio on rue des Petits Champs, Paris; renews friendship with Monet

1872: Early in year: Monet introduces Renoir to Durand-Ruel

March: Durand-Ruel buys two works

Spring Salon: One work rejected, *The Harem (Parisian Women Dressed as Algerians)* (1872)

Spring: Murer buys first Renoir; Murer's Wednesday dinners begin and continue for eight years

April: Lise marries and ceases to model for Renoir

May: Durand-Ruel exhibits in London gallery, 168 New Bond Street (one work, *Ponts des Arts, Paris,* 1867)

Summer: In Argenteuil with Monets

1873: Café de la Nouvelle-Athènes replaces Café Guerbois as meeting place; friendship with Rivière; meets Caillebotte and Desboutin; moves apartment to rue de Norvins

Spring Salon: One work rejected; *A Morning Ride in the Bois de Boulogne* (1873) hung at Salon des Refusés

Summer and fall: Spends time in Argenteuil with Monets

September: Moves studio to 35 rue St.-Georges

December 27: Founding charter of Society of Painters, Draftsmen, Sculptors, and Engravers

1874: Henriette Henriot, Nini "Gueule de Raie," and Nini Lopez become models

Early winter: Worldwide economic crash and depression

Spring Salon: Submission rejected

April 15–May 15: First Impressionist exhibition, Nadar's studio, 35 boulevard des Capucines (seven works)

Early summer: Durand-Ruel exhibition, London gallery (two works); last visit to Fontenay-aux-Roses with Le Coeur family

July: In Argenteuil with Monets; Sisley and Manet also visit

December 22: Father dies

1875: Margot Legrand becomes model and probably mistress

March 24: 20 works auctioned at first Impressionist auction, Hôtel Drouot, Paris; highest price for a Renoir is 300 francs for *The Pont Neuf, Paris* (1872)

Meets Charpentier and Chocquet

April: Leases second studio at 12 rue Cortot for one and one-half years

Spring Salon: Submission rejected

Winter: Durand-Ruel closes London branch

1876: Does architectural decoration for Charpentier stairwell

April: Second Impressionist exhibition, Galerie Durand-Ruel, 11 rue Le Peletier (16 works)

Spring Salon: Does not submit

November 3: Caillebotte's will names Renoir documentary executor

1877: Experiments with painting on MacLean cement; actress Jeanne Samary begins to model

Spring Salon: Does not submit

April: Third Impressionist exhibition, 6 rue Le Peletier (21 works); publishes two articles in *L'Impressionniste: Journal d'Art*

May 28: Second Impressionist auction, Hôtel Drouot (16 works); highest price for a Renoir is 285 francs

1878: Illustrates writings for Zola and Duret (published in May)

Spring: No Impressionist exhibition

Spring Salon: Address given as 35 rue St.-Georges; one work accepted: *The Cup of Chocolate* (1878)

June 5–6: Hoschedé auction (three works); highest price for a Renoir is 84 francs for *Woman with a Cat* (c. 1875)

October 15: Completes *The Actress Jeanne Samary* and *Mme. Charpentier and Her Children*

1879: Early January: Margot contracts smallpox and dies February 25

March: Meets Paul Bérard

April: Does not exhibit at fourth Impressionist show

Spring Salon: Address given as 35 rue St.-Georges; four works accepted: *The Actress Jeanne Samary* (1878), *Mme. Charpentier and Her Children* (1878), and two pastel portraits, *Paul C...* and *Théophile B...*

June 19–July 3: First one-man show of pastels and paintings at offices of *La Vie Moderne*, 7 boulevard des Italiens

July–September: In Wargemont with Bérards; also visits Berneval and, in September, Dieppe, where he meets Jacques-Émile Blanche and agrees to give him painting lessons in Paris

Fall: Meets Aline Charigot in Paris and paints at Chatou; does panels for Blanche château

1880: January: Falls off bicycle and breaks right arm

April: Does not exhibit at fifth Impressionist show

Spring Salon: Address given as 35 rue St.-Georges; four works accepted: *Mussel Fishers at Berneval* (1879), *Sleeping Girl with Cat* (1880), and pastel portraits of Lucien Daudet and of Mlle. M. B...

May: Drafts two proposals to reorganize Salon; with Monet writes letter to minister of fine arts, and May 23 publishes article in *La Chronique de Tribunaux*

July 14: Murer's last Wednesday dinner in Paris

Summer: In Wargemont with Bérards

Late summer: Begins *Luncheon of the Boating Party* at Chatou

1881: Mid-February–mid-April: In Algeria

April: Does not exhibit at sixth Impressionist show

April 18: Moves apartment to 18 rue Houdon

Mid-April–mid-July: Works in Paris and in suburbs of Chatou (with Whistler), Bougival, Croissy

Spring Salon: Address given as 35 rue St.-Georges; two works accepted: *Pink and Blue: Alice and Élisabeth Cahen d'Anvers* (1881) and *Portrait of Mlle. (?)*

July 19: In Dieppe with Blanche

July 20–mid-September: In Wargemont with Bérards

Early October: In Paris

Late October–mid-January: In Italy: Venice (late October–early November), Rome (mid-November), Naples (November 21–January 17), Calabria (December), Sorrento, and Capri (December 26–28)

1882: January 15: At Palermo, paints Wagner's portrait for the Charpentiers

January 17: Naples, soon leaves Italy

January 23: Via Marseilles to L'Éstaque with Cézanne until early March

February 1: Paris stock market crashes; ensuing depression lasts four to five years

February 7: Pneumonia for five months

March 1–31: Durand-Ruel exhibits Renoir's work at the seventh Impressionist show, 251 rue St.-Honoré (25 works)

Spring Salon: One work accepted: *Mlle. Yvonne Grimprel with the Blue Ribbon* (1880)

March 5–May 3: In Algeria

May 3: In Paris

Mid-August: In Wargemont with Bérards

Mid-September: In Dieppe with Durand-Ruels

1883: Café Riche monthly dinners begin and continue for a decade

Valadon models for Renoir

April 1–25: First major one-man show at Durand-Ruel's, 9 boulevard de la Madeleine (seventy works)

April 20–July: Dowdeswell and Dowdeswell, Grosvenor Gallery, 133 New Bond Street, London (ten works)

April 30: Édouard Manet dies

Spring Salon: One work accepted: *Mme. Clapisson* (1883)

July: In Argenteuil with Caillebotte

August: In Paris

August 21: In Yport with Nunès

September 3–October: First U.S. exhibition: Mechanics Building, Boston (three works); other works exhibited in Rotterdam and Berlin

September 5–October 8: Via Jersey to Guernsey

December 16–30: To Riviera with Monet: Marseilles (meets Cézanne), Hyères, St.-Raphaël, Monte Carlo, Menton, Bordighera, and Genoa

1884: Moves studio to 37 rue de Laval

Spring: Does not exhibit at Salons 1884–89

May: Drafts platform for Society of Irregularists

Summer: In La Rochelle and Wargemont with Bérards

1885: Morisot's Thursday evening dinners (including Mallarmé) begin and continue until 1895

March 23: Aline gives birth to Renoir's son Pierre

June: Durand-Ruel sends works to Hôtel du Grand Miroir, Brussels (thirty-two works)

June–August: Rents house at La Roche-Guyon with Aline and Pierre

June 15–July 11: Cézanne, Hortense Fiquet, and their son stay with Renoir at La Roche-Guyon

Late August: In Paris

September–October: In Essoyes with Aline and Pierre

Fall: Occasional bouts of depression begin and continue throughout late 1880s

Early November: In Wargemont with Bérards

1886: February: Exhibits at Les Vingt, Brussels (eight works)

April 10–25: French Impressionist show, Madison Square South, New York City; show moves May 25–June 30, to National Academy of Design, New York City (thirty-eight works)

May 15–June 15: Does not exhibit at eighth Impressionist show

June 15–July 15: International Exhibition, Galerie Georges Petit, 8 rue de Sèze, Paris (five works)

July: In La Roche-Guyon with Aline and Pierre

August 1–October 1: In La Chapelle-St.-Briac with Aline and Pierre

October 15: Moves studio to 35 boulevard Rochechouart, Paris; destroys all paintings of past few months

Late December: In Essoyes with Aline and Pierre

1887: May 8–June 8: International Exhibition, Galerie Georges Petit (six works)

May 25–June 25: National Academy of Design, New York (seven works)

Summer: Paints Julie Manet's portrait in Paris

September 20: In Auvers with Aline and Pierre; meets Pissarro

1888: Durand-Ruel opens New York branch

February: With Aline and Pierre, visits Cézanne for several weeks in Jas de Bouffon; late February and March to Les Martigues, with brief trip to Louveciennes

April: In Cagnes

May 25–June 25: Pissarro, Renoir, Sisley exhibition, Galerie Durand-Ruel (twenty-four works)

November–December: In Essoyes with Aline and Pierre

Late December: First attack of rheumatoid arthritis

1889: Makes first etching based on drawn illustration of Mallarmé poem

Summer: Renoir, Aline, and Pierre rent house in Montbriant from Cézanne's brother-in-law

October: In Paris, problems with teeth

1890: January: Exhibits at Les Vingt, Brussels (five works)

March 6–26: Peintres-graveurs, Galerie Durand-Ruel (one etching)

April 14: Marries Aline Charigot in Paris; studio address given as 11 boulevard de Clichy

Spring Salon: *The Daughters of Catulle Mendès* (1888), the last work he sends to a spring Salon

July: In Essoyes with Aline and Pierre

September: With Aline and Pierre moves to house at 13 rue Girardon (6 Château des Brouillards); visits Morisot in Mézy

Fall: Aline has miscarriage

1891: Paul Gallimard begins to collect Renoirs

January 9–April 29: Toulon, Tamaris-sur-Mer (February–March), Les Martigues, Le Lavandou (April), Nîmes: part of time with Wyzewa, Aline, and Pierre; part of time alone

April 7: Chocquet dies

April 29: Returns to Paris

July: Galerie Durand-Ruel (1890–91 works)

Early July: In Mézy with Aline and Pierre; returns to Mézy in August and October

August 25: Durand-Ruel buys 3 dance panels (1883) for 7,500 francs each

September: In Petit Gennevilliers (near Argenteuil) with Caillebotte

1892: Attends Wednesday evening gatherings at Mallarmé's home

February–April: Paints Mallarmé's portrait

April 13: Eugène Manet dies

April 25: First French government purchase: *Girls at the Piano* (1892)

May 7–21: Largest one-man exhibition: Galerie Durand-Ruel, 9 boulevard de la Madeleine (one hundred ten works)

June 25: Denis writes review

Summer: In Spain with Gallimard

August–October: In Brittany: Pont-Aven, Noirmoutiers, Pornic

September 18: In Paris to attend Charles Durand-Ruel's funeral

October 15: Moves studio to 7 rue Tourlaque

1893: April 27: In Beaulieu with Aline and Pierre

May: In Paris

June: In Dieppe with Gallimard

July: Takes Aline and Pierre to Montebourg (Dune de St.-Marcouf)

August: In Pont-Aven with Aline and Pierre

October: Publishes first lithograph (of Pierre)

1894: Meets André

February 21: Caillebotte dies

April: Paints Berthe Morisot and daughter, Julie Manet

Summer: Fifteen-year-old Gabrielle Renard comes to be nursemaid; stays with family for nineteen years

September 15: Aline gives birth to Jean

1895: In Holland and London with Gallimard

March 2: Morisot dies; Renoir becomes guardian of Julie Manet

July 27: Caillebotte bequest accepted by French government (six Renoirs)

Summer: In Brittany with Aline, Pierre, Jean, and Gabrielle

August–September: Renoir invites Julie Manet and Jeanne and Paule Gobillard to Brittany

Fall: Renoir meets Vollard

1896: January–early March: Assists Julie Manet in planning and hanging Morisot's posthumous exhibition, Galerie Durand-Ruel

March 28–June 20: Renoir exhibition, Galerie Durand-Ruel (forty-two works)

Late summer: In Bayreuth at Wagner festival with Martial Caillebotte

July: Moves apartment to 33 rue de La Rochefoucauld; moves studio to 64 rue de La Rochefoucauld

November 12: Mother (age eighty-nine) dies

1897: February: Caillebotte collection opens to public at Palais du Luxembourg

Late summer: In Essoyes with family

Early September: In Essoyes falls off bicycle and breaks right arm (same accident as in 1880)

September 14–October 17: Julie Manet visits Renoirs in Essoyes

November and December: At Louvre gives painting lessons to Julie Manet, Jeanne and Paule Gobillard, and Jeanne Baudot

1898: May 29–June 16: Exhibition, Galerie Durand-Ruel; Durand-Ruel sends works to Guild Hall, London

Summer: In Berneval with family

Late summer: Buys house in Essoyes, where he will spend part of every year henceforth

Early September: In Louveciennes

September 9: Mallarmé dies at Valvins; Renoir takes Julie Manet and Jeanne and Paule Gobillard to his funeral

October: In Holland with Faivre, Bérard, and Joseph Durand-Ruel

1899: January–February: French exhibition in St. Petersburg (twelve works)

January 29: Sisley dies

February 1: Count Armand Doria sale; *Girl Thinking* (1877) sells for 22,100 francs

Mid-February–mid-April: In Cagnes and Nice

April 10–20: Impressionist exhibition, Galerie Durand-Ruel (forty-one works)

Summer: Rents house at 39 rue Gounod, St.-Cloud

July 29–August 12: Aline and children go to Essoyes and Renoir invites Julie Manet and Jeanne and Paule Gobillard to spend fifteen days with him

Mid-August: To Aix-les-Bains spa for two weeks

Early November: Renoir and Degas quarrel

December 22: In Grasse, where he remains with Gabrielle

1900: January–May: Remains in Grasse and is joined by Aline and Jean

January 25–February 10: Renoir exhibition, Galerie Bernheim-Jeune (fifty-nine works)

April: Exhibition with Monet, Durand-Ruel Gallery, New York (twenty-one works); other exhibitions, Berlin and Glasgow

April–June: Exposition Universelle, Paris (eleven works)

May: In Avignon and St.-Laurent-les-Bains

June: Wedding of Julie Manet and Ernest Rouart

August: In Louveciennes

August 16: Accepts appointment as *chevalier* of Legion of Honor

Mid-November: Returns to Grasse; visited by Valtat, D'Espagnat

1901: January–April: In Grasse, side trips to Magagnosc, Le Trayas (St.-Raphaël) Cannes

Late February: Redon visits

April: Hanover Gallery, London (nine works)

May: In Aix-les-Bains

July–August In Essoyes

August 4: Aline gives birth to Claude (Coco) in Essoyes

September: In Fontainebleau to paint portraits

Late September: In Paris and then to Essoyes

October: Moves apartment to 43 rue Caulaincourt; moves studio to 73 rue Caulaincourt

October 16–December 1: Exhibition, Paul Cassirer, Berlin (twenty-three works)

1902: Late January–April: In Le Cannet with Gabrielle and André

May: In Paris and Essoyes

June: Exhibition, Galerie Durand-Ruel (forty works)

September: Exhibition in Dresden (three works)

1903: January: Departure from Paris to Midi delayed because of foot treatment

February In Le Cannet

February–March: Exhibitions in Vienna and Budapest

April: Rents Villa de la Poste in Cagnes-sur-Mer, where he stays part of every year through 1908

Easter: Family comes to Cagnes for short visit

Mid-May: To Paris via Laudun with André

Summer: In Paris and Essoyes

Mid-November: In Marseilles en route to Cagnes, where he hears of Pissarro's death (November 13); returns to Paris for funeral

Late November–December: In Cagnes; faces problem of forged paintings and false signatures

1904: February 15: In Paris to deal with problems of forgeries

February 25–March 29: Exhibits at La Libre Esthétique, Brussels (twelve works)

Early March: In Cagnes; family comes during Easter

Spring: Maurice Denis and wife visit

May: In Laudun with André

June–July: In Paris

August: In Essoyes

August 12–September 12: Bourbonne-les-Bains with Aline, Jean, Coco, Gabrielle

October: Gangnat begins to collect Renoirs

October 15–November 15: Renoir room at Salon d'Automne, Paris (thirty-five works); exhibits in St. Louis (two works) and at Cassirer's gallery, Berlin

October–December: In Paris

Late 1904–early 1905: Executes twelve lithographs for Vollard

1905: Georges Charpentier dies

January–spring: In Cagnes

January–February: Large French exhibition, Grafton Galleries, London (fifty-nine works)

March: Paul Bérard dies

May 8–9: Bérard's collection sold at Galerie Georges Petit

Summer: In Paris and Essoyes

Late fall: In Cagnes with Gabrielle

1906: January–March: In Cagnes; Maurice Denis visits in March
March: Durand-Ruel sends works to Basel
June: In Paris; Rodin visits studio
Early August: In Essoyes
Late August: In Bourbonne-les-Bains
September: In Essoyes; Rivière visits
Mid-September: Maillol executes bust of Renoir
October: Salon d'Automne (one work)
October 22: Cézanne dies
December 4–late June, 1907: In Cagnes
1907: April 11: Charpentier sale; *Mme. Charpentier and Her Children* goes for 84,000 francs ($63,000) to the Metropolitan Museum, New York
June 28: Purchases property at Les Collettes, Cagnes-sur-Mer, and commissions construction of villa
Exhibitions in Prague (seven works), Krefeld (four works), Strasbourg (one work), Bernheim-Jeune (two works)
Early July: In Paris and Essoyes
December: In Cagnes
December 1907–January 1908: Exhibition of "Modern French Painting," City Art Gallery, Manchester, England (twelve works)
1908: Pach meets Renoir and talks with him over the next four years
March 24: Accepts membership in Royal Society of Brussels; Durand-Ruel sends twelve works to be exhibited in Brussels; also sends works to Cincinnati, London, and Zurich
May: Vollard visits Renoir in Cagnes and encourages him to do soft wax sculpture; Renoir makes two sculptures of Coco, the only sculpture entirely by his hands
May–June: Landscapes by Monet and Renoir exhibited Galerie Durand-Ruel, Paris (thirty-six works); also still lifes (forty-two works)
June: In Paris
Fall: Moves into villa at Les Collettes, Cagnes, where he lives for part of each year henceforth; Monet is one of first houseguests
November 14–December 5: Renoir exhibition, Durand-Ruel Gallery, New York (forty-one works)
Mid-November–June 1909: In Cagnes
1909: January: André visits in Cagnes
March: Paul Durand-Ruel visits in Cagnes
July: Begins writing preface to new edition of Cennino Cennini's *Il Libro delle'Arte* (Craftsman's Handbook)
December–May 1910: In Cagnes
1910: January: Durand-Ruel visits Cagnes
March: Denis visits Renoir, helps with Cennini essay (as does Rivière), and executes tiny painting of Renoir with Jeanne Baudot
June 1–June 25: Monet, Pissarro, Renoir, Sisley exhibition, Galerie Durand-Ruel (thirty-four works); other exhibitions in Brussels (two), Chicago, Paris, and Bremen
June 15: In Paris
Late summer: In Wessling (Germany) with entire family at Thurneyssens' home
Mid-September: In Paris
Mid-November: In Cagnes until July 1911
1911: First biography of Renoir published, by Meier-Graefe
Renoir's eight-page preface to Cennini's text published
July 6: In Paris
Fall: Moves studio and apartment to 57 bis boulevard Rochechouart
October 20: Accepts promotion to rank of *officier* of Legion of Honor
Early November: In Cagnes
Late November: Rents apartment in Nice
1912: Exhibitions: modern painting, Manzi-Joyant, Paris (twenty-seven works); French painting exhibition, St. Petersburg (thirty-two works); also in Frankfurt, Budapest, and Düsseldorf
January–March: Rents apartment in Nice and spends time in Grasse
February–March: Exhibition, Paul Cassirer's gallery, Berlin (forty-one works)
February 14–March 9: Exhibition, Durand-Ruel Gallery, New York (twenty-one works)

300

April 17–May 15: Exhibition, Galerie Durand-Ruel (seventy-one works)
May: Pach's article appears in *Scribner's Magazine*
May: In Cagnes
Late spring: Suffers stroke but recovers
June 5–June 20: Portraits exhibited, Galerie Durand-Ruel (fifty-eight works)
July–October: In Paris and Essoyes
November: In Cagnes
December: At Henri Rouart sale, *A Morning Ride in the Bois de Boulogne* sells for 95,000 francs
1913: January 15–February 15: Exhibition, Galerie Thannhauser, Munich (forty-one works); exhibitions also in Berlin, Dresden, and Stuttgart
February: Denis visits Renoir in Cagnes
Mid-February: New York Armory Show (five works)
March 10–29: Renoir exhibition, Galerie Bernheim-Jeune (fifty-two works), accompanied by book with fifty-eight critical pieces
April: Begins four-and-one-half-year sculptural collaboration with Guino
1914: January: Spends time in Nice and Grasse
January: Gabrielle marries and leaves Renoir household
February: In Cagnes
February 7–21: Renoir paintings, Durand-Ruel Gallery, New York (thirty works); other exhibitions: Kunsthalle, Bremen (eight works); Galerie Bernheim-Jeune, Paris (two works); Galerie Arnold, Dresden; Grosvenor House, London (ten works)
March: Rodin visits and poses for portrait commissioned by Bernheims
Late spring: Grandson Claude, son of Pierre, born to Véra Sergine
May–June: French exhibition, Statens Museum for Kunst, Copenhagen (twelve works)
Mid-June: Returns to Paris with Aline
August 3: Germany declares war on France; Pierre and Jean in military service
September 3: Renoir and Aline leave Paris for Cagnes
Late September: Pierre seriously wounded; Jean less seriously
1915: Early in year: Dédée becomes model
April 16: Jean seriously wounded after returning to combat
June 27: Aline (fifty-six years old) dies and is buried in Essoyes
Mid-July: Renoir goes to Paris, Jean leaves hospital and visits Renoir at boulevard Rochechouart
Late July: In Essoyes to work out plans for Aline's tomb with Guino; then returns to Paris
November 1–June 1916: In Cagnes
1916: Renoir directs Guino to execute six medallions
Early in year: Bonnard visits Renoir
March–April: Triennale, Paris, where Vollard sends cast of Renoir's large *Venus Victorious*
June 24: In Paris
July–September: In Essoyes
October 29–November 26: French exhibition, Winterthur, Switzerland (twenty-six works)
November–early July 1917: In Cagnes
1917: January 6–20: Renoir exhibition, Durand-Ruel Gallery, New York (eighteen works)
Late January: André visits; Jean comes home for week's leave
April 6: U.S. enters war
June–July: General exhibition, Paul Rosenberg Gallery, Paris (sixteen works)
Mid-July: In Paris
Summer: Receives tribute from one hundred English artists and collectors
August: In Essoyes, where Vollard visits
September: In Cagnes
September 26: Degas dies
October 5–November 14: General exhibition, Kunsthaus, Zurich (sixty works); other exhibitions in Barcelona (five works) and at Nationalmuseum, Stockholm (eight works)
November 17: Rodin dies
December: Collaboration with Guino ends

December: Matisse visits Cagnes

1918: January–February: General exhibition, Nasjonalgalleriet, Oslo (thirteen works)

January: André, Maleck, Bessons visit in Cagnes

February: André sends preface of his Renoir book to artist, published in 1919

February 19–March 9: Exhibition, Durand-Ruel Gallery, New York (twenty-eight works); also at Petit Palais, Paris

March: Vollard sends artist six hundred sixty-seven reproductions from first volume of book on Renoir

Mid-March: Cassatt visits Cagnes

September: Brief sculptural collaboration with Morel

November 11: Armistice ends war

1919: February 19: Accepts promotion to rank of *commandeur* of the Legion of Honor

April 5–19: Exhibition, Durand-Ruel Gallery, New York (thirty-five works); also at Petit Palais, Paris

Late July: In Essoyes with sons; Rivière visits

August: In Paris; carried through Louvre to see state's installation of *Mme. Georges Charpentier*

Late August: In Cagnes

November: Begins sculptural collaboration with Gimond

December 3: Dies at Les Collettes, Cagnes-sur-Mer; is buried next to Aline in Essoyes Cemetery

BIBLIOGRAPHY

Listed here are the writings that have been of use in the preparation of this book, but this is by no means a complete record of all the works and sources that have been consulted. It provides full documentation for previously published works; unpublished sources are given in full in the Notes. Any book, article, or review not listed below is cited in full in the Notes.

L'Abbaye, Librairie de. *Autographes & Documents Historiques.* Paris, n.d. Sale catalogues 215, 241, 243, 246, 247, 248, 261.

Adhémar, Hélène, with the collaboration of Sylvie Gache. *L'Exposition de 1874 chez Nadar (rétrospective documentaire).* Paris: Réunion des Musées Nationaux [1974]. Exhibition catalogue.

Alley, Ronald. *Tate Gallery Catalogues: The Foreign Paintings, Drawings, and Sculpture.* London: Tate Gallery, 1959. Exhibition catalogue.

André, Albert. *Renoir.* Paris: Crès, 1919, 1923.

————, and Elder, Marc. *L'Atelier de Renoir.* 2 vols. Paris: Bernheim-Jeune, 1931.

Apollinaire, Guillaume. *Apollinaire on Art: Essays and Reviews 1902–1918.* Edited by LeRoy C. Breunig and translated by Susan Suleiman. New York: Viking, 1972.

Baird, Joseph Armstrong, Jr., ed. *Pre-Impressionism: 1860–1869: A Formative Decade in French Art and Culture.* Davis: University of California Press, 1969. Exhibition catalogue.

Barnes, Albert C., and de Mazia, Violette. *The Art of Renoir.* Merion, Pa.: The Barnes Foundation Press, 1935.

Bataille, Marie-Louise, and Wildenstein, Georges. *Berthe Morisot: Catalogue des peintures, pastels et aquarelles.* Paris: Les Beaux-Arts, 1961.

Baudot, Jeanne. *Renoir: Ses Amis, ses modèles.* Paris: Éditions Littéraires de France, 1949.

Bell, Clive. *Since Cézanne.* London: Chatto & Windus, 1922.

Bellony-Rewald, Alice. *The Lost World of the Impressionists.* Boston: New York Graphic Society, 1976.

Bérard, Maurice. "Un Diplomate ami de Renoir." *Revue d'histoire diplomatique* (July–September 1956): 239–46.

————. *Renoir à Wargemont.* Paris: Larose, 1938.

Berès, Pierre. *Autograph Letters and Manuscripts 1576–1940.* New York City, 1941. Sale catalogue 5.

————. *Autographes anciens & modernes.* Paris, n.d. Sale catalogue 50.

Berhaut, Marie. *Caillebotte: Sa Vie et son oeuvre.* Paris: La Bibliothèque des Arts, 1978.

Besson, Georges. *Renoir.* Paris: Crès, 1929.

Blanche, Jacques-Émile. *La Pêche aux souvenirs.* Paris: Flammarion, 1949.

Bodelsen, Merete. "Early Impressionist Sales 1874–94 in the Light of Some Unpublished 'Procès-Verbaux.' " *Burlington Magazine* 110 (June 1968): 331–49.

Bodin, Thierry. *Les Autographes.* Paris, Spring 1980. Sale catalogue 7.

Boime, Albert. *The Academy and French Painting in the Nineteenth Century.* New York and London: Phaidon, 1971.

Braun, Galerie d'Art. *L'Impressionnisme et quelques précurseurs.* January 22–February 13, 1932. Paris. Exhibition catalogue.

————. *Renoir.* Paris, November 14–December 3, 1932. Exhibition catalogue.

Cabanne, Pierre, et al. *Renoir.* Paris: Hachette, 1970.

Cahiers d'Aujourd'hui. New series, no. 2 (January 1921), n.p. [Marie Le Coeur letters].

Callen, Anthea. *Renoir.* London: Oresko, 1978.

Cézanne, Paul. *Paul Cézanne, Correspondance.* Edited by John Rewald. Paris: Bernard Grasset, 1937.

Charavay, Étienne and Noel. *Lettres autographes et documents historiques.* Paris: Maison Jacques Charavay, October 1980. Sale catalogue. Also card-index.

Clergue, Denis-Jean. *La Maison de Renoir: Musée Renoir du Souvenir.* Cagnes-sur-Mer: R. Zimmermann, 1976.

The Collector: A Magazine for Autograph and Historical Collectors. New York: Walter R. Benjamin. June 1951: Sale catalogue 709. April 1952: Sale catalogue 718.

Cooper, Douglas. *The Courtauld Collection: A Catalogue and Introduction.* London: Athlone, 1954.

————. "Renoir, Lise and the Le Coeur Family: A Study of Renoir's Early Development," *Burlington Magazine* 101 (May, September–October 1959): 163–71, 322–28.

Daulte, François. *Alfred Sisley: Catalogue raisonné de l'oeuvre peint.* Lausanne: Durand-Ruel, 1959.

————. *Auguste Renoir.* Paris: Diffusion Princesse, 1974.

————. *Auguste Renoir: Catalogue raisonné de l'oeuvre peint.* Vol. 1: Figures 1860–1890. Lausanne: Durand-Ruel, 1971.

————. *Frédéric Bazille et son temps.* Geneva: Pierre Cailler, 1952.

Denis, Maurice. *Journal.* 3 vols. Paris: La Colombe, 1957–59.

————. *Théories, 1890–1910.* Paris: L. Rouart and J. Watelin, 1920.

Dorival, Bernard. *Les Étapes de la peinture française contemporaine.* 3 vols. Paris: Gallimard, 1943.

Drouot, Hôtel. Paris. Sale catalogues.

Catalogue des tableaux composant la collection Maurice Gangnat: 160 Tableaux par Renoir. Prefaces by de Flers, Robert, and Faure, Élie. June 24–25, 1925.

Autographes anciens et modernes. December 18, 1959.

Autographes et documents divers. June 19, 1970.

Collection particulière: Lettres et manuscrits autographes de peintres. June 10, 1974.

Collections Bignou: Lettres autographes d'artistes. June 6, 1975.

Collection de Monsieur X . . .: Lettres autographes de peintres des XIXe et XXe siècles, quelques-unes illustrées de dessins originaux. June 25, 1975.

Archives de Camille Pissarro. November 21, 1975.

Manuscrits et correspondance autographes. December 19, 1977.

Livres anciens et modernes, manuscrits, autographes. February 16, 1979.

Lettres et manuscrits autographes anciens et modernes. June 22, 1979.

Autographes littéraires, historiques, artistiques. June 11, 1980.

Drucker, Michel. *Renoir.* Paris: Pierre Tisné, 1944.

Duret, Théodore. *Histoire des peintres impressionnistes.* Paris: Floury, 1922.

————. *Renoir.* Paris: Bernheim-Jeune, 1924.

Eudel, Paul, ed. *Hôtel Drouot.* 9 vols. Paris: G. Charpentier, 1882–91. Sale catalogues.

Feldman, Franklin, and Weil, Stephen E. *Legal and Business Problems of Artists, Art Galleries and Museums: Sources and Materials.* New York: Practising Law Institute, 1973.

Fénéon, Félix. *Les Impressionnistes en 1886.* Paris: Publications de la Vogue, 1886. Reprinted in Fénéon. *Au-delà de l'Impressionnisme.* Paris: Hermann, 1966.

Florisoone, Michel. *Renoir.* Translated by George Frederic Lees. Paris: Hyperion, 1938. In English.

_____. "Renoir et la famille Charpentier: Lettres inédites." *L'Amour de l'Art* 19 (February 1938): 31–40.

Frère, Henri. *Conversations de Maillol.* Geneva: Pierre Cailler, 1956.

Gachet, Paul. *Deux Amis des impressionnistes: Le Docteur Gachet et Murer.* Paris: Éditions des Musées Nationaux, Paris, 1956.

_____. *Lettres impressionnistes.* Paris: Bernard Grasset, 1957.

Geffroy, Gustave. *Claude Monet: Sa Vie, son oeuvre.* 2 vols. Paris: Crès, 1924.

Gilot, Françoise, and Lake, Carlton. *Life with Picasso.* New York: McGraw-Hill, 1964.

Gold, Arthur, and Fizdale, Robert. *Misia: The Life of Misia Sert.* New York: Knopf, 1980.

Goldschmidt, Lucien. *Autograph Letters & Manuscripts.* New York City, 1954. Sale catalogue new series 4, special list 81.

Goldwater, Robert, and Treves, Marco, eds. *Artists on Art: From the XIVth to the XXth Century.* New York: Pantheon, 1945.

Gutekunst & Klipstein. *Künstler-Autographen von 1850 bis 1950.* Bern, May 14, 1958. Sale catalogue 89.

Haesaerts, Paul. *Renoir Sculptor.* New York: Reynal & Hitchcock, 1947.

Hugon, Henri. "Les Aïeux de Renoir et sa maison natale," *La Vie Limousine* (January 25, 1935): 453–55.

Huth, Hans. "Impressionism Comes to America." *Gazette des Beaux-Arts* 29 (April 1946): 225–52.

Impressionists and Some of Their Contemporaries. Basel: Beyeler, 1970. Exhibition catalogue.

Isaacson, Joel, et al. *The Crisis of Impressionism, 1878–1882.* Ann Arbor: University of Michigan Museum of Art, 1980. Exhibition catalogue.

Jamot, Paul. Preface to *Renoir.* Catalogue entries by Charles Sterling. Paris: Musée de l'Orangerie, 1933. Exhibition catalogue, 2 vols.

Jaques, Elliott. "Death and the Mid-Life Crisis." *International Journal of Psycho-Analysis* 46, pt. 4 (1965). Reprinted in Jaques. *Work, Creativity, and Social Justice.* New York: International Universities Press, 1970.

Joëts, Jules. "Lettres inédites: Les Impressionnistes et Chocquet." *L'Amour de l'Art* 16 (April 1935): 120–25.

Johnson, Una E. *Ambroise Vollard, Éditeur: Prints, Books, Bronzes.* New York: Museum of Modern Art, 1977. Exhibition catalogue.

Knoedler & Cie. *Cézanne Watercolors.* New York, April 1963. Exhibition catalogue.

Lambert, Jacques. *Autographes.* Paris. n.d. Sale catalogue 27.

Leroy, Alfred. *Histoire de la peinture française.* Paris: Albin Michel, 1934.

Lethève, Jacques. *Impressionnistes et symbolistes devant la presse.* Paris: Armand Colin, 1959.

Levinson, Daniel J. *The Seasons of a Man's Life.* New York: Knopf, 1978.

Lockspeiser, Edward. "The Renoir Portrait of Wagner." *Music and Letters* 18 (1937): 14–19.

Loliée, Marc. *Éditions originales anciennes et modernes, autographes, manuscrits.* Paris. 1936: Sale catalogue 61, no. 445 and 446. 1954–55: Sale catalogue 85.

Lövgren, Sven. *Genesis of Modernism: Seurat, Gauguin, Van Gogh, and French Symbolists in the 1880s.* Stockholm: Almqvist & Witsell, 1959.

Mallarmé, Stéphane. *Correspondance Mallarmé-Whistler.* Edited by Carl-Paul Barbier. Paris: A. G. Nizet, 1964.

_____. *Oeuvres complètes de Mallarmé.* Edited by Henri Mondor and G. Jean-Aubry. Paris: Gallimard, 1945.

_____. *Stéphane Mallarmé: Correspondance.* Edited by Henri Mondor and Lloyd James Austin. 7 vols. Paris: Gallimard, 1959–82.

Manet, Julie. *Journal (1893–1899).* Preface by Jean Griot. Paris: C. Klincksieck, 1979.

Marandel, J. Patrice, and Daulte, François. *Frédéric Bazille and Early Impressionism.* Catalogue entries by J. Patrice Marandel, letters translated by Paula Prokopoff-Giannini. The Art Institute of Chicago: March 4–April 30, 1978. Exhibition catalogue.

Maus, Madeleine-Octave. *Trente Années de lutte pour l'art.* Brussels: L'Oiseau Bleu, 1926.

Meier-Graefe, Julius. *Auguste Renoir.* Munich: R. Piper, 1911. French edition, translated by A. S. Maillet. Paris: Floury, 1912. Richly illustrated edition, Leipzig: Klinkhardt and Bierman, 1929.

Mirbeau, Octave. Preface to *Renoir.* Paris: Bernheim-Jeune, 1913. Includes fifty-eight reviews by other critics. Exhibition catalogue.

Moncade, C.-L. de. "Le Peintre Renoir et le Salon d'Automne" [interview], in *La Liberté de penser: La Revue démocratique* 10 (October 15, 1904), n.p.; in White, ed., *Impressionism in Perspective,* 21–24. Translated by Lucretia Slaughter Gruber.

Mondor, Henri. *Vie de Mallarmé.* 16th ed. Paris: Gallimard, 1941.

Monneret, Sophie. *L'Impressionnisme et son époque.* 4 vols. Paris: Denoël, 1978–81.

Moreau-Nélaton, Étienne. *Manet, raconté par lui-même.* 2 vols. Paris: Henri Laurens, 1926.

Morisot, Berthe. *Correspondance de Berthe Morisot.* Edited by Denis Rouart. Paris: Quatre Chemins-Éditart, 1950.

Morssen, G. *Autographes.* Paris, February 1962. Sale catalogue no. 258.

Muehsam, Gerd, ed. *French Painters and Paintings from the Fourteenth Century to Post-Impressionism: A Library of Art Criticism.* New York: Unger, 1970.

Niculescu, Remus. "Georges de Bellio, L'Ami des impressionnistes." *Revue Roumaine d'Histoire de l'Art* 1, no. 2 (1964): 209–78.

Pach, Walter. "Pierre Auguste Renoir." *Scribner's Magazine* 51 (January–June 1912): 606–15.

_____. *Renoir.* New York: Abrams, 1950.

Parke-Bernet Galleries. *Public Auction Sale.* New York City, October 31, November 1, 1961. Sale catalogue no. 2058.

Perruchot, Henri. *La Vie de Renoir.* Paris: Hachette, 1964.

Pissarro, Camille. *Camille Pissarro—Letters to His son Lucien.* Edited with the assistance of Lucien Pissarro by John Rewald. Santa Barbara and Salt Lake City: Peregrine Smith, 1981.

_____. *Camille Pissarro—Lettres à son fils Lucien.* Edited by John Rewald. Paris: Albin Michel, 1950.

_____. *Correspondance de Camille Pissarro. Vol. 1: 1865–1885.* Edited by Janine Bailly-Herzberg. Paris: Presses Universitaires de France, 1980.

Poulain, Gaston. *Bazille et ses amis.* Paris: La Renaissance du Livre, 1932.

Rauch, Nicolas. *Autographes, photographies anciennes, bibliographie, livres anciens, livres modernes.* Geneva, November 24–25, 1958. Sale catalogue no. 58.

Redon, Odilon. *Lettres d'Odilon Redon, 1878–1916.* Preface by M. A. Leblond. Paris and Brussels: G. van Oest, 1923.

Reff, Theodore. "Copyists in the Louvre, 1850–1870." *Art Bulletin* 46 (December 1964): 552-59.

Régnier, Henri de. *Renoir, peintre du nu.* Paris: Bernheim-Jeune, 1923; in Muehsam, ed., *French Painters.*

Rendells, The. *Autograph Letters, Manuscripts, Drawings: French Artists & Authors.* Newton, Mass., [1977]. Sale catalogue 129.

_____. *Autograph Letters, Manuscripts, Documents.* Newton, Mass., [1977]. Sale catalogue 130.

Renoir, Edmond. "Cinquième Exposition de 'la Vie Moderne.' " *La Vie Moderne,* no. 11 (June 19, 1879); in Venturi, *Archives,* 2:334–38.

Renoir, Jean. *Renoir.* Paris: Hachette, 1962.

_____. "Renoir My Father." *Look* 26 (November 6, 1962): 50–68.

Renoir, Pierre-Auguste ["Un Peintre"]. "L'Art décoratif et contemporain." *L'Impressionniste: Journal d'art* (April 28, 1877); in Venturi, *Archives,* 2:326–29.

_____. *Renoir: Carnet de Dessins—Renoir en Italie et en Algérie (1881–1882).* Preface by Albert André and Introduction by Georges Besson. 2 vols. Paris: Daniel Jacomet, 1955.

_____ ["Un Peintre"]. "Lettre au directeur de 'L'Impressionniste.' " *L'Impressionniste: Journal d'Art* (April 14, 1877); in Venturi, *Archives,* 2:321–22.

_____. "Lettre d'Auguste Renoir à Henry Mottez." In Cennino Cennini. *Le Livre de l'art ou traité de la peinture.* Translated by Victor Mottez, pp. v–xii. Paris: Bibliothèque de l'Occident, 1911.

_____. "Lettres de Renoir à Paul Bérard (1879–1891)." Edited by Maurice Bérard. *La Revue de Paris* (December 1968): 3–7.

Rewald, John. "Auguste Renoir and His Brother." *Gazette des Beaux-Arts,* 6th series, 27 (March 1945): 171–88.

_____. *Cézanne, Geffroy, et Gasquet: Suivi de souvenirs sur Cézanne de Louis Aurenche et de lettres inédites.* Paris: Quatre Chemins-Éditart, 1959.

_____. *The History of Impressionism*. New York: The Museum of Modern Art, 1973. 4th rev. ed.

_____. *Post-Impressionism from Van Gogh to Gauguin*. New York: The Museum of Modern Art, [1962].

_____. *Renoir Drawings*. New York and London: Thomas Yoseloff, 1958.

Rey, Robert. *La Renaissance du sentiment classique dans la peinture française à la fin du XIXᵉ siècle*. Paris: Les Beaux-Arts, 1929.

_____. "Renoir à l'École des Beaux-Arts." *Bulletin de la Société d'Histoire de l'Art Français* (1926): 33–37.

Rivière, Georges. "L'Exposition des Impressionnistes." *L'Impressionniste: Journal d'Art* (April 6, 1877); extract in White, ed., *Impressionism in Perspective*, 7–12. Translated by Lucretia Slaughter Gruber.

_____. "Renoir." *Art Vivant* (July 1, 1925): 1–6.

_____. *Renoir et ses amis*. Paris: Floury, 1921.

Robida, Michel. *Le Salon Charpentier et les impressionnistes*. Paris: La Bibliothèque des Arts, 1958.

Roger-Marx, Claude. *Renoir*. Paris: Floury, 1937.

Rouart, Denis. Introduction to *Berthe Morisot and Her Circle: Paintings from the Rouart Collection, Paris*. Art Gallery of Toronto, 1952. Exhibition catalogue.

Saffroy, Librairie Henri. *Autographes et documents historiques*. Paris, November–December 1979. Sale catalogue 106.

Schapiro, Meyer. "The Nature of Abstract Art." In *Modern Art: 19th and 20th Centuries, Selected Papers*, 185–211. New York: George Braziller, 1978. First published in *Marxist Quarterly* 1, no. 1 (January–March 1937): 2–23.

_____. *Paul Cézanne*. New York: Harry Abrams, 1962. 2d ed.

Scharf, Aaron, *Art and Photography*. Harmondsworth, England: Penguin, 1968.

Schneider, Marcel. "Lettres de Renoir sur l'Italie." *L'Âge d'Or—Études* 1 (1945): 95–99.

Shikes, Ralph E., and Harper, Paula. *Pissarro: His Life and Work*. New York: Horizon Press, 1980.

Sloane, Joseph C. *French Painting Between the Past and the Present: Artists, Critics, and Tradition from 1848 to 1870*. Princeton, N.J.: Princeton University Press, 1951.

Städtische Galerie, Munich. *Auguste Renoir*. 1958. Exhibition catalogue.

Stargardt, J. A. Marburg, Germany. Sale catalogues.

Autographen aus allen Gebieten. May 26–27, 1964. Catalogue 567.

Autographen aus allen Gebieten. November 24–25, 1964. Catalogue 570.

Autographen aus Verschiedenem Besitz. November 11–13, 1965. Catalogue 574.

Autographen aus allen Gebieten. February 16–17, 1971. Catalogue 595.

Autographen. June 10–11, 1980. Catalogue 620.

Sterling, Charles, and Salinger, Margaretta M. *French Paintings: A Catalogue of the Collection of the Metropolitan Museum of Art*. Vol. 3. New York: The Metropolitan Museum of Art, 1967.

Tabarant, Adolphe. *Pissarro*. Paris: Rieder, 1924; New York and London: Dodd, Mead, 1925.

_____. "Suzanne Valadon et ses Souvenirs de modèle." *Le Bulletin de la Vie Artistique* (December 15, 1921): 626–29.

Thiébault-Sisson, François. "Claude Monet" [interview]. *Le Temps* (November 27, 1900); quoted in Rewald, *Impressionism*, 197.

Varnedoe, J. Kirk T. "The Artifice of Candor: Impressionism and Photography Reconsidered." *Art in America* 68 (January 1980): 66–78.

_____, and Lee, Thomas P. *Gustave Caillebotte: A Retrospective Exhibition*. Houston: Museum of Fine Arts, 1976. Exhibition catalogue.

Venturi, Lionello. *Les Archives de l'Impressionnisme: Lettres de Renoir, Monet, Pissarro, Sisley et Autres. Mémoires de Paul Durand-Ruel. Documents*. 2 vols. Paris and New York: Durand-Ruel, 1939. Reprint. New York: Burt Franklin, 1968.

_____. *Cézanne: Son Art et son oeuvre*. 2 vols. Paris: Paul Rosenberg, 1936.

Verhaeren, Émile. *Sensations*. Paris: Crès, 1927.

Viallefond, Geneviève. *Le Peintre Léon Riesener (1808–1878)*. Paris: Albert Morancé, 1955.

Vollard, Ambroise. *Auguste Renoir*. Paris: Crès, 1920.

_____. *Tableaux, Pastels et Dessins de Pierre-Auguste Renoir*. 2 vols. Paris: Ambroise Vollard, 1918, n.d.

Weisberg, Gabriel P. "Jules Breton, Jules Bastien-Lepage and Camille Pissarro in the Context of 19th-Century Peasant Painting and the Salon," *Arts Magazine* (February 1982): 115–19.

_____. "Jules Breton in Context," in H. Sturges. *Jules Breton and the French Rural Tradition*, 30–42. Omaha: Joslyn Art Museum, 1982. Exhibition catalogue.

_____. *The Realist Tradition: French Painting and Drawing 1830–1900*. Cleveland and Bloomington: The Cleveland Museum of Art in cooperation with Indiana University Press, 1981. Exhibition catalogue.

_____, ed. *The European Realist Tradition*. Bloomington: Indiana University Press, 1983.

White, Barbara Ehrlich. "An Analysis of Renoir's Development from 1877 to 1887." Ph.D. diss., Columbia University, 1965.

_____. "The *Bathers* of 1887 and Renoir's Anti-Impressionism." *Art Bulletin* 55 (March 1973): 106–26.

_____. "Renoir's Sensuous Women." In Thomas B. Hess and Linda Nochlin, eds. *Woman as Sex Object: Studies in Erotic Art, 1730–1970*, 166–81. New York: Newsweek, 1972.

_____. "Renoir's Trip to Italy." *Art Bulletin* 51 (December 1969): 333–51.

_____, ed. *Impressionism in Perspective*. Englewood Cliffs, N.J.: Prentice-Hall, 1978.

White, Harrison C., and White, Cynthia A. *Canvases and Careers: Institutional Change in the French Painting World*. New York: John Wiley, 1965.

Wildenstein, Daniel. *Claude Monet: Biographie et catalogue raisonné*. 3 vols. to date. Paris-Lausanne: Bibliothèque des Arts, 1974–79.

Wyzewa, Téodor de. "Pierre-Auguste Renoir." *L'Art dans les deux mondes* (December 6, 1890). Reprinted with additions in Téodor de Wyzewa. *Peintres de jadis et d'aujourd'hui*. Paris: Perrin & Cie., 1903.

Wyzewska, Isabelle. *La Revue Wagnérienne: Essai sur l'interprétation esthétique de Wagner en France*. Paris: Librairie Académique, 1934.

Zola, Émile. *Émile Zola—Salons*. Edited by F. W. J. Hemmings and Robert J. Niess. Geneva and Paris: Librairie Droz and Librairie Minard, 1959.

311

NOTE ON THE ILLUSTRATIONS

Unless otherwise specified, all paintings are oil on canvas. Height precedes width in the dimensions. Paintings bearing a date affixed by Renoir are designated with a "d."

PHOTOGRAPH CREDITS AND ACKNOWLEDGMENTS

The author and publisher would like to thank the following people, who kindly helped to locate paintings, provide photographs, and arrange photography. Without their assistance, this book would not have been possible:

William Acquavella and Lynn W. Hanke, Acquavella Galleries, New York; Ernst Beyeler, Galerie Beyeler, Basel; Shelagh Coogan, Sotheby's, New York; Guy-Patrice Dauberville, Bernheim-Jeune & Cie., Paris; Philippe Gangnat, Paris; Ay-Whang Hsia, Wildenstein & Co., New York; Nancy Little, M. Knoedler & Co., New York; Dr. Peter Nathan and Helga Richter-Friederich, Galerie Nathan, Zurich; Yoshiko Nihei, Harry N. Abrams, Inc., Tokyo; Jean Dominique Rey, Paris; Robert Schmit, Galerie Schmit, Paris; David Somerset and Mary Giffard, Marlborough Fine Art (London) Ltd.; S. Martin Summers and Desmond L. Corcoran, Lefevre Gallery, London; Eddi Wolk, Christie's, New York.

The author and publisher would also like to thank the following collectors, photographers, and institutions for providing the photographs on the pages listed after each name:

A. C. Cooper Ltd., London, 126; Acquavella Galleries, New York, 48, 248; AgNO3, Besançon, 276 right; Alpha-Fotostudio & Werbefotografie, Essen, 27; © Arch. Phot. Paris/ S.P.A.D.E.M., 92 top, 177, 200; ARIXU MAS, Barcelona, 236 bottom right; Atelier de L'Épine, Michel Vuillemin, 213 top; J. Babinot, Reims, 49; Photograph © 1984 The Barnes Foundation, 75, 102 left, 118 bottom, 143, 178, 180–81, 184 top, 188, 197 top, 207, 209 top, 230 both, 273, 277 left; Bernheim-Jeune & Cie., Paris, 220 top, 221 top, 221 bottom left, 272 right, 274–75; Jacqueline George Besson, Paris, 222 bottom, 227 top left, 241; Galerie Beyeler, Basel, 117 top; Bibliothèque Nationale, Paris, 90 top left, 222 top; Bildarchiv Preussischer Kulturbesitz, Berlin 148–49; Joachim Blauel/Artothek, Planegg, 100; Bridgeman Art Library, London, 54 top; Will Brown, Philadelphia, 229 top left; Bulloz, Paris, 146, 170 top, 185 top, 189 top, 244, 286; Christie's, New York, 79 left; Denis-Jean Clergue, Les Collettes, Cagnes-sur-Mer, 238–39; Michel De Lorenzo, Nice, 228 top; Deutsche Fotothek Dresden, 40 top; A. E. Dolinski Photographic, San Gabriel, 81; Durand-Ruel & Cie., Paris, 78 right, 94 right, 117 bottom right, 128 bottom, 147, 158 top, 163 top, 168 bottom right, 175 both, 209 bottom, 224, 256 top left; Philippe Gangnat, Paris, 247; Giraudon, Paris, 24 top, 85 top, 90 top right, 103 top, 106 top, 223 bottom right, 226 top left, 226 bottom left, 251, 256 bottom left, 256 right; Hachette, Paris, 24 bottom, 220 bottom, 223 top left, 268, 272 left; Harlingue-Viollet, Paris, 192 left, 239, 240; R. H. Hensleigh, Detroit, 144; H. Humm, Zurich, 20, 56, 183; Fondation Custodia, Institut Néerlandais, Paris, 242, 281; Anahid Iskian, New York, 269; Ralph Kleinhempel, Hamburg, 46; Lefevre Gallery, London, 124 right; M. Knoedler & Co., New York, 33 top, 47 bottom, 58 bottom, 60 top left, 90 bottom, 127 top, 184 bottom, 199, 217, 219, 225, 226 bottom right, 229 bottom, 234 top left, 234 top right, 236 top, 237, 260, 261, 277 right; Marlborough Fine Art (London) Ltd., 113, 160 bottom left; The Metropolitan Museum of Art, New York, 43 right; Musée National de la Légion d'Honneur, Paris, 218 bottom; Musée Renoir, Les Collettes, Cagnes-sur-Mer, 276 left; Musées Nationaux, Paris, 8, 17 left, 25, 32 both, 64, 69–70, 76–77, 88 bottom, 91 top right, 91 bottom, 95 bottom, 109 both, 138, 139, 141, 150 top, 151, 173 bottom, 174 both, 186 top, 193 left, 205 bottom, 208 bottom, 211 bottom, 228 bottom; Galerie Nathan, Zurich, 14 top right, 159; National Gallery of Art, Washington, D.C., Rosenwald Collection, 201 both; Otto Nelson, New York, 21 top; Gallery Nichido, Tokyo, 214; The Pierpont Morgan Library, New York, 87; Beatrice Richard, Essoyes, 284; Roger-Viollet, Paris, 208 top; Denis Rouart, Paris, 192 right; Georges Routhier, Paris, 44 right, 128 top right, 160 top left, 235 top right, 253 top, 279; John D. Schiff, New York, 15; Galerie Schmit, Paris, 130; Schweizerisches Institut für Kunstwissenschaft, Zurich, 16 top, 128 top left; Sirot-Angel, Paris, 152; Sotheby's, New York, 14 left, 215, 231; Walter Steinkopf, Berlin, 33 bottom; Joseph Szaszfai, Hartford, 59 bottom; Henri Tabah, Paris, 170 center; Toppan Photo Studio, Tokyo, 278; O. Vaering, Oslo, 129 bottom right; Annette Vaillant, Paris, 213 bottom; Étienne Weill, Paris, 38, 198; Wildenstein & Co., Inc., New York, 60 top right, 170 bottom; Ole Woldbye, Copenhagen, 66.